Spotlights

Collected by the
Mildred Lane
Kemper
Art Museum

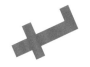
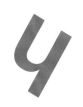

Edited by
SABINE ECKMANN

Essays by

Bradley Bailey

Matthew Bailey

Marisa Anne Bass

Svea Bräunert

Karen K. Butler

Bryna Campbell

Elizabeth C. Childs

Paul Crenshaw

John J. Curley

Sabine Eckmann

Ryan E. Gregg

Keith Holz

Rachel Keith

John Klein

Meredith Malone

Catharina Manchanda

Angela Miller

Erin Sutherland Minter

Eric Mumford

Michael Murawski

Jennifer Padgett

Noelle C. Paulson

Anne Popiel

Matthew Robb

Lynette Roth

Ila N. Sheren

Kelly Shindler

Allison Unruh

Anna Vallye

James A. van Dyke

Elizabeth Wyckoff

Orin Zahra

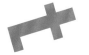

Collected by the Mildred Lane Kemper Art Museum

Mildred Lane Kemper Art Museum

Sam Fox School of Design & Visual Arts

Washington University in St. Louis

CONTENTS

SPOTLIGHTS

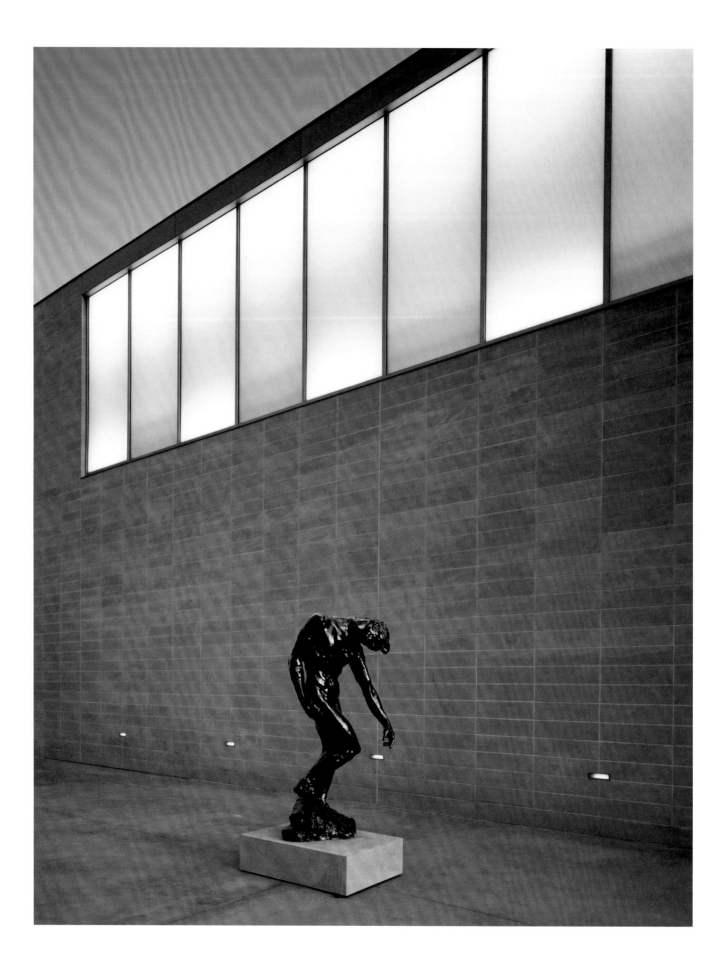

Dean's Foreword

It is an exciting moment as we celebrate the ten-year anniversary of the opening of the Mildred Lane Kemper Art Museum building as part of the Sam Fox School of Design & Visual Arts, which brings together the art museum and schools of art and architecture at Washington University in St. Louis. The Kemper Art Museum traces its history back to 1881, when it was founded as part of the University's School and Museum of Fine Arts and began to amass its celebrated collection. This is a fitting occasion to share the Museum's legacy of collecting significant works of art over the last 135 years.

When contemplating the move to St. Louis in 2005 to become the first dean of the Sam Fox School, I was particularly intrigued by the chance to help steward this extraordinary collection. Ten years later it remains thrilling to be close to the objects and to work with Director Sabine Eckmann, the curatorial team, and the collections committee to shape and grow this body of art, building on our strengths in modern and contemporary art.

As dean I am constantly reminded of how fortunate we are to have this remarkable resource. The collection supports a wide range of study in the humanities, social sciences, and medicine across campus and beyond, particularly enriching the interdisciplinary study of art, architecture, and design that is central to the mission of the School. One of my favorite ways of welcoming people to campus—from out-of-town visitors, to people from the local community, to students and their families, not to mention the many scholars and historians— is to walk through the galleries with them. I always enjoy seeing them discover the high caliber of the paintings, sculptures, prints, drawings, photographs, and videos on view.

As the E. Desmond Lee Professor for Collaboration in the Arts, I consider the Spotlights program to be a prime example not only of the cultural value of the collection but also of the benefits of collaborative study and learning. As the essays demonstrate, scholars throughout the region participate. Represented is expertise from the area's leading arts institutions as well as the many other universities and colleges in and around St. Louis, in addition to the intellectual wealth of Washington University. I am truly grateful for such broad participation and for how these unique interpretations collectively illuminate the history of art, past and present.

A university museum is likewise the result of great collaboration. Of the many donors, collectors, and community leaders who have supported the Kemper Art Museum throughout its history, I want to thank especially the Steinberg Weil family, whose deep investment over generations has helped build and sustain this important institution. In the last decade Anabeth and John Weil have played pivotal roles as chairs of the Museum's Art Collection Committee and the School's National Council, respectively. They are a dynamic force, and I am truly grateful for their passion and extraordinary support. My heartfelt gratitude goes as well to the Kemper family— James M. Kemper Jr., David Kemper, Julie Kemper Foyer, Jonathan Kemper, and Laura Fields Kemper, the late daughter of James Kemper Jr. and Mildred Lane Kemper. Their ongoing generosity, which launched the new era ten years ago, continues today, and I look forward to many years of friendship to come as we enter the next phase of our growth and the expansion of the Museum's galleries. The shared view that a university museum offers a unique opportunity to educate and provoke conversation is something that Jim Kemper inspires in us all. I also extend deep thanks to all the dedicated individuals from campus and beyond who have helped shape the collection, especially those listed on pages 268 and 269.

I am very proud of the collaboration between the Sam Fox School and the Kemper Art Museum, which is truly unique and special. This publication attests to the remarkable leadership of Sabine Eckmann, both as director and as chief curator. It is always a pleasure to work with her. And last but far from least I want to thank Chancellor Mark S. Wrighton. Our collaborative endeavors would not have been possible without his vision and commitment over the past ten years.

Carmon Colangelo
Dean, Sam Fox School of Design & Visual Arts
E. Desmond Lee Professor for Collaboration in the Arts

Auguste Rodin (French, 1840–1917), *The Shade*, 1880. Bronze, 74 1/4 × 35 1/2 × 31". Gift of Morton D. May in honor of William N. Eisendrath, Jr., 1968; installation view, Florence Steinberg Weil Sculpture Plaza, Mildred Lane Kemper Art Museum, 2006.

Director's Foreword

This collection of Spotlight essays is the result of the sustained labor of years of research, writing, and public discussion about the collection of the Mildred Lane Kemper Art Museum. Its publication coincides with the celebration of a decade of thought-provoking exhibitions, stimulating public engagement, and new ways of thinking about both art and the world around us. The Spotlight series is an ongoing project that began when the Mildred Lane Kemper Art Museum moved into Fumihiko Maki's elegant modernist building, which opened to the public in the fall of 2006. We invite Washington University faculty, postdoctoral fellows, and graduate students—particularly from the Department of Art History & Archaeology in Arts & Sciences and from the Sam Fox School of Design & Visual Arts—as well as our own curators and outside art historians to research an artwork of their choice within their area of specialization. The findings are presented in public talks, and the essays are made available on the Museum's website. As we approached our tenth anniversary in the new museum building, we decided that the time was long overdue to publish in print a selection of these essays as well as some that we newly commissioned. Departing from a conventional "masterpieces" format—the choice of artworks is based on the research interests and expertise of each author—this catalog offers an array of diverse scholarly voices and perspectives on an equally diverse range of works from the permanent collection.

For a teaching museum within a major research university, this approach to scholarship on the collection, reflecting academic strengths and intellectual curiosity, is appropriate insofar as it supports the aim of expanding art history beyond established canons and preconceived narratives. As my introductory essay explains, the intention to probe and further develop the history of art— particularly modern and contemporary art—is also evident in the ways in which the collection itself has been presented in thematic constellations. These installations traced artistic responses to major sociopolitical transformations brought about by modernization and globalization.

The Mildred Lane Kemper Art Museum is one of the oldest collecting university museums in this country. It opened in 1881 as the St. Louis School and Museum of Fine Arts, part of Washington University. From the beginning the Museum has focused on acquiring the significant art of its time. The introduction includes an account that delves into significant chapters of the Museum's history and collecting goals. The contributions of such leaders as Halsey C. Ives, who conceived of this teaching museum following the social ideals of John Ruskin and the British Arts & Crafts movement, are foregrounded. This also includes the German émigré art historian and Renaissance scholar H. W. Janson and his acquisitions of predominantly European modernism, establishing Washington University's museum as a gallery of modern art; the Renaissance specialist Frederick Hartt, who during and after World War II served with the Monuments Men, rescuing looted and displaced art throughout Europe, and who was one of the first to acquire Abstract Expressionist art in St. Louis; and William N. Eisendrath Jr., whose institutional influence extended from acquisitions of international postwar abstraction to an energetic modern and contemporary exhibition program.

Following the footsteps of such bold and innovative museum leaders over the last decade has been a very special honor and exceptionally rewarding. I have also had the pleasure to work with a dedicated and open-minded staff that made this and many other projects a reality. Curators Catharina Manchanda (2006–8), Karen K. Butler (2009–15), Meredith Malone, and Allison Unruh contributed in critical ways to this catalog with their scholarly expertise, patience, and intellectual rigor. My sincere appreciation and thanks are due to Jane Neidhardt for her astute editing of the essays collected in this catalog, for her incisive communication with all thirty-two authors, and for her oversight of the entire project. Designer Michael Worthington deserves all the credit for bringing such a wide range of texts into a visually coherent whole. He, freelance editor Karen Jacobson, and Holly Tasker in the Museum's publications office were a critical part of the team. Needless to say, without the important and

perceptive contribution of the authors this catalog would not exist. My special thanks are therefore due to Bradley Bailey, Matthew Bailey, Marisa Anne Bass, Svea Bräunert, Karen K. Butler, Bryna Campbell, Elizabeth C. Childs, Paul Crenshaw, John J. Curley, Ryan E. Gregg, Keith Holz, Rachel Keith, John Klein, Meredith Malone, Catharina Manchanda, Angela Miller, Erin Sutherland Minter, Eric Mumford, Michael Murawski, Jennifer Padgett, Noelle C. Paulson, Anne Popiel, Matthew Robb, Lynette Roth, Ila N. Sheren, Kelly Shindler, Allison Unruh, Anna Vallye, James A. van Dyke, Elizabeth Wyckoff, and Orin Zahra. I am also grateful to the Museum staff who helped make this publication possible, in particular Kim Broker, Kristin Good, and Molly Moog.

At a time when the humanities are facing some of their biggest challenges nationally and internationally, I cannot overstate my gratitude for the unfettered support of Washington University for its museum. I am especially indebted to Chancellor Mark S. Wrighton, Provost Holden Thorp, and Executive Vice Chancellor for Administration Henry (Hank) Webber, who over and over again have demonstrated their commitment to the Museum and its programs.

This catalog also marks a decade of collaboration between the Sam Fox School of Design & Visual Arts and the Museum. It has been a period of growth, experimentation, and innovation, evidenced by new programs such as faculty-curated exhibitions and a slate of architecture and design exhibitions, to name just two examples. My heartfelt thanks go to Carmon Colangelo, E. Desmond Lee Professor for Collaboration in the Arts and dean of the Sam Fox School, for his collaborative spirit, critical voice, and unflagging enthusiasm for the Museum and its diverse programs. It is a rewarding and productive collaboration.

Lastly, without our supporters the Museum would not thrive as it does. I am very grateful to the Kemper family, especially James M. Kemper Jr., David Kemper, and Julie Kemper Foyer. Their foundational support established the endowment of my position, enables the Museum's exhibition and acquisition programs, and will in the next few years make possible the coming expansion of the Museum building and its display galleries.

The Museum's growth and success have occurred under the critical leadership of both John Weil of the Sam Fox School's National Council and Anabeth Weil of the Museum's Art Collection Committee. Their deep investment in the development of the School and Museum are instrumental. In addition heartfelt thanks are due to those whose ongoing support of and participation in the Museum and its activities have helped make this past decade possible, including the committee members and donors to the collection listed on pages 268 and 269. The growth of the collection as well as the exhibition and public education programs would not happen without their remarkable involvement.

Sabine Eckmann, PhD
William T. Kemper Director and Chief Curator

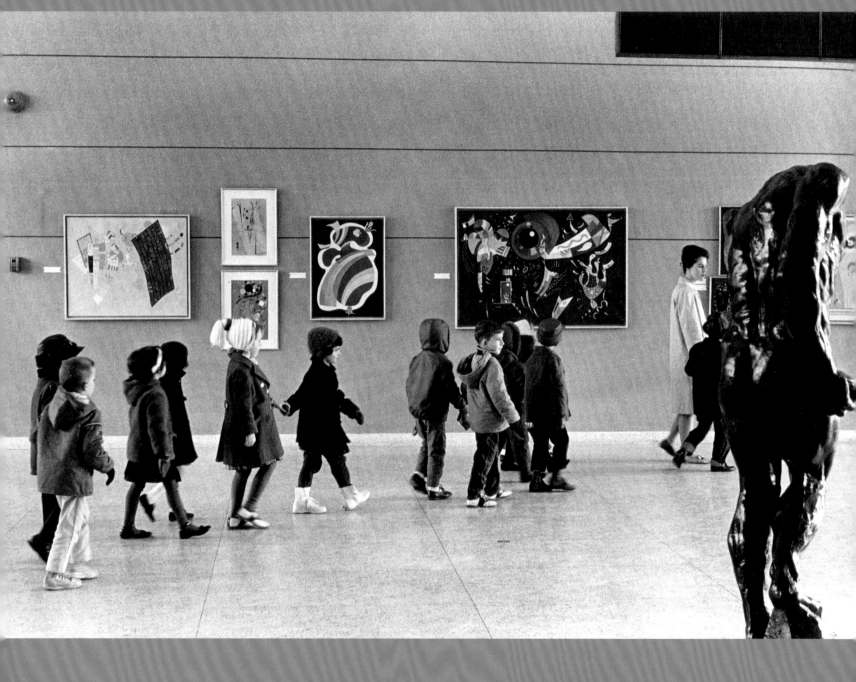

FIG. 1.
Schoolchildren visit *Vasily Kandinsky (1866–1944)—
A Retrospective Exhibition*, Washington University Gallery
of Art, Steinberg Hall, 1964.

Introduction; or, The (Re)Making of Art History

Sabine Eckmann

Spotlights

The book at hand has an unusual format for a collection catalog, which most often comprises a selection of so-called masterpieces, those artworks in a museum collection deemed of highest quality. By contrast this catalog is an experiment, devoted to ongoing and new research rather than to canonized artworks and their established positions within the history of art. It offers a substantial variety of voices and methodological approaches to interpreting fifty artworks in the Museum's collection. Scholars both established and emerging, from campus and beyond, have investigated paintings, sculptures, prints, videos, and photographs ranging in date from the thirteenth to the twenty-first centuries.

Although the artworks explored in these essays by more than thirty authors do not constitute a selection of "masterpieces," they do represent areas of strength and depth in the collection: French and American nineteenth-century art, such as Narcisse Virgile Diaz de la Peña's *Wood Interior* (1867) and Frederic Edwin Church's *Sierra Nevada de Santa Marta* (1883); European and American modernism, such as Max Beckmann's *Les artistes mit Gemüse* (*Artists with Vegetable*, 1943) and Jackson Pollock's *Sleeping Effort* (1953); and increasingly global contemporary practices, as exemplified by the recently acquired works by Yto Barrada, *Landslip, Cromlech de Mzora* (2001) and *Tunnel—Disused Survey Site for a Morocco–Spain Connection* (2002). Also examined are artworks acquired in the last ten years by other leading contemporary artists, including Nicole Eisenman, Olafur Eliasson, Andrea Fraser, and Carrie Mae Weems. Lastly, important historical artworks such as the Native American *Repoussé Plaques* (c. 1200–1400), Albrecht Dürer's *Melencolia I* (1514), and Rembrandt van Rijn's *The Three Crosses* (1653) are discussed.

Art History on Display

This discursive and collaborative engagement with collection research and interpretation is mirrored in the ways in which the artworks were exhibited over the past ten years. Guided by the mission-driven notion that a university museum should make connections between art (both contemporary and historical) and broader sociopolitical, ideological, philosophical, and phenomenological contexts, the artworks were always installed in thematic clusters. Considering the collection's strengths in nineteenth-, twentieth-, and twenty-first-century art, it seemed important to ask how the conditions of modernization are manifested in these artworks. It was our goal to trace shifting notions of subjectivity and self as they are addressed in modern and contemporary art in order to better understand fundamental questions that are raised by artists in the face of radical social, political, economic, and technological changes.

For example, we highlighted how landscape painting gained in popularity in the nineteenth century and became a subject for projection and interpretation. Nature was conceived as wilderness—in need of being civilized, cultured, historicized, or domesticated—yet it was also seen as providing a retreat from the alienating experiences of the modern city and served as an imprint of the unconscious imagination. The display also explored abstraction (fig. 2), the celebrated invention of the early twentieth century. We visualized how it has been interpreted as both the epitome of originality and creative subjectivity, especially in relation to Abstract Expressionism, and the complete loss thereof through an emphasis on the phenomenological nature of the painting process itself, or the use of rational systems of order (such as the grid) that suggest the subordination of artistic creativity to a technologized reality. Focusing on the everyday, we demonstrated how the modern subject collides with the world of objects. With the invention of the readymade, collage, and assemblage came the

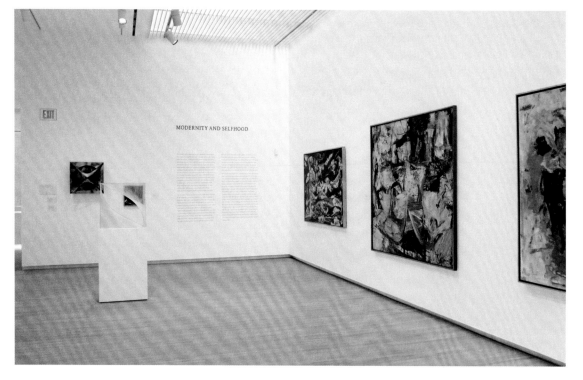

Fig. 2.
Installation view, *Abstraction* section, Bernoudy Permanent Collection Gallery, Mildred Lane Kemper Art Museum, 2006.

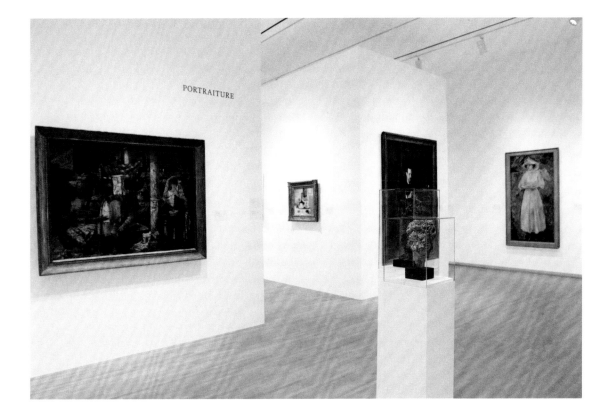

integration of quotidian materials into the artwork, challenging the very foundation of the institution of art. The use of everyday objects seemed to offer a way to bridge the gap between art and life, yet it also demonstrates how the external world of things shapes human subjectivity. Looking at portraiture (fig. 3), we foregrounded how the artist's "I" and relation to the other is negotiated through the conception, questioning, and alteration of individualism. While some artworks still assume an unfettered notion of the self, others complicate such ideas through distortions and fragmentations or replace human likeness with insignia and found images. Implied in such artistic approaches is the persistent question of how (and whether) one can lay claim to subjectivity, human agency, and self-realization in an era of rapid modernization.

While this organization of the permanent collection allowed for a nonchronological and cross-cultural installation that was especially appropriate for a university museum, after some years it appeared limited, as it lacked the possibility of probing conceived narratives of modern art. In 2010 the curatorial team reorganized the presentation of the collection in a way that would complicate well-known and often teleological conceptions of modern art, such as the progressive development from figuration (the various forms through which artists imitate and interpret the visible world) to abstraction. According to this narrative, art, especially painting, ultimately abandons all ties to reality, or the "real." In fact, throughout the era of modernism proper, the notion of art as an autonomous endeavor gained amplified attention. The thematic section of the permanent collection installation *Abstract | Real* (fig. 4) probed this trajectory by illuminating dialogical relations, even tensions, between abstraction and elements that either imitate or are derived from the real. Although some early twentieth-century artworks at first glance seem solely to visualize various abstract and geometric patterns, in the context of

the artists' writings and research they in fact can be understood as alluding to experiential reality. Playfully appropriating technological schematics and nonobjective structures that facilitated the advancements of modernization, many modern artists were inspired to create new worlds, with often utopian visions of society. In the aftermath of World War II, particularly in Europe, artists became interested in the body, rather than the intellectual mind, as a medium for shaping the creative process. Embodied painting, conceived as a move away from traditional notions of the artist as a willful and autonomous creator, typically emphasizes the physicality of the artistic process. Also manifesting the unconscious, such abstraction was an attempt to give form to the struggle over what it means to be human in an era of unprecedented violence and destruction. *Abstract | Real* brought together these and other thematic groupings that were meant to stimulate new dialogues between abstraction and figuration,

nonobjectivity and everyday materials, artistic subjectivity and the loss thereof.

The theme *Body | Self* (fig. 5) moved beyond the genre of portraiture to investigate tensions between representations of the physical body and shifting understandings and experiences of the self. *Body | Self* was divided into two categories of artworks: those that emphasize the human figure in terms of negotiations between individual subjectivity and social identity, and those that employ the body to visualize broader cultural or political aspects of the human condition. Several of the selected works engage concepts of identity and individuality through the traditional painted portrait. The genre of portraiture has historically served a key representational function, as a marker of class, rank, and social standing. It has also been employed to express a state of mind or to mediate the ways in which modernity and technology affect subjectivity. Fidelity to likeness,

Fig. 4. Installation view, *Abstract | Real* section, Bernoudy Permanent Collection Gallery, Mildred Lane Kemper Art Museum, 2011.

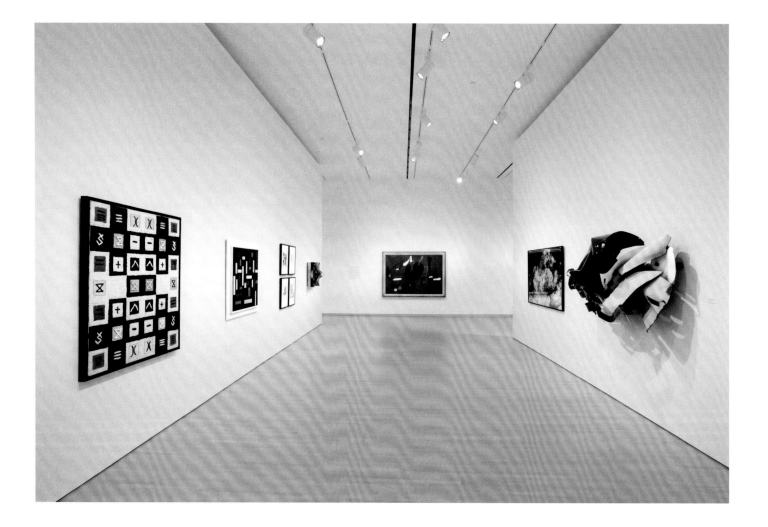

for instance, has often been superseded by experimentation with form and material in which the body is represented as fragmented, distorted, obscured, or abstracted, reflecting a modern understanding of selfhood as vulnerable and contingent rather than fixed and unified.

Insofar as culture is the creation of humans, nature is often considered to be outside the realm of the man-made. But while artists have long used nature as inspiration, subject, and allegory, it has never been a neutral construct. Rather, there are well-developed aesthetic codes for conveying "naturalness" and nature, at the heart of which lies the assumption that nature derives its meaning or value in opposition to notions of civilization and culture. The installation of *Nature | Culture* (fig. 6) reconsidered the genre of landscape painting and its expansion into photography and video. Throughout the modern era artists have consistently turned to landscape as a site of refuge from the onslaught of

modernization and the rise of cities. Especially in the nineteenth century the countryside was often depicted as a pastoral retreat, a wilderness imbued with spiritual elements, and a world untouched by civilization. Yet artists also embraced modern technologies and the built environment, integrating new mediums and incorporating new subject matter in ways that reflect the transformations taking place in the world around them. Still others turned to landscape to explore inner psychological states, using unconventional means to tap into what was perceived as untouched or primordial. Lastly, attention to the material conditions of art-making— to gesture, color, and texture—also became ways of likening artistic practice to natural processes.

Following these different yet related approaches to thematic installations, which focused on notions of the new and ever-changing signifiers of the modern era, we are now, for the Museum's tenth anniversary in the current building, returning to

Fig. 5.
Installation view,
Body | Self section,
Bernoudy Permanent
Collection Gallery,
Mildred Lane Kemper
Art Museum, 2011.

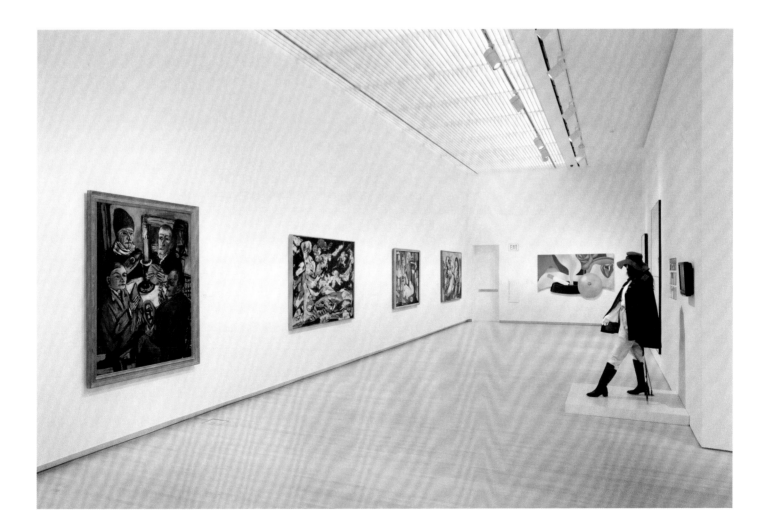

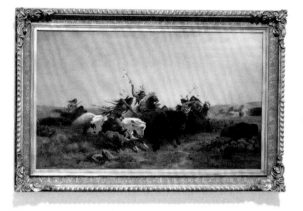

Fig. 6.
Installation view,
Nature | Culture section, Bernoudy Permanent Collection
Gallery, Mildred Lane Kemper Art Museum, 2015.

chronology and history, albeit retaining some thematic leitmotifs. The concepts of "real," "radical," and "psychological" will serve for the next few years as the basis to connect artists and artworks from different cultures and centuries in their quest to understand, participate in, and visualize the worlds they inhabit.

Historical Cornerstones

In addition to these thematic installations of the Museum's collection over the last ten years, we have also extended our investigations into our institutional history. We presented these early and more recent findings in such exhibitions as *The Taste of*

the Founders (2000), *H. W. Janson and Legacy of Modern Art at Washington University* (2002–5),[1] *The Barbizon School and the Nature of Landscape* (2005),[2] *Focus on Photography* (2010),[3] *Frederick Hartt and American Abstraction in the 1950s* (2012),[4] and *From Picasso to Fontana: Collecting Modern and Postwar Art in the Eisendrath Years, 1960–1968* (2015).

The first art museum west of the Mississippi, the Mildred Lane Kemper Art Museum opened in 1881 as the St. Louis School and Museum of Fine Arts (fig. 7), a department of Washington University, under the leadership of Halsey C. Ives.[5] Its founding—downtown at Nineteenth and

16

1. Sabine Eckmann, *H. W. Janson and the Legacy of Modern Art at Washington University in St. Louis* (St. Louis: Washington University Gallery of Art; New York: Salander-O'Reilly Galleries, 2002), and the expanded German edition *Exil und Moderne: H. W. Janson und die Sammlung der Washington University in St. Louis* (St. Louis: Mildred Lane Kemper Art Museum; Rüsselsheim, Germany: Stiftung Opelvillen Rüsselsheim; Erfurt, Germany: Angermuseum; Lübeck, Germany: Sankt Annen Museum; Freiburg, Germany: Museum für Neue Kunst; Heidelberg: Edition Braus im Wachter, 2004).

2. Rachel Keith, *The Barbizon School and the Nature of Landscape* (St. Louis: Mildred Lane Kemper Art Museum, 2005).

3. Karen K. Butler, *Focus on Photography: Recent Acquisitions* (St. Louis: Mildred Lane Kemper Art Museum, 2010).

4. Karen K. Butler, *Frederick Hartt and American Abstraction in the 1950s: Building the Collection at Washington University in St. Louis* (St. Louis: Mildred Lane Kemper Art Museum, 2012).

5. "The St. Louis School and Museum of Fine Arts originated in a free evening drawing class organized ... in 1874. It was formally established as a department of Washington University in 1879, under the presidency of ... James E. Yeatman and the directorship of Halsey C. Ives. A home for the work was provided through the generosity of [university founder] Wayman Crow." *Bulletin of Washington University: Fifty-Second Annual Catalogue* (February 1909), 123.

Locust Streets—was part of a nationwide boom in the establishment of metropolitan public art museums. In 1870 the Metropolitan Museum of Art in New York City opened; six years later the Museum of Fine Arts in Boston and the Philadelphia Museum of Art opened, and the Art Institute of Chicago followed in 1879. Today these cathedrals of modern urbanity may be seen as indexes of aesthetic tastes and values, revealing much about each institution's and city's cultural identity, international affinities, political positions, and educational ideals. In this sense the history of collecting reveals a history of the changing ideas of its professionals and a crossroads of private and institutional taste.

The original building of the St. Louis School and Museum of Fine Arts was designed by Peabody and Stearns of Boston in a quasi-Renaissance style

inspired by the leading English art critic and social theorist John Ruskin. The Museum's mission was to educate and enlighten audiences in a systematic manner about world civilization. Included in the first display of the collection were more than two hundred plaster casts and bronze replicas of important examples of world culture, including copies of the Laocoön from the Vatican collection, Lorenzo Ghiberti's Baptistery doors in Florence, and Peter Vischer's shrine for Saint Sebald in Nuremberg. Works of applied arts and contemporary American art were presented as well. Featured were Harriet Hosmer's *Oenone* (1854–55; fig. 8; page 62) and Thomas Ball's *Freedom's Memorial* (1875).

Ives, who was trained as a designer, had a vision to emphasize an art education that wedded the applied with the fine arts, modeling the new museum after the South Kensington Museum

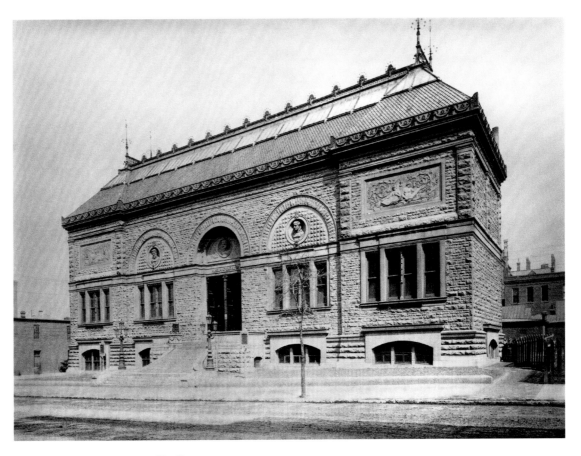

Fig. 7.
St. Louis School and Museum of Fine Arts, c. 1881.

Fig. 8.
St. Louis School and Museum of Fine Arts, 1881.

(today the Victoria and Albert Museum).[6] In light of America's progressing industrialization, thriving middle class, vast poverty within the working class, and accelerated immigration, this approach expressed currency as it attempted to promote advantageous effects of art on economy and social life. Ives was particularly engaged in advancing contemporary American art. His early acquisitions include such important works as William Merritt Chase's *Garden of the Orphanage, Haarlem, Holland* (1883). He also gained significant support from the St. Louis collector William Van Zandt, who in 1886 bequeathed four paintings by Carl Wimar romanticizing Native American culture.[7] Importantly, the Boston collector Nathaniel Phillips donated in 1890 the landmark frontier painting *Daniel Boone Escorting Settlers through the Cumberland Gap* (1851–52; fig. 9) by George Caleb Bingham. That year the US government had declared the end of the Western

frontier. As articulated in this painting from forty years earlier, Bingham's vision of a powerful and unified American nation seemed, in 1890, reality.

In the first decade of the twentieth century the university museum's collecting pattern turned more and more toward contemporary fine arts, a nationwide trend exemplified by such institutions as the Museum of Fine Arts, Boston. William K. Bixby—an industrialist, rare book collector, prominent supporter of Washington University, and head of the University's art school—established in 1906 the Bixby Fund for acquisitions of American art. Significant early purchases include Thomas Wilmer Dewing's *Brocart de Venise* (*Venetian Brocade*, c. 1904–5) and George Inness's *Storm on the Delaware* (1891; fig. 10), a pastoral landscape of the American countryside underscoring a spiritual dimension of nature, in contrast to the hectic bustle of contemporary

6. Ives's view on this was presented in a public lecture in 1880. "Professor Halsey C. Ives's lecture on the British Museum and the South Kensington Museum was heard by a large audience in the hall of Washington University. The speaker described the two museums, and said that America should learn a lesson from England." "Art in the Cities," *Art Journal*, n.s., 6 (1880): 192.

7. A native of Germany, Carl Wimar immigrated to St. Louis with his family in 1843, at the age of fifteen.

8. In addition to contemporary genre and landscape paintings, Charles Parsons's eclectic collection included mummies and antiquities purchased

on his extensive world-
wide travels, such as
"curios, bric-a-brac,
bronzes, pottery, porce-
lain, weapons, carvings,
and lacquer-ware," as his
last will attests. *Charles
Parsons Collection of
Paintings* (St. Louis:
Washington University in
St. Louis, 1977), 12.

9. In addition, the previous
year Parsons and Robert S.
Brookings, the influential
civic leader and head of
the University's Board of
Trustees from 1895 to

urban life. The largest donation of artworks during the first decade of the twentieth century was made by the pioneering St. Louis collector Charles Parsons.[8] In 1905 he bequeathed approximately four hundred works of art to the St. Louis School and Museum of Fine Arts.[9] His art collection is representative of nineteenth-century American aesthetic taste and was included in Edward Strahan's 1879–80 publication *The Art Treasures of America, Being the Choicest Works of Art in the Public and Private Collections of North America*.[10] Parsons's collection offers an impressive array of contemporary paintings executed with technical

perfection. Genre paintings such as Gustave Brion's *Paysans des Vosges fuyant l'invasion de 1814* (*Vosges Peasants Fleeing before the Invasion of 1814*, 1867), which stresses patriotism, and Adolf Schreyer's *Arab Warriors* (c. 1870s; fig. 11), which conveys historical subject matter, cover some characteristic motifs. Parsons was especially captivated by landscape painting, as his correspondence with the American painter Frederic Edwin Church reveals.[11] Paintings such as Church's *Sierra Nevada de Santa Marta* (1883), Narcisse Virgile Diaz de la Peña's *Wood Interior* (1867), Jean-Baptiste-Camille Corot's *Le chemin*

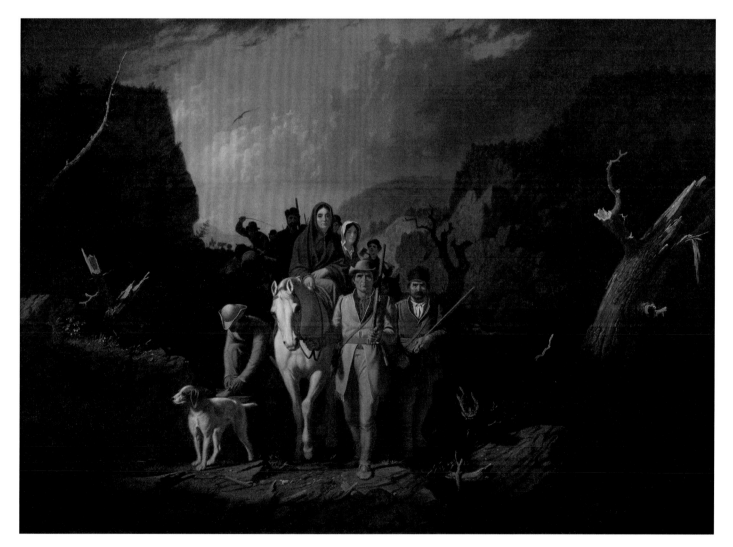

Fɪɢ. 9.
George Caleb Bingham (American, 1811–1879), *Daniel Boone Escorting Settlers through the Cumberland Gap*, 1851–52. Oil on canvas, 36 1/2 × 50 1/4". Gift of Nathaniel Phillips, 1890.

des vieux, Luzancy, Seine-et-Marne (*The Path of the Old People*, 1871–72), and Sanford Robinson Gifford's luminist *Rheinstein* (1872–74) (pages 86, 74, 78, 69, respectively) bespeak Parsons's taste for tonal and delicate landscapes, modernist in their subjectivity yet providing an alternative to Impressionist depictions of nature's materiality.

Beginning in 1909 Washington University's art collection was housed at the newly established City Art Museum (today the Saint Louis Art Museum). Although the collection enjoyed support within the University community, it somewhat disappeared from the public consciousness. A 1915 publication featuring the City Art Museum shows Washington University's collection as an integral part of the new museum.[12] The gifts and purchases made during the 1910s, 1920s, and

1930s, while Edmund Wuerpel was director of the University's art school, show parallels to nation-wide collecting tastes. Especially during the 1930s many American collectors turned to old masters, perhaps an index of disappointment with con-temporary politics and economics. In the 1930s Malvern B. Clopton, then president of Washington University, donated more than 130 prints, among them many old master works by such artists as Albrecht Dürer and Rembrandt van Rijn (page 56). Furthermore, the nationwide fascination with Native American art is evidenced by the 1937 acquisition of eight important Native American repoussé plaques donated by John Max Wulfing (page 34). In addition many portraits entered the collection, such as Franz Seraph von Lenbach's *Portrait of Prince Otto von Bismarck* (1884–90; page 90), first exhibited at the 1904 World's Fair in

1928, had donated twenty-two Greek vases to the collection.

10. Edward Strahan [pseud.], ed., *The Art Treasures of America, Being the Choicest Works of Art in the Public and Private Collections of North America*, vol. 2 (Philadelphia: George Barrie, 1880), 64–65.

11. See J. Gray Sweeney's analysis in Joseph D. Ketner et al., *A Gallery of Modern Art at Washington University* (St. Louis: Washington University Gallery of Art, 1994), 42.

12. The January 1915 *Bulletin of the City Art Museum of St. Louis* listed Childe Hassam's painting

Fig. 10.
George Inness (American, 1825–1894), *Storm on the Delaware*, 1891. Oil on canvas, 30 1/8 × 45 3/8".
University purchase, Bixby Fund, 1910.

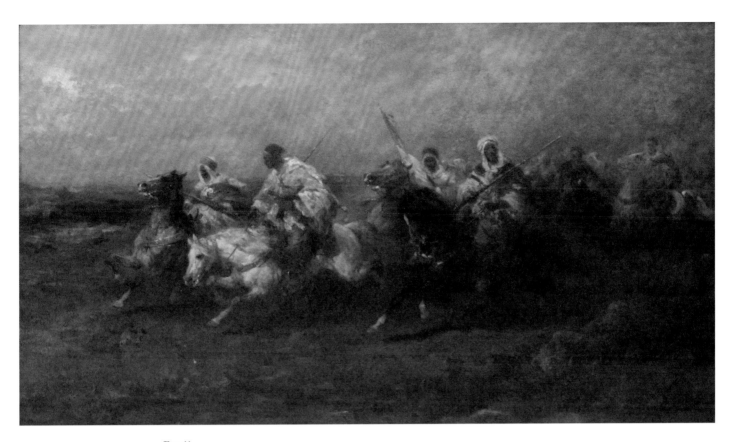

Fig. 11.
Adolf Schreyer (German, 1828–1899), *Arab Warriors*,
c. 1870s. Oil on canvas, 18 3/4 × 32 7/8". Bequest of
Charles Parsons, 1905.

Diamond Cove, Isles of Shoals (1908), acquired through the University's Bixby Fund, under the City Art Museum's 1914 acquisitions. This is just one example of how intertwined the City Art Museum and the Washington University collection it housed had become. "Acquisitions Made by the City Art Museum in 1914," *Bulletin of the City Art Museum of St. Louis* (January 1915): 29.

13. For a more detailed history of this, see

St. Louis and donated by the German expatriate beer magnate August A. Busch in 1929, and Thomas Eakins's *Portrait of Professor W. D. Marks* (1886) purchased with University funds in 1936. While the painting by Eakins of Marks demonstrates belief in modernization, particularly the significance of science and rationality, the Bismarck portrait clearly appealed to the German immigrant community. Bismarck—known as the Iron Chancellor—became the first chancellor of the new German nation in 1871, at a time when Germans, already well established in St. Louis, were continuing to immigrate to the United States; the painting certainly played to their collective memory, embracing issues of acculturation and

assimilation. By 1929 many Germans hoped for a unifying and authoritarian political figure, such as Bismarck, to solve the massive ideological, economic, and social problems facing Germany's new democracy—problems that must have resonated all too closely for the immigrants with the Great Depression besieging their new homeland.[13]

Tellingly it was the German émigré H. W. Janson (fig. 12), curator of the collection from 1944 to 1948, who effected a significant institutional change focusing on international contemporary art. It all happened in a matter of months during the 1945–46 academic year, at a time when modern art was still highly contested, not only in the

Midwest but also throughout the United States.[14] In that year Washington University purchased approximately forty twentieth-century artworks by European and American modernists. Although the collection was modest in size, the purchases amounted to the largest and most focused acquisition project the University had ever undertaken. Artworks such as Georges Braque's *Nature morte et verre* (*Still Life with Glass*, 1930; page 136), Pablo Picasso's *La bouteille de Suze* (*Bottle of Suze*, 1912; fig. 14), Fernand Léger's *Les grands plongeurs* (*The Divers*, 1941; fig. 17), and Joan Miró's *Peinture* (*Painting*, 1933) still form the core of the modern art collection. This initial acquisition campaign stimulated subsequent acquisitions as well as important donations of modern art. In the 1950s and 1960s curators Frederick Hartt and William N. Eisendrath Jr.—along with St. Louis art collectors Joseph Pulitzer Jr., Morton D. May, Nancy Singer, Etta Steinberg, Sidney M. Shoenberg, and Florence and Richard Weil—added key artworks to the collection.[15] Postwar artworks by Jackson Pollock (page 172), Willem de Kooning (page 178), and Pierre Soulages (page 188) were acquired, as was an expressionistic painting, *Brücke I* (*Bridge I*, 1913) by Lyonel Feininger (fig. 13), and *The Iron Cross* (1915; page 114), a key early American modernist canvas by Marsden Hartley.

The majority of artworks acquired by Janson in 1945 and 1946 date from the 1930s and 1940s, a period of twentieth-century art that is still marginalized within the established narrative of modernism. Janson's selection of modern art demonstrates a strong emphasis on Cubism, Constructivism, and exile art, complemented by an array of contemporary modernist American art. Surprising in Janson's selection is the lack of modern German Expressionism. He also rejected the latest American expressionistic abstractions—as exemplified by works by Jackson Pollock and Arshile Gorky acquired after his tenure here. Janson's ventures into the American art world led to purchases of primarily figurative and metaphysical works—such as Philip Guston's *If This Be Not I* (1945; page 160)—and ones that reveal ties to modern French art, such as Alexander Calder's organic and surrealist sculpture *Bayonets Menacing a Flower* (1945; fig. 15). Janson's focus on Cubism, the art of Paris, and rational aesthetic tendencies drew on the concepts of enormously influential American art historians

and institutions such as Alfred H. Barr Jr. and the Museum of Modern Art. Many of Janson's acquisitions in the area of exile art, in particular works by the émigré Surrealists, exemplify the engagement of modern art with processes of creation that involve the unconscious. With the acquisition of Max Ernst's *L'oeil du silence* (*The Eye of Silence*, 1943–44; page 148) and Yves Tanguy's *La tour marine* (*Tower of the Sea*, 1944), examples of exile art representing the most advanced contemporary voices were added to the Washington University collection. Janson also purchased two paintings by German exile artists: Max Beckmann's *Les artistes mit Gemüse* (1943; page 144) and Karl Zerbe's *Armory* (1943; fig. 16). While the Beckmann canvas

Fig. 12.
H. W. Janson, 1935.

Sally Bixby Defty, *The First Hundred Years, 1879–1979: Washington University School of Fine Arts* (St. Louis: Washington University in St. Louis, 1979).

14. For more on this history and Janson's notion of modernism, see my essay "Exilic Vision: H. W. Janson and the Legacy of Modern Art at Washington

Fig. 13.
Lyonel Feininger (American, 1871–1956), *Brücke I* (*Bridge I*), 1913. Oil on canvas, 31 1/2 × 39 1/2". University purchase, Bixby Fund, 1950.

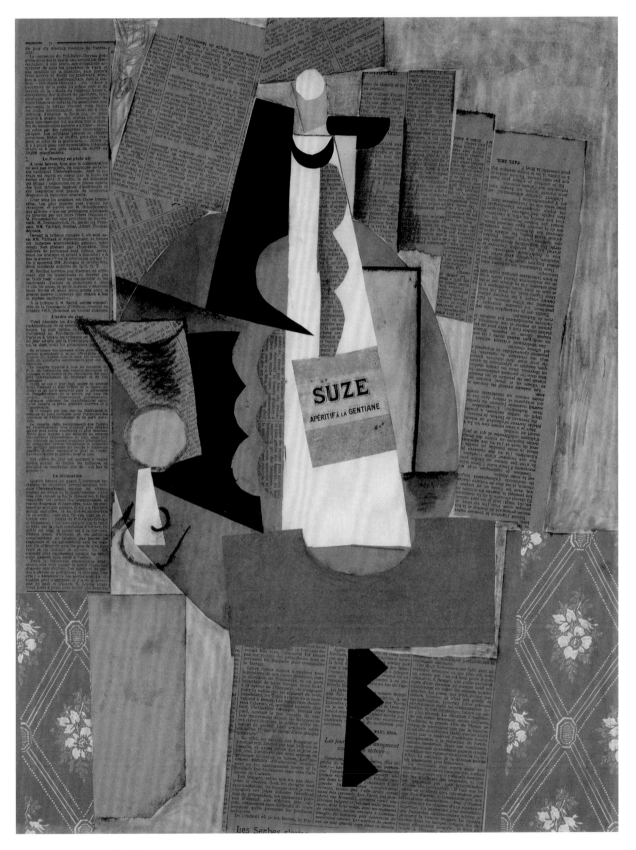

Fig. 14.
Pablo Picasso (Spanish, 1881–1973), *La bouteille de Suze*
(*Bottle of Suze*), 1912. Pasted papers, gouache, and charcoal,
25 3/4 × 19 3/4". University purchase, Kende Sale Fund, 1946.

was executed during the artist's Amsterdam exile in 1943 and emphasizes the spiritual life among materially deprived modern artists in exile, Zerbe's *Armory* alludes to the persecution of modern art in Nazi Germany and the United States' entry into World War II. Relative to German Expressionist works, these paintings rely on a less emotional mode of depiction realized through a static pictorial structure that includes a reduction of gestural elements and a heightened naturalism.

Frederick Hartt, a respected scholar of Italian Renaissance art, succeeded Janson as curator of the collection from 1949 to 1960.[16] Hartt's slate of acquisitions in the 1950s, like Janson's in the previous decade, significantly shaped the University's collection. His focus on seminal works of American abstraction came at a critical moment when American avant-garde practices began to dominate the world of art. Hartt's farsighted acquisitions— paintings by de Kooning, Gorky, Guston, and Pollock—were among the first American Abstract Expressionist artworks to be purchased in St. Louis. For Hartt, who as a Monuments and Fine Arts officer with the Allied Military Government during World War II saw the violence and destruction of the war firsthand, large-scale gestural abstraction best captured the qualities of the postwar human condition. The spontaneous painterly gesture that marks so many of these works was often understood as a direct translation of the feelings of the artist onto the canvas. Like many critics and curators of his day, Hartt associated this expression of radical aesthetic freedom with the values of American democracy, which were instrumental in the victory over fascist regimes during World War II and in the Cold War battle against Soviet communism. Hartt also acquired works by artists he considered pioneers—American artists such as Stuart Davis, Arthur Dove, and Marsden Hartley, who emerged in the 1910s or 1920s and were among the first to work in abstract modes. These acquisitions complemented the works of European modernism acquired by Janson.

Our research into institutional history also included an exploration of the tenure of William N. Eisendrath Jr., who, from 1960 to 1968, like his predecessors, continued to focus on significant examples of contemporary art. Under Eisendrath's leadership the Museum—then called the Washington

University Gallery of Art—acquired an important collection of European and American post–World War II abstraction.[17] These works were attained largely through donation. Artworks by Karel Appel, Alberto Burri, Richard Diebenkorn, Jean Dubuffet, Sam Francis, Lucio Fontana, Pierre Soulages, and Antoni Tàpies entered the collection. What is rare is the fact that an American art museum and community embraced European postwar art to such an extent. Among the few other institutions with a similar emphasis at the time are the Solomon R. Guggenheim Museum in New York and the Menil Collection in Houston. Capitalizing on the newly opened galleries in Mark C. Steinberg Memorial Hall

University," in *H. W. Janson*, 10–42.

15. For more on Etta Steinberg, see Elizabeth C. Childs, "St. Louis and Arts Philanthropy at Midcentury: The Case of Etta E. Steinberg," kemperartmuseum.wustl.edu/files/The_Case_of_Etta_Steinberg.pdf.

16. For a discussion of Frederick Hartt's impact on the collection, see Butler, *Frederick Hartt and American Abstraction*.

17. Eisendrath also acquired a number of historical

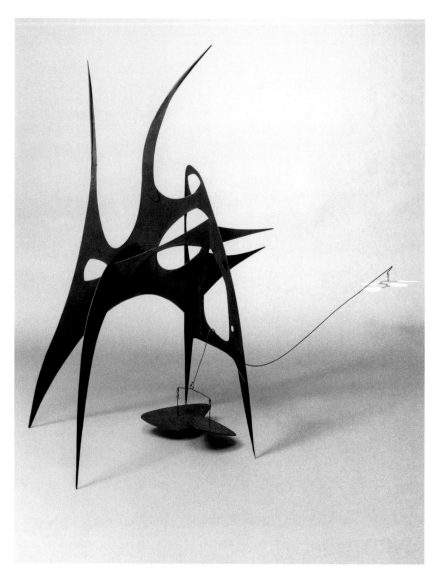

Fig. 15.
Alexander Calder (American, 1898–1976), *Bayonets Menacing a Flower*, 1945. Painted sheet metal and wire, 45 × 51 × 18 1/2". University purchase, McMillan Fund, 1946.

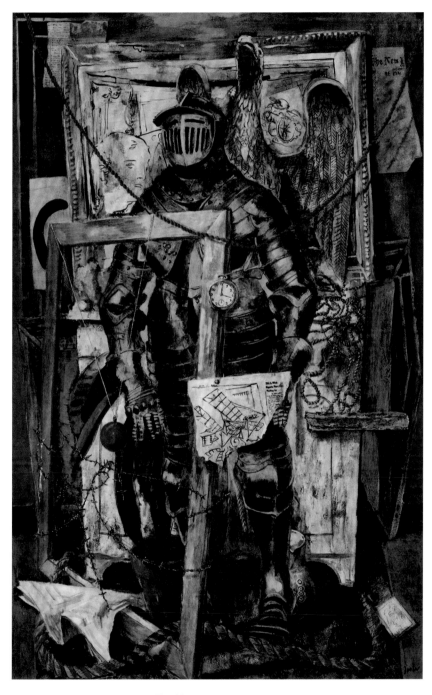

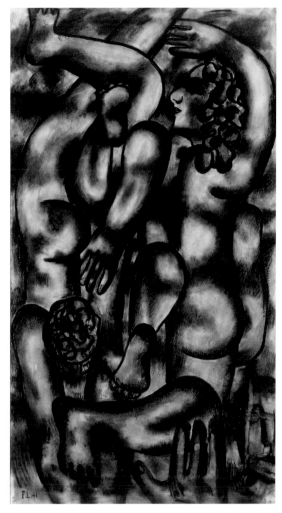

Fig. 17.
Fernand Léger (French, 1881–1955), *Les grands plongeurs* (*The Divers*), 1941. Charcoal and ink wash with gouache on paper, 75 3/8 × 41 7/8". University purchase, Kende Sale Fund, 1946.

Fig. 16.
Karl Zerbe (American, b. Germany, 1903–1972), *Armory*, 1943. Encaustic on canvas, 62 1/2 × 40". University purchase, Kende Sale Fund, 1946.

(1960), Eisendrath also initiated the Museum's first robust exhibition program. Between 1960 and 1968 he presented a dynamic series of major international loan exhibitions. These included *New Spanish Painting and Sculpture* (1961), a circulating exhibition organized by the International Council of the Museum of Modern Art, New York, and *Paintings from the Fifties* (1965), an exhibition of forty paintings from the Carnegie Museum of Art in Pittsburgh, organized by the American Federation of the Arts, which explored international postwar abstraction and its modern precursors. Traveling exhibitions such as these established Washington University's museum as a center for the study of abstract art in the United States. Produced during the height of Cold War politics, a number of these exhibitions were specifically conceived to associate postwar abstraction with the cultural values of American democracy, including artistic freedom, individual creativity, and uncensored communication. Other exhibitions—such as *Jean Arp and Sophie Taeuber-Arp*, organized by the Galerie Chalette, New York, in 1961, and *Vasily Kandinsky (1866–1944)—A Retrospective Exhibition* (fig. 1), jointly organized in 1963–64 by the Solomon R. Guggenheim Museum and the Pasadena Art Museum—examined influential early twentieth-century European abstract art and its relevance to contemporary practices. Toward the end of the 1960s the work of a new generation of contemporary artists constituting the so-called neo-avant-garde, including Pop and assemblage art, was introduced. Eisendrath's ambitious exhibition program created an environment of intellectual excitement and artistic vibrancy that illuminates a vital moment in the development of the collection and in the history of the Museum and still serves as a guiding principle today.

works, among them etchings by Giovanni Battista Piranesi from the series *Le Carceri* (*The Prisons*, c. 1760s) and James Ensor's *Le Christ tourmenté* (*Christ Tormented*, 1888).

18. Sabine Eckmann, ed., *Reality Bites: Making Avant-garde Art in Post-Wall Germany* (St. Louis: Mildred Lane Kemper Art Museum; Ostfildern, Germany: Hatje Cantz, 2007).

19. Meredith Malone, *Chance Aesthetics* (St. Louis: Mildred Lane Kemper Art Museum, 2009).

20. Karen K. Butler and Renée Maurer, *Georges Braque and the Cubist Still Life, 1928–1945* (St. Louis: Mildred Lane Kemper Art Museum; Washington, DC: Phillips Collection;

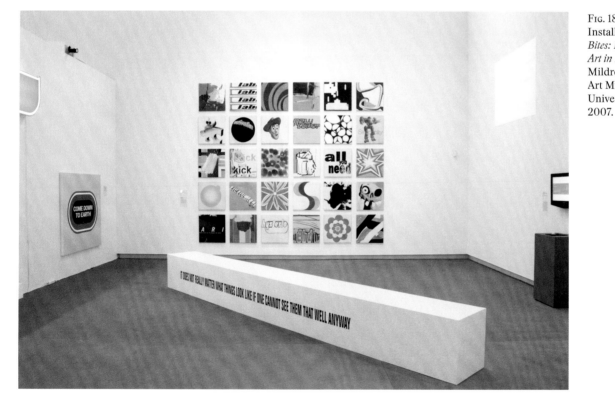

Fig. 18.
Installation view, *Reality Bites: Making Avant-garde Art in Post-Wall Germany*, Mildred Lane Kemper Art Museum, Washington University in St. Louis, 2007.

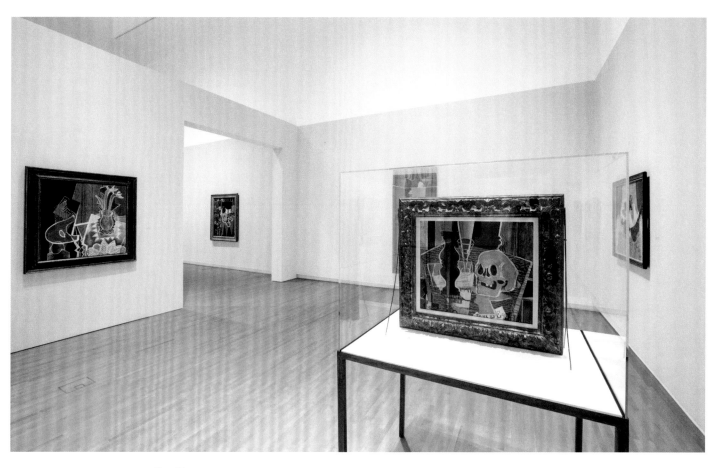

Fɪɢ. 19.
Installation view, *Georges Braque and the Cubist Still Life, 1928–1945*, Mildred Lane Kemper Art Museum, Washington University in St. Louis, 2013.

New York: DelMonico • Prestel, 2013).

21. Carmon Colangelo, *On the Margins* (St. Louis: Mildred Lane Kemper Art Museum, 2007).

22. Sabine Eckmann, *In the Aftermath of Trauma: Contemporary Video Installations* (St. Louis: Mildred Lane Kemper Art Museum, 2014).

23. Svea Bräunert and Meredith Malone, *To See Without Being Seen: Contemporary Art and Drone Warfare* (St. Louis: Mildred Lane Kemper Art Museum, 2016).

Endnote

In addition to presenting exhibitions that explored our history through the leadership of H. W. Janson, Frederick Hartt, and William Eisendrath, the Museum has also over the past ten years mounted a rigorous exhibition program that tried to balance display of holdings in the collection with timely modern and contemporary exhibitions, some thematic, others monographic in nature. Major research exhibitions included *Reality Bites: Making Avant-garde Art in Post-Wall Germany* (2007; fig. 18),[18] *Chance Aesthetics* (2009),[19] and *Georges Braque and the Cubist Still Life, 1928–1945* (2013; fig. 19),[20] all of which explored how artists have employed advanced art forms that are reflexive of specific sociopolitical moments in history, including World War II, German unification, and the 1950s and 1960s with their increased consumerism and commodification of culture. These explorations also connect to such thematic exhibitions as *The Political Eye: Nineteenth-Century Caricature and the Mass Media* (2009), *On the Margins* (2008),[21] *In the Aftermath of Trauma: Contemporary Video Installations* (2014),[22] and most recently, *To See Without Being Seen: Contemporary Art and Drone Warfare* (2016),[23] all of which were dedicated to examining the relation between art and politics then and now. While in the museum field art more often than not is framed within a context set

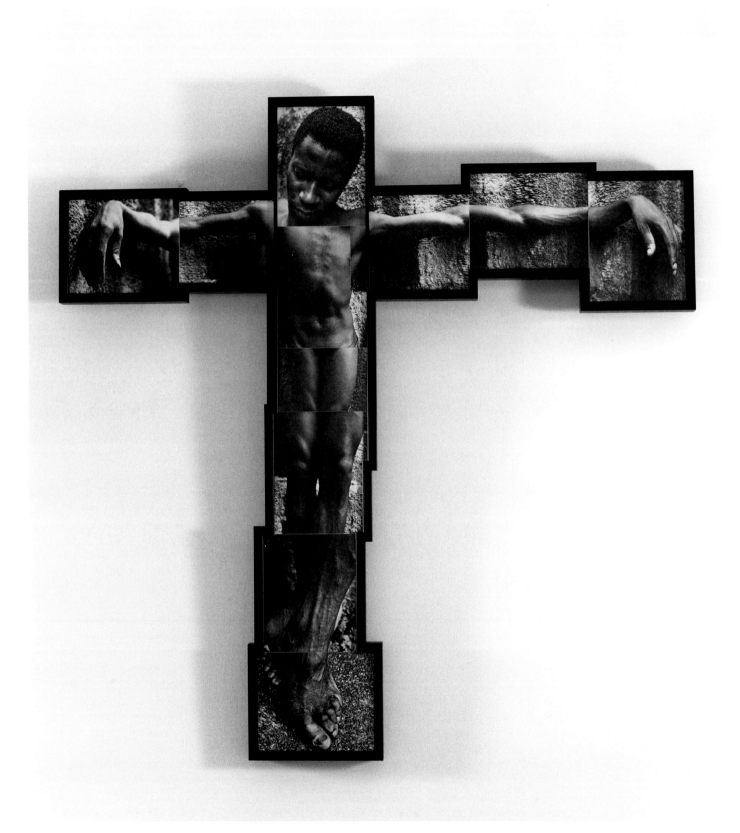

Fig. 20.
Renée Cox (American, b. Jamaica, 1960), *It Shall Be Named*, 1994.
11 gelatin silver prints in mahogany frame, 105 × 104 $^1/_2$ × 4 $^3/_4$".
Gift of Peter Norton, 2015.

FIG. 21.
Sharon Lockhart
(American, b. 1964), *Outside
AB Tool Crib: Matt, Mike,
Carey, Steven, John, Mel
and Karl*, 2008. C-print,
6/6, 48 × 67 1/2". University
purchase, Bixby Fund, and
with funds from Helen
Kornblum, 2009.

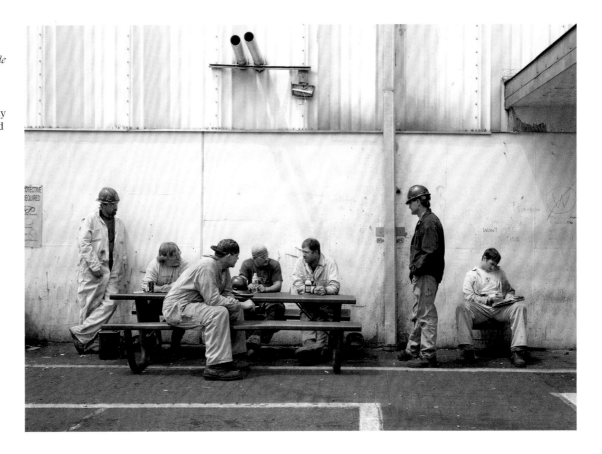

24. Eeva-Liisa Pelkonen and
 Donald Albrecht, eds.,
 *Eero Saarinen: Shaping
 the Future* (New Haven,
 CT: Yale University Press,
 2006).
25. Elizabeth Armstrong,
 ed., *Birth of the Cool:
 California Art, Design,
 and Culture at Midcentury*
 (Newport Beach, CA:
 Orange County Museum
 of Art; New York: Prestel,
 2007).
26. Heather Woofter,
 Metabolic City (St. Louis:
 Mildred Lane Kemper Art
 Museum, 2009).
27. Igor Marjanović and
 Jan Howard, *Drawing
 Ambience: Alvin Boyarsky
 and the Architectural
 Association* (St. Louis:
 Mildred Lane Kemper Art
 Museum; Providence:
 Rhode Island School of
 Design Museum, 2014).

apart from everyday realities, these investigations intentionally focused on the role and significance of artist practices in understanding and responding to contemporary life.

In partnership with the Sam Fox School of Design & Visual Arts, founded in 2005 to join the University's graduate and undergraduate schools of art and architecture with the Kemper Art Museum, the Museum has also aspired to present some of the most daring and relevant voices in contemporary art. Monographic exhibitions have featured the work of Cosima von Bonin, Luis Camnitzer, Sam Durant, Andrea Fraser (page 226), Tom Friedman, Rashid Johnson, Balázs Kicsiny, Sharon Lockhart, Rivane Neuenschwander, Elizabeth Peyton, Julian Rosefeldt, Tomás Saraceno, Allison Smith, John Stezaker, Thaddeus Strode, and Rirkrit Tiravanija, among others. As part of the interdisciplinary Sam Fox School, the Museum has deemed it important to undertake an exhibition program devoted to

architecture and design. Significant exhibitions over the last decade include *Eero Saarinen: Shaping the Future* (2009),[24] *Birth of the Cool: California Art, Design, and Culture at Midcentury* (2009),[25] *Metabolic City* (2010),[26] *On the Thresholds of Space-Making: Shinohara Kazuo and His Legacy* (2014), and *Drawing Ambience: Alvin Boyarsky and the Architectural Association* (2014).[27] What distinguished these exhibitions is that they all in a variety of ways explored the intersection between architecture, design, and the visual arts. While *Drawing Ambience* considered the genre of contemporary drawing as it pertains to both architecture and art, *On the Thresholds of Space-Making* illustrated close links between architectural practice and advanced installation art. These and other exhibitions demonstrated how the two fields often intersect to generate new forms of museum experiences and installations that are more architectural than sculptural in nature, at the same time broadening the scope of medium-specific considerations.

The Museum's focus on art and politics in its exhibition programs is mirrored in several recent acquisitions that foreground critical projects by an international array of artists, such as Renée Cox (fig. 20), Willie Doherty, Mike Kelley, Valeska Soares, Kara Walker, and Carrie Mae Weems (page 258), whose work addresses issues of race, nationalism, and violence.[28] Another of the Museum's commitments has been to collect the work of artists presented in exhibitions to create a permanent presence for them in the collection. This resulted in the acquisition of works by Rashid Johnson, Sharon Lockhart (fig. 21), and Rivane Neuenschwander, among many others, quite often of sociopolitical relevance as well as being rigorously reflexive of the artistic mediums employed. Other newly added important artworks—by Arman, Robert Breer, Marcel Duchamp, Man Ray, Dieter Roth, and Jacques Villeglé—complement the existing painting and sculpture collection through experimental art forms such as assemblages, kinetic art, multiples, and fabricated everyday objects. The Museum has also been fortunate to be able to add significant examples of contemporary German art to its holdings, including paintings, sculptures, fabric objects, and photographs by Franz Ackermann (fig. 22), Thomas Bayrle, Cosima von Bonin, Thomas Demand, Isa Genzken (pages 242, 245), Andreas Gursky (fig. 23), Charline von Heyl, Wolfgang Tillmans, and Corinne Wasmuht.[29] Along with the strength of German pre- and postwar art in the Saint Louis Art Museum, the Kemper Art Museum's German post-Wall collection underscores the importance of German art to the St. Louis art world.[30]

Drawing on this distinguished history of collecting and interpreting modern and contemporary art within the context of a major research university, the Museum's intention is to demonstrate that art matters. As we seek to understand and to meaningfully contribute to an ever more complex and fundamentally changing contemporaneity, we turn to artworks, past and present, to evince how visualizations of the world, as idiosyncratic as they may look, produce lasting impressions of the significance of individual and collective creativity. It is with this in mind that the Museum intends to carry its legacy of exhibiting and collecting relevant art into an increasingly globalized and diverse future.

28. Many of these were part of a donation of more than fifty contemporary artworks gifted to the Museum by Peter Norton, selections of which were on view in the exhibitions *Rotation 1: Contemporary Art from the Peter Norton Gift* (summer 2015) and *Rotation 2: Contemporary Art from the Peter Norton Gift* (fall 2015).

29. An exhibition of many of these acquisitions was on view in fall 2011, made possible in part by a major gift from the David Woods Kemper Memorial Foundation, accompanied by the publication *Precarious Worlds: Contemporary Art from Germany*, by Sabine Eckmann (St. Louis: Mildred Lane Kemper Art Museum, 2011).

30. Notable additions to the collection over the last decade also include prints executed at the Sam Fox School's Island Press, video art from

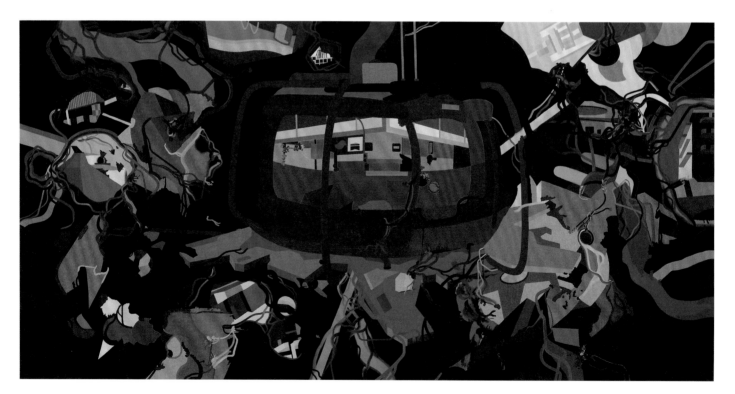

Fig. 22.
Franz Ackermann (German, b. 1963), *Untitled (yet)*, 2008–9. Oil on canvas, 109 5/8 × 216 1/8". University purchase with funds from the David Woods Kemper Memorial Foundation, 2011.

the 1960s and 1970s, photographs by prominent women artists, thanks in large part to the ongoing support of Helen Kornblum, and a collection of late nineteenth- and early twentieth-century photographs donated by Robert Frerck and Laurie Wilson.

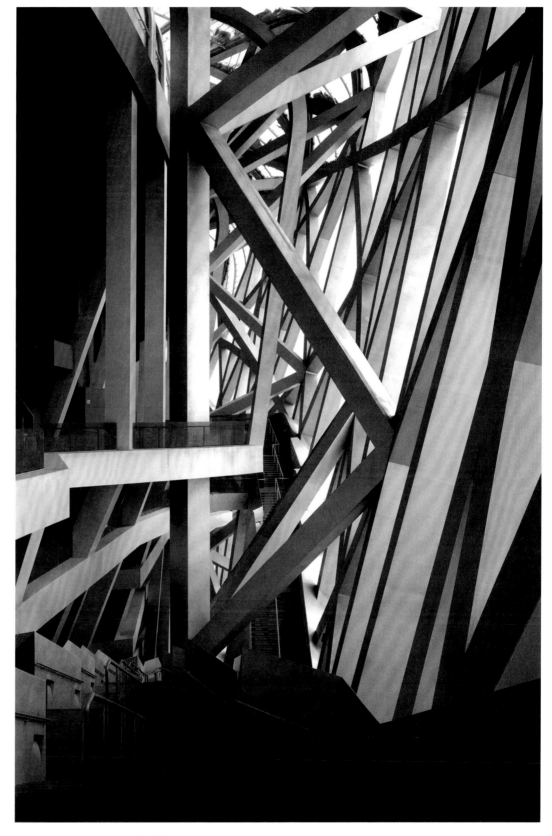

FIG. 23.
Andreas Gursky (German, b. 1955), *Beijing*, 2010. Inkjet print, 4/4, 120 7/8 × 83 7/8 × 2 3/8" (framed). University purchase with funds from the David Woods Kemper Memorial Foundation, 2012.

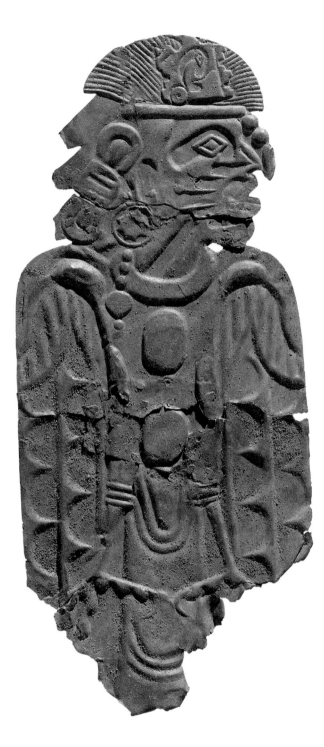

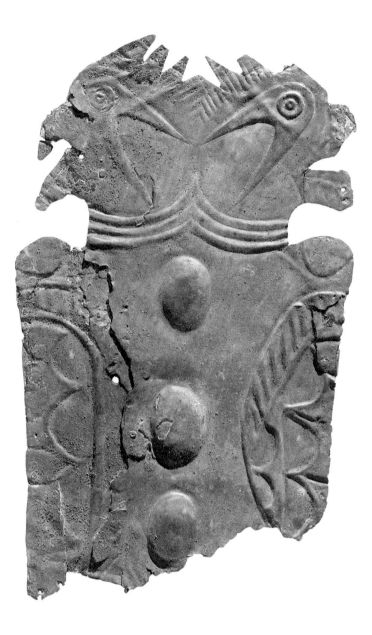

Repoussé Plaque, c. 1200–1400

Copper, 12 × 5 5/8"

Gift of J. Max Wulfing, 1937

WU 3679

Repoussé Plaque, c. 1200–1400

Copper, 10 1/2 × 6 9/16"

Gift of J. Max Wulfing, 1937

WU 3680

Unknown

(Native North American, Mississippian, Dunklin County, Missouri, Woodlands, United States)

Repoussé Plaques, c. 1200–1400

IN 1910, IN HIS SURVEY OF THE ANTIQUITIES of Missouri, the anthropologist Gerard Fowke published images of eight copper plates that had recently been discovered by a farmer outside the town of Malden, in Dunklin County, just north of the state's southeastern boot heel.[1] Few comparable objects from the ancient Midwest were known at the time, so these plates, with their repoussé avian images, almost instantly achieved canonical status soon after their publication.

The intervening century has seen the discovery of similar objects in locales across the Midwest and Southeast, from the site of Spiro, Oklahoma, to Etowah Mounds in Georgia, as well as other sites in Missouri, Illinois, Alabama, and Florida.[2] Scholars in the mid-twentieth century, noting the consistency of iconography on copper objects, ceramics, and incised shells, suggested the existence of a shared cultural tradition that they called the Southeastern Ceremonial Complex, or SECC, lasting from the tenth to seventeenth centuries, during what is called the Mississippian period.[3]

Throughout the Mississippian period, centers of ritual, economic, and political power waxed and waned, but their reliance on exotic materials such as copper remained relatively constant. Although today copper may not seem to be a particularly exotic substance and knowledge of its properties is not particularly esoteric, the ancient inhabitants of the Midwest saw the landscape and its contents in very different terms. Copper work has a history going back thousands of years in North America, with distinct episodes in the Late Archaic (c. 3000–c. 1000 BC), Woodlands (c. 1000 BC–c. AD 1000), and Mississippian (c. 900–c. AD 1500) periods.[4] For all these peoples the diligent search for copper sources and an understanding of copper's manipulation required generations of patient preparation and transmission of experience. This

knowledge was protected and preserved by subsequent generations, helping some members of the elite classes enhance and project their power.

The mounds of Cahokia in Illinois (as well as those that once existed in the urban grid of St. Louis) were a central place in this network of Mississippian period sites across the Midwest and Southeast. Indeed, some have argued that much of the iconography now associated with the SECC drew on imagery that had earlier developed in and around Missouri and Illinois, indicating that Cahokia was where the SECC was first articulated and amplified.[5] Elites in centers like Cahokia—along with their peers at Spiro, Etowah, and Moundville, Alabama, as well as smaller sites in between—relied on the acquisition, manufacture, and trade of valuable materials like copper. For them, copper and the objects crafted out of it were simultaneously a manifestation and a symbol of the esoteric knowledge that was a primary cultural currency binding the landscape. Yet despite our increased understanding of the iconographic, cultural, and economic system that produced them, the copper plaques retain a great deal of mystery, as there are still many questions about their precise function and meaning. In light of this, it is worth revisiting some primary accounts to understand how we know what we do know about them.

In his survey of 1910 Fowke gave the account of Max Groomes, who found the plaques while plowing a field owned by Mrs. W. O. Baldwin just south of the town of Malden:

> [Groomes] was plowing much deeper than usual, probably 16 or 18 inches. His attention was attracted by something shining or glittering on the land turned over by his plow at this point, and he stopped to examine it. He found a few small scraps of copper. On looking at the bottom of the furrow, whence they had come, he found that his plow had struck the upper end of these copper pieces, which lay in close contact, "with the heads down," and inclined at an angle of 45°. . . . Mr. Groomes is positive in his statement that

> the specimens were in immediate contact, as he lifted them out one after another, and that very little earth had worked in between them.[6]

Groomes's family members reminisced about the discovery fifty years later; these and contemporaneous accounts suggest that Groomes sold the objects to Bob Wade and A. I. Davis and that they were on view at various times on the Groomes's porch, at a local school, and then in a general store owned by Davis before the latter sold the objects to John Max Wulfing, a prominent St. Louis businessman and avid antiquities collector who later gave the plates to Washington University.[7] These events must have taken place by 1907, as a letter written in May of that year by Wulfing to Davis constitutes the earliest extant discussion of the plaques and suggests that they were already in Wulfing's possession.[8] Wulfing sent the letter hoping to find out more about the discovery; his straightforward questions and Davis's equally terse replies largely corroborate the story that Groomes told Fowke.[9]

From all these accounts we learn something of the haphazard manner in which ancient objects of the Midwest were often treated in the early twentieth century. Wulfing's fleeting interest in objects from ancient Missouri appears idiosyncratic when compared with his long-standing interest in classical antiquities, but when we consider that his collection consisted largely of ancient coins, the potential relevance of ancient American copper becomes clearer.[10] None of the literature of the day explicitly invokes currency when discussing the plaques, but for a numismatist the formal connection between the iconography on antique coins and the imagery on the thin plates from outside Malden was surely inescapable. More importantly, these early accounts are valuable because they underscore the isolation of the plates in the local landscape, suggesting that the plates did not come from a burial context. In fact the closest group of mounds was some nine miles away.

Although they were on display at the Saint Louis Art Museum for many years, the plates did not

receive sustained scholarly attention until Virginia Watson, then a lecturer at Washington University in St. Louis, published a comprehensive study in 1950 documenting their condition and variance in execution of design. She paid particular attention to the extensive riveting, crucial details suggesting careful preservation in ancient times.[11] It is in fact these repairs that help us understand that the plates are probably earlier than their findspot near the surface would indicate. Without a firm archaeological context, specific dates are speculative, based on stylistic comparisons with other similar objects associated with more secure contexts.[12] Aside from these eight plates from Malden, the known corpus—about five dozen identified to date—almost always came from burials. The most famous are from Spiro and Etowah, where copper plates and other objects have been found in great quantity, but examples from smaller sites are stylistically close to the six all-avian Wulfing plates. As categorized by James A. Brown, Wulfing's plates are characteristic of the Late Braden style and probably date to the later thirteenth or fourteenth century, following on the apparent elaboration of the Classic Braden style at and near Cahokia around AD 1100–1200.[13]

Of the eight, the plate with the human head (WU 3679) and the plate with two avian heads (WU 3680) are the most distinctive. Both plates offer suggestive formal and stylistic links to larger and more elaborately articulated plates from burials at Etowah.[14] The Wulfing and Etowah plates, as well as the other known copper avian plates, are thought to depict aspects of the Birdman, a major character in Mississippian iconography whose roles touch on the various domains of warfare, ritual dancing, and sports.[15] The human head of WU 3679 most closely matches the veristic depictions of the figures on certain Etowah objects. The two-headed bird of WU 3680 most closely resembles the composition of the "fighting birds" plate recovered from another Etowah burial.[16] The remaining six plates more clearly represent avians derived from peregrine falcons, with their characteristic wing and head plumage patterns.[17]

The small upward-facing head seen at the top of WU 3679, with its crenellated diadem, immediately recalls a small wooden effigy mask (originally probably sheathed in copper) from the Emmons site in Illinois,[18] as well as trophy heads wielded by the characters on other plates. The Wulfing plates and their companions are, in this respect, objects about other objects. On another plate from Etowah, a human figure is shown wearing an avian plaque as a headdress, giving us a hint as to their possible function.[19] At some point, in some places, these plaques became self-reflexive signifiers of political power and elite status as well as bearers of iconographic data. Their mere inclusion and presentation as part of a ruler's costume complemented and may have eventually superseded their function as transmitters of ritual knowledge.

The prestige surrounding the creation and presentation of these plates and other objects appears to have originated at Cahokia some centuries before.[20] Although no such plates have ever been found at the site, excavations of a copper workshop at Mound 34, near Monk's Mound, indicate the metal's prominent place in the site's ritual economy.[21] In addition, avian imagery occupies a central place in Cahokian visual culture, as exemplified by a sandstone tablet, incised with an image of the Birdman, that was recovered from Monk's Mound.[22] Even more striking was an astonishing burial in Mound 72 of a middle-aged man on top of thousands of shell beads laid out in the silhouette of a bird, suggesting the beginnings of a visual and material culture that would come to play an important role in the developing interaction sphere beyond Cahokia.[23]

This interaction between the elites of Mississippian centers would have depended on the creation and maintenance of a visual symbol system that was not tied to a specific language and could be readily recorded on portable, semipermanent materials.[24] This is part of the power that resides in the Wulfing plates. In this interpretation, they compressed the ritualized knowledge surrounding something like the Mound 72 burial into a compact and transferable package of iconography, allowing

a religious practitioner, leader, or merchant to move across the landscape with this distilled and essential knowledge carefully protected. Just as the buried man was arrayed inside the beaded silhouette of a bird, the Wulfing plates layer the human form within and on top of avian outlines. Are the Wulfing plates and this burial simply articulations of the same ideological system, or could the layering of the imagery on the copper plates somehow describe and proscribe the sequence of ritual actions actually carried out at Cahokia? Although we will likely not be able to answer such questions, the creation, acquisition, and presentation of such ritual paraphernalia and their attending esoteric information would have allowed rulers and elites to proclaim their own political legitimacy. The plates eventually became prized in their own right, preserved as heirlooms and diligently repaired over generations, even as some of the precise knowledge surrounding their iconography and original purpose slowly spalled away.[25]

This is part of what has made the Wulfing plates so mysterious since their discovery. Their extraordinary isolation in the local landscape is exceptionally rare.[26] If we could be certain that the plates were cached in Mississippian times, we could more reliably construct hypotheses about the nature of way-finding, localized cartographies, and place-making, but it is possible, given their proximity to the surface, that the plates were hidden centuries after they were originally made. Perhaps the spot in which they were buried was once not isolated at all but served as a marker of centrality—this area of Missouri is in fact roughly equidistant from Spiro and Etowah, arguably the two most significant heirs to Cahokia's power and dominance. Perhaps a now-vanished feature on the landscape signaled to a journeying merchant, warrior, or artist where the objects had been safely stored. Perhaps the plaques served as a kind of news bulletin, conveying and dispersing the inherited wealth and wisdom of an individual like that buried in Cahokia's Mound 72. The Wulfing plates are at once promising and baffling: their geographic proximity entices us with possible insight into regional ritual significance, while chronological and cultural distance obscures many of these details.

Matthew Robb

Notes

First published March 2010; revised 2016

1. Gerard Fowke, *Antiquities of Central and Southeastern Missouri*, Bulletin of the Smithsonian Institution Bureau of American Ethnology, no. 37 (Washington, DC: Government Printing Office, 1910), 98, pls. 15-19.

2. For a comprehensive census of these and other copper plates, see Jeffrey P. Brain and Philip Phillips, *Shell Gorgets: Styles of the Late Prehistoric and Protohistoric Southeast* (Cambridge, MA: Peabody Museum Press, 1996), 363-71.

3. For the seminal articulation of the SECC, see Antonio J. Waring Jr. and Preston Holder, "A Prehistoric Ceremonial Complex in the Southeastern United States," *American Anthropologist* 47, no. 1 (January–March 1945): 1-34. Recently scholars have proposed identifying this tradition more broadly as the Mississippian Ideological Interaction Sphere, or MIIS. In their view this name more accurately reflects the elaborate array of multi-ethnic exchanges bound together by a panregional visual symbol system. See F. Kent Reilly and James F. Garber, introduction to *Ancient Objects and Sacred Realms: Interpretations of Mississippian Iconography* (Austin: University of Texas Press, 2007), 3.

4. For a brief overview of these periods and the varied uses to which they put copper, see Amelia M. Trevelyan, *Miskwabik, Metal of Ritual: Metallurgy in Precontact Eastern North America* (Lexington: University Press of Kentucky, 2004), 9-14.

5. See, for example, James A. Brown and John E. Kelly, "Cahokia and the Southeastern Ceremonial Complex," in *Mounds, Modoc, and Mesoamerica: Papers in Honor of Melvin L. Fowler*, ed. Steven R. Ahler (Springfield: Illinois State Museum, 2000), 219; see also Carol Diaz-Granados and James R. Duncan, *The Petroglyphs and Pictographs of Missouri* (Tuscaloosa: University of Alabama Press, 2000), table 6.1.

6. Fowke, *Antiquities*, 98.

7. See Bill Dye, "Dunklin Field Gives Up Mysterious Plates," *Daily Dunklin Democrat*, October 21, 1957; compare with Louis Houck, *A History of Missouri from the Earliest Explorations and Settlements until the Admission of the State into the Union* (Chicago: R. R. Donnelley & Sons, 1908), 402-3. Wulfing gave the plates to Washington University in 1937.

8. John Max Wulfing to A. I. Davis, March 1, 1907, J. Max Wulfing Collection, Washington University Libraries, Department of Special Collections, St. Louis.

9. Ibid.

10. For more on Wulfing's interest in numismatics, see Roy C. Flickinger, "John Max Wulfing," *Classical Journal* 24, no. 7 (1929): 481-82. His coin collection was given to Washington University in 1928.

11. Virginia Watson, *The Wulfing Plates: Products of Prehistoric Americans* (St. Louis: Washington University, 1950). Watson speculated that the copper itself probably came from the deposits of Upper Michigan, but subsequent researchers have determined that copper was also available (if not always easily found) throughout the southeastern portion of the United States. See Vernon J. Hurst and Lewis H. Larson Jr., "On the Source of Copper at the Etowah Site, Georgia," *American Antiquity* 24, no. 2 (October 1958): 177-81.

12. See James A. Brown, "Sequencing the Braden Style within Mississippian Period Art and Iconography," in Reilly and Garber, *Ancient Objects and Sacred Realms*, 237-41, fig. 9.8.

13. See James A. Brown, "The Cahokian Expression: Creating Court and Cult," in *Hero, Hawk, and Open Hand: American Indian Art of the Ancient Midwest and South*, ed. Richard F. Townsend (Chicago: Art Institute of Chicago; New Haven, CT: Yale University Press, 2004), 105–24.

14. For a discussion of the Rogan plates (named after the archaeologist John P. Rogan, who excavated Etowah in 1884) and their sequence in Mound C's construction history, see Adam King, "Power and the Sacred: Mound C and the Etowah Chiefdom," in Townsend, *Hero, Hawk*, 151–66.

15. See James A. Brown, "On the Identity of the Birdman within Mississippian Period Art and Iconography," in Reilly and Garber, *Ancient Objects and Sacred Realms*, 56–106.

16. See Douglas S. Byers, "The Restoration and Preservation of Some Objects from Etowah," *American Antiquity* 28, no. 2 (1962): fig. 10.

17. Ibid.

18. See Townsend, *Hero, Hawk*, no. 273.

19. See Brain and Phillips, *Shell Gorgets*, 370.

20. See Brown and Kelly, "Cahokia."

21. See John E. Kelly, Lucretia S. Kelly, and James A. Brown, *Summary of 2008 Field Excavations to Locate the Copper Workshop in the Mound 34 Area* (Cahokia, IL: Cahokia Mounds Museum Society, 2009).

22. See Biloine W. Young and Melvin L. Fowler, *Cahokia, the Great Native American Metropolis* (Urbana: University of Illinois Press, 2000), 162–64.

23. For a discussion of Mound 72, see Robert J. Watson, "Sacred Landscapes at Cahokia: Mound 72 and the Mound 72 Precinct," in Ahler, *Mounds, Modoc, and Mesoamerica*, and Brown, "On the Identity of the Birdman."

24. See Reilly and Garber, introduction, 3.

25. See Brown, "Sequencing the Braden Style," 237–39.

26. See Claire Garber Goodman and Anne-Marie E. Cantwell, *Copper Artifacts in Late Eastern Woodlands Prehistory* (Evanston, IL: Center for American Archeology at Northwestern University, 1984), 67.

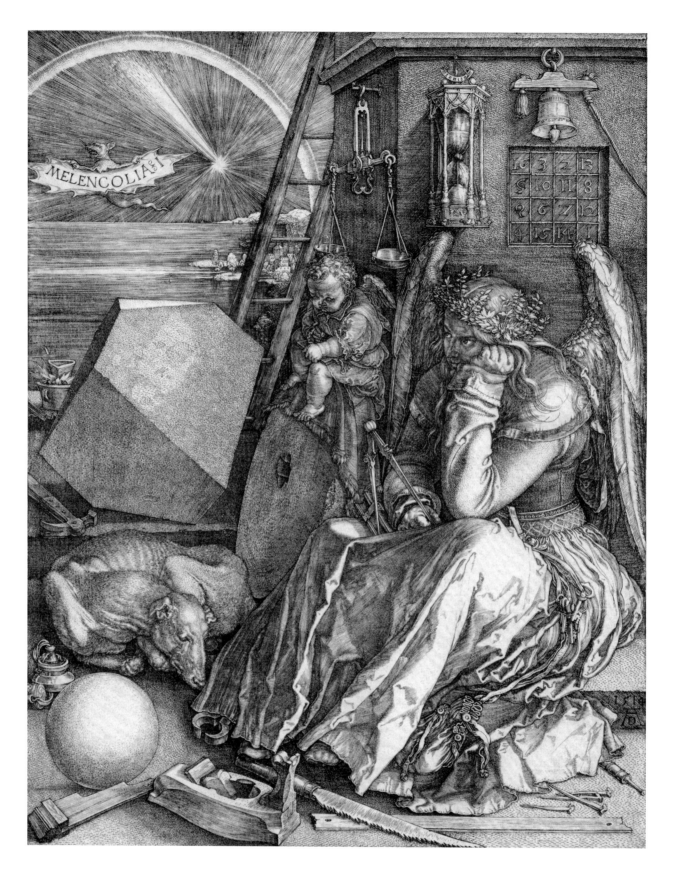

Melencolia I, 1514

Engraving, 9 3/8 × 7 5/16"

Transfer from Olin Library, Washington University, 1977

Albrecht Dürer

(German, 1471–1528)

Melencolia I, 1514

ALBRECHT DÜRER ENGRAVED *Melencolia I* at a time when the visual arts were undergoing a revision in status. From the lower position of craftsmen, artists of the Renaissance slowly raised themselves to the level of intellectuals by incorporating mathematics into their work, bringing the visual arts to a level equal to that of the liberal arts. In *Melencolia I*, one can see Dürer's participation in this process. Scholars commonly describe the image as a "spiritual self-portrait," in which Dürer declares his melancholic despondency, thought to be a condition of genius.[1] With its multitude of objects, winged figures, and allusions to cosmic phenomena, *Melencolia I* can be understood further, I propose, as a deliberate product of Dürer's program to elevate the status of prints and printmaking, as well as his own stature as an artist, by altering the valuation of art from a material appraisal to a theoretical assessment.

In order to argue for his appraisal, Dürer turned to his contemporaries' ideas on creativity as an intellectual process. Renaissance theorists understood inspiration to be stimulated by the planet Saturn. The rainbow and comet in the print's background may refer to these astrological ideas, while the dog and the bat were animals traditionally understood to have Saturnian natures. The unfortunate side effect of Saturn's cosmic gift was interspersed bouts of frustrated inactivity and a corresponding depression, or melancholy. The engraving's title suggests, furthermore, that Dürer illustrated a specific type of melancholy—a first melancholy. Dürer's compatriot Heinrich Cornelius Agrippa proposed a popular theory of three types of melancholy in his book *De occulta philosophia* (1531).[2] Agrippa described the first (related to the imagination) as affecting artists. The next two levels (related to reason and the spirit) he attributed to scholars and theologians, respectively.

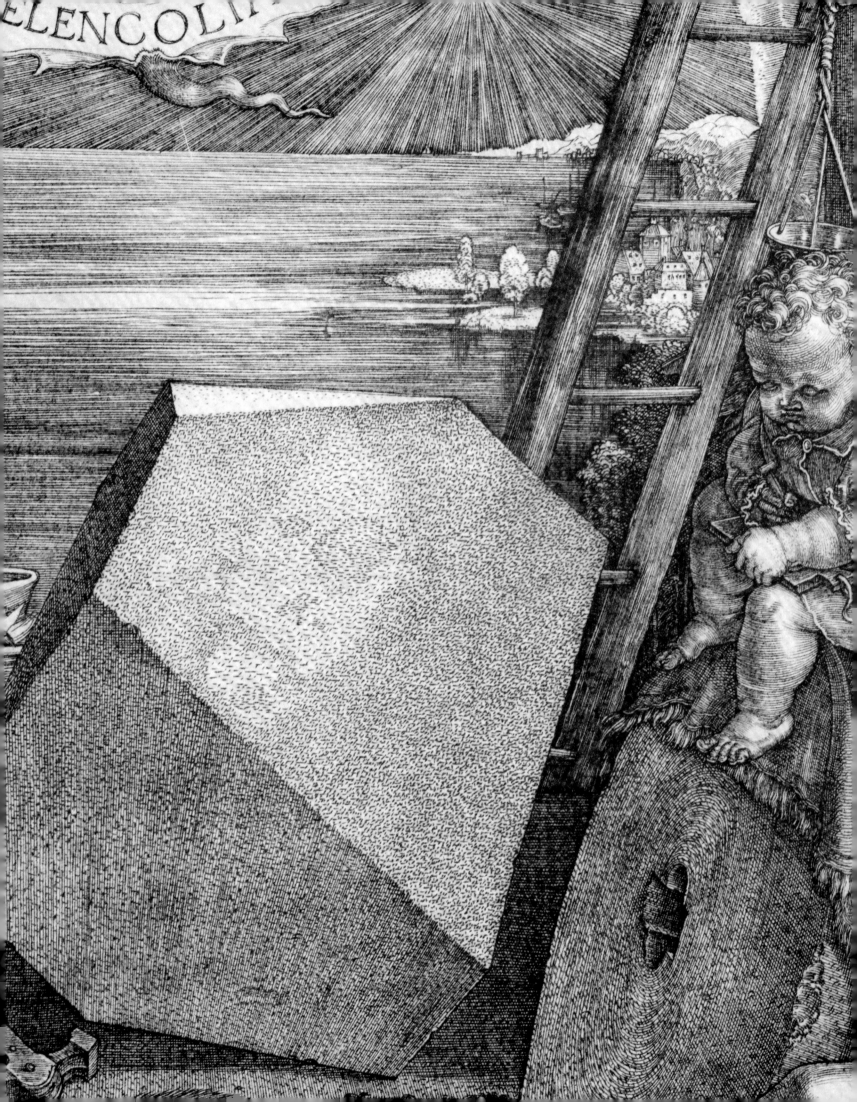

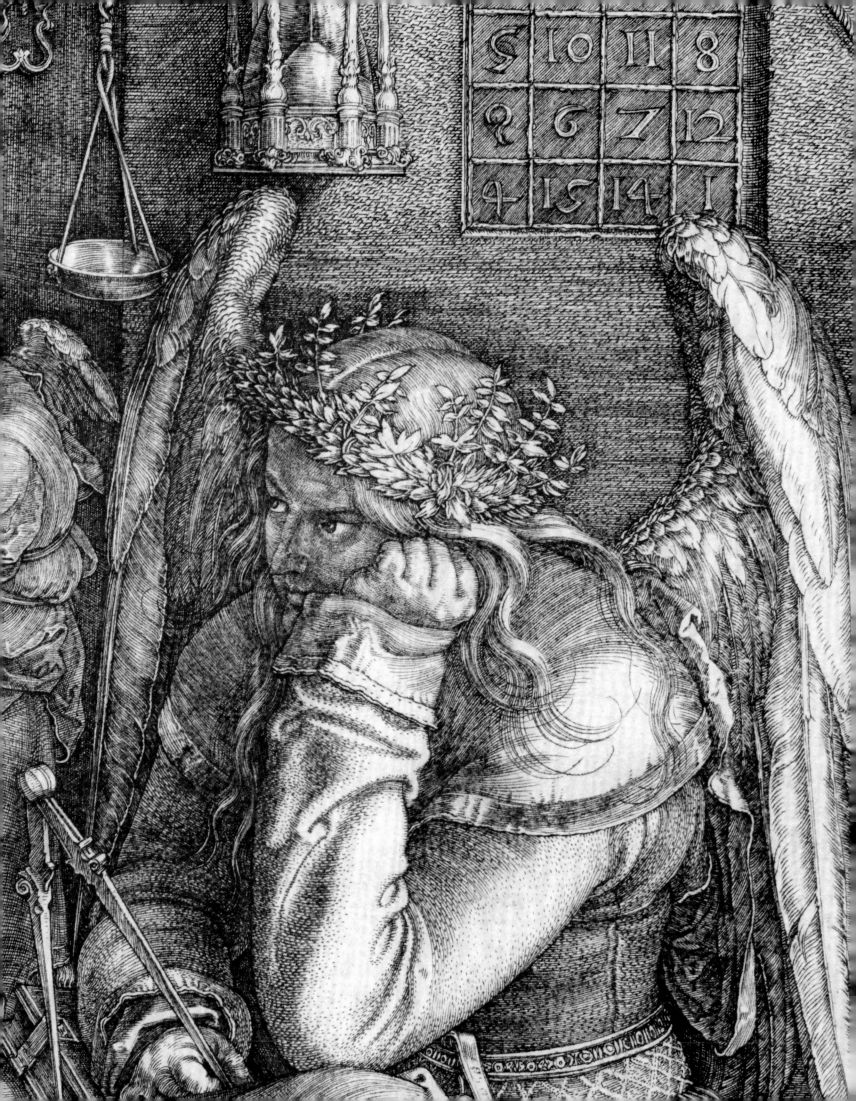

Whereas artists in their traditional roles as craftsmen had previously been associated not with Saturn but with Mercury, who lent them a steadier disposition more suited to the practical nature of their work, Agrippa's explanation linked them with the more traditional intellectual groups. The new, Saturnian artist, as described by Agrippa and illustrated by Dürer, suffered occasional debilitating bouts of melancholy but was rewarded with the advanced stature of those capable of intellectual discourse.[3]

In the engraving, the winged figure sitting with her head on her hand personifies that new artist. Yet while she sits stymied by intellectual inactivity, representing the melancholic frustration that accompanies true creativity, next to her a winged child, a putto, perched on a grindstone busily inscribing a tablet, engages in a lower, craft-level task that requires no thought, only physical work. The products and tools of these two figures further present this comparison. Dürer understood the key difference between artist and craftsman to be the former's mathematical knowledge, specifically of geometry, which offered an intellectual system to rationalize beauty. The adult holds the tool of the geometrician, a compass, as an attribute. The putto's grindstone, a tool for manual labor that meets only practical needs, meanwhile contrasts directly with the complex geometric solid next to it. The latter shape is made of six pentagons. As a representative of geometric knowledge, it is a product of the compass in the adult's hand and the intellect in her head. Similarly, the sphere in the lower left corner contrasts with the carpentry tools of the craftsman throughout: littering the foreground are a plane, a saw, and nails, while a hammer lies below the geometric solid. The tools of the craftsman lie discarded in favor of the learned application of geometry by the adult.

Other elements also attest to the print's call for geometry as a purveyor of ideal beauty. The bell, the hourglass, and the scale, for instance, represent measurement in various forms, to complement the compass. In fact, these three objects as well as others—such as the grindstone, the ladder, and the purse and keys—illustrate a second source of

Dürer's: Plato's *Hippias Major* (c. 390 BC), in which the ancient Greek philosopher argues for various forms of beauty.[4] The grid of numbers above the winged adult's head, called a magic square, offers a conclusion to Dürer's argument for the beauty of mathematics. It too is derived from Agrippa's *De occulta philosophia*, in which the author describes nine different magic squares, each associated with one of the planets. Dürer's square reverses Agrippa's second square, with its columns, rows, corners, and diagonals that each add up to thirty-four. The middle two numbers in the lowest row then match the date of the print, 1514, making a very literal connection between the print itself and its theoretical basis.

The conveyance of geometry's importance for artists was ultimately Dürer's intention for *Melencolia I*. He worked most of his career to gain a working knowledge of mathematics and its artistic applications, in order to bring it to Germany and reform German art. Dürer traveled to Italy twice during his lifetime, once in 1494 and again in 1505, and there he endeavored to learn the principles of the new, classically inspired Italian Renaissance art, such as linear perspective and proportion.[5] He may have learned mathematics and perspective, for instance, from Luca Pacioli, a renowned geometrician who wrote a treatise on the subject illustrated with designs by Leonardo da Vinci.[6] Dürer illustrated some of his Italian learning in another print, *Adam and Eve* (1504), in which the two nude figures are presented with classical proportions. Like the later *Melencolia I*, *Adam and Eve* disseminated Dürer's idea of how art should look, in hopes of influencing his fellow countrymen's work.[7] The artist adopted this philanthropic idea of German cultural reform from his friends Willibald Pirckheimer and Konrad Celtis. These two classical scholars, or humanists, along with Dürer, dreamed of altering the view of Germany as barbaric, an opinion expressed in classical writings and still commonly held in Italy.[8] While the scholars pursued this program through their medium of writing, Dürer sought to use his prints to achieve similar goals.

Prints were a useful medium for the visual dissemination of information given their relative

inexpensiveness and nature as multiples. Dürer and other artists frequently used them for advertising and propagandistic purposes. The Italian artist Andrea Mantegna, for instance, much admired by Dürer, pursued the advertising potential of engravings at a very early stage of the medium's history to disseminate his own artistic style. Dürer took a cue from his predecessor, using prints not just to disseminate a proportional system, as in *Adam and Eve*, but also to portray himself in particular light, as in *Melencolia I*.

As Dürer sought to construct for himself an artistic identity as a learned intellectual, he included printmaking as a facet of that identity. The value of printmaking, to Dürer, lay in its creative freedom. The more traditional forms of art, painting and sculpture, were expensive in their materials, and artists made them primarily in response to commissions, which came with strictures on subject, iconography, and meaning. In the early sixteenth century the value of such artworks lay not in the artist's handling of such strictures but in their materiality. A painting was valuable mostly for the amounts of pigment, gold leaf, and other materials used within it. By contrast, artists could afford to make prints on speculation, and the market for their sale was burgeoning. Dürer could therefore pursue his own ideas about what to include and display within a print. Their inexpensive materials, however, meant that prints were valued less than paintings and sculptures. As a printmaker Dürer sought to change this system of appraisal, thereby increasing his stature along with his income. In *Melencolia I*, the composition as well as the objects reveal Dürer's idea that prints should be valued based on their artistic qualities rather than their materials. The polyhedron sits in front of a crucible, a tool used by goldsmiths for melting metals in a fire, while the needle end of a hand bellows, used to stoke that fire, pokes out from under the winged adult's dress in the lower right corner. In both cases, the new intellectual value overtakes and replaces the old materiality of gold.

Engraving in fact originated out of goldsmithing. The former borrowed the technique of inscribing lines into metal from the latter.[9] Dürer shared these origins: his father was a prominent goldsmith in Nuremberg.[10] The crucible and bellows thus represent the past, both personally and artistically, for Dürer and his project. The print itself, through both its medium of engraving and its subject matter of melancholy, represents the present or, ambitiously, the future. In other words, while *Melencolia I* emphasizes what mathematical knowledge is required for making this new form of art, it also argues for a new valuation based on that theoretical substance. It offers Dürer as a new type of artist, an intellectual one, superseding the lower-status craftsmen of the past. And it disseminated this information within the very medium for which it argued, in hopes of inspiring his countrymen to similar levels of learnedness and judgment.

Ryan E. Gregg

Notes

First published September 2011

1. The literature on *Melencolia I* is extensive; it has often been described as the most discussed print in scholarship. I have limited the sources referenced here to a few key works in English that are among the most accessible. The "spiritual self-portrait" description derives from Erwin Panofsky, as does the iconographic reading given in the following two paragraphs, which is still the standard understanding of the print. See Erwin Panofsky, *The Life and Art of Albrecht Dürer* (Princeton, NJ: Princeton University Press, 1955), esp. 156–71. For a general biography of Dürer, see Jane Campbell Hutchison, *Albrecht Dürer: A Biography* (Princeton, NJ: Princeton University Press, 1990).

2. Agrippa finished the manuscript in 1509–10; it circulated widely before it was eventually published, in an altered form, in 1531. See Panofsky, *Albrecht Dürer*, 168–69.

3. Panofsky, with Raymond Klibansky and Fritz Saxl, elaborated on these ideas in their *Saturn and Melancholy: Studies in the History of Natural Philosophy, Religion, and Art* (New York: Basic Books, 1964).

4. For more on the connection between this print and Plato's text, see Patrick Doorly, "Dürer's *Melencolia I*: Plato's Abandoned Search for the Beautiful," *Art Bulletin* 86 (June 2004): 255–76.

5. See Hutchison, *Dürer*, 43.

6. See Panofsky, *Albrecht Dürer*, 252, 259, and Doorly, "Dürer's *Melencolia I*," 259–61.

7. See Charles Talbot, "Dürer and the High Art of Printmaking," in *The Essential Dürer*, ed. Larry Silver and Jeffrey Chipps Smith (Philadelphia: University of Pennsylvania Press, 2010), 50.

8. See Hutchison, *Dürer*, 48–49.

9. The history of printmaking is also an extensively covered topic. Perhaps most appropriate to the current subject, see David Landau and Peter Parshall, *The Renaissance Print, 1470–1550* (New Haven, CT: Yale University Press, 1994).

10. On Dürer's family history, see Hutchison, *Dürer*, 3–20, 23.

The Peasant Feast, c. 1533–36

Etching from two plates, 9 $^{7}/_{8}$ × 19 $^{5}/_{8}$"
University purchase, Art Acquisition Fund and with funds from Mrs. Mahlon B. Wallace Jr.,
and Leicester Busch Faust and Audrey Faust Wallace, by exchange, 2004

Daniel Hopfer

(German, c. 1470–1536)

The Peasant Feast, c. 1533–36

DANIEL HOPFER'S ETCHING *The Peasant Feast* has an unexpectedly complex genealogy, which provides a bird's-eye view of sixteenth-century German visual culture. Hopfer was an almost exact contemporary of the well-known painter and printmaker Albrecht Dürer, whose enduring legacy was already deeply felt in his life-time. Hopfer has been widely credited with introducing etching around 1500 as one of the options available to artists making prints. In contrast to Dürer, however, who is celebrated as much for the virtuosity of his technique as for the ingenuity of his inventions, Hopfer utilized his newfound technique as a tool for popularizing many different types of prints designed not only by himself but also by others. This resulted in a long life for his plates, which were reprinted into the nineteenth century, but a less illustrious reputation.

Although Hopfer's etchings were written off or ignored by earlier generations of art historians and considered derivative or worse, recent scholarship has begun reassessing his contributions.[1] More generally, the role of copies, replicas, and reinter-preted motifs in early modern visual culture is also being reconsidered.[2] This is thus an appropriate moment to consider *The Peasant Feast* in light of this and, more specifically, to resituate Hopfer's role in the print market and to frame his project as an innovative new business model.

Etchings—in which a design is etched into metal by the corrosive action of acid—were made by increasing numbers of artists all over Europe by the 1530s.[3] The earliest etchings were printed from iron or steel plates, and it is clear that the same technique had already been in use for decorating armor and other iron objects.[4] Hopfer, who in 1493 registered as a citizen of Augsburg, an important armor-making

center, is considered to be the first artist to adapt etching from the iron trades to printmaking, probably around 1500. He was in any case the first artist truly to specialize in the technique. Although Dürer and a handful of other contemporaries tried their hand at etching on iron, only Hopfer and his sons produced significant bodies of work in the medium.[5]

Hopfer is credited with single-handedly establishing the salability of etchings, but a less widely acknowledged point is his successful deployment of an innovative business model based on his exploitation of this new printmaking technique and, significantly, his production of a large stock of varied subjects and types of prints. In doing this, he was among the earliest of the entrepreneurs we would now call print publishers.

The subject and even the scale of *The Peasant Feast* were also new at the time: madcap, frolicking groups of peasants such as these are associated with the kermis, an annual Catholic Church festival. Prints representing the kermis and displaying excess consumption and violence by peasants in the countryside first appeared in Nuremberg in the late 1520s, as the Lutheran Reformation was taking hold there. The compositions are filled with figures who drink, dance, and fight to the point of collapse. Hopfer's etching was undoubtedly inspired by the peasant kermis woodcuts from post-Reformation Nuremberg, in particular by those of Sebald Beham, who is credited with inventing the genre.[6] Hopfer's use of two plates to create the continuous horizontal composition of this print also echoes Beham's use of multiple blocks to produce large-scale woodcuts.[7]

Like other examples in the peasant genre, Hopfer's print is an elaborately composed work, full of engaging and telling details. The composition is roughly bifurcated by a slim central tree trunk, which handily disguises the seam between the two plates from which it was printed. The stage is set in an alpine landscape with a tavern operating at capacity and a broom above its door. The animated revelers drink, converse, dance, flirt, make out, fight, vomit, and defecate. The effects of drink are thus present at every stage, from celebration to violence to drunkenness.

Much has been written about sixteenth-century peasant prints, framing them to varying degrees as moralizing, comic, and affirming of a national identity.[8] Be they tragic or comic, there is no simple explanation for these images. They should be seen, on the one hand, in the context of Martin Luther's criticisms of the kermis as a sign of the excesses of the Catholic Church and, on the other, as a celebration of an indigenous tradition harking back to the roots of the German people as rough peasant stock during the Roman Empire.[9]

Hopfer borrowed liberally from his peers, and his relationship to his model in this particular case demonstrates how such borrowing informed his business.[10] Although Hopfer's source was clearly the earlier Nuremberg kermis prints, his etching is not a slavish copy but rather an adaptation of the theme to the Augsburg context. This localization is evident in the broom hanging from the tavern roof, designating this locale as a *Besenwirtschaft* (literally "broom tavern"), which was distinctive to Augsburg, where the broom was the sign of a seasonal home-grown wine tavern.

Echoes of Beham's figure types are present in Hopfer's print, as are compositional devices such as the table in the foreground and the central tree trunk, but the etching is truly a new variation on the theme. *The Peasant Feast* is furthermore signed in both plates with the initials *DH* flanking a decorative pinecone borrowed from Augsburg's coat of arms: Hopfer was clearly not trying to pretend that his etching was by Beham.[11] It is thus possible to see Hopfer the entrepreneur still active at the end of his four-decade career, adapting and modifying this new category of peasant prints for his own stock and thereby avoiding accusations of verbatim reproduction.[12]

Taking into consideration notions of the copy before the age of copyright, Hopfer can thus be seen as a skilled artist and forward-looking businessman who created a niche business based on his exploitation of a new printmaking medium rather

than as a plagiarizer.[13] He built up a varied stock of plates for sale consisting of his own designs, copies, and adaptations. The wide variety of seemingly disparate subjects may make his production appear chaotic today, but it is in fact stylistically distinctive and, with his monogram, also self-promoting, as was Dürer's.

Hopfer's printing plates survived long beyond his death, as did those of Dürer and others. The longevity of Hopfer's etchings is revealed in a second impression of the left-hand plate of *The Peasant Feast* in the Kemper Art Museum's collection. The numeral 200 in the lower left corner of this plate was added in the late seventeenth century by David Funck of Nuremberg, who published 230 plates by Hopfer and sons in 1684.[14] This was a common practice among printer-publishers, who, by the mid-sixteenth century, were both producing and commissioning new printing plates and also acquiring used ones and incorporating them into their own stock.

The distinct business that we now call print publishing was only just beginning to emerge in Hopfer's time. A comparison of Dürer and Hopfer once again proves useful, since they each presented a distinct model for this new category of entrepreneurs. Dürer, on the one hand, transformed the very nature of what a woodcut or an engraving could be, and he kept firm control over his prints and their distribution, resulting in a distinctive (and elite) "house style" that was thoroughly his own. Hopfer, on the other, created an equally distinctive style based on the recognizability of his etchings, but his output was also distinguished by the variety of his subjects and sources. As print publishing developed throughout Europe in the second half of the sixteenth century, there continued to be artist-dominated houses, but more and more publishers were printers rather than artists, who built up varied stocks of prints, commissioning and acquiring plates from disparate sources. It is the latter model of the print publisher, I would argue, that Hopfer's example of eclectic and wide-ranging sources anticipated.

Elizabeth Wyckoff

Notes

First published December 2012; revised 2016

1. Albrecht Haupt characterized Hopfer as "the most thieving artistic riffraff" in the history of etching ("das diebischste Kunstgesindel, was geistiges Eigentum anlangt, das wohl jemals in . . . Eisen . . . gestochen hat"). Haupt, "Peter Flettners Herkommen und Jugendarbeit," in *Jahrbuch der preussischen Kunstsammlungen*, vol. 26 (Berlin: G. Grote'sche Verlagsbuchhandlung, 1905), 148. For the first monograph on Hopfer, see Ed Eyssen, "Daniel Hopfer von Kaufbeuren: Meister zu Augsburg 1593 bis 1536" (PhD diss., Ruprecht-Karls-Universität, 1904). Recent studies include Freyda Spira, "Originality as Repetition / Repetition as Originality: Daniel Hopfer (c. 1470–1536) and the Reinvention of the Medium of Etching" (PhD diss., University of Pennsylvania, 2006), and Christof Metzger et al., *Daniel Hopfer: Ein Augsburger Meister der Renaissance* (Munich: Deutscher Kunstverlag, 2009).

2. See Lisa Pon, *Raphael, Dürer, and Marcantonio Raimondi: Copying and the Italian Renaissance Print* (New Haven, CT: Yale University Press, 2004), and Rebecca Zorach and Elizabeth Rodini, *Paper Museums: The Reproductive Print in Europe, 1500–1800* (Chicago: David and Alfred Smart Museum of Art, University of Chicago, 2005).

3. See David Landau and Peter Parshall, *The Renaissance Print* (New Haven, CT: Yale University Press, 1994), 323–47. For a history of etching in Italy, see Sue Welsh Reed and Richard Wallace, *Italian Etchings of the Renaissance and Baroque* (Boston: Museum of Fine Arts, 1989).

4. Although quickly supplanted by copper, iron and steel were both used by early sixteenth-century etchers. See A. R. Williams, "The Metallographic Examination of a Burgkmair Etching Plate in the British Museum," *Historical Metallurgy* 8, no. 2 (1974): 92–94.

5. Approximately 150 iron etchings by Hopfer survive; most of his plates also survive. Metzger's *Daniel Hopfer* catalogues 154 etchings in addition to woodcuts and decorated metal objects.

6. See Alison G. Stewart, *Before Bruegel: Sebald Beham and the Origins of Peasant Festival Imagery* (Aldershot, UK: Ashgate, 2008), and Jürgen Müller and Thomas Schauerte, eds., *Die Gottlosen Maler von Nürnberg: Konvention und Subversion in der Druckgrafik der Beham-Brüder* (Nuremberg: Albrecht-Dürer-Haus, 2011).

7. See Larry Silver and Elizabeth Wyckoff, eds., *Grand Scale: Monumental Prints in the Age of Dürer and Titian* (Wellesley, MA: Davis Museum and Cultural Center, Wellesley College; New Haven, CT: Yale University Press, 2008).

8. For a review of the extensive and wide-ranging literature on this topic, see Stewart, *Before Bruegel*.

9. See ibid., 68–70, and Margaret D. Carroll, "Peasant Festivity and Political Identity in the Sixteenth Century," *Art History* 10, no. 3 (1987): 289–314. Carroll cites, for example, the Roman historian Tacitus's *Germania*: "No nation indulges more freely in feasting and entertaining than the German" (290). For views on drunkenness, see B. Ann Tlusty, *Bacchus and Civic Order: The Culture of Drink in Early Modern Germany* (Charlottesville: University Press of Virginia, 2001), esp. chap. 3, "The Drunken Body," 48–68.

10. Spira points out that roughly 29 percent of Hopfer's etchings imitate or replicate work by other artists. Spira, "Originality as Repetition," 241.

11. Ibid., 23–24.

12. *The Peasant Feast* is not dated but was probably made around 1535–36. It cannot be later than 1536, since that was the year of Hopfer's death; nor does it seem plausible that it could be earlier than Beham's *Large Kermis*, with which it shares many general compositional devices and which is dated 1535 in the block. See Max Geisberg, *The German Single-Leaf Woodcut, 1500–1550* (1930), ed. Walter L. Strauss (New York: Hacker, 1974), 251–54; see also Stewart, *Before Bruegel*, 60. The device of the tree trunk down the middle may be borrowed from Beham's *Feast of Herod* (c. 1530). See Geisberg, *German Single-Leaf Woodcut*, 179–80.

13. On the origins of copyright, see Pon, *Raphael, Dürer, and Raimondi*, 39–66.

14. See Metzger, *Daniel Hopfer*, 24–34.

The Great Hercules, 1589

Engraving, 22 ¹/₂ × 16 ¹/₄"

University purchase with funds from Mrs. Mahlon B. Wallace Jr., by exchange, 2004

Hendrick Goltzius

(Dutch, 1558–1617)

The Great Hercules, 1589

HENDRICK GOLTZIUS'S ENGRAVING *The Great Hercules* assaults the viewer with the bulging musculature and blatant nudity of its protagonist.[1] It is a mere two-dimensional image printed on paper, which nonetheless claims a monumentality akin to that of a colossal sculpture. The copper plate from which Goltzius created this composition not only surpasses all his previous engravings in its formidable size (22 3/16 × 15 13/16"), but Hercules himself is one of the largest figures ever produced from a single engraved plate. It is surely no coincidence that Goltzius chose as the subject of this imposing print a hero of equally grand proportions. For an artist who one year later would journey from his home in the Netherlands to Italy, where he would quench his desire to master the antiquities of Rome and the models of the Italian Renaissance, the impressive scale of his Hercules would seem to be an unequivocal assertion of confidence in the face of his anticipated encounter with those famous monuments.

Beyond the physical scale of Goltzius's 1589 engraving, two main aspects of the image immediately provoke curiosity. The first and most striking is, as already noted, the treatment of the hero's body. A magnificent congregation of swirling tapered lines endows Hercules's physique with a powerful dimensionality and simultaneously demonstrates Goltzius's skill at wielding the burin and incising unforgiving copper with exceptional agility. As famously recounted by the artist's biographer and close friend Karel van Mander, Goltzius fell into a fire as a very young child and burned his hands on hot coals: for the rest of his life he could not fully open his right hand. This impediment made his achievements in both drawing and engraving all the more astonishing to his contemporaries.[2] Indeed, Van Mander even refers to the "heroic

power of his draftsmanship" when describing one of Goltzius's print series made just a few years before *The Great Hercules*.[3]

Van Mander's emphasis on the artist's draftsmanship also points to Goltzius's exceptional status as a printmaker who both drafted and engraved his own designs, a position that allowed him a freedom of experimentation with the medium that few others enjoyed. Although many of Goltzius's engravings display his virtuosity as a draftsman, *The Great Hercules* stands out in demonstrating his remarkable control of the burin. In earlier engravings he employed line more as a means to lend tonality to his compositions, but here he mastered its use to define volume, adapting each swelling stroke to the shape of the form that it models.[4] His use of bold shorter lines that visibly swell and taper, almost seeming to vibrate in areas of cross-hatching, also serves to heighten this volumetric effect. Hercules's bulging muscles not only appear more impressive and dimensional as a result, but they also provide the perfect vehicle for showcasing Goltzius's skillfully engraved lines. These technical feats, combined with the dramatic size of the engraved plate, make *The Great Hercules* one of the boldest statements in the artist's prolific and storied career.

Stocky yet aggressively strong, with popping veins and muscles in excess of actual human anatomy, Goltzius's Hercules stands in a wide frontal stance spanning more than half the width of the composition.[5] The hero's pose conveys a combination of stasis and movement: although his feet seem fixed in place, the subtle torsion of his chest as he looks askance over his shoulder—his lion's cloak fluttering behind him—suggests that he has stopped only for a moment, just long enough so that we as viewers might survey his indomitable form. This restiveness extends even to his furrowed brow, which shades large round eyes sunk deep and longingly in thought.

According to the most commonly accepted interpretation of the engraving, the image is an elaborate political allegory of the Dutch Revolt, the ongoing struggle to overthrow oppressive Spanish rule that had begun in the late 1560s. Goltzius's Hercules, by this argument, is not only a heroic embodiment of Dutch spirit and strength in adversity but also a representation of the political body of the unified Netherlands, akin to the image of the roaring lion (*Leo Belgicus*) that would come to stand for the nascent Dutch Republic.[6]

I will argue instead that Goltzius's intentions with this work were personal rather than political. Without denying that the fraught situation in the Low Countries may have informed the reception of *The Great Hercules* for some viewers, an alternative interpretation of the engraving sheds light on its larger significance within Goltzius's oeuvre. As Van Mander's praise for the artist already implies, *The Great Hercules* represents a hero of battle, but it also figures Goltzius as a hero in his own right by showcasing his mighty feats and powers as an engraver.[7] It is my contention that the artist employed this analogy not merely as an unequivocal statement of artistic achievement but also, and still more provocatively, as a nuanced exploration of the difficult balance between his physical labor and his love of making art.

We have to begin by looking beyond Goltzius's conspicuous representation of the body in the foreground to the scenes unfolding in the background landscape, where Hercules appears twice more. On the left side of the composition, he wrestles the powerful river god Achelous, who transformed himself into a bull in the midst of their combat. As the Roman poet Ovid describes in his *Metamorphoses*, Hercules dramatically ripped off one of Achelous's horns as a spoil of battle, thereby sealing his victory and at the same time creating the very first cornucopia, which a trio of nymphs in the background are filling with abundant fruits.[8]

The point of contention in his battle with Achelous, however, and Hercules's true victory prize, was the beautiful Deianira, whom the hero subsequently married. Although she is not pictured in Goltzius's *Great Hercules*, any viewer familiar with the myth would recognize her implied presence in the narrative and recall that Hercules's conquest

resulted both in his marriage and, ultimately, in his own demise. When Deianira was later captured by the deceitful centaur Nessus, Hercules rescued her but not soon enough to stop the dying Nessus from giving Deianira his bloodied cloak and deceiving her into believing that it had powers to revive a waning love. Years later, when Deianira hears a rumor that Hercules has fallen for another woman, she desperately sends him the cloak, which poisons and kills him. Thus the story of Hercules's encounter with Achelous is not just about heroic victory; it also exposes the hero's vulnerability to love.

Turning to the scene in the background right of Goltzius's *Great Hercules*, we find our protagonist locked in yet another struggle, but one that conveys—by contrast—his mastery over desire. When traveling through the region of Libya, Hercules encounters the giant Antaeus, who challenges him to a wrestling match.[9] Because Antaeus derives all his strength from the earth, Hercules defeats the giant by cleverly and forcefully lifting him up into the air. Goltzius chooses to depict the dramatic moment just before the giant's defeat, in which only the tip of one toe on Antaeus's left foot flexes desperately to maintain contact with the ground, clearly indicating that Hercules is the inevitable victor.

Beginning already in the sixth century, Hercules's defeat of Antaeus was frequently understood to represent his victory over lust.[10] This interpretation stemmed not only from the giant's close association with the earthly realm—and, by extension, with the baser aspects of the human condition—but also from a creative etymological association between Antaeus's home, Libya, and the libido. The way in which Goltzius depicts Antaeus, flinging back his head as if caught more in a moment of erotic ecstasy than one of fierce combat, may well resonate with this libidinous characterization of the giant. Whereas the battle with Achelous evokes Hercules's vulnerability to love, his opposing contest with Antaeus represents the hero's triumph over excessive passion.

The inscription at the bottom of the engraving, like most texts appended to Renaissance prints, goes only so far toward illuminating the image that it accompanies, but it does juxtapose Hercules's opponents, Achelous and Antaeus, in the same line of verse:

> Does anyone not know of Hercules's courage on land and at sea,
>
> And the cruel stepmother who did him so much harm?
>
> He was exposed to so many monsters: to the Hydra and you,
>
> Three-bodied Geryon, and to the fire-breathing Cacus.
>
> Here he conquers Antaeus and you, Achelous, who was once two-horned,
>
> Now the Naiads enrich the broken one with abounding fruits.[11]

While the verses are straightforward in treating Hercules as a courageous conqueror, the image has already proven to be more complex. Goltzius depicted the hero both engaging in physical combat and struggling metaphorically with desire. Even as he overcomes the lust of Antaeus, he wins—by defeating Achelous—the fatal love of Deianira. Moreover, if we return to the looming figure of Hercules in the foreground, it becomes clear that Goltzius also emphasized the opposing nature of these two exploits through the juxtaposed objects that the hero holds: the broken horn of Achelous in his right hand, which he seems almost to caress with his thumb, and the knotted club in the left, confidently slung over his shoulder. Both objects are also amorously charged, and more than a little humorous, in that they both allude to—and greatly overshadow in size—Hercules's own exposed manhood. At the same time the peculiar way in which Hercules holds the objects in his hands calls to mind the hands of the artist who brought the entire engraving into being.

Elsewhere in his oeuvre, Goltzius attested to the significance of love as a generative force in his artistic enterprise.[12] Perhaps the boldest and most virtuosic example is his *Venus, Bacchus and Ceres* (1606), executed in pen and red chalk on prepared canvas.[13] In the background of an amorous assembly convened by the goddess of love and fueled by the gods of food and wine, Goltzius depicts himself standing over Venus's forge and holding not one but two burins in each of his hands. It is a self-portrait that expresses his love for his art and devotion at the altar of the goddess who now warmly inspires the same hands that were once scarred by flame. Van Mander also emphasizes this passion throughout his biography of Goltzius, declaring that "he is someone who, because of outstanding love of art likes to have peace of mind, be quiet and solitary, while art has claimed the whole person for herself."[14] At the same time, however, Van Mander distinguishes Goltzius from those artists who, like the mythical sculptor Pygmalion, "fall blindly in love with their own creations" and, so consumed by passion, receive nothing but derision from their colleagues.[15] Whereas Pygmalion ardently prayed at the altar of Venus for his beautiful female statue to come to life and be his bride, Goltzius far more temperately asked only that love spark his creative spirit.

With *The Great Hercules*, Goltzius can thus be seen to adopt the guise of the hero himself. The muscular and towering body of Hercules represents the courageous feat that Goltzius undertook in producing such a large and ambitious engraving. At the same time, Hercules—positioned between Achelous and Antaeus—embodies the strong love that inspires the artist's hand but that also must be kept in check lest it overtake him entirely. The horn and club held by Hercules, like the pairs of burins that the artist holds in his *Venus, Bacchus and Ceres*, represent the tools of Goltzius's art but also suggest his double dexterity as both hero and lover. As Hercules pauses in his massive stride and looks over his shoulder, reflecting on his past accomplishments, we can imagine Goltzius himself looking back over his previous works as he prepares for his imminent trip to Rome, driven by desire and the strength of his artful hand.

Marisa Anne Bass

Notes

First published October 2013

1. For key sources from the vast literature on this print, see Marjolein Leesberg and Huigen Leeflang, eds., *Hendrick Goltzius*, vol. 22 of *The New Hollstein: Dutch and Flemish Etchings, Engravings and Woodcuts, 1450-1700* (Ouderkerk aan den Ijssel: Sound & Vision, 2012), vol. 1, 257-59, no. 156, and Huigen Leeflang, Ger Luijten, and Lawrence W. Nichols, *Hendrick Goltzius (1558-1617): Drawings, Prints and Paintings* (Zwolle, Netherlands: Waanders, 2003), 106-8, no. 36.

2. Karel van Mander, *The Lives of the Illustrious Netherlandish and German Painters, from the First Edition of the Schilder-boeck (1603-1604)*, ed. H. Miedema (Doornspijk, Netherlands: Davaco, 1994), vol. 1, 384-407. For useful discussion of the significance of Van Mander's biography, see Walter S. Melion, "Karel van Mander's 'Life of Goltzius': Defining the Paradigm of Protean Virtuosity in Haarlem around 1600," *Studies in the History of Art* 27 (1989): 113-33.

3. Van Mander, *Lives*, vol. 1, 396-97 ("de heldighe cracht der Teycken-const"), in reference to Goltzius's series of the *Roman Heroes*, published in 1586. On this series, see also Walter S. Melion, "*Memorabilis aliquot Romanae strenuitatis exempla*: The Thematics of Artisanal Virtue in Hendrick Goltzius's *Roman Heroes*," *MLN* 110 (December 1995): 1090-1134.

4. For more on this discussion, see Nadine M. Orenstein, "Finally Spranger: Prints and Print Designs, 1586-1590," in Leeflang, Luijten, and Nichols, *Hendrick Goltzius*, 82-83, and Jan Piet Filedt Kok, "Hendrick Goltzius: Engraver, Designer, and Publisher, 1582-1600," in *Goltzius Studies: Hendrick Goltzius (1558-1617)*, ed. Reindert Falkenburg, Jan Piet Filedt Kok, and Huigen Leeflang, special issue, *Nederlands Kunsthistorisch Jaarboek* 42-43 (1991-92): 159-218, esp. 173-74.

5. The characterization of *The Great Hercules* as an accurate and scientific representation of human anatomy has been effectively disproven by Beth L. Holman in "Goltzius' *Great Hercules*: Mythology, Art and Politics," in Falkenburg, Filedt Kok, and Leeflang, *Goltzius Studies*, 397-412, esp. 398-400. There has also been much discussion of Goltzius's visual models for the figure, with a convincing link to Bartholomaeus Spranger's muscular Hercules in his 1587 engraving *The Wedding Feast of Cupid and Psyche* and other, less compelling connections to Federico Zuccaro and Willem Danielsz. van Tetrode. On the Spranger connection, see also Ger Luijten and Ariane van Suchtelen, eds., *Dawn of the Golden Age: Northern Netherlandish Art, 1580-1620* (Zwolle, Netherlands: Waanders, 1993), 345-46, no. 13, esp. 346; and Leeflang, Luijten, and Nichols, *Hendrick Goltzius*, 106. For the proposed relation to Zuccaro's vault fresco in Caprarola, see Leeflang, Luijten, and Nichols, *Hendrick Goltzius*, 106, and for Goltzius's alleged debt to the small bronze *Hercules Pomarius* of Tetrode, see Anthony Radcliffe, "Schardt, Tetrode, and Some Possible Sculptural Sources for Goltzius," in *Netherlandish Mannerism: Papers Given at a Symposium in Nationalmuseum Stockholm, September 21-22, 1984*, ed. Görel Cavalli-Björkman (Stockholm: Nationalmuseum, 1985), 97-108, esp. 102; and Stephen H. Goddard and James A. Ganz, *Goltzius and the Third Dimension* (Williamstown, MA: Sterling and Francine Clark Art Institute, 2001), 13-15, 48-56.

6. Holman, "Goltzius's *Great Hercules*," passim, reiterated by Luijten and Van Suchtelen, *Dawn of the Golden Age*, 346; and by Leeflang, Luijten, and Nichols, *Hendrick Goltzius*, 108.

7. This suggestion was briefly put forth by Walter S. Melion, on whose argument this essay builds. See Melion, "Self-Imaging and the Engraver's *Virtù*: Hendrick Goltzius's *Pietà* of 1598," *Nederlands Kunsthistorisch Jaarboek* 46 (1995): 104–43, esp. 110–11, and Melion, "Piety and Pictorial Manner in Hendrick Goltzius's *Early Life of the Virgin*," in *Hendrick Goltzius and the Classical Tradition*, ed. Glenn Harcourt (Los Angeles: Fisher Gallery, 1989), 44–51, esp. 46.

8. For the full story of Hercules's battle with Achelous and its aftermath, see Ovid, *Metamorphoses*, 9.1–272.

9. For the story of the hero's conquest over Antaeus in classical sources, see Apollodorus, *Biblioteca*, 2.5.11; Diodorus Siculus, *Bibliotheca historica*, 4.17.4; Philostratus, *Imagines*, 2.21; and Lucan, *De bello civili*, 4.589–660.

10. See Fulgentius, *Mythologiae*, 2.4. For additional discussion, see Ursula Hoff, "The Sources of 'Hercules and Antaeus' by Rubens," in *In Honour of Daryl Lindsay: Essays and Studies,* ed. Franz Philipp and June Stewart (Melbourne: Oxford University Press, 1964), 67–79, esp. 68, 74n11, and Patricia Simons, "Hercules in Italian Renaissance Art: Masculine Labour and Homoerotic Libido," *Art History* 31, no. 5 (2008): 632–64, esp. 637–45.

11. "Amphitryoniadae virtus terraque marique / Quem latet? et tanti saeva noverca mali? / Ille tot expositus monstris, Hydraeque, tricorpor / Geryon atque tibi, flammivomoque Caco. / Ille hic Antaeum, et superat te Acheloe bicornem; / Naiades at truncum fruge ferace beant," adapted from Leeflang, Luijten, and Nichols, *Hendrick Goltzius*, 106 (translation mine).

12. On this point, see Eric Jan Sluijter's seminal article "Venus, Visus and Pictura," in his *Seductress of Sight: Studies in Dutch Art of the Golden Age* (Zwolle, Netherlands: Waanders, 2000), 86–159, originally published in Falkenburg, Filedt Kok, and Leeflang, *Goltzius Studies*, 337–96.

13. State Hermitage Museum, St. Petersburg, Russia, inv. no. 18983 (86 $\frac{1}{4}$ × 64 $\frac{3}{16}$"). On this image, see especially Walter S. Melion, "Love and Artisanship in Hendrick Goltzius's *Venus, Bacchus and Ceres* of 1606," *Art History* 16, no. 1 (1993): 60–94, and Leeflang, Luijten, and Nichols, *Hendrick Goltzius*, 277–79, no. 100.

14. Van Mander, *Lives*, vol. 1, 402–3.

15. Ibid., 404–5.

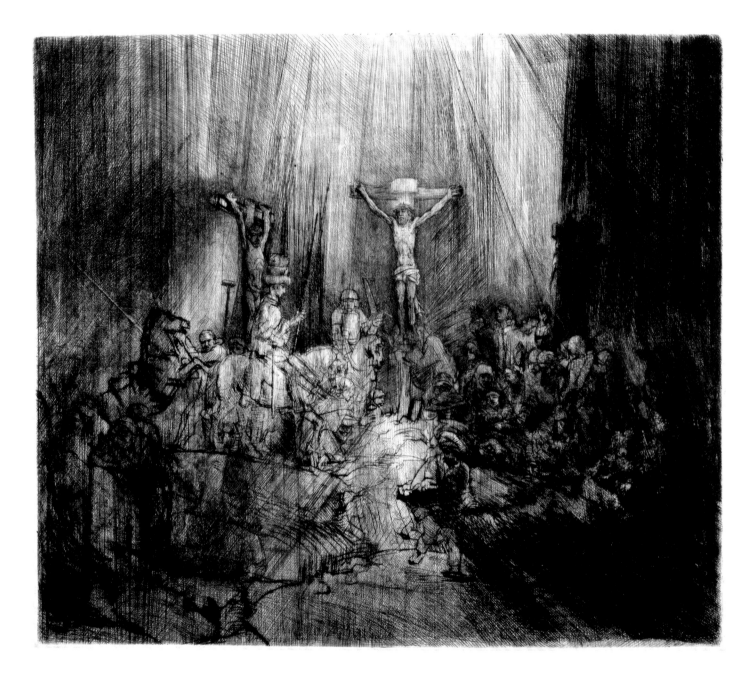

The Three Crosses, 1653

Drypoint, 15 $\frac{1}{4}$ × 17 $\frac{13}{16}$"

Gift of Dr. Malvern B. Clopton, 1930

Rembrandt van Rijn

(Dutch, 1606–1669)

The Three Crosses, 1653

ONE OF THE MOST DYNAMIC PRINTS EVER MADE, Rembrandt van Rijn's drypoint *The Three Crosses* displays technical innovation and engagement with the human subjectivity of Christ's death. A torrential downpour of lines envelops dozens of figures on the hill of Golgotha, where Christ is pictured crucified between the two thieves. Even though it is an inherently tragic subject commonly portrayed in Christian tradition, never before had it been staged with such sweeping emotional force. Rembrandt was inspired by the text of the Gospels (Matthew 27:45–54) proclaiming that a darkness covered the land from noon to three o'clock, when Jesus cried out in a loud voice, "Elí, Elí, lemá sabachtháni?" (My God, my God, why have you forsaken me?). When Jesus died, the passage continues, the earth shook, rocks split, tombs opened, and the bodies of many sleeping saints arose. To achieve these supernatural effects, Rembrandt employed the kind of bold technical ingenuity that helped define him as one of the most significant printmakers of his age. The Kemper Art Museum's impression is a fine example of the fourth state of the print, which gives a dramatically different tenor and narrative focus to his subject than earlier states did.

Rembrandt turned to the Bible as a source for his etchings throughout his career, and the 1650s were a particularly innovative period for him. He depicted scenes from both the Old and New Testaments, particularly those centered on the life of Christ, transforming the written word into a compelling pictorial language. *The Three Crosses* was made entirely in drypoint, a technique in which furrows are scratched directly into a copper plate with a stylus. These gouges create rough edges, called burr, which retain an abundant amount of ink when the plate is inked and gently wiped, resulting in velvety lines when printed. In contrast to the more common printing techniques

of Rembrandt's time—such as the crisp incisions made with an engraver's tool called a burin, or the free-flowing acid-etched lines—drypoint imbues the lines with a vigorous forcefulness that adds an aspect of the printmaker's touch akin to the bold impasto and brushstrokes of Rembrandt's painting style. Drypoint lines are more fragile, however, not holding up long under the force of the printing press, and for that reason drypoint-only prints were rarely attempted in the early modern period. They were economically unfeasible, and never before had one been made of this size. Making especially deep gashes into the copper plate, Rembrandt covered the land in a cascading shadow, smothering the scene in a tumultuous atmosphere that heightens the raw desperation of the sacrificial figure of Christ on the central cross and his followers spread across the hill of Golgotha.

The decision by Rembrandt to make this print in 1653 was not a straightforward one. He had encountered a number of financial difficulties, construction on his house had severely restricted his painting activity, and it seems that he was forced to sell the majority of his earlier etching plates to a dealer that year.[1] Any other artist of his day in such a predicament might have worked in a more commercially viable technique of engraving or deeply bit etching; had he done so, a large number of impressions could have been pulled and sold in markets locally and throughout Europe, as Rembrandt's fame had already spread far abroad from his home in Amsterdam. Drypoint had the advantage of directness and attractive, rich lines, but the artist must have known that the edges would wear down and the quality of the impressions would quickly degrade.

One reason he may have felt emboldened was his own success over the preceding few years. In 1649 he had completed a print that was widely hailed as his best, a large-format etching with some drypoint that represented Christ's ministry of preaching and healing the sick. This print quickly earned the nickname "the Hundred Guilder Print" because it began to fetch extraordinary triple digit prices in an era when most prints were worth far less

than one guilder.[2] Not only was the subject of the Hundred Guilder Print compelling, as it combined several disparate vignettes from chapter 19 of the Gospel of Saint Matthew, but it was also admired for its extraordinary range of lighting effects. Moreover, it now seems clear that the price was artificially inflated by Rembrandt's manipulation of the supply. He gave away the print on a number of occasions, as we know from inscriptions on the back of several early impressions, and he printed very few impressions altogether.[3] The highest prices were realized, evidence suggests, not to the artist's own benefit, but in secondary markets in which prints were sold to enthusiasts who craved the master's greatest, and rarest, work in this medium.

Knowing that his most curious and bold works were in such demand, Rembrandt embarked on the ambitious *The Three Crosses*. The scholar Erik Hinterding has surveyed extant impressions of all Rembrandt's prints and their various states, with a special focus on the watermarks embedded in the European papers that Rembrandt used. With respect to *The Three Crosses*, Hinterding concluded that Rembrandt was able to print about sixty impressions from the plate in the first three states before it started to noticeably wear down.[4] Once again, one can compare Rembrandt's decisions with standard practices of the era: other printmakers at this point would have been faced with a decision as to whether to continue printing impressions that would drastically decline in quality or to abandon the plate. Rembrandt, however, discovered an alternative. He had already begun, over the course of several decades, to make an unusual number of alterations to his etching plates, strengthening a line here or there and occasionally scraping away a small portion to alter or add an element. These different states became a trademark feature of Rembrandt's work, and collectors began to take note.[5]

The impression in the collection of the Kemper Art Museum represents the radical fourth state of *The Three Crosses*. When the quality of the drypoint lines began to degrade, Rembrandt made an extreme departure, strengthening and redrawing

the outlines of many figures, including Christ, and scraping away others entirely and placing them in different positions with changed poses. Along with other changes, there were originally two figures directly below Christ, leading away from the scene and toward a cave-like area to the lower right. These figures were presumably Nicodemus and Joseph of Aramathea, moving toward the tomb from which Christ would be resurrected. In the fourth state Rembrandt scraped one of them away entirely, but the vestiges of the figure can still be seen. Another dramatically altered figure was the centurion, who was originally prostrate on the ground next to Christ. Rembrandt scraped him away, again without repolishing the plate, and recast him on horseback wearing a tall hat and hoisting a lance to pierce Christ's side. Similarly, the figures clustered around the swooning Virgin Mary were completely remodeled.

The most dramatic alteration to the print, however, is the effect caused by the angled lines that Rembrandt bore into the copper, which cast the right third of the print into immense darkness. His intention may have been to particularly distinguish the "good" thief from the "bad" one (Luke 23:39–43). To make these lines, Rembrandt not only had to slash hard into the metal, but he was also cutting across the grain of lines already present in the earlier image. Never before had a print been so fundamentally reworked. So different were the scenes before and after the change that connoisseurs were not sure they came from the same plate until the following century. By surrounding the scene with darkness and opening an alley of light up the center of the hill, Rembrandt directed more focus to the figure of Christ himself than to the array of other narrative elements. In doing so, he reoriented the emphasis to Christ's own suffering and moment of doubt, depicting the moment as happening just at the onset of supernatural chaos.

The dating of the fourth state of *The Three Crosses* has recently been refined, in large part due to Hinterding's research. The plate was signed and dated 1653 in the third state, but for years scholars had assumed that the fourth state was made later,

around 1660–61, after Rembrandt had time to thoroughly rethink, and reenvision, his subject. Experts believed that the similarity of the tall hat worn by the centurion in the fourth state to that worn by the central character of Claudius Civilis in Rembrandt's 1661 painting *The Oath of the Batavians* (Stockholm, Nationalmuseum) further supported this theory. Hinterding's research, however, strongly suggests otherwise. Watermarks were introduced in the papermaking process in Europe to distinguish one producer from another, and each batch of paper had a unique design, a sort of coat of arms, embedded into each large sheet. Not every print will reveal a watermark, however: sometimes they are obscure, and other times they may not have one at all, as smaller prints may have been made with only a section of the available sheet.

Watermark designs on Rembrandt's prints can be dated with some accuracy based on the signed and dated prints they were used to create. This can be complicated, though, because he printed in batches as needed, using whatever papers he had at hand that he felt were appropriate. For example, his etching *The Death of the Virgin* in the Museum's collection, the plate for which is signed and dated 1639, exists in early impressions on papers with several different watermarks. The Museum's impression bears a Strasbourg bend (variant D́.a.) watermark, which is the same watermark found on all impressions of *The Three Crosses* on which watermarks are visible, both before and after the major change to the fourth state of the plate. This indicates that Rembrandt made the Museum's impression of *The Death of the Virgin* around the same time, using the same paper that he used for the 1653 printings of *The Three Crosses*. When Rembrandt made another print of nearly identical size, *Ecce Homo*, in 1655, he did not use the same paper again, suggesting that he had run out of that paper by then. This also provides further evidence that the changes to the fourth state of *The Three Crosses* would have had to come prior to the printing of *Ecce Homo*. Unfortunately the Kemper Art Museum's impression of *The Three Crosses* does not have a clearly visible watermark, but judging from

the quality of the impression—the drypoint lines are still fresh and printed with clarity—it must have been made at the same time as all the other impressions of *The Three Crosses*.

In the fourth state of the print, Rembrandt's alterations were not limited to the changes he made in the drypoint lines; he also inked and printed the plates in a great variety of ways. The Kemper Art Museum's impression is richly inked, giving an even more plush effect than many other impressions of the fourth state. Rembrandt had begun this practice of varied wiping many years earlier, but his encounter in the late 1640s with papers that arrived from the Far East drastically increased his experimentation.[6] He found that leaving a thin layer of ink on otherwise polished surfaces of the plate where there were no printed lines produced especially prominent atmospheric effects. Overall, one gains the sense of Christ as a man, in his final moment, as the land is overwhelmed by the natural forces emanating from God. While such a view of Christ could be widely appreciated, it presented a particularly poignant Protestant perspective, contrasting as it did with depictions of a heroic, muscle-bound, writhing Christ found so frequently in Catholic imagery of the seventeenth century, particularly coming from Italy and from the studio of Peter Paul Rubens in Antwerp. By choosing drypoint, by dramatically changing the plate, by printing with varied inkings, and by contrasting the humanity of Christ with a cosmic onslaught, Rembrandt reenvisioned a common subject in Christian art, imbuing it with a new sensibility of subjective emotional response.

Paul Crenshaw

Notes

First published October 2008

1. On Rembrandt's finances and descent into insolvency, which he declared in 1656, see my volume *Rembrandt's Bankruptcy: The Artist, His Patrons, and the Art World in Seventeenth-Century Netherlands* (Cambridge: Cambridge University Press, 2006). On the conclusion that Rembrandt sold his plates in 1653, see Erik Hinterding, *Rembrandt as an Etcher*, vol. 1 (Ouderkerk aan den Ijssel, Netherlands: Sound & Vision, 2006), 124–29.

2. Other prints by Rembrandt had nicknames in the seventeenth century, but this moniker persisted through the ages, not only because of the print's extraordinary price but also because it is difficult to give the subject a proper and succinct title.

3. See my essay "Rembrandt & Company," in Francesca Herndon-Consagra and Paul Crenshaw, *Rembrandt: Master Etchings from St. Louis Collections* (St. Louis: Saint Louis Art Museum, 2006), 119.

4. Hinterding, *Rembrandt as an Etcher*, vol. 1, 124–26.

5. The documentation is slender, but it seems likely that some collectors bought multiple impressions of the same print, to see and compare the different versions that Rembrandt would create. Arnold Houbraken, for example, suggested that collectors had to have both versions of the woman by the stove, the one with the key in the oven door and the one without. Houbraken, *De groote Schouburgh der Nederlantsche konstschilders en schilderessen*, vol. 1 (Dordrecht, Netherlands: Arnold Houbraken, 1718), 259. While this may seem like a trivial example for Houbraken to cite, it is further evidence of Rembrandt's manipulation of the market demand for his work, constantly leading collectors and connoisseurs in new directions. The "collectible" nature of Rembrandt's prints has never subsided, and the Kemper Art Museum's impression of *The Three Crosses* has enjoyed prominent appreciation for centuries. The verso of *The Three Crosses* bears several notations and collectors' marks that allow us to trace much of its provenance. It was once possibly in the collection of the Hon. John Spencer (1708–1746) or his son George John, the second Earl Spencer (1758–1834). It passed via auction from their family to the dealer P. & D. Colnaghi of London, which sold it to the prominent Dutch collector Hendrikus Egbertus ten Cate (1868–1955), who owned several hundred paintings in addition to prints and drawings. It was acquired by Malvern B. Clopton (1875–1947) in New York from the dealer M. Knoedler and Company and was given to Washington University in 1930. Clopton, a surgeon and teacher at the Washington University School of Medicine who had served in World War I, donated more than one hundred prints and drawings, which remain in the Kemper Art Museum collection, including six prints by Rembrandt.

6. See Thomas E. Rassieur, "Looking over Rembrandt's Shoulder: The Printmaker at Work," in *Rembrandt's Journey: Painter, Draftsman, Etcher*, by Clifford S. Ackley et al. (Boston: MFA Publications, 2003), 45–60. These so-called Japanese papers (the Dutch also imported types from China and India) did not soak up ink in the same way as the thicker European papers but instead tended to allow the ink to sit more readily on the surface.

Harriet Hosmer

(American, 1830–1908)

Oenone, 1854–55

OENONE, HARRIET HOSMER'S FIRST FULL-LENGTH, life-size sculpture, masterfully demonstrates the young artist's technical acumen as well as her insightful engagement with the artistic discourse of American sculpture of the mid-nineteenth century. With a perceptive assessment of contemporary American viewers and potential patrons, Hosmer designed *Oenone* to balance classical decorum and pathos, erudition and accessibility, nudity and modesty. These dichotomies are inherent in the relationship between Neoclassical sculpture—with its traditional focus on idealized nude figures of heroic subjects—and American culture in the nineteenth century. While European, especially Italian, academic art demanded mastery of the nude figure, the relatively conservative American public had reservations about viewing nude sculpture, and a female artist evoking the nude was even more problematic.[1] *Oenone* satisfies the academic viewer, accustomed to the undraped figures of ancient and modern European art, without offending a broader public with an unmitigated nude display. The traditionally reserved American audience had a growing interest in romantic, emotional literature and sculpture with a straightforward, sympathetic narrative. Hosmer creatively reconciled the refined, idealized classicism favored in academic art with the emotionally engaging qualities that appealed to broad audiences of popular exhibitions.

The modest amount of critical scholarship devoted to Hosmer since the early twentieth century, most of it written since the 1980s, has focused largely on her identity as a female sculptor and how gender informed her art.[2] While this approach is valuable, I would like to consider *Oenone* in relation to its elucidation of Hosmer's engagement with the cultural milieu of her time and her active positioning of herself

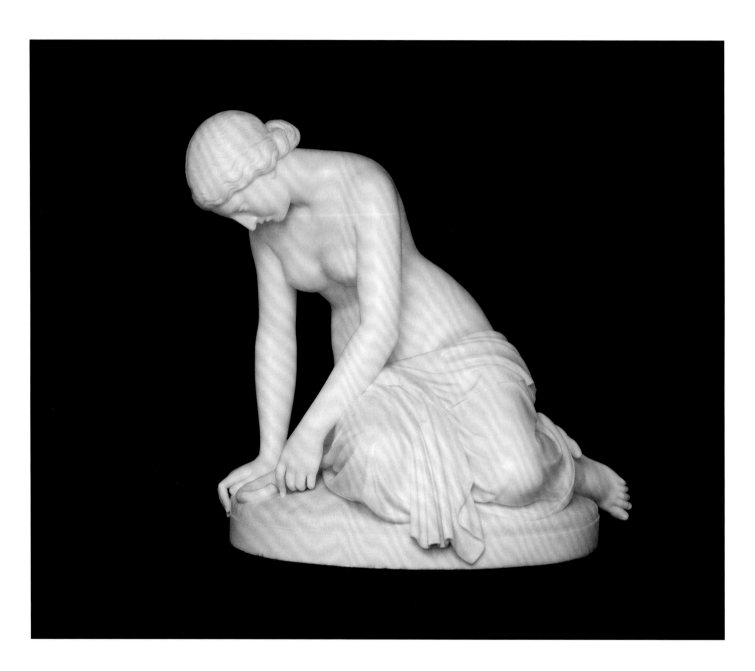

Oenone, 1854–55

Marble, 33 3/8 × 34 3/4 × 26 3/4"
Gift of Wayman Crow Sr., 1855

within it as a professional sculptor of international acclaim.

In the 1780s Antonio Canova and his followers in Rome, especially Bertel Thorvaldsen, established the international style of Neoclassical sculpture.[3] Inspired by the refined forms, idealized beauty, and harmonious figures of ancient sculpture, these artists developed the aesthetic principles favored by art academies in Europe and the United States throughout most of the nineteenth century. American Neoclassical sculpture remained devoted to beauty and idealized figures, but art and literature in the mid-nineteenth century increasingly appealed to a sense of pathos or romantic poignancy, engaging the audience's sympathy. The unprecedented success of Harriet Beecher Stowe's *Uncle Tom's Cabin*, published in 1852, for example, demonstrated the appeal of emotionally charged literature to a broad audience. Sculpture with heroic, tragic, and romantic subjects similarly captivated American viewers, both in the 1850s and throughout the nineteenth century. Commenting years later on Daniel Chester French's *Millmore Memorial* (1889–93), Hosmer wrote, "Here the sculptor presents to us not only historic truth, but beauty of form and sentiment, pathos and outlines of harmony and grace."[4] In her own work Hosmer strove for this synthesis of beautiful forms, physical truth, and pathos.

In 1852, determined to forge a professionally successful artistic identity, Hosmer went to Rome, where she studied with John Gibson, one of Canova's pupils.[5] Two years later Hosmer created *Oenone* as a commission by her American benefactor Wayman Crow. The sculpture also served as her artistic debut in the United States. Assessing the artistic and cultural environment of her intended American audience, Hosmer chose to represent the nymph whom Paris loved but abandoned to pursue Helen of Troy. Relegated to a brief mention in Ovid's account of the Trojan War, Oenone was revived as a tragic, suffering victim in Alfred Lord Tennyson's eponymous poem first published in 1832.[6] The love-struck Oenone prophesied that Paris would be injured and

offered to heal him if he returned. Shot by an arrow, the ill-fated soldier returned to his scorned love, who, indignant and heartbroken, refused to heal him, thus assuring his death. Overcome with despair afterward, she took her own life. Hosmer's depiction of the nymph compels viewers to wonder whether Oenone awaits her lover's return or remorsefully contemplates suicide. Although the Greek maiden's perspective on the Trojan War was nearly unheard of in art prior to Tennyson's poem, Hosmer's most learned contemporaries were familiar enough with the subject that in a letter to Crow in 1856, the artist simply wrote "the figure represents Oenone abandoned by Paris."[7] While the mythological and literary associations of the figure appealed to erudite audiences, even the most casual viewer could engage with the sculpture's palpable sense of sorrowful reflection.

To demonstrate her training among the Neoclassical masters of Rome, Hosmer used a fine-quality block of creamy white marble and worked the surface up to a high polish. *Oenone*'s features—including a strong nose, small mouth, and smooth features reminiscent of a Roman deity—masterfully emulate classical models. Her hair is parted in the middle and pulled back gently, allowing soft waves to frame her face. With the dignity of an allegorical bust sculpture, her idealized features betray little emotion. Rather, the sculpture's mournful pathos is expressed through the body. Her lowered head and downcast gaze suggest an inward focus. The long, sinuous curve of *Oenone*'s back draws the eye downward, as her left foot slips off the circular base. Her left arm listlessly drops over her right leg; in contrast, she supports herself with her strong right arm. Gazing on the shepherd's crook that Paris left behind, she seems lost in reflection. Her right hand and a bit of drapery spill over the edge of the sculpture base. This breach into the viewer's space makes the sculpture more immediate, heightening the pathos without compromising the work's classical appeal.

Throughout her career Hosmer maintained her devotion to classical aesthetics, asserting, "Lovers of all that is beautiful and true in nature will seek

their inspirations from the profounder and serener depths of classic art."[8] Steeped in the masterpieces of Rome's museums, Hosmer would have known the emotive power of the Dying Gaul, an ancient Roman copy of a Hellenistic sculpture of a fallen warrior wounded on the battlefield. One of the most praised antiquities in Rome when Hosmer was there, the Dying Gaul has the firmly downcast gaze, supporting right arm, and resolute expression that reappear in Hosmer's *Oenone*. The warrior's pained yet controlled posture as he sinks to the ground also serves as a model for the classicized emotion that characterizes *Oenone*. In an age when art schools and museums in the United States displayed casts of famous antiquities, viewers would have recognized this artful allusion to the venerated past, as well as to Lord Byron's dramatization of the ancient mythological figure in *Childe Harold's Pilgrimage* (1818), in which the poet described the Dying Gaul as one who "consents to death, but conquers agony."[9]

The most commercially successful sculpture in the United States in the mid-nineteenth century was Hiram Powers's *Greek Slave*, which arrived in New York in 1847. Several copies of the sculpture toured commercial galleries in the late 1840s and 1850s, attracting unprecedented audiences. The nude sculpture depicted an adolescent girl "cloaked in modesty," who was promoted as the victim of Turkish captors.[10] Bound by chains, she stands tall, her head held high, her face blank and expressionless.[11] While the nudity of Powers's statue caused some backlash, the controversy seemed to enhance the sculpture's notoriety. Hosmer's decision to represent *Oenone* half-nude suggests an engagement with the contemporary art scene, yet she was simultaneously careful to maintain a sense of modesty. While the *Greek Slave* presents a fully nude female for visual consumption by the audience, Hosmer's partially draped *Oenone* seems to turn inward, to deflect the viewer's gaze.

Moreover, Hosmer preserved the dignified expression of the *Greek Slave* while suggesting mournful reflection rather than a dispassionate, uncomprehending stare. Although Powers's *Greek Slave* seems detached, pamphlets accompanying the work told a teary-eyed tale of a virtuous Christian maiden sold at a Turkish auction.[12] Audiences, won over by the contrived narrative, waxed poetic about "her virgin soul" being "debased, defiled and trampled in the dust."[13] Arguably, Hosmer's *Oenone* does not require a sentimental tale to evoke an emotional response. The art critic James Jackson Jarves wrote of Hosmer: "Her style is a decided rebuke to inane sentimentalists of the Powers class, which is a weak echo of the third-rate classical manner after it had abandoned beauty for prettiness. Miss Hosmer's manner is thoroughly realistic."[14]

While deftly infusing classically inspired sculpture with romantic pathos, *Oenone* offers viewers a glimpse of the predominant cultural and artistic trends that engaged a broad American audience in the mid-nineteenth century. Viewers steeped in Ovidian tales and Tennyson's poetry could appreciate the sculpture's narrative associations; at the same time, any viewer could appreciate the figure's emotive expression. With this sculpture, Hosmer achieved a concordant synthesis of a classicizing mode and romantic pathos, popular appeal and erudition, nudity and propriety, while remaining firmly grounded in the traditions of ancient sculpture.

Harriet Hosmer's purposeful integration of aesthetic elements demonstrates a determination that led to professional success. To this end, she managed to cultivate American patrons even while she lived in Rome. In a letter to Crow, Hosmer suggested, "If you hear of anybody who wants an equestrian statue ninety feet high, or a monument in memory of some dozen departed heroes, please remember that nun-like I am ready for orders. However, to be moderate and earnest, I mean that if anybody wants any small decent-sized thing I should be glad to furnish it."[15] The young sculptor's quixotic jest betrays her boundless ambition and gently reminds her patron that, no longer a student, she was ready to support herself as a professional artist. Sending *Oenone* to St. Louis, in fact, proved to be instrumental to her success. Within a few years, she had sold numerous copies of her playful sculpture *Puck* (1855)

and won significant commissions, including one for *Beatrice Cenci* (1856) at the Mercantile Library of St. Louis, thus launching her career as an ambitious and pragmatic professional artist.

Erin Sutherland Minter

Notes

First published June 2008

1. See Laura R. Prieto, *At Home in the Studio: The Professionalization of Women Artists in America* (Cambridge, MA: Harvard University Press, 2001), 86.

2. The artist's biography is best known through Cornelia Carr, ed., *Harriet Hosmer: Letters and Memories* (New York: Moffat, Yard, 1912), and Dolly Sherwood, *Harriet Hosmer: American Sculptor, 1830–1908* (Columbia: University of Missouri Press, 1991). For feminist approaches to her work, see especially Nicolai Cikovsky, *Nineteenth-Century American Women Neoclassical Sculptors, Vassar College Art Gallery, April 4 through April 30, 1972* (Poughkeepsie, NY: Merchants Press, 1972); Alicia Faxon, "Images of Women in the Sculpture of Harriet Hosmer," *Woman's Art Journal* 2, no. 1 (1981): 25–29; Joy S. Kasson, *Marble Queens and Captives: Women in Nineteenth-Century American Sculpture* (New Haven, CT: Yale University Press, 1990); Joseph Leach, "Harriet Hosmer: Feminist in Bronze and Marble," *Feminist Art Journal* 5 (Summer 1976): 9–13, 44–45; and Vivien Green Fryd, "The 'Ghosting' of Incest and Female Relations in Harriet Hosmer's *Beatrice Cenci*," *Art Bulletin* 88, no. 2 (2006): 292–309.

3. Developing on the heels of the Enlightenment, Neoclassical art favored clarity, naturalism, and the idealized representations of the human body associated with Periclean Greek sculpture. Johann Joachim Winckelmann's publications *The Reflections on the Imitation of the Painting and Sculpture of the Greeks* (1765) and *History of Ancient Art* (1764) built on recent excavations of antiquities in Herculaneum and Pompeii, introducing artists and the public to the forms and subjects of ancient art. Antonio Canova developed a sculptural style of Neoclassicism that reveled in the beauty of pure white marble and idealized nude figures. Horatio Greenough was the first American sculptor to study the style in Rome, traveling to Italy in 1825. American artists continued to work in Italy to study antique models and have access to white marble and skilled carvers. Neoclassical sculpture in the United States focused on biblical, literary, classical, and moralizing themes. The style dropped off in popularity in the late 1870s. See William H. Gerdts, *American Neo-Classic Sculpture: The Marble Resurrection* (New York: Viking, 1973).

4. Carr, *Harriet Hosmer*, 332.

5. Although Hosmer traveled widely, she maintained a successful atelier in Rome for most of her career.

6. In a letter from the early 1850s Hosmer described herself and a friend "going frantic together over Tennyson and Browning." Quoted in Sherwood, *Harriet Hosmer*, 35.

7. Hosmer to Wayman Crow, September 13, 1856, in Sherwood, *Harriet Hosmer*, 72.

8. Hosmer to an acquaintance, January 19, 1894, in Carr, *Harriet Hosmer*, 334.

9. Lord Byron, *Childe Harold's Pilgrimage* (1818), 4.140.

10. Reverend Orville Dewey was one of many writers who suggested that the slave's nudity was excused by her virtue. See Kasson, *Marble Queens and Captives*, 58.

11. Through the 1860s Powers produced dozens of replicas from his original conception of 1843, ranging from six full-length statues to numerous smaller-scale and bust-length marbles. Joy Kasson remarked, "In the middle years of the nineteenth century, no American artwork was better known." Ibid.

12. The pamphlets that Powers published to accompany his *Greek Slave* had the dual function of justifying the girl's nudity and casting her as the tragic heroine of a heartbreaking tale.

13. Quoted in Kasson, *Marble Queens and Captives*, 65.

14. James Jackson Jarves, *Art Thoughts* (New York: Hurd & Houghton, 1870), 308.

15. Hosmer to Crow, January 9, 1854, cited in Sherwood, *Harriet Hosmer*, 102.

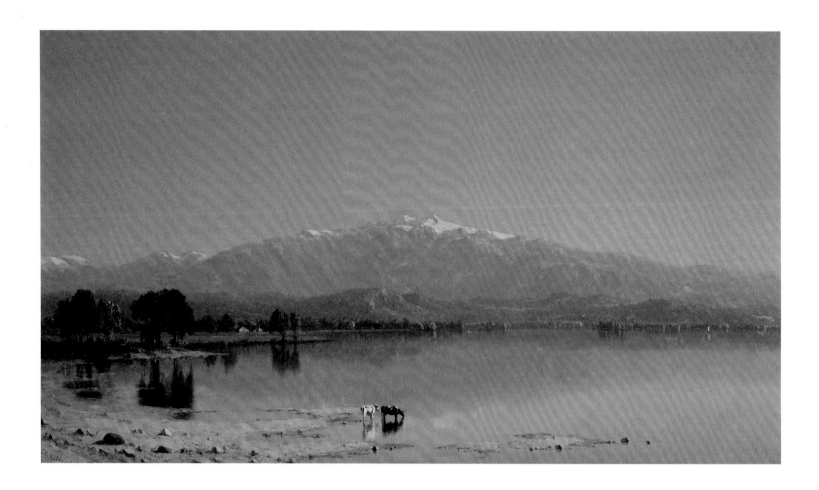

Early October in the White Mountains, 1860

Oil on canvas, 14 $^1/_8$ × 24 $^1/_8$"

Bequest of Charles Parsons, 1905

Sanford Robinson Gifford

(American, 1823–1880)

Early October in the White Mountains, 1860

Rheinstein, 1872–74

Venetian Sails: A Study, 1873

THREE WORKS BY SANFORD ROBINSON GIFFORD in the collection of the Kemper Art Museum, while depicting greatly varied locations and subjects, together form a group that illuminates the role of travel in nineteenth-century landscape paintings by American artists. As both a thematic motif and an activity necessary to generate views of distant places, travel played an integral part in the production and reception of Gifford's works. In many cases he would look back to scenes witnessed years earlier and access his memory of visual encounters to create paintings that appealed to the far-reaching imaginations of his American audience. The placid stretch of New Hampshire's Androscoggin River in *Early October in the White Mountains*, the romantic vision of a medieval castle along the Rhine presented in *Rheinstein*, and the accumulation of boats staged before the maritime city in *Venetian Sails: A Study* constitute a complementary triad that highlights the relationship between real places and imaginative visions in Gifford's work.[1] Each of the images reveals—whether in the freshness of a pastoral scene within national bounds or through sentimentalized views of the Old World—the artist's interest in traveling to a captivating location and subsequently depicting it as an idealized realm separate from the developments of modern life and industrial progress.

Early October in the White Mountains, painted by Gifford in 1860, presents a New Hampshire locale in which nature and human presence appear to exist in peaceful harmony. The even tones and subtle color transitions of the painting unite foreground,

middle ground, and background, with the peaks of the Presidential Range in the center framed by a wide horizontal view. The Androscoggin River stretches across the foreground, depicted as a remarkably undisturbed surface whose mirrorlike reflection repeats visual elements farther back—the mountain outline and the tree-lined banks of the river—to create a visual dynamic that collapses distinct spatial zones into the unified representational order of the picture plane. The emphatically horizontal orientation of the painting conveys a sense of tranquillity, providing an even balance between the lower register with the water and valley and the upper half with the mountain peaks and sky portraying a still and stable realm. The cows in the center and the farmhouse far across the valley on the left, with a tract of open and inviting land, convey agricultural activity being carried out by humans, whose absence reinforces the scene's utter stillness.

Gifford's representation of the White Mountains as a serene locale omits any visual references to the technological developments and modern conveniences that made the attainment of such a view possible for him and others. The White Mountains of New Hampshire were a popular destination for artists and tourists in the late nineteenth century, as the continued development of the region's railroad system allowed for more convenient access to the range.[2] Easy travel routes from the metropolitan areas of Boston and New York led to an influx of tourism, and grand resort hotels opened throughout the mountains to accommodate the growing crowds of visitors. Over several decades more than four hundred artists traveled to paint the scenery, and subjects such as Crawford Notch and Mount Washington became popular motifs in the landscape paintings they produced.[3] During this period of burgeoning tourism, Gifford's painting would have connected to the experience of Americans who visited the locale for an escape from increasingly industrialized cities, yet his treatment of the scene imagines an even more dramatic remove from the realities of modern life. The suffusion of atmospheric light and the balanced composition

intimate a frozen moment within a world apart, heightening the sense of an idealized encounter with nature.

The image conveys the romantic suggestion of a world separate from modern developments with a striking sense of immediacy for the viewer. Gifford's travels to the location and his pictorial strategies for conveying visual experience are both crucial factors in establishing this effect. He visited the White Mountains first in 1854 and returned multiple times during his career, sometimes staying at the location for months. He likely based *Early October* on a sketch he made during a trip in 1859, as the composition and viewing angle of the geographic features of this painting bear close similarity to a drawing from his 1859 portfolio.[4] He mediated the lived experience of viewing the mountain range by first sketching *en plein air*, then transforming the scene through oil paint in a manner that suggests the contingency of vision. The mountains in the distance appear ephemeral, softened by the layers of atmosphere that veil the viewer's perception. Objects in the foreground have a much greater degree of clarity, and the sandy and rocky surface of the shore has a particularly material quality due to a thicker and more tangible application of paint. These formal elements suggest a direct perception of the natural world even as the image also conveys an idealized vision; thus the painting plays on both the real and the imagined.

Later in his career Gifford increasingly turned to European subject matter to create romanticized depictions of a world separate from modern technologies and developments. His production of paintings such as *Rheinstein*—of which he completed two versions, one that he exhibited in 1860 and this one, created in 1872–74—coincided with a period in which the American appetite for views of the Old World increased significantly. Spurred by a craze for travel literature and nostalgia for earlier times, many Gilded Age patrons exhibited a fascination for distinguished monuments and past cultures.[5] In *Rheinstein*, Gifford depicted the imposing German castle on a dramatic promontory from the point of view of the road below, presenting an impression of

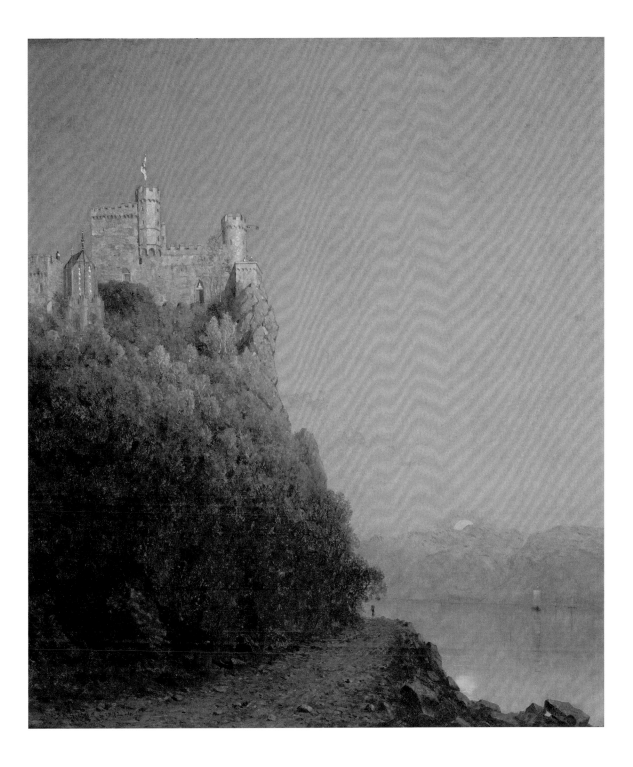

Rheinstein, 1872–74

Oil on canvas, 31 3/8 × 27 1/4"
Bequest of Charles Parsons, 1905

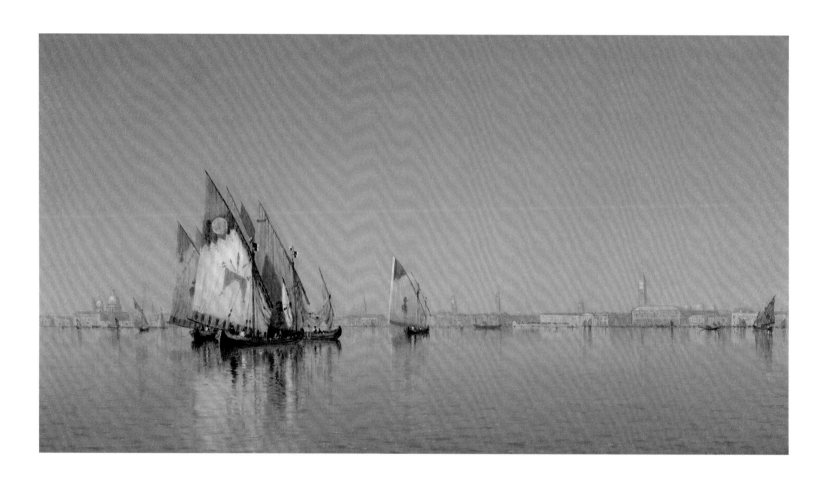

Venetian Sails: A Study, 1873

Oil on canvas, 13 × 24"
Bequest of Charles Parsons, 1905

how the viewer might encounter the site in real life. The picturesque quality of the composition, defined by the rocky cliff and shadowed pathway balanced with the open sky and view into the distance over the river, combines with genre elements such as peasant figures to communicate a sense of harmony between civilization and nature much like his earlier White Mountains work.

Gifford first journeyed along the Rhine during his European travels of 1855–57, in which he embarked on a standard grand tour that marked the culmination of his artistic training.[6] The son of a wealthy iron foundry owner, Gifford did not have to rely on sales of his artistic production as his primary source of income and could afford the lengthy trip abroad to view the lauded sites of Old World grandeur.[7] When back in the United States in the following years, Gifford worked from sketches made during this trip to create finished paintings such as his Rheinstein scenes.[8] In the maturity of his career, he increasingly sought to depict foreign subjects in order to counter critiques from some of his contemporaries that his images of American locales had become repetitive and formulaic.[9]

Rheinstein melds both past and present, as the castle stands not in ruins but in a viable working state. Rheinstein had been restored between 1825 and 1829 by Frederick of Prussia; thus Gifford's depiction reflects the condition of the structure as he first saw it in 1856, returned to its medieval splendor.[10] An iron basket hangs over a parapet, where two figures stand presumably looking out over the river, and a colored flag emerges from the highest point of the castle's towers. The narrow vertical windows of a small chapel to the left of the main architectural feature are marked by bright spots of paint, representing the glint of light against stained windows. Animated by these details, the castle appears as an operational structure, giving the medieval history of the place a vital and contemporary presence in the viewer's experience.

As a vision of the past in an apparently resplendent present, the image also invites the viewer into a deeper consideration of the phenomena of the visual encounter. The contingent effects of light in the painting are crucial to this dynamic, as the play between illuminated surfaces indicates a specific spatial arrangement and time of day. The light reflected off the windows of the chapel is the same light that bathes the entire fortress in warm tones. The shadows cast on the bottom portion of the promontory suggest a late afternoon sun low in the sky, during the golden hour in which the angle of the sun's rays produces an evocative glow. The moon in the distance, just above the horizon, is reflected in short, thick strokes on the water, further enhancing the sense of multiple physical surfaces animated by the effects of illumination. The depiction effectively transforms a moment experienced in the material world into a representation that indicates the contingency of vision. The painting presents a complex meditation on how the act of perception operates in real conditions, while at the same time the peasants and medieval castle appeal to a nostalgic, sentimental imagination.

Gifford's exploration of the nature of vision and his foray into the fruitful material of foreign views continued in *Venetian Sails: A Study*. In this oil study of 1873, which shows a high degree of finish, boats with vivid sailcloth designs are set against the background of the city's recognizable architecture. On the left, the church of Santa Maria della Salute, with its distinctive domed construction, glimmers on the horizon, balanced by the Doge's Palace and the brick campanile on the right. The painting has a strong horizontal emphasis, with the distance between the two main architectural features in the composition exaggerated in order to create a broader space as a background for the boats. The clear light at the horizon suggests that the viewer is closer to the elements at the center, with the edges and periphery of the painting slowly growing hazier toward the distance.

For Americans and others encountering the diverse landscapes of Europe, Venice had a romantic, almost magical quality and seemed a part of the distant past. The city provided a unique architectural landscape, in which the terra firma had

been almost entirely covered by human construction and boats traversed the interconnected waterways as the central means of transportation. Gifford was not the only artist who became enthralled by Venice, and during the late nineteenth and early twentieth centuries a boom in artistic depictions evidences how the city captured the American imagination.[11] For Gifford, as for many other Americans, Venice was an exotic space in which the architecture and monuments evidenced the splendor of a once-great society, separate from the concerns of modern industrialism and urbanization yet tragic in its fall from glory.[12]

Many of Gifford's contemporaries praised his images for the spirit of contemplation that they provoked. For them, the placid, luminous pictures encouraged a tranquil emotional response and offered an encounter with the world through the perfected vision of the artist.[13] Depictions of nature or past cultures apparently unscathed by the deleterious effects of modern industrial life are paradoxically linked to the rise of tourism and new forms of transportation. As these developments of the late nineteenth century progressed, however, access to rural or distant places made the acquisition of these views more easily available to the artist.

Though the images might evoke the perception of a direct encounter with nature, Gifford disrupted a straightforward connection between painted scenes and the unmediated natural realm by formulating unique light effects and employing formal means that make apparent the act of viewing and its contingency. All three paintings offer commentary on the nature of perception and the transformation of a real site into an idealized vision. Within the context of a society fascinated by visiting and viewing distinct, interesting places—whether domestic or international—Gifford effectively created scenes that drew from his personal experience of travel and provided an imaginative escape for his late nineteenth-century audience.

Jennifer Padgett

Notes

First published December 2013

1. For an account of Gifford's work that details his various travels during the course of his life, see Ila Weiss, *Poetic Landscape: The Art and Experience of Sanford R. Gifford* (Newark: University of Delaware Press, 1987). An additional valuable resource for information on Gifford's trips is the extensive biographical chronology by Claire A. Conway and Alicia Ruggiero Bochi in *Hudson River School Visions: The Landscapes of Sanford R. Gifford*, ed. Kevin J. Avery and Franklin Kelly (New York: Metropolitan Museum of Art, 2003).

2. Eric Purchase analyzes railroad development, tourism, and how "the White Mountains became America's 'most accessible wilderness'" in *Out of Nowhere: Disaster and Tourism in the White Mountains* (Baltimore: Johns Hopkins University Press, 1999), 45. The first arrival of the St. Lawrence train line into the station at Gorham, New Hampshire, in July 1851 also figures prominently in the account of White Mountains history told by Bryant F. Tolles Jr., in *The Grand Resort Hotels of the White Mountains: A Vanishing Architectural Legacy* (Boston: Godine, 1998).

3. Thomas Cole, regarded as the father of the Hudson River school, was one of the first prominent landscape painters to travel to and depict the White Mountains, inspiring many other artists, including Gifford, to make similar treks. For extensive documentation of artists who visited and depicted the White Mountains, see Catherine H. Campbell and Marcia Schmidt Blaine, *New Hampshire Scenery: A Dictionary of Nineteenth-Century Artists of New Hampshire Mountain Landscapes* (Canaan, NH: Phoenix Publishing for the New Hampshire Historical Society, 1985).

4. For a reproduction of the drawing, see Avery and Kelly, *Hudson River School Visions*, 112.

5. Sean Dennis Cashman, *America in the Gilded Age: From the Death of Lincoln to the Rise of Theodore Roosevelt*, 3rd ed. (New York: New York University Press, 1993), 168–82. For a more complex analysis of the interest in past cultures (including the medieval) as part of a broader antimodernist impulse in industrial America, see T. J. Jackson Lears's seminal text *No Place of Grace: Antimodernism and the Transformation of American Culture, 1880–1920* (New York: Pantheon, 1981).

6. Heidi Applegate, "A Traveler by Instinct," in Avery and Kelly, *Hudson River School Visions*, 53.

7. Rheinstein and numerous other castles in the Rhine Valley had become popular features for grand tour travelers since the early nineteenth century. Images of the sites were disseminated widely through artistic prints, and travel accounts describing the medieval structures appealed to the romantic imaginations of contemporary Europeans and Americans. Robert R. Taylor, *The Castles of the Rhine: Recreating the Middle Ages in Modern Germany* (Waterloo, ON: Wilfrid Laurier University Press, 1998), 59–60.

8. Gifford visited Europe again in 1868–69—also traveling to the Middle East to see sites in Egypt, Syria, and Lebanon—to revive his repertoire of foreign subject matter.

9. Applegate, "A Traveler by Instinct," 60.

10. For more on Gifford's interest in the German past as seen in *Rheinstein*, see J. Gray Sweeney's analysis in Joseph D. Ketner et al., *A Gallery of Modern Art at Washington University in St. Louis* (St. Louis: Washington University Gallery of Art, 1994), 48.

11. Margaretta M. Lovell's texts on American artists in Venice offer useful studies that consider specific examples in relation to broader social and cultural contexts; see Lovell, *A Visitable Past: Views of Venice by American Artists, 1860–1915* (Chicago: University of Chicago Press, 1989), and *Venice: The American View, 1860–1920* (San Francisco: Fine Arts Museums of San Francisco, 1984).

12. Lovell, *Visitable Past*, 1.

13. On contemporary responses to Gifford's paintings, see Franklin Kelly's insightful essay "Nature Distilled: Gifford's Vision of Landscape," in Avery and Kelly, *Hudson River School Visions*, 3–23.

Narcisse Virgile Diaz de la Peña

(French, 1807–1876)

Wood Interior, 1867

IN NARCISSE VIRGILE DIAZ DE LA PEÑA'S PAINTING *Wood Interior*, sunlight bathes a forest clearing created by a break in a dense canopy of trees. Sparkling sunlight dances across the tree trunks and foliage at the center of the canvas; around its perimeter, gnarled branches interlace to form a rich tapestry of leaves and bark. This dark, tunnellike frame simultaneously emulates the impenetrable depths of the forest and functions as a bridge between the viewer's space and the forest's interior. Diaz de la Peña, known in his day as a first-rate colorist and a master of light, harnessed dramatic effects of color and light to simulate the sensations of walking through a dense forest.[1] Serving as a portal into the furthest depths of the Forest of Fontainebleau, *Wood Interior* immerses viewers in what many understood to be a depiction of pristine nature, devoid of any sign of either man or modernization. The opportunity for momentary escape provided by such a painting would have been especially enticing to nineteenth-century urban dwellers desperate to connect with a natural world that seemed increasingly removed from their experience of life in the modern city.[2]

The Barbizon school, a loosely associated group of landscapists working between 1830 and 1870, produced paintings of the French countryside that were much beloved, as they offered viewers a brief reprieve from the realities of everyday urban life. At the same time these artists were living out their own escapist desires in the rustic village of Barbizon, on the edge of the Forest of Fontainebleau.[3] As a core member of the group, Diaz de la Peña shared its utopian aspirations to experience nature and rural life directly and to depict such scenes poetically through painterly techniques that highlighted the subjective expressions of the artist.

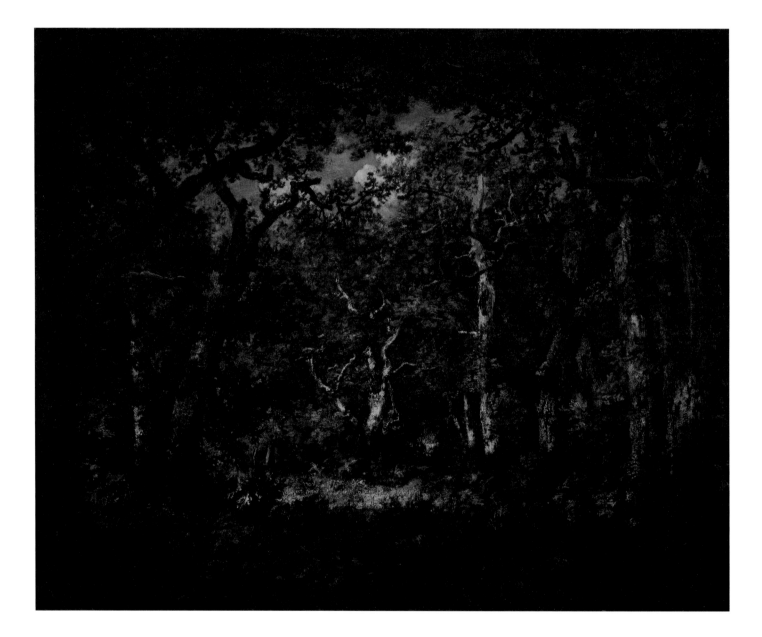

Wood Interior, 1867

Oil on canvas, 43 $^{1}/_{4}$ × 51 $^{1}/_{2}$"
Bequest of Charles Parsons, 1905

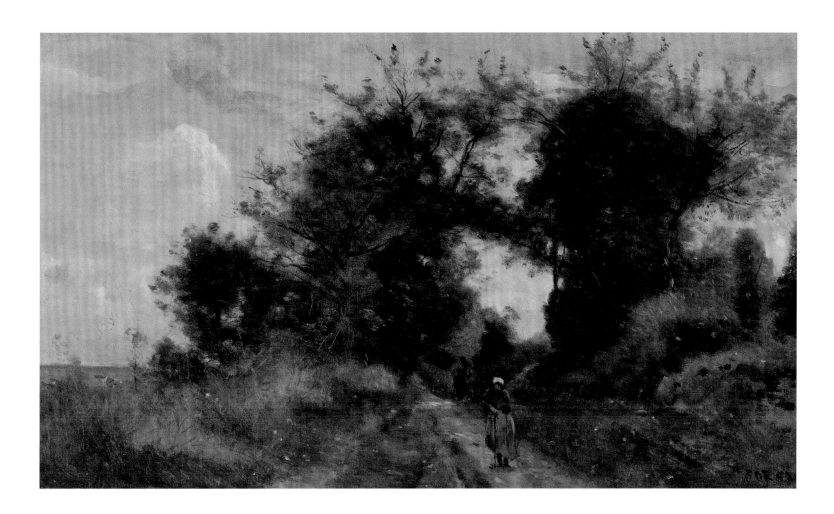

Le chemin des vieux, Luzancy, Seine-et-Marne
(*The Path of the Old People*), 1871–72

Oil on canvas, 12 7/8 × 22"
Bequest of Charles Parsons, 1905

3. The Barbizon school included Jean-Baptiste-Camille Corot, Jules Dupré, François Louis Français, Charles Emile Jacque, Jean-François Millet, Constant Troyon, and Théodore Rousseau, among others.

4. See Alexandra R. Murphy's analysis in Joseph D. Ketner et al., *A Gallery of Modern Art at Washington University in St. Louis* (St. Louis: Washington University Gallery of Art, 1994), 24.

5. Théophile Thoré, "Le Salon de 1844 précédé d'une lettre à Théodore Rousseau," reprinted in *Art in Theory, 1815–1900: An Anthology of Changing Ideas*, ed. Charles Harrison, Paul Wood, and Jason Gaiger (Oxford: Blackwell, 1998), 223.

6. By the 1820s plein air studies had become de rigueur practice for land-scapists, largely through the advocacy of Pierre-Henri de Valenciennes. An early and extremely influential devotee of plein air painting, Valenciennes published a textbook in 1800, *Eléments de perspective pratique, à l'usage des artistes*, in which he insisted that all landscape painters must paint outdoors, creating quick studies that could be used in the studio to create large, highly finished Salon paintings. For more on plein air painting in the nineteenth century, see Philip Conisbee, Sarah Faunce, and Jeremy Strick, *In the Light of Italy: Corot and Early Open-Air Painting* (Washington, DC: National Gallery of Art, 1996).

7. From "Originality," in *The Crayon*, quoted in Peter Bermingham, *American Art in the Barbizon Mood* (Washington, DC: National Collection of Fine Arts and Smithsonian Institution Press, 1975), 42.

8. The compositional device of a dark periphery was likely borrowed from Diaz de la Peña's friend and fellow Barbizon artist Théodore Rousseau. In fact, the entire composition may be based on one of Rousseau's favorite compositions, *Edge of the Forest of Fontainebleau, Sunset* (1848–49), Musée du Louvre, Paris.

9. Albert de la Fizelière, "Les auberges illustrées," quoted in Jones, *In the Forest of Fontainebleau*, 12.

10. The author Philippe Burty, writing in 1872, complained about the inescap-able human presence of in the forest: "Man can be felt everywhere. Large red and blue arrows shoot forth from the intersections of all the trails, as if a forest wasn't made for getting lost in!" Quoted in Jones, *In the Forest of Fontainebleau*, 19. The novelist George Sand penned a similar sentiment after returning to the area in 1856, "The surroundings have become a bit too like a pleasure garden. There are too many names and emblems on the rocks. There are too many of them everywhere." Quoted ibid.

11. Jones, *In the Forest of Fontainebleau*, 17.

12. Pierre Miquel and Rolande Miquel, *Narcisse Diaz de la Peña (1807–1876)*, vol. 2, *Catalogue raisonné de l'oeuvre peint* (Courbevoie: ACR, 2006). By the 1860s Diaz de la Peña had achieved great commercial success and was able to live well solely from sales of his paintings. See Robert Herbert, *Barbizon Revisited* (Boston: Museum of Fine Arts, 1962), and Arthur Hoeber, *The Barbizon Painters, Being the Story of the Men of Thirty* (New York: Frederick A. Stokes, 1915), 129–58.

our eyes adjust to the darkness, however, we find an unexpected richness of color and texture. Soft, loose brushstrokes make up indecipherable forms in these dark corners of the canvas—as in the deepest recesses of the forest—and leave much to the viewer's imagination. Diaz de la Peña created this depth of subtle color and sumptuous surface by applying thin glazes over very dry pigment, which accounts for the lack of fine detail and the clearly visible brushstrokes. The cool glossiness of the shadowed areas creates an atmospheric effect redolent of the cool, moist air of the forest. By attempting to reproduce aspects of the visual and tactile experience of a walk in the forest, Diaz de la Peña brought nature one step closer to his audience.

Diaz de la Peña's aesthetic techniques succeeded in conveying the impression of great naturalism that led to the popular understanding of his paintings as faithful—almost scientific—in their depiction of nature. Indeed, the critic Albert de la Fizelière was so taken with the impression of an empirically rooted naturalism in the work of Diaz de la Peña and his Barbizon colleagues that he proclaimed in 1853, "Barbizon has given birth to a new science of painting."[9] Rather than generating a scientific manifestation, however, Diaz de la Peña depicted nature viewed through the subjective lens of the artist—a lens that edited and manipulated, eliminating evidence of modernization or other outside encroachments into the landscape in order to heighten the poetry and emotional effect of the scene.

Wood Interior exemplifies Diaz de la Peña's practice of selective editing. With not even a path visible, the scene is utterly devoid of signs of human presence. Despite the area's reputation as wild and untamed, its "pristine" quality was largely fictionalized, initially by entrepreneurial locals in an effort to stimulate economic development through tourism and later by many of the artists who flocked to the area. In 1867 Diaz de la Peña would have been hard-pressed to find such a location in the forest, which had become a popular tourist destination for Parisians seeking a quick break from the hustle and

bustle of urban life.[10] By the second half of the nineteenth century, in fact, Fontainebleau had become a veritable amusement park of natural sites, packaged and marketed as a romantic destination for tourists to experience *natura naturans*. C. F. Denecourt, the area's foremost author of travel guides and the leading force behind the region's development as a tourist site, promoted a vision of a forest steeped in timeless otherworldliness; he whimsically bestowed on trees and rocks names suggestive of great importance, constructed fake landmarks, erected placards identifying imagined events, and cleared paths—marked by large, colorful arrows painted on trees—through the forest.[11]

Diaz de la Peña edited out any sign of these commercial activities, composing a woodland scene that was true to the commonly accepted myth that the area was untouched by the industrializing hand of humankind. With his keen business sense, he dwelled on this theme, creating several *sous-bois*, or forest undergrowth, scenes—all similarly edited renderings of the forest depths intended for commercial sale—in 1867 and 1868.[12] Offering an escape from modern life, these paintings promised nineteenth-century urban audiences a much-desired panacea for the ills of urban industrialization and modernization. By answering the public's yearning for paintings depicting an impossibly pure idea of *natura naturans*, Diaz de la Peña bolstered the myth of a pristine nature existing just outside Paris, thereby implicating himself in the commercialization and commodification of the area and further removing it from this ideal vision.

Rachel Keith

Notes

First published July 2008

1. Of Diaz de la Peña, one critic insisted, "He thinks only of light. It is that which he pursues, that which is the inexhaustible subject of his work." Kimberly Jones, *In the Forest of Fonainebleau: Painters and Photographers from Corot to Manet* (New Haven, CT: Yale University Press, 2008), 124.

2. For more on this argument, see my essay in *The Barbizon School and the Nature of Landscape* (St. Louis: Mildred Lane Kemper Art Museum, 2008).

More than any shared style or credo, however, it was the area's landscape that bound these artists together. *Wood Interior* likely depicts the Bas-Bréau, one of the oldest sections of the forest.[4] About thirty miles outside Paris, these expansive woods—full of ancient, craggy oaks, silvery beeches, and a thick undergrowth of shrubbery—were the background for the farming village–cum–artists' colony of Barbizon. The area's diverse landforms provided rich source material for the artists' modest paintings of nature, and its reputation as an unspoiled natural enclave appealed to their desires to commune with nature. In an 1847 Salon review praising a painting by Diaz de la Peña, the art critic Théophile Thoré noted the appeal of this escapist impulse: "We all have quite enough worries in our political and private lives to forgive the arts for reminding us of natural nature, *natura naturans*, as the ancients called it, that nature eternally fecund and luxuriant which contrasts so cruelly with our artificial ways."[5] Thoré's clear distinction between an "eternally fecund" nature—that for which Fontainebleau was renowned—and the artificiality that defines modern life was, in reality, never so clearly delineated. This tension between notions of the natural and the artificial is key to understanding Diaz de la Peña's painterly practice. The aesthetic techniques that he wielded in *Wood Interior* reveal an inherent contradiction between the artist's studio practice and the popular perception of his unmediated relationship with nature. The ways in which he knowingly appealed to his audience's escapist desires ultimately implicated him in the commercialization and commodification of the forest that he so admired.

For Diaz de la Peña and the other artists of the Barbizon school, perhaps the most fundamental aspect of their practice—and that which led to the widespread perception of their paintings' direct connection to nature—was working *en plein air*.[6] Not only did it provide an opportunity to observe light effects directly, but it appeared to promise an unmediated engagement with nature that would ensure the artistic independence of their vision. To viewers as well, a painting executed *en plein air*—without the semblance of studio mediation—would have seemed to bring them one step closer to nature. The large brushstrokes, soft edges, and lack of fine detail in *Wood Interior* create the impression that the painting was executed quickly, with the spontaneity demanded by working outdoors. This unfinished quality was typical of Diaz de la Peña's work, which led one critic to complain disdainfully: "M. Diaz, if we may use a vulgar expression, 'chucks' his pallet against his canvas, and adroitly takes advantage of the stain thus produced."[7] Although this lack of finish was one of his critics' largest sources of irritation, it served the artist and the patron by giving the impression that his compositions were created entirely outdoors, appearing to underscore his paintings' direct connection to nature.

The critic's objection also suggests that Diaz de la Peña's compositions were casually or even haphazardly organized. In actuality he, like most of his peers, painted studies and sketches outdoors but then typically returned to his studio to create final compositions using these studies. On closer examination the clear oval composition of *Wood Interior* appears deliberately arranged, with Diaz de la Peña carefully working and reworking minute details in the composition to achieve his desired results.[8] Starting with a careful layering of first sky and then trees, he constructed his composition logically and intentionally. In several areas, he went back in to strategically place on top of the darkened areas pinpoints of blue sky that appear to be peeking through the trees. These very intentional azure dots play an important role in balancing the weight of the blackness framing the center of the canvas as well as increasing the naturalistic effect of the scene.

Diaz de la Peña's apparently spontaneous application of paint not only heightened the naturalistic effect of the painting, but it also simulated the natural (dis)order of the forest. He used several other methods to replicate the sensations of being deep within the forest. At first glance, much of the periphery of the painting appears black—dim, as though we have suddenly entered the forest. As

Jean-Baptiste-Camille Corot

(French, 1796–1875)

Le chemin des vieux, Luzancy, Seine-et-Marne (The Path of the Old People), 1871–72

"BEAUTY IN ART IS TRUTH STEEPED IN the impression made upon us by the sight of nature. I am struck on seeing some place or other. While seeking conscious imitation I do not for an instant lose the emotion that first gripped me. Reality forms part of art, feeling completes it."[1] With these words, written as friendly advice to the young painter Berthe Morisot in 1857, Jean-Baptiste-Camille Corot summarized his approach to painting, a philosophy that he would continue to put into practice throughout the rest of his career. Corot also spoke in concert with prominent aesthetic theories of the time, perhaps most famously aphorized by the novelist Émile Zola in his definition of the naturalistic work of art as "a corner of nature seen through a temperament."[2]

Reality completed by feeling or nature evidenced through temperament is certainly apparent in Corot's *Le chemin des vieux, Luzancy, Seine-et-Marne*, a gentle, elegantly designed landscape scene completed in the early 1870s as the painter approached the end of his long, highly successful career. Two figures, a woman facing the viewer near the front of the picture plane and a man leaning on a walking stick with his back to the viewer in the middle ground, walk on a well-worn dirt path that winds through grass, brush, and trees. The trees are carefully structured. Their bold, dark forms dominate the composition, backlit by the blue sky.[3] While a few distant buildings are visible near the horizon, the setting is resoundingly rural, without further visual elements to indicate the specifics of either place or historical time. The noon-time sun shines from straight above—the female figure in the foreground casts no angled shadow—and the richness of the foliage suggests that the season is summer or early autumn. White flecks of pigment, especially in the areas of foreground brush, may indicate the full flowering of late summer. Although the woman in the foreground

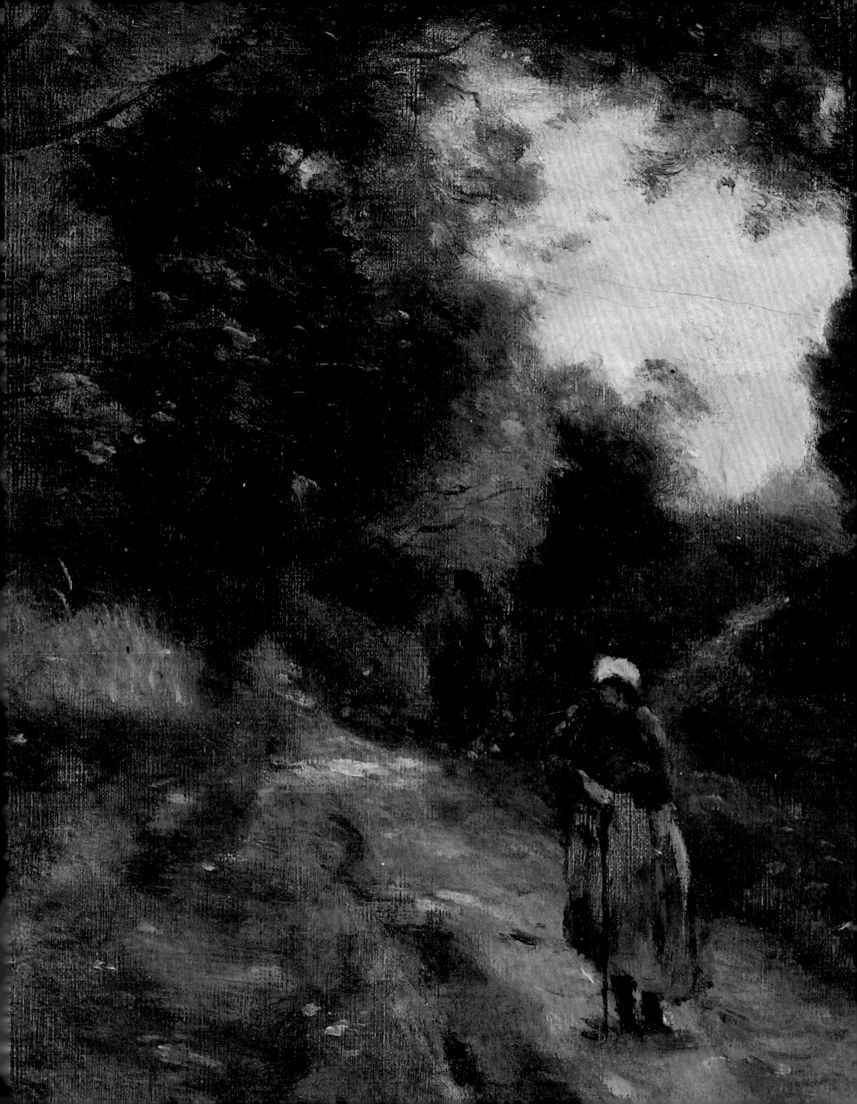

appears to wear a white bonnet and a plain brown and blue dress, her clothing cannot be understood as representative of a specific region or time period. The hem at the bottom of her skirt seems uneven and may perhaps be tattered by poverty, but given the overall indistinctness of Corot's brushstrokes, it is also not possible to interpret her dress as indicative of a particular social status or profession.

As Corot himself wrote, "I'm never in a hurry to arrive at details; the masses and the general character of a picture interest me more than anything else."[4] The painterly masses that most interested Corot in *Le chemin des vieux* were arguably those of the two largest trees. Interestingly, he constructed an opening between them, where the shock of the blue sky and the white clouds provides contrast to the deep greens of the trees' foliage, but this is a framing device that frames only empty sky rather than figures or buildings, once again emphasizing broad formal massing over details.[5] Corot repeated the bright white of the clouds in the woman's bonnet, effectively drawing the viewer's attention from the gap in the trees down to the figures on the path. The same white appears again dotted lightly in the brush on either side of the path, thus unifying the composition and encouraging one's eye to dance across the surface.

Despite the painting's lack of detail, its title is highly specific. It explicitly identifies the location as a particular path—Le chemin des vieux, or the Path of the Old People—in Luzancy, a village in central France. Luzancy is situated on a bend in the rather narrow Marne River but is otherwise distant from any large body of water. Yet the strip of blue on the left side of the horizon suggests an ocean or lake in the distance. Indeed, Alfred Robaut—the painting's first owner, Corot's biographer, and coauthor of the catalogue raisonné of the artist's paintings—described this blue patch as "a horizon of sea."[6] Furthermore, Robaut himself apparently requested this alteration to the view and gave the painting its title.[7] Robaut's few short words about *Le chemin des vieux* prompt questions about landscape painting, memory, and the roles of the patron and the artist

in conversation with each other. Why would Robaut request the addition of the sea but then give the location of Luzancy in the title? Robaut wrote that the purpose was to "give a false impression" (*donner le change*) about the place where the painting was painted.[8] Why might Robaut want to do this? And why would Corot comply?

Le chemin des vieux resembles another work by Corot, *Luzancy—Arcade de verdure sur un sentier du coteau* (*Luzancy—Arcade of Greenery on a Hillside Path*) (1871-72; present location unknown), which depicts what is likely the same path, identifiable because of the same prominent, distinctively shaped trees that arch over it. That canvas is more squarely shaped, however, and the composition is more closely cropped, so the distant view of buildings and a body of water does not appear.[9] Presumably *Luzancy—Arcade de verdure* is the more accurate depiction of the landscape in Luzancy, while the addition of the sea in *Le chemin des vieux* marks it as a fictional locale. As Fronia Wissman has noted, "Robaut's request for the change, and Corot's acquiescence, point out what a small role topographical accuracy played in Corot's late works; the formal construction of the picture and the mood it created were far more important than the delineation of a specific locale."[10]

In its lack of details, including the intentional obscurity of the location depicted, Corot's scene is deliberately timeless. What results is an embodiment of the memories that a place can evoke. Recent scholarship on Corot's late works has focused on the role of memory in his construction and depiction of landscape scenes. The art historian Eileen Yanoviak emphasizes the contrast between Corot's earlier landscapes, the titles of which often include the word *vue* (view) and which portray identifiable locations, including recognizable structures or other landmarks, and his later landscapes, which are typically titled with the word *souvenir* (remembrance). The late works might still depict specific, identifiable locations, but they are often interpreted first and foremost as poetic recollections of the feelings evoked by a place, as if the artist drew as much from his emotional memories as from his sketches

made *en plein air*. As Yanoviak writes, "While the late paintings are not particularly concerned with a topographical view, the sense that they project attachment and sentiment towards the landscape is pervasive."[11] In both depictions of the grove of trees over the path at Luzancy, memory and topography combine. Indeed, particularly later in his career, Corot often painted numerous depictions of the same location, emphasizing different aspects in each variation as mood or memory struck him. As he told his biographer Théophile Silvestre, "When a collector wants a repetition of one of my landscapes, it is easy for me to give it to him without seeing the original: I keep a copy of all my works in my heart and in my eyes."[12]

Attachment and sentiment are evident in *Le chemin des vieux*, with its atmospheric layering of pigments and delicate, carefully placed touches of paint, thick in places and very thin in others. The location was clearly meaningful to Corot. Between 1850 and August 1874, when he last visited the area, he returned frequently to the small village of Luzancy (which would later be occupied by German troops during World War I). His friend the painter Louis-Jean Marie Rémy, who, like Corot, had begun as an apprentice to a draper before starting his artistic training in the studio of Jean-Victor Bertin, had a vacation house in Luzancy. Corot visited there often, even after Rémy's death in 1869.[13] Other artists were also attracted to the area around Luzancy since it offered a more secluded retreat compared to the popular nearby Forest of Fontainebleau.[14]

Following his friend's death, Luzancy may have taken on a new significance for Corot. Its paths and groves might have reminded him of their long friendship and the times they spent there together. If the painting is interpreted as a meditation on memories and comradery, its title—*Le chemin des vieux*—takes on an additional subtext. It is possible that the path's name, like the patch of sea in the distance, is fictional. The other painting of the same trees does not include the specific name of the path; its inclusion here may be a reflection not only on the two figures depicted on the path but also on the artist's age and the loss of friends with whom he had

shared a lifetime. Corot and Rémy may have walked this path—or one like it—together as "old people."[15] In any case, Corot extended the path to the bottom of the picture plane, giving viewers unhindered entry into the composition, as if to invite us too to walk along the path of the old people.

In Robaut's catalogue raisonné of Corot's oeuvre, *Le chemin des vieux* is dated 1870–71. Subsequent scholars have dated the work a year later, however, to 1871–72, based both on the dates of many other works depicting Luzancy from that time as well as the frequency of Corot's travels there during that period.[16] Whatever the actual date of creation, *Le chemin des vieux* may certainly be placed near the end of Corot's life, during a time when he had witnessed not only the tragic deprivations of the Franco-Prussian War and the Paris Commune in 1870–71 but also the more personal, immediate tragedies of the loss of friends and family members, including Rémy of Luzancy. With its evocative atmosphere that eludes a precise geographic mapping, *Le chemin des vieux* may be understood as one of Corot's *souvenirs*. Memory and nature are combined, producing a meditation on the pleasures of friendship through a landscape that surely had deeply personal meaning for the artist.

Noelle C. Paulson

Notes

First published November 2007; revised 2016

1. Camille Corot, letter to Berthe Morisot, 1857. Quoted and translated in Kathleen Adler and Tamar Garb, *Berthe Morisot* (Ithaca, NY: Cornell University Press, 1987), 16. All other translations are mine except as noted. Many thanks to Allison Unruh and Jane Neidhardt for their helpful comments and suggestions.

2. Émile Zola, "Proudhon et Courbet I," *Le salut public*, July 26, 1865; quoted and translated in Henri Dorra, *Symbolist Art Theories: A Critical Anthology* (Berkeley: University of California Press, 1994), 319n1.

3. The art historian Eileen Yanoviak has argued that backlighting of the type Corot used here may relate to the effects produced by the collodion photographic process. Beginning in the 1850s that process was popular with landscape photographers such as Eugène Cuvelier, whom Corot knew well. Yanoviak, "From Vue to Souvenir: Time, Memory, and Place in Corot's Late Landscapes," *Southeastern College Art Conference Review* 16 (January 1, 2012), www.thefreelibrary.com /From+Vue+to+Souvenir%3a+time%2c+memory%2c+and+place+in+ Corot%27s+late...-a0314801320.

4. Corot, quoted in Dorit Schäfer and Margret Stuffmann, *Camille Corot: Natur und Traum* (Karlsruhe, Germany: Staatliche Kunsthalle Karlsruhe, 2012), 406n21.

5. On emptiness versus fullness in Corot's late work, see Dorit Schäfer, "Der reflexive Blick: Anmerkungen zu Corots Bildstrukturen," ibid., 406.

6. Alfred Robaut, *L'oeuvre de Corot* (1905; Paris: Léonce Laget, 1965), 3:268; see also Fronia E. Wissman's analysis of this work in Joseph D. Ketner et al., *A Gallery of Modern Art at Washington University in St. Louis* (St. Louis: Washington University Gallery of Art, 1994), 26.

7. Robaut, *L'oeuvre de Corot*, 3:268.

8. Ibid.

9. See *Luzancy—Arcade de verdure sur un sentier du coteau*, in Robaut, *L'oeuvre de Corot*, 3:274–75, no. 2084.

10. Wissman, in Ketner, *A Gallery of Modern Art*, 26.

11. Yanoviak, "From Vue to Souvenir."

12. Corot, quoted and translated in Simon Kelly, "Strategies of Repetition: Millet/Corot," in *The Repeating Image: Multiples in French Painting from David to Matisse*, ed. Eik Kahng (Baltimore: Walters Art Museum, 2007), 81.

13. Noël Coret, *Les peintres de la vallée de la Marne: Autour de l'impressionisme* (Tournai, Belgium: Renaissance du livre, 2000), 56.

14. The Forest of Fontainebleau, near the village of Barbizon and the Château de Fontainebleau, had by this time been overrun by artists and photographers following the success of the influential school of Barbizon painters, who were active in the area from the 1830s to about 1870. Ibid., 56. See also the essay on Narcisse Virgile Diaz de la Peña's *Wood Interior* in this volume, pages 73–77.

15. That the figures in the painting appear to be walking away from each other, in opposite directions, perhaps could be seen as a poignant allusion to a departed friend.

16. For the time period 1870–71, Robaut's catalogue raisonné lists no other depictions of Luzancy. A larger group of works was painted there in 1871 or 1872, however, and one painting is even specifically dated to August 1872; see *Luzancy–Le chemin des bois*, in Robaut, *L'oeuvre de Corot*, 3:274, no. 2087. With a vigor belying his seventy-six years, Corot spent much of 1872 traveling from place to place, visiting many friends throughout France, and the chronology of his travels places him at Luzancy on August 21. Such a date, at the height of summer, is in keeping with the direct sunlight and lush vegetation depicted in *Le chemin des vieux*. Since Robaut requested the addition of the sea, however, Corot may have worked on this painting over a number of months or even years, both on-site and in the studio. For a chronology of Corot's activities in 1871 and 1872, see Françoise Cachin, *Corot, 1796–1875* (Paris: Réunion des Musées Nationaux, 1996), 35.

Frederic Edwin Church

(American, 1826–1900)

Sierra Nevada de Santa Marta, 1883

FREDERIC EDWIN CHURCH'S *Sierra Nevada de Santa Marta* is one of the last of the artist's celebrated large-scale landscapes of South America. Along with his renowned *Heart of the Andes* (1859; Metropolitan Museum of Art, New York) and *Morning in the Tropics* (1877; National Gallery of Art, Washington, DC), this painting was inspired by Church's travels to the continent as a young man, in 1853 and 1857. Characteristic of his landscape aesthetic, in *Sierra Nevada*, Church rendered the eponymous mountain range that skirts the northern coast of Colombia in painstaking detail, using Western conventions of the picturesque to compose the view. These include the tripartite division of nature, consisting of a foreground filled with dense vegetation and a middle ground marked by a tranquil waterway fed by cataracts flowing from the mountain range in the background, all unified by a soft golden light. Also conventional was the use of trees to frame the composition. While the blasted tree stump to the right was a visual trope used by Church and his fellow Hudson River school artists in their paintings of the American landscape to signify the sublime power of nature, unique to landscapes of South America by Church and other American painters was the symbolic use of palm trees, which in this work rise triumphantly above the skyline. Equated with the "tree of life," the palm tree gave pictorial form to the North American ideal of tropical America as the "long-lost Garden of Eden."[1]

Like many of Church's works, the painting does not reproduce an actual view but instead presents a composite of features conveying the essence of the region. Each meticulous touch and stroke of the brush was aimed at articulating the character of specific types of vegetation and geological formations. Representing the first

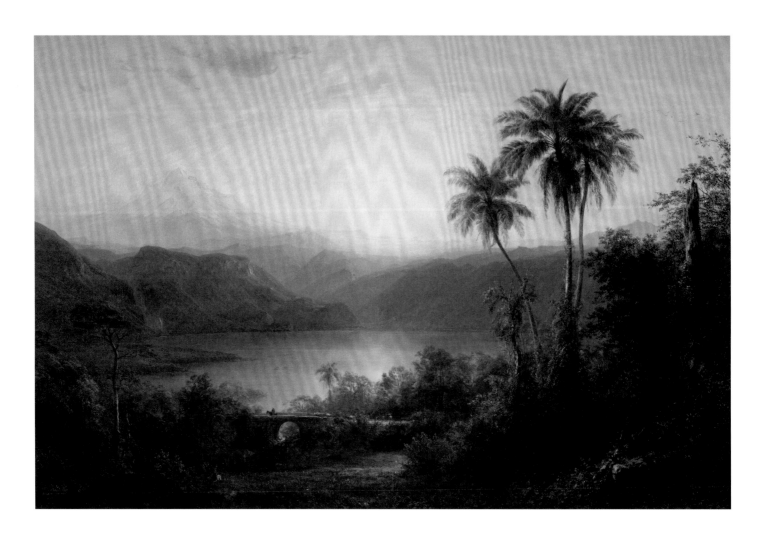

Sierra Nevada de Santa Marta, 1883

Oil on canvas, 40 $^1/_{16}$ × 60 $^1/_8$"

Bequest of Charles Parsons, 1905

natural landmark that Church encountered in his initial Colombian expedition in 1853, *Sierra Nevada* occupies an important and complex position in his career and in American art.[2] Painted thirty years after this expedition, at a time when such detailed panoramic landscapes had fallen out of fashion, it is a triumphant reprisal and culmination of a subject to which Church periodically returned throughout his career, evincing his enduring devotion to dated attitudes toward art and nature at the same time as it reflects back on an exultant place and time of the artist's youth.

Church's aesthetic in *Sierra Nevada* was shaped by the antebellum Romantic belief that nature was the direct embodiment of God. The function of landscape painting, in this view, was to reveal truths of a divine plan and purpose and give audiences a sublime spiritual experience of nature. This took on special resonance with paintings of South America, whose primal paradise seemed untainted by civilization and was thought to bear, more than any other landscape, the traces of divine providence. Also shaping Church's fascination with South America, however, was an expanding scientific interest in the region; in the early nineteenth century biologists, geologists, and geographers turned their attention to the tropics for its rich, exotic flora and fauna. Influenced by the writings of prominent naturalists, Church's paintings of South America couple science with spirituality. For the artist and many others of this time, painting was a means of description and classification in which both minute features and the broader laws of the cosmos were delineated, providing insight into the order of nature and the workings of God, whose powers of creation were reflected in the very act of painting.[3] In this way artists such as Church took on the role of priest as well as artist, scientist, and heroic explorer, serving as conduits between primeval nature and civilization, between the public and the divine.

Especially influential to Church were the writings of the German naturalist Alexander von Humboldt. Humboldt had traveled to South America from 1799 to 1804, writing highly detailed descriptions of its various climates, natural monuments, vegetation, and animal life, extolling in particular the ability to observe multiple climatic zones within single locales. Finding the tropics to be the supreme manifestation of divine order and of the magnificent complexity of creation, Humboldt called on artists to paint the region as a means of charting its "physical phenomena" and bringing to nonnative audiences its natural wonders. For him, the close study of tropical nature in particular provided "knowledge of the chain of connection, by which all natural forces are linked together, and made mutually dependent upon each other," and he believed that "it is the perception of these relations that exalts our viewers and ennobles our enjoyments."[4]

Thus encouraged by the German naturalist's model, Church and other American artists took it as a cultural responsibility to paint the South American tropics. From the 1830s to the late 1870s some thirty artists made voyages to the exotic paradise filled with natural wonders.[5] In *Sierra Nevada*, Church presented, to use Humboldt's words from decades earlier, a scene in which "the depths of earth and the vaults of heaven display all the richness of their forms and the variety of their phenomena." In the foreground lies the "inexhaustible fertility of the torrid zone" (the warm, wet, and verdant climate that extends north and south of the equator), and beyond the waters rise the cataracts, or what Humboldt described as the "rocky walls and abrupt declivities of the Cordilleras [Andes]."[6] Considering the image in its entirety, with its synthesis of vignettes, Church also represented the cycles of nature and the "great chain of connection." The sun provides energy for the vegetation while melting the snow of the mountains, which streams down the cataracts into the river, feeding the flora and fauna of the lowlands, which in turn release their energy into the air, beginning the cycle anew.

Sierra Nevada, however, was painted in 1883, when such idealizing beliefs about nature were undermined by materialist worldviews. Charles Darwin's radical theories in *The Origin of Species*

(1859), which held increasing sway in the United States in the last quarter of the century, posited a godless, amoral world of chance, violence, and conflict in place of the benign world of unity and order cherished by Church and others of his generation. In its representation of a universe of balance and harmony, *Sierra Nevada* can be seen as a bulwark against post-Darwinian perspectives, defending pantheistic attitudes toward nature as well as the importance of the landscape painter's role as an emissary for the divine.

Church's initial fascination with South America in the 1850s was not only scientific and spiritual but was also influenced by political relations between the United States and Latin America, especially as defined by the Monroe Doctrine of 1823. In this official policy the United States took a proprietary attitude toward Central and South America and overtly attempted to prevent European countries from interfering with them. Though political interests were focused primarily on countries in immediate physical proximity to the United States, this attitude extended to regions to the south as well. Indeed, South America was even seen as "the geographical extension of the United States" and often referred to as "our southern continent" or "our tropical regions."[7] In this framework the very act of painting the landscape was one of appropriation, claiming a kind of patriarchal ownership and further encouraging the expansionist mindset in the age of manifest destiny. Although political interests in South America were on the wane by the 1880s, *Sierra Nevada* still manifests this patriarchal and expansionist attitude toward the continent. Eliding any portrayal of the modernization that had begun "spoiling" South America's pristine nature, the painting depicts the realm as a sublime, Edenic paradise untainted by modernity and bearing the traces of divine presence.

J. Gray Sweeney observes that *Sierra Nevada* can also be seen as an effort to reclaim the success of Church's earlier South American landscapes, which created a sensation both for critics and the public when first exhibited in the 1850s.[8] Serving as a final valediction to his tropical series, *Sierra Nevada* is also tinged with nostalgia for a time when his art was at the height of its power and popularity and his tropical views of South America brought the artist national fame. The towering, epic mountains featured in such earlier paintings as *Heart of the Andes* give way here to a range that, by contrast, seems diminished and enervated, worn by the passage of time. This, along with the implication of a waning sunset casting its last golden light on the landscape below, suggests the closing of an era and perhaps symbolizes a yearning for the sublime, exotic experience affiliated with his past. Or they may also allude to the declining popularity of monumental landscape painting and scientifically detailed panoramas, of which Church was one of the most famous practitioners. At a time when representations of the human figure and nature cast through more subjective, poetic lenses were more fashionable and artists, accordingly, turned toward the subjects and styles of European art rather than American nature itself for inspiration, *Sierra Nevada* represents a vindication of its own style. Executed when the artist was afflicted by rheumatism to the point that he was forced to learn to paint with his left hand, the painting may also symbolize a longing for the technical prowess of his youth. Read this way, *Sierra Nevada*, though infused with melancholy, stands as a defense of Church's craft and a tribute to unwavering ideals of art and nature in the face of sweeping cultural transformations at a time when his prominent position in American art was fading from public memory.

Matthew Bailey

Notes

First published May 2011

1. Katherine Manthorne, "The Quest for Tropical Paradise: Palm Tree as Fact and Symbol in Latin American Landscape Imagery, 1850–1875," *Art Journal* 44 (Winter 1984): 374–82.

2. In a letter to a friend, Church recalled: "[Santa Marta] was the first snow peak I ever witnessed and [it] made a profound impression which my memory has perhaps exaggerated. . . . I saw it from sea level at Barra[nq]uilla, looking across the Magdalena River where it is several

miles wide and a low horizon. . . . I noticed a peculiar light high up in the sky which a single glance revealed to be 'Sta Marta'—Little else than the great pyramid of snow was visible but it was wonderfully grand." Quoted in J. Gray Sweeney's analysis of this work in Joseph D. Ketner et al., *A Gallery of Modern Art at Washington University in St. Louis* (St. Louis: Washington University Gallery of Art, 1994), 44.

3. On this peculiarly American and Romantic role of the artist, see Barbara Novak, *Nature and Culture: American Landscape Painting, 1825–1875* (New York: Oxford University Press), 47.

4. Alexander von Humboldt, *Cosmos: A Sketch of the Physical Description of the Universe*, vol. 1 (1845), trans. E. C. Otte (Baltimore: Johns Hopkins University Press, 1997), 23.

5. For an in-depth study of this cultural phenomenon and its aesthetic and political implications, see Katherine Manthorne, *Tropical Renaissance: North American Artists Exploring Latin America, 1839–1879* (Washington, DC: Smithsonian Institution Press, 1989).

6. Humboldt, *Cosmos*, 33.

7. See Manthorne, *Tropical Renaissance*, 3–5.

8. Sweeney, in Ketner, *A Gallery of Modern Art*, 44.

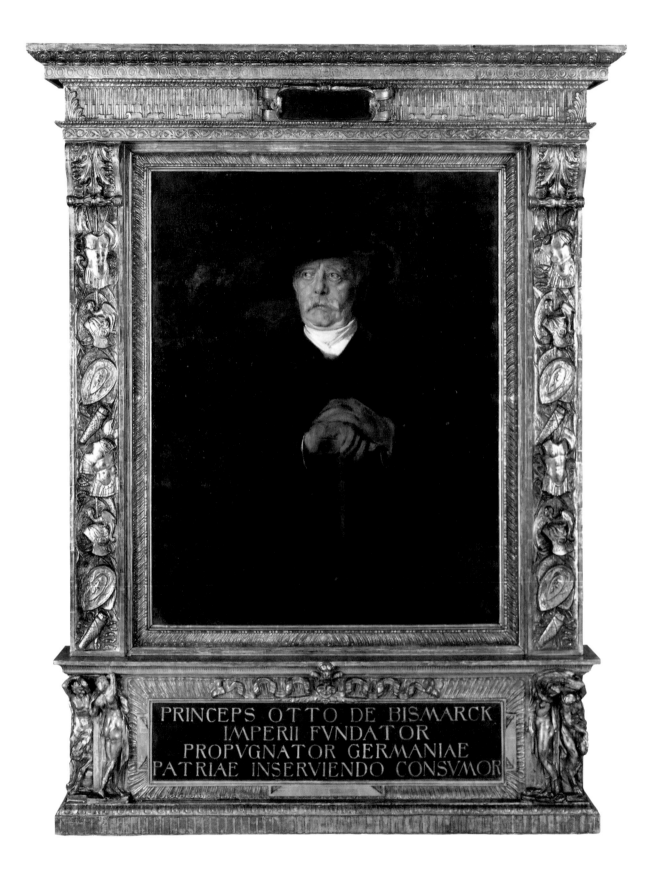

PRINCEPS OTTO DE BISMARCK
IMPERII FVNDATOR
PROPVGNATOR GERMANIAE
PATRIAE INSERVIENDO CONSVMOR

Portrait of Prince Otto von Bismarck, 1884–90

Oil on canvas, 46 × 36 ⁵/₈"

Gift of August A. Busch, 1929

Franz Seraph von Lenbach

(German, 1836–1904)

Portrait of Prince Otto von Bismarck, 1884–90

FRANZ SERAPH VON LENBACH'S *Portrait of Prince Otto von Bismarck*, painted in the mid- to late 1880s, is a typical example of the painter's work of the last two decades of the nineteenth century. Like most of his pictures of those years, this painting takes as its subject a prominent member of imperial Germany's economic, social, and political elite. In this case the sitter was the man who had played an instrumental role in the founding of the imperial German nation-state in 1871 and who, by 1895, had become a larger-than-life figure to many Germans. Described with painterly dash, the figure of the elderly yet apparently still robust Prussian statesman emerges auratically from a dark, mysterious ground in which it is difficult to distinguish anything clearly. Light falls from the viewer's left onto Bismarck's hands, which are sheathed in yellowish leather gloves, folded over a walking stick and rendered with summary virtuosity. The light even more strongly illuminates his face, which is the unmistakable focal point of the picture. Bismarck turns toward this light, looking not at the viewer but rather up and into the distance with an expression that seems to mix imperiousness and thoughtful reflection. Though Bismarck is soberly dressed, the understated Titianesque elegance of the picture and the richness of its frame produce an effect of carefully controlled magnificence. The picture contains painterly flourishes but challenges no traditional artistic standards. This was an object that plainly spoke for, not to, power.

Lenbach began in the mid-nineteenth century as a painter of pleasant pastoral genre scenes but made his fortune as Germany's best-known high-society portraitist between 1870 and his death in 1904. Today, however, Lenbach's work is marginalized by art history, and only rarely does it hang in museums, which devote themselves primarily to the art of the modernist avant-gardes.[1] This is unfortunate, because pictures such as

this portrait occupied an important position in the field of German cultural production. Pictures like this one can be examined to understand the materialization of ideology, the measurement of success, and the convergence of patronage and politics.

The Painting

Lenbach was an ardent admirer and close personal acquaintance of Bismarck, visiting him frequently at home and publicly identifying himself with the towering Prussian politician in a variety of ways. Above all, Lenbach profiled himself in the three decades after the founding of the German Empire as "the Bismarck painter." While it was once said that Lenbach had no idea how many portraits of the man he had painted, recent accounts have estimated the number to be between 80 and 150. Many were commissioned or acquired by prominent public museums and private collectors in Germany.[2]

The painting in the collection of the Kemper Art Museum is a typical example of this large body of work, which consists largely of a variety of busts, half-portraits, and three-quarter figures. Quite a number of them depict Bismarck in uniform. This painting, however, belongs to another type, namely one that shows him wearing civilian clothes while on the grounds of the wooded estate that was given to him to reward his service to the new nation-state. The stone wall and vegetation just discernible in the shadows suggest this location. The popularity of this representation of the empire's elder statesman is suggested by the number of variations and replicas of this type that the painter made.

In this picture and others of its type, Lenbach avoided the regalia of imperial authority frequently visible in caricatures of Bismarck, whose policies against the Social Democratic Party and Catholics were sharply divisive, and in history paintings including Bismarck by official painters such as Anton von Werner. Lenbach depicted Bismarck not as a man identified with and defined by the Prussian state and the Hohenzollern dynasty but rather as the wise patriarch of a bourgeois nation.[3] This image is in keeping with what Friedrich Naumann wrote about

Lenbach in 1909, claiming the artist's independence from aristocratic culture. Specifically, Naumann related how the painter had left a teaching position in Weimar in the 1850s to escape court life there and described him as later becoming an "artist who could paint aristocrats without becoming a courtier."[4] This portrait reinforced the conservative cult of Bismarck but was not the work of a court artist.

The Frame

The magnificent neo-Renaissance gilt frame in which the viewer encounters Lenbach's painting certainly adds to the aesthetic impact and potential political message of the portrait. Such tabernacle or aedicular frames were popular in Europe in the late nineteenth century, as a taste for historical styles emerged with the wealth created by the industrial revolution. They not only elevated the pictures they enclosed, as elaborate frames always had, but they also referred to the elite culture of the Renaissance and thus signified a link between the patronage of the Medici, for instance, and the buyers of paintings by artists such as Lenbach.[5] Lenbach himself was a serious art collector and placed Titian's *Portrait of Philip II*—or a copy of it—in a frame very similar to the one in the Museum's collection.[6] The Bismarck portrait's frame corresponded to the taste for opulence of the wealthy institutions and patrons who desired such pictures. It is an expression of the fortunes made during the economic boom that followed the founding of the German Empire in 1871, the so-called *Gründerzeit*.

At the same time the frame also advances a political message. Most obviously, the Latin inscription on its pedestal describes Bismarck as the founder of the empire, as the defender of Germany, and as a man consumed by service to his country: "Princeps Otto de Bismarck / Imperii Fundator / Propugnator Germaniae / Patriae Inserviendo Consumor." Trophies of war—breastplates, helmets, weapons, shields, and banners—carved in low relief on the moldings to the left and right of the painting add a triumphal note. The frame thus bespeaks Bismarck's role in the formation of the German

Empire on the basis of military victories against the Austro-Hungarian Empire and France.

Lenbach employed variants of this frame design on several occasions. In addition to Titian's *Portrait of Philip II*, a second portrait at the Bismarck estate in Germany is mounted in an almost identical frame, although with a less elaborate inscription and with eagles on the pedestal.[7] A photograph of Lenbach's house taken in the late 1890s shows one of his portraits of Field Marshal Helmuth von Moltke in a frame that appears to be virtually identical to the Kemper Art Museum's.[8] The motifs on the frame thus were not tailored specifically to Bismarck. Yet one can understand them as elements of a programmatic iconography distinguishing between the Prussian bourgeois virtues of austerity and masculinity embodied by Bismarck (and Moltke) and the sensuosity of those whom he had subjugated (exemplified both by the female nudes embossed on the shields on the lateral moldings and by the two pairs of satyr and nymph in high relief on the frame's pedestal). Seen in this way, the frame not only serves as a splendid supplement to the sober canvas that it surrounds, exalting the mythical figure of Bismarck, but also establishes a moralizing, gendered contrast and hierarchy between the victor and the vanquished, the virtuous and the licentious.

The Definition of Success

The brewing magnate Adolphus Busch acquired this painting when it was among the five by Lenbach, selected by Emperor Wilhelm II himself, that were posthumously included in the official German art exhibition at the Louisiana Purchase Exposition in St. Louis in 1904. Given Busch's deep ties to Germany, his wealth, and his taste for magnificence, the desirability of a critically acclaimed portrait of the great Prussian leader by the famous Bavarian artist is easy to explain.[9] Busch belonged to the class of people to whom Lenbach's expensive Bismarck portraits had always appealed most.[10] At the moment, however, it is unclear why Busch's son August donated the picture to Washington University in St. Louis in 1929. Perhaps this was a late effect of World War I. Several

Bismarck portraits reportedly hung at the brewery until 1914 but were then removed, and the family had faced sharp attacks during the war.[11] Perhaps Busch wished to align his family with a traditional conservatism far from the radical nationalism that marked post–World War I German politics, especially in the form of Nazism.[12]

In any case, the popularity of Lenbach's work had declined precipitously by 1929, as modern art moved to the center of the international art world. In the decade before 1904, when Lenbach's portrait of Bismarck was among the 317 works sent to St. Louis by the German government, new artistic movements had already begun to emerge in Germany, challenging the cultural establishment in which Lenbach had been such a prominent figure. The artists associated with these new trends paved the way for the eventual establishment of modernism in Germany but were not represented in the German pavilion in St. Louis in 1904. The judgment of posterity about their exclusion has not been kind. As the historian Peter Paret characterized it in a groundbreaking study of the emergence of German modernism, the official German art exhibition in St. Louis "consisted almost entirely of mediocre and bad paintings," of "miles of visual cotton candy."[13]

In the late nineteenth century the society portraiture of Franz von Lenbach, the son of a Bavarian stonemason who parlayed his talent and connections into the status of a "painter prince," epitomized bourgeois cultural success, distinct not only from mass culture and the nascent modernism of that time but also from the art associated with the imperial court. His work received the public encomia, state prizes, and high prices that signified its respectability and prestige for people who thought in such terms. By today's standards, however, the ones to which Paret gives voice, pictures such as Lenbach's portrait of Bismarck are bound to fail. Yet it is important to recall that at any given moment multiple artistic positions, their respective claims of quality and value, and their respective definitions of success struggle for legitimacy. These rival positions are not isolated: "Every position, even the dominant

one, depends for its very existence, and for the determinations it imposes on its occupants, on the other positions constituting the field."[14] Thus, if one wishes to understand the total modern history of art, it is crucial to engage with pictures such as Lenbach's portrait of Bismarck. To ignore them is to produce a distorted account of the past, as selective, affirmative, and troublesome in its way as some might find Lenbach's celebration of power was a century ago.

James A. van Dyke

Notes

First published March 2014; revised 2016

1. One notable exception in the United States is the exhibition *Celebrity Soul: Lenbach's Portraits*, presented by the Frye Art Museum, Seattle, in 2005; see fryemuseum.org/exhibition/87/. It should be mentioned that the Frye is atypical in its focus on academic and *juste milieu* German art of the late nineteenth and early twentieth centuries. In Germany, scholarship on Lenbach exists. Even there, however, it is unusual to encounter his work on permanent public display in museums in places other than Munich.

2. See Friedrich Naumann, "Lenbachs Bismarckbilder," in *Form und Farbe* (Berlin-Schöneberg: Buchverlag der "Hilfe," 1909); Sonja von Baranow, *Franz von Lenbach: Leben und Werk* (Cologne: DuMont, 1986), 138; and Alice Laura Arnold, "Zwischen Kunst und Kult: Lenbachs Bismarck-Porträts und Repliken," in *Lenbach: Sonnenbilder und Porträts*, ed. Reinhold Baumstark (Munich: Pinakothek-Dumont, 2004), 152.

3. See Arnold, "Zwischen Kunst und Kult," 166.

4. See Naumann, "Lenbachs Bismarckbilder," 75.

5. See Eva Mendgen et al., *In Perfect Harmony: Picture + Frame, 1850–1920* (Amsterdam: Van Gogh Museum; Zwolle, Netherlands: Waanders, 1995), 29–42, 75–83. For more on this in general, see the exhibition *Tabernacle Frames from the Samuel H. Kress Collection at the National Gallery of Art*, National Gallery of Art, Washington, DC, 2007, www.nga.gov/exhibitions /tabernacleinfo.shtm.

6. A photograph of the painting in its frame is found in Gollek and Ranke, *Franz von Lenbach, 1836–1904*, 172. On Lenbach's engagement with Titian, see also Stephanie R. Miller, "A Tale of Two Portraits: Titian's Seated Portraits of Philip II," *Visual Resources: An International Journal of Documentation* 28, no. 1 (March 2012), www.tandfonline.com/doi/abs /10.1080/01973762.2012.653485.

7. This inscription, in German, reads: "Otto Fuerst von Bismarck. Kanzler des Deutschen Reiches" (Otto, Prince Bismarck. Chancellor of the German Empire).

8. For a reproduction and photographs, see Arnold, "Zwischen Kunst und Kult," 154, and Mendgen, *In Perfect Harmony*, 38–39.

9. A newspaper clipping from the time emphasizes Lenbach's technical mastery and "almost infallible psychology" while describing the painting (or one like it) as "destined to become a great historical representation of the mighty chancellor." Unidentified source, Mildred Lane Kemper Art Museum, object file WU 2929.

10. See Arnold, "Zwischen Kunst und Kult," 163. On the prices fetched by these pictures, see Mehl, *Franz von Lenbach*, 32.

11. For more on this topic, see Peter Hernon and Terry Ganey, *Under the Influence: The Unauthorized Story of the Anheuser-Busch Dynasty* (New York: Simon & Schuster, 1991), 92–93, 97–98, 100–102, 143.

12. This possibility was suggested by Sabine Eckmann at the symposium "The Legacy of German Art and Culture in St. Louis," held at Washington University in St. Louis, September 7, 2013.

13. Peter Paret, *The Berlin Secession: Modernism and Its Enemies in Imperial Germany* (Cambridge, MA: Belknap Press of Harvard University Press, 1980), esp. 149, 153.

14. Pierre Bourdieu, "The Field of Cultural Production, or: The Economic World Reversed," in *The Field of Cultural Production*, ed. Randal Johnson (New York: Columbia University Press, 1993), 30.

Paul Gauguin

(French, 1848–1903)

Te Atua (The Gods), 1899

PAUL GAUGUIN WRESTLED WITH what he regarded as the limitations of easel painting. Even as he painted canvases with the Paris art market in mind, he simultaneously explored the expressive potential of many mediums, including printmaking, ceramics, drawing, and wood carving. His experiments in printmaking, begun in 1889, include work in etching, zincography, lithography, and monotype, but his most sustained engagement came with woodblock prints. Gauguin's innovations in woodcut stand out both for their expressive and simplified forms and for the varying effects he achieved through the use of a variety of papers, inks, and printing and mounting techniques.

Gauguin valued prints as a vehicle to distribute his art to what he believed would be a growing circle of collectors, critics, and fellow artists. Exemplifying this aspiration is *Te Atua*, one of a series of fourteen woodcuts he made in Tahiti between 1898 and 1899. These are generally referred to as the Vollard suite, as he sent some thirty sets of them to Ambroise Vollard in 1900 in hopes that the entrepreneurial art dealer would promote them in Paris.[1] He also intended that some could be exhibited alongside his paintings at the upcoming Exposition Universelle of 1900, a plan that did not come to fruition.

Gauguin printed *Te Atua* in black ink on a sheet of japan paper, a tissue-thin paper used in European printmaking since the time of Rembrandt, which was later laid down on a heavier page of watercolor paper.[2] It is significant that he printed this series on japan paper. Whereas Gauguin had chosen a heavy commercial paper for his Volpini suite of zincographs in 1889,[3] he selected for the Vollard series a fine-art paper, one that he would have had to import to Tahiti from France. Thus, even in his last years

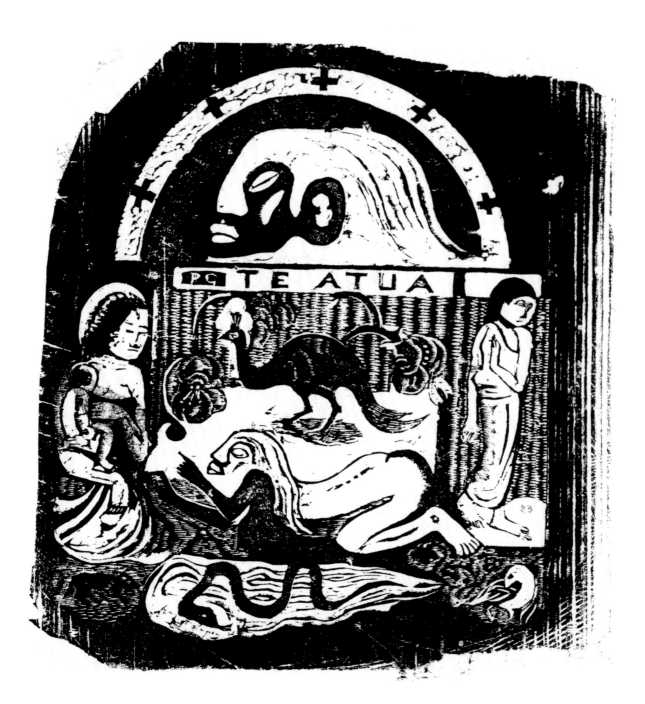

Te Atua (*The Gods*), 1899

Woodcut, 14 $^3/_4$ × 12 $^{13}/_{16}$"

University purchase, Charles H. Yalem Art Fund, 2001

in Tahiti, as Gauguin complained of the islands' colonial modernity and was preparing to retreat to the more remote Marquesas Islands, he kept the target audience of a Parisian art clientele clearly in mind.

The vertical stacking of motifs, capped by a framing arch, and the central position of its bold inscription suggest that this may be the title image in the series.[4] In a narrow horizontal band at the top center, Gauguin's initials, carved in a cartouche, claim authorship; next appear the Tahitian words *Te Atua*, meaning "the gods."[5] In the title and in the imagery that surrounds it, Gauguin introduced some of the central concerns of the Vollard suite: the subjects of god(s), veneration, and the enigmas of religious symbolism. The imagery is a rich fusion of Christian, Polynesian, Buddhist, and indeterminate referents, indicating the global span of his religious interests.

The scene is compressed in a friezelike shallow space under the expansive framing arch, inscribed with small cross or star forms that create the illusion of a vault of the heavens. This frame is reminiscent of the rounded vaults and arches of Romanesque churches, an earlier "primitive" form within Gauguin's own French Catholic tradition. The arch frames a decidedly non-French figure, however—a monumental head that in its facial features may be read, albeit ambiguously, as Polynesian. If so, one literate with the Tahitian pantheon would readily associate it with Ta'aroa, the supreme creator god. But part of the power of this print is that clear identifications of its imagery are elusive, and the large head, highlighted by flowing white hair and a sober countenance, may also be read as a godhead that declares its authority simply through its iconic profile, monumental scale, and dominant position over the scene that plays out below. Like Gauguin's Parisian viewers, we may surmise that it is a god without knowing its precise identity.

The scene is bordered at the left by a woman and infant whose halos clearly identify them as the Madonna and Christ Child. The woman bows her head slightly toward the center ground, which is occupied by a figure as grotesque as Mary is graceful.[6]

This gender-ambiguous deity unites the realms of earth and sky: its impossibly long, curving torso echoes the snake below, while its flowing white hair and bold profile repeat features of the god hovering in the heavens above. The scene invites comparison to the Christian nativity, in which angels and kings pay homage in the stable, but this figure is neither angelic nor Magus-like in countenance; rather, Mary and Jesus confront a being of divine equivalence, perhaps again the Tahitian creator god Ta'aroa, who rules the upper domain of the image. Offering symmetrical balance to Mary, a female figure at far right holds up her hand in a gesture of reverence, or at least in acknowledgment of the extraordinary encounter before her. Gauguin has adapted this pose of veneration from depictions of Buddhist figures in a frieze from the Borobudur temple, Java, known to him via a photograph.[7] As he believed (erroneously) that the Polynesian people he lived among had originated from populations in southeastern Asia, Gauguin regarded the adaptation of ancient Buddhist temple reliefs as appropriate to his goal of visualizing the sacred spheres of Polynesia. Such thinking was not derived from anthropological or historical research on his part but rather from a kind of poetic affiliation that he forged between southeastern Asia, as a region whose art, he felt, bore witness to a heightened spirituality, and his current preoccupation with the religious heritage of Tahiti.

A varied animal world further populates the scene and enticingly raises the possibility of animals serving as sacred symbols. A peacock, almost equal in scale to the human figures, strides across the top of the image; the snake writhes in a small pond or field at the bottom. At the lower left corner a small dog or fox curls in a cartouche-like space that suggests a nest or den, and at the right corner a bird resembling a goose assumes a balancing position. None of these animals are likely to have been present in Gauguin's daily life in Tahiti. Rather, they are derived from religious and classical traditions. The peacock was a long-held Catholic symbol of Christ's resurrection and more generally of renewal, and the snake is the famous harbinger of evil in the Garden of Eden.[8] The

fox and bird are more difficult to pinpoint; they might be derived from folk tales and fables that Gauguin referenced elsewhere in his art, such as the fables of Jean de La Fontaine (which offer numerous tales of foxes, rats, crows, and other animals), but no specific stories are invoked here. The white bird in particular echoes the prominent white bird in the lower left foreground of Gauguin's monumental painting *D'où venons-nous? Que sommes-nous? Où allons-nous?* (*Where Do We Come From? What Are We? Where Are We Going?*) of 1897–98 (Museum of Fine Arts, Boston).

As we know from Gauguin's letter of 1898 to the artist George-Daniel de Monfried, the bird in the canvas exemplifies the sheer inadequacy of literal interpretations: it simply "represents the futility of words," Gauguin writes.[9] As in that epic painting, the animals in *Te Atua* may reflect more generally Gauguin's philosophical concern over where animals, as our fellow living creatures, fit within religious systems of meaning. In his essay "L'esprit moderne et le Catholicisme" (The Catholic Church and modern times), which he drafted in Tahiti in 1897–98 (and continued to develop until shortly before his death), he quoted a biblical verse from Ecclesiastes (3:21) that queries the fate of the spirits of animals. He also mused in the essay over where and how the soul begins, discarding the idea of any barrier that separates animal and human souls.[10] Thus in both his text and his imagery, Gauguin pondered the place of humanity in relation to animal beings and to spiritual and (his own) artistic renewal.

Consonant with his interest in doctrines of theosophy, to which he had at that time been exposed for a decade, Gauguin refused to grant one traditional religious system—especially Catholicism, from his own background—primacy over others. Rather, he set symbols and personages from different world faiths in visual dialogue in an orchid-laden, Edenic landscape that is peacefully inhabited by a diverse cast of gods. Gauguin was reading, and even copying into his essay, passages from the theosophical writings of the popular English spiritualist Gerald Massey.[11] Massey's basic proposal was that all religions owed their origins to ancient myths that had been transmitted and adapted over time and that they all shared common insights into universal truths. Following such thinking, Gauguin found it appropriate to combine Christian, Polynesian, and Buddhist forms in this scene, as the gods of these religions were for him equivalent.

If, as suggested above, *Te Atua* is the title image in the Vollard series, it can be understood as both a scene of creation (Ta'aroa) and a foundational myth (Jesus). Some of the other prints in the series can be read as following a Christian narrative, if we read them in terms of paradise, temptation, the fall, a flight from Eden, and redemption by Christ through the crucifixion.[12] It has been suggested that the scenes in these prints could be lined up in a kind of continuous frieze, so that a paradisiacal world unfolds like a scroll.[13] But if we do not seek to establish narrative or a set visual order, and if we consider the sequence of the printed scenes as an interchangeable set of topoi, the series implies a fresh proposition: interchangeability as a conceptual and visual value that foregrounds Gauguin's belief in the creative process as ongoing and open-ended.[14] On a basic formal level he may have been inspired, as Elizabeth Prelinger argues, by the format of myriorama cards, a nineteenth-century parlor game in which a set of cards with different printed landscapes that shared like-scaled border motifs could be laid out by the player in any sequence. The cards could then be reordered at will to create a new scene.[15]

This kind of poetic flexibility, and indeed this affirmation of the creative power of both the artist and the print collector or viewer, accords well with Gauguin's embrace of the potential of multiples. By incorporating a new participatory role for the viewer, while at the same time allowing for the power of indeterminacy, this series aligns with *Le Livre*, the major unfinished literary project by Gauguin's friend the poet Stéphane Mallarmé, who had just died in 1898.[16] Mallarmé intended his project to exist perpetually in process, as a group of poems on discrete pages that could be performed or combined in different ways, thus enabling the reader to generate fresh interpretations with each reading.

This notion of the inherent flexibility of both the form and the ideas represented in a series coincides not only with the myriorama-like interchangeability of the prints in Gauguin's Vollard series but also with his consideration of the great deities of the world religions as equal and interconnected. Buddha, Christ, and Ta'aroa could all hold equal and interchangeable places in his spiritual imagination. Similarly, individual prints in the series could be reshuffled by the artist or the viewer to suggest new narratives and to capture fresh spiritual insights with each new sequence.

In this way *Te Atua* and the Vollard suite more generally demonstrate that, in Gauguin's later career, creating a series of related woodcuts aligned the materiality and format of his printed art with his most immediate spiritual concerns. These experiments negotiated the philosophical challenges of seeking elusive but fundamental connections between some of the world's most disparate religious traditions, figures, and symbols.

Elizabeth C. Childs

Notes

I am grateful to Ellen Birch for her help with some of the research for this essay.

1. See Tobia Bezzola and Elizabeth Prelinger, *Paul Gauguin: The Prints* (Zurich: Kunsthaus; New York: Prestel, 2013), 103.

2. The print was numbered 23 (in an edition of approximately 25) by the artist in ink, lower right. In the catalogue raisonné the print is identified as number 53, state iiA. See Elizabeth Mongan, Eberhard Kornfeld, and Harold Joachim, *Paul Gauguin: Catalogue Raisonné of His Prints* (Bern, Switzerland: Galerie Kornfeld, 1988). Hereafter Gauguin's prints are identified simply by their Galerie Kornfeld numbers, with a *K*.

3. K1–K11.

4. The other to bear a title inscription is K55. K54 also bears the word Tahiti inscribed vertically in the image.

5. The title *Te Atua* appears as well in a print in Gauguin's earlier Noa Noa suite of 1893–94 (K17). In that image he depicts four gods, all of whom are based on sculptures he completed in Tahiti. See Bezzola and Prelinger, *Paul Gauguin*, 72.

6. Scholars have sometimes identified the figure as the Tahitian spirit Oviri. Traditionally Oviri was a female spirit of the forest connected with death. Gauguin adapted the idea to embody concepts of strangeness or savagery. See K35, K36, and the stoneware figure *Oviri* of 1894 (Musée d'Orsay, Paris). But the relationship of that figure to the prostrate figure at the center of this print is speculative and is not supported by any strong visual resemblance. See Bezzola and Prelinger, *Paul Gauguin*, 105.

7. For a reproduction of the photograph that inspired Gauguin, see Elizabeth C. Childs, *Vanishing Paradise: Art and Exoticism in Colonial Tahiti* (Berkeley: University of California Press, 2013), 97.

8. Caryl Coleman, "Birds (in Symbolism)," in *The Catholic Encyclopedia*, vol. 2 (New York: Robert Appleton, 1907), www.newadvent.org/cathen/02576b.htm.

9. Paul Gauguin, cited in George Shackelford et al., *Gauguin: Tahiti* (Boston: Museum of Fine Arts, 2004), 180. The letter is reproduced on page 168.

10. For more on this, see my essay "Catholicism and the Modern Mind: The Painter as Writer in Late Career," in Shackelford, *Gauguin*, 235.

11. The book from which Gauguin copied passages is Gerald Massey, *The Natural Genesis*, first published in 1883. See ibid., 230–32.

12. K41–K55.

13. Richard Brettell et al., *The Art of Paul Gauguin* (Washington, DC: National Gallery of Art, 1988), 433.

14. Starr Figura proposes that Gauguin's practice, evident in this series, of the reprisal and recombination of motifs taken from his earlier art foregrounds his faith in art as a process of transformation. By inviting the viewer's intervention in the reordering of the prints in a series, Gauguin acknowledged the open-ended nature of the creative process. Figura, "Gauguin's Metamorphoses: Repetition, Transformation, and the Catalyst of Printmaking," in *Gauguin: Metamorphoses* (New York: Museum of Modern Art, 2014), 29, 32.

15. Bezzola and Prelinger, *Paul Gauguin*, 104.

16. Gauguin had known Mallarmé since 1890. That Gauguin was still considering the poet's ideas, particularly regarding the power of suggestion and the irrelevance of fixed narrative, is evident from his letters of spring 1899. See Maurice Malingue, ed., *Paul Gauguin: Letters to His Wife and Friends*, trans. Henry Stenning (New York: World, 1949), letter 170. On *Le Livre* as a perpetually experimental work-in-process, see Blake Bronson-Bartlett and Robert Fernandez, "Translators' Note," in *Azure: Poems and Selections from the "Livre,"* by Stéphane Mallarmé (Middletown, CT: Wesleyan University Press, 2015), xvi–xx.

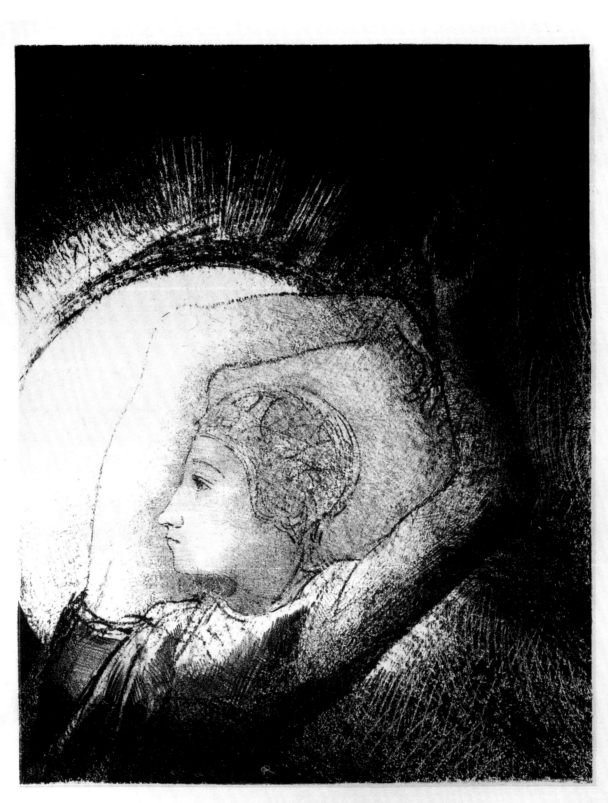

.... une femme revêtue du Soleil,

Une femme revêtue du soleil
(*A Woman Clothed with the Sun*), 1899

Lithograph, ed. 100, 20 $^{1}/_{2}$ × 15 $^{3}/_{4}$"
University purchase, 1944

Odilon Redon

(French, 1840–1916)

Une femme revêtue du soleil
(*A Woman Clothed with the Sun*), 1899

ODILON REDON'S *Une femme revêtue du soleil* captivates the viewer with its rendering of an enigmatic woman, her arms elevated and fingers gently curled in the stance of a graceful ballerina. She is seen in profile, silhouetted against an incandescent orb that emits dazzling sparks of light. Her dress and cap suggest that she is not supernatural but a woman of the corporeal world. Yet her dreamy, inexpressive face and the rendering of her lower body, cut off from the viewer and consumed by shadow, imbue her with an ethereal spirit. With no other indications of her surroundings or identity, she exists within and is defined solely by this nebulous realm of light and darkness.

This print is the sixth of twelve plates from Redon's final lithographic series, an album of images illustrating the Apocalypse of Saint John, the last and only prophetic book of the New Testament, also known as the book of Revelation.[1] Redon's twelve plates correspond to different sections of the biblical text, and the captions below each image are quotations taken from the book in sequential order. The caption "une femme revêtue du soleil" refers to chapter 12, in which a heavenly figure described as "a woman clothed with the sun" is set in a cosmic battle against a fire-breathing dragon.[2] Redon's print provides us with none of the details needed to place this woman within this biblical allegory, and the composition's setting is so abstract that the original religious context would be undetectable were it not for the inclusion of the caption. The artist deliberately complicates any simple understanding of the work by shrouding the image in an aura of ambiguity.

Redon's embrace of the ambiguous and idiosyncratic was symptomatic of the Symbolist movement prevalent at the time, which arose in the 1880s as a reaction against artistic representations of an objective and rational real world, advocating instead for art

to express abstract ideas, the imagination, and subjectivity.[3] Symbolist artists frequently explored opposites or dualities, such as the fantastic and the real, good and evil, light and dark, as exemplified in this print. While Redon's interpretation of the apocalyptic allegory appears tame in comparison to the rest of his work—much of which includes mutilated, distorted, and fused bodies of humans, animals, plants, and inanimate objects—*Une femme revêtue du soleil* still bespeaks Symbolist sensibilities, particularly the desire to evoke something felt rather than to describe something tangibly seen. Instead of using traditional iconography to visualize the allegory, Redon invokes a vision of a celestial being, albeit an earthly woman's face, whose purity is alluded to through penetrating light contrasting with opaque darkness.

The sense of ambiguity comes not only from the content—the allusive subject matter—but also from the form, in particular the multitextured surface created through the lithographic medium. The combination of halo-like light and dense black areas may allude to the battle between the woman and the dragon or perhaps to the conventional depiction of the woman bathed by the sun with a crown on her head. But the composition also consists of gradations of gray, seen especially on the lower right edge, overtaking the woman's left arm and parts of her head. This shading invokes a liminal space, one that is not determined by such binaries as good or light versus evil or dark but rather recalls the Symbolist emphasis on ambiguity and mystery.

Between 1878 and 1900 Redon produced close to thirty etchings and 170 lithographs that were conceived in part as a way to publicize his richly textured, often cryptic charcoal drawings, which he termed *noirs*.[4] The *noirs* exemplify Redon's fascination with the impact and resonance of black.[5] As with this lithograph, he printed almost exclusively using chine appliqué, a type of print in which an impression is made on a thin sheet, backed by a stronger, thicker wove paper to which the image is transferred using a press. Through both the subtle range of colors offered by the chine appliqué and his use of the lithographic crayon, Redon's primary tool for making prints, the artist was able to achieve intense and nuanced effects of hues and contrasts of light and dark. In *Une femme revêtue du soleil*, it is precisely because of the density of the black spaces that the lighter surrounding areas appear to glow, demonstrating the artist's exceptional understanding of the potential effects of black in a lithograph.

Redon's prolific production of lithographs was part of a larger nineteenth-century print revival, championed by Ambroise Vollard, the prominent art dealer who commissioned and published Redon's *Apocalypse of Saint John*. At the turn of the century, apocalyptic visions in literature and art were common, a reflection of a broader societal anxiety, the belief that the end of civilization was imminent.[6] As Starr Figura contends, the choice to publish this album in 1899, the year many feared would usher in the end of the world, suggests that Vollard as well as Redon may have been trying to capitalize on these widespread anxieties.[7] In the same year Sigmund Freud published his *Interpretation of Dreams*, which explores how human impulses and desires are released through dreams and the unconscious, certainly congruent with Symbolist ideas. The works of Freud and fellow psychiatrist Carl Jung were highly influential for Symbolists, and concurrently Freud once described Redon as a man who "molds his phantasies into new kinds of realities, which are accepted by people as valuable likenesses of reality."[8] Thus, in connecting the prophecy from the book of Revelation to the very real fin-de-siècle fears of an actual Armageddon, Redon established a new imagined reality. Though born from his fantasy, the imagery in this album would surely have resonated with those who were consumed by such forebodings.

These apocalyptic fears correspond to a turn to spirituality, which was a major component of Symbolism that contested the secularism of the government under the Third Republic.[9] Some artists, such as Maurice Denis, focused on Catholicism for inspiration, while others, such as Redon and Gustave Moreau, were deeply interested in mysticism, invoking imagery not only from Christianity but also from Buddhism, Hinduism, and other Eastern

philosophies. In earlier works Redon had used the motif of the isolated head in multiple religious and cultural contexts. *The Golden Cell* (1892) and *Sita* (1893), for example, feature this motif and refer to Hindu mythology and Buddhist concepts of the origins of the universe. Another print, *The Druidess* (1891), shows the enigmatic profile bust of a Celtic priestess; in Redon's time the Celts widely represented irrational and primitive power, in contrast to the instrumental reason and rationality of their Roman conquerors.[10] Symbolists such as Redon and Moreau often focused on images of the eye and the head, the principal sites of contemplation and awakening. With her arms outstretched, her head outlined against the light, and her expression suggesting introspection, it appears as if the woman in *Une femme revêtue du soleil* is emerging out of the darkness into a state of spiritual awakening. The connections to other belief systems add layers of meaning beyond the Christian revelation itself, but as in much of Rodin's work, these references are elusive.

And yet for all its spiritual connotations, *Une femme revêtue du soleil* is simultaneously secular, a point that becomes clearer when it is compared with various precedents. In Albrecht Dürer's influential series of fifteen woodcuts, also titled *Apocalypse of Saint John* (1498), the artist filled the scene with a profusion of details—angels, God, a distinct landscape, and the evil dragon as a clear foil to the holy woman. More than a hundred years later, Diego Velázquez's companion pieces painted in 1618, *St. John the Evangelist on the Island of Patmos* and *The Immaculate Conception*, feature the traditional religious iconography of the moon at the woman's feet and a crown of stars above her head, in celebration of the 1617 papal decree defending Marian dogma.[11] In contrast to these earlier variations, with the exception of the radiating lines also seen in Dürer's woodcut, Redon stripped his composition of overt religious imagery, dramatically simplifying the image to focus solely on the woman. And although the album may have been intended to tap into the apocalyptic fascinations of its time, unlike Velasquez's paintings, it was not commissioned for a religious occasion.

Redon was not the only artist to leave the viewer with questions regarding the meaning of the subject. William Blake's painting *The Great Red Dragon and the Woman Clothed with the Sun* (1803–5) shows a monstrous anthropomorphic dragon with wings, horns, and human legs standing over a reclining woman with long, flowing golden hair, the connection between the two adversaries oddly sensual. Although he strays from the traditional representations of the dragon and Marian figure, Blake, too, subtly includes the moon and stars, providing clues to the woman's identity. Furthermore, though her arms are raised like those of Redon's figure, her hands appear to be together in prayer. There are no such recognizable markers of ritual in Redon's lithograph; rather, his Virgin Mary can even be read as a type of stage performer along the lines of Loïe Fuller.[12] The ambiguity in Blake's painting is a result of reworking the allegory into a romanticized mythological drama between the woman and the dragon, while the equivocal nature of Redon's print comes from the near exclusion of religious references, thereby conflating the sacred with the profane.

In *Une femme revêtue du soleil*, form complements content; the indeterminate dark, light, and shadowy gray spaces created by the lithograph perfectly suited the Symbolist desire to render a deeply evocative image. Musing in his diary in 1888 about those who view his prints, Redon wrote, "What have I put into my work to suggest so many subtleties to them? I placed a little door opening on mystery. I have made fictions. It is for them to go further."[13] Indeed, Redon's seemingly simple composition refers to the biblical vision of the Apocalypse of Saint John, hints very broadly at other spiritual beliefs, simultaneously presents a secular image through the absence of a fully developed traditional religious iconography, and can be seen as echoing fin-de-siècle apocalyptic fears. He leaves it to the viewer's imagination to arrive at a conclusion, but perhaps above all Redon's lithograph signifies the Symbolist belief in the subjectivity of art and the impossibility of fixed meaning.

Orin Zahra

Notes

First published December 2015; revised 2016

1. Redon executed an extraordinary number of lithographic albums over a period of twenty years and was already transitioning to color works at the time he created the *Apocalypse of Saint John*; this was his last album in the lithographic medium before he shifted over fully to pastels and oils. See Francis Carey, ed., *The Apocalypse and the Shape of Things to Come* (Toronto: University of Toronto Press, 1999), 297.

2. The book of Revelation contains apocalyptic warnings to Christians about the consequences of straying from their faith through a series of allegories. The woman in Revelation 12 is about to give birth to a powerful child while being pursued by an enormous red dragon. The child is swept up to God as the woman flees into the desert for safety. The woman is commonly interpreted as the Virgin Mary, the dragon as Satan, and the child as Christ with allusions to his inevitable resurrection. Traditionally the woman is depicted standing on the moon wearing a crown of twelve stars, and the dragon has seven heads, ten horns, and a crown on each head. See Natasha O'Hear and Anthony O'Hear, *Picturing the Apocalypse: The Book of Revelation in the Arts over Two Millennia* (Oxford: Oxford University Press, 2015), 110–12.

3. See Michelle Facos, *Symbolist Art in Context* (Oakland: University of California Press, 2009), 14.

4. See Starr Figura, "Redon and the Lithographed Portfolio," in *Beyond the Visible: The Art of Odilon Redon*, ed. Jodi Hauptman (New York: Museum of Modern Art, 2005), 77.

5. Interest in the color black in the latter half of the nineteenth century had preludes in the earlier part of the century, namely, the dark Romanticism of such artists as William Blake, Eugène Delacroix, and Francisco de Goya, whose art evokes a dark, savage, irrational world in the midst of turbulent times. See Lee Hendrix, ed., *Noir: The Romance of Black in 19th-Century French Drawings and Prints* (Los Angeles: J. Paul Getty Museum, 2015), 17–19.

6. Examples include H. G. Wells's novel *The War of the Worlds* (1897), which symbolizes changes to traditional life caused by technological advancements in Western society, and Auguste Rodin's monumental sculpture *The Gates of Hell* (1880–1917), which reflects the immorality of modern society and its consequences through a depiction of forbidden love, sexuality, and suffering. Edvard Munch similarly explored the intense alienation and melancholy of the modern individual in such works as *The Scream* (1893) and *Anxiety* (1894). Redon's color lithograph was published in Vollard's 1896 *Album des peintres-graveurs*. See Phillip Dennis Cate, Gale B. Murray, and Richard Thomson, *Prints Abound: Paris in the 1890s; From the Collections of Virginia and Ira Jackson and the National Gallery of Art* (Washington, DC: National Gallery of Art, 2000), 23.

7. Figura, "Redon and the Lithographed Portfolio," 93.

8. Sigmund Freud, quoted in Alfred Werner, introduction to *The Graphic Works of Odilon Redon* (London: Dover, 1969), xiii. Jung was also interested in Redon's work, which he likely encountered in Paris; he owned a catalog of Redon's graphic works as well as a study of the artist. See Sonu Shamdasani, "*Liber Novus*: The 'Red Book' of C. G. Jung," in C. G. Jung, *The Red Book: A Reader's Edition*, ed. Sonu Shamdasani, trans. Mark Kyburz, John Peck, and Sonu Shamdasani (New York: Norton, 2009), 33–34.

9. The political philosophy of the Third Republic, established in 1871, after the Franco-Prussian War, was based on democratic and egalitarian principles of French republicanism. This secular form of government caused friction with opposition groups, including the Roman Catholic Church, dividing all classes on either side of the conflict. From these circumstances of church versus state arose both anticlerical artists and a Catholic and religious revival in the arts, as seen particularly in the work of the Symbolists. See Facos, *Symbolist Art in Context*, 95–96.

10. Dario Gamboni, "Parsifal / Druidess: Unfolding a Lithographic Metamorphosis by Odilon Redon," *Art Bulletin* 89, no. 4 (2007): 773.

11. O'Hear and O'Hear, *Picturing the Apocalypse*, 125. In Marian dogma the "woman clothed with the sun" signifies the immaculate conception of Mary and the pure, privileged state of her body in which the Church places hope for salvation. See Timothy Verden, *Mary in Western Art* (New York: Hudson Hills, 2005), 53–55.

12. Loïe Fuller was a highly popular American performer at the turn of the century, famous for her visually spectacular skirt dancing and luminescent lighting on stage. The light behind Redon's female figure makes a particularly convincing connection with Fuller's trademark use of light during her performances. See O'Hear and O'Hear, *Picturing the Apocalypse*, 127.

13. Redon, quoted and translated in Robert Goldwater, *Symbolism* (Boulder, CO: Westview, 1980), 116.

Henri Matisse

(French, 1869–1954)

Nature morte aux oranges (II)
(*Still Life with Oranges [II]*), c. 1899

IN FALL 1905 CRITICS DUBBED HENRI MATISSE "King of the Fauves" for his leading role in a new tendency among young artists to paint with bright, arbitrary color and a seemingly inconsistent, hasty-looking style. Fauvism not only refuted the idea of painting as a record of the visual appearance of the world (as in Impressionism), but its apparent incoherence also challenged more subjective tendencies, such as Symbolism, in which an artist presented a personal "vision" of the world. *Nature morte aux oranges (II)* (*Still Life with Oranges [II]*) would seem at first to have all the characteristics of a Fauvist painting. But it is well established that Matisse made it around 1899, long before his Fauvist period. So how should we think about this vividly colored canvas, especially in light of its unfinished nature? Is it "proto-Fauve," precociously anticipating Fauvist innovations and the increasingly abstract qualities of advanced painting? Or was it an anomaly, a one-off effort that the artist didn't follow up on for another five or six years?

To begin with, as the "II" in the title suggests, this is the second of two nearly identical compositions, showing the same vessels and pieces of fruit, placed on a table in a similar way, situated against a wall and open window.[1] But while the compositions are similar, Matisse painted the two canvases very differently. The first version is thoroughly and consistently, if roughly, painted over its whole surface. By contrast, *Still Life with Oranges (II)* has an uneven surface, with some areas receiving extensive treatment and some only sketchily painted, while in others the artist applied no color at all to the primed canvas. Moreover, even the completely painted areas look unresolved. As several writers have observed, this was possibly the first of numerous times when the artist painted two distinct versions of the same composition, a practice that he pursued periodically over the next fifteen years.[2]

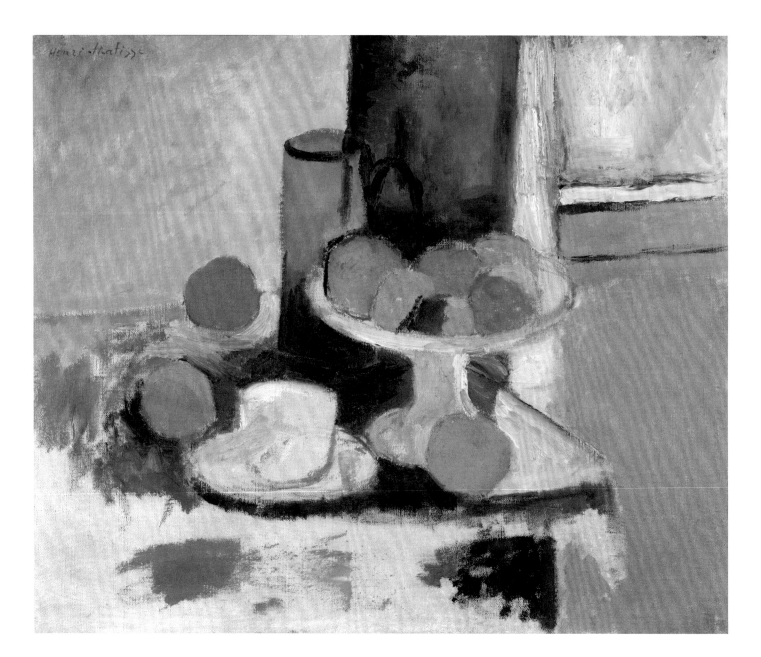

Nature morte aux oranges (II) (*Still Life with Oranges [II]*), c. 1899

Oil on canvas, 18 $^{1}/_{16}$ × 21 $^{7}/_{8}$"

Gift of Mr. and Mrs. Sydney M. Shoenberg Jr., 1962

This characteristic of *Still Life with Oranges (II)*—that it is a variation on a theme—leads to an understanding of its significance and to answers to some of the questions posed above. Matisse's approach to his painting at this time had an experimental, probing quality that he valued as a respite from the demands on a young artist of the marketplace and the public exhibition system.[3] In 1898 and 1899, working in Corsica and Toulouse, he made paintings in an enormous variety of styles. Many of these canvases are brilliantly colored and some are quite tactile, with thick, unctuous brushstrokes, emphasizing a painting's materiality and physical presence and suppressing its function as a vehicle of representation, or a window on the world.[4] Most of them are landscapes or still lifes. These genres burgeoned in the nineteenth century as sites of avant-garde innovation. They offered artists the privileges of isolation and lack of obligation to other people (as in portraiture) or to the authority of events or texts (as in paintings of historical, mythological, literary, or religious subjects). Moreover, landscape and still-life painting did not form part of the academic art-school curriculum in France. Paintings such as *Still Life with Oranges* were, typically, sidelines for artists determined to achieve success within the academic system. Matisse, well trained in the academic tradition, nevertheless pushed hard against the strictures of his formation while maintaining much of the greater ambition that elevates the practice of painting above the level of mere personal expression. This ambition led him to conceive paintings in relation to one another, developing them as reflexive investigations of the relationship between matter and meaning as well as depictions of things next to other things.

Of course, the materiality of things in a still life is not irrelevant, and Matisse found a way to integrate paintings such as *Still Life with Oranges (II)* into the framework of academic ambition. The still-life subject in general, consisting of objects that can be manipulated and arranged by the hand, acts as a surrogate for the artist's control over the practice of painting itself, and the freedom to invent. As

a student, Matisse had copied still-life paintings by Jean-Siméon Chardin (1699–1779) and Jan Davidsz. de Heem (1606–1683/84), pillars of the northern tradition. His first independent painting was a still life (*Still Life with Books*, 1890), and he would continue to paint such humble subjects by preference, even when he came to the point of making his first major exhibition painting, *The Dinner Table*, in 1897. Although *The Dinner Table* was conceived in the academic tradition of the chef d'oeuvre, the masterpiece that would demonstrate a young artist's powers and mark the end of his apprenticeship, it was a large canvas showing a woman in contemporary dress setting an elaborate table for a sumptuous meal—like still life, a distinctly nonacademic subject. Here Matisse was trying to have it both ways—to buck the system but from within its patented structures.

Variations on the theme of *The Dinner Table* followed, all of them eliminating the woman but retaining the objects, arranged in various ways. Leaving out the figure leads to the suppression of narrative possibility and suspends in time the objects that remain. In Matisse's work at this time, these are always objects of daily use and consumption that he would have had around him. The culture of domestic objects and routines is central to the still-life tradition. Even so, the arrangement of objects throughout the history of still-life painting is typically artificial and sometimes quite arbitrary, with knife blades hanging over the edges of tables, stacks of carrots balanced precariously on ledges, or gatherings of objects that seem to have no business together. In contrast to such artificiality of arrangement, traditional still-life painters rendered their motifs in generally realistic styles, sometimes with extreme clarity and a high degree of detail.

Matisse directly inverted this conventional relationship between subject and style. In *Still Life with Oranges (II)* and other still-life paintings at this time, the arrangements are natural looking, as if excerpted from daily life. These are examples of what Norman Bryson has called "rhopography"—the depiction of "the overlooked," of "those things which lack importance, the unassuming material

base of life."[5] Matisse's arrangements would not look out of place in a middle-class home and would not seem capable of demanding attention in themselves. In other words, they do not seem to be "artfully" arranged. Rather, it is the painting style of Matisse's still lifes that is artificial and that does demand our attention. In this experimental environment, the still-life subject acts as a constant, the style as a variable. The distance of Matisse's move from his first version of a still life with oranges to the second one makes it clear that variations—experimental risks—are more meaningful when they are set against such a constant.

There is another variable as well. As in more traditional still-life paintings, light operates to signify the passage of time. Matisse's treatment of light varies from one still life to another, marking them with a temporality outside narrative. Full daylight in one painting gives way, implicitly, to twilight effects in another. Matisse also positioned himself and the objects he painted in different relations to the source of natural light. Sometimes the light is ambient, and the way it illuminates the objects seems direct and uncomplicated. In other paintings the artist positioned the objects between himself and the inflow of sunlight into a room so that he saw his motif *à contre jour* (as is the case with *Still Life with Oranges [II]*). The relationships between the range of colors and different light effects multiply the possibilities for manipulating the means of representation. Their descriptive powers are stretched thin, and their properties become ends more than means.

Nowhere is this transposition of means and ends more evident than in *Still Life with Oranges (II)*. Whereas in other of Matisse's still lifes, including *Still Life with Oranges (I)*, the spatial relations among objects retain at least a residual sense of order (signaled by tonal or coloristic modeling and logical, consistent lighting), this sense of spatial order, as well as the entire descriptive goal of painting, is what *Still Life with Oranges (II)* disrupts. As in the first painting, the main light source appears to be the open window at rear right, but here Matisse eliminated many cues of modeling and shadow that would normally contribute to a logical rendering of objects in this specific environment. The pieces of fruit that had previously been rendered with fullness are signified by nearly uniform orange disks, their modeling reduced to schemata. Its solidity dissolving in a patchwork of painted marks, the table surface is no longer a stable resting place for the objects on it. The walls and the view out the window (this last, paradoxically, the area of thickest paint) are reduced to indiscriminate fields of arbitrary color. Whole passages—cup and saucer, fruit dish, tabletop, and table front—are not fully realized, indeed are sometimes barely begun, and some painted passages float free of anything, signifying nothing, starkly calling attention to how they have slipped the anchor of representation.

The color in *Still Life with Oranges (II)* is no brighter or more arbitrary than that in its first version, but the striking thing about the color here is that Matisse mainly applied it in flat, uniform, thin areas, as if simply filling in outlines, like using crayons in a coloring book.[6] This flat, decorative quality of the color, all hue and no tone, as much as its brightness, is the characteristic that has led to this painting being thought of as foreshadowing his later work and being dubbed "proto-Fauve."[7] Coupled with this decorative quality is the lack of a definitive light source or shadowed areas, resulting in a quality of light that seems immanent, as if it is generated by the color itself. Luminous color rather than illuminated color—this would become one of the hallmarks of Fauvism several years later.

But perhaps we should not take this analysis of Matisse's achievement or intentions too seriously, since he clearly did not complete this painting. The whole character of the canvas is that of an *ébauche*, the rough outline for a painting, with the motif laid in but not elaborated. We do not know why Matisse did not finish *Still Life with Oranges (II)*, but two main possibilities may be suggested. One is that he may not have needed to finish it—from the process he had already carried out, he may have learned what he needed to in this effort, so that his work was done even if the painting was not. His working method at

this time, after all, was clearly exploratory, not necessarily to pose a problem that had a definite solution. The other is that he did not know how to finish it—that his work on this canvas took him down a path that did not lead to a place he could recognize at this time. The variable of the means in his experimental procedures may have strayed too far even for Matisse to consider it as an outcome that he could acknowledge as a painting.

Nevertheless, even though he clearly left the painting unfinished, the canvas is signed. Many artists, Matisse included, frequently did not bother to sign paintings until they delivered them to their dealers or otherwise released them into the public domain, whether by selling them, giving them to someone, or putting them into an exhibition. The painting's early provenance is unknown, but we can speculate that Matisse later came to believe in this canvas as a just expression of his goals, especially as the brightly colored paintings of his Fauve period may have seemed to validate this earlier experiment.[8] Whereas in 1899 he likely would not have risked its public exposure, in retrospect it must have seemed more coherent, and it may have seemed more conclusive. Looking back on *Still Life with Oranges (II)*, Matisse may have "discovered" what he did not know, or could not know, he had been seeking.

Whatever truth may lie in these speculations, there is no question that a transient period for Matisse was reaching an end. In May 1899, after nearly a year in the south, he returned to Paris with more than fifty small but incendiary canvases, failed to sell any of them, was discharged from art school because at age thirty he was too old, and applied at the Louvre to copy Italian Renaissance paintings with historical subjects. The experiment was over—for now.

John Klein

Notes

First published April 2011

1. The first, *Still Life with Oranges (I)* (1899), is in the Cone Collection, Baltimore Museum of Art.

2. For more on this and other issues of importance in the painting, see Jack Flam's excellent analysis in Joseph D. Ketner et al., *A Gallery of Modern Art at Washington University in St. Louis* (St. Louis: Washington University Gallery of Art, 1994), 74.

3. See Hilary Spurling, *The Unknown Matisse: A Life of Matisse; The Early Years, 1869–1908* (New York: Knopf, 1998), 159.

4. For a full display of this variety, see the extensive illustrations in Xavier Girard and Alain Mousseigne, *Matisse, Ajaccio-Toulouse, 1898–1899: Une saison de peinture* (Toulouse: Musée d'Art Moderne, 1986).

5. Norman Bryson, *Looking at the Overlooked: Four Essays on Still Life Painting* (Cambridge, MA: Harvard University Press, 1990), 61.

6. Matisse seems to have had in mind Paul Signac's 1899 book *From Eugène Delacroix to Neo-Impressionism*, which he had read in serial form a few months earlier (see Spurling, *Unknown Matisse*). In this influential text, Signac cited the ringing declarations of Delacroix, one of Matisse's gods of painting: "Gray is the enemy of all painting"; and "Banish all earth colors!" (Delacroix, quoted ibid., 176).

7. On the varying thoughts regarding this idea of the "proto-Fauve," see John Elderfield, *"The Wild Beasts": Fauvism and Its Affinities* (New York: Museum of Modern Art, 1976), 18. For further discussion of this topic, see also Lawrence Gowing's extended and sensitive description of the painting in his *Matisse* (London: Thames & Hudson, 1979), 24–27 (where it is called *Le compotier et la cruche de verre* [*Fruit Dish and Glass Pitcher*]).

8. I thank Kimberly Broker of the Mildred Lane Kemper Art Museum for her assistance in researching provenance information on this painting.

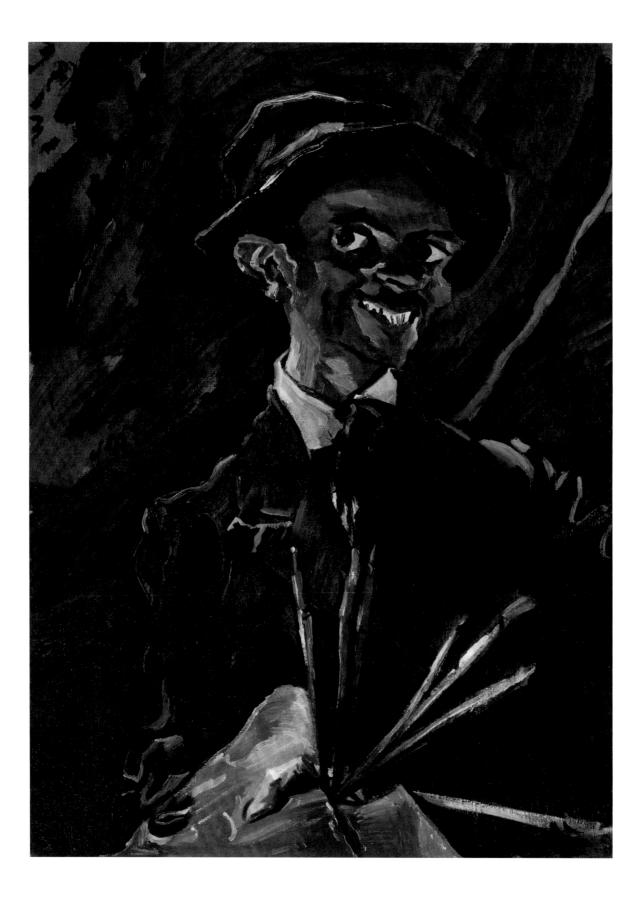

Selbstbildnis (*Self-Portrait*), 1912

Oil on canvas, 31 $^3/_4$ × 23 $^{11}/_{16}$"

Gift of Mr. and Mrs. Sydney M. Shoenberg Jr., 1963

Ludwig Meidner

(German, 1884–1966)

Selbstbildnis (Self-Portrait), 1912

PAINTED IN THE SAME YEAR THAT HE COFOUNDED the artists' group
Die Pathetiker,[1] named for those of passionate temperament, Ludwig Meidner's
Selbstbildnis (Self-Portrait) reveals a complex dialogue between the painter's individualism
and the urban environment of Berlin at the height of German Expressionism.
Beginning with a rejection of classical and realist doctrines, Expressionist painters like
the Pathetiker artists "shared a common determination to subordinate form and nature
to emotional and visionary experience."[2] Further, the manipulation of form to reflect
emotional conditions, or the pathos of the individual, can be seen as the attempt of
"the individual to preserve the autonomy and individuality of his existence in the face
of overwhelming social forces," which Georg Simmel, a prominent Berlin sociologist,
examined in his 1903 study "The Metropolis and Mental Life."[3] Simmel reflected on the
modern city's impersonality, or "hypertrophy of objective culture," which stifles the
uniqueness of the individual. The desire to exaggerate the personal element, as he noted,
often incorporated a larger utopian goal of improving the world in a time of growing
discontent in the face of Germany's burgeoning materialism, industrialization, and
urbanization.[4] In addition, revolutionary upheavals in religious, scientific, and moral
thinking, such as Nietzsche's *Thus Spoke Zarathustra* (1883–85), Freud's dream theory
(1900), and Einstein's theory of relativity (1905), for example, challenged traditional
cultural foundations and paradigms of thought, while a number of political crises
leading up to World War I exacerbated the general sense of social anxiety.[5]

In the destabilized and tumultuous environment of prewar Berlin, Meidner, like
his fellow Expressionists, both exalted in the city's dynamism and was repulsed by its
corruption. He chose to turn inward, giving primacy to emotional states over material

depictions in an extensive series of self-portraits, to which this example belongs. Not simply a realistic representation of his physical appearance and surroundings, Meidner's self-portrait synthesizes his emotions, body, and environment. His expressive strokes evoke an identity of a tormented and isolated artist while at the same time conveying a connection to, as well as a dependence on, the very culture that he mocks and rejects.

In his 1914 instructional essay published in the journal *Kunst und Künstler*, translated as "An Introduction to Painting Big Cities," Meidner explained the close connection between the modern urban environment and his painting practice, expressing the need for "a deeper insight into reality" through a more intense seeing. According to Meidner, a painter should no longer attempt merely to represent exactly the sights, sounds, and movement of the metropolis but must organize the multitude of sensual impressions of the city into a new composition, one that expresses more than a simple mirroring of images. "A street isn't made out of tonal values," Meidner wrote, "but is a bombardment of whizzing rows of windows, of screeching lights between vehicles of all kinds and a thousand jumping spheres, scraps of human beings, advertising signs, and shapeless colors." The painter must absorb the urban bustle, the escalating technologies, "the roaring colors of buses and express locomotives, the rushing telephone wires" and, Meidner instructed, must paint "brutal[ly] and unashamed[ly]," for "your subject is also brutal and without shame." The dynamism of the city, both the "glorious" and the "grotesque," the "elegance of iron suspension bridges" and the "confused jumble of buildings," must penetrate the painter's sensitivities and be integrated into the final depiction in a vibrant and forceful manner.[6] As a prime example of this, one may see that the tension of conflicting negative and positive energies of the flurry of urban activity, as well as of the city's cultural upheaval, are expressed with the required pathos in his *Self-Portrait*. By incorporating such conflicting impressions, Meidner's painting may well be seen as an indirect portrait of

the big city itself, filtered through his own subjective experiences and projected onto a physical rendering of his "self."

A detailed exploration of the colors, forms, and structure of his self-portrait reveals many clues that help to visualize this interplay between the individual and the environment of the modern metropolis, between the painter and the painting. Meidner's mocking, eerie grin and piercing, skewed stare accost the viewer first. The contours of his face are exaggerated, bold; jerky twists of the brush express something disquieting in the arch of his brow. The unsteady application of paint seems to embody an anxious state of mind. Indeed, the result is a rather negative alteration, and despite Meidner's later denunciation of such self-projection as self-worship,[7] the portrait does not seem to flatter him at all. The connection between self and surroundings is further extended to the browns and midnight blues of his body, which are repeated in the colors of the background, while the expressive, chaotic brushwork of his skin and clothing echoes almost exactly the unstable shapes and irregular color fields behind the figure. The jagged shapes might be seen as Meidner's interpretation of the city's right-angled architecture: "We see beauty in straight lines and geometric forms," he wrote. "Don't be fooled. A straight line is not cold and static! You need only draw it with real feeling.... It can be first thin and then thicker and filled with a gentle, nervous quivering."[8] In this repetition of background and foreground, Meidner's receptive response to his surroundings is made visible: the colors and shapes of the background seem to have penetrated and altered the figure in the foreground.

Further signifying the importance of the individual artist's sensory and emotional receptivity to the environment, the most intensely colored parts of Meidner's body are also the most exposed: the neck, highlighted in the brightest yellow; his right ear, standing out in a streak of red; the eyes, which glow blue. These body parts, almost vibrating in flashes of color, appear the most receptive to the constant motion, noise, and vitality of Berlin's metropolis, which is evoked in the painting's background as

an interior space distorted by a disorienting sweep of diagonals. Indeed the diagonal line in the background on the right-hand side heightens the tension in the work as it jabs into the painted figure's shoulder, pulsing unsteadily with the diagonal lines of the thick colors of his neck and the brushes he holds in his hand. The nervous, shaky geometry conveys an anxious feeling, one that culminates in a sense of the threat of impending social or mental collapse.[9]

Dressed thus almost in camouflage and armed with palette and brushes, like a shield and so many spears, Meidner's self-image is presented as if ready to fight in the urban cityscapes he called "battlefields."[10] In describing the urban battlefield, he frequently referenced dynamic lines that "rush past us on all sides," as well as "many-pointed shapes" that "stab at us."[11] His use of violent and inflammatory imagery, in both textual and painterly contexts, complemented the sentiment at a time when many Expressionist artists and thinkers looked forward to the upcoming war as an opportunity for revolution and a new beginning, a throwing-off of the old authoritarian Wilhelmine Empire.[12] The old regime was associated with the dominant culture of the bourgeoisie, a social class to which Meidner makes indirect and sardonic references in several of his writings, implying an embrace of his own working-class culture and a condemnation of the higher class. Indeed, in the painting he wears the suit and hat most typical of the bourgeoisie, yet his vicious grin suggests a mockery and rejection of that very same society.[13]

In this complex relationship to his environment, Meidner seems both to defend his subjective autonomy and to glorify the power of the very culture that threatens him as an individual. In the end, by distorting the forms of objective reality to reflect an emotional state, he can be seen as reacting to the complex social forces of the metropolis that Simmel described. This results in a painting that exudes a palpable sense of anxiety, eliciting from the viewer the state of emotional and sensory perceptivity that the painting embodies. Just as Meidner's self-portrait

presents a mirror image, however much distorted, of the painter looking at himself, saturated by the vibrancy and chaos of the modern times around him, so too may it bring us as viewers around to ourselves, drawing our attention to the (discomfiting) moment of our own time and place and transforming us, in a way, into the portrait's mirror image.

Anne Popiel

Notes

First published January 2008

1. Along with Meidner, the group consisted of Richard Janthur and Jakob Steinhardt. See Rose-Carol Washton Long, *German Expressionism: Documents from the End of the Wilhelmine Empire to the Rise of National Socialism* (New York: Maxwell Macmillan International, 1993), 101.

2. Victor H. Miesel, *Voices of German Expressionism* (London: Tate Publishing, 2003), 1.

3. Georg Simmel, "The Metropolis and Mental Life" (1903), excerpted in *Art in Theory, 1900–1990: An Anthology of Changing Ideas*, ed. Charles Harrison and Paul Wood (Oxford: Blackwell, 1992), 130.

4. Ibid., esp. 130, 135.

5. See Miesel, *Voices of German Expressionism*, 6.

6. Ludwig Meidner, "Das neue Programm: Einleitung zum Malen von Großstadtbildern," originally published in *Kunst und Künstler* 12 (1914): 312–14; reprinted in Miesel, *Voices of German Expressionism*, 110–15.

7. See "Heiteres Zwiegespräch über Porträtmalerei, hauptsächlich das Selbstporträt, zwischen Ludwig Meidner und Rudolf Grossmann," in *Verteidigung des Rollmopses: Gesammelte Feuilletons 1927–1932*, ed. Michael Assmann (Frankfurt am Main: Schöffling, 2003), 206–7.

8. Meidner, "An Introduction to Painting Big Cities," in Miesel, *Voices of German Expressionism*, 113.

9. See Peter Vergo, *Twentieth-Century German Painting* (London: Sotheby's Publications, 1992), 270.

10. "Are not our big-city landscapes all battlefields filled with geometric shapes?" Meidner, cited ibid.

11. Meidner, "An Introduction to Painting Big Cities," in Miesel, *Voices of German Expressionism*, 113.

12. See Long, *German Expressionism*, 77.

13. This notion was suggested by Claudia Marquart in "Die früheren Selbstbildnissen 1905-1925," in *Ludwig Meidner: Zeichner, Maler, Literat 1884-1966*, ed. Gerda Breuer and Ines Wagemann (Stuttgart: Gerd Hatje, 1991), vol. 1, 31. For a darkly humorous example of Meidner's references to the bourgeoisie, see his "Verteidigung des Rollmopses," in Assmann, *Verteidigung des Rollmopses*, 150–58.

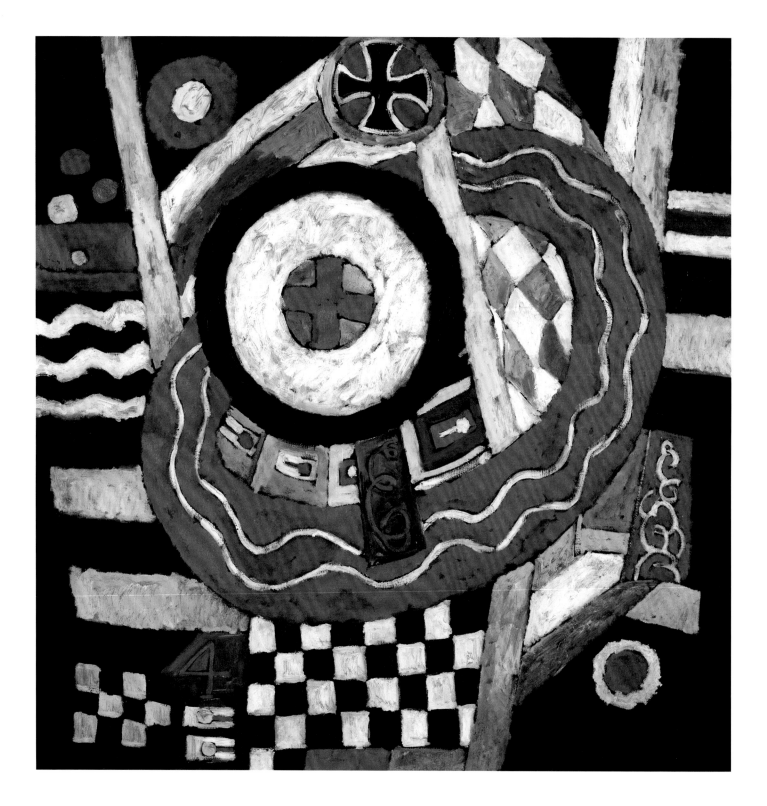

The Iron Cross, 1915

Oil on canvas, 47 1/4 × 47 1/4"
University purchase, Bixby Fund, 1952

Marsden Hartley

(American, 1877–1943)

The Iron Cross, 1915

IN MARSDEN HARTLEY'S PAINTING *The Iron Cross*, recognizable symbols and abstract shapes intertwine in a boldly colored composition. The black and white cross of the painting's title hangs from the top edge of the canvas, embedded in a red and green circle. A commanding band of red color sweeps across the frenetic composition of this square canvas. Inscribed with white serpentine lines, this red band weaves through an unglued collage of checkered patterns, colored bars, letters, numbers, and key-shaped insignia, terminating behind a set of black, white, and green concentric circles surrounding a red cross. The deep black background appears to thrust this jumble of brightly colored shapes outward, beyond the painting's frame, yet the loose brushwork accentuates the materiality of paint on the canvas.

Painted during Hartley's two-and-a-half-year stay in Berlin (May 1913 to December 1915), *The Iron Cross* is part of the artist's War Motif series—a group of paintings begun in 1914, after the start of World War I and the subsequent death of Karl von Freyburg, Hartley's close friend and possible lover.[1] This series of twelve paintings has frequently been the subject of scholarship aimed at deciphering Hartley's pictorial codes through his personal biography. In *The Iron Cross*, the white and blue checkered Bavarian flag, the number 4, the letter *E*, the black-and-white grid of a chessboard, and the Iron Cross itself have been interpreted as direct references to von Freyburg and the regiment in which he served until his death in the first campaigns of World War I.[2]

An approach based primarily on biographical facts, however, limits our understanding of this complex painting, which can be seen as more than a symbolic portrait of Hartley's lost friend or lover. Through the advanced visual vocabulary evident in Hartley's entire War Motif series, *The Iron Cross* offers a snapshot of the vibrant yet

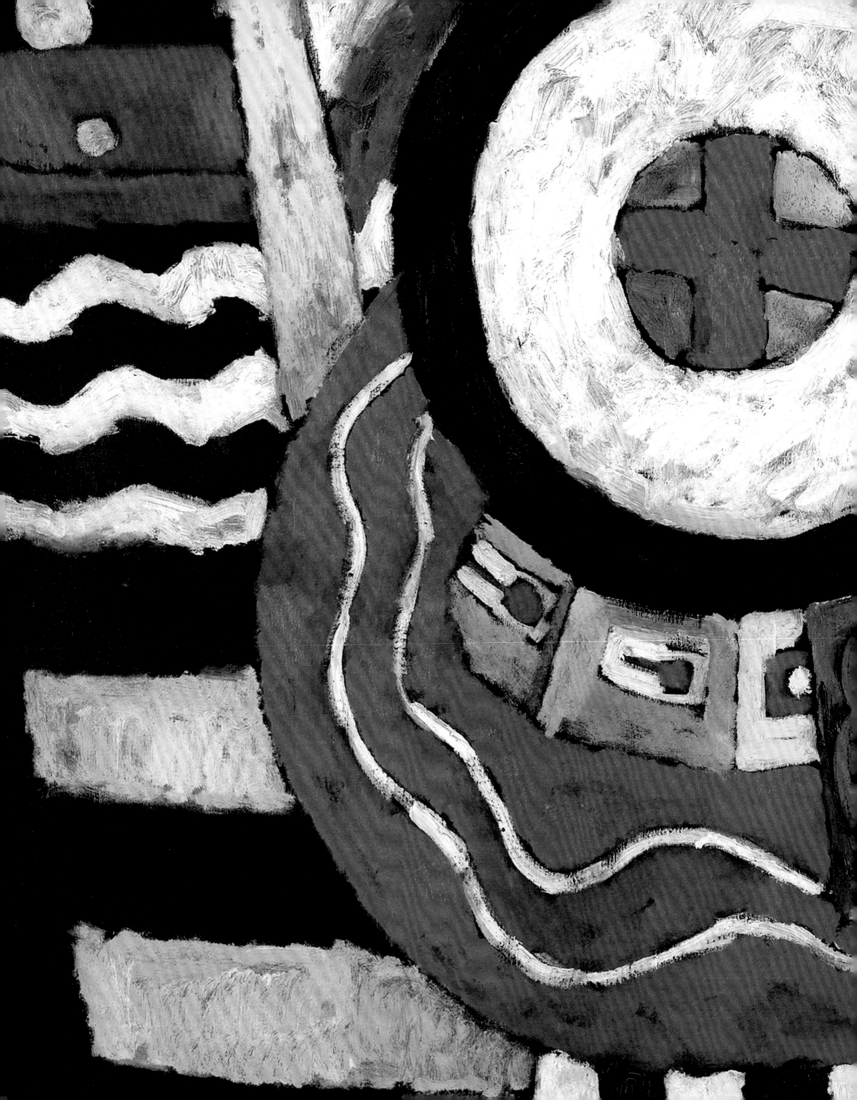

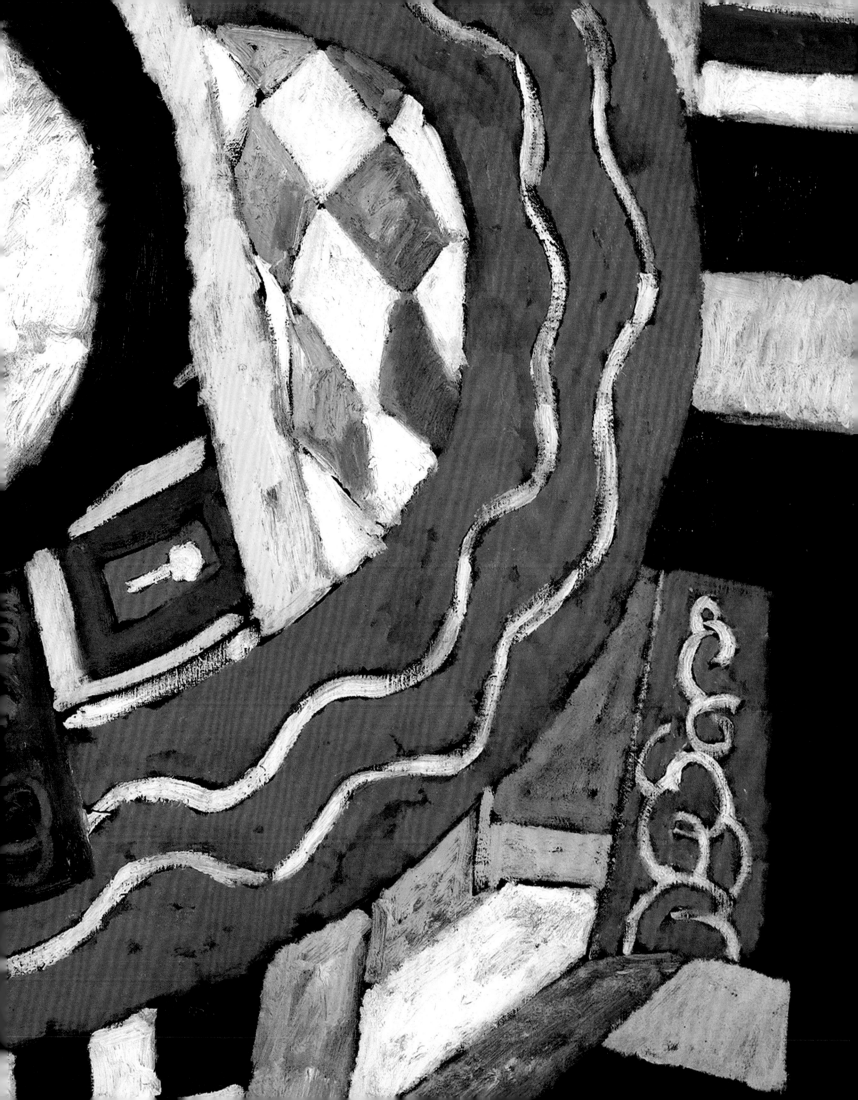

fragmentary visual experience of modern life as mediated through the artist's subjective perceptions. The work negotiates a complicated network of urban modernity and military spectacle—a central presence in imperial Berlin on the cusp of World War I.

While living in Berlin, Hartley experienced the metropolis during a particularly aggressive surge in urban spectacle. Electric lighting, bold advertising signs, speeding streetcars, and other urban amusements flooded the city's streets. In a letter to Gertrude Stein, Hartley described his immediate impression of Berlin: "There is an interesting source of material here—numbers + shapes + colors that make one wonder—and admire—It is essentially mural this German way of living—big lines and large masses—always a sense of pageantry of living. I like it—."[3] Assimilating formal elements from both Cubism and German Expressionism, Hartley invented a radical pictorial vocabulary of visual fragments and saturated colors to mediate his visual "observations" of modern Berlin. As the art historian Patricia McDonnell suggests, the abstracted insignia, chance numerals, and flag patterns "jostle for space in the compacted image and replicate the disjunctive but invigorating experience of the urban environment."[4] *The Iron Cross* assimilates the dynamic, vibrating spectacle of the imperial capital packed with a "live-wire feeling," as the artist himself described it.[5] Flashing colors emerge from the black background like brightly lit signs on a city street. The small red, yellow, and green circles in the upper left of the painting almost resemble a modern traffic signal.[6]

The ubiquitous display of military pageantry was also a central aspect of the imperial capital's urban spectacle during this time, as evidenced throughout many of Hartley's Berlin paintings. Under the rule of Kaiser Wilhelm II, large formal parades of martial guard units in full regalia were staged to show off Germany's military power. Even before the war broke out, Hartley adopted military symbolism into his artistic language, as in his prewar pageantry paintings (1913–14) and his Amerika series (1914).[7] His Berlin paintings showcase his keen attraction to military costume, choreography, and the macho spectacle of the warrior.[8] In *The Iron Cross*, circles, bars, and patterns mimic the array of colorful buttons, collars, ribbons, cuffs, and flags that decorated the parading cavalrymen in Berlin. In addition, varying combinations of black, white, red, yellow, green, and blue serve simultaneously as unit colors, state colors, and national colors.

Readings of this painting, as with the entire War Motif series, were strongly informed by the public and widespread association between the German military and homosexuality—a perception largely shaped by the Eulenberg Affair.[9] While lost on most current audiences, these commonplace associations would have been more readily apparent to Wilhelmine Berliners at the time.[10] Berlin sustained a large and active gay subculture beginning in the late nineteenth century. Just prior to World War I the visual vocabulary of pageantry, muscularity, and virility was utilized in the construction of both masculinity and homosexuality. Hartley's Berlin paintings celebrated the homoeroticism and cult of manliness in Wilhelmine German military culture, conditioned by the artist's own identity as a gay man and his involvement in Berlin's gay subculture.

With the outbreak of World War I in August 1914 and the death of von Freyburg in October of the same year, the realities of modern warfare challenged Hartley's previous idealized aesthetics of military pomp and parades. His work shifted with the War Motif paintings, concentrating on the formal vocabulary of the military uniform within the milieu of Berlin. In *The Iron Cross*, the tangle of military insignia, flags, and regalia is depicted in a fragmented, flattened manner. The inclusion of the Iron Cross itself engages a military decoration awarded to more than four million German soldiers, in many cases posthumously, for bravery in the battlefield. Additionally, the red cross nearer to the center of the painting makes a reference to the International Red Cross, a symbol that became commonplace in Berlin after the war broke out. In the context of conflict, the recognizable military regalia and crosses depicted in the painting become a reminder of wartime trauma,

is retained only in areas where he used thick, stippled brushwork as well as in very small areas where there is no paint at all—most noticeably in the ellipsoid at the upper edge of the newspaper clipping. In the lower left quadrant of the work, Stella applied actual pieces of newspaper and wallpaper in two areas loosely outlined by lead wire. These fragments literally depict the newspaper or book that the man is reading, conflating the real with the illusionistic.

Stella's *Man in Elevated (Train)* clearly expresses a dynamic sense of movement and simultaneity, ideas that were central to Italian Futurist aesthetics.[3] Even prior to his experiments with either collage or glass, Stella's work already evinced a great degree of abstraction and dynamism. In works such as *Battle of Lights, Coney Island, Mardi Gras* (1913–14), the geometric shapes, agitated lines, and intense kaleidoscopic colors recall the work of the Futurists. Like many other European and American artists working in New York during the first decades of the twentieth century, Stella was drawn to capturing the sights and sensations of the urban environment, especially the modern bridges and transportation systems that feature prominently in his works from this period.[4] In his *Autobiographical Notes*, he described the energy and modernity of New York City as he imagined it during these early years: "Steel and electricity had created a new world. A new drama had surged from the unmerciful violation of darkness at night, by the violent blaze of electricity and a new polyphony was ringing all around with the scintillating, highly colored lights. The steel . . . with the skyscrapers and with bridges made for the conjunction of worlds. A new architecture was created, a new perspective."[5]

While Stella tended to resist direct associations with the Futurist movement due to its radical politics, he was increasingly involved with Futurist aesthetics during trips to Italy and Europe and through the growing exposure of the Italian style in New York during this period. After immigrating to New York in 1896 from his family's home in a small village near Naples, Stella studied at the Art Students League under William Merritt Chase and spent much of his time drawing immigrant and working-class figures. From 1909 to 1912 Stella's brother supported his extended travels in Europe, first in Italy and then in Paris. During this time the artist sharply departed from his more realist style to adopt the radical aesthetics of his Italian countrymen.[6] In 1912 he attended the first major Futurist exhibition at the Galerie Bernheim-Jeune in Paris and met a number of artists from the group, befriending Gino Severini. Stella was drawn to Futurist theory and aesthetic practice for its embrace of what was new in modern life: speed, dynamism, and the mechanistic aspects of the contemporary urban and technological environment.[7] However, he was never drawn to the provocative political implications that led many Futurists to depict subjects of violence and war.

In *Man in Elevated (Train)*, space and motion are fused through Stella's deliberate use of sharp lines and angles—a key structural and expressive concept of Italian Futurism. Futurist artists such as Umberto Boccioni believed that these forms, which they referred to as "force-lines" in their theoretical writings from the period, were the principal means to artistically convey a sense of implied movement and dynamic tension in objects.[8] The development of this concept of force-lines and the interrelationship of space and time relied on the ideas of the French philosopher Henri Bergson, who suggested that the simultaneous combination of multiple perceptions and memories was one of the essential characteristics of modern life. In the catalog for the Futurists' 1912 exhibition, Boccioni described these lines as "fleeting, rapid and jerky, brutally cutting into half lost profiles of faces or crumbling and rebounding fragments of landscape."[9] In Stella's painting, the lines of force similarly pierce the man's profile and serve to energize the space by symbolizing the implied movement of the urban commuter train.

Stella's decision during this period to experiment with nontraditional materials such as glass and collage may have also been influenced by Boccioni and his "Technical Manifesto of Futurist Sculpture" (1912). In this pivotal text Boccioni called for modern artists to use the everyday materials

Joseph Stella

(American, b. Italy, 1877–1946)

Man in Elevated (Train), c. 1916–18

IN THE YEARS DURING AND FOLLOWING WORLD WAR I, the Italian-born American artist Joseph Stella began to experiment with a variety of avant-garde artistic strategies clearly adapted from Cubism, Futurism, and New York Dada. At the center of Stella's early experiments was a largely unknown work titled *Man in Elevated (Train)*, likely completed around 1918.[1] In this work Stella combined the emerging techniques of collage and reverse painting on glass, pairing them with his continued artistic exploration of urban technological themes. While his early paintings on glass have been predominately framed in terms of the direct influence of the Dada artist Marcel Duchamp's experimental use of the medium during this period, Stella's unique trans-atlantic identity as an Italian expatriate, as the art historian Wanda Corn has argued, should not be overlooked.[2] This essay aims to further enrich the study of *Man in Elevated (Train)* by reexamining it within the context of Italian Futurist aesthetics.

 Man in Elevated (Train) depicts a man from the shoulders up as viewed through the window of an urban commuter train. Stella created it by first outlining the forms with lead wire on the reverse side of the glass and then filling them in with oil paint and collage fragments. The viewer is quickly drawn to the sharp vertical and horizontal lines that may suggest the iron window posts of the train, indicating the rhythm of movement as they recede into the upper right-hand side of the composition. By inter-weaving the man's head in front of and behind these rapidly repeated vertical lines, Stella attempts to convey a sense of movement through space and time. The artist's distorting geometric visual vocabulary fragments the view of this figure, further empha-sizing motion and speed. Through his application of paint and collage materials, Stella specifically drew attention to the surface of the glass. The transparency of the glass

Man in Elevated (Train), c. 1916–18

Oil, wire, and paper on glass, 14 1/4 × 14 3/4"
University purchase, Kende Sale Fund, 1946

which gained immediate significance in Germany and across Europe as the devastation of World War I deepened. In *The Iron Cross*, therefore, Hartley not only created an assemblage of the exuberant paraphernalia of military tradition as central to the urban spectacle of Berlin but also linked this experience to the deadly results of modern warfare.

The Iron Cross thus occupies a unique position between notions of modernity and military tradition, private and public, subjective and objective. Moving away from mimetic representation yet embracing recognizable visual referents, Marsden Hartley forged a new syntax to represent a reality transformed by technology, war, and the jolt of modernity.

Michael Murawski

Notes

First published August 2007

1. See Jonathan Weinberg, *Speaking for Vice: Homosexuality in the Art of Charles Demuth, Marsden Hartley, and the First American Avant-Garde* (New Haven, CT: Yale University Press, 1993), and Patricia McDonnell, "'Essentially Masculine': Marsden Hartley, Gay Identity, and the Wilhelmine German Military," *Art Journal* 56 (Summer 1997): 62–68. While little concrete information exists regarding Hartley's relationship with Karl von Freyburg, it is generally accepted that the two were lovers.

2. After Marsden Hartley's death in 1943, Arnold Rönnebeck, Karl von Freyburg's cousin, wrote a letter to an American collector that gave his interpretation of the iconography of the War Motif paintings, which has become the basis for scholars' interpretations. See Patricia McDonnell, *Dictated by Life: Marsden Hartley's German Paintings and Robert Indiana's Hartley Elegies* (Minneapolis: Frederick R. Weisman Art Museum, University of Minnesota, 1995), 28.

3. Marsden Hartley to Gertrude Stein, August 1913, cited in McDonnell, *Dictated by Life*, 23.

4. Patricia McDonnell, "'Portrait of Berlin': Marsden Hartley and Urban Modernity in Expressionist Berlin," in *Marsden Hartley*, ed. Elizabeth Mankin Kornhauser (Hartford: Wadsworth Atheneum Museum of Art; New Haven, CT: Yale University Press, 2002), 52.

5. Hartley to Stein, May 1913, cited in McDonnell, "Portrait of Berlin," 49.

6. Interestingly, the first modern traffic light with all three colors was installed in the United States during the same year Hartley began this painting.

7. See Wanda Corn, "Marsden Hartley's Native Amerika," in Kornhauser, *Marsden Hartley*, 69–85, for a discussion of Hartley's attraction to military pageantry as reflected in his Amerika series.

8. See Donna M. Cassidy, *Marsden Hartley: Race, Region, and Nation* (Lebanon, NH: University Press of New England, 2005), 228–32.

9. The Eulenberg Affair was a highly publicized controversy surrounding a series of courts-martial and trials regarding accusations of homosexual conduct among prominent cabinet members and close friends of Kaiser Wilhelm II during 1907–9. This scandal was imprinted on the public imagination and would likely have been a topic of conversations during Hartley's time in Berlin (four years after the final trial was concluded). See McDonnell, "Essentially Masculine," 65–67.

10. See George Chauncey, *Gay New York: Gender, Urban Culture, and the Making of the Gay Male World, 1890–1940* (New York: Basic Books, 1994), and McDonnell, "Essentially Masculine."

around them—glass, cardboard, cloth, mirrors—to create works that would integrate art and modern life. His sculpture *Fusion of a Head and a Window* (1912), shown in the 1912 Paris exhibition, exemplifies the fusion of a figure with elements of its environment. As the scholar Christine Poggi describes this now-destroyed work, "the frame and glass of the real window seem to impale a horribly grimacing head, while other bits of reality . . . remain discrete and isolated."[10] Although he departed from the suggested violence in Boccioni's sculpture, Stella similarly established a dynamic interpenetration of the figure of a man and his surroundings, in this case the train's window. Not only do the newspaper fragments interject elements of reality into the work, but the use of glass is analogous to the physical properties of the window depicted in the painting, a feature that sets it apart from Stella's other glass paintings.

Strong similarities also exist between Stella's early collages and the work of Severini, the Futurist artist with whom he may have felt the strongest affinities—due in part perhaps to their friendship but also to Severini's rejection of the subject matter of war by 1916. In Severini's collages from 1912 to around 1915, pasted clippings from newspapers served as actual bits of reality within the works as well as providing pictorial contrast to the abstract elements and force-lines of his compositions. He later explained his early use of collage: "the contrast of a realistic element . . . and other elements brought to a level of absolute abstraction generates, like all contrasts, dynamism and life."[11] Severini's *Still Life: Bottle, Vase, and Newspaper on a Table* (1914–15) bears a striking formal resemblance to Stella's initial study for *Man in Elevated (Train)*, contrasting the fragments of newspaper clippings within a monochromatic abstract charcoal drawing. Similar to both Boccioni and Severini, Stella adopted a rather literal use of materials in his work to enhance their expressive properties.

With *Man in Elevated (Train)*, Stella struggled with the problem of communicating the perception of high-speed travel through the city, applying new materials in ways that both embraced and challenged the parameters of Futurist aesthetics. Much of the theory and visual language that he adapted from the Italian Futurists was certainly further reinforced and questioned through his close friendship with Marcel Duchamp in New York. *Man in Elevated (Train)* presents a moment in Stella's career when he was actively assimilating a variety of artistic styles drawn from his transatlantic encounters with Futurism, Cubism, and Dadaism. His experiments with glass and collage were undoubtedly influenced by Duchamp's work in glass and his experiments in the static representation of movement and four-dimensional geometry, yet Stella's continued engagement with Italian artistic styles is worthy of further exploration.

Michael Murawski

Notes

First published November 2008

1. For a detailed discussion of a 1918–22 dating of *Man in Elevated (Train)*, see Ruth L. Bohan, "Joseph Stella's *Man in Elevated (Train)*," in *Dada / Dimensions*, ed. Stephen C. Foster (Ann Arbor, MI: UMI Research Press, 1985), 187–219, esp. note 2. Bohan later argues for a completion date of 1918 for this work in her essay in Joseph D. Ketner et al., *A Gallery of Modern Art at Washington University in St. Louis* (St. Louis: Washington University Gallery of Art, 1994), 154. For another argument for a 1918 dating of this work, see Joann Moser, "The Collages of Joseph Stella: 'Macchie / Macchine Naturali," *American Art* 6 (Summer 1992): 60, 66, 77n14. Moser's argument is based on Stella's early collage *Man Reading a Newspaper*, which was likely a study for *Man in Elevated (Train)* and is clearly dated 1918 on the work itself.

2. Stella's relationship to Duchamp and the link between Stella's paintings on glass and Duchamp's *The Bride Stripped Bare by Her Bachelors, Even (The Large Glass)* (1915–23) are discussed at length by Bohan, in Ketner, *A Gallery of Modern Art*, 154. In addition to Duchamp, several artists at this time were also experimenting with the medium of glass, including Marsden Hartley, Rockwell Kent, Franz Marc, August Macke, Paul Klee, and Jean Crotti. In fact, Crotti also used lead wire to outline some of his forms and then covered the entire surface of the glass with oil paint, as in his 1916 construction *The Mechanical Forces of Love in Movement*. Between 1916 and 1926 Stella completed more than a dozen glass paintings. On Stella's Italian expatriate identity, see Wanda Corn, *The Great American Thing: Modern Art and National Identity* (Berkeley: University of California Press, 2001), 135–90. Corn notes that studies of early twentieth-century art in the United States often present Stella as a New York modernist, with little notice of his being an Italian expatriate, which she considers to be an important aspect of his work.

3. Founded by the poet Filippo Tommaso Marinetti in 1909, Futurism was an artistic movement originating in Italy that rejected traditional culture and embraced an idea of aesthetics generated by technology, modern machines, warfare, and speed. After publishing his manifesto, Marinetti was joined by the artists Giacomo Balla, Umberto Boccioni, Carlo Carrà,

and Gino Severini, who proclaimed their allegiance to the movement in 1910. The Futurist style drew on a number of sources, including Cubism, and favored faceted forms, multiple viewpoints, and a sense of movement and dynamism. Especially after 1913, Futurist artists became involved in radical and controversial politics, embracing aspects of war and violence in their art. Although the movement lingered on in Italy until the 1930s, it faded from prominence around 1918 with the end of World War I.

4. Stella's best-known paintings at the time—and still today—include *Brooklyn Bridge* (1919–20, Yale University Art Gallery, New Haven, CT) and the large-scale five-panel work *The Voice of the City of New York Interpreted* (1920–22, Newark Museum, New Jersey), which depicts scenes of Manhattan's factories, theaters, multicolored bright lights, skyscrapers, subway tunnels, and the Brooklyn Bridge in a distinctly Cubo-Futurist visual vocabulary.

5. Joseph Stella, *Autobiographical Notes*, cited in Barbara Haskell, *Joseph Stella* (New York: Whitney Museum of American Art, 1994), 81.

6. See Corn, *Great American Thing*, 135–36.

7. See Haskell, *Joseph Stella*, 38–39.

8. See Linda Henderson, "Italian Futurism and 'The Fourth Dimension,'" *Art Journal* 41 (Winter 1981): 317–23, and Dominic Ricciotti, "The Revolution in Urban Transport: Max Weber and Italian Futurism," *American Art Journal* 16 (Winter 1984): 56–57.

9. Umberto Boccioni et al., "The Exhibitors to the Public" (Paris: Galerie Bernheim-Jeune, 1912), cited in Christine Poggi, *In Defiance of Painting: Cubism, Futurism, and the Invention of Collage* (New Haven, CT: Yale University Press, 1992), 170. Boccioni created two portraits using collage in 1914, including *Dynamism of a Man's Head* (Civico Museo d'Arte Contemporanea, Milan), which depicts a geometric, straight-edged profile of a man's head infused with a series of curving, fragmented planes.

10. Poggi, *In Defiance of Painting*, 179.

11. Gino Severini, *Tutta la vita di un pittore*, vol. 1 (Rome: Garzanti, 1946), 89, cited in Poggi, *In Defiance of Painting*, 172. As Poggi states, through their emphasis on this contrast of elements, Severini's collages were quite different from those produced by his Cubist contemporaries (ibid., 172–77).

Antoine Pevsner

(French, b. Russia, 1886–1962)

Bas-relief en creux (Sunken Bas-relief), 1926–27

A CUBED CHASSIS OF POLISHED BRASS and bronze, a foot deep and hollow, houses an intricate mechanism of bent or folded metallic sheets and angled blades with delicate ribs, tense and taut like strings. The apparatus is dormant but vested with the latent force of its inferred productive function, some obscure operation that extracts energy from matter, implicating human agency in the world; for now it is only light, air, and the particles of ambient space that circulate through its interstices. The work is deceptive, however. The engineered economy of its forms (a circle within a square, bisected by a cross) is destabilized by the perceptual effects generated through their interactions and through a set of deviations from the sculpture's overall symmetry. The deviations have a strict binary discipline: the structure is symmetrical along its horizontal axis, but along the vertical axis there is symmetry only in the overall arrangement of shapes, while their articulation in detail follows a logic of alternating open and closed forms, convexity and concavity, solid and pierced. The raised channel that bisects the middle of the sculpture on the ground plane, for example, is grooved on one side and open on the other; likewise, the blades of the cross are alternately perforated and solid while the metal plate pushed up into a half-moon shape at the right edge is folded in on the left. Such details compose a spectrum of complex irregularities that, combined with differences in the textural and reflective qualities of the work's materials, generate effects of virtual forms or volumes sketched in light and shadow, which moreover shift, attenuating or condensing, as one moves around the piece. The virtual motifs contribute a secondary, illusive, and transient architecture subject to the mind's irrepressible search for pattern. This second space dwells inside the first, suggesting another kind of latency.

Bas-relief en creux (*Sunken Bas-relief*), 1926–27

Brass and bronze
23 $^5/_8$ × 24 $^5/_{16}$ × 13 $^1/_8$"
University purchase, McMillan Fund, 1946

Antoine Pevsner's career spanned the tumultuous first half of the twentieth century and took him from his birthplace in imperial Russia to Paris, where he would eventually settle after 1923 and where he would make *Bas-relief en creux* (*Sunken Bas-relief*). During a brief tenure in postrevolutionary Moscow between 1920 and 1923, he cofounded a branch of the International Constructivist movement with his brother, the sculptor Naum Gabo. Pevsner's cosmopolitan artistic and intellectual upbringing introduced him to a set of ideas in circulation among early twentieth-century European avant-garde artists, from which he would distill an abstract conception of space as the dominant medium and expressive goal of modern sculpture.

On an artistic pilgrimage to Paris around 1913, Pevsner was introduced to key trends in prewar art, including primitivism, Futurism, and Cubism. The problem of how to disrupt the physical integrity of the art object with respect to its spatial milieu, or how to incorporate space as a "concrete material" into the work of art, which both Pevsner and Gabo would soon declare to be their primary pursuit, was a widely shared concern for avant-garde sculptors.[1] It was frequently expressed as part of the very essence of modernity, the inheritance of modern physics (the theory of relativity), mathematics (non-Euclidean geometry), and philosophy (the vitalism of Henri Bergson) that eradicated boundaries between objects and subjects and unveiled a "fourth dimension" of reality in the flux of space-time.[2] The focus on ambient properties of light and air and the perceptual effects of movement in *Bas-relief en creux* suggests an aspiration to convey a universal spatiotemporal fluidity. This latent dynamism links the sculpture, in the words of Gabo and Pevsner's 1920 Constructivist "Realist Manifesto," to the perpetual motion of planetary orbits and of modern machines—in the same way that modern science and technology harness and put to work the rhythmic energies of the universe.[3] Beyond such general allusions, however, the concrete formal operations by means of which Pevsner's work attains its expression of space are derived from the conjunction of a specific set of intellectual influences, mainly the innovations of Cubist painting, collage, and sculpture as put forward in the work of Pablo Picasso and Georges Braque, filtered through the neo-Kantian aesthetics current among Russian artists.[4]

"The conception which surprised me . . . in all the Cubists," Pevsner once reminisced, "was that they had utilized and applied a strongly drawn line and were thus adopting the formula of Byzantine art. . . . At all times [Cubism] gave importance to line, and the procedure of cutting out and superimposing objects was its principal revolt."[5] Here the artist associated the emphasis on "a strongly drawn line" with both the "primitive" tradition of the Byzantine icon and the Cubist technique in both painting and collage in which the line functions as a delimiting edge or boundary between forms (as in a paper cutout). An early encounter with icon painting in the Eastern Orthodox (or Byzantine) tradition was a favored personal foundation myth for both Pevsner and Gabo, as it was for many Russian avant-garde artists. Both brothers recalled having been struck by the icon painter's use of line as a sharp contour or edge that not only precisely delimited the objects in a composition but also served as the principal conduit for the organization of pictorial space known as "inverse perspective" (according to which parallel lines diverge in implied depth, rather than converging as they do in classical perspective).[6] Pevsner also recalled his astonishment at noting that the eyes of Jesus in an icon appeared either open or closed as the artist changed position while observing the work; likewise the Bible in his hands appeared to be inclined either inward or outward.[7] "The inverted laws of ancient perspective," he observed, "struck me deeply. Giving an impression of mobility, forms appeared sometimes open, sometimes closed . . . at the same time moving in and moving out, hollow and raised—a phenomenon which produced the sensations of life itself."[8] In *Bas-relief en creux*, we may trace the impact of Byzantine perspective in the systematic alternation of solids and voids pursued across the vertical axis of symmetry, as well as in the linear treatment of motifs, especially that of the cross.

Pevsner defined sculptural space specifically as giving rise to, or "generating," the void. His stated aim was to create sculpture "that would proceed from the void, and would thus be similar to architecture, which makes use of the solid only in order to generate the void."[9] *Bas-relief en creux* belongs to a series of "hollow constructions" (*construction en creux*) produced by the artist throughout his life. Virginie Pevsner, the artist's wife, interpreted the series precisely as an exploration of the emotional power of the void, prompted by the perceptual effects of inverse perspective.[10] It must also, however, be related to the discovery of "absence, of emptiness, as a positive term" that Yve-Alain Bois identifies in Picasso and Braque's work of around 1912, inspired by African masks.[11] As a relief, a hybrid of painting and sculpture, the mask is linked by Bois to hollow relief constructions such as Picasso's sheet metal and wire *Guitar* (1912), in which the functions of projection and depression are reversed with respect to what would be expected from the Western representational standpoint.[12] This inversion, Bois argues, led Picasso and Braque to a comprehension of the differential nature of the pictorial sign—that is, that the elements of visual representation acquire meaning only in relation to other elements within the work's overall communicative structure. Empty space could be given a concrete function within the relief because all its pictorial marks could now be seen as likewise "nonsubstantial" in themselves, comprehensible only as part of a relational network.[13] Pevsner's relief, we could say, situates the spatial void within a differential system of forms freed from representational functions. It is in fact precisely the series of binary formal permutations—in which concavity and convexity, solid and pierced, light and shadow mirror each other and alternate—that "generates" the void as a perceptual-emotional effect or, as Daniel-Henry Kahnweiler said of Cubist reliefs, a product of "the creative imagination of the spectator."[14]

Pevsner must owe his conception of an insubstantial or virtual volume originating from the subjective faculties of perception to yet another set of intellectual sources. The relief as an intermediary stage between two- and three-dimensional art forms was proposed as a key site for the negotiation of the problem of space in the discourse of German neo-Kantian aesthetics in the first part of the twentieth century.[15] For the Cubists, Bois argues, the African mask, as relief, represented an overcoming of a "fear of space" that German aesthetic discourses associated specifically with the bas-relief form.[16] Perhaps the most illuminating, for our purposes, articulation of that thesis was provided by Pevsner's contemporary Aloïs Riegl. For Riegl the art object was comprehended as a function of the spectator's imagination or perception, which combined an "optical" grasp of space with a "tactile" memory of three-dimensional objects. At the origin of Western art, he believed, ancient Egyptian sculpture focused on the "tactile surface," as though the work asked to be observed in extreme close-up or the "near view."[17] This aesthetic revealed that ancient Egyptian sculptors "eschewed space at all costs [as] chaos dwells in space, clarity and order in spaceless individuality."[18] The fear and denial of space found both their apex and their crisis in the sunken relief, or bas-relief (in which figures are carved into the ground material rather than raised above it). Here everything was done to avoid the impression that the material ground functioned as background to the carved figure, which would suggest a perception of depth. "Ground and space," Riegl wrote, "were originally irreconcilable opposites; ground was introduced so that space might be evaded."[19] Nevertheless, the figure-ground relationship of the relief was already pregnant with the potential of depth, which would indeed be finally realized in the classical high relief. Thus the bas-relief became the origin, or "the first step on the path toward an art of space."[20]

According to Virginie Pevsner, for the Byzantine icon painter (just as for Riegl's ancient Egyptian), "the point of departure in the representation of [depth] is situated closest to the eye."[21] I have found no evidence that Pevsner was a reader of Riegl, but certainly his preoccupation with the bas-relief format must owe something to the problem of the

relief as the origin of artistic space posed in German aesthetics. The interest in the strong line as a delimiting edge or boundary, as in the collage cutout, emerged here. The Egyptian sunken relief, for Riegl, maintained its distance from space by treating the ground as "merely a nothing, a void; [because] artists knew that any concessions they made to it would lead to space."[22] Is it not possible that Pevsner's *Bas-relief en creux* seeks to reinvigorate the aesthetics of space at its presumed historical point of origin by instead activating the void of the ground as the very virtual volume of spatial sensation?

Anna Vallye

Notes

First published March 2015

1. See Steven A. Nash and Jörn Merkert, eds., *Naum Gabo: Sixty Years of Constructivism* (Munich: Prestel, 1985), 26n72.

2. For the impact of the concept of the "fourth dimension" in the work of Pevsner, see Paul-Louis Rinuy, "Pevsner et l'espace-temps dans la sculpture du XXe siècle," in *De la sculpture au XXe siècle*, ed. Thierry Dufrêne and Paul-Louis Rinuy (Grenoble, France: Presses Universitaires de Grenoble, 2001), 29–49.

3. Naum Gabo and Anton Pevsner, "The Realist Manifesto" (1920), in *Art in Theory, 1900–2000: An Anthology of Changing Ideas*, ed. Charles Harrison and Paul Wood (Malden, MA: Blackwell, 2003), 298.

4. For more on this, see Christina Lodder, *Russian Constructivism* (New Haven, CT: Yale University Press, 1983), and Maria Gough, *The Artist as Producer: Russian Constructivism in Revolution* (Berkeley: University of California Press, 2005).

5. Antoine Pevsner, cited in Ruth Olson and Abraham Chanin, "Antoine Pevsner," in *Naum Gabo, Antoine Pevsner* (New York: Museum of Modern Art, 1948), 52.

6. See Guy Massat, "Pevsner et le vide comme puissance et jouissance créatrices," in *Pevsner (1884–1962): Colloque international Antoine Pevsner tenu au Musée Rodin en décembre 1992*, ed. Jean-Claude Marcadé (Villeurbanne, France: Art Édition, 1995), 189.

7. Ibid.

8. Pevsner, quoted in Olson and Chanin, "Antoine Pevsner," 52.

9. Antoine Pevsner, cited in Mady Ménier, "Aux pieds de la Tour Eiffel . . . ," in Marcadé, *Pevsner (1884–1962)*, 74. Translation mine.

10. Virginie Pevsner, "Avant-propos," in *Le dessin dans l'oeuvre d'Antoine Pevsner*, ed. Bernard Dorival (Paris: Collection Prisme, 1965), n.p.

11. Yve-Alain Bois, "Kahnweiler's Lesson," *Representations* 18 (Spring 1987): 53.

12. While Pevsner was unlikely to have seen those sculptures in Paris in the teens, he must have derived a similar lesson from Cubist painting's fixation on *l'art nègre*, a version of primitivism in heavy circulation among early twentieth-century avant-garde artists. For a discussion of Pevsner's prewar artistic milieu in Paris, see Ménier, "Aux pieds de la Tour Eiffel," 58–80. He notes particularly the probability that Pevsner would have known there the Russian painter and formalist critic Vladimir Markov and would have then been familiar with his *Iskusstvo negrov* (The art of the negroes), 1913–14 (published 1919). On Markov's significance, see

Bois, "Kahnweiler's Lesson," 48–49. Notably also, the influential Russian formalist critic Viktor Shklovsky drew a connection between the treatment of space in Suprematism and the "inverse perspective" of the Byzantine icon in "L'espace de la peinture et les Suprématistes," *L'Art*, no. 8 (September 5, 1919), cited in Jean-Claude Marcadé, "Le manifeste réaliste et l'oeuvre d'Antoine Pevsner," in *Pevsner (1884–1962)*, 97n24.

13. Bois, "Kahnweiler's Lesson," 54.

14. Daniel-Henry Kahnweiler, preface to *The Sculptures of Picasso* (London: Rodney Phillips, 1949), cited in Bois, "Kahnweiler's Lesson," 53.

15. Pevsner would have had numerous opportunities to be introduced to this discourse, first and most notably through conversations in the 1910s with Gabo, who was then immersed in the intellectual milieu of Munich. See, for example, Martin Hammer and Christina Lodder, *Constructing Modernity: The Art and Career of Naum Gabo* (New Haven, CT: Yale University Press, 2000), 22–25.

16. Bois refers specifically to the thesis of Adolph von Hildebrand on the bas-relief as the ideal reconciliation of the sensation of surface with that of depth. Bois, "Kahnweiler's Lesson," 41.

17. Aloïs Riegl, *Historical Grammar of the Visual Arts*, trans. Jacqueline E. Jung (New York: Zone, 2004), 401. See also Michael Podro, *The Critical Historians of Art* (New Haven, CT: Yale University Press, 1982), 72–73.

18. Riegl, *Historical Grammar*, 403.

19. Ibid., 411.

20. Ibid., 409.

21. Pevsner, "Avant-propos." Translation mine.

22. Riegl, *Historical Grammar*, 412.

Le bon samaritain (*The Good Samaritan*), 1930

Oil on canvas, 39 1/4 × 31 7/8"

University purchase, Kende Sale Fund, 1946

Eugene Berman

(American, b. Russia, 1899–1972)

Le bon samaritain (*The Good Samaritan*), 1930

ONE MAN DELIVERS ANOTHER PIGGYBACK onto a well-lit stoop, where a third man greets the pair. Horses stir in the foreground and middle ground, while a heap of equine flesh and bones writhes on the ground at left. These characters reenact the parable of the Good Samaritan within the strikingly geometric architectural setting of this canvas from 1930 Paris. A student of painting and architecture, the Russian-born Eugene Berman engaged here with the stables and courtyards of his 15th arrondissement neighborhood.[1] Redolent of the compositions of Giorgio de Chirico, whom Berman had encountered in Italy during the 1920s, the flat, overlapping color planes flush with the picture plane approximate Cubist pictorial construction.

Modernism's adamant futurity encourages us to forget that modern painters on occasion did return to old masters to rejuvenate their pictorial practices. A canvas in the Louvre from around 1650, formerly believed to be by Rembrandt but now attributed to Constantijn van Renesse and also titled *The Good Samaritan*, appears to have informed Berman's adoption of this theme in this and three other canvases from the same year.[2] Berman's look back was also a gaze averse to any future associated with the Bolshevik Revolution and the upending of Russian society and artistic practices. That revolution had also spelled the downfall and flight of Berman's affluent banking family and the relocation of Eugene and his painter brother, Leonid, through Finland and London to Paris by the end of 1918.

Compared to the decidedly nostalgic and romantic canvases and stage designs for which Eugene Berman is best known—compositions often dominated by classicizing architectural ruins set within perspectival spaces—his Good Samaritan compositions, which combine literary sources within rigorous architecturally

determined designs, were less estranged from the absolute propositions and radical practices of the Constructivists and their Cubist precursors than any others in his oeuvre. Addressing this series' distinctiveness, Julian Levy—who had met Berman before 1930 in Paris, exhibited his art at his New York gallery, and facilitated his immigration in 1935 to the United States—noted in 1947: "This kind of organization had been a solution when Berman was trying to combine representational images with the architectonics of Picasso's cubism. . . . [The] pictures would have looked almost as if they were abstractions had they not been so evidently arrangements of recognizable courts, walls and windows."[3]

In the Kemper Art Museum's painting, the courtyard walls establish an enclosure of architectonically arranged, overlapping, rectilinear colored planes across a picture plane structured by five rectilinear doors, windows, and their openings. Together with the nearly cloudless sky and the dirt of the foreground yard, they blanket the surface of the canvas. The edges of walls, rooflines, and vertical smokestacks also impose geometry on the natural blue sky. Symmetry is enhanced through the piers flanking the rectangular black stable-door opening at center. Originally each pier was crowned with a vase, and pentimenti suggest that Berman reworked this aspect of the composition, as only the vase on the right remains fully visible.

What precisely captivated Berman in the Louvre's canvas remains unknown, but a few general commonalities stand out. As with the Dutch canvas, Berman's casts the New Testament characters in a dim nocturnal light on a proscenium-like platform, surrounded by the unadorned planes of the courtyard's inner walls. Both canvases share a procession from left to right of human protagonists passing horses as they approach an illuminated porch at the right. Furthermore, the Good Samaritan theme shared by both paintings foregrounds the issue of neighborliness among different ethnic groups. This reading was already suggested by Levy, whose recollection of his first encounter with Berman's "pictures. . . of the stables and courtyards of Paris" is telling: "The old tale

of the biblical Samaritan provides a good indication to the mood of those paintings: the neighborhood neighborliness lifted parabolically by Berman's interpretation to the level of some contemporary myth."[4]

Living in the multiethnic 15th arrondissement, Berman may have identified with Rembrandt's residence in a Jewish neighborhood beginning in 1639. There Jewish neighbors modeled for the Dutch artist's religious figures, including Jesus. The nearly suburban 15th shared one key characteristic with Rembrandt's quarter in Amsterdam: both served as urban havens for refugees from many lands.

After the stock market crash and ensuing economic depression, an influx of refugees joined the highly concentrated immigrant populations living in Parisian districts such as the 15th. Migrants and especially refugees were subject to federal laws regulating foreigners. Already in 1922 the Soviet government had stripped Russian emigrants like Berman of their nationality, leaving them stateless. Russian refugees in Paris were also often subject to *refoulement*, or forced repatriation to their homeland, a fate Berman would surely have done anything to avoid.[5] With the onset of the Depression, public outcry against immigrants taking French jobs and other expressions of xenophobia and anti-Semitism were on the rise.[6] Russians in France suffered higher unemployment rates and were jobless for longer periods than previously, and they were also arrested for vagrancy more often than other foreigners.[7] In this environment Berman's experience as a Russian Jew in Paris would have triggered instincts of self-preservation but also heightened his concern for the destabilized status of fellow countrymen and other refugees. Regarded in this context, Berman's move to restage the story of the injured, possibly Jewish traveler aided by a Samaritan (Samaritans and Jews typically scorned each other) was no simple reckoning with an old master canvas from the French state's premier art museum. Rather, it marks his timely recognition of the potential for humane, neighborly relations across ethnic and religious divisions in the face of the state-sanctioned duress that he was beginning to witness in 1930.[8] For a stateless migrant during this

insecure period of rapidly shifting attitudes toward foreigners and a tightening dragnet of legislation affecting refugees and migrants—even Russian Jews who had enjoyed a decade of relatively little turbulence—the stakes of demonstrating assimilation to French society and professional belonging had seldom been higher.

Despite the gentle syncretic character of his art at this time, Berman's *Good Samaritan* is notably devoid of Jewish or "primitivist" motifs or style (Eastern European, Russian, or otherwise), either of which might have pulled him into the crosshairs of xenophobic and anti-Semitic sentiment within the right-leaning French public sphere. Instead the canvas, with its balance approaching symmetry and its reconciliation of dramatic figures within a geometrically stable and sheltering surround, betrays its proximity to the French classical tradition—think of the compositions of Nicolas Poussin, Pierre Puvis de Chavannes, or even Paul Cézanne and André Derain—just as it marks out its distance from the radical Russian or Western avant-gardes of the day. In this respect the American collector and Wadsworth Athenaeum curator James Thrall Soby's comment that Neo-Romantic paintings were "free at last from the burden of revolutionary ideas" rings true.[9] By staging the injured, transient, and agitated horses within a protective architectonic surround, this canvas seems attuned to Charles Baudelaire's 1863 challenge that painters of modern life come to terms with the old masters and to his definition of modernity as "the ephemeral, the fugitive, the contingent, the half of art whose other half is the eternal and the immutable."[10] Berman builds both halves of this modernism into *The Good Samaritan*.

It is important to acknowledge that the Neo-Romantic painters' work was not always met with enthusiasm. Those committed to the rigorous development of Cubism and its legacy were often harshly critical. Consider the view of the German expatriate art historian and critic Carl Einstein. Around 1930 Einstein offered only scorn for what he took to be the facile pictures of the Neo-Romantics. Although it was the paintings of Christian Bérard,

Berman's fellow student from the Académie Ranson, whose art had begun to embrace fashion illustration, that triggered Einstein's acerbic critique of contemporary painting, his comments could have applied to Berman's work as well. In an often-overlooked essay, "Kleine Bilderfabrik" (The little picture factory, 1931), Einstein delivered an institutional critique of the Paris art trade. Particularly offensive was the robust market for fashionable paintings, which, according to Einstein, Neo-Romantics like Berman fueled:

> The fabrication of pictures without world-view or risk is lower than the traffic in young women, for the facile dauber is menaced by no punishment, only comfortable income. . . . Many people believe in their talent, mostly because they sit in Paris, where the legacy of painting flies around in tatters like nowhere else. One even belongs to the School of Paris and addresses cousin Cézanne in the familiar. One finally destroys the sham of a dubious commodity market. The abused Seine is dammed up with oil paint, the docks sink before the shame, Notre Dame is violated, and nudes, painted right down to the enameled skin, swing over moth-eaten sofas that emit outdated anecdotes and insect-spray.[11]

The very qualities that Einstein decried in the work of the Neo-Romantics, however, would be embraced with warmth and discernment across the Atlantic by Soby. In his 1935 book *After Picasso*, Soby praised the canvases Berman initiated on returning from Italy to Paris in 1930:

> From his drawings, [Berman] painted a series of pictures of courtyards which have centers of dramatic excitement in contrast to the calm of the buildings beyond. . . . In pictures like *The Wounded* and *Le Bon Samaritain*, figures bend over a wounded man and horses stand ready to be ridden away. The light on these activities is derived

from Rembrandt, and falls from a doorway on the right; there is no other light except the moonlight on the roofs and the dull glow from windows beyond. The painter's melancholy is more active here, and no longer suggests a calm malaise but a quiet concern.[12]

This description refers to a different painting of the same title, formerly in the collection of Soby's friend Edward M. M. Warburg, an early Museum of Modern Art board member, but it also befits the canvas in the collection of the Kemper Art Museum.

Stationing Berman's painting amid key social and discursive contexts of the early 1930s, it is possible to regard it as a hybrid creation of the migrant imaginary seeking assimilation and acculturation. First, the Good Samaritan theme adapted from Rembrandt appears to express Berman's hope for better ethnic relations in his neighborhood as well as improved relations with French immigration authorities. Second, the modernist application of flat, architectonic planes to frame a stage set is a subtle nod toward Cubist picture construction while retaining the architectonic framing of a rather conventional proscenium to stage the biblical narrative that Berman found timely. Third, the general maneuver of taking art backward—to an old master canvas depicting a biblical parable—in order to reinvent it, nudges Berman's painting into a modernist tradition responsive to Baudelaire. In following each of these dualities negotiated in paint by Berman, we are able to discern how his painting also staked out a middle ground for itself between opposing critical factions concerned with contemporary Parisian pictorial aesthetics. With Berman's residency and welcome in France precarious, and with critical views of his art polarized, *The Good Samaritan* brokers these dichotomies without effacing them, perhaps with the hope of ameliorating current and future discord.

Keith Holz

Notes

First published March 2013; revised 2016

1. See Julian Levy, *Eugene Berman* (New York: Viking, 1947), v–viii, and James Thrall Soby, *After Picasso* (New York: Dodd, Mead, 1935), 36.
2. For other artworks by Berman with this title see Levy, *Berman*, pls. III, VI, no. 17.
3. Ibid., viii.
4. Ibid., v–vi.
5. See Mary Dewhurst Lewis, *The Boundaries of the Republic: Migrant Rights and the Limits of Universalism in France, 1918–1940* (Stanford, CA: Stanford University Press, 2007), 158, 159.
6. Ibid., 173.
7. Ibid., 171–72.
8. Another Jewish painter in Paris, the Belorussian Chaïm Soutine, painted his Carcass paintings from 1924 to 1929, a theme previously pioneered by Rembrandt. Like Berman's Good Samaritan works, which triangulated with an outlying Parisian neighborhood and a canvas attributed to Rembrandt, Soutine's paintings engaged with Parisian slaughterhouses of similar outlying, déclassé Parisian neighborhoods and Rembrandt's paintings of bovine carcasses.
9. Soby, *After Picasso*, 8.
10. Charles Baudelaire, "The Painter of Modern Life," in *The Painter of Modern Life and Other Essays*, ed. and trans. Jonathan Mayne (London: Phaidon, 1964), 13.
11. Carl Einstein, "Kleine Bilderfabrik," *Weltkunst* 5 (April 1931): 2–3, reprinted in *Carl Einstein (1885–1940): Kleine Bilderfabrik; Eine Auswahl unbekannter Aufsätze* (Siegen, West Germany: Universität-Gesamthochschule Siegen, 1988), 24–26 (translation mine).
12. Soby, *After Picasso*, 35–36.

Georges Braque

(French, 1882–1963)

Nature morte et verre (*Still Life with Glass*), 1930

IF SCHOLARSHIP IS ANY INDICATION, the 1930s are Georges Braque's lost years. For his Fauve and Analytical Cubist work, Braque's position as a leader of the avant-garde is unassailable. For the years between World War I and the 1920s, we have the scholarship of Kenneth Silver and Christopher Green, who discuss his place in the *retour à l'ordre*, a general rejection of the innovation and progress of the prewar years and a return to *la grande tradition*, an art of neoclassicism and thematic wholeness.[1] And Braque's late work, created between 1940 and the artist's death in 1963, was featured in an international exhibition in 1997 that focused on his grand cycles of paintings—the Billiard Tables, the Studios, and the Birds—in which the artist continued his lifelong investigation of the complexities of spatial representation.[2] Only more recently have scholars begun to examine the years between 1928 and 1940—an interim period of experimentation that does not allow for easy categorization.[3]

Braque's *Nature morte et verre* (*Still Life with Glass*) was made during this period of transition. It marks the work of a mature and relatively reclusive artist who is negotiating his place in the changing field of artistic practice. *Still Life with Glass* was made in the years immediately preceding Braque's canonization as one of the great masters of the School of Paris (his first important retrospective was held in Basel in 1933), but it also follows the neoclassicism of the mid-1920s. In it he returns to a method of representation that he knew well—his Cubist practices of the 1910s, as demonstrated by the overlapping planes, the separation of volume from contour, and the play with texture.

In much art historical scholarship, Pablo Picasso—Braque's colleague and, with him, the cofounder of Cubism—is celebrated for his recognition that all representation is by nature semiotic, while Braque is sometimes passed over—as if a willing

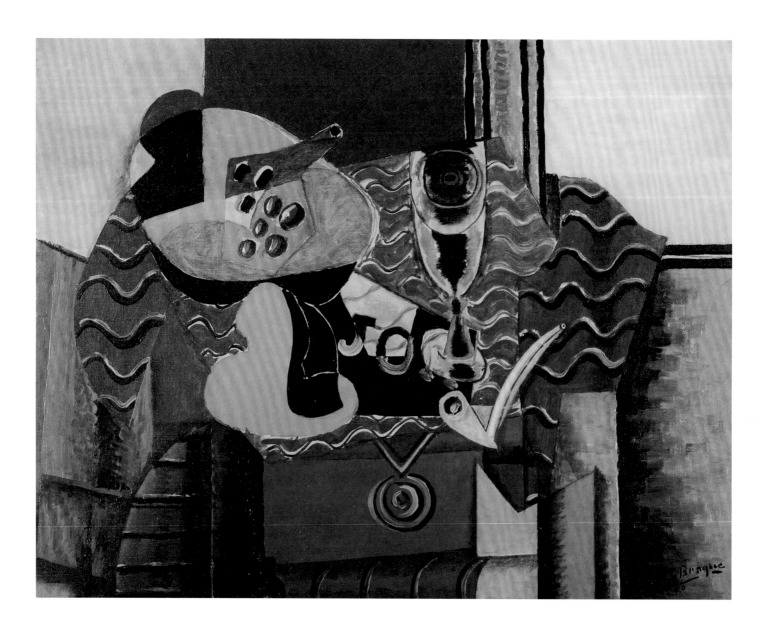

Nature morte et verre (*Still Life with Glass*), 1930

Oil on canvas, 20 3/16 × 25 5/8"

University purchase, Kende Sale Fund, 1946

partner in Picasso's investigations but one who might not have fully understood the complexity of the game. Christine Poggi, however, has successfully shown that these are not the correct terms in which to frame the study of Braque's early work. "Braque's goal," she writes, "seems to have been to discover a means of representation that would avoid the deformations of perspectival illusion, while conveying a strong sense of the material presence of objects."[4] Both artists rejected illusionism but for different reasons. Braque, like Picasso, rejected an idealized association of representation with reality. Yet, while he recognized that illusionism was simply a method for imitating volume and depth, he never relinquished an interest in individual sensation and perception. He still sought out methods of painting that would materialize space and the physicality of objects themselves.

During the early Cubist years Braque turned his attention more and more to still lifes, associating the genre with the depiction of objects that were within reach of the hand. In an interview conducted toward the end of his life, he explained that the tendency of still life to evoke the material quality of an object "corresponded to the desire that I have always had to touch the thing, not just to see it."[5] For Braque the question of how to depict the tactile quality of an object and what he described as "the space between things" was one that compelled him throughout his life. The 1930s were years in which these questions came to the fore in particularly provocative ways as, after the "return to order" of the late 1910s and 1920s, he began to reengage with the problem of three-dimensional representation on a two-dimensional canvas.

It may be that in searching for a way out of the neoclassicism and the more conventional illusionism of some of his works of the 1920s, such as the Canephora series, Braque returned to a moment of progressive creativity. Thus *Still Life with Glass* is governed by a tension between flatness and a materialized experience of space that is characteristic of the works of the teens (such as *Table with a Pipe*, 1912). On a square wooden table covered with a patterned

tablecloth, Braque has arranged a group of objects: a pipe, a glass, a fruit bowl with a bunch of grapes, a brown gourd-shaped object, and the letters *J O R*. A number of different spatial perspectives are at work here, creating a conflict between the illusion of physical presence and the flatness of the canvas itself.

This tension is most manifest in the breakdown of the perspectival system. Numerous areas of the picture are governed by fragmented systems of perspective: the legs of the table; the drawer at the front, which is slightly ajar; the left side of the canvas, where the table extends out and back at a broken angle; and the objects on the table, such as the round pipe and the glass that is rendered volumetrically but from two different perspectives (as if seen both from above and frontally). Other objects are resolutely flat and seem to work against the illusion of three-dimensionality. The gourd- or hat-shaped object on the left side of the table is a flat ocher field defined only by the limits of contour line and an unidentifiable black shape that appears to fold over it (though in fact there is no suggestion of depth to indicate a fold, just overlapping shapes). The fruit bowl and the bunch of grapes inside it are also flat; this is primarily because the different passages of color that make up the two objects are essentially independent of form. The separation between fragmented illusionism and flatness is most evident in the application of language to the canvas. The letters *J O R* evoke the French word *journal*, suggesting the presence of a newspaper on the table, yet there is no form or even the outline of a form that could be a newspaper. The viewer must conceptually "see" this newspaper by imagining a paper folded in such a way that the "u" in the middle of the word is hidden. For Braque, the letters of a word inserted onto the pictorial field heightened the difference between flatness and illusionism: "They were forms that could not be deformed because, being flat, the letters were outside of space, and their presence in the painting, by contrast, permitted one to distinguish the objects that were situated in space from those that were outside of space."[6]

The tension between flatness and illusionism defies perceptual certainty but also invites

sensory investigation. The viewer is given enough clues to read the objects as three-dimensional but not enough to place them in the real world beyond the frame of the canvas. The objects on the table tilt toward the viewer, as if they were to slip into the viewer's space, and some, such as the pipe and the gourd-like object, even appear to reside above it or precariously balance on the edge. There is an unexpected combination of thick, volumetric space and an adamant sense of flatness in the area around the table. On the right, Braque has emphasized the shadow at the edge of the table with thick black strokes that transition from dark to light. Contrary to this suggestion of depth and presence on the sides of the table, the tabletop is pushed flatly up against the vertical plane of the wall, as if there was no space behind it at all. The tabletop itself consists of a series of overlapping planes that create an almost accordion-like pleating of space, similar to the folding indicated by the letters *J O R*. This telescoping between depth and flatness creates a space that challenges the viewer's perceptual navigation.

Braque's continual investigation of the hermetic world of the still life has tended to invite interpretation of a singular kind: earlier critics of his work of the 1930s often resorted to purely formalist descriptions of the pictures that did not contextualize them.[7] Though only a beginning, this essay strives to reframe the discussion of the work of the 1930s in more productive terms.[8] Let us instead open up the question of the 1930s and investigate the embodied, sensory work of this artist who "painted without seeing," as the French writer Jean Paulhan, a colleague and friend of Braque, described him.[9] Much remains to be done to understand this incredibly productive, transitional time in the career of one of the twentieth century's leading avant-garde artists.

Karen K. Butler

Notes

First published March 2009; revised 2016

1. See Kenneth E. Silver, *Esprit de Corps: The Art of the Parisian Avant-garde and the First World War, 1914–1925* (Princeton, NJ: Princeton University Press, 1989), and Christopher Green, *Cubism and Its Enemies: Modern Movements and Reaction in French Art, 1916–1928* (New Haven, CT: Yale University Press, 1987).

2. See John Golding, Sophie Bowness, and Isabelle Monod-Fontaine, *Braque: The Late Works* (New Haven, CT: Yale University Press, 1997). The exhibition was organized by the Menil Collection, Houston, in collaboration with the Royal Academy of Arts, London.

3. Two recent exhibitions begin to redress this lacuna. One focused exclusively on this interim period; see the exhibition catalog Karen K. Butler and Renée Maurer, *Georges Braque and the Cubist Still Life, 1928–1945* (St. Louis: Mildred Lane Kemper Art Museum; Washington, DC: Phillips Collection; Munich: DelMonico Books · Prestel, 2013). The other, a major retrospective at the Grand Palais in Paris, examined Braque's entire career and was accompanied by a catalog that included essays on the work of the years; see *Georges Braque, 1882–1963* (Paris: Réunion des musées nationaux, 2013).

4. Christine Poggi, *In Defiance of Painting: Cubism, Futurism, and the Invention of Collage* (New Haven, CT: Yale University Press, 1992), 104. For a discussion of Picasso's Cubism in these years, see Rosalind Krauss, "The Motivation of the Sign," and Yve-Alain Bois, "The Semiology of Cubism," in *Picasso and Braque: A Symposium* (New York: Museum of Modern Art, 1992), 261–86, 169–208, respectively.

5. Braque, in interview with Dora Vallier, "Braque la peinture et nous," *Cahiers d'art* 29 (October 1954): 16 (translation mine).

6. Braque, ibid.

7. See, for example, Magdalena M. Moeller, "The Conquest of Space: Braque's Post-Cubist Work after 1917," in *Georges Braque* (New York: Solomon R. Guggenheim Museum, 1988), 25–30.

8. In 1972 the well-known Cubist scholar Douglas Cooper officially condemned Braque's work from the first half of the 1930s: "the paintings Braque produced between 1930 and 1936 are among the least alive, the least interesting and the least substantial of his entire *œuvre*." Cooper, *Braque: The Great Years* (Chicago: Art Institute of Chicago, 1972), 68. Cooper's statement was made in the context of an exhibition that investigated works from the later years—1918 and on—and was (somewhat ironically) intended to redress what Cooper saw as the problem of preference for Braque's early years.

9. Jean Paulhan, *Braque, le patron* (Geneva: Editions des Trois Collines, 1946), 33, first published in *Poésie* 43 (March–April 1943).

Joseph Jones

(American, 1909–1963)

Landscape, 1932

RENDERED IN STARK COMPLEMENTARY COLORS, primarily reds and greens, but in a visual vocabulary reminiscent more of body parts than of nature, Joseph Jones's *Landscape* produces an uncomfortable and disquieting effect. Amid a sullen forest of barren trees lies an undulating path; its soft pink bulges suggest snow but also cloth or folds of flesh. This path dematerializes behind an entanglement of attenuated branches on the right side of the canvas that are bare save for a few green leaves undermining any specificity of season. On the left, more virile trunks thrust upward from the billowing shapes of dull bluish-green earth. These trees fight for attention not only with their weaker companions in the right foreground but also with the slits of negative space between them, which appear to swell outward. It is a scene composed of abstract shapes and voids—a scene more evocative than descriptive. Although this painting has previously been interpreted as a study in form, this essay will consider the political and social engagement underlying Jones's *Landscape*. Painted during the Great Depression, a moment that directly preceded the St. Louis artist's public embrace of the radical politics of the left, *Landscape* can be seen as a critique of the social conditions of the period.

Landscape is part of a series of paintings from 1931–33 that stand apart from Jones's well-known body of midwestern farm landscapes and urban labor scenes.[1] The setting for *Landscape*, painted when the artist was living on Lindell Boulevard in St. Louis, is likely the nearby Forest Park, though specific references to locality are missing.[2] A shared quality of "tension and dynamic energy," as a *St. Louis Post-Dispatch* journalist phrased it in 1933, characterizes Jones's early works, each of innocuous subjects activated through the suggestive arrangement of simplified forms and painted in a limited

Landscape, 1932

Oil on canvas, 40 × 32 1/8"

Gift of the Estate of Mrs. Ernest W. Stix, 1970

palette.[3] These paintings have received little critical attention in a body of scholarship largely devoted to Jones's career after he publicly declared his communist sympathies in 1933; they have been instead viewed primarily as early explorations by the artist in the modernist idiom.[4] Several factors, however, point to an earlier political consciousness than scholars have generally acknowledged. For instance, Jones fashioned himself as an artist-laborer very early in his career. We can also find rebellious and anticapitalist posturing on the part of the artist as early as 1931.[5] Jones's political awareness has significant implications for these early works, of which *Landscape* is exemplary.

Like many of his Social Realist contemporaries, such as Ben Shahn and Philip Evergood, who began taking up politically radical subjects around this time, Jones wished to break with the academic traditions that he associated with the upper classes. With works like *Landscape*, however, it was the conventions of form more than subject matter that he sought to undermine in an effort to critique the capitalist system of art patronage. Viewing art production as experimentation in the "composition of forms and color in rhythm," Jones, like his contemporary Stuart Davis, considered modernist abstraction a tool for social engagement in a world gone awry under a capitalist economic system.[6] Abstraction, he believed, was a stimulating force that could activate class consciousness, especially, as in works like *Landscape*, through an active viewing experience. Jones's goal in this period was to "paint things that knock holes in the walls," as he explained in a *St. Louis Post-Dispatch* interview in January 1933, by using a pictorial language that breaks down traditional modes of viewing and emphasizes underlying tensions in the existing social order.[7]

Whereas Davis wove together disparate elements in his paintings to create a visual montage that ruptured the representational plane, Jones never fully challenged the autonomy of the subject in *Landscape*. Nor did he incorporate any objects of everyday life, a salient feature used by Davis to explicitly engage with issues of modernity. Rather,

working within an established genre that has its own symbolic logic, Jones employed a distinctly sensuous language to disarm his viewers. This bodily language becomes almost sexual in *Landscape*, as the trees take on the quality of various appendages.

Within this conceit, Jones capitalized on visual elements that manifest dialectical tensions, all of which were evocative at the time of underlying political conflicts and class struggle. While not readily evident today, this language would likely have been apparent to viewers in the period.[8] A tension exists between the language of the body and that of nature but also between mass and void and between the complementary colors of red and green that dominate the scene. This oppositional language is most literally depicted in the two sets of trees on the left and right sides of the canvas: one set strong and thick, the other thin and weak; one set light, and one dark. That the sturdier, thicker trees are the darker ones is particularly suggestive; Jones would later employ this vocabulary of organic expression in his more explicitly political antilynching and proletarian paintings to subtly highlight racial injustice in formal ways.[9]

Though *Landscape* is largely abstracted, Jones still grounded it in the romantic traditions of landscape painting. The attenuated branches, for example, hark back to a long tradition in which trees symbolize human loneliness. And while it is unclear if Jones had a specific intent in mind when he created this work, the familiar motif of the forest path recalls the journey of life, cynically portrayed in this instance as a barren scene that is particularly evocative of Depression-era conditions. The symbolic implications of Jones's works did not go unnoticed by his contemporaries. Describing a similar landscape with a "tree struggling to survive," one writer saw the painting as "tinged. . . with the philosophy that inspired its creation."[10] To this journalist the landscape was evocative of those negatively affected by capitalist conditions.

The landscape genre was repeatedly used in the nineteenth century to foster American nationalism and westward expansion through the use of

symbolic content and through compositions that emphasized the conditions of a new frontier nation, or one without a storied past.[11] Jones replaced the familiar nationalistic motifs—which often included grand mountains, broad waterways, and picturesque hills—with a stark and desolate scene. Stripped of the exuberant idealism that characterizes many nineteenth-century American landscapes, the painting expresses cynicism about the conditions of its time. Moreover, with his use of dialectical elements, Jones mapped a politically leftist vocabulary onto this genre, implicitly questioning the nation's capitalist foundations. In these ways, *Landscape* may also be understood as subverting an American pictorial tradition to critical effect.

Bryna Campbell

Notes

First published February 2008

1. Because of his Missouri upbringing and his large body of work depicting farmers and rural landscapes, scholars often consider Jones a Regionalist artist devoted to promoting American ideals through localized subject matter, in the vein of populist artists such as Thomas Hart Benton. Beginning in 1933, however, Jones was a member of the Communist Party, and consequently a significant portion of his oeuvre is devoted to issues of racial injustice, urban blight, and labor inequalities. His contemporaries' understanding of his rural work also complicates categorizing him as a Regionalist. In a review of Jones's work from the leftist journal *New Masses*, for example, Stephen Alexander drew sharp distinctions between the "straightforward, honest observation" in Jones's landscapes and the "chaos" in the work of Benton, who was widely critiqued by the left for his perceived conservative political views. See Stephen Alexander, "Joe Jones," *New Masses*, May 28, 1935, 30. For a summary of Jones's biography, see Karal Ann Marling, "Joe Jones: Regionalist, Communist, Capitalist," *Journal of Decorative and Propaganda Arts* 4 (Spring 1987): 46–59, and Louisa Iarocci, "The Changing American Landscape: The Art and Politics of Joe Jones," *Gateway Heritage* 12 (Fall 1991): 68–71. For his political work, see Karal Ann Marling, "Heartland Dreaming: Utopias, Dystopias, and the Wonderful Kingdom of Oz," in *Illusions of Eden: Visions of the American Heartland*, ed. Robert Stearns (Minneapolis: Arts Midwest, 2000), 36–75, and Andrew Hemingway, *Artists on the Left: American Artists and the Communist Movement, 1926–56* (New Haven, CT: Yale University Press, 2002), 34–39.

2. Jones was living at 4490 Lindell Boulevard during this period and painted at least one explicitly local landscape, *Lindell Towers* (c. 1931), around the same time he created *Landscape*. See Guy Forshey, "From House Painting to Portrait Painting," *St. Louis Post-Dispatch Sunday Magazine*, June 14, 1931.

3. "What Young Man Thinks about Life Put on Canvas," *St. Louis Post-Dispatch*, January 29, 1933.

4. See Marling, "Joe Jones," 46–59; Iarocci, "Changing American Landscape," 68–71; and Hemingway, *Artists on the Left*, 34.

5. Jones was raised in a working-class family as the son of a housepainter, a fact that he capitalized on to distinguish himself from the "students from richer families" who were academically trained. See Forshey, "From House Painting." His earlier posturing, before he officially announced his communist sympathies, is also raised, but not discussed in relation to his early work, in Hemingway, *Artists on the Left*, 35–36.

6. See Carl Benn, "Joseph Jones Holds First One-Man Show," *Art World*, November 1931, 1; Forshey, "From House Painting"; and especially "What Young Man Thinks," in which Jones makes his views about art most explicit. For more on Stuart Davis's views on art in the 1930s, see Lowery Stokes Sims, "Stuart Davis in the 1930s: A Search for Social Relevance in Abstract Art," in *Stuart Davis: American Painter* (New York: Metropolitan Museum of Art, 1991), 56–69.

7. Jones, quoted in "What Young Man Thinks."

8. See Alexander, "Joe Jones." For a larger discussion of Communist art, see Hemingway, *Artists on the Left*.

9. This is particularly evident in Jones's antilynching painting *American Justice* (1933) and in his *Roustabouts* (1934), a proletarian painting depicting men at work at Mississippi River boatyards. For a discussion of *American Justice* in this context, see Francis Pohl, *In the Eye of the Storm: An Art of Conscience, 1930–70* (Petaluma, CA.: Pomegranate, 1995), 50, and Dora Appel, *Imagery of Lynching: Black Men, White Women, and the Mob* (New Brunswick, NJ: Rutgers University Press, 2004), 143–44.

10. "What Young Man Thinks."

11. See Angela Miller, *The Empire of the Eye: Landscape Representations and American Cultural Politics, 1825–1875* (Ithaca, NY: Cornell University Press, 1993).

Max Beckmann

(German, 1884–1950)

Les artistes mit Gemüse
(*Artists with Vegetable*), 1943

BETWEEN APRIL 6, 1942, AND JANUARY 17, 1943, the German artist Max Beckmann, who was living in exile in Amsterdam, conceived his multilayered and ambiguous group portrait *Les artistes mit Gemüse (Artists with Vegetable)*.[1] During that time the world political situation was in many ways reaching a climax. The Nazi regime was in the process of implementing the "final solution" to systematically eradicate the European Jewry, and Beckmann witnessed the occupation of the Netherlands by Nazi Germany. Dutch Jews were deported to Auschwitz, and Jews throughout Western Europe were forced to wear the yellow star. Concurrently Nazi Germany incurred significant losses on the eastern front. Beckmann's depiction of four men who appear materially deprived gathered around a small white candlelit table in a constricted interior—as if joined in conspiracy—captures this atmosphere of uncertainty, persecution, and war.

The painting is often interpreted as a paradigmatic exile artwork visualizing German artists' and intellectuals' resistance to the Third Reich and its derogatory cultural politics.[2] It was not the image alone that advanced such a political reading but also the manner in which Beckmann constructed himself as a persecuted modernist German artist. He arrived in Amsterdam as a voluntary exile on July 19, 1937. It was a carefully chosen date: the very day Adolf Hitler gave his programmatic speech about German art on the occasion of the opening of the *Große deutsche Kunstausstellung* (Great German art exhibition) at the Haus der Kunst in Munich, and precisely one day after the opening of the exhibition *Entartete Kunst* (Degenerate art), which pilloried modernist art on a scale that was yet unknown.[3] In his speech Hitler called for a cleansing war against modern art, denouncing it as degenerate based on its distorting depiction of

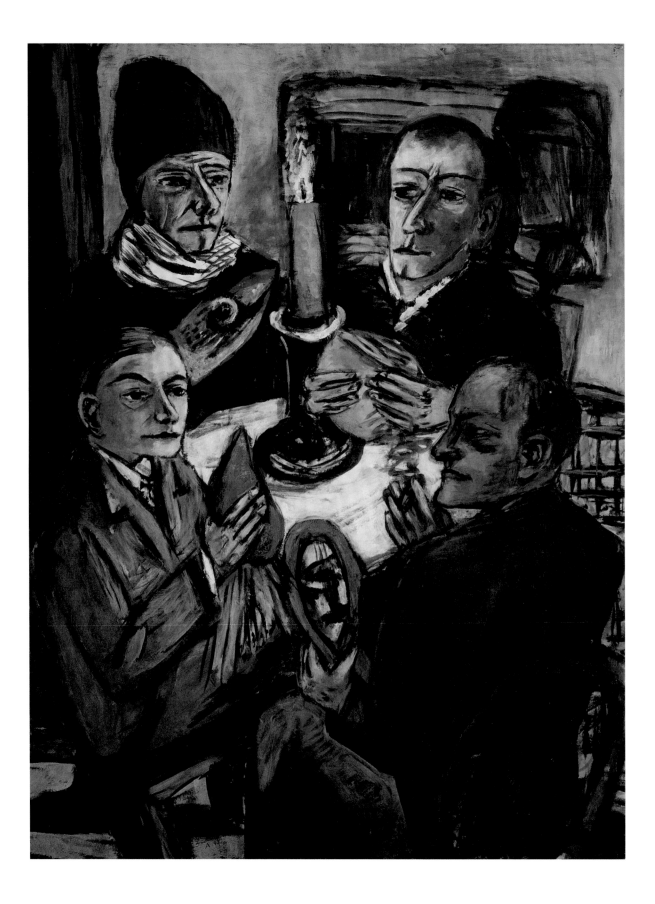

Les artistes mit Gemüse (*Artists with Vegetable*), 1943

Oil on canvas, 58 $^{15}/_{16}$ × 45 $^{3}/_{16}$"

University purchase, Kende Sale Fund, 1946

the visible world, the elitism implicit in its alleged inaccessibility, its internationalism, and its Jewish and Bolshevik creators and distributors.

Despite Beckmann's fate as one of most prominent persecuted German artists (twenty-one of his artworks were included in *Entartete Kunst*, and more than six hundred of his paintings were confiscated from German public collections between 1933 and 1937), his notion of the artist's involvement in the political sphere was highly ambiguous, and not only during his exile from 1937 to 1947. Beckmann's writings on art and politics situated the artist as belonging to an elitist and spiritual world autonomous from politics. For example, in his 1927 essay "The Artist in the State," he defined the artist as a shaper of transcendent ideas in order to carry on the project of humanity.[4] In a similar vein, in his 1938 speech "On My Painting,"[5] delivered at the opening of the *Exhibition of 20th-Century German Art* at London's New Burlington Galleries (initially envisioned to protest the exhibition *Entartete Kunst*),[6] Beckmann reinforced a separation between the spiritual and political realms, embedding the artist firmly in the former. "Painting is a very difficult thing. It absorbs the whole man, body and soul—thus I have passed blindly many things that belong to real and political life."[7]

However, Beckmann's diaries from his Amsterdam exile give a different impression; in them all aspects of his life interpenetrate. His philosophical musings appear tied to the political situation, and considerations of his status as an exile are interspersed with reports about his daily life, his health, and his career. Seamlessly interwoven are observations regarding the transportation of Dutch Jews to concentration camps, his continuing success on the German art market (effected by the modernist art dealer Karl Buchholz, who was also under orders to confiscate modern art for the Third Reich), Beckmann's creativity in exile, and reflections on his identity. These writings articulate his strong, almost fatalistic feelings about his homelessness, both on a metaphysical level and on one grounded in the realities of his uprooted life.

The interpenetration of intellectual concerns, actual exile experience, and political realities evident in Beckmann's diaries parallels the aesthetic strategy he employed in *Les artistes mit Gemüse*. The title itself conveys a sense of irony or even cynicism about the status of the modern artist during the Third Reich. This is accomplished by its combination of French and German, indexical of Beckmann's status as exile and of the loss of a mother tongue. While the French *artistes* emphasizes the superiority of the creative individual, the elitist or even transcendent role of the artist, the German *Gemüse* (vegetable) faces the facts of artistic life in wartime Amsterdam.

The painting depicts four cultural figures in exile: the abstract and constructivist painter Friedrich Vordemberge-Gildewart (1899–1962) in the lower left corner; the figurative painter Otto Herbert Fiedler (1891–1962) above; to his right the philosopher Wolfgang Frommel (1902–1986); and at the bottom right Beckmann himself. Each exile holds an object, only one of which clearly resembles a vegetable: the carrot or turnip held by Vordemberge-Gildewart. Fiedler's object is a fish; Frommel's resembles a loaf of bread, a booklet, or possibly a cabbage but is ultimately unidentifiable; and Beckmann holds a mirror in his left hand. These objects take on the character of attributes, for which various readings exist. Vordemberge-Gildewart's carrot or turnip has been read as a symbol of money as well as of wartime deprivation. The fish in Fiedler's hand might stand for fertility, be a sign of recognition among believers, or represent food for sacred meals.[8] The mirror in Beckmann's left hand reflects a strongly lit and somewhat distorted clown face. In comparison to his actual profile, which is the only dark face in the image, this heightening encourages interpretations that distinguish the artist as an outsider and isolated individual. The double self-portrait also invites readings that center on Beckmann's identity negotiated by and through the other men, whose faces are, in contrast to Beckmann's, partially lit by the candle, suggesting a spiritual mood and linking the three exiles.

But how do these artists relate to Beckmann, and what do they have in common with him? What are their positions toward the Third Reich, politics, and their situation as exiles? Beckmann was fifty-eight years old when he executed *Les artistes mit Gemüse*. The other men pictured were much younger, but all four were isolated from both the Dutch art world and the German exile community, and none was active in antifascist resistance. These shared factors suggest an emphasis on the conditions of exile rather than a focus on the spiritual world.

Vordemberge-Gildewart had moved in 1938 to Amsterdam, where he worked in advertising. Prior to his exile, which was necessitated by his wife being Jewish, he had lived in Hannover, Berlin, and Switzerland. He was a member of de Stijl in 1925 and of the group Abstraction-Création in 1931, and between 1940 and 1944, together with a group called Underground, he produced illegal publications on Hans Arp and Wassily Kandinsky. Today he is considered a main representative of abstract and constructivist art. Although Vordemberge-Gildewart's aesthetic program was opposed to that of Beckmann, who was skeptical about pure abstract art,[9] he, like Beckmann, kept aloof from politics and was concerned mainly with defending his aesthetic position. In contrast, the Berlin painter Fiedler, who had lived in Paris in the 1920s and was a friend of George Grosz, executed realistic portraits. By choosing to represent these painters in a group portrait, Beckmann illuminated two modes of painting decisively different from his own concerns with creating a transcendental world. His reference to both abstract art and realistic painting can thus be understood as a means of emphasizing his outsider status and his belief in an individualistic artistic practice positioned in between abstraction and figuration.

The German philosopher Wolfgang Frommel had more in common with Beckmann.[10] Between 1933 and 1935 Frommel headed a radio program in Nazi Germany called "Vom Schicksal des deutschen Geistes" (On the fate of the German spirit). A follower of the German poet Stefan George who embraced art for art's sake, Frommel was politically conservative and attempted, while subtly criticizing the totalitarian demands of the National Socialist regime, to nevertheless promote Germans as world leaders. Frommel, whose radio program included Jewish authors, took a stance in between acquiescence and resistance. His 1932 programmatic publication *The Third Humanism* exposes a utopian-reactionary notion of the world. Devoid of anti-Semitism, it assumes an elitist intellectual position. Like Beckmann, Frommel privileged spiritual values, which he attempted to set against the visible world of National Socialism. Yet he also shared beliefs with the Nazis: he defended nationalism and Nazi ideals of the simple life; he mythologized the state and history in irrational ways; and he resisted progressiveness and modernity. In the summer of 1935 he was denounced, and in 1937 he left Germany for Amsterdam, where he worked for publishers and also sheltered Jews. He is undoubtedly the most important exile depicted in this painting, a point emphasized by the golden frame surrounding his head. With Frommel's portrait Beckmann references both political positions and spiritual life; he shared with the philosopher a passion for the classical intellectual world as well as contempt for racial persecution.

The painting's unnatural color, simple shapes, rough brushwork, and distorted perspective distinguish *Les artistes mit Gemüse* as clearly indebted to a modernist idiom. Yet typologically Beckmann also drew on traditions of seventeenth-century northern European group portraiture (as exemplified by Peter Paul Rubens's *Self-Portrait in a Circle of Friends from Mantua* [1602–4]), thus taking up a convention specific to his place of exile. This historicist reference can be seen as an attempt to assimilate with northern culture, although not with contemporary art as it was then practiced in the Netherlands. Seventeenth-century northern art had been held in high esteem by German collectors and museums since the founding of the German Reich in 1871. Dutch and Flemish art of the seventeenth century as well as Italian Renaissance art were seen

as symbols of power and intellectualism, an appreciation that continued well into the Third Reich, as Hitler's selections for his envisioned Linz Museum demonstrate. Beckmann was certainly aware of this. Although he never would have intended any association between his group portrait and the aesthetic preferences of the Nazis, Hitler's all-encompassing politicization of art, used to legitimize National Socialist ideology, makes possible such parallels. However, seventeenth-century Dutch and Flemish group portraiture not only was highly valued by the Nazis and significant to Beckmann's place of exile, but also encompassed metaphysical notions such as immaterial presence and spiritual content that were at the very center of his intellectual interests.

In accordance with Beckmann's conception of modernism as an independent venture, *Les artistes mit Gemüse* is not informed by any actual event that might have brought these four men together. Instead Beckmann constructed a discourse that ambiguously alternates between creating a fictitious narrative and representing individual German exiles. All four are known to have lived as exiles in the Netherlands, where they shared a common fate, and their sitting together around a table suggests a probable situation. Moreover, the red background behind Frommel's head implicates the theater of war penetrating into the small interior, emphasizing their collective experience. Other elements of the composition underscore their individuality. The figure of Beckmann, for example, avoids any visible interaction with the others that would suggest a narrative line. In addition, the white tablecloth, the large candle in its center, and the attributive character of the objects that the exiles hold in their hands establish a religious or at least pseudo-religious context, elevating the meeting into a transcendental realm in which Frommel again takes center stage, as he seems to be dressed as a priest. Beckmann's dual demands on narrative and representation, group and individual, collectivism and individualism, illuminate both his perception of the unavoidable penetration of political realities into the aesthetic realm and his desire for a utopian practice of modernism in which

art, detached from politics, "is the mirror of God embodied by man."[11]

Sabine Eckmann

Notes

First published in English July 2007; revised 2016. Originally published in French as "Quatre homes autour d'une table," in *Beckmann: Centre Pompidou*, ed. Didier Ottinger (Paris: Éditions du Centre Pompidou, 2002), 274–78.

1. Beckmann worked on the painting on April 6, 1942; August 12, 1942; October 9, 1942; October 23, 1942; January 1, 1943; and January 17, 1943. See Erhard Göpel, ed., *Max Beckmann: Tagebücher, 1940–1950* (Munich: Piper, 1984), 44, 50, 52, 53, 58.

2. See, for example, Carla Schulz-Hoffmann and Judith C. Weiss, eds., *Max Beckmann Retrospective* (St. Louis: Saint Louis Art Museum; Munich: Prestel, 1984), 286; Charles W. Haxthausen, "Max Beckmann: *Les Artistes mit Gemüse*," in *A Gallery of Modern Art at Washington University in St. Louis*, by Joseph D. Ketner et al. (St. Louis: Washington University Gallery of Art, 1994), 102; and George Speer, "Max Beckmann: *Les Artistes mit Gemüse*," in *H. W. Janson and the Legacy of Modern Art at Washington University*, by Sabine Eckmann (St. Louis: Washington University Gallery of Art; New York: Salander O'Reilly Galleries, 2002), 56.

3. See Stephanie Barron, ed., *Degenerate Art: The Fate of the Avant-garde in Nazi Germany* (Los Angeles: Los Angeles County Museum of Art; New York: Abrams, 1991); and Klaus-Peter Schuster, ed., *Nationalsozialismus und "Entartete Kunst": Die Kunststadt München 1937* (Munich: Prestel, 1987).

4. Max Beckmann, "The Artist in the State" (1927), reprinted in *Max Beckmann: Self-Portrait in Words; Collected Writings and Statements, 1903–1950*, ed. Barbara Copeland Buenger (Chicago: University of Chicago Press, 1997), 287–90.

5. Max Beckmann, "On My Painting" (1938), reprinted ibid., 298–307.

6. See Cordula Frowein, "Ausstellungsaktivitäten der Exilkünstler," in *Kunst im Exil in Großbritannien, 1933–1945* (Berlin: Fröhlich & Kaufmann, 1986), 35–38; Stephan Lackner and Helene Adkins, "Exhibition of 20th Century German Art, London 1938," in *Stationen der Moderne* (Berlin: Berlinische Galerie, 1989), 314–37; and Keith Holz, *Modern German Art for Thirties Paris, Prague, and London: Resistance and Acquiescence in a Democratic Public Sphere* (Ann Arbor: University of Michigan Press, 2004).

7. Beckmann, "On My Painting," 302.

8. See Barbara Buenger, "Antifascism or Autonomous Art: Max Beckmann in Paris, Amsterdam, and the United States," in *Exiles and Emigrés: The Flight of European Artists from Hitler*, ed. Stephanie Barron and Sabine Eckmann (Los Angeles: Los Angeles County Museum of Art; New York: Abrams, 1997), 61–62.

9. For example, in his 1938 speech, Beckmann said, "I hardly need abstract things, for each object is unreal enough already, so unreal that I can make it real only by means of painting." Beckmann, "On My Painting," 302–3.

10. For more on Frommel, see Michael Philipp, "'Vom Schicksal des deutschen Geistes': Wolfgang Frommels oppositionelle Rundfunkarbeit in den Jahren 1933–1935," *Castrum Peregrini* 209, no. 19 (1993): 124–40.

11. Beckmann, "Artist in the State," 288.

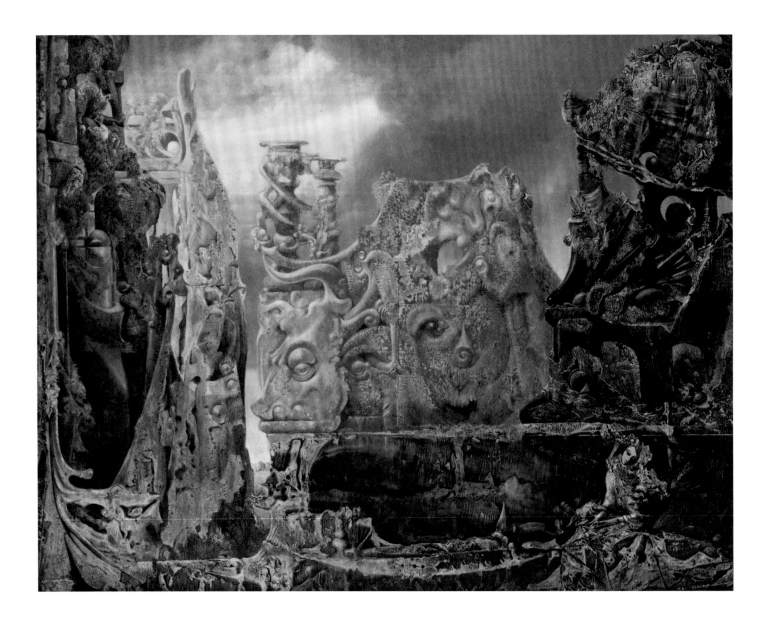

L'oeil du silence (*The Eye of Silence*), 1943–44

Oil on canvas, 43 $^1/_4$ × 56 $^1/_4$"

University purchase, Kende Sale Fund, 1946

Max Ernst

(German, 1891–1976)

L'oeil du silence (*The Eye of Silence*), 1943–44

MAX ERNST'S OTHERWORLDLY LANDSCAPE *L'oeil du silence* (*The Eye of Silence*) depicts what may be described as an artificial hell. Considering the many artificial paradises produced by artists over the last two hundred years in order to compensate for the modern experience of loss of nature, Ernst certainly added to this trajectory a dichotomous position. The painting does not render a refined or composed expression of a natural site but collages together elements that have their origin in fantastic and exotic garden architectures, as exemplified by the columns in the background. Grottoes populated by stalactites and stalagmites surround and are reflected in the central lake, and surreal circular forms resembling eyes animate the geologic forms. The fairy-tale woman who lounges on the rock formation in the lower right-hand corner further transforms the landscape into an uncanny and imaginary space. Underscoring these haunting, even terrifying effects is Ernst's palette, which includes a wide variety of earth tones but is dominated by an eerie green that evokes both beauty and ghostly worlds. The dark cloud formation above the grotto is moving on, however, as if to leave the scene, making way for a brighter, more expectant sky in which an optimistic and peaceful blue breaks through white clouds in the distance.

Ernst painted *The Eye of Silence* while in exile in the United States and traveling with his then-wife, Peggy Guggenheim, in the American West; through a small opening between the rock formations on the left side of the canvas we glimpse what could be the seemingly endless and wide-open landscape of that region. Yet Ernst's reception in the United States as an exile and famous Surrealist artist from Nazi Germany was not what one would call a success.[1] Although he was an undeniable presence in the New York art world during his first year of exile, in 1941, in the following years he was largely

absent from exhibitions and other cultural activities. He described his exilic experience as one marked by isolation and estrangement.[2] Given these alienating circumstances, it is not surprising that Ernst—like fellow Surrealist exiles such as André Masson, Roberto Matta, and Yves Tanguy—took up the genre of landscape painting rather than engaging with American modernization and the manifold sensuous and sensational experiences of its bustling cities.

In contradistinction to his colleagues, however, Ernst inflected his landscapes with conventions of German Romanticism. *The Eye of Silence*, for example, evokes the work of the German painter and philosopher Carl Gustav Carus and his so-called earth-life paintings, such as *Fingal's Cave* (after 1844), depicting an underground grotto.[3] Instead of imitating or improving upon nature, Carus was interested in exploring nature itself. Coinciding with the importance of speculative physics, the sciences in general, and the newly established interrelation between science, art, and nature in the nineteenth century, Carus was interested in comprehending nature as a geologic formation, as a living organism that is unstable, continuously changing, and constantly in motion.[4] In short, Carus attempted to "learn to speak the language of nature" in order to visualize an unmediated state of nature that prefigures any and all enlightened conceptions of landscape.[5] This ambition was coupled with a notion of the artist as an autonomous shaper of invisible, divine, or better natural worlds.

But how, we have to ask, did Ernst utilize and transform Carus's concept of earth-life painting under the condition of exile in the new world? Was Ernst, in line with Carus, invested in reaching back to a status of natural history that predates and prefigures the devastations enabled by rational order, including the destruction of the European continent by the Nazi regime? Similar to Carus, Ernst depicted a combination of natural forms: those that we can see, such as the pool of water and the sky, and those that lie behind and below the surface, such as stalactites and stalagmites.[6] Yet Ernst moved these nether formations aboveground, from the inside of caves

to the exterior, under a foreboding sky, where their visual quality is one of movement and transformation. In contrast to the water and sky, which we can fix with our eyes, the unstable and fragmented structures seem to be undergoing a visual metamorphosis into shapes that resemble human figures, animals, architectural elements, and natural forms.

To underscore this perceptual experience of change, instability, and hybridity, Ernst experimented with the technique of decalcomania. Replacing the usual modernist and individualistic artistic mark-making, decalcomania, by contrast, relies on chance and preexisting visual forms. Developed by Ernst and Hans Bellmer in the concentration camp of Les Milles in the South of France in 1938–39, decalcomania encompasses the process of pressing thin paint with the help of an object, such as a flat piece of cardboard, onto the canvas.[7] The uneven amounts of paint generate shapes that bear a resemblance to stalactites and stalagmites. In paintings such as *The Eye of Silence*, Ernst also imitated the results of decalcomania through painterly means.

The Eye of Silence is thus composed of chance forms, naturalistically rendered geologic structures and landscape elements, and fantastic, surreal shapes, all of which are arrested within a loosely conceived perspectival order in which background elements push into the foreground, toward the picture plane, while others recess spatially. Through the technique of decalcomania, Ernst consciously indicated the removal of artistic subjectivity and creative ambitions from the painting, contesting the treasured analogy between the natural and artistic expression.[8] Moreover, the artist collaged together different landscapes in fragments not usually experienced together. By bringing ulterior elements of nature to the surface—depicted as undergoing metamorphosis and resembling surrealistic and fantastic forms that are, however, as inanimate as the lifeless, silent eyes that populate the eerie scene—Ernst inverted the notion of nature as a living organism. It is in this sense that we may comprehend the ossified structures as metaphors for the destroyed Europe.

Since Ernst painted similar grotto-like landscapes in Europe, some of which he brought with him to the United States, we can read the painting as a combination of narrative threads from the past and present that also anticipate a utopian future. To be sure, both the painting's title and the uncanny scene itself allude to a frozen moment, first and foremost bespeaking silence and death, and hence might be seen as referring to the European situation that the artist had left behind. Nevertheless, other elements in the painting direct us to a possibly more humane present and future. Together with the figure of the woman, who indicates new beginnings, we can read the small opening onto a vast and bright, albeit still blurry and unspecific, natural space as promising new life.[9] And although this landscape remains at an auratic distance, it marks *The Eye of Silence* as a transitory image that includes both decay and regeneration and that notably converts political history into metaphors for natural processes.

Despite this glimmer of optimism, it is important to recognize that in *The Eye of Silence* Ernst visualized the experience of exile and estrangement by turning nature into a lifeless—unhomely and uncanny—space, as opposed to articulating a place of belonging where one can experience sensory pleasures and comfort.

Sabine Eckmann

Notes

First published March 2008

1. See my essay "Max Ernst in New York, 1941–45," in *Exiles and Emigrés: The Flight of European Artists from Hitler*, ed. Stephanie Barron and Sabine Eckmann (Los Angeles: Los Angeles County Museum of Art; New York: Abrams, 1997), 156–63.

2. Ibid., 156.

3. Oskar Bätschmann, "Carl Gustav Carus (1789–1869): Physician, Naturalist, Painter, and Theoretician of Landscape Painting," in *Carl Gustav Carus: Nine Letters on Landscape Painting*, ed. Oskar Bätschmann (Los Angeles: Getty Publications, 2002), 11–73.

4. Ibid., 29.

5. Ibid., 30.

6. It is interesting to note that the German artist Thomas Demand created a life-size model of an underground grotto out of paper and cardboard, which he photographed for his work *Grotto* (2006).

7. See Günther Metken, "Europa nach dem Regen—Max Ernsts Dekalkomanien und die Tropfsteinhöhlen in Südfrankreich," *Städel Jahrbuch* 5, no. 7 (1975): 287–89; Metken, "Zwischen Europa und Amerika," in *Max Ernst–Retrospektive*, ed. Werner Spies (Munich: Prestel, 1979), 79–96; and Metken, "Werkinterpretationen," ibid., 312.

8. Richard Shiff, "Expression: Natural, Personal, Pictorial," in *A Companion to Art Theory*, ed. Paul Smith and Carolyn Wilde (Oxford: Blackwell, 2002), 159–73.

9. Not only Ernst but also his fellow Surrealist exile André Breton articulated the hope of a new world order led by women. For example, in 1945 Breton explained that "the time should come to assert the ideas of woman at the expense of those of man the bankruptcy of which is today so tumultuously complete." Cited in Roszika Parker and Griselda Pollock, *Old Mistresses: Women, Art, and Ideology* (New York: Pantheon, 1981), 138.

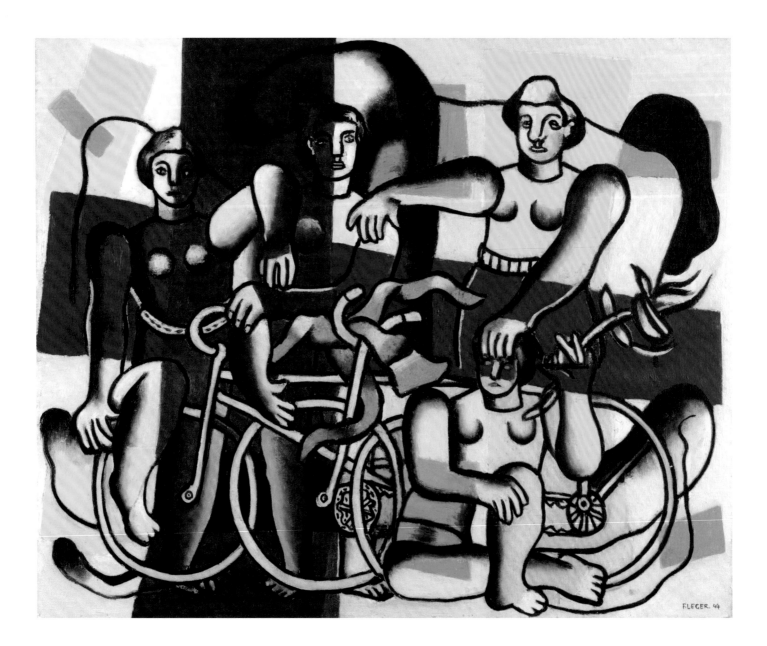

Les belles cyclistes (*The Women Cyclists*), 1944

Oil on canvas, 29 × 36"
Gift of Charles H. Yalem, 1963

Fernand Léger

(French, 1881–1955)

Les belles cyclistes (*The Women Cyclists*), 1944

FERNAND LÉGER'S *Les belles cyclistes* (*The Women Cyclists*) depicts a group of four physically powerful women dressed in shorts and T-shirts at rest during a bicycle outing. The women stand or sit together with their arms on one another's shoulders, their highly stylized and disjointed bodies intertwined with their bicycles. Rendered using only thickly drawn outlines and selective modeling, these stout, frontal figures appear emotionless, staring out blankly at the viewer as if posing for a picture. But this is not to say that Léger's composition is devoid of emotion or feeling. The artist's considered use of vibrant contrasts of bold line, simplified form, and abstract planes of pure color (red, blue, yellow, and green) infuses the composition with a joyous visual dynamism and energy. Unlike Léger's other versions of the theme of the cyclists from this period—in which his bicycle parties were clearly anchored in rural settings through the inclusion of elements such as a rustic fence, trees, rocks, flowers, and clouds—the figures in *Les belles cyclistes* are not situated in any recognizable location. Existing in neither city nor country, these robust women and their vehicles are depicted in an abstract colored space.

Painted at the height of World War II, while the artist was in exile in the United States during the German occupation of France, this modest easel painting offers a compelling view of Léger's struggle to advance his long-standing sociopolitical ambition to put modern art at the service of the common man through an exploration of the psychological effects of light and color.[1] *Les belles cyclistes* represents a confluence of ideas first formulated in France and influenced by Léger's involvement with the cultural debates of France's short-lived leftist Popular Front government in the mid-1930s—namely, a turn to popular subjects with the goal of establishing a

new optimistic civic art with the human body as its object—but notably conditioned by the outbreak of war and the artist's exile in the United States.[2]

Ideologically Léger was always more concerned with the France he had left in 1940 than with the United States and its distanced position from the struggle against fascism in Europe. The artist was never interested in assimilating; rather, as his friend the architecture critic Sigfried Giedion explained, Léger re-created "a kind of Parisian atmosphere" around his studio near Fifth Avenue in New York, "expounding plans and commenting upon the American scene" with friends such as the artist Alexander Calder and the architect Josep Lluís Sert.[3] What most intrigued Léger about the United States were the country's abundant contrasts, between its vast natural resources and immense mechanical forces, its great vitality and its excessive waste.[4] "Nowhere else have I found such an energetic and dynamic atmosphere," he stated. "The French public will be amazed when it compares my American painting with my pre-American output. America has added color to my palette."[5] What the artist was referring to is the bright color overlays that appeared in his paintings in the early 1940s, layers of free-floating color planes that seem to arbitrarily interpenetrate the strong black outlines of his simplified figures and objects. While the separation between color and drawing was a fundamental Cubist device, one that had been of paramount importance for Léger since the 1910s, it became markedly more acute in his paintings of the 1940s.

In *Les belles cyclistes*, Léger juxtaposed color and representational form in a way that maintains these elements as distinct from each other. The geometric bands both highlight and fragment the human figure, confusing the spatial relationships between the bodies while also complicating any clear division between background and foreground. The seemingly random swaths of primary and secondary color introduce into the composition a complex sense of space and movement despite the static nature of Léger's drawing style.

The artist attributed much of the increased chromatic vitality in his American work to the garish fashions and the modern advertising techniques that he experienced in New York and other American cities.[6] He noted in particular the impact of the colorful fashions of the young American women he encountered: "Girls in sweaters with brilliant colored skin; girls in shorts dressed more like acrobats in a circus than one would ever come across on a Paris street. If I had only seen girls dressed in 'good taste' here I would never have painted my *Cyclist* series."[7] Léger's discourse on color theory was often organized around descriptions of popular clothing styles, accessories, and even women's makeup.[8] Modern art, in Léger's view, needed to share the creative impulse, adaptability, and relentless urge to modernize that characterizes fashion design.

The appearance of flat, geometric color planes of blue, red, yellow, and green moving in and out, as well as across, the group of figures in *Les belles cyclistes* was also inspired by the flashing lights of Broadway. Speaking to Dora Vallier in 1952, Léger explained: "In 1942, when I was in New York I was struck by the advertising spotlights on Broadway which played upon the street. . . . You're talking to someone and all of a sudden he becomes blue. As soon as that color passes another comes and he becomes red or yellow. That kind of color, the color of the spotlight, is free; free in space. I would like to have the same thing in my canvases. It is very important for mural painting because that has no scale, but I have also used them in my easel paintings."[9]

In *Les belles cyclistes*, Léger created with paint a new visual equivalent to the ambient effects of the spotlights and neon signs of Broadway, letting color act as an abstract agent that both enlivens and fragments his stylized bodies. It is important to note that while Léger recognized the innovations and pervasiveness of advertising—in his writings he often marveled at its ability to take possession of the roads and transform the landscape—he was never interested in merely illustrating or reproducing the chaos of publicity posters and the colored spectacle

littering the urban metropolis. Rather, his aesthetic approach, based on the translation and precise orchestration of the visual world of the modern city, was very much driven by a progressive social imperative formulated in France and underscored by a belief in the mental and physical effects of color in everyday life.

Beyond a mere decorative supplement or ornament, Léger valued color as a necessary life force. In a 1938 essay titled "Color in the World," he wrote, "Color is a vital necessity. It is a raw material indispensable to life, like water and fire. Man's existence is inconceivable without an ambience of color."[10] He went on to discuss the colors of the countryside in the years preceding World War I, the colorlessness of the war years, and the confused cacophony of color produced by modern advertising. It was up to the painter to "organize this whole riot of colors."[11] Convinced that modern space must be colored space, he strove to extend his painterly practice beyond the individual-oriented and commodified easel painting to that of the communal wall, creating environments for the common man through a new orientation in mural painting. Despite the cataclysmic world picture of the 1940s and the drastically different environment politically and materially in the United States, Léger's positivist theory of color did not appear to waver. If anything, his desire to invest modern art and architecture with new means of collective expression was given renewed urgency during the war.[12] Though the poor man "cannot find a space of liberation through the help of a masterpiece upon his wall," he could, Léger reasoned in his 1943 essay "On Monumentality and Color," be stimulated by the realization of a colored space that responds to humanity's vital need for light and color.[13]

While easel painting dominated the nineteenth and twentieth centuries, Léger strongly believed that a renaissance of mural arts was on the horizon and regarded collaboration with modern architects as the most promising avenue for shaping the emotional life of the masses.[14] He believed that mural painting, as a genre subordinate to architecture,

functioned to enhance spatial awareness through color contrast, and it remained for Léger the ideal terrain for nonobjective formulations. The easel painting, in contrast, stood alone, unable to completely surrender the possibility of thematic associations.[15] Les belles cyclistes displays an adroit unification of the type of nonobjective compositional strategies the artist was concurrently exploring in his mural paintings—such as the now destroyed Consolidated Edison mural commissioned for the "City of Light" building at the New York World's Fair of 1939—with an equally strong figurative component that reflects Léger's growing ambition since the 1930s to develop legible iconography that would appeal to the masses.[16] His focus on popular leisure activities and the ennobled working class has its roots in nineteenth-century French figure painting. Léger reinvented the tradition without anecdote or allusion to topography, however, using the popular motif of cycling (an activity of necessity during the war due to gas shortages) as a means of involving the public in a concerted exploration of pictorial form.

By placing emphasis on painting first, rather than on narrative or descriptive sentimentality, Léger aimed to set a new course for an advanced, politically conscious artistic practice distinct from that of the didactic pictorial language of Social Realism or the broadly popular representations increasingly available through movies, photography, and advertising. The artist optimistically intended that his modernist paintings would provide the common man (that is, the workers of France) a sort of aesthetic relief, helping them to fully grasp "the joys and satisfactions which the modern art work can give."[17]

While Les belles cyclistes exemplifies Léger's ongoing aesthetic experimentation with hybrid relationships between abstraction and figuration, between line and color, it could also be understood as a prototype, presenting in small scale his grand vision to expand his aesthetic practice beyond the canvas and flood the urban space using dynamic light spectacles with new chromatic emotion. The liberation of pure color in the environment, no longer bound to any

object or surface, was for Léger a crucial step in the psychological advancement of the working masses.[18] The idea of a multicolored city had come to him while on leave during World War I, a dynamic vision of urban life given expression in his early canvas *The City* (1919). He discussed the idea in Paris with Leon Trotsky, who was enthusiastic and urged Léger to realize his idea in Moscow, but the project was never achieved.[19] Léger revived the notion after his first visit to New York City in 1931, and proposed an expanded version for the Paris International Exposition in 1937, which would have involved engaging three hundred thousand unemployed French laborers to sandblast the facades of Paris so that powerful floodlights installed in the Eiffel Tower could bathe the city in colored light. The municipal authorities rejected this spectacular proposal.

Wartime New York—with its dynamic commercial, architectural, and technological infrastructure—offered renewed possibilities for the realization of Léger's projected chromatic vision. In 1942, for example, he was invited by the architect Paul Nelson to speak to a committee of the US Housing Authority in Washington, DC, which was charged with providing housing for war workers, about his ideas for using color in town planning. Léger outlined a theory that involved combining colors to produce different effects in various areas of the town: in the center, brilliant colors would be combined in a "cocktail" in order to reflect the excitement and variation of its activity. Outside the city center, color was to become less intoxicating, with one strong color balancing more neutral tones in residential areas to produce a more intimate atmosphere that would have a positive emotional effect on the inhabitants.[20] While Léger met with sympathetic supporters in the United States, including Nelson, his leftist political views and modernist aesthetic were never to garner backing from officials. When read against the backdrop of World War II, Léger's idealistic belief in human emancipation through the careful organization of color and light appears as a gesture of hope for the future, for a radical rebuilding and restructuring of Europe (and France specifically) based on collective ideals, and for overcoming the chasm opened up between rationalist thought and feeling.

Despite Léger's monumental public aspirations, commissions for large-scale mural paintings, other than temporary manifestations, did not occur in any great number until the last decade of his life, and his projects for spectacular colored environments never materialized beyond his elaborate proposals. Easel painting always remained for him of primary importance for both aesthetic experimentation and economic stability. *Les belles cyclistes* stands as a formidable statement of Léger's aesthetic response to his life as an émigré in wartime America, as well as his ongoing efforts to advance ideals of activist social improvement through avant-garde aesthetic practice.

Meredith Malone

Notes

First published July 2011

1. Léger would not become an official member of the Communist Party until the end of his stay in New York, in 1945, but his leftist political leanings had been evident since the 1910s, dating back to his time as a soldier during World War I. Léger often referenced his experience during the war, in which he lived alongside workers, laborers, and miners, as a foundational moment that allowed him "to discover the People and to change completely." See Léger, "Art and the People" (1946), in *Functions of Painting*, trans. Alexandra Anderson (New York: Viking, 1965), 143. For more on Léger's political beliefs during this period, see Sarah Wilson, "Fernand Léger: Art and Politics, 1935–1955," in *Fernand Léger: The Later Years*, ed. Nicholas Serota (London: Whitechapel Art Gallery, 1987), 55–75.

2. Léger arrived in New York on November 12, 1940, and stayed until December 1945. For overviews of his life, work, and reputation in America, see Carolyn Lanchner, "Fernand Léger: American Connections," in *Fernand Léger* (New York: Museum of Modern Art, 1998), 15–70, and Simon Willmoth, "Léger and America," in Serota, *Fernand Léger*, 43–54.

3. Sigfried Giedion, "Some Words on Fernand Léger" (1955), in *Architecture, You and Me: The Diary of a Development* (Cambridge, MA: Harvard University Press, 1955), 53–54. Léger always maintained a strong predilection for his native culture and language: though he lived in the United States for many years, he never learned English.

4. See Léger's interview with James Johnson Sweeney, "Eleven Europeans in America," *Bulletin of the Museum of Modern Art* 13, no. 4–5 (1946): 13–14.

5. Léger, quoted in "Art: Machine Age, Paris Style," *Time*, March 18, 1946.

6. Léger spent much time in New York City during his period of exile, but he also made trips to the American Midwest, the Southwest, and California.

7. Léger, quoted in Sweeney, "Eleven Europeans," 15.

8. For more on Léger's color theory and its relationship to both the economy of fashion and the modernist white wall, see Mark Wigley, *White Walls,*

Designer Dresses: The Fashioning of Modern Architecture (Cambridge, MA: MIT Press, 1995), 262.

9. Léger, quoted in Dora Vallier, "La vie fait l'oeuvre de Fernand Léger," *Cahiers d'Art* 29, no. 2 (1954): 156.

10. Léger, "Color in the World" (1938), in *Functions of Painting*, 119.

11. Ibid, 121.

12. While living in the United States, Léger gave many lectures on color in modern painting and in architecture, and he coauthored the 1943 position paper "Nine Points on Monumentality" with Giedion and Sert. In this paper, plans for postwar rehabilitation were laid out, with special emphasis on the crucial relationship between aesthetics and civic representation in postwar society. In point nine, Léger reiterated his belief in the social and psychological benefits of color and light in the urban environment.

13. Léger, "On Monumentality and Color" (1943), reprinted in Giedion, *Architecture, You and Me*, 43.

14. Since the 1920s Léger had been a tireless proponent of the synthesis of the major arts (art, architecture, and sculpture) and was a longtime friend and associate of the French architect Le Corbusier. For more on the mutually influential relationship between these two men, see Joan Ockman, "A Plastic Epic: The Synthesis of the Arts Discourse in France in the Mid-Twentieth Century," in *Architecture and Art: New Visions, New Strategies*, ed. Eeva-Liisa Pelkonen and Esa Laaksonen (Helsinki: Alvar Aalto Academy, 2007), 30–61.

15. In his 1950 essay "Mural Painting and Easel Painting," Léger wrote: "I believe and I maintain that abstract art is in trouble when it tries to do easel painting. But for the mural the possibilities are unlimited. In the coming years we will find ourselves in the presence of its achievements" (*Functions of Painting*, 162).

16. The social role of mural painting was also very current in the United States in the 1930s as the Works Progress Administration offered new opportunities for creating public art. Léger understood the context of New Deal America as an opportunity for securing his own commissions for murals. Before his exile during World War II, he visited the United States on three occasions, in 1931, 1935, and 1938. See Willmoth, "Léger and America," 44.

17. Léger, "The New Realism Goes On" (1937), in *Functions of Painting*, 118.

18. See Léger, "Modern Architecture and Color" (1946), in *Functions of Painting*, 152.

19. See Léger, "A New Space in Architecture" (1949), in *Functions of Painting*, 158.

20. Simon Willmoth describes Léger's 1942 proposal in "Léger and America," 47. See also Ruth Ann Krueger Meyer, "Fernand Léger's Mural Paintings 1922–55," (PhD diss., University of Minnesota, 1980), 253.

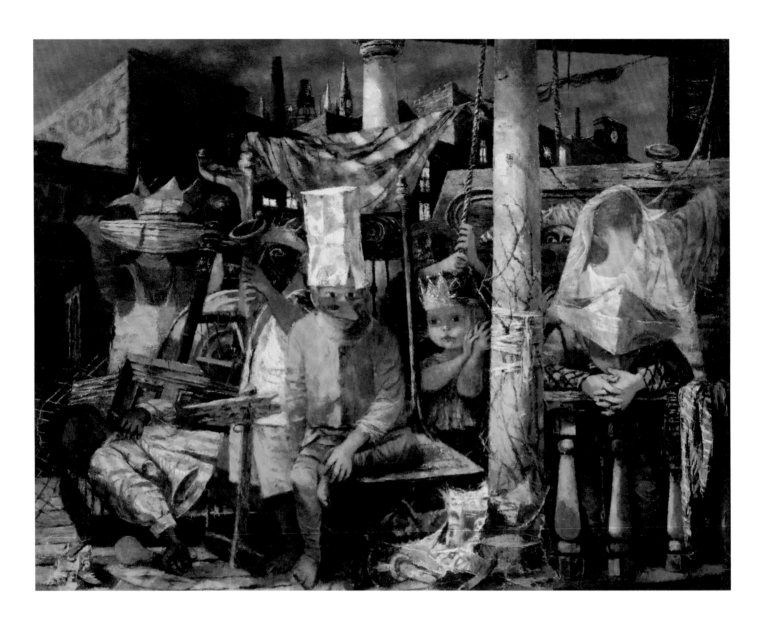

If This Be Not I, 1945

Oil on canvas, 42 $\frac{1}{4}$ × 55 $\frac{1}{4}$"
University purchase, Kende Sale Fund, 1945

Philip Guston

(American, b. Canada, 1913–1980)

If This Be Not I, 1945

WHEN IT DEBUTED AT THE ARMORY SHOW IN 1945, Philip Guston's *If This Be Not I* was hailed as a success by critics and the artist alike. While more recent commentators have presented primarily allegorical readings of the painting, critics of the time praised *If This Be Not I* for its formal strength. The canvas was also seen as a sign of Guston's successful engagement with the European avant-garde and, in partic- ular, with the work of the German painter Max Beckmann. In what follows, *If This Be Not I* will be examined as it relates to Guston's foremost concern when the painting was created: the construction of space.

On the painting's completion, Guston felt that he had finally mastered easel painting.[1] Although he would later produce artworks in concentrated one- to two-hour sessions, in the 1940s Guston was far from prolific. He worked on *If This Be Not I* for almost an entire year, at one point making major changes and completely recomposing it.[2] It was also one of the biggest easel paintings he had attempted to date, measuring 42 1/4 by 55 1/4 inches.[3] Once finished, the painting, previously referred to simply as "the large picture," was given a title based on a nursery rhyme.[4] In the unsettling tale, an old woman questions her own identity after changes are made to her outward appearance by another. The title, like the painting, thus refers to a narrative, albeit one that remains enigmatic and fragmentary.[5] Most accounts of *If This Be Not I* focus on its mysterious portrayal of nine children at play in an urban landscape. Surrounded by detritus such as a stray lightbulb and torn newspapers, the figures wear mystical amulets and playful dress (striped pajama tops, a makeshift crown). For all their depicted movement—arms raised, pulling on a cord, winding a blindfold, or ringing a bell—the children appear frozen in time. The mood of *If This Be Not I* is one of pervasive melancholy, underscored

by the haziness of its color and exemplified perhaps by the detail of the dead branches crawling up a central pillar, stifled by the very binding intended to help them grow straight and tall.

Shortly after the painting's debut at the Armory show, the German-born art historian H. W. Janson, then instructor of art history at Washington University and the head of its art collection, purchased *If This Be Not I* as part of his major campaign for the acquisition of modern art.[6] In his writings Janson presented Guston early on as an exception to the throngs of American painters churning out work in self-imposed isolation from European developments.[7] Because Janson saw Guston as a painter unusually engaged with European art, his work provided a complement to that of other artists Janson added to the collection, such as Max Beckmann; in 1951 Janson argued that Guston's work illustrated Beckmann's legacy in the United States.[8] In fact, in the late 1930s Guston had seen an exhibition of Beckmann's paintings at the Buchholz Gallery in New York and later acknowledged an interest in his work.[9] Not coincidentally, because of their shared advocates, Beckmann eventually replaced Guston on the faculty of the Washington University School of Fine Arts in 1947. In his typical fashion, Beckmann invented a term for his predecessor, arrogantly calling him a "big Beckmanjaner," the German equivalent of a follower or devotee of Beckmann.[10]

Guston, however, was not simply a follower of Beckmann. The most striking affinity between the two men's painting lies not in their well-known recourse to personal symbolic content but in their shared concern with the construction of pictorial space. Both Guston and Beckmann explicitly emphasized an investment in spatial problems in statements about their painting. While hard at work on *If This Be Not I*, Guston claimed that "space with its whole scale of near and far must become as charged with meaning, as inevitable to the composition as a whole as the figures themselves."[11] Guston was also struck by Beckmann's paintings of the early 1920s, in which space was, as Guston called it, "compressed" and "loaded."[12] The nine figures in *If*

This Be Not I are contained within a space much like a proscenium or, as Janson called it, the "porch of a tumble-down house."[13] In fact, the structure seems almost like a ship with two large masts, fabric draped from a rope like a sail, and wooden slats of flooring. One critic in early 1945 noted that Guston's newest interest was the painting of space, "but the hard way, without compositional props or perspectival aids."[14] The careful placement of large and small objects at various angles in *If This Be Not I*—from an upside-down coatrack to a massive door—lend a sense of layered depth. Forms are flatter and less volumetric than in previous paintings by the artist, and their sheer number creates a claustrophobic effect akin to Beckmann's signature work. Indeed, Guston's array of imagery functions as much as structural markers as personal allusions.

The spatial complexity of *If This Be Not I* is further heightened by Guston's attention to texture, or what one reviewer called "richness of surface."[15] Critics praised Guston as a colorist and for his ability to create contour without sharp-edged lines. "Now, for the first time," wrote Janson of *If This Be Not I*, "the evocative power of the work springs as much from the richness and depth of its color as from the design."[16] By restricting his palette to a few colors (primarily grays, blues, whites, and the occasional burnt sienna) and painting wet-on-wet, Guston created tonal modulations and depth.[17] For example, in the far left register of the painting, directly above the head of the reclining boy, is a plane of textured color resembling wood grain. It is painted on top of a grid of lines resembling a grate, which winds up and back into space at an oblique angle. Behind it, an open door creates the only opportunity of escape from the cluttered surroundings. In the painterly quality of this layering, *If This Be Not I* has more in common with Beckmann's work from the 1930s, the very canvases that Guston would have seen at the Buchholz Gallery. In other words, both artists created not just figural but textural depth by painterly means, thereby charging space itself with "meaning."

If This Be Not I plays a pivotal role in Guston's development both because he proclaimed himself a

master of the medium on its completion and because this sense of mastery was extremely short-lived. In 1946 Guston expressed public dissatisfaction with the canvas *Sentimental Moment* (1944), which had earned him first prize at the Carnegie Institute's annual the year before.[18] Lacking the complexity of *If This Be Not I*, the earlier canvas depicts a single figure against a singular backdrop. With *If This Be Not I*, Guston internalized the problem of space and began to move in a different direction formally, albeit with strikingly similar subject matter. Janson described Guston's work after *If This Be Not I* as still figurative but nonetheless making "no distinction any more between figures and setting, between the formal and representational aspects of the design."[19] And although Janson did not view this move critically, Guston was apparently so dissatisfied with these canvases that he destroyed much of his work from the St. Louis period.[20] His forms moved ever closer to the picture surface and, eventually—unlike Beckmann, who remained committed to figuration until his death, in 1950—Guston turned to complete abstraction. Today, thanks to the success of Abstract Expressionism on the American art scene, Guston's abstract canvases of the 1950s, such as *Fable I* (1956–57) in the collection of the Kemper Art Museum, remain his best-known works.[21]

Lynette Roth

Notes

First published October 2010

1. Likely based on conversations with the artist, Dore Ashton makes this claim regarding Guston's mastery of the medium in *A Critical Study of Philip Guston* (Berkeley: University of California Press, 1990), 65.

2. See correspondence between Philip Guston and Alan Gruskin, Midtown Galleries Records, Archives of American Art, Smithsonian Institution, reel 5383.

3. Only *Holiday* (1944) was comparable in size, albeit a vertical format.

4. "The Old Woman and the Pedlar," in *The Real Mother Goose* (Chicago: Rand McNally, 1916).

5. See David Anfam, "Telling Tales: Painter Philip Guston's Career Examined," *Artforum* 41 (May 2003): 134–36.

6. H. W. Janson, "Modern Art in the Washington University Collection," *Bulletin of the City Art Museum of St. Louis* (March 1947): 6, 11. For more on Janson and his role, see Sabine Eckmann, "Exilic Vision: H. W. Janson and the Legacy of Modern Art at Washington University," in *H. W. Janson and the Legacy of Modern Art at Washington University* (St. Louis: Washington University Gallery of Art; New York: Salander O'Reilly Galleries, 2002). The image caption on page 50 that indicates that *If This Be Not I* was purchased in 1946 is erroneous. The receipt of sale is dated October 11, 1945, and was paid on November 2. Midtown Galleries Records, Archives of American Art, Smithsonian Institution, Reel 5383.

7. See H. W. Janson, "'Martial Memory' by Philip Guston and American Painting Today," *Bulletin of the City Art Museum of St. Louis* (December 1942): 34–41.

8. H. W. Janson, "Max Beckmann in America," *Magazine of Art* 44 (March 1951): 92.

9. Ashton claims that Guston saw Beckmann at the Buchholz Gallery in 1938 in *A Critical Study*, 64, 73. Later authors have dated the visit to 1939. See, for example, Robert Storr, *Philip Guston* (New York: Abbeville, 196), 14. Curt Valentin, director of Buchholz Gallery, held exhibitions of Beckmann's recent work in both 1938 and 1939, so either date is a possibility.

10. Cornelia Wieg, *Max Beckmann seiner Liebsten: Ein Doppelportrait* (Ostfildern-Ruit: Hatje Cantz, 2005), 107.

11. Guston, cited in Rosamond Frost, "Guston: Meaning out of Monumentality," *Art News* 43 (February 1, 1945): 24.

12. Ashton, *Critical Study*, 73. A prime example of such work is Beckmann's *The Dream* (1921), now in the collection of the Saint Louis Art Museum. As opposed to the work later that decade, these canvases, while crowded with depicted objects, are more restrained in their brushwork and feel more closely related to Beckmann's graphic work at the time.

13. H. W. Janson, "Philip Guston," *Magazine of Art* 40 (February 1947): 55. The 1944 *Holiday* also takes a porch as its defining structure, as do the aptly titled *The Porch* (1946–47) and *Porch II* (1947).

14. Frost, "Guston," 24.

15. Emily Genauer of the *World-Telegram*, cited in "Our Box Score of the Critics," *Art News* 43 (February 1, 1945): 28.

16. Janson, "Philip Guston," 55.

17. For more on Guston's technique, see Storr, *Philip Guston*, 111.

18. "Philip Guston: Carnegie Winner's Art Is Abstract and Symbolic," *Life*, May 27, 1946, 90–92.

19. Janson, "Philip Guston," 56. The example Janson refers to is *Night Children* (1947).

20. Musa Mayer, *Night Studio: A Memoir of Philip Guston by His Daughter* (New York: Knopf, 1988), 37. Details about exactly which works were destroyed are difficult to reconstruct. A photograph featured in *Life* magazine of Guston in his studio (see note 18 above) with a number of canvases from 1946 hints at the extent of the destruction.

21. Guston famously returned to figuration around 1968 under very different terms.

Interior with Pink Nude, 1951

Oil on Masonite, 43 $^7/_8$ × 54 $^{15}/_{16}$"
University purchase, Charles H. Yalem Art Fund,
and Gift of the Dedalus Foundation, Inc., 1995

Robert Motherwell

(American, 1915–1991)

Interior with Pink Nude, 1951

ROBERT MOTHERWELL'S *Interior with Pink Nude* resides in an uncertain space between figuration and abstraction. While the picture is a fairly straightforward composition, the multiple layers of paint on the surface and the obvious reworking and overpainting contribute to a general spatial and figural ambiguity. The two black and pink forms with multiple appendages are painted on a cloudy ocher ground that is unevenly applied and of varying thickness. With the title as a guide, it is not hard to imagine the pink organic forms on the left as the bulbous limbs of a woman. A more ambitious reading might go so far as to suggest that the balloon-shaped black mass is her head thrown back and the yellow mark on its dark surface is a reflection of light. Such an interpretation of this picture is undermined, however, by the small black five-pronged shape sitting above a pink rectangle to the right, which is even more difficult to identify. Numerous objects can come to mind: a bouquet on a shelf, a reflection in a mirror, perhaps a second figure set back in the distance. Moreover, the traces and marks of the layers that have been painted over or scraped off—notably on the right, where they suggest a box or door-like form—contribute to the picture's spatial indeterminacy, creating a sensation of interior depth.

All of this suggests that the process of arriving at the painting's endpoint was protracted and improvisational. As the work was painted in New York City in 1951, a moment when improvisation was particularly valorized in American art and literature, it is tempting to read *Interior with Pink Nude* as Motherwell's effort to engage with the pervasive aesthetic of spontaneity. Doing so, however, would provide only a limited reading of what is in fact his fascinating, if conflicted, investigation into the dominant pictorial languages present in the United States after World War II, including

gestural abstraction, Surrealism, and the work of such influential modernists as Henri Matisse and Pablo Picasso.

In a well-known essay written for a group show in 1951, Motherwell attempted to define the methods and goals of what he termed the New York School, a loosely associated group of artists who painted in an abstract gestural style. He emphasized the bond between the artist's individuality and the painterly gesture or mark, which he believed translated the private emotions and feelings of the artist directly onto the canvas. One of the defining aspects of the group, Motherwell stated, was a heightened commitment to the act of painting as an "authentic" record of that experience. "The process of painting," he wrote, "is conceived of as an adventure, without preconceived ideas on the part of persons of intelligence, sensibility, and passion. Fidelity to what occurs between oneself and the canvas, no matter how unexpected, becomes central."[1] Although he was attempting to distinguish what would become known as Abstract Expressionism from modern art in general and from geometric abstraction more particularly, Motherwell was also setting out his own objectives as an artist.[2] Indeed, one of his tenets, repeatedly stated in his writings and interviews, is the notion that the picture is the end result of a spontaneous process, the traces of which are left visible on the surface of the canvas. (As he would say ten years later, "The subject does not pre-exist. It emerges out of the interaction between the artist and the medium."[3])

Motherwell's interest in the spontaneous act came out of Surrealist automatist techniques.[4] He was less interested in revealing the imagery of the unconscious, however, than he was in emphasizing the act of creation itself as a generative process. For him, the picture and the artist's identity were bound together by the material trace and the very act of painting: "painting and sculpture are not skills that can be taught in reference to preestablished criteria, whether academic or modern, but a process, whose content is found, subtle, and deeply felt. . . . [It] is only by giving oneself up completely to the painting medium that one finds oneself and one's own style."[5] Motherwell's insistence on the autographic nature of the creative act, that painting was the outcome of a specific and often fraught individual experience, was bound up with theories of existentialism, the philosophy that Jean-Paul Sartre had popularized in France during and after World War II, which had emerged in the United States by the late 1940s.

In both the United States and Europe in the postwar period, the belief that the abstract gesture was a trace of an individualistic act of creation became conflated with a universalist and somewhat contradictory position that held that gestural abstraction was a particularly modern phenomenon and thus universally accessible in the modern era.[6] This position was commonly expressed in Motherwell's writings and those of other Abstract Expressionist artists, critics, scholars and in the press. *Life* magazine's 1948 "Round Table on Modern Art" is a case in point. Published after a meeting of high-profile scholars and critics—including Clement Greenberg, Meyer Schapiro, H. W. Janson, and various museum directors from the United States and Europe—at the Museum of Modern Art in New York, the article concluded that "the troubles of modern art lead back into the troubles of the age. . . . The meaning of modern art is, that the artist of today is engaged in a tremendous individualistic struggle—a struggle to discover and to assert and to express him*self.*"[7]

Interior with Pink Nude was made at the height of the art world's conflation of this kind of discourse with gestural abstraction, yet the painting does not fit neatly within this trajectory. Although Motherwell considered abstraction to be the aesthetic form that best captured the qualities of the modern condition, he did not always practice pure abstraction. *Interior with Pink Nude* calls on the venerable figurative tradition of a female nude in an interior, one that goes back as far as the Renaissance and was still present in the work of many of Motherwell's contemporaries, notably Henri Matisse and Pablo Picasso. The work of the European avant-garde, many of whom were living in exile in the Unites States during and after World War II, was for many American high

modernists something to engage with as the most important form of advanced art at the time but also something to overcome.[8]

This painting—with the curving, ballooning forms of the woman and the bulbous, petallike shapes of the black object set within a space that ever so slightly recedes into depth—engages with the work of the historical avant-garde but filters it through ideological and aesthetic concerns that were particular to the United States in the postwar period. Picasso's slightly Surrealist depictions of the rounded forms of the sleeping Marie-Thérèse Walter from the 1930s and Matisse's renderings of exotic nudes with still lifes of mirrors and bouquets, often with a window view to the exterior, seem particularly relevant here. Motherwell's scumbling, or dry application of layers of opaque color, along with the small drips of pink and orange along the bottom edge of the nude, is evocative of Matisse's vibrant canvases, which also often exhibit reworking and traces of the painting process. What Motherwell seems to have discovered in this painting was a way to come to terms with the weight of European tradition while embracing a modern interest in material process. One might best think of the picture as a statement, unconscious or not, demonstrating both the artist's debt to and mastery of historical models and his search for new artistic forms that speak to the condition of postwar America.

Karen K. Butler

Notes

First published January 2010

1. Robert Motherwell, preface ("The School of New York") to *Seventeen Modern American Painters* (Beverly Hills, CA: Frank Perls Gallery, 1951); reprinted in *The Collected Writings of Robert Motherwell*, ed. Stephanie Terenzio (Oxford: Oxford University Press, 1992), 83. Motherwell wrote this at the request of the gallery owner Frank Perls, who believed that the exhibition—which included the work of the Abstract Expressionists William Baziotes, Hans Hofmann, Jackson Pollock, Ad Reinhardt, Mark Rothko, and others—needed an explanation.

2. Motherwell—who received his undergraduate education at Stanford, studied philosophy at Harvard University for one year, and began a PhD program in art history at Columbia University with the art historian Meyer Schapiro—often published writings and gave public lectures about the objectives of the New York School. His rhetoric was essential to the dissemination of many of the ideas and assumptions about abstract art in the 1940s and 1950s. Although his position as the de facto speaker for this loosely knit group was often contested by his contemporaries, his writings remain important sources of information about the movement.

3. Motherwell, "A Process of Painting," October 5, 1963, reprinted in Terenzio, *Collected Writings*, 139.

4. Motherwell practiced automatic drawing, a form of graphic free association used to bypass the conscious mind and open up new avenues for unexpected and unpredictable forms, off and on throughout his career, sometimes utilizing it directly in his painting and at other times mediating it through more controlled procedures, as is the case with *Interior with Pink Nude*.

5. Motherwell, preface, 83.

6. During and after World War II a mixture of existentialism, various forms of watered-down psychoanalytic theory, and anthropological discourse, often combined with a centrist political position, took hold in the United States and were popularized by the media. The art historian Michael Leja has called the resulting combination of a psychoanalytic reading of the internally fragmented condition of modern man with a more essentialist position of liberal optimism and universalism the "Modern Man discourse." See Leja, *Reframing Abstract Expressionism: Subjectivity and Painting in the 1940s* (New Haven, CT: Yale University Press, 1997).

7. *Life*, October 11, 1948, 78–79, cited in Leja, *Reframing Abstract Expressionism*, 3. The article included illustrations of artworks by Picasso, Joan Miró, Willem de Kooning, Adolph Gottlieb, Pollock, and Baziotes.

8. The Museum of Modern Art in New York and its support of the European avant-garde were an extremely important reference point for many American artists. For instance, the Museum of Modern Art mounted retrospectives of both Picasso, in 1946, and Matisse, in 1951. Motherwell was well versed in the work of these Europeans and in their writings and manifestos in particular; since 1944 he had edited the Documents of Modern Art series, which famously included *The Dada Painters and Poets: An Anthology* (1951), the first anthology of Dada literature in English.

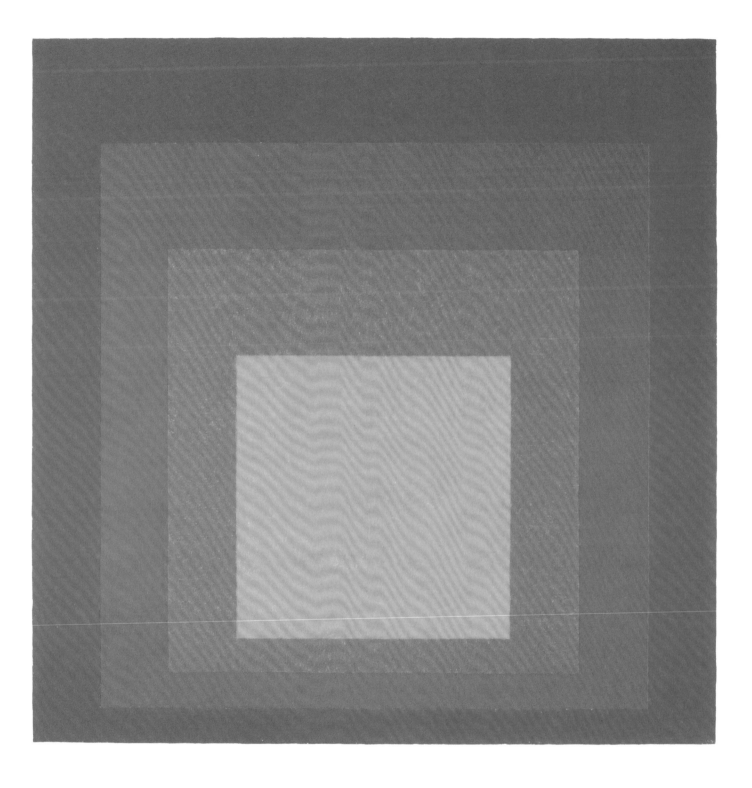

Homage to the Square: Aurora, 1951–55

Oil on Masonite, 40 ¹/₈ × 40 ¹/₂"
University purchase, Bixby Fund, 1966

Josef Albers

(American, b. Germany, 1888–1976)

Homage to the Square: Aurora, 1951–55

IN 1963 JOSEF ALBERS published his *Interaction of Color*, representing one of the few serious analytical attempts by a twentieth-century artist to revise and extend existing color theory.[1] As stated in the publication's introduction, it represents the artist's articulation of "an experimental way of studying and of teaching color," placing experiential practice before academic theory. Albers continues: "In visual perception a color is almost never seen as it really is—as it physically is. This fact makes color the most relative medium in art. In order to use color effectively it is necessary to recognize that color deceives continually."[2] The essential instability of color, which Albers described as "the discrepancy between the physical fact and the psychological effect" of a work of art, was repeatedly manifested in his seminal series Homage to the Square (1950–76). This series of abstract paintings and prints has often been seen as the culmination of Albers's experimentation with color and light, a central focus throughout his career as an artist and teacher. In works such as *Homage to the Square: Aurora* and throughout the series, Albers negotiated the opposition between the physical materiality and subjective phenomena of color.

Albers painted more than one thousand Homage to the Square works during the last twenty-six years of his life, and many more were produced as lithographs and screen prints. Albers often used oil paint straight from the manufacturer's tube, precisely applying thin coats with a palette knife to the rough side of a Masonite panel. He carefully recorded the technical details of each painting on the back of the panel, including the dimensions, the names of the paints used, and any varnishes or other materials applied to the surface of the painting. Through the self-imposed restriction of the square and his methodical articulation of color, Albers's work

moves against acknowledging the personal, expressive hand of the artist.

This tendency toward objectivity, however, is complicated by the paintings' strong "psychic effect," as Albers referred to it. For each arrangement of superimposed squares, the artist selected and positioned colors based on their interactions and "relationality."[3] In *Aurora*, the colors migrate across their borders; while they do not physically overlap in the painting, a slight unevenness at the edges heightens the ability of the colors to jump across these boundaries. Strong contrasts between hues—as well as alternating squares of light reflection and light absorption—draw our attention to the edges as "hot points" of activity.[4] As contrasting hues interact, the color of an inner square jumps toward the outer boundary of the next square out, and vice versa. For instance, the yellow of the innermost square can be perceived along the outermost boundary of the gray square, and likewise with other color relations throughout the painting. Through this performance of color, combined with the slightly reflective surface of some of the alternating squares, the luminescent colors seem to glow and emit their own light. The vertical asymmetry in the composition also suggests movement among the colored squares, with the blue square receding and the yellow square projecting forward in a telescopic manner.

As the viewer enters into a dialogue with Albers's Homage paintings, these color interactions exceed the material form of the artwork. "Painting is color acting," Albers wrote. "The act is to change character and behavior, mood and tempo."[5] The Homage paintings engage the viewer's process and understanding of visual perception, presenting ambivalent forms that demand from the viewer different decisions. Albers noted, "Some spectators are led to notice their preferred color or colors first. Others begin with 'firsts' in quality (i.e., high intensities in light and hue) or 'firsts' in quantity, measured either by extension or recurrence. . . . When it comes to reading advancing and receding color, there will rarely be agreement—regardless of

convincing decisions offered by theories based on color temperature or wave length."[6]

A major source of inspiration for Albers's treatment of color as subjective phenomena was Goethe's 1810 *Farbenlehre* (Study of color), adapted at the Bauhaus (where Albers was both a student and a teacher) through Johannes Itten's own teaching and experiments with color.[7] Of particular interested to Albers was Goethe's examination of the phenomenon known as "simultaneous contrast"—the tendency of colors to shift based on their adjacent surroundings. Albers capitalized on the human response to these color relationships, evoking philosophical, expressive, or emotional reactions to color.[8] In later works in the Homage series, he used closely related hues of the same color, requiring a more extended period of contemplation from the viewer.

Albers certainly placed an emphasis on the autonomy of color and its pure perception in the eyes of the spectator. As described by Achim Borchardt-Hume, the Homage series "annihilates anything beyond itself" and "exists only in the here and now of visual experience."[9] Yet at the same time Albers also directed the material facts of the painting to preface and advance a particular subjective response, and the artist himself became an active player in this game of artistic activity. In *Aurora*, the notes on the back of the panel record Albers's path in creating this painting, including his mixing of some paint colors, layering of paint and varnish, and later overpainting with additional color and varnish.[10] While these notes are not available to the viewer, his elaborate and instrumental process acts to govern the range of effects that can be culled from this particular painting.

Furthermore, Albers assigned his own descriptive subtitles for many of the works in this series after they were completed. In addition to *Aurora*, subtitles such as *Apparition*, *Kind Regards*, *New Hope*, and *Tranquil* suggest and reinforce certain transcendental or meditative responses in the viewer. *Aurora* references the Roman goddess of the dawn and generates associations with the warm glow of a morning sunrise. *Homage to the Square: Aurora* is a prime example of an Homage that achieves an

unexpected spiritual or mythological ambiguity. Yet for other works Albers provided subtitles such as *Saturated*, *Saturated II*, *R III-a 6*, and *R I c-i*, countering the transcendental associations these paintings evoke with an emphasis on the formal "facts" of color and manufacturer's codes. This constant flux between the objective and subjective characteristics of color defines the core of Albers's project to translate the instability of color into artistic form.

Through his Homage series Albers established an unresolved dialogue between the material facts of the painting (nested squares, oil paint, manufactured colors) and its expressive subjectivity—between "the physical fact" and "the psychic effect." On our initial perception of these works, we create the conditions for an exchange in much the same way that we return a serve in a game of tennis (to borrow a metaphor from Nicolas Bourriaud).[11] The perceptual exercises in Albers's series experiment with and complicate the relationship between artist, artwork, and audience, drawing attention to this relationality within the reduced format of strict geometry and color.

Michael Murawski

Notes

First published April 2007

1. Achim Borchardt-Hume, "Two Bauhaus Histories," in *Albers and Moholy-Nagy: From the Bauhaus to the New World*, ed. Achim Borchardt-Hume (New Haven, CT: Yale University Press, 2006), 71.

2. Josef Albers, *Interaction of Color*, rev. ed. (New Haven, CT: Yale University Press, 2006), 1.

3. Hal Foster, "The Bauhaus Idea in America," in Borchardt-Hume, *Albers and Moholy-Nagy*, 99. In this essay Foster claims that this "attention to 'relationality' is key to both Albers's practice and his pedagogy; it might well qualify as his version of the Bauhaus idea."

4. Margit Rowell, "On Albers' Color," *Artforum* 10 (January 1972): 26.

5. Josef Albers, in *Josef Albers: Formulation Articulation* (London: Thames & Hudson, 2006), portfolio II: 29.

6. Ibid., portfolio I: 5.

7. Itten is assumed to have taught color in the basic course from 1919 to 1923, and then Paul Klee and Wassily Kandinsky taught color after Itten's departure in 1923. Both Itten and Kandinsky examined the various effects of color through exercises using the square-in-square format, which Albers adopted in his color courses in the United States. Color appears to have been dropped from the basic course entirely after the Bauhaus moved to Dessau in 1925. See John Gage, "Color in Western Art: An Issue?," *Art Bulletin* 72 (December 1990): 518–41. For more on Albers's color courses, see Frederick A. Horowitz and Brenda Danilowitz, *Josef Albers: To Open Eyes; The Bauhaus, Black Mountain, and Yale* (London: Phaidon, 2006).

8. See Nicholas Fox Weber, "The Artist as Alchemist," in *Josef Albers: A Retrospective* (New York: Solomon R. Guggenheim Museum and Abrams, 1988).

9. Borchardt-Hume, "Two Bauhaus Histories," 78.

10. In addition to Albers's notes written in black ink on the back of the panel during and at the end of its production (1951–55), there are also some notes written in pencil on the right side dated "Oct. '58." These notes provide the details of some overpainting that occurred to the yellow and green squares over the course of three years after the painting's "completion" in 1955.

11. Nicolas Bourriaud, *Relational Aesthetics*, trans. Simon Pleasance and Fronza Woods (Dijon, France: Presses du Réel, 2002), 23.

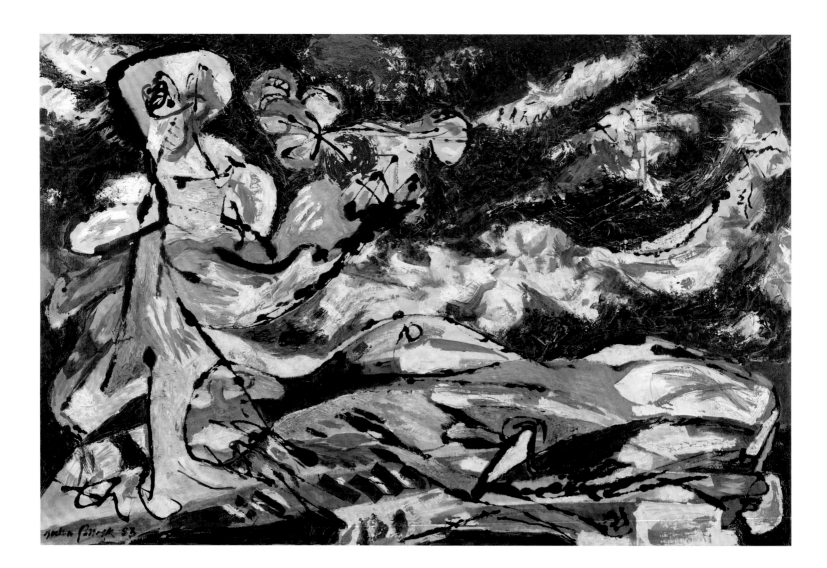

Sleeping Effort, 1953

Oil and enamel on canvas, 49 7/8 × 76"
University purchase, Bixby Fund, 1954

the canvas with it, daubing and swabbing color and scratching through the paint surface with the end of his brush. Transitions between color areas are frequently awkward and uncertain, with a muddy gray laid on top of thinly painted orange and globs of pure white squeezed onto a static gray field. Pollock applied saturated blue—along with whites, creamy pinks, coppery oranges, grays, and metallic greens—over a pastel yellow ground, diluted to a thinness that allows the weave of the canvas to show through. This process, while resulting in shapes that oscillate between figural and spatial allusions in a manner that renders the structure of the forms themselves ambiguous, nonetheless contrasts with his poured paintings, in which the relation between figure and ground disappears into a unitary visual field.

Sleeping Effort's fraught surfaces convey the anxiety associated with Pollock's return to this older visual language, burdened by his combative relationship with earlier art history. His poured paintings had clearly established his standing as an American originator of extraordinary technical and aesthetic power.[5] Retreating from his field paintings back into recognizable subject matter placed him directly in competition with his earlier masters—Pablo Picasso above all but also José Clemente Orozco and Joan Miró.

Pollock's ambivalent return to figural references was shared by other artists associated with New York School abstraction at midcentury. As the artist Elaine de Kooning (the wife of Willem de Kooning) pointed out, to submit to a representational language grounded in nature was to relinquish any claims to the autonomy of art, claims on which this generation had staked its unique position in history.[6] Central to this position was a release from historical precedent, part of a more general purge of all limiting conditions—narrative, inherited style, recognizability, and received iconography—on the potentially limitless freedom to which the American artist, in his newfound position at the forefront of modernism, laid claim. Pollock's now legendary pronouncement to Hans Hofmann, when asked about whether he painted from nature—"I am nature"—captures a moment of

visionary confidence that ultimately proved impossible for the artist to maintain.[7]

In the breakthrough poured works, Pollock's immersion in the fluidity of enamel paint—a medium with virtually no history of prior use in the fine arts—offered a temporary escape from this historical haunting, enabling an unburdened lyricism that, at its finest, conveyed a weightless freedom of movement, an immersion in the dance-like rhythms of his body in the act of painting.[8] In such moments Pollock seems to have escaped both history and artistic ego in a form of euphoric fusion with, as the artist Paul Brach stated, "the forces of nature."[9] This quality of lyricism is evident not only in the airy, uncongested skeins of paint but also in the dance of figure and ground that characterizes his most fully realized poured works. If occasionally an index of the artist reasserts itself, as in the handprints Pollock left in paintings such as *Number One* (1948), it is little more than a faint echo of the artist's voice, emerging out of the paint like the handprints on the walls of Neolithic caves, which held such interest for this generation.[10] The movement from the pure dispersed energy of the poured paintings to the abstracted figural forms of Pollock's late oil paintings represents, I propose, a move from an activated energy field to the coalescence of cultural form, and from embodied sensation to cognition, memory, and identity, bringing with it a tortured awareness of self from which Pollock—for a few years—had fled into the undifferentiated and immersive field of his poured paintings. Figural forms activated a region of his consciousness that troubled his fleeting sense of accommodation to the world.

Indeed Pollock's shifting psychic state seems to have been strikingly aligned with his changing relationship to figural representation. According to Jeffrey Potter, the painter Alfonso Ossorio recalled that when his friend Pollock wasn't drinking, his work "tended to be wholly abstract," but when he was drinking, "figures would appear." Alcohol, as Potter remarked, seemed to have been linked in Pollock's painting "to memory": the discipline required for him to hold to "the products of the unconscious"—the fields of his poured paintings—was lost when he drank, releasing

Jackson Pollock

(American, 1912–1956)

Sleeping Effort, 1953

JACKSON POLLOCK'S *Sleeping Effort* of 1953 is a late work by the artist, evidence of his return to figural references following the poured paintings of 1947–51, which brought him considerable fame. The focus of the composition is a central serpentine or odalisque-like form that unfolds on the right side of the canvas into an area suggestive of a landscape, including hills and a deep blue sky. Other forms seem to rise out of the reclining body, metamorphosing into fishlike, birdlike, and flowery petallike forms that hover midway between landscape and woman.[1] With gaudy overstatement, Pollock reprised two of the central themes of Western art—body and landscape—now, however, troubling the boundaries between them.[2] *Sleeping Effort* moves unsettlingly back and forth between references to body and nature, never resolving into stable figure-ground relationships. The fluid and open shapes suggest a universe of forms in flux, yet they also convey—in their grating masklike allusions, their awkward paint application, and their garish palette outlined in black—a suggestion of psychic unease, even violence.

Pollock's return to the figural and the allusive was bound up with a return to older methods of mark-making, substituting the paintbrush and palette knife for trowels, basters, sticks, and knives.[3] Though he painted the work mainly in oil, he also evidently placed the canvas on the floor, where the fluid black enamel paint that he used to create rough outlines of the main figures would not run. He also created drips and spatters with this more fluid paint, the physical properties of which were essential to his earlier drip style. Here, though, his primary use of a viscous and clotted oil paint brings with it a sense of material entanglement with a more resistant and difficult medium.[4] Pollock alternately squeezed pure pigment onto the canvas and ran a scraper over the surface in places; he also swept his brush across the canvas in decisive strokes or scrubbed

the more ready memories and reflexive habits that drew him back to the figure.[11] This was a curious inversion of the Surrealist effort to subvert the censoring mechanisms of the conscious mind through such processes as automatism. In Pollock's case, accessing the unfettered energies of the unconscious was an act of discipline, involving the repression of the more insistent contents of the conscious mind.

And yet, despite apparently achieving "pure" abstraction in his poured paintings, Pollock struggled with the hold of the figure over his artistic language throughout his career. As Ossorio recalled, "Jackson often started with a figure and veiled it with linear patterns."[12] The artist Lee Krasner, Pollock's wife, observed that figural allusions in his work existed on a continuum with his abstractions, with all his work evolving from his powerful figural paintings of the mid-1930s: "I see no more sharp breaks, but rather a continuing development of the same themes and obsessions." Krasner also observed that Pollock's monumental drawn paintings in black and white "began with more or less recognizable imagery—heads, parts of the body, fantastic creatures." Prior to 1951, when such apparitions appeared in Pollock's art, he chose to veil them, but in his work after his poured paintings, "he chose mostly to expose the imagery."[13] Even in the poured work, according to Mervin Jules, figural elements would appear to Pollock, who, inspired by the story of Leonardo da Vinci finding images in clouds and blots on the wall, used them as stimuli.[14]

Pollock's return to the figural brought with it not only a return to the fraught field of art history—with its limiting conditions on the freedom of the artist—but also to his own struggle to surpass the example of such earlier figures as Picasso. It also triggered—via a stream of metaphoric linkages—associations with his own youthful emergence into a beleaguered selfhood, a process in which masculine individuation out of the emotionally adhesive—and in his case viscous—matrix of the family was hard-won. Pollock's intimates have testified repeatedly to his extreme swings between a quasi-pantheistic embrace of elemental natural energies and his sense of spiritual homelessness and unbelonging. Such pantheism not only reflected his reading and intellectual formation (he was devoted to the teachings of Carl Jung) but also provided a sense of relief from the psychic pressures of ego formation and the normative expectations concerning the coherence and unbreachable strength of the male ego.

Pollock's peculiar creative process seems to have mimicked the symptoms associated with a cognitive disorder known as aphasia, in which similar concepts, linked through resemblance, become interchangeable ("house" and "hut," "woman" and "nature"). His aphasia—if such it was—worked to encourage the slippage (both linguistic and, I would suggest, visual) between things already closely proximate within his psyche yet deprived of any defining context or framework that might maintain their distinction. Figural allusions recalled Pollock to an unstable field of intersubjective relations in which the boundaries between self and other became dangerously permeable. Without the emotional or psychological context of self-differentiation, the creative transmutation of forms into other forms—swelling hips into hills and horizon—pointed toward a psychic realm of dangerous fluidity, in which the universal principle of metamorphosis he explored with his Jungian analyst now threatened an already fragile sense of self. Pollock's deep emotional bonds with family members, in particular with his mother, Stella, were bound up with anxieties of suffocating intimacy. As Cile Downs recalled, Lee Krasner reported that the appearance of figural references troublingly reengaged for Pollock the image of his mother, which "came over him so strongly that he'd see her," causing him to withdraw from the image.[15] It is perhaps no coincidence that this period when Pollock returned to the figural also produced several explicit self-portraits, as if he were exploring the space within which an image of self could emerge from a buzzing universe of sensory immersion.

Part of a broader postwar generation of New York painters in flight from history, Pollock suffered from a crippling self-consciousness. The artists of the New York School found various unstable resolutions:

Apollonian withdrawal, negation, reabsorption, and transformation of historical legacies. Pollock found release in the alchemy of matter into energy. But by 1951 his aesthetic fluency would increasingly give way to clotted surfaces and acid colors that suggest—in a savagely parodic way—the impossibility of escaping history. The sheer excess of *Sleeping Effort*—with its vulgar pinks, automotive greens, and mutating forms—seems to bear out the critic Harold Rosenberg's observation in 1962 that the present generation, struggling with the feeling that the greatest work had been created in the past, was left with little more to do than merely reprise the modern tradition as "allusion, parody, and quotation."[16] Resisting the fully realized figure in space, Pollock created forms that reside uncertainly between figure and ground: one of the few recognizable forms in the painting is the grotesque cyclopean head with its monstrous single eye. Flesh meets bone; vision is blinded by the black blossom that pierces the eye. Echoing the swooping forms of Picasso's *Guernica* (1937), *Sleeping Effort*, in its stridency, exposes Pollock's sense of belatedness, thrown back on both history and the confines of his own psyche.

Angela Miller

Notes

First published March 2012

1. Steven Naifeh and Gregory White Smith, in their biography of Pollock, relate the work to "core memories" and to a return to the "biomorphic, semifigurative forms that had characterized his work of the early 1940s." See Naifeh and Smith, *Jackson Pollock: An American Saga* (Aiken, SC: Woodard/White, 1989), 725.

2. In 1951 Pollock made a black-and-white work that strikingly anticipated *Sleeping Effort*. This piece, titled *Number 14*, also used enamel paint. In *Number 14* the outline of hills on the right is more clearly traced, and some of the shapes found in *Sleeping Effort*, such as faces, are recognizable as well. If *Number 14* is indeed related to the thought process that gave rise to *Sleeping Effort*, it also suggests the process of formal transmutation whereby outlines generate associations with unrelated objects through visual resemblance. For instance, the petal form on the left side of *Sleeping Effort* relates visually to the flowerlike face on the right in the earlier work.

3. For more on his turn to these implements, see Pollock's own statement in *Possibilities* (1947–48), cited in *Jackson Pollock: Interviews, Articles, and Reviews*, ed. Pepe Karmel (New York: Abrams and Museum of Modern Art, 2000), 17–18.

4. Francis V. O'Connor and Eugene V. Thaw date this shift in method to 1953. See O'Connor and Thaw, *Jackson Pollock: A Catalogue Raisonné* (New Haven, CT: Yale University Press, 1978), 199.

5. On a good day Pollock ranked himself as one of the "only three painters," along with Henri Matisse and Pablo Picasso. See Jeffrey Potter, *To a Violent Grave: An Oral Biography on Jackson Pollock* (New York: Putnam, 1985), 234. Other commentators saw references to Wassily Kandinsky. See, for instance, Deborah Solomon, *Jackson Pollock: A Biography* (New York: Simon & Schuster, 1987), 239. For more on Pollock's influences, see B. H. Friedman on Pollock's admiration for Picasso's *Guernica*. Friedman, "An Interview with Lee Krasner Pollock," in *Jackson Pollock: Black and White* (New York: Marlborough-Gerson Gallery, 1969), 7. See also Patsy Southgate's memory of Pollock's hatred of French painting, a hatred based on his sense of intense competition with the School of Paris. Potter, *To a Violent Grave*, 188.

6. See Elaine de Kooning, "Subject: What, How, or Who?," in *The Spirit of Abstract Expressionism: Selected Writings*, ed. Marjorie Luyckx (New York: Braziller, 1994), 143. Elsewhere de Kooning said that the concept that "something totally new, not subject to any influence, *can* be created" was "ridiculous." See Selden Rodman, *Conversations with Artists* (New York: Devin-Adair, 1957), 77.

7. Pollock himself elsewhere acknowledged the importance of history to the evolution of modernism, saying in a 1950 interview that modern art "didn't drop out of the blue; it's a part of a long tradition back with Cézanne, up through the cubists, the post-cubists, to the painting being done today." A transcription of the interview is published in O'Connor and Thaw, *Catalogue Raisonné*, 79–81.

8. Pollock's contemporaries commented frequently on the lightness conveyed by the artist's poured paintings. See, for instance, Frank O'Hara, *Jackson Pollock* (New York: Braziller, 1959), 21, 24, and passim. In the experimental workshop of David Siqueiros, which Pollock attended in the mid-1930s, students also experimented with new materials, such as nitrocellulous pigments used in the automotive industry, though they did not use enamel paints. Siqueiros used Duco enamels in his own work. See Laurence P. Hurlburt, "The Siqueiros Experimental Workshop: New York, 1936," *Art Journal* 35 (Spring 1976): 237–46.

9. Paul Brach, "Laocoon in the Water Lilies," *Art in America* 87 (May 1999): 115.

10. For more on this fascination with prehistoric painting, see Philip Pavia, *The Club without Walls: Selections from the Journals of Philip Pavia*, ed. Natalie Edgar (New York: Midmarch Arts, 2007), 51.

11. See Potter, *To a Violent Grave*, 134.

12. Alfonso Ossorio, in Potter, *To a Violent Grave*, 148.

13. Krasner, in "Interview with Lee Krasner Pollock," 7. Alfonso Ossorio also dismissed distinctions between figurative and nonrepresentational art in Pollock's work. See Potter, *To a Violent Grave*, 147. Fritz Bultman recalled that "the image was central to Jackson and everything that grew from it" (ibid., 148). See also O'Connor and Thaw, *Catalogue Raisonné*, viii.

14. Jules misidentified the artist as Michelangelo rather than Leonardo; see Potter, *To a Violent Grave*, 99. For more on figuration as the origin of Pollock's abstractions, see Peter Wollen, "The Triumph of American Painting: 'A Rotten Rebel from Russia,'" in *Raiding the Icebox: Reflections on Twentieth-Century Culture* (Bloomington: Indiana University Press, 1993), 98. According to Wollen, Pollock's mural for Peggy Guggenheim originated in a very specific memory of landscape and of the West—wild horses stampeding across the plains—which he then disguised or suppressed, in Wollen's words, through "'automatic' scrawlings-through and overpainting."

15. Cile Downs in conversation with Lee Krasner, in Potter, *To a Violent Grave*, 204. For a similar suggestion that the poured paintings concealed figural references to mother or father, see T. J. Clark, "The Unhappy Consciousness," in *Farewell to an Idea: Episodes from a History of Modernism* (New Haven, CT: Yale University Press, 1999), 300.

16. Harold Rosenberg, *Arshile Gorky: The Man, the Time, the Idea* (New York: Sheepmeadow, 1962), 61.

Willem de Kooning

(American, b. Netherlands, 1904–1997)

Saturday Night, 1956

EXECUTED IN 1956, Willem de Kooning's *Saturday Night* is a canvas full of frenetic painterly activity. Befitting the title's associations with a night out on the town, the painting's brushstrokes and planes of colors articulate a simultaneously sensual and dissonant cacophony. Thomas Hess, de Kooning's most perceptive critic, picked up on this urban vibe, labeling this and similar paintings from 1956 "abstract urban landscapes."[1] He perceived the grimy, chaotic streets of New York in these paintings. Other de Kooning titles from the period explicitly reference the urban world of cheap detective novels and film noir: *Gotham News*, *Street Corner Incident*, *Police Gazette*.[2]

This glimmer of the popular world of urban kitsch is important to *Saturday Night*, as it challenges the usual seriousness of 1950s discussions about Abstract Expressionism, the movement with which de Kooning is usually associated.[3] While *Saturday Night* declaims its status as a painting with its emphasis on mauled and stretched pigment, it is also a canvas that seems to negate elevated notions of painting, or at least the expectations of authenticity tied to the medium in the 1950s. At this time, critics viewed abstract painting largely as a vehicle for the unmediated expression of the existential artist—an utterance outside of societal and mass-cultural influences. The importance of *Saturday Night* lies in the ways in which de Kooning turned this view against itself, how he employed the syntax of Abstract Expressionism in order to demonstrate its limitations. By deemphasizing the handmade nature of his marks, he suggested that such gestural painting, which was considered emblematic of direct, subjective experience, is at best a fragmentary mode of expression. It is always mediated, always embedded within a larger social field. The artist conveys this embeddedness, an idea antithetical to the high modernist tradition, by finding a way to

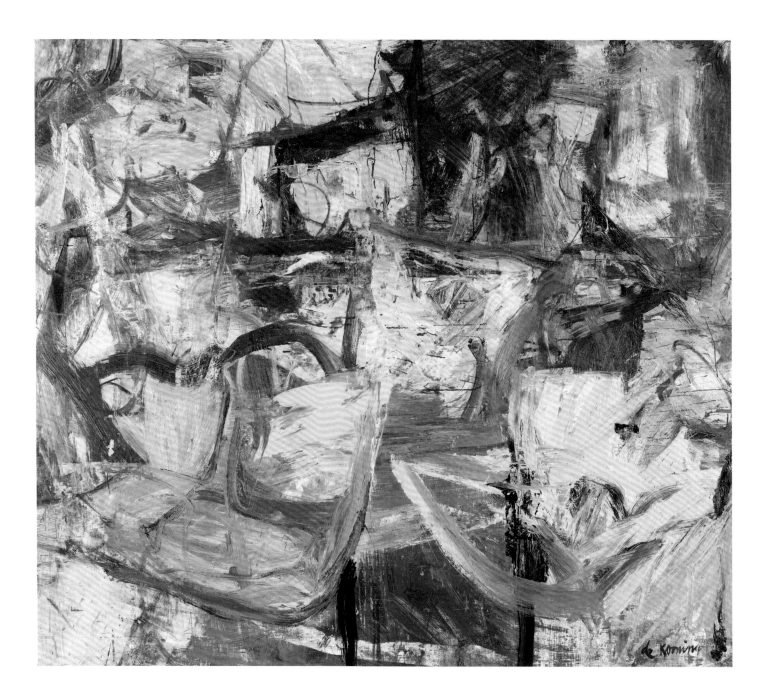

Saturday Night, 1956

Oil on canvas, 68 $^3/_4$ × 79"

University purchase, Bixby Fund, 1956

visually approximate the debased and deferred pleasures of the city. In a sense, de Kooning is "slumming it" within the language of high modernism. As such, *Saturday Night* is a 1950s hybrid—stuck between the humorless existential rhetoric of Harold Rosenberg's notion of "action painting" and the glib, acculturated utterances of Robert Rauschenberg and Andy Warhol, both of whom incorporated found images from the media into their work.[4]

Despite de Kooning's reputation as an expressionist painter who makes marks, subtraction is an equally important gesture in his repertoire. For instance, he would often drag a scraper or other edge across his painted surfaces, thus stripping his brushstrokes of their immediacy and friction. The top right quadrant of *Saturday Night* dramatizes such a negation of the artist's hand. De Kooning scraped down the prominent red passage until it reads as flat and semitransparent. The artist also blended the area to the right of this red passage—with its green, blue, and white patches—under a unifying haze. As such, these areas appear mediated, almost as if they are photographic reproductions of brushstrokes.[5] Such scraped and flattened passages occur throughout *Saturday Night*. One small passage, however, is the exception that proves the rule: an oval of heavily impastoed black and white pigment, located just above and to the right of the painting's center. If a memento mori is an object in a painting that prompts thoughts of death (a skull in a still life, for instance), then this particular passage serves as a memento mori in reverse. By reminding viewers of Abstract Expressionism's vitality, tactility, and viscosity, this glob of paint emphasizes the mediation and flatness of the rest of the painting.

Throughout his career de Kooning also employed strategies of collage to mock painting's singular authenticity, and *Saturday Night* appears as such a collection of separate parts.[6] This process of painterly collage is not unrelated to his gestures of removal. For instance, he isolated the impastoed oval, detaching it from its surroundings by scraping away paint. This is comparable to cutting out material from a source; both actions create the appearance of a fractured surface. Furthermore, de Kooning's studio practice was based on a collage aesthetic. At any given time the artist had a number of smaller drawings and oil sketches lying around his working area. He would often temporarily attach one of these examples to a larger painting, use this new element to rethink and change the canvas's overall composition, and then remove the drawing. Of course, such a process created disjunctive pictorial effects.[7] The blue line that begins to define an organic form in the lower left of the picture might well be one such passage. Additionally, de Kooning masked and covered elements within his paintings, thereby creating hard edges and awkward transitions. The pink stripe floating just beneath the blue sea of pigment at the painting's bottom, as well as the way in which dashing brushstrokes halt along straight lines, dramatizes the complex processes through which the artist manipulated his painted surface. For de Kooning, painting was like collage: disjunctive and additive.

Despite the literal and figurative removal associated with de Kooning's aesthetics of subtraction and collage, the painting's energy and frenzy still convey a carnal sexuality. In the years leading up to his urban abstractions in the mid-1950s, de Kooning was primarily painting images of women, the most famous being *Woman I* (1950–52). He worked on this particular canvas on and off for more than two years—repeatedly painting, scraping down the canvas, and repainting. The end result shows its age and offers viewers something residing between an ancient fertility god and a brazen pin-up, rendered in the type of frenetic brushstrokes visible in *Saturday Night*. The latter work, despite its lack of an identifiable woman, is likewise a sensual painting with its orgiastic frenzy, organic curves, and fleshy pink hues. So although de Kooning violently fractured and dispersed one of his canonical women across the surface of *Saturday Night*, her radically abstracted parts nevertheless maintain a sense of carnality.

Saturday Night's flatness and collage elements clearly converse with Cubism, a movement that de Kooning admired.[8] Furthermore, many of the

most important Cubist works are in fact portraits of women—Pablo Picasso's *Ma Jolie* (1912), for instance. Some critics have interpreted this painting as a flattened, angular representation of Picasso's lover that is drained of three-dimensional, curvy carnality; she is more diagram than portrait.[9] In emulation of Cubist practice, *Saturday Night* is also organized around a loose grid; two black vertical lines anchor both the painting's top and bottom portions, providing a foil for the many horizontal brushstrokes. Yet with the painting's fleshy and frenzied sexuality, de Kooning could reclaim a paradoxical sense of Cubist lustfulness; he could have the loose, diagrammatic grid of Cubism *and* a debased eroticism.

Ultimately *Saturday Night* dramatizes a sexist urban visuality—a flat, disjunctive site of dispersed and deferred desire. The painting can approximate a momentary glimpse of a fetishized body part, whether spotted on a crowded city bus or on the street, whether real or in an advertisement. For the artist the city is a place of artificial and collaged desires, and *Saturday Night*'s cool blues and fleshy pinks—collaged together into a flat, chaotic field— suggest this experience. Even de Kooning's Cubist grid seems to be in a hurry. By reorienting the canvas to make his painterly drips move from right to left (thus defying gravity), the artist suggested the mobility of the viewer or the painting itself. Despite its stasis on the gallery wall, the painting always threatens to slide out of view.

In 1960 de Kooning declared, "content is a glimpse," thus acknowledging the fleeting qualities of imagery in his paintings.[10] *Saturday Night* is obsessed with such glimpses but ultimately dramatizes a frustrated and frenzied urban vision. While in dialogue with the action painting of Jackson Pollock, the canvas also crosses over into the world of everyday life, comparable to Rauschenberg's use of found images in his combine paintings from the 1950s or Warhol's blurry photographic silk screens from the early 1960s. If the latter two artists used photography as a kind of brushstroke, de Kooning's work in a sense allows for brushstrokes to take on qualities of photography—at a slight remove from reality and

its immediacy. With *Saturday Night*, the artist both speaks the language of Abstract Expressionism and negates it. As such, the painting looks both inward and outward—back to modernist notions of authenticity and autonomy and forward to postmodern ideas of fragmentation and mediation.

John J. Curley

Notes

First published April 2008

1. Thomas B. Hess, *Willem de Kooning* (New York: Museum of Modern Art, 1968), 103.

2. See Mark Stevens and Annalyn Swan, *De Kooning: An American Master* (New York: Knopf, 2004), 378.

3. David Sylvester refers to de Kooning as a "post-Abstract-Expressionist." See David Sylvester, "Flesh Was the Reason," in *Willem de Kooning: Paintings*, ed. Marla Prather (Washington, DC: National Gallery of Art; New Haven, CT: Yale University Press, 1994), 15–31, esp. 26.

4. On action painting, see Harold Rosenberg, "The American Action Painters," *Art News* 51 (December 1952): 22–23.

5. These mediated passages operate in a way similar to the found photographic images arranged under gauze or scrim in the "combine" paintings of Robert Rauschenberg. Rosalind Krauss has described these as akin to "a splinter under the skin." Rosalind Krauss, "Rauschenberg and the Materialized Image," *Artforum* 12 (December 1974): 36-43.

6. Formerly a sign painter in the 1930s and 1940s, de Kooning incorporated painted letters and other letter-like forms into his paintings of the late 1940s, such as *Zurich* (1947). Despite their hand-painted nature, these appropriated letters acknowledge collage traditions. In other paintings from 1956, de Kooning employed a technique of newspaper transfer: he placed a sheet of newspaper flush onto the canvas's wet paint and removed it, thus leaving faint traces of the original sheet's text and images embedded in the pigment. Such a gesture refers back to Picasso's first collages from 1912.

7. See Richard Shiff, "Water and Lipstick: De Kooning in Transition," in Prather, *Willem de Kooning*, 33–73, esp. 54. Additionally, the cover of Mark Stevens and Annalyn Swan's de Kooning biography (see note 2 above) features the artist standing in front of a collage of painted fragments.

8. In 1951 de Kooning said, "Of all movements, I like Cubism most. It had that wonderful unsure atmosphere of reflection." Willem de Kooning, "What Abstract Art Means to Me" (1951), reprinted in *Willem de Kooning: Pittsburgh International Series* (Pittsburgh: Carnegie Museum of Art, 1979), 23.

9. Rosalind Krauss, "The Motivation of the Sign," in *Picasso and Braque: A Symposium*, ed. Lynn Zelevansky and William Rubin (New York: Museum of Modern Art, 1992), 269.

10. A text derived from an interview with David Sylvester conducted in 1960 is thus titled. See Willem de Kooning, "Content Is a Glimpse" (1963), reprinted in *Pittsburgh International Series*.

Jean Dubuffet

(French, 1901–1985)

Poches aux yeux (*Bags under the Eyes*),1959

Tête barbue (*Bearded Head*), 1959

JEAN DUBUFFET'S SCULPTURES *Tête barbue* (*Bearded Head*) and *Poches aux yeux* (*Bags under the Eyes*) follow his practice of making intentionally childlike, humorous, and even scatological art. *Tête barbue* is made from a piece of driftwood that the artist found on the beach in the Côte d'Azur. Attracted by the object's natural resemblance to a human head, and in particular the barnacle-like protrusions that suggest hair and a beard, the artist burned holes for eyes and a nose and then placed it upright on a pedestal, elevating the lowly object to the level of fine art. Not much bigger than an actual head, the little wooden sculpture seems to equivocate between the banality of a child's plaything and a more bothersome sensation caused by the unsightly knobs and bumps that spread across the face and head. *Poches aux yeux* also vacillates between prosaic charm and visceral ugliness. Here, using the craft technique of papier-mâché instead of a found object, the artist shaped and formed an elongated and flattened head. With judicious incisions, he accentuated the ridges and folds of the crumpled newspaper, making long cracks around the eyes, nose, and mouth and forming bags under the eyes. He then rubbed the sculpture with black shoe polish, giving its surface a scuffed and worn-out appearance. Made of ephemeral materials, both sculptures are fragile, unstable little objects that speak to Dubuffet's desire to undermine traditional notions of the accepted monumentality of sculpture while also commenting on the disposable, commodity-driven nature of life in 1950s France.

These sculptures are part of a larger series that Dubuffet began in 1954 titled *Petites statues de la vie précaire* (*Little statues of precarious life*), made from diverse and nontraditional materials such as newspaper, cinders, steel wool, sponges, and found objects, which he scavenged for in places as varied as neighborhood waste

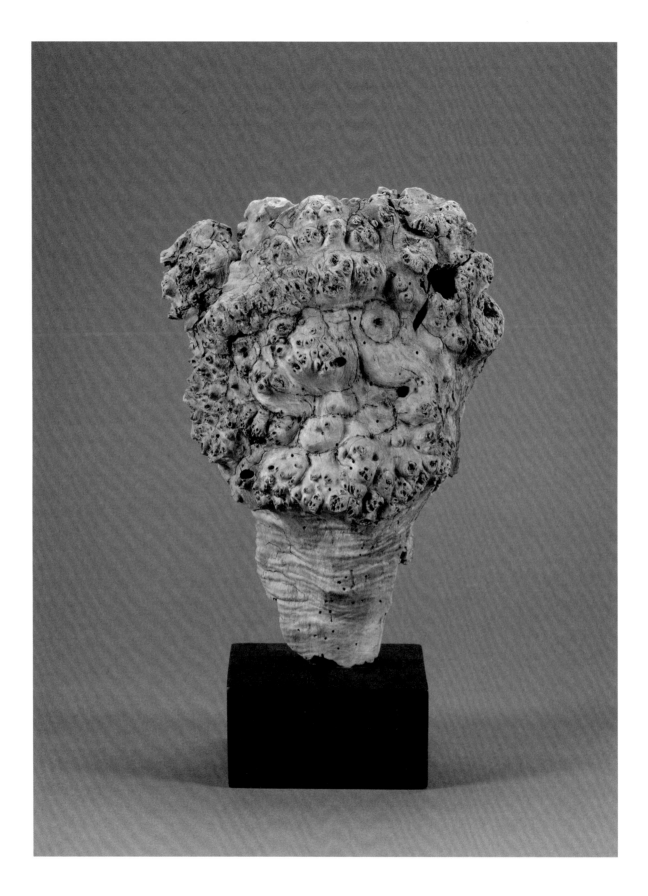

Tête barbue (*Bearded Head*), 1959

Driftwood, 11 $1/8$ × 8 $1/2$ × 4"

Gift of Florence S. Weil, 1982

bins, steam locomotive depots, and even the garage where he parked his car. Between October 1959 and November 1960 Dubuffet made a second group of sculptures in which he used not only found debris but also papier-mâché and common household materials such as crumpled and torn aluminum foil, floor wax, and shoe polish.[1] In a letter written to his friend the Surrealist writer André Pieyre de Mandiargues in 1960, the artist explained how he made the works:

> The little statues are merely papier-mâché (newspapers crudely torn, soaked, and molded with glue, forming a paste that I then dye en masse with colored inks). In certain cases the statues remained as they were (and it is these that I prefer); this forms a barbarous material, nonhomogeneous, endowed with expression; in other cases, once they have dried and hardened, they have been more or less rubbed with oil paint . . . and sometimes after that waxed with pure wax or with shoe polish (two of these which are at Berggruen's have been treated like old combat boots, these are "Le Cigare" and "Poches aux yeux"). Two or three have been covered with sheets of aluminum paper that has been crumpled and polished with oil paint.[2]

Here Dubuffet responds to his friend's curiosity with an air of matter-of-factness, emphasizing both the simplicity and rawness of his means of production and the lack of refinement with which he has treated his materials. He also hints at his more conceptual objectives—to create a barbarous, nonhomogeneous sculpture that, because of its unrefined nature, is endowed with a more "authentic" form of expression.

From the time he began actively making art around 1942, Dubuffet had set out to bring art down from its pedestal, so to speak, rejecting the established notions of taste, skill, and beauty that

he felt were at the core of Western culture. Some of the alternative models for his approach to art were the work of the mentally ill as well as tribal, naive, and folk art, which he compiled under the rubric *art brut*.[3] Dubuffet coined the term to describe a type of crude or raw art made by individuals "unscathed by artistic culture." For the first exhibition of *art brut* in 1949, much of which came from the artist's personal collection, he wrote his best-known text on the subject, defining the "brut" artist as one who was by nature free from all convention: "These artists derive everything—subjects, choice of materials, means of transposition, rhythms, styles of writing, etc.—from their own depths, and not from the conceptions of classical or fashionable art. We are witness here to a completely pure artistic operation, raw, brute, and entirely reinvented in all of its phases solely by means of the artist's own impulses."[4] Although Dubuffet, by his own definition, was not a maker of *art brut*, he embraced its outsider position and transgressive procedures—caricature, humor, and untutored crudeness, to name a few—as an alternative to what he saw as the stultifying, deadening effects of an outdated fine arts tradition.

Indeed, the *Petites statues de la vie précaire* utilize not only the naive materials of *art brut* but also, and perhaps more importantly, the distortions of the body common to the genre, including grossly enlarged facial features and crudely rendered, flattened bodies. With these statues the artist's attack on culture coalesces around the figure, more particularly the face and head, the traditional sources of psychological expression. The titles of some of the works in the series do, in fact, point to inner emotion: for example, *Le fanfaron* (*The Boaster*), *Le boudeur* (*The Sulker*), *L'étonné* (*The Surprised One*), *Le funébreux* (*The Gloomy One*), or even more obliquely *Poches aux yeux* (*Bags under the Eyes*). But rather than being the outcome of careful mimetic rendering and traditional descriptive artistic practices, or even a more modern form of gestural expressionism, these emotions are suggested by the disfiguring outcomes of the haphazard application of papier-mâché or crumpled tinfoil or simply by the chance operations

of nature on a piece of wood. In short, they are "found" emotions, having nothing to do with the traditional values of authenticity and genuineness associated with the marks left by the artist's hand on the raw sculptural material.[5] Dubuffet's emphasis on facial expression also recalls the tradition of the *tête d'expression* or *tête de caractère*, a form of figure painting that emerged in the eighteenth century but was prevalent in academic practice throughout the nineteenth and even into the early twentieth century, appearing frequently in the Salons. These were almost always depictions of life-size heads, representing simple passions such as fear, anger, or joy and titled as such. Dubuffet's sculptures, however, call this academic practice into question by replacing it with caricature and exaggeration as well as banal and untutored artistic techniques that are more common in the art of children or the insane than they are in the fine arts tradition of portraiture.

In 1960, on the occasion of a small retrospective of his work at the World House Galleries in New York, Dubuffet published one of his best-known explanations of his own work, titled "Anticultural Positions." He argued that a revolution was occurring in art that promised the complete liquidation of humanism and the dead language that was culture of the West.[6] For the artist, this transformation was to come from everyday life: "For myself, I aim for an art which would be in immediate connection with daily life, an art which would start from this daily life, and which would be a very direct and very sincere expression of our real life and our real moods."[7] Seen in this light, Dubuffet's emphasis on disposable materials and his practice of de-skilling might be seen as the flip side of the heroism and existential angst associated with postwar gestural abstraction. In its place, he offers a new "humanism," one conditioned by nothing more serious than bearded heads and bags under the eyes. Indeed Dubuffet's provocative celebration of a precarious art that emphasized values such as extreme contingency, antimonumentality, ugliness, lack of skill, and a preoccupation with base gestures such as smearing and smudging was

a successful deflation of much of the seriousness of artistic politicking in postwar Paris.

Karen K. Butler

Notes

First published December 2009

1. The first series of statues created in 1954 consisted of forty-four sculptures. The second related group of thirty-two sculptures, also referred to as *Petites statues de la vie précaire*, was made between October 1959 and November 1960. *Tête barbue* and *Poches aux yeux*, both made in December 1959, are part of this second group of statues. For a discussion of these works, see Max Loreau, *Catalogue des travaux de Jean Dubuffet: Fasc. XVII, Matériologies* (Lausanne, Switzerland: Weber, 1969), and Andreas Franzke, *Jean Dubuffet: Petites statues de la vie précaire* (Bern, Switzerland: Gachnang & Springer, 1988).

2. Jean Dubuffet to André Pieyre de Mandiargues, May 13, 1960, in *Prospectus et tous écrits suivants*, vol. 2 (Paris: Gallimard, 1967), 449 (translation mine). Dubuffet's letter is written in response to a letter from Pieyre de Mandiargues in which he asks how the artist made the *Petites statues*. See letter dated May 8, 1960, cited in *Dubuffet* (Paris: Editions du Centre Pompidou, 2001), 385. A selection of these little statues, including *Poches aux yeux*, was exhibited with Dubuffet's lithograph series *Phénomènes* at the Galerie Berggruen in Paris, although the sculptures are not listed in the catalog. See *Jean Dubuffet: Lithographies, Série des Phénomènes* (Paris: Berggruen & Cie, 1960).

3. In 1948—along with André Breton, Jean Paulhan, Charles Ratton, Henri-Pierre Roché, and Michel Tapié, among others—he formed the Compagnie de l'Art Brut, a group of individuals devoted to collecting and exhibiting this kind of art. The first exhibition of *art brut* (approximately two hundred works by sixty-three artists) was held in October 1949 at the contrastingly elegant Galerie René Drouin on the Place Vendôme in Paris.

4. Jean Dubuffet, "Art Brut in Preference to the Cultural Arts" (1949), trans. Paul Foss and Allen S. Weiss, *Art and Text* 27 (December–February 1988): 31–33.

5. In comparison one might think of Rodin's more refined and traditional sculptures, in which expression comes from the artist's touch on a clay model and from the brilliant patina of the centuries-old tradition of bronze casting.

6. See Jean Dubuffet, "Anticultural Positions," in *J. Dubuffet* (New York: World House Galleries, 1960), n.p. This is the text of a lecture given by Dubuffet at the Arts Club of Chicago in December 1951. The exhibition included *Tête barbue*, which is number 40 on the checklist.

7. Ibid., n.p.

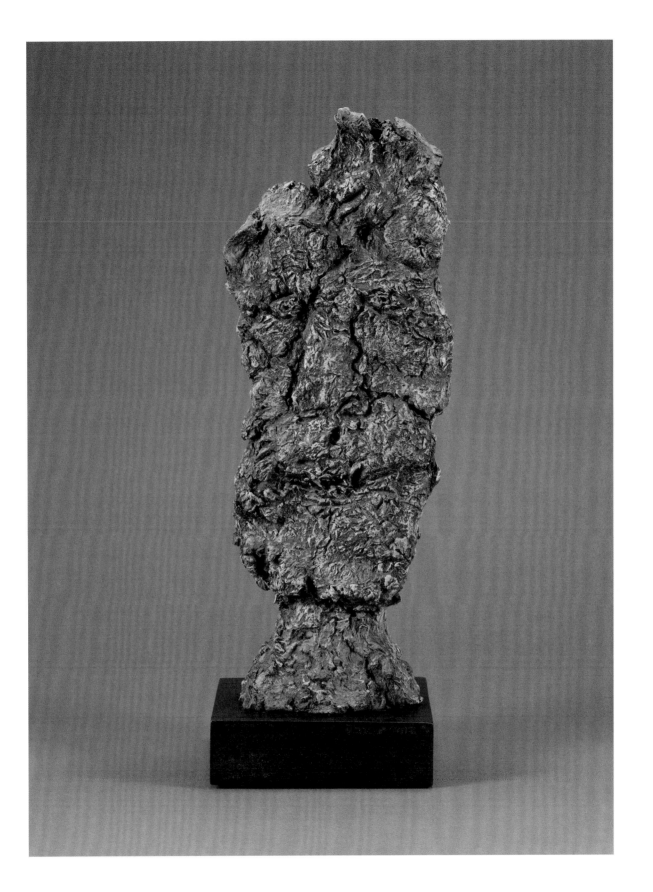

Poches aux yeux (*Bags under the Eyes*), 1959

Papier-mâché, 18 $^5/_8$ × 7 $^1/_{16}$ × 3 $^1/_2$"

Gift of Florence S. Weil, 1982

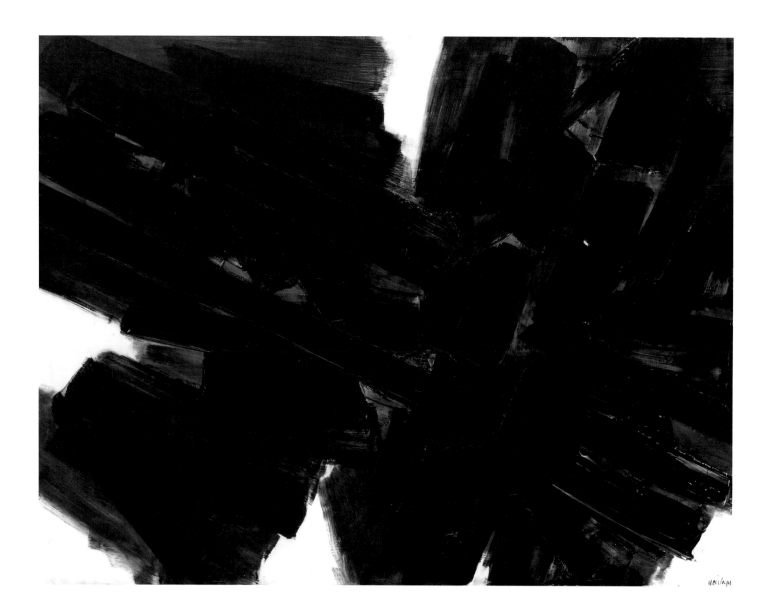

Peinture 200 × 265 cm, 20 mai 1959
(*Painting 200 × 265 cm, 20 May 1959*), 1959

Oil on canvas, 78 5/8 × 104 5/16"
Gift of Mr. and Mrs. Richard K. Weil, 1961

Pierre Soulages

(French, b. 1919)

Peinture 200 × 265 cm, 20 mai 1959
(*Painting 200 × 265 cm, 20 May 1959*), 1959

PIERRE SOULAGES'S PAINTING *Peinture 200 × 265 cm, 20 mai 1959* seems to defy explanation beyond mere description of materials and process. This is evident even in the title. In a system used almost exclusively by Soulages throughout his career, the title indicates only the medium (*peinture*, or painting), the dimensions of the work, and the day on which it was made, May 20, 1959. On the surface this information resists interpretation: it does not suggest an existential or religious position or refer to a historical event, for example. Rather it is purely factual, emphasizing the conditions of the painting's making by pointing to its large size, its material qualities, and the sequential nature of the work. The painting consists of a series of black strokes on a blue and white ground. The black paint has been systematically scraped on and then off with a hard, flat tool, perhaps a palette knife or a rubber spatula, to create layers that are more or less thick and reveal blue underpainting.[1] The black paint is thick and shiny and forms ridges along the edges of the strokes where the tool has spread the paint. Some of the strokes are long and continuous and appear to extend the length of the large canvas (which is more than eight and a half feet long), while others are shorter and approximately twice as wide and move vertically toward the top and bottom of the canvas (which is six and a half feet tall).[2] The opposition of long, thin, continuous strokes and short, wide, abbreviated strokes set on a slightly off-center axis makes the black strokes appear both to contract and to expand across the flat white field of the canvas.

The resistance to narrative meaning that is inherent to the picture—and is evident in the description of it above—is also part of Soulages's own rhetoric. In statements about his practice, he consistently eschews any reference to subjective experience outside the field of the canvas and the materiality of paint itself. By

focusing on the intrinsic qualities of the picture in a way that is autonomous and self-reflexive, he limits the work to the pure experience of painting. He explained this in an interview: "What matters to me is what happens on the canvas. No two brushstrokes are ever the same. Every stroke has its own specific and irreducible attributes: shape, length, thickness, consistency, texture, color, and transparency. Any particular brushstroke establishes relationships with other forms on the canvas, with the background and with the surface as a whole. It is these attributes and relationships that concern me and by which I am guided."[3]

Soulages's desire not to participate in the larger cultural discourse of his day—and in the debates that arose around abstraction in particular—was in fact a way of staking out a space of individual autonomy in the face of the political and commercial realities of postwar France. Gestural abstraction emerged in the late 1940s and 1950s in the United States and Europe as a pictorial language that seemed both authentic and liberated from political and economic constraints. The spontaneous gestures visible on the canvas were widely interpreted as the physical traces of the artistic ego, and thus the abstract gesture became a metaphor for the isolated individual searching for meaning in the upheaval of a postwar world.[4] This version of abstraction quickly took hold in the United States, particularly with the Abstract Expressionists, for whom the concept of subjective free will was easily conflated with the ethos of American democracy. France, which had been occupied by the Germans during World War II and had a strong Communist Party affiliation in the immediate postwar period, saw a similar flourishing of abstraction, but instead of coalescing around a single ideology, abstraction had to jockey for position with older styles such as Fauvism and Cubism as well as the official painting of the Communist regime, Socialist Realism.

By the mid-1950s French abstraction was clearly divided between two camps: geometric abstraction and lyrical abstraction (the latter variously characterized as gestural abstraction, *tachisme*,

and *art informel*). When Soulages arrived in Paris in 1947, he had to negotiate the contested postwar art scene. His work was quickly associated with lyrical abstraction by the critic Charles Estienne, who championed a purely abstract but more creative and spontaneous style that could be easily mapped onto a vague universal humanism.[5] This association of artistic autonomy with humanism is apparent in Estienne's review of Soulages's first solo show in Paris in 1949, in which he described his work as having: "a simple, virile, and almost rough drawing style, with dark, warm harmonies; an innate feeling for the substance of the paint and for the possibilities specific to oil painting; and, most importantly perhaps, a tone that is at once both human and concrete."[6] Estienne went on to promote lyrical abstraction throughout the 1950s, perhaps because it was the closest French style to American Abstract Expressionism and thus the best able to compete on the strong American market, but Soulages, throughout his life, positioned his own work outside of any artistic style or group. In 1980, when an interviewer suggested that his work could be associated with gestural painting, he replied: "Gestural indeed? I have always been against labels of that kind, but it is not my fault if historians and critics insist on using them. In any case I am not particularly interested in the subject."[7] For Soulages, making a painting was merely a process of working through a pictorial problem inherent to the work itself: "The painting poses a question and I seek to answer it by more clearly defining, by intensifying what I feel is there in embryo."[8]

Of course, art history does not stand on an artist's own words of explanation, but there is something to be said for the difficulty that one has in reading the materials of *Peinture 200 × 265 cm, 20 mai 1959* semantically. The painting cannot be explained by the usual references to spontaneous gesture, and in fact when one looks for traces of artistic ego or psyche in the marks on the canvas, one is constantly returned to the material as a kind of hermetic, controlled, systematic production that is antithetical to the liberatory quality of most gestural

abstraction. All this specific attention to form, both in the artist's rhetoric and in the work itself, claims a kind of ahistorical and apolitical autonomy but one that cannot be separated from the historical and social conditions of culture at the time. During the German occupation, to avoid affiliation with the politics of the occupier, some artists made a conscious choice not to create, which was conceived as an act of resistance in itself. In France, particularly in the postwar period, the act of creation was thus charged with national and political import, and abstraction was less a symbol of political democracy than it was a sign of individual autonomy.

For Soulages, as for other artists of his time, defiance of symbolic or even subjective meaning was indeed an attempt to carve out a space of intellectual freedom in the years after World War II and during the rise of the Cold War, when cultural propaganda was at its height. He may have been successful, for the paintings do indeed resist external reference. Historical context, such as the changing social conditions of postwar France, which were the result of rapid commodification and economic development—that would be left to the next generation.

Karen K. Butler

Notes

First published May 2009

1. Beginning in 1946 Soulages replaced the refined artist's paintbrush with a plaster knife and the broad, utilitarian brush of the housepainter, and by the early 1950s he was fabricating his own tools, which resembled long spatulas, using blades made first of leather and then rubber held by two pieces of plywood and mounted on handles of different lengths. See Pierre Encrevé, *Soulages: L'oeuvre complet, peintures* (Paris: Seuil, 1994–98), 1:167.

2. When Soulages first began to use such large-format canvases in 1950, they were "hors dimension," or larger than most readily available commercially prepared canvases, and he had to special-order canvases to meet his needs.

3. Soulages, in "Interview with Pierre Soulages," in Bernard Ceysson, *Soulages* (New York: Crown, 1980), 77.

4. One example of this secular humanist position can be found in James Fitzsimmons's review of *Younger European Painters* at the Solomon R. Guggenheim Museum, New York, in 1953, an exhibition that included the work of Soulages: "They have . . . the power to command, to transport us out of our daily lives with a glimpse of a larger reality, to make a bit of the Unknown real to us." Fitzsimmons, "New York: A Glittering Constellation," *Art Digest* 28 (December 1, 1953): 8, 25.

5. The fact that early on Soulages exhibited with both camps may be indicative of a kind of ambiguity that arises from the semantic neutrality of his pictures. He exhibited at the Salon des Surindépendants in 1947, a large annual group show that was dominated by gestural abstraction but was also a locus for painters influenced by Surrealism. The following year he exhibited at the third Salon des Réalités Nouvelles, where the abstraction was of a more geometric, rational, and constructivist type that had been influenced by the prewar Abstraction-Création movement.

6. Charles Estienne, *Combat*, May 25, 1949; translated in Natalie Adamson, "Pierre Soulages, the Nouvelle École de Paris, and *Painting 202 × 143 cm, 6 November 1967*," *Art Bulletin of Victoria*, no. 41 (2002): 33. Estienne, reviewing Soulages's show at the Galerie Lydia Conti in Paris, was writing in *Combat*, which had been a Resistance newspaper during World War II and was directed by Albert Camus immediately after the war. By the early 1950s *Combat* had become more mainstream, though still retaining a Marxist bent.

7. Soulages, in "Interview," 74. This did not prevent critics from trying to assign meaning to the paintings, as is the case with James Johnson Sweeney, one of Soulages's earliest American supporters, who conceived of the alternating patterns of luminosity and darkness in his pictures as abstract but elemental representations of the space of a Romanesque cathedral. See Sweeney, *Soulages* (Neuchâtel, Switzerland: Ides & Calendes, 1972). Even more recent scholarship has interpreted the paintings as metaphors for the human condition after the destruction of World War II, as is the case with Donald Kuspit, who describes Soulages's works as "negatively sublime," an illustration of Theodor W. Adorno's suggestion that there is no longer a possibility for representation after the Holocaust and World War II. See Kuspit, *The Rebirth of Painting in the Late Twentieth Century* (Cambridge: Cambridge University Press, 2000).

8. Soulages, in "Interview," 74.

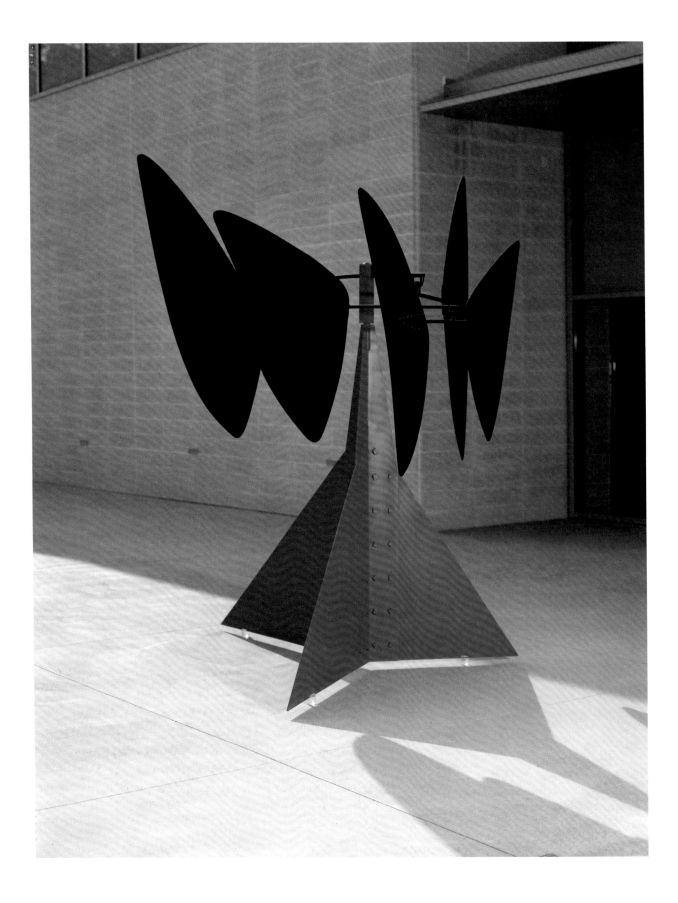

Five Rudders, 1964

Painted sheet metal and rods, 126 × 98 1/4 × 112"

Gift of Mrs. Mark C. Steinberg, 1964

Alexander Calder

(American, 1898–1976)

Five Rudders, 1964

STANDING TEN FEET SIX INCHES HIGH, Alexander Calder's *Five Rudders* is composed of a large tripod base painted bright red, which balances a sequence of black sheet-metal elements at its apex using a series of steel rods.[1] Incorporating both a *stabile*, an abstract construction that is completely stationary, and a *mobile*, a sculptural work in which motion is a defining property, *Five Rudders* is a hybrid form known as a *standing mobile*, or a *stabile-mobile*.[2] The bolted sheets of steel making up the base fore-shadow the monumentality of some of the artist's large-scale stabiles produced later in the decade, while the steel rods function as lever arms that support the kinetic element above. Both the name of the sculpture and the industrial materials employed in its fabrication suggest a direct link to the devices used to steer ships and aircrafts, yet the sculpture also evokes biomorphic imagery such as flower petals and butterfly wings, which belies the weighty character of its materials.[3]

Functioning like a weather vane, the vertically oriented black "rudders" can be placed in motion by a slight touch of the hand or by atmospheric forces such as wind. Because the kinetic sequences of the mobile depend on equilibrium and cannot be fixed or programmed, the movement of the rudders through space is intermittent and irregular rather than mechanically continuous or predictable. Jean-Paul Sartre's eloquent description of the inherent tension between stasis and motion in Calder's sculptures speaks to the effect of *Five Rudders*: "For each [mobile] Calder establishes a general fated course of movement, then abandons them to it: time, sun, heat and wind will determine each particular dance. Thus the object is always midway between the servility of the statue and the independence of natural events."[4] It is important to note that—in contrast to Calder's lighter hanging mobiles, which exhibit a lively

dynamism and often include an aural element—*Five Rudders*, given its scale and considerable weight, produces a more limited range of motion. It is only during periods of severe weather that the speed and velocity of the separate elements become highly erratic and the rudders freely collide.

Created in 1964,[5] *Five Rudders* in many ways epitomizes Calder's sculptural production at this late moment in his career. Since the 1950s the artist had devoted his greatest efforts to large-scale sculpture.[6] In addition to making mobiles by hand, he dramatically increased the scale of his works, and as is the case with *Five Rudders*, he entered into collaborations with foundries in France and the United States to aid in the production of his sculptures, which were regularly commissioned as monumental public works.[7] At the same time an international kinetic art revival was under way, and Calder was positioned—along with Marcel Duchamp, Naum Gabo, László Moholy-Nagy, and Vladimir Tatlin—as one of its major progenitors.

From the mid-1950s to roughly the end of the following decade, numerous artists sought a more experiential approach to sculpture and began exploring the subtleties in the phenomena of speed and time as an experience generated between work and spectator.[8] Introducing actual motion into sculpture was one way to achieve an art reflective of the viewer's shifting sensory and perceptual point of view. While Calder was frequently singled out in this period as one of the forefathers of the postwar craze for kinetic art, he was no longer considered an innovator in the field.[9] The American kinetic artist and critic George Rickey put it bluntly in 1965: "[Calder] put the word 'mobile' into the language. Yet once he had hit on his image, thirty years ago, he developed it little. . . . Calder has not clarified the form of kinetic art. It has been left to others to survey the scope of Calder's idiom and to establish his place as progenitor by their development from his postulates."[10] As artistic production changed dramatically in the postwar period—Pop art and Minimal art superseded Abstract Expressionism as the dominant artistic movements in the United

States, and assemblage and kinetic art flourished internationally—Calder continued with his signature style.

It was in part because of his predictable production that Calder received numerous commissions for public works, both in the United States and abroad, throughout the last two decades of his life.[11] During the postwar building boom of the 1950s and 1960s, public art was in high demand, and Calder's stabiles and stabile-mobiles evinced a certain universal appeal—abstract yet retaining a strong resonance with natural forms, resolutely modern yet lighthearted—that rarely generated any significant public dissent.[12] His works quickly became not only popular urban landmarks but also status symbols, as noted by the Calder scholar Joan Marter, indicating by their presence in cities, corporate headquarters, sculpture gardens, and college campuses the commitment of their patrons to the public arts.[13] Calder's own statements about his work in the postwar period compounded the notion that his sculptures were devoid of criticality or historical consciousness; according to him "the lugubrious aspect. . . is eliminated in my approach to sculpture. But the gay and the joyous, when I can hit it right, are there. . . . I want to make things that are fun to look at, that have no propaganda value whatsoever."[14]

Miwon Kwon's identification of three distinct paradigms within the postwar history of the public art movement in the United States— "art-in-public-places," "art-as-public-spaces," and "art-in-the-public-interest"—is particularly helpful in situating Calder's work within the larger sociohistorical context of the 1960s. During the initial phase of the revival of public sculpture in the 1960s, public art was dominated by the "art-in-public-places" paradigm: modernist abstract sculptures by internationally established male artists—including Calder, Henry Moore, and Isamu Noguchi—that were basically enlarged replicas of works normally found in museums and galleries.[15] What distinguished them as "public," other than size and scale, was the fact that they were placed outdoors in parks, university

campuses, civic centers, plazas, and airports, often removed from plinths and displayed directly on the ground, where access was unrestricted. In most cases Calder produced autonomous works of art whose relationship to a given site was largely incidental; the particular qualities of the site were taken into account only insofar as they affected the aesthetic quality of the artwork as installed.[16]

While the goals of the public art movement initially included the edification of the public and the beautification of the urban environment, by the mid-1970s many critics felt that neither goal was being met. Rather than making a genuine gesture toward public engagement, artworks sited in public places were understood as functioning more like advertisements for individual artists. Criteria for public art sponsorship and funding subsequently evolved to promote an integrationist approach in which the specificities of a given site were considered integral to the outcome of a work. Public art would no longer merely consist of an autonomous sculpture but would necessarily engage in a meaningful dialogue with the surrounding architecture or landscape.[17]

Calder's large-scale works made an undeniable, if in hindsight conflicted, contribution to the resurgence of public art in both the United States and Europe during the postwar years. Larger than human scale but not monumental, *Five Rudders* has, since its original installation in 1964 outside Steinberg Hall, become a readily identifiable symbol of the Kemper Art Museum. In its present location on the Museum's sculpture plaza, its biomorphic imagery and dynamic forms add life to the rational elegance of the surrounding architecture. *Five Rudders* stands as a prominent example of Calder's late experiments with wind-driven mobiles and ambitious, large-scale constructions while also serving as an important indicator of the changing conceptualization of public art in the highly volatile decade of the 1960s.

Meredith Malone

Notes

First published August 2008

1. Throughout his career Calder used mainly the primary colors, black, and white. While this may reflect a commitment to the orthodoxy of Neoplasticism (it was, after all, Piet Mondrian's studio in 1930 that instigated Calder's turn to abstraction and eventually to the invention of his mobiles), Calder frequently discussed his choice of color as a means of achieving greater contrast: "I have chiefly limited myself to the use of black and white as being the most disparate colors. Red is the color most opposed to both of these—and then, finally the other primaries. The secondary colors and intermediate shades serve only to confuse and muddle the distinctness and clarity." Alexander Calder, "What Abstract Art Means to Me," *Museum of Modern Art Bulletin* 18 (Spring 1951): 8.

2. Calder first developed the standing mobile in the mid-1930s and then refined it in the 1940s, creating much larger variations throughout the 1950s and the early 1960s. His largest standing mobile, *Spirale* (1958), is installed on the grounds of the UNESCO headquarters in Paris.

3. Joan Marter, a leading scholar on Calder's work, connects the bolting technique used to join the steel forms and the paddle-like shapes directly to Calder's fascination with ships and shipbuilding. See Marter's analysis of *Five Rudders* in Joseph D. Ketner et al., *A Gallery of Modern Art at Washington University in St. Louis* (St. Louis: Washington University Gallery of Art, 1994), 164. Calder's early works from the 1930s have a strong Surrealist vein running through them, and even in this much later piece, the Surrealist biomorphism characteristic of the work of his close friends Jean Arp and Yves Tanguy is still very much in evidence.

4. Jean-Paul Sartre, "Les Mobiles de Calder," originally published in the exhibition catalog *Alexander Calder: Mobiles, Stabiles, Constellations* (Paris: Galerie Louis Carré, 1946), 9-19; reprinted in *The Aftermath of War: Jean-Paul Sartre*, trans. Chris Turner (Calcutta: Seagull, 2008).

5. Mrs. Mark C. Steinberg purchased *Five Rudders* from the artist specifically for the Washington University Gallery of Art, which later became the Mildred Lane Kemper Art Museum.

6. In 1960 Calder discussed the scale of his work and his many commissions, stating, "There's been an *agrandissement* in my work. It's true I've more or less retired from the smaller mobiles. I regard them as sort of fiddling. The engineering on the big objects is important. . . . Lots of times companies or government agencies have a big vacuum in their projects that they feel ought to be filled—that's where I come in." Alexander Calder, in Geoffrey T. Hellman, "Onward and Upward with the Arts: Calder Revisited," *New Yorker*, October 22, 1960, 169; reprinted in Marla Prather, *Alexander Calder, 1898-1976* (Washington, DC: National Gallery of Art; New Haven, CT: Yale University Press, 1998), 279.

7. According to Joan Marter, when working with fabricators, Calder would oversee the execution of his large works, approving all enlargements of his original maquettes and supervising the bolting and buttressing. See Marter, *Alexander Calder* (Cambridge: Cambridge University Press, 1991), 229. Calder also severely restricted the number of works created from any one maquette. In an unpublished letter dated September 18, 1964, to William N. Eisendrath Jr., then curator of the collections at Washington University, Calder assured Eisendrath that *Five Rudders* was the only larger version in existence and that he would "see to it that it remains so. As a matter of fact the only time I have made 2 of any model is when I first made a moderate sized enlargement—and then wanted to increase that size."

8. The postwar reception of kinetic art is marked by a split history, stemming from its scientific attitude, on the one hand, and its reception as merely playful entertainment, on the other. For more on this, see Pamela Lee, *Chronophonia: On Time in the Art of the 1960s* (Cambridge, MA: MIT Press, 2004), 93-105, and Guy Brett, *Forcefields: Phases of the Kinetic* (Barcelona: Museu d'Art Contemporani de Barcelona, 2000). It is important to note

that there was no single leader, manifesto, or aesthetic establishing a set program for postwar kinetic art. The movement was malleable enough to include a diversity of investigations into both perceived and actual motion. While Calder experimented with mechanical energy in the 1930s, for the most part he represented those interested in the movement of an object through natural forms of energy.

9. It is generally accepted that the 1920s through the 1930s was the most significant period in Calder's development of a personal idiom. See Marter, *Alexander Calder*, 98.

10. George Rickey, "The Morphology of Movement, a Study of Kinetic Art," in *The Nature and Art of Motion*, ed. György Kepes (New York: George Braziller, 1965), 113.

11. From the mid-1950s until his death in 1976, Calder devoted his greatest efforts to large-scale sculpture, making more than three hundred monumental works, which were fabricated at an ironworks and designed for the outdoors. See Marla Prather, "1953–1976," in *Alexander Calder*, 279. The vast majority of Calder's monumental works were stabiles, which could withstand the elements more readily than kinetic works.

12. Marter notes that Calder was also considered a safe choice for public works during the McCarthy era. Marter, *Alexander Calder*, 204.

13. Ibid., 232. In Grand Rapids, Michigan, for example, Calder's monumental stabile *La grande vitesse* (1969) became a civic symbol, acting as the logo on official stationery and city garbage trucks.

14. Alexander Calder, in Selden Rodman, *Conversations with Artists* (New York: Devin-Adair, 1957), 139–40.

15. See Miwon Kwon, *One Place after Another: Site-Specific Art and Locational Identity* (Cambridge, MA: MIT Press, 2002), 60.

16. Ibid., 63. Calder selected the original location for *Five Rudders* on Forsyth Boulevard, in front of the Museum's home in Steinberg Hall, while on a trip to St. Louis in 1964.

17. For more on the history of public art in the late 1970s and after, see Kwon, *One Place after Another*, 66–99, and Harriet F. Seine, *Contemporary Public Sculpture: Tradition, Transformation, and Controversy* (New York: Oxford University Press, 1992).

Howard Jones

(American, 1922–1991)

Solo Two, 1966

HOWARD JONES'S EXPERIMENTAL LIGHT and sound work *Solo Two* consists of a life-size silhouette of the artist painted on a mustard yellow wood panel, which is covered by a grid of orange lightbulbs (7 1/2 watt) in porcelain sockets typically used for commercial signage. A mirror is hinged to the top of the panel to reflect the light from the bulbs as well as the image of viewers as they stand in front of the piece. The entire structure is plugged into an electrical box with an amp meter and a series of toggle switches that control the programmed sequences of lights and sounds that fill the gallery space. The programs are multiple and vary depending on which switches are turned on and which ones are left off. One sequence begins, for instance, with all the lights randomly flickering while a low electronic chirping sound resonates from the bulbs. Then suddenly all the lights go dark except for those around the head of the figure, which blink swiftly while one lone bulb in the chest area slowly pulses, like a thumping heart. The low chirping sound concurrently gives way to a loud, rapid clicking noise before diminishing, leaving only the faint buzz of the electrical box audible. At this point all the lights go out except for the light in the chest, which rhythmically beats on and off. After a few seconds a single light in the groin area begins to throb, and shortly thereafter the lights resume their frenzied dance across the surface of the piece, returning us to the start of the sequence.

Jones was one of numerous artists working in the United States and in Europe engaged in the exploration of light, motion, sound, and technology as aesthetic mediums.[1] The fascination with kinetic and light art reached a high point in the late 1960s and early 1970s, as evidenced by a plethora of exhibitions devoted to the genre across the United States and abroad.[2] Robert Doty, curator of the exhibition *Light: Object and Image* at the

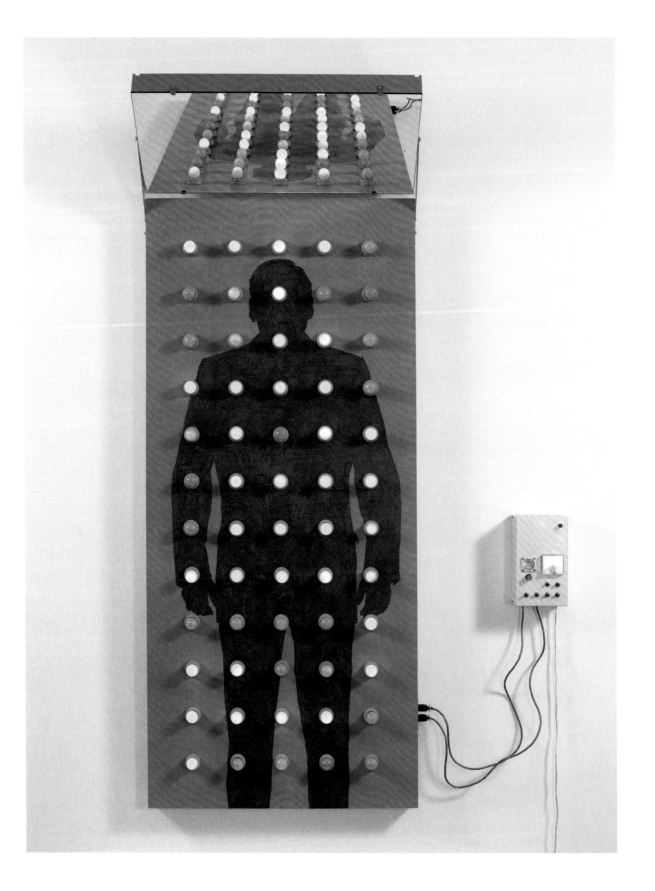

Solo Two, 1966

Painted wood, mirror, and programmed light and sound, 81 × 31 $^3/_8$ × 15 $^3/_8$"
Gift of Donald M. Jacobsen, 1984

Whitney Museum of American Art, New York, in 1968, in which Jones participated, described the widespread artistic interest in the subject: "Artificial light, and its allied technical fields, is the fastest growing area in the arts today. Discoveries in theoretical and applied science seem to be limitless, and the artist will try to use whatever information and materials the scientist can produce."[3] In Europe, artist collectives such as Zero in Germany, the Groupe de Recherche d'Art Visuel (GRAV) in France, and Gruppo N and Gruppo T in Italy defined themselves through their experimental work integrating movement, light, and technological methods to create dynamic, often interactive works of art. In the United States, E.A.T. (Experiments in Art and Technology, Inc.) notably attempted to bring together art and technology. Founded in 1967, the organization acted as a matching agency, connecting artists and engineers early in the creative process in order to explore how technology could play a role in the development of an artist's ideas.[4]

Jones's work is a direct product of this experimental environment. His efforts to pursue the relationship between human experience and man-made materials and tools were largely motivated by the conviction that in an electronic age artists must actively apply the products of technology in order to address philosophical and moral questions raised by its rapid development. The mustard yellow color covering the background of Jones's "plugged-in painting"[5]—in combination with the programmed electrical lights, the thick electrical cords hanging off the right side of the piece, and the prominent display of hardware—infuse the work with a now dated yet distinctly futuristic sensibility befitting the space age. The mirror atop the structure multiplies the staccato rhythm of the flashing lights and directly implicates the spectator standing below in the sensory experience of the work. The effect of dynamic light displays and the associated gesture toward interactivity—as evidenced in a work such as *Solo Two*, which can be turned on and off—were often criticized as gimmicky, "more suitable to amusement parks or department store displays than for galleries or museums," and were accused by some as being closer to an exercise

in mechanical engineering than a compelling work of art.[6] For Jones, however, the greater aspiration was to expand the viewer's perception of the technologically altered conditions of the self.

Recognizing the techno-euphoria inherent in Jones's work from this period, the critic Robert Pincus-Witten labeled the artist "an ardent McLuhanite," making reference to the influential media theorist Marshall McLuhan.[7] In his 1964 publication *Understanding Media: The Extensions of Man*, McLuhan maintained that the technologies of the media of communication, covering the globe like nature itself, were far more influential than any specific content in their ability to alter both our sensibilities and our means of perception. "The medium," he famously declared, "is the message": "The 'message' of any medium or technology is the change of scale or pace or pattern that it introduces into human affairs."[8] As extensions of the human body, technologies thus irrevocably alter human perceptual capabilities. A sense of ambivalence runs throughout McLuhan's writings between suspicious and mystical attitudes about media and between pessimistic visions of technological control and sanguine fantasies of an interconnected "global village."

In *Solo Two*, Jones appears to have literalized the manner in which media technologies wash over us, both physically and psychically, to change our awareness and experience of the world in which we live. The silhouette, in this reading, becomes an everyman, someone with whom we might identify and through whom media communication is literally radiated. While the programmed sequence of lights and sounds can be changed with the flip of a switch, the greatest emphasis is always placed on the head, the heart, and the groin, the most vital centers of the body. Rather than simply being dominated by electromechanical systems, *Solo Two* presents an integrated response to the new realities of a technologically advanced society, providing a model for how art and technology can interact as catalysts for aesthetic and intellectual development.

Meredith Malone

Notes

First published August 2009

1. Artists such as László Moholy-Nagy, György Kepes, and Thomas Wilfred experimented with light and movement in the early twentieth century, yet it was the 1960s that witnessed a marked surge in the use of natural and electric light among artists. For an overview of light art throughout the twentieth century and into the realm of contemporary art, see Peter Wiebel and Gregor Jansen, eds., *Light Art from Artificial Light: Light as a Medium in 20th and 21st Century Art* (Ostfildern, Germany: Hatje Cantz, 2006). See also Jack Burnham, *Beyond Modern Sculpture: The Effects of Science and Technology on the Sculpture of This Century* (New York: George Braziller, 1968).

2. Notable exhibitions include *Light as a Creative Medium*, Carpenter Center for the Visual Arts, Harvard University, Cambridge, MA, 1965; *Kunst-Licht-Kunst*, Stedelijk Van Abbemuseum, Eindhoven, Netherlands, 1966; *Sound, Light, Silence: Art That Performs*, Nelson Gallery of Art, Kansas City, MO, 1966; *Light / Motion / Space*, Walker Art Center, Minneapolis, 1967; *Light: Object and Image*, Whitney Museum of American Art, New York, 1968; and *The Magic Theater: Art Technology Spectacular*, Nelson Gallery of Art, Kansas City, MO, 1970. The Howard Wise Gallery in New York also gave early support to the use of technology in art in the United States and mounted numerous exhibitions on the subject from 1960 to 1970.

3. Robert Doty, *Light: Object and Image* (New York: Whitney Museum of American Art, 1968), n.p.

4. See Burnham, *Beyond Modern Sculpture*, 361–62, and Catherine Morris, "9 Evenings: An Experimental Proposition (Allowing for Discontinuities)," in *9 Evenings Reconsidered: Art, Theatre, and Engineering, 1966*, ed. Catherine Morris (Cambridge, MA: MIT List Visual Arts Center, 2006), 9.

5. Nan R. Piene, "Light Art," *Art in America* 55 (May–June 1967): 30–32. Piene describes "plugged-in painting" as one variation of light art in which artists make works with predetermined perimeters, usually rectangular, which the viewer is intended to look at frontally. This is in distinction to other categories, including "light-receiving and light-giving sculptures" and "environments and performances."

6. John Perreault, "Literal Light," in *Light: From Aten to Laser*, ed. Thomas B. Hess and John Ashbery (New York: Macmillan, 1969), 138.

7. Robert Pincus-Witten, review in *Artforum* 4 (June 1966): 55.

8. Marshall McLuhan, *Understanding Media: The Extensions of Man* (New York: McGraw-Hill, 1964), 8.

Romare Bearden

(American, 1911–1988)

Black Venus, 1968

BEGINNING WITH CUBISM IN THE 1910S, collage has been celebrated as a particularly appropriate means of responding to and representing the simultaneity of difference within everyday life. The medium has been variously employed by avant-garde movements throughout the twentieth century—including Futurism, Constructivism, and Surrealism—as a means of achieving the modernist utopia of bridging the gap between art and life. Collage offered artists associated with these movements an inventive means of constructing an image while destabilizing existing views of the world through discontinuity, fragmentation, and the inclusion of everyday objects and materials. In works such as *Black Venus*, the African American artist Romare Bearden appropriated and transformed this eminently modernist strategy in order to register and deconstruct issues of race and identity as they informed his experiences in 1960s America.

In contrast to the essentialist conceptions of African American cultural identity and the type of Afrocentrism espoused by groups such as the Black Arts Movement, Bearden always emphasized the composite aspects of African American life, viewing it as an amalgamation of disparate elements.[1] Throughout his writings, he revealed a complex understanding of black subjectivity and identity as something that has itself been "collaged" by the vicissitudes of modern history.[2] "It is not my aim to paint about the Negro in America in terms of propaganda," he wrote in his 1969 article "Rectangular Structure in My Montage Paintings." "My intention, however, is to reveal through pictorial complexities the richness of a life I know."[3] *Black Venus* encapsulates the artist's dual efforts to acknowledge the significance of the art historical canon while revising its forms to assert new representations of African American identity.

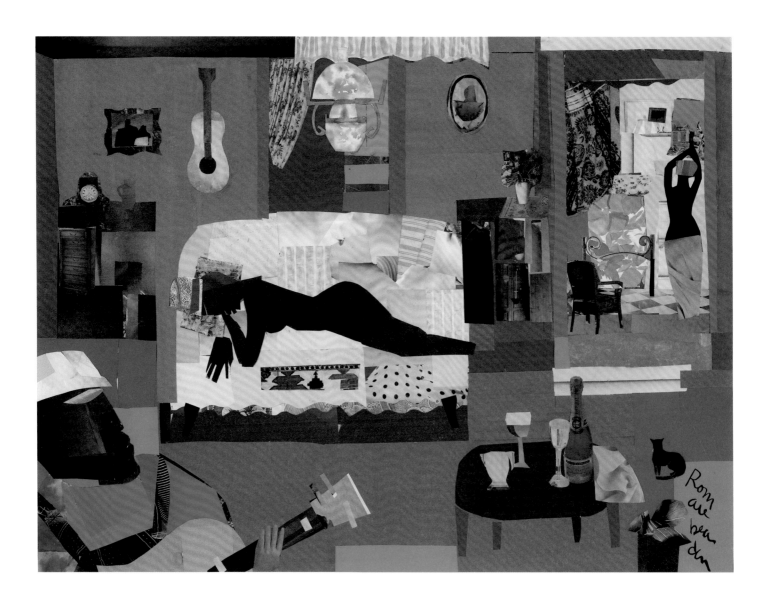

Black Venus, 1968

Mixed-media collage, 29 3/4 × 40 3/16"
University purchase, Charles H. Yalem Art Fund, 1994

Morris Louis, Kenneth Noland, and Jules Olitski, adopted the method of applying thin washes or stains of color to large pieces of unprimed canvas, letting paint literally fuse with the support. The resultant works stressed pictorial flatness, frontality, and "opticality," a construct proposed by the art critic Clement Greenberg in his influential 1960 essay "Modernist Painting." According to Greenberg, modernist painting progressed only to the extent that it reflected on its own properties as a medium. The one characteristic unique to painting was the flatness of the picture plane, which privileges a purely optical experience without bodily involvement.[10] McCollum, however, quickly began to consider this kind of thinking absurd, coming to the realization that the meaning of an artwork resides in the role it plays in the culture before anything else.[11] His practice of staining and his attention to the flatness of the unstretched canvas, as seen in *Pam Beale*, evince only a superficial link to the tenets of postpainterly abstraction, one that actually refuses such an overdetermined emphasis on opticality.[12] The choice of title reveals an additional element of irreverence and a desire to question the formalist theory of painting as autonomous, completely divorced from the world outside its borders.

Pam Beale represents an important step in McCollum's career. It was, in part, by working through the type of self-reflective inquiry demonstrated in his constructed paintings that he became increasingly conscious of how process and the context-dependent contingency of all objects inform practice at multiple levels, from the studio to the systems that support the institutions of art. After testing these formalist, Minimalist, and Postminimalist trains of thought, he arrived at his more conceptually driven Surrogate Paintings (begun in 1978), "unique multiples" consisting solely of a minimal frame, mat, and rectangle overlaid with many coats of paint. This body of work marked the artist's move beyond preoccupations with form and content to a focus on the strategies and systems through which objects are more broadly assigned meaning and value in contemporary culture. The literalism demonstrated in *Pam Beale* was ultimately displaced by the Surrogates as

McCollum moved from an emphasis on process and the unstretched canvas to an exploration of the devices that frame a work, both literally and figuratively.[13]

Meredith Malone

Notes

First published August 2010

1. For a detailed description of McCollum's method of making his constructed paintings, see Cara Montgomery, *New Painting in Los Angeles* (Balboa, CA: Newport Harbor Art Museum, 1971), n.p.

2. Allan McCollum, e-mail correspondence with the author, April 28, 2010.

3. For excellent overviews of McCollum's early work, see Anne Rorimer, "Self-Referentiality and Mass-Production in the Work of Allan McCollum, 1969–1989," and Lynne Cooke, "Allan McCollum: The Art of Duplicitous Ingemination," in *Allan McCollum* (Eindhoven, Netherlands: Stedelijk Van Abbemuseum, 1989), 6–14 and 15–23, respectively.

4. Allan McCollum, in Robert Enright, "No Things but in Ideas: An Interview with Allan McCollum," *Border Crossings* 20 (August 2001): 31.

5. Morris, Serra, Hesse, and Le Va were all included in the groundbreaking exhibition *Anti-Illusion: Procedures / Materials,* which opened at the Whitney Museum of American Art in New York on May 19, 1969, and ran through July 6, 1969. The exhibition and its catalog were extraordinarily influential, the latter including copious photographs of works in the exhibition as well as of artists in the process of making them.

6. McCollum, in Enright, "No Things," 32.

7. Exhibitions of this sort include *Off the Stretcher*, Oakland Museum, 1971–72; *24 Young Los Angeles Artists*, Los Angeles County Museum of Art, 1971; and *Unstretched Surfaces: Los Angeles–Paris*, Los Angeles Institute of Contemporary Art, 1977. Examples of McCollum's constructed paintings were included in each exhibition.

8. In her 1978 review of the exhibition *Unstretched Surfaces*, Susan C. Larsen offers a detailed description of the diverse methods and materials employed by the artists in the exhibition. See Larsen, "Los Angeles: Inside Jobs," *Art News* 77 (January 1978): 110–11.

9. For on overview of these tendencies in Southern California art, see Howard N. Fox, "Tremors in Paradise, 1960–1980," in *Made in California: Art, Image, and Identity, 1900–2000*, by Stephanie Barron, Sheri Bernstein, and Ilene Susan Fort (Los Angeles: Los Angeles County Museum of Art; Berkeley: University of California Press, 2000), 193–234. See also Peter Plagens, *Sunshine Muse: Contemporary Art on the West Coast* (New York: Praeger, 1974).

10. See Clement Greenberg, "Modernist Painting" (1960), in *The Collected Essays and Criticism*, ed. John O'Brian, vol. 4 (Chicago: University of Chicago Press, 1993), 85–93.

11. Allan McCollum, in D. A. Robbins, "An Interview with Allan McCollum," *Arts Magazine* 60 (October 1985): 41.

12. McCollum was well versed in these practices. His work was exhibited at the Nicholas Wilder Gallery in the early 1970s, which was among Los Angeles's leading contemporary art venues in the 1960s and 1970s. Wilder exhibited the work of numerous painters championed by Clement Greenberg and associated with color-field painting, including Helen Frankenthaler, Barnett Newman, Kenneth Noland, and Jules Olitski.

13. For an insightful analysis of the shift at this time in artistic practice toward an analysis of the systems and relations of artistic production more broadly, see Craig Owens, "From Work to Frame, or, Is There Life after 'The Death of the Author?,'" in *Beyond Recognition: Representation, Power, and Culture* (Berkeley: University of California Press, 1992), 122–39.

a cocktail waitress at the Troubadour, a nightclub in West Hollywood, near where the artist was working as an art handler. He arbitrarily decided to name the series of constructed paintings after the waitresses at the Troubadour in an attempt to demystify the act of titling an artwork.[2] The randomness, levity, and absurdity conveyed by the title belie McCollum's otherwise highly structured approach.

In the overall context of the artist's prestigious career, *Pam Beale* is an utterly transitional piece, linking McCollum to the formalist dialogues of the 1950s and 1960s while anticipating his growing preoccupations with issues of serial production and strategies of display in the late 1970s and beyond. At the same time this unstretched canvas offers intriguing perspective on the dominant discourses surrounding abstract painting in the beginning of the 1970s and McCollum's aspiration—as a young, untrained artist living in Los Angeles—to test and strain them.[3]

After deciding to become a painter in 1967, McCollum learned about contemporary art by culling information from art magazines, articles, museums, galleries in Los Angeles, and his experiences as an art handler. He freely experimented with a variety of methods and techniques. In a 2001 interview the artist recalled his approach in the early 1970s as "a cross between post-painterly abstraction and post-minimalism."[4] Indeed, *Pam Beale* is a curious hybrid of stylistic references. The artist's use of elements of chance and predetermined systems recalls the work of John Cage, the application of dyes to unprimed canvas calls to mind Helen Frankenthaler's stained paintings, the mechanical method of his patterned construction resembles Frank Stella's Minimalist abstractions, the emphasis on mathematical seriality evokes Sol LeWitt's structures, and the overt emphasis on process and raw materials points to works by such artists as Eva Hesse, Barry Le Va, Robert Morris, and Richard Serra.[5] Although he drew on an eclectic array of sources, McCollum recognized intersecting and shared strategies running through his chosen models, including a general thrust toward literalism: "I sensed how different they were, but, on the other hand, the issues were not that dissimilar. There was an interest in

literalism, in Helen Frankenthaler's concern with the honesty of the materials of painting compared to, say, Robert Morris's interest in 'making.' There's a whole lot of parallels if you haven't been trained to think one way or the other."[6] Although Frankenthaler's formalist painting and Morris's process art are philosophically distinct, even antithetical, what they held in common was a heightened emphasis on materials and process, characteristics that directly informed *Pam Beale*.

McCollum was one of a number of Los Angeles–based artists concurrently, if independently, testing accepted tenets of painting through experimentation with unstretched supports and unconventional materials. The move "off the stretcher" became a verifiable trend in the city, acknowledged by a series of group exhibitions mounted throughout the 1970s around the theme of "soft" painting in Southern California.[7] The majority of the artists included in these exhibitions rejected the rigidity imposed by the stretcher bars, viewing it as a means of advancing a fatigued tradition of abstraction. Hardly a coherent movement, the explorations of the unstretched surface covered a wide variety of divergent experiments in terms of both method and material. While some artists used paint, others incorporated cast polyester resin, nylon, fiberglass cloth, and paper, often slashing, sewing, wrinkling, or pasting their chosen medium.[8] In many cases this experimentation resulted in decorative or lyrical compositions that emphasized both plastic and metaphysical concerns. McCollum's interests, in contrast, were always more structural, driven by a systematic approach and a desire ultimately to push painting's literalness toward more conceptual ends.

While the development of soft painting in Southern California can be understood as a challenge to the dominance of the slick, precise art known as Finish Fetish or "the L.A. Look,"[9] it is more commonly characterized as a response to Abstract Expressionism (most notably Jackson Pollock's allover paintings executed on large unstretched canvases laid out on the floor) and the ensuing influence of color-field painting, also known as postpainterly abstraction. As early as 1953 Helen Frankenthaler, followed by

Pam Beale, 1971

Dyed and bleached canvas with caulk, 103 × 103"
Gift of Anne V. Champ, 1974

Allan McCollum

(American, b. 1944)

Pam Beale, 1971

ALLAN MCCOLLUM'S *Pam Beale* is one in a series of "constructed paintings" begun in the late 1960s. The piece is composed of a series of three-inch-wide rectangular strips of torn and dyed canvas adhered together with industrial caulking in an overlapping manner that evokes brickwork, shingles, or venetian blinds. Created at a moment when many artists and critics alike were interested in defining what a painting was by reducing it to its essential terms (two-dimensional canvas, pigment, and the stretcher), *Pam Beale* works within those terms but simultaneously demonstrates McCollum's interest in and distance from this type of formalist investigation.

To make the work, McCollum first accordion-pleated standardized strips of canvas into compact bundles before dipping them into vats of gray dye. Because the cloth absorbed the dye unevenly, the edges and folds appear darker than the middle areas. He then caulked together the variegated strips, carefully juxtaposing dark, saturated pieces of canvas next to much lighter passages to create a large diamond shape around the outer edges of the work. While the artist's mechanized practice remained consistent throughout the series, no two constructed paintings are ever alike as he used a different systematic approach to arrive at a unique pattern for each work.[1]

McCollum's intention that *Pam Beale* be displayed stapled flat against the wall serves to emphasize the work's two-dimensional character while also heightening the viewer's awareness of it as an object with weight and tactility. Because the threads from the tattered edges of the raw canvas are left to fall where they will and the caulk holding the strips together remains a visible element of the painting, it is difficult to distinguish between the work's form and the process of its fabrication. Yet the title of the work complicates such formalist concerns. According to McCollum, Pam Beale was

Although Bearden's *Black Venus* clearly emulates certain aspects of the art historical canon, his collage also evinces moments of significant confrontation between the themes and techniques of Western art history and black visual culture. For instance, the collaged and masklike face of the male guitar player in the foreground appears to allude obliquely to the cross-cultural borrowings of early modern artists such as Pablo Picasso.[8] As noted by the art critic Hilton Kramer, the use of the African mask motif suggests "the morphology of certain forms that derive originally from African art, then passed into modern art by way of cubism, and, are now being employed to evoke a mode of Afro-American experience."[9] It is left unclear if the reference to Picasso is intended as an homage or if it expresses a more critical relationship to his place at the center of the canon. *Black Venus* thus elucidates the profound challenges and contradictions inherent in Bearden's particular practice of collage as he attempted to mediate between a Western tradition of art that he so greatly admired, contemporary popular culture, and the politics of the multiethnic and racially divided American society in which he lived.

Meredith Malone

Notes

First published February 2007

1. For more on the notion of Afrocentrism and its relationship to the logic of Eurocentrism, see Carole Boyce Davies, "Beyond Unicentricity: Transcultural Black Presences," *Research in African Literatures* 30 (Summer 1999): 96–109.

2. Kobena Mercer, "Romare Bearden, 1964: Collage as Kunstwollen," in *Cosmopolitan Modernisms* (Cambridge, MA: MIT Press, 2005), 125.

3. Romare Bearden, "Rectangular Structure in My Montage Paintings," *Leonardo* 2 (January 1969): 18. See also Bearden, "The Negro Artist's Dilemma," *Critique* 1 (November 1946): 22.

4. In a 1964 interview Bearden described his turn to collage in terms of the medium's ability to incorporate "a variety of images into one unified expression." See Charles Childs, "Bearden: Identification and Identity," *Art News* 63 (October 1964): 62.

5. Bearden was notably influenced by the writings of French author and statesman André Malraux (1901–1976). For more on Bearden's borrowings from art historical tradition and his understanding of Malraux, see Sarah Kennel, "Bearden's Musée Imaginaire," in *The Art of Romare Bearden* (Washington, DC: National Gallery of Art, 2003), 140–55.

6. Ruth Fine notes that Storyville scenes appeared in Bearden's collages about the time of the Museum of Modern Art's 1970 exhibition of photographs of Storyville's prostitutes by E. J. Bellocq. See Fine, "Romare Bearden: The Spaces Between," in *The Art of Romare Bearden* (Washington, DC: National Gallery of Art, 2003), 92.

7. For one of the few feminist interpretations of Bearden's work, see Judith Wilson, "Getting Down to Get Over: Romare Bearden's Use of Pornography and the Problem of the Black Female Body in Afro-U.S. Art," in *Black Popular Culture*, ed. Gina Dent (Seattle: Bay Press, 1992), 112–22.

8. In his 1964 series of photomontages known as Projections, Bearden literally cut and pasted images of African masks to create composite faces.

9. Hilton Kramer, "Black Experience and Modernist Art," *New York Times*, February 14, 1970, 23.

It was not until 1963, after spending more than a decade as an abstract painter, that Bearden turned to collage as his primary mode of artistic expression. He began experimenting with the medium because it offered him the means to deconstruct, fragment, improvise, and reconstruct, in a manner similar to that of the improvisational techniques of jazz musicians, a variety of images. Bearden's turn to collage was part of a broader resurgence of interest in this avant-garde medium, as artists in both Europe and the United States searched for ways to address the shifting sociocultural conditions of an everyday life transformed by the rise of a postwar consumer society. In contradistinction to artists such as Allan Kaprow, Robert Rauschenberg, and Andy Warhol—who were experimenting with environments, assemblage, and installation art— Bearden employed the collage aesthetic toward predominantly representational and often autobiographical ends, cutting diverse pieces of magazine and newspaper illustrations and pasting them into coherent narrative montages. Some of the more radical implications of collage, such as the rupturing of a unified field of representation through the incorporation of ambiguous fragments from daily life and the refusal to subsume these diverse elements into a homogeneous whole or a narrative resolution, were sublimated, if not negated, by Bearden's concern for the overall unity of his compositions.[4] In *Black Venus*, for example, the juxtaposition of diverse imagery and patterns serves predominantly decorative ends, as he ultimately subsumed these elements into a cohesive framework.

Bearden's incorporation of elements from mass culture shows an engagement with the representational techniques of advertising and marketing; his compositions do not challenge the autonomy of the art object, however, and his borrowings from the art historical canon were never presented as satire. For Bearden, art history provided a preexisting visual vocabulary that the artist must acknowledge and transform according to personal and sociohistorical circumstances.[5] At a time when the country was embroiled in the civil rights movement and

struggling over issues of segregation, *Black Venus* provocatively took up the long tradition of the female odalisque as a subject in Western art and recast it in an African American context. The image of a black nude reclining on a sofa that is covered by a patchwork quilt immediately recalls both folk art conventions and the highly ornamental work of Henri Matisse, an artist whom Bearden very much admired.

In addition to clear allusions to the work of Matisse, Bearden's collage may also slyly evoke Edouard Manet's *Olympia* (1863), a canonical image that brazenly depicts a female prostitute accompanied by a black servant and a small black cat at her feet. The subject of prostitution was frequently represented in modernist European painting throughout the nineteenth and early twentieth centuries. While Bearden certainly references this tradition, his inclusion of a guitar player and several musical instruments throughout the scene also recalls the history of jazz music and its emergence from within the high-class brothels of New Orleans. The artist is known to have begun depicting the parlors of Storyville, the legendary turn-of-the-century brothel district in New Orleans, by the early 1970s.[6]

In light of these dual contexts, one may extend the interpretation of *Black Venus* beyond that of a benign celebration of the beauty of the black woman and read it more critically as a problematic depiction of the black female body. The majority of art historical scholarship on Bearden emphasizes his benevolent representation of the black body but fails to address some of the key implications of his appropriation of the conventions of the Western high-art nude.[7] Although he did attempt to transcend the widespread stigmatization of black sexuality in popular culture, his works tend to reproduce standard gender tropes and objectifying strategies such as the voyeuristic gaze. In his Storyville collages, as in *Black Venus*, Bearden approached his female subjects in a manner similar to that of Manet or Matisse: as an observer of life, with his artistic position enabling him to occupy an intimate place while at the same time remaining a distanced, outside observer.

Barbara Kruger

(American, b. 1945)

Untitled (*Don't tread on me / Don't tempt me*), 1989–90

BARBARA KRUGER'S UNTITLED SCREEN PRINT of 1989–90 is a prime example of her immediately recognizable aesthetic, in which familiar yet oblique phrases are set against an appropriated, generally black-and-white photograph. In the print she presents a closely cropped photograph of the head and surrounding torso of a coiled snake. A bold red border frames the image, which is flanked above and below by two red text boxes, each containing a phrase printed in white in the typeface with which she has become inextricably associated, the eminently legible Futura Bold Oblique, a simple, highly geometric sans serif design that is commonly used in advertising.[1] According to Kruger, she uses the aesthetic of advertising design specifically as a "device to get people to look at the picture, and then to displace the conventional meaning that that image usually carried with perhaps a number of different readings."[2] Kruger juxtaposed stock and editorial photographs taken from advertisements with brief, generally suggestive texts ("I shop therefore I am," "make my day," "your body is a battleground"), pitting polarities against each other (contemporary / classic, high / low, personal / political) in ways that create new commentaries through their myriad levels of association. The box above the snake's head contains the phrase "don't tread on me," while the text in the box at the bottom reads "don't tempt me." In spite of the latter plea (or threat), it is indeed tempting to locate the link that binds the three main elements that would provide the content or meaning of the work. Kruger's methodology, however, resists such a traditional approach to reading and interpreting visual culture.

At nearly twelve feet high, Kruger's untitled screen print is reminiscent of the banners and billboards that have featured her work worldwide. In addition to appearing

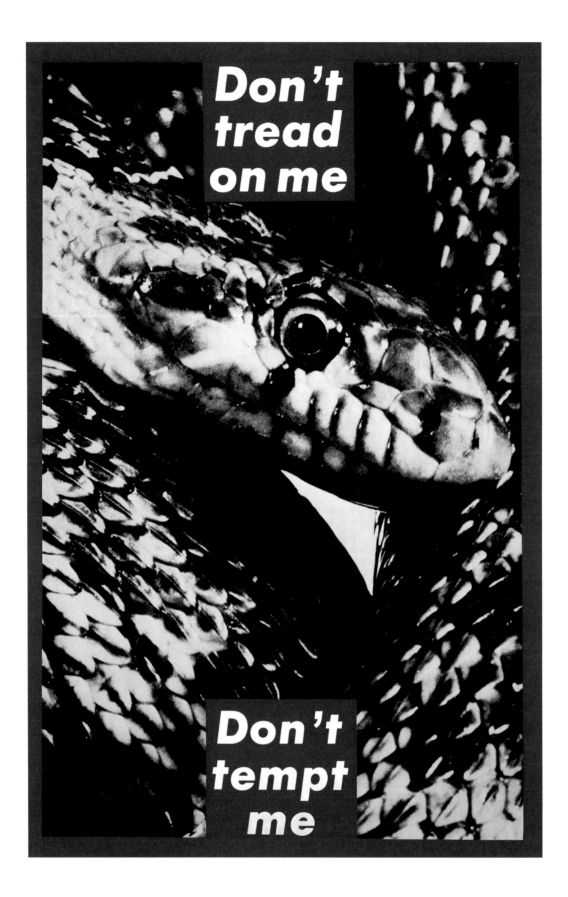

Untitled (Don't tread on me / Don't tempt me), 1989–90

Photographic screen print on vinyl, 140 1/4 × 92 1/4 × 2 5/8"
University purchase, Bixby Fund, 1990

in traditional museum and gallery spaces, her art has been equally effective and arguably more complex when exhibited in customarily non-art spaces and contexts, such as on billboards, on the facades of public edifices, inside subway cars, and on common consumer goods such as T-shirts, coffee mugs, and matchbook covers. These are all venues where an unsuspecting public is generally less prepared to be confronted with messages that generate more questions than answers. Screen printing itself, a process through which an image is produced by forcing ink through a woven mesh screen, was used almost exclusively as a commercial medium before Andy Warhol popularized its use for fine art in the 1960s.[3] And rather than printing on the more traditional canvas, Kruger chose vinyl, a durable plastic support that, like screen printing, is better known for its commercial applications and is regularly used for large-scale outdoor signage.

The materials used in Kruger's print exemplify Marshall McLuhan's adage that "the medium is the message," by which he suggests that the content of the message cannot be interpreted independently of the medium through which that content is circulated.[4] Indeed, her signature aesthetic reflects McLuhan's concept on multiple levels, as it acknowledges that both materials and language are part of larger systems of signification that are subject to interpretation and deconstruction. In a sense, the artist's work is a confluence of two radically different vectors of meaning: advertising, which seeks to persuade and sell, and art, which seeks to provoke thought and generate discourse. Counted among the members of the generation of artists who emerged at the time of the highly influential exhibition *Pictures* in New York in 1977, Kruger started to establish her aesthetic in the early 1980s.[5] Influenced by Jean Baudrillard's philosophy regarding mass media consumption and the simulacrum, as well as Jacques Derrida's concern with deferred meaning and the deconstruction of text, she began to explore an aesthetic that sought to question not only the nature of originality—a foundational aspect of modernism—but

also the underlying structures of power that seek to control language and its meaning.[6]

The dislocation stemming from the simultaneous cohesion and detachment of image and text in Kruger's untitled print is carried over into the experience of the viewer, whose traditional role in processing art is to find the relationship between the image(s) and text(s) that will provide meaning. The stern warning "don't tread on me" is tempered dramatically by the more vulnerable, perhaps even seductive tone of the plea "don't tempt me" below, resulting in a dichotomy of meaning that is mediated by the central image. Read in association with the snake, the phrase "don't tempt me" conjures numerous Judeo-Christian themes, from the temptation of Eve by the serpent in the Garden of Eden, to a line from the Lord's Prayer, "lead us not into temptation."

This dichotomy of strength versus vulnerability is of particular interest to second-generation feminists like Kruger, whose work explores how the power structures that inform language are gendered. For example, her *Untitled (We don't need another hero)* (1987) demonstrates how clichéd gender roles and stereotypes are dictated and reinforced through the media by superimposing the phrase "we don't need another hero" onto an image resembling a Norman Rockwell illustration for the cover of the *Saturday Evening Post*, which shows a young girl cooing over a little boy's effort to flex his bicep. Such works not only remind the viewer that the very systems of signification that Kruger uses cannot be understood outside the prevailing power structure but also reveal the irony that her textual commentary cannot exist outside the larger sociocultural discourse in which she must by necessity participate. Critical to this fluid, negotiable, and polysemous signification is Kruger's characteristic use of pronouns such as *you / your* and, in the case of the Kemper Art Museum's untitled print of 1989–90, *me / my*, which not only creates a polarity or protagonist/antagonist relationship within the narrative but also decenters viewers' position within the narrative in accordance with their perceived sociocultural frameworks. The

privileging of the subjectivity of "little narratives" over the modernist master narrative—wherein experience is universally meaningful, timeless, and seeks to establish "truth"—is central to her dialogue with viewers.[7]

Dominating the composition of Kruger's untitled print is the image of the snake, one of the most potent signifiers in ancient and modern cultures throughout the world. The phrase "Don't tread on me" immediately recalls the use of the rattlesnake as a familiar symbol of the American colonies in the eighteenth century, and it was used liberally on flags and standards during the American Revolution. The most famous of these—the Gadsden flag, named for its designer, General Christopher Gadsden of South Carolina—has been in use since it was instituted as a naval ensign in 1775 and has in recent years been more commonly identified with the United States Marine Corps.[8] Though many variations exist, the most common version shows a coiled rattlesnake with thirteen rattles at the tip of its tail, representative of the original thirteen colonies. The snake in the photograph appropriated by Kruger is not a rattlesnake, however, but rather a bull snake or pine snake, a species that is also exclusively found in the Americas. It is perhaps of some significance that the bull snake, while not poisonous, carefully mimics the defensive behavior of the rattlesnake, coiling its body in a striking position and vigorously vibrating its rattleless tail in manner highly reminiscent of its venomous brethren.[9] The bull snake's clever simulation of its considerably more dangerous relative as a form of defense is perhaps analogous to Kruger's similar use of appropriated texts and photographs, which comprise individual signifying elements that are not of her own invention but, as in the case of this print, combine to convey a powerful and provocative statement of caution.

In contrast to the brash confidence of the colonial revolutionary, invoked by "Don't tread on me," the phrase, "Don't tempt me" casts the work's "voice" in a considerably more complicated light, introducing the possibility of vulnerability or seduction, as the snake is potentially transformed from a symbol of liberty against tyranny into the very face of evil itself and a cold reminder of the human capacity for frailty and sin.[10] Of course as Kruger has appropriated these popular phrases herself, one cannot ignore the aggregated meanings compounded by the appropriations of others. We cannot, for example, deny the potential significance of the fact that both phrases have been appropriated by gay activists. The Gadsden flag was adopted by thousands of gay rights marchers at the Democratic National Convention in San Francisco in July 1984,[11] and the Lord's Prayer by the lesbian social activist Rita Mae Brown, whose slightly altered and often-repeated version states, "Lead me not into temptation; I can find the way myself." The Grammy-nominated British singer and songwriter Richard Thompson also used the phrase in the title of his song "Don't Tempt Me" from his 1988 album *Amnesia*, in which he invokes the phrase "snakes alive," a variation on "saints alive" or "sakes alive," generally used as a more wholesome substitute for the expression "for the Lord's sake."

Indeed, depending on the viewer's level of investment, a rigorous analysis of Kruger's untitled print can lead to labyrinthine depths of meaning that function much like a spider's web: the more intensively you struggle, the more treacherously you become entangled. As the artist herself has noted, "I would rather say that I work circularly, that is around certain ideational bases, motifs and representations. To fix myself, by declaring a single methodology or recipe, would really undermine a production that prefers to play around with answers, assumptions and categorizations."[12] Indeed, in Kruger's work the fictional and the factual, as well as the personal and political, collide and collude in ways that reveal ever greater potential for meaning—meanings that result not only from the artist's intention but also from multifarious, seemingly unlimited intersections with society and culture at large.

Bradley Bailey

Notes

First published November 2010

1. Kruger developed a facility with the language and visual structure of advertising while working as a graphic designer for several different publications at Condé Nast, where she eventually became art director for *Mademoiselle*. There are several excellent books and exhibition catalogs that exhaustively detail her background, chief among which are Kate Linker, *Love for Sale: The Words and Pictures of Barbara Kruger* (New York: Abrams, 1990); Ann Goldstein, ed., *Barbara Kruger* (Los Angeles: Museum of Contemporary Art; Cambridge, MA: MIT Press, 1999); and Alexander Alberro et al., *Barbara Kruger* (New York: Rizzoli, 2010).

2. Kruger, in Jeanne Siegel, "Barbara Kruger: Pictures and Words" (interview), in *Art Talk: The Early 1980s* (New York: Da Capo, 1988), 303 (originally published in *Arts Magazine* 61 [June 1987]: 17–21).

3. When the photographic image is transferred to a photochemically sensitive emulsion applied to the screen, the resulting negative image functions as a stencil, with the ink able to pass through only the permeable areas of the screen.

4. McLuhan's often-cited phrase was first introduced in his book *Understanding Media: The Extensions of Man* (New York: McGraw-Hill, 1964).

5. While Kruger was not included in the *Pictures* exhibition, which art critic Douglas Crimp organized in 1977 for Artists Space in New York (where Kruger was also showing her work in the 1970s), her work is closely associated with the postmodern approach of the artists who were, among them Troy Brauntuch, Jack Goldstein, Sherrie Levine, Robert Longo, and Philip Smith. Kruger joins Cindy Sherman, Richard Prince, Jenny Holzer, and Laurie Anderson, among others, whose conceptual cross-media explorations of the late 1970s and 1980s have come to exemplify this aesthetic. Crimp's essay "Pictures," which extended his commentary beyond the scope of the exhibition, was published in *October* 8 (Spring 1979): 76–88. For more on this subject, see the recently published exhibition catalog by Douglas Eklund, *The Pictures Generation, 1974–1984* (New York: Metropolitan Museum of Art; New Haven, CT: Yale University Press, 2009).

6. See Jean Baudrillard, "The Precession of the Simulacra," trans. Paul Foss and Paul Patton, *Art and Text* 11 (September 1983): 3–47, and Jacques Derrida, "Structure, Sign, and Play in the Discourse of the Human Sciences," in *Writing and Difference*, trans. Alan Bass (Chicago: University of Chicago Press, 1978), 278–93. Kruger's work also calls on Walter Benjamin's theories regarding the influence of mechanical reproduction on the creative process and Michel Foucault's understanding of power and sexuality as powerful factors in defining discourse. See Walter Benjamin, "The Work of Art in the Age of Mechanical Reproduction," in *Illuminations*, ed. Hannah Arendt, trans. Harry Zohn (New York: Schocken, 1969), 219–26, and Michel Foucault, *The Archaeology of Knowledge*, trans. A. M. Sheridan Smith (New York: Routledge, 2002).

7. This distinction was first defined by Jean-François Lyotard in *The Postmodern Condition: A Report on Knowledge*, trans. Geoff Bennington and Brian Massumi (Minneapolis: University of Minnesota Press, 1984).

8. The origin of the snake as an American symbol can likely be traced back to Benjamin Franklin's 1754 woodcut of a snake separated into eight sections (the head represented New England), accompanied by the caption "join, or die," which reappeared in November 1774 in the *Massachusetts Sun* newspaper with the same caption. Shortly after, the version popularized by Gadsden came to represent a wide variety of colonial regiments in the Carolinas, Pennsylvania, Virginia, and elsewhere. For more on the origins of the Gadsden flag and the rattlesnake as an American symbol, see William Rea Furlong and Byron McCandless, *So Proudly We Hail: The History of the United States Flag* (Washington, DC.: Smithsonian Institution Press, 1981), 71–77; Edward W. Richardson, *Standards and Colors of the American Revolution* (Philadelphia: University of Pennsylvania Press and the Pennsylvania Society of Sons of the Revolution and Its Color Guard, 1982); and Michael Corcoran, *For Which It Stands: An Anecdotal Biography of the American Flag* (New York: Simon & Schuster, 2002).

9. I thank Robert D. Aldridge, herpetologist in the Department of Biology at Saint Louis University, for identifying the animal as a bull snake. The description of the bull snake's behavior was found in Carl H. Ernst and Roger W. Barbour, *Snakes of Eastern North America* (Fairfax, VA: George Mason University Press, 1989), 102.

10. This is not the first instance in which Kruger used a theme from Genesis in her work. Her *Untitled (You Invest in the Divinity of the Masterpiece)* of 1982 superimposes the phrase over the Creation of Adam scene from Michelangelo's ceiling frescoes in the Sistine Chapel. Here, the "you" being chastised in the statement can be a male spectator or anyone complicit in the maintenance of what she perceives as the patriarchal systems of art-making, art history, and art criticism.

11. See Robert L. Loeffelbein, *The United States Flagbook: Everything About Old Glory* (Jefferson, NC: McFarland, 1996), 147.

12. Kruger, in Siegel, "Barbara Kruger," 304.

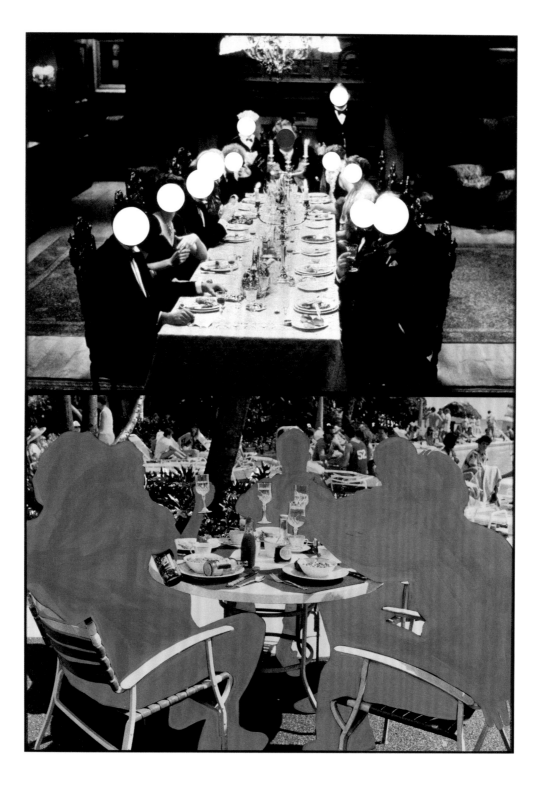

Two Compositions (Formal / Informal;
Interior / Exterior), 1990

Two color photographs and vinyl paint, 96 ¹/₄ × 68 ¹/₈" (overall)
University purchase, Charles H. Yalem Art Fund, 1992

John Baldessari

(American, b. 1931)

Two Compositions (Formal / Informal; Interior / Exterior), 1990

IMAGES APPROPRIATED FROM MOVIES, advertisements, and stock photography have been the source material for much of John Baldessari's art since the 1970s. How visual conventions—old and new, painterly, photographic, and filmic—inform the way we interpret images is a central question posed by his work. Baldessari not only investigates how formal devices reinforce the narrative content of an image or image sequence but also asks us to consider the ways in which images circulate in our mediated environment.

The vertically stacked diptych *Two Compositions (Formal / Informal; Interior / Exterior)* reexamines the conventions of group portraiture.[1] Rather than commemorating an occasion or event, Baldessari here focuses on the pictorial strategies that communicate class, rank, and authority among members of a social group. In the upper image, the artist presents us with a long table, around which are seated a group of elegantly dressed dinner guests whose faces are obliterated by monochromatic circles of paint; in the lower image, he likewise manipulates a scene by painting over the entire bodies of a group seated outdoors at a poolside table. Baldessari introduced these invasive obliterations in the mid-1980s, following a decade in which he explored the relationship between image sequences and sentence structure.[2] Painterly obliterations overlaid onto photographic images provided an opportunity to intervene within the structure of the image, and he has used them ever since.

In *Two Compositions (Formal / Informal; Interior / Exterior)*, Baldessari's cancellations not only render each figure anonymous but also prompt us to consider the social inflections of the settings, in this case a formal dining room and a casual outdoor scene. His painterly interventions also draw attention to how such details as facial

expressions, gazes, body language, and dress function as markers of both individuality and meaning in portraiture, as well as how settings communicate issues of social class. The painted portrait in a gilded frame in the upper left corner of the top photograph, for example, is instrumental in conveying an air of aristocratic class, which is reinforced by the elegant dress of the guests around the table, the fine dinnerware, tablecloth, and candles. By contrast, the visual language of the lower image is marked as "informal," an exterior scene with bathers in the background, in which our attention is directed at the surroundings: the plastic chairs, the ketchup bottle, and the incongruously elegant glasses.

Representations of class, social status, and rank, as much as the role of hand gestures and facial expressions as a means of communication, are rooted in the visual conventions of group portraiture. While the individual portrait is traditionally charged with conveying a likeness of the sitter as well as a psychological resonance that reveals the person beneath the mask, the group portrait is concerned with group identities—a family, an institution, a professional circle. It serves as a vehicle to communicate social values or a group's civic responsibility and power. Social hierarchies and economics traditionally determine who assumes a prominent place within the portrait and who is assigned a marginal role. Dress, setting, and accessories convey information about the individual as much as the social status of the group as a social unit. These are also the formal strategies that Baldessari has consistently investigated and disrupted in his work. The painted areas are abstract and flat, disrupting the coherence of the scene and puncturing its perspectival space. The colored dots that cover the faces in the upper image of *Two Compositions* not only map the logic of perspective, with the red one designating the vanishing point, but also indicate a social hierarchy—in this case, rendering visible how the perspective highlights the person at the head of the table. By contrast, the abstract gray paint that covers the figures of the seated group in the lower image removes the boundaries between the individual figures to create larger,

undefined shapes. In this case, Baldessari does not stress hierarchical differences between figures but the cohesion of the group as a social unit.

Baldessari's interest in how images convey meaning reaches back to his artistic beginnings as a conceptual artist in the 1960s. At that time the photograph's relationship to "the real" and to interpretive frameworks was of particular interest to a number of American and European artists, including Baldessari, Robert Barry, Jan Dibbets, Hans-Peter Feldmann, and Douglas Huebler. Much of the work of photo-conceptual artists in the late 1960s centered on the presumed objectivity and accuracy of the photographic image, which they upended through image sequencing or the pairing of seemingly incongruous images and titles.[3] In contrast, Baldessari used nondescript photographs and art historical texts to disrupt the pictorial conventions and values that were taught in art schools or communicated through photography manuals.[4] In the 1970s he became increasingly interested in popular culture images—for instance, advertisements and movie stills that traditionally operate in a different context—and the associations that arise from arranging two or more unrelated images in sequences. In the 1980s he frequently used movie stills as source material for his work, and this is the case with *Two Compositions*.[5] While a photograph, like a painting, is traditionally meant to be viewed, studied, shared, and displayed on its own, a film still, in contrast, is a split-second frame that is part of the flow of a larger narrative, usually accompanied by sound and not seen by itself. By "halting" the movie, the artist is asking us to read the film stills as photographs, shifting our approach and expectations. In doing so, he returns our attention to those signs and gestures that are indebted to painterly and photographic conventions—conventions that communicate meaning on a purely visual level.

In the end Baldessari underscores the importance of reading the literal information in the image against a cultural and contextual framework, and he does so by eluding narrative interpretation. Neither

his two images nor his title gives us any indication of who the people are or what occasion brings them together. Are we looking at "real people" or actors? Are these actual representations of social gatherings, or scenes staged for a movie or advertisement? This uncertainty fundamentally affects our interpretation of the images, reminding us that we are dealing with a mediated and fragmented reality. The pictures we see refer back to a narrative context—a news story, a film, an advertisement, or possibly an account of history—that we can no longer reconstruct.

Catharina Manchanda

Notes

First published September 2007

1. The group portrait gained particular prominence in seventeenth-century Holland. For a detailed history and analysis of the genre, see Harry Berger Jr., *Manhood, Marriage, and Mischief: Rembrandt's "Night Watch" and Other Dutch Group Portraits* (New York: Fordham University Press, 2007).

2. For example, in Baldessari's artist's book *Brutus Killed Caesar* (1976), each spread consists of three photographs that echo the three-word structure of the title. On the left and right we see profile views of two men who are "looking at each other." These portraits remain constant throughout the book; what changes is the image between the two men. The first sequence reads like a rebus—portrait-knife-portrait—but subsequent examples offer different, often humorous interpretations, as the knife is replaced by images of a gun, a coat hanger, a banana peel, a potted plant, and a can of paint, among other items.

3. In 1969 Robert Barry famously photographed gas containers in a landscape. The photographs had titles such as *Inert Gas Series: Helium. Sometime during the morning of March 5, 1969, 2 cubic feet of Helium will be released into the atmosphere*. According to the title, the image documents an empirical act; the pun centers on the fact that gas is invisible to the eye—the eye of the camera as much as the eye of the viewer.

4. A good example is Baldessari's 1967 series of photo-transfer paintings. *Wrong* (1967) shows a snapshot of the artist standing in front of a palm tree that looks as if it is growing out of his head; the stenciled caption below the image reads "wrong" and follows the pattern of photography manuals that illustrate "good" and "bad" composition. With this series, Baldessari positioned himself against such conventions, further distancing himself from expectations of artistic craftsmanship by having a friend take the photograph and hiring a sign painter to stencil the caption below the image. These photo-transfer works should be seen in context with his text paintings, white canvases on which he had a sign painter stencil phrases such as "Everything is purged from this painting but art, no ideas have entered this work" (1967–68).

5. The top image is from the film *Haunted Honeymoon* (1986); the bottom is from the film *Revenge of the Nerds II: Nerds in Paradise* (1987). Thanks to Allison Unruh for bringing this to my attention.

Your Imploded View, 2001

Aluminum, 51 ³/₁₆" diameter
University purchase, Parsons Fund, 2005

Olafur Eliasson

(Icelandic, b. Denmark, 1967)

Your Imploded View, 2001

AT FIFTY-ONE INCHES IN DIAMETER and over six hundred pounds, *Your Imploded View* appears at first glance like a massive wrecking ball, menacingly suspended just a few feet above the heads of all who pass through the Museum's atrium. When set in motion, the tension increases as the aluminum sphere moves rhythmically on a north-south axis, inducing sensations of surprise and trepidation among those individuals in close proximity. In addition to its kinetic and temporal character, the sphere's uneven and reflective surface distorts the surrounding space, creating new images of the museum environment and engaging the viewer in an active dialogue with it.

Central to all of Olafur Eliasson's work is the experience of the viewer. What the artist is after is "the self-reflexive potential in art: our ability to evaluate ourselves in our surroundings."[1] His oft-recited mantra "seeing oneself seeing" aptly articulates his ambition for the individual spectator and for society as a whole.[2] A close reading of *Your Imploded View* allows for an examination of the various implications of Eliasson's call for a proactive subject, including his principal belief that heightened awareness of the subjective character of perception may provide a means toward greater social consciousness in everyday life, as opposed to the pacifying effects of mass-media entertainment.

Eliasson's emphasis on activated spectatorship and its implied relationship to active engagement in the sociopolitical arena directly builds on a long line of artistic precedents, including the Hungarian artist László Moholy-Nagy's experiments with light, space, and motion in the early twentieth century and the Zero group's production of kinetic sculptures and light events in the late 1950s in Düsseldorf. The California-based Light and Space artists' focus on the contingent character of the viewer's sensory

Your Imploded View, 2001

Aluminum, 51 ³/₁₆" diameter
University purchase, Parsons Fund, 2005

experience in the late 1960s and the perceptual investigations undertaken by the American artists Dan Graham and Bruce Nauman in the 1970s are also frequently singled out as among the artist's more immediate influences.[3] Eliasson's work, like that of his predecessors, explores the ways in which the subject's encounter with his or her surroundings prompts larger revelations about the nature of perception itself.

Eliasson's debt to phenomenological philosophy has been pointed out by critics and by the artist himself, who often returns to the writings of Maurice Merleau-Ponty, Henri Bergson, and Edmund Husserl, with whom he shares the conviction that perception is not simply a question of vision but involves the whole body and that what one perceives is dependent on being at any one moment physically present in a matrix of unfolding circumstances that determine how and what one perceives. Rather than presupposing a "neutral" or "universal" subject detached from any specific social context, however, a point that critics of phenomenological theory have taken issue with since the 1970s, Eliasson emphasizes the nonprescriptive individuality of the spectator's responses.[4] The greatest potential of phenomenology, he claims, is its ability to introduce an element of relativity and uncertainty into one's routine experience of space and time.[5]

The artist frequently employs the possessive "your" in the titles of his works to emphasize the primacy of the viewers' embodied reception. He intentionally plays on the ambiguity between a singular "your" and a collective "your" that might potentially arise in relation to his work.[6] Looking at the reflective sphere of *Your Imploded View*, spectators enter into a disorienting experience in which neither subject (viewer) nor object (artwork) can claim dominance, as the two are in fact intertwined. The dings and black pockmarks covering the uneven surface of the work not only highlight the fact that the ball was handmade but also complicate the distinction between reality and representation. Unlike a mirror, in which one merely looks at a reflection of oneself, the polished aluminum presents a softened, warped,

and thus overtly mediated image meant to heighten our ability to see ourselves seeing the artwork—to experience ourselves from both a third-person and a first-person perspective.[7]

It is important to recognize that Eliasson's art is never solely about private experience; it is also about social interaction. While we see ourselves seeing, we also become aware of others negotiating the same work simultaneously. Through disorientation, *Your Imploded View*, like the majority of Eliasson's works, is intended to expose the degree to which our shared reality is culturally constructed and thus help us to reflect more critically on our experience of it.[8] While bodily interaction is crucial, the artist also draws attention to the fact that it is not only our immediate corporeal experiences that need to be taken into account but also our individual psychological states, as "our memories and expectations also have a highly individual impact on how we perceive what we see."[9] The meaning of the encounter in the atrium is thus deeply relational and constantly changeable, depending entirely on who you are and what you are doing, as well as on the presence of others sharing the same space. The experience can be considered communal, but not universal, as each individual always brings something different to the work.

Eliasson's installations are undeniably popular in their appeal and have received both praise and criticism for their awe-inspiring and generally spectacular character.[10] It could be argued that *Your Imploded View* does little more than playfully alter the gallery space and that Eliasson's critique is so subtle and theoretical that its relationship to the viewer's actual experience of the work is often lost.[11] While the artist embraces diverse interpretations of his work, he also ardently asserts that his practice is a form of institutional critique. Unlike those practitioners of institutional critique in the 1970s who staged grand oppositions, Eliasson recognizes that the museum and the artist are unavoidably linked and attempts to alter the perception of the institution by emphasizing each visitor's subjective position, for, as he states, "changing a basic viewpoint necessarily must mean

that everything else changes perspective accordingly."[12] In the case of *Your Imploded View*, the sphere simultaneously reflects and implicates not only the body of the individual viewer but also the architectural environment, along with the constructed arrangement of artworks hanging on the building's white walls, the bodies of other people negotiating the social space of the atrium, and even the outside world glimpsed through the glass walls that flank the north and south entrances.

The curator and art historian Madeleine Grynsztejn deftly summarized Eliasson's position as one that ultimately sets out "less to deconstruct the museum antagonistically than to embolden it as a place from which to articulate a speculative and critical approach."[13] In opposition to what he understands to be a dominant trend toward universalized and increasingly standardized experiences in today's consumer culture, Eliasson holds faith in the museum as one possible site "where we can still use our senses to define our surroundings, rather than just being defined by our surroundings by means of the commodification of our bodies."[14] Through both his work and his extensive writings, he challenges the museum to separate itself from commercial venues—to preserve an oppositional space, however provisional, for discussion, negotiation, and potential dissent from the prevailing logic of consumer culture. Providing an experience of sharpened awareness, not only of the work of art but also of our position in relation to the institution, is regarded by the artist as a social responsibility. His call for change is not directed at external considerations but, as exemplified by *Your Imploded View*, at organizing a consciousness of one's perceiving body within the ideological framework of the museum. For Eliasson, purposeful engagement with the world is an ethical imperative, and it is through an intense focus on the subjective moment of perception—the root condition of all subsequent inquiry—that independent thinking and social action become possible.

Meredith Malone

Notes

First published December 2007

1. Olafur Eliasson, in conversation with Doug Aitken, in *Broken Screen: Expanding the Image, Breaking the Narrative; 26 Conversations with Doug Aitken*, ed. Noel Daniel (New York: D.A.P., 2006), 110.

2. Eliasson admits that his phrase was greatly influenced by the California Light and Space artist Robert Irwin's earlier phrase "perceiving yourself perceiving." See Olafur Eliasson and Robert Irwin, "Take Your Time: A Conversation," in *Take Your Time: Olafur Eliasson*, ed. Madeleine Grynsztejn (San Francisco: San Francisco Museum of Modern Art; London: Thames & Hudson, 2007), 55.

3. For a general overview of these movements and others, see Annelie Lütgens, "Twentieth-Century Light and Space Art," in *Olafur Eliasson: Your Lighthouse; Works with Light, 1991-2004* (Wolfsburg, Germany: Kunstmuseum Wolfsburg, 2004), 32-40. Pamela Lee explored the historical relationship between Eliasson's work and the California Light and Space movement in her essay "Your Light and Space," in Grynsztejn, *Take Your Time*, 33-49.

4. In the 1970s, with the rise of feminist and poststructuralist theory, phenomenology was criticized for its assumption that the subject was timeless and universal, unmarked by social and cultural determinations that shape one's experience of the world. As Claire Bishop has noted, "writings of Michel Foucault, Jacques Derrida, and others placed the subject in crisis, dismantling Merleau-Ponty's assertion of the primacy of perception to reveal it as one more manifestation of the humanist subject." Bishop, *Installation Art: A Critical History* (New York: Routledge, 2005), 76. Bishop offers a thorough discussion of the history of phenomenological theory in relation to the practice of installation art; see especially pages 48-81.

5. Eliasson and Irwin, "Take Your Time," 52.

6. Caroline Jones astutely described Eliasson's use of the second-person pronominal as an assembly of differences compelling negotiation, contrasting it with 1980s postmodernism and the work of Barbara Kruger in particular: "Where Kruger's pronouns emphasize difference, Eliasson dreams of volitional community, mining English for the unique ambiguity between a singular 'you' and a collective 'You' that might eventually form." Jones, "The Server / User Model," *Artforum* 46 (October 2007): 321.

7. Eliasson speaks of his works as tools that encourage the spectator, "to step aside and think about what you are doing while you do it, as if from an external point of view." See Eliasson, in *Broken Screen*, 110. Calling the work a tool also emphasizes the choice that a viewer makes whether to actively engage with a given work or not.

8. Eliasson's essay "Vibrations," published in the exhibition catalog *Your Engagement Has Consequences: On the Relativity of Your Reality* (Basel: Lars Müller, 2006), is among his most succinct statements regarding his artistic practice and its larger sociopolitical implications.

9. Eliasson, "Vibrations," 62.

10. This is especially the case for Eliasson's large-scale installation *The Weather Project*, displayed in the Turbine Hall at the Tate Modern in 2003. For an insightful critique of this project, see James Meyer, "No More Scale: The Experience of Size in Contemporary Sculpture," *Artforum* 42 (Summer 2004): 220-28.

11. Claire Bishop clearly lays out this contradiction in Eliasson's work. See Bishop, *Installation Art*, 77.

12. Eliasson, quoted in Angela Rosenberg, "Olafur Eliasson: Beyond Nordic Romanticism," *Flash Art* (May–June 2003): 112.

13. Madeleine Grynsztejn, "(Y)our Entanglements: Olafur Eliasson, the Museum, and Consumer Culture," in *Take Your Time*, 23. In this essay Grynsztejn offers an excellent analysis of Eliasson's practice of institutional critique and his relationship to spectacle culture.

14. Eliasson, in "In Conversation: Daniel Buren and Olafur Eliasson," *Artforum* 43 (May 2005): 211.

Andrea Fraser

(American, b. 1965)

Little Frank and His Carp, 2001

SHOT WITH HIDDEN CAMERAS INSIDE the Guggenheim in Bilbao, Spain, Andrea Fraser's six-minute video *Little Frank and His Carp* documents an unauthorized intervention into the museum designed by the architect Frank Gehry, the "Little Frank" of the work's title. During the course of her visit, cameras follow Fraser as she rents the museum's official audio guide—which doubles as the video's sound track—and listens raptly to the British-accented male narrator as he describes the sensuous grandeur of Gehry's building. As she obeys the instructions to surrender, in amazement, to the genius of the architect and the power of his titanium and glass structure, she begins to vigorously rub her body against a pillar, experiencing an intense and physical identification with the museum. The video is a send-up of contemporary museological seduction that takes as its target an institution that has, since the opening of the Guggenheim Bilbao in 1997, become the pioneering model for global, supranational museum brands and neoliberal ideals.[1]

Fraser's work is closely associated with the conceptually driven artistic practice known as institutional critique.[2] Throughout her more than twenty-year career, she has questioned art's institutional and economic relationships through humorous, performative interventions that often center on the critical analysis of various art world positions, functions, and didactic forms: the docent, the curator, the collector, and the artist, as well as the museum brochure, the exhibition catalog, and the audio guide.

Unlike Fraser's earlier works, such as *Museum Highlights: A Gallery Talk* (1989), in which she assumed the role of Jane Castleton, a fictitious docent, and presented a subversive tour of the Philadelphia Museum of Art based on extensive research culled from archival sources and the museum's publications, *Little Frank* was inspired

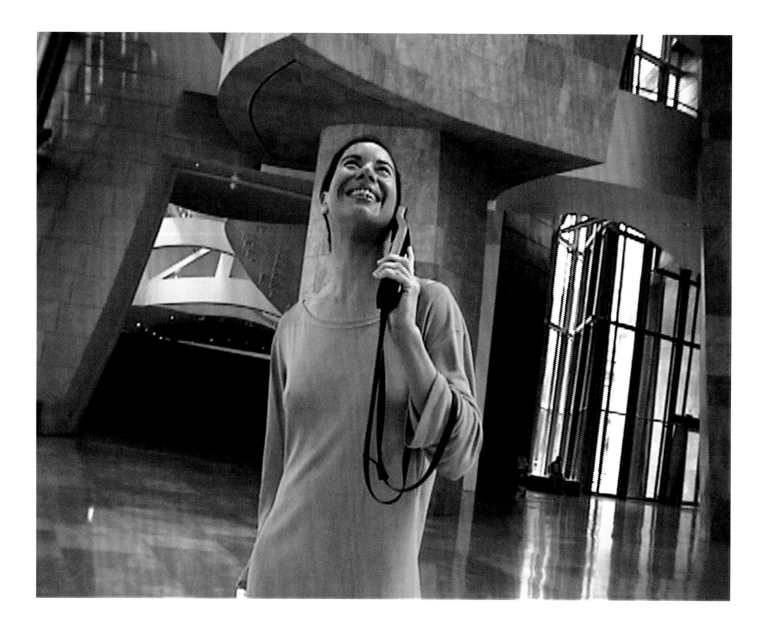

Little Frank and His Carp, 2001

Single-channel color video with sound on DVD, 12 / 25, 6 min.
University purchase, Parsons Fund, 2006

by the over-the-top institutional "voice"—complete with sexually suggestive language, anecdotes, and grandiloquent descriptions of technological prowess—presented by the Guggenheim Bilbao.[3] As the artist excessively demonstrates in *Little Frank*, the aural affect of audio guides can be intensely influential, even to the extent of displacing the viewer's own inner dialogue and intuitive responses. Museum audio guides involve the viewer in the alluring climate generated by the sound script through the tone of the spoken voice and the sense of presence it generates, directly engaging the viewer's emotional sensibility.[4] The sound track of *Little Frank* not only compels particular reasoning and identifications on Fraser's part but actually puts her body into motion, drawing her through a series of suggestions, emotional states, and sensorial experiences. During her visit to the Guggenheim the artist internalizes the amplified rhetoric of the museum and exaggerates, to an absurd extent, the manner in which the prepackaged tour champions Gehry's genius, the inspiring power of his architecture, and the freedom of its unprogrammed flows.[5] Visitors to the museum are encouraged to understand their experience as a unique and highly intimate one despite the fact that the Guggenheim is an international tourist destination and has become something of a global franchise.[6]

"Isn't this a wonderful place?" the guide suggests in reference to the museum's atrium during the first few minutes of the audio tour. "It's uplifting. It's like a Gothic cathedral. You can feel your soul rise up with the building around you." As the recording rambles on about the glories of this revolutionary architecture, never mentioning the art it contains, Fraser mockingly enacts a series of exaggerated emotional states in direct correlation to the tour's prompts: she appears variously amazed, pensive, relieved, perplexed, and reassured. As the audio guide continues, the voice of the male narrator invites Fraser to reach out and touch the "powerfully sensual" curves of the atrium's walls. The camera follows her as she willingly obeys, becoming so excited by the invitation to feel the walls of the building that she is driven to perform actions the museum never intended.

In analyzing *Little Frank and His Carp*'s humorous critique of the museum's inflated rhetoric and its affective architecture, there is another element that must be taken into account, namely, the role of the viewer. To understand this role, we need to consider the choices that the artist made in the conception and production of the video. Four individuals with hidden cameras shot the footage, which was then carefully edited and pieced together.[7] The perspective of the video frequently shifts, so that the viewer is continually placed in various positions of identification—with the protagonist, the passerby, the onlooker, and, in one instance, that of museum surveillance—while also being displaced through the use of wider, less intimate shots. At moments when the camera focuses solely on Fraser's body or actually assumes the artist's viewpoint, there is a seeming neutralization of the medium. As the camera enters the building's atrium, for example, the viewer does not follow behind the artist but rather sees what she sees: a sign detailing the procedures for renting the museum's audio guide. In other instances the camera follows closely behind Fraser as she moves through the atrium and begins to feel the smooth surface of a pillar.

One of the most humorous shots of the short video comes after Fraser stops rubbing up against this pillar and returns her dress to its normal position. As she looks behind her, the camera zooms out and pans to the right to reveal a large crowd of onlookers watching from a few feet away. Seeing the audience displaces the spectator, for the viewer can no longer assume a direct identification with the crowd. This is a key moment in the film, as the artist is caught in the act, yet no one from the museum staff or the general public intervenes. Eventually an older man walks by and, apparently unaware of what just transpired, strokes the surface of the same pillar at the suggestion of the audio guide, thus comically validating the motivation for Fraser's outrageous actions.

In recent years Fraser has taken to describing her particular practice of institutional critique as an ethical one in that she does not work in opposition to the institution so much as within it, interrogating, through strategic interventions and performances, the manner in which cultural producers not only expose but also participate in the reproduction of relations of power in the art world. The artist's analytic practice does not express certainty or transparency—qualities that once defined politicized artistic practice—but rather pointedly articulates and exemplifies the contradictions and complicities, ambitions and ambivalence, of which institutional critique is often accused. The destabilizing potential of *Little Frank and His Carp* is located precisely in its ability to make manifest the complex and often overlooked social, psychological, and economic relations that subtend today's art world, prompting critics, curators, artists, and visitors alike to reflect on their roles within this system and to question what it is they really want from art.

Meredith Malone

Notes

First published June 2007

1. Under the leadership of Thomas Krens, the Guggenheim set out to become an international chain of satellite institutions operating in semiautonomous fashion. Abu Dhabi's $27 billion tourist and cultural development on Saadiyat Island is currently set to include a Guggenheim Abu Dhabi, designed by Frank Gehry, as well as a Louvre Abu Dhabi, designed by Jean Nouvel. See Alan Riding, "The Industry of Art Goes Global," *New York Times*, March 28, 2007. Fraser is just one of many critics to address the positive and negative aspects of museum-driven urban revitalization, what is called the "Bilbao effect." For further perspectives, see the excellent essays in Ana María Guasch and Joseba Zulaika, eds., *Learning from the Bilbao Guggenheim* (Reno: Center for Basque Studies, University of Nevada, 2005).

2. The practice of institutional critique first emerged in the late 1960s and early 1970s in reaction to the growing commodification of art and the prevailing ideals of art's autonomy and universality. Closely related to conceptual and site-specific art, institutional critique is concerned with the disclosure and demystification of how the artistic subject as well as the art object are staged and reified by the art institution. Fraser's particular practice is also strongly influenced by the French sociologist Pierre Bourdieu's exploration of the conflicts and hierarchies of the art world and the role of culture in the wielding of symbolic power as a source of social differentiation.

3. In *Museum Highlights*, Fraser superimposed the discourses of the nineteenth-century art museum and the poorhouse, producing a witty critique of the museum as an institution for the discipline of classes without taste. Fraser's script for this performance was first published as "Museum Highlights: A Gallery Talk" in *October* 57 (Summer 1991): 104–22, and includes stage directions, epigraphs, and extensive footnotes.

4. See Jennifer Fisher, "Speeches of Display: The Museum Audioguides of Sophie Calle, Andrea Fraser, and Janet Cardiff," *Parachute*, no. 94 (April–June 1999): 24–25.

5. The script of the audio guide makes a clear distinction between the structured and rigid format of the great museums of previous ages versus Gehry's atrium, which is described metaphorically as a pumping heart through which people freely pass.

6. Lucy Lippard recently addressed the mass appeal of the Guggenheim Bilbao, stating, "Like its contents, the often-forgotten art, it will be as familiar to international visitors as other franchises have become—upscale McCulture, like Armani or Prada." Lippard, "On Not Having Seen the Bilbao Guggenheim," in Guasch and Zulaika, *Learning from the Bilbao Guggenheim*, 68.

7. María Mur, Arantza Pérez, José Luis Roncero, and Alfonso Toro employed hidden cameras to tape the artist's visit to the Guggenheim Bilbao. Several takes were necessary to produce the final version.

Michel Majerus

(Luxembourgian, 1967–2002)

mm6, 2001

DURING HIS SHORT CAREER Michel Majerus never shied away from competing with and attending to the world of popular, and especially technological, media.[1] In his large-scale paintings and massive installations, he demonstrated his fascination with the new image worlds of the digital era by exploring their potential for his own conceptually reflexive aesthetic practice. A student of the American conceptual artist Joseph Kosuth at the Staatliche Akademie der Bildenden Künste in Stuttgart, Germany, Majerus energetically participated in the resurgence of painting in the 1990s after the fall of the Berlin Wall. His paintings reflect an eclectic and heterogeneous array of references that include painterly gestures, postpainterly abstraction, Pop art, reproductions of logos, mass-produced products, and postmodern quotations and other short and evocative texts.[2] Like many of his artworks, *mm6* deliberately acts in response to the fast pace and flickering effects of the digital image, confronting it with a large-scale painting, penetrated by empty grounds, that suspends digital motion into stasis.

Majerus once described his artistic practice as follows: "My work operates precisely on the assumption that every claim to 'authentic' culture and lifestyles is illusionary."[3] Nevertheless, at least on the surface *mm6* appears to inscribe itself into the long-standing art history of self-portraiture, belonging to a series of four paintings that the artist conceived in 2001 in Berlin. Between 1989 and 2006 the German metropolis, then a center of cutting-edge techno culture, annually staged Love Parade, an electronic music and dance festival that sometimes drew more than one million fans from around the world. In 2000 Majerus asked a Berlin video jockey (VJ), whose stroboscopic light and laser shows were featured at that year's

mm6, 2001

Acrylic on canvas, 119 $\frac{1}{16}$ × 134 $\frac{1}{16}$"
University purchase, Parsons Fund, 2003

Love Parade, to collaborate with him on a digital video animation consisting of sound, color, and the artist's name, Michel Majerus. Like the painting *mm6*, the video *Michel Majerus*, which was displayed on a large-scale video wall comprising twenty-five monitors, is a composition of abstract and flattened areas of color, featuring digital design sensibilities of the turn of the millennium that alternate with a graphic treatment of the artist's name. While the abstract electronic animation employs flashing lights and fast-paced cuts, however, the painting freezes this movement into a single large-scale image that reveals some painterly marks, staging the man-made beside the technologically manufactured. Yet the fragmentation of the artist's name, combined with the frozen and spatialized abstract design elements, creates a visual instability that resembles the character of electronic images and their ability to blur the boundaries between the visible and the invisible. Hence the painting *mm6* adopts and challenges the visual effects of rapid electronic flashes delivered from multiple video screens at once.

In this painting and others, Majerus hybridized contemporary electronic media culture, conventions of high art, and popular culture through his employment of the medium of painting. While his art historical adaptions draw on the works of artists such as Willem de Kooning and Jean-Michel Basquiat, in the case of *mm6* he employed an inexpressive and graphic vocabulary with hardened forms, smooth surfaces, and a Pop color scheme that seem to defy the notions of individual self-expression and authenticity typically understood as characterizing self-portraiture. By combining this form of artistic language with the creation of a self-portrait, the foremost genre of artistic self-referentiality, Majerus illuminated subjectivity as complex and hard to attain in the digital age. The fact that his painted self-portrait is also a reproduction of sorts—a small slice of the video *Michel Majerus*—further complicates established visualizations of subjectivity tied to individual creativity and uniqueness. Moreover, the painting

largely refuses to do what we usually expect modern painting to do: immerse the viewer in the texture of paint and the visibility of the brushstroke, indices of the gesture of the artist and his "authentic" self.

A consideration of Majerus's iconographic and aesthetic engagement with the digital and his concurrent dismissal of artistic authorship—as in his life-size and functional skateboard ring *if we are dead so it is* (2000), which declares "fuck the intention of the artist," or through the incorporation into his paintings of phrases such as "Produce-Reduce-Reuse"—raises questions: How do the digital and the artistic collide in his artworks? And to what extent do they complement each other or cancel each other out? Daniel Birnbaum has observed that Majerus "mediates the way through which digital methods of picture production seem to alter space, the very space of representation itself, producing a strange sense of emptiness and a visual dissonance."[4] Tilman Baumgärtel came to a similar conclusion, suggesting that we should consider Majerus's pictures "as a form of painting that has also taken new digital design methods aboard without making a great to-do about it."[5] By joining methods of image-making that are at odds with one another—the residue of the electronic flickering screen, the iconography of popular media culture, and the painterly interpretation of electronic images—Majerus's paintings can be conceptualized as a new and different genre, with the artist in the role of creative competitor, or they can be comprehended, considering the trajectory of painting in the twentieth century, as a climax of nonform. In short, *mm6* and other formally heterogeneous paintings mix characteristics that are specific to the medium of painting with those used in the realm of digitization. Both aesthetic approaches penetrate experiential reality as a location for the visualization of such collisions. Along with Clement Greenberg we may claim them as "impurities," stretched to their very limits in order to eventually generate a new form.[6]

Yet obviously this hybridization of different image-making strategies, which at once embraces

and dislocates the design of electronic media into the medium of painting, ultimately connects visual worlds that, seen together, problematize perceptions of place, location, and the "real." The material (the painted fragment of the video) and the immaterial (the video), time (the electronic animation) and space (the abstracted self-portrait), suddenly exist together. Majerus bends the mediums of static painting and flickering electronic image-worlds to create a new visual universe, one that elucidates the coexistence of man-made and machine-calculated imagery in such a way that it establishes unique perceptual sensations, which, in contrast to his claims, are authentic. And, while Majerus repeatedly called on the "now" to describe his endeavors, presence (the materiality of the painting) and absence (the fragmented image) manifest themselves at the same time.[7]

Spatial ruptures, frequently mismatched iconographies (the popular design of the video animation and the self-portrait), empty backgrounds on which images and text float, and a general lack of homogeneity and coherence are reason enough for Birnbaum to conclude that Majerus's art demonstrates the ontological status of painting under the conditions of electronic media. Although I do not object to this thesis, I am skeptical of considering Majerus's endeavors solely as a mediation, if not transformation, of digital aesthetics into the sphere of expanded painting. Majerus invested too much energy converting canvases into spatial and experiential objects, as he demonstrated in installations such as *it's cool man* (1997) and the skateboard ring from 2000. His painted canvases not only expand the frame of the conventional painting in order to assert a spatial presence as materiality in its own right, but they also circumvent the perceptual immersion typical of the digital in their inclusion of evocative texts and other narrative elements as well as in their massive scale, which not only necessitates a multiplicity of viewing angles but also generates a differentiation from the virtual image-worlds that they illustrate or reference.

Furthermore, not only did Majerus appropriate the iconography and aesthetic languages of electronic media, but his works also persistently comment on diverse painterly styles that, as incarnations of artistic invention, become meaningless (through reuse and repetition) and instead acquire the status of exchangeable image-worlds, similar to electronic designs. His paintings therefore demonstrate that he was investigating the condition of painting in the age of electronic media while also scrutinizing the state of electronic media in relation to the medium of painting. However, it is unclear whether Majerus's works signify that the virtual-turned-real shuts us off as individuals, exposing the digital as immaterial, or that the virtual-turned-art demands unapproachability and distance. It is obvious that his hybridization of various image-making strategies connects visual worlds that, seen together, nevertheless probe what we commonly call the real. This questioning produces another order of reality. Like the simulacrum, Majerus's painting makes the distinction between original and copy superfluous and even uninteresting. On the contrary, what sparks our fascination is an aesthetic experience that is built on false likeness, bringing about new perceptions that mediate the effects of a digitized world.

Seen in the context of Majerus's overall exploration of making art under the conditions of the digital era, his investigation of self-portraiture in the *mm* series suggests—maybe in unison with the way in which we employ social media today to promote ourselves—that unique individual identity has become a matter of the past. In radical discontinuity with both previous and contemporary forms of portraiture that either visualize the many social identities that shape the twentieth and twenty-first centuries or idealize or exaggerate individual features and attributes, Majerus's self-portraits appear to blank out the personal and the social. In their place he presents us with a frozen, zoomed-in screen that attracts attention through the very dissonances between digital design and the painted canvas.

Sabine Eckmann

Notes

1. Michel Majerus was born in Esch-sur-Alzette, Luxembourg, in 1967. He lived and worked in Berlin until 2002; he died in a plane crash in November of that year.

2. For an overview of Majerus's career, see the retrospective catalog Peter Pakesch, ed., *Michel Majerus: Installationen 92-02 / Installations 92-02* (Cologne: König, 2005). The exhibition was shown at Kunsthaus Graz, Austria; Stedelijk Museum, Amsterdam; Deichtorhallen, Hamburg; Kestnergesellschaft, Hanover, Germany; and Musée d'Art Moderne Grand-Duc Jean, Luxembourg.

3. Michel Majerus, quoted in Raimar Stange, "Frenetic Stasis," *Mousse*, no. 10 (September 2007): 50.

4. Daniel Birnbaum, "Search Engine: The Art of Michel Majerus," *Artforum* 44 (February 2006): 171.

5. Tilman Baumgärtel, "Super Mario and the Night of the Visual," in Pakesch, *Michel Majerus*, 233.

6. Clement Greenberg, "Avant-Garde and Kitsch" (1939), reprinted in *Art in Theory, 1900–1990: An Anthology of Changing Ideas*, ed. Charles Harrison and Paul Wood (Oxford: Blackwell, 1992), 529–41.

7. For more on this, see my essay "Aura, Virtuality, and the Simulacrum," in *After the Digital Divide? German Aesthetic Theory in the Age of New Media*, ed. Lutz Koepnick and Erin McGlothlin (Rochester, NY: Camden House, 2009), 69–87.

Landslip, Cromlech de Mzora, 2001

C-print mounted on aluminum, 1 / 5, 23 ⁵/₈ × 23 ⁵/₈"
University purchase with funds from Helen Kornblum, 2013

Yto Barrada

(French, active in Morocco, b. 1971)

Landslip, Cromlech de Mzora, 2001

Tunnel—Disused Survey Site for a Morocco–Spain Connection, 2002

YTO BARRADA'S PHOTOGRAPHS *Landslip, Cromlech de Mzora* and *Tunnel— Disused Survey Site for a Morocco-Spain Connection* are from a series dealing with international, continental, and cultural boundaries, *A Life Full of Holes: The Strait Project* (1998–2004). The series title refers to the Strait of Gibraltar, the narrow channel that separates Europe from North Africa while simultaneously connecting the Mediterranean Sea to the Atlantic Ocean. Prior to 1991 Moroccan citizens were able to cross the strait and enter Spain on a regular basis, but Spain's signing of the Schengen Agreement that year effectively closed this connection. Although not the sole barrier to crossing the sea, the Strait of Gibraltar has come to stand for the much larger cultural, political, and social divide between the two continents.

Throughout *The Strait Project*, Barrada uses photographic documentation of the Moroccan city of Tangier to obliquely represent the separation between North Africa and Europe. The series transports the viewer to a region coded in fantasy and "otherness," even to this day. Through Barrada's lens, landscape, domestic interiors, and street scenes activate the city, portraying it as a multivalent site of both stagnation and potential. While Barrada never depicts the physical separation between Spain and Morocco, *The Strait Project* finds other ways to evoke the reality of migration and exile. Although Tangier is only nine miles from the Spanish coast, that number fails to capture the magnitude of the linguistic, cultural, and political distance that separates it from Europe.

The art historian T. J. Demos has argued that Barrada's photography "is freed from representation. . . . The documentation of bare life . . . can only take place *negatively*, that is, indicated through the lacuna, blurs, and blind spots that mar the image,

but also open up possibility within it."[1] Demos references the Italian political philosopher Giorgio Agamben's controversial construct of *bare life*, which Agamben defines as the point at which life and law become indistinguishable.[2] On a practical level, the condition occurs when everyday actions are completely subsumed under the power of the state. In the case of Tangier, bare life is apparent in the construction of the city's identity, solely through its proximity to Europe and the resultant restrictions placed on mobility.

This tension Demos notes between negative space and possibility permeates *Tunnel* and *Landslip*. The former frames an abandoned survey site for a project that would have connected Tangier with Spain, while the latter juxtaposes in the foreground a naturally occurring erosion (the "landslip" near the ancient megalith of Mzora, approximately thirty miles from Tangier) with a pastoral field in the background. By making photographs that suggest gaps, boundaries, and connectivity without resorting to their straightforward depiction, Barrada navigates the nuances between documentation and aestheticization. She compels the viewer to question the nature of artificially constructed boundaries as well as the natural, cultural, and psychological impediments to human mobility.

Landslip, Cromlech de Mzora depicts a pastoral landscape divided. Rolling green hills occupy the middle and background, while the foreground reveals a rupture. A mud-filled stream flows down the divide, disappearing into the verdant distance. An isolated group of trees sits to the upper left. The sky behind is dominated by an undefined grayish white cloud cover. The only sign of human intervention is a nondescript dirt road. It is that geologic rift, however, that captures the viewer's attention, evoking a fault line, a deep disturbance within the earth. The rift is frozen in time and yet continually evolving—the viewer can make out loose rocks barely adhering to the steep sides, indicating that the landslide is ongoing. The ground is inherently unstable, reflecting the danger intrinsic not only to such geologic change but also to political instability

and the complex nature of larger divides. Rather than simply dismissing religious and political differences as mere social constructs, Barrada reminds us of the physical obstacles to movement. Reading the photograph in terms of the larger series, it is as if the trauma of separation—Northern Africa from Southern Europe—is both recorded and prefigured in the landscape.

The title Barrada gave this work is significant as it refers both to the landslide in the foreground and to the ancient monument known as the Cromlech of Mzora. A cromlech traditionally refers to a circular array of large stones, Stonehenge in the United Kingdom being the best-known example. The Neolithic-era Cromlech of Mzora, however, is a circular mound more than 177 feet in diameter that rises to around 20 feet high at its apex. The mound is bordered by a ring of smaller stones, anywhere from three to seven feet tall, and is located close to the present-day town of Assilah, also thirty miles from Tangier (and the strait).[3] No part of the monument is visible in Barrada's photograph, but the association with the megalithic structure adds much to the interpretation of the piece and draws a connection to a long, unbroken past. The Cromlech of Mzora was a source of legend, one cited in the mythology of ancient Greece.[4] The disjuncture between the ancient civilization of legend and the ruins that remain leads the viewer to consider that longer history—the rise and fall of empires and how, through it all, the land stands as witness. In particular, the juxtaposition of the prehistoric with the contemporary, punctuated by that deep divide in the earth, speaks to the transient nature of geopolitical boundaries. After all, when the Cromlech was first constructed, the artificial divides between Spain and Morocco, Christian and Muslim, did not yet exist. The European Union, the Schengen Agreement, and the rest of the political entities that restrict movement across the strait become denaturalized within a time frame that spans millennia.

To cross that watery divide from Tangier to Spain, one must travel by ferry, a journey that takes around two hours, ending in the Spanish town of

Algeciras. Migration in both directions across the strait is a reality for millions of people each year, and the present-day ferry system is not equipped to handle the volume.[5] The governments of Morocco and Spain have spent more than a quarter century discussing the complex nature of constructing a tunnel between the two coasts, but logistical issues continue to keep plans at the level of speculation. In 2009, long after the completion of Barrada's photographic exploration of Tangier, the commission set up to explore construction of the strait tunnel issued a report that called into question the feasibility of the project.[6] In light of this later development, Barrada's *Tunnel—Disused Survey Site for a Morocco–Spain Connection* is both a monument and a memorial to this undertaking.

Barrada depicts this survey site as abandoned, a condition more prosaically described in the title as "disused." The bare concrete platform stands in stark contrast to the vivid blue sea in the middle ground. Rust corrodes the steel beams that cut the photograph almost in half diagonally. Together, the blue and the rust make for a spare palette within this minimalist composition. A lone weight hangs from a cable, frozen in space, completing the delicate composition. We wonder how long it has hung there, hooked to the neighboring cable. The entire apparatus rests on a flat concrete surface, but even this has chipped away, with a solitary weed forcing its way upward. All the elements are in place, suggesting a stable, albeit neglected site, but the viewer can make no sense of the structure, its purpose, or even its scale.

Tunnel renders the present ancient, while *Landslip* alludes to the presence of the ancient. In both these images, time dissolves and creates distance. It is no coincidence, then, that Barrada turns to two sets of ruins to remind the viewer of the malleability of time. Ruins traditionally go hand in hand with absence, in this case the palpable absence of the human figure. This is not the case for much of the series, in which Barrada photographs the inhabitants of Tangier in ways that are both intimate and yet removed from the immediacy of daily life in the city. For *Tunnel* and *Landslip*, however, human presence is implied by what has been left behind. This human involvement is more evident in *Tunnel*, to be sure, but it permeates *Landslip* in the lonely dirt road that winds through the landscape of Mzora.

Barrada's choice to present her photographs from this series in a variety of sizes lends its display the air of a curio or travelogue. In person, the viewer must negotiate the different dimensions, stepping toward or away from the photographs accordingly. Across the series, however, Barrada consistently maintains a square format, unlike traditional landscape photography. While the proliferation of similar formats on social media sites such as Instagram has rendered this a common sight, from 1998 through 2004, when Barrada was shooting the Strait series, this choice of format would have echoed the obsolete Polaroid. These images both allude to and deny the instant gratification of the Polaroid, as well as its disposable nature. Combined with their lack of human presence or temporal markers, these photographs also exude a timeless, enduring quality. The scale, however, is somewhere in between, too large for the immediacy (and intimacy) of the Polaroid and too small for monumental landscape.

We, the viewers, hover in between modes of interpretation and, much like the inhabitants of Tangier, find ourselves in a limbo of sorts. Barrada's entire series emits the slice-of-life aesthetic of an instant camera, occupying that gray area between documentation and the aestheticization of bare life. The ethical implications of aestheticizing this condition are numerous, however, and run the risk of experiencing enjoyment at the expense of others.

The lack of context, the minimalism of the elements, and the aforementioned in-betweenness of format and scale give the viewer no clear answer as to Barrada's intent with the series. As others, such as the critic Nadia Tazi, have observed, the photographs are "consistent with a certain tendency of contemporary art that attempts to 'document' realities and ordinary practices in a manner that is both politically modest and formally understated."[7] In other words, Barrada focuses on the banality of everyday

*Tunnel—Disused Survey Site for a Morocco–Spain
Connection*, 2002

C-print mounted on aluminum, 4 / 5, 39 3/8 × 39 3/8"
University purchase with funds from Helen Kornblum, 2013

life in order to characterize a much larger social and political system. Specifically these photographs interrogate how the decisions of those in power affect the lives of ordinary people, those living on the "wrong" side of the strait. Barrada is not the only contemporary artist to work in this mode. Her work has been discussed frequently in conjunction with that of Steve McQueen and Emily Jacir, to name just two examples. Both McQueen and Jacir have used documentary (film and photography, respectively) to interrogate the economic disparities created by barriers to immigration. Barrada's contribution to this mode of image-making is, I would argue, the way she creates a portrait of a border zone without resorting to clichés.

This lack of cliché keeps us guessing. As Barrada herself has stated, "approaching something indirectly is a form of elegance and, in a paradoxical way, of precision."[8] By choosing to forgo the stereotypical depiction of the boundary between Spain and Morocco, Europe and North Africa, Barrada reveals far more about the reality of this border zone. This condition is one of desire but, at the same time, palpable ennui. Anthony Downey, in his review of the series, notes that this paradoxical nature of the photographs stems from Tangier being a place of both transit and stagnation.[9] The muted colors throughout Barrada's series support this conclusion. The images evoke a life spent in perpetual limbo—the state of the would-be emigrant, the refugee, or the expatriate. The disjuncture between Tangier as imagined tourist paradise, vibrant and exoticized, and the city's portrayal as a gloomy way station on the path to Europe drives this reading of the work.

I wonder, however, if the constant subordination of Morocco in this comparison is truly what Barrada's work implies. If Tangier is a paired city longing for its European counterpart yet forever thwarted by geography and geopolitics, then what to make of Spain's position? By restricting immigration and actively discriminating against ethnic minorities, Spain (and the rest of Europe) also loses. Barrada portrays only Tangier, and the viewer is left to fill in the other end of the journey. Does Algeciras

exude that same ennui, and could we find similar paradoxes throughout the major European capitals? The question is at once absurd, for these tensions—between movement and stasis, longing and memory—are a part of any transcultural milieu. The strait that divides may appear to leave Morocco and North Africa in a subordinate position, but Barrada's series is intentionally ambiguous about where (and how) to draw the line.

Ila N. Sheren

Notes

First published April 2014

1. T. J. Demos, "Life Full of Holes," *Grey Room* 24 (Summer 2006): 77.

2. See Giorgio Agamben, *Homo Sacer: Sovereign Power and Bare Life*, trans. Daniel Heller-Roazen (Stanford, CA: Stanford University Press, 1998); first published in Italian as *Homo sacer: il potere sovrano e la nuda vida* (Turin: Einaudi, 1995).

3. All dimensions come from Youssef Bokbot, "La pierre et son usage à travers les âges: Jardin des Hespérides," *Revue de la Société Marocaine d'Archéologie et de Patrimoine* 4 (2008): 25–29, bokbot.e-monsite .com/pages/le-cromlech-de-mzora-temoin-du-megalithisme-ou -symbole-de-gigantisme-de-pouvoir.html.

4. As recounted by Plutarch in the first century AD, the Cromlech of Mzora was the probable location of the tomb of the Libyan giant Antaeus, killed by Hercules during one of his Twelve Labors.

5. The proposed tunnel was intended to carry more than nine million passengers per year. See Giles Tremlett, "By Train from Europe to Africa—Undersea Tunnel Project Takes a Leap Forward," *Guardian*, October 20, 2006.

6. The report, released in 2008 by the Spanish company SECEG, is no longer available online. See "Doubts Cast over Spain-Morocco Undersea Tunnel Plan," *Middle East Online*, September 29, 2008, www.middle-east -online.com/english/?id=28090.

7. Nadia Tazi, "The State of the Straits," trans. Lucy McNeece, *Afterall* 16 (Autumn-Winter 2007): 95; first published in Kamal Boullata, ed., *Belonging: Sharjah Biennial 7* (Sharjah, United Arab Emirates: Sharjah Art Foundation, 2005).

8. Yto Barrada, quoted in "Conversation between Sina Najafi and Yto Barrada," in *Yto Barrada*, ed. Lionel Bovier and Clément Dirié (Zurich: JRP Ringier), 146.

9. Anthony Downey, "A Life Full of Holes," *Third Text* 20 (September 2006): 619.

Bill II, 2001

Reflective glass, holographic foil, and paper on fiberboard support,
110 1/4 × 12 3/16 × 12 3/16"
University purchase, Charles H. Yalem Art Fund, 2003

Isa Genzken

(German, b. 1948)

Bill II, 2001

Little Crazy Column, 2002

BILL II AND *LITTLE CRAZY COLUMN* belong to a group of column-shaped sculptures that Isa Genzken produced between 1994 and 2003. The columns are slender pillars that are slightly above human height, making for a vertical impression without appearing monumental. Their surfaces are adorned with inexpensive yet shiny and at times outright gaudy materials from everyday life, including mirrored tiling, reflective and overlaid holographic foil, and multicolored industrial tape; in the case of *Bill II*, there are also photographs from popular American cookbooks and magazines. With their collage of quotidian materials, their vertical orientation reminiscent of skyscrapers (albeit in miniature), and their use of a sculptural idiom, the columns are typical of Genzken's approach, for although her oeuvre is heterogeneous, architecture, sculpture, modernism, and the readymade remain touchstones of her artistic practice. The alignment of these principles in the columns makes for a highly intriguing and at times outright dizzying viewing experience, which is playful with serious implications.

A significant part of that tension is mediated by the collaged surfaces, as can be seen in *Little Crazy Column* and its realization of the term *crazy*. According to the Oxford Dictionary, *crazy* has its origin in the late sixteenth century, when its meaning was "full of cracks": "The root here is the verb to craze (Late Middle English), which is now 'to drive mad, send crazy' or 'to develop a network of small cracks' but originally meant 'to break in pieces, shatter.' So a crazy person has had their sanity shattered. Crazy formerly meant 'broken, damaged' and 'frail, unwell, infirm.'"[1] The fragmented and pieced-together surface of *Little Crazy Column* enacts that Late Middle English meaning of *crazy*. For even though it is adorned with shiny materials, the surface is also literally full of cracks and is broken where one pattern of mirrored tiles meets

another. Gaps open up between them, revealing the column's base structure. Paint is dripped all over, and neon-colored industrial tape is plastered on top of the mirroring surfaces, in some parts in monochrome pink and in others in layers of different colors. The tape is crumpled, and air pockets have formed, which contributes to the general impression that, despite its glitzy surface, *Little Crazy Column* is not a sleek and impenetrable pillar or tower. Rather, it is defined by a handmade quality that at times tips over into the untidy, broken, damaged, and frail—it is, in a word, crazy.

Furthermore, the column's positively crazy dimension plays out not only in the realm of the sculpture's materiality but also in that of a viewer's perception. For it is not just the column that is full of small cracks; the viewer's body image also becomes fractured. *Little Crazy Column*'s mirrored surfaces allow for an encounter between viewer and sculpture by reflecting both body and gaze, thus furthering the column's social dimension.[2] Instead of generating holistic physiognomies, however, the reflections create fragmented bodies that are reminiscent of the ways in which a digital image collapses into discernible pixels when blown up to the point at which figuration tips over into abstraction. This physical-optical disintegration occurs in instances in which the colorful tape disrupts the silver coating and, in the mirror image, both dissects and becomes part of one's body. There are also cases in which the cracks between the mirroring tiles and their divergent patterns make for an image in which body parts appear in different sizes and at various angles and the body—and with it the experience of the viewing subject—is broken up into pieces. It is in these moments that the contemporary notion of crazy comes to the fore, including references to madness and extreme enthusiasm, but also, such as when speaking of angles, to something that appears absurdly out of place or unlikely or to something you do to an extreme degree and with great intensity. In that sense too, *Little Crazy Column* is crazy, and it conveys its craziness to viewers by constantly displacing, shifting, and fragmenting

their experiences of vision, perception, and the physical self.

While craziness, bodily fragmentation, and looking askew may suggest a negative or even clinical state of mind, this is not necessarily the meaning of *crazy* in its crossover definition between Late Middle and contemporary English, and it is certainly not what Genzken's *Little Crazy Column* effects. For one, there is a powerful dimension of cultural criticism in her work. As Lawrence Weiner has said about her, Genzken is one of those people who are "not happy with society as they see it" and who continually attempt to criticize society.[3] The columns realize that criticism through a mediation of alienation and relationality, which viewers enact, among other things, in the encounter with the mirroring surfaces that let them experience the work and the self in a mutual state of associative dissociation. Still, stimulation, exuberance, and playfulness are equally important aspects of that viewing experience. They come into play particularly when looking at the bronze- and purple-colored holographic foil that adorns *Little Crazy Column*. The circular patterns within the holographic foil are reminiscent of old-fashioned television sets screening one's crazy self-productions many times over. Moving in front of them, one becomes witness to a disco swirl that is lively and upbeat yet highly disorienting. The world around me seems to be dancing. Or is it me who is making the world spin?[4] An uncertainty arises that is indicative of a merging between sculpture and viewer, thus confusing the divide between an aesthetic of production and an aesthetic of reception.

While the mirroring surfaces play a crucial part in creating a relational effect, the works' titles are also important. Genzken named several of her columns after friends and colleagues—including Wolfgang Tillmans (*Wolfgang*, 1998), Kai Althoff (*Kai*, 2000), and Daniel Buchholz (*Daniel*, 1999)—and also named one after herself (*Isa*, 2000). *Bill II* is one of four columns named after her longtime friend Wilhelm (Bill) Schnell, an artist based in New York.[5] Naming the columns after friends and colleagues places them not just in a familiar context but also

Little Crazy Column, 2002

Reflective glass, holographic foil, and tape on fiberboard support,
102 $^3/_8$ × 12 $^3/_{16}$ × 12 $^3/_{16}$"
University purchase, Charles H. Yalem Art Fund, 2003

into a familial one, which is reinforced by the fact that they are often "exhibited in sociable groups of three or more."[6] The familial constellation makes for an intimate and highly reciprocal setting in which relations are established and solidified by looking and being looked at. As Marianne Hirsch writes: "The familial look . . . is not the look of a subject looking at an object, but a mutual look of a subject looking at an object who is a subject looking (back) at an object. Within the family, as I look I am always also looked at, seen, scrutinized, surveyed, monitored. Familial subjectivity is constructed relationally, and in these relations I am always both self and other(ed), both speaking and looking subject and spoken and looked at object: I am subjected and objectified."[7]

The familial gaze enacted by the columns works in a similar way—and not just because the columns' mirroring surfaces literally look back at the viewer and make her feel "subjected and objectified" at the same time. For beyond the direct and immediate exchange between sculpture and viewer and sculpture and sculpture, there is also an exchange on the level of discourse, particularly where it concerns architecture, modernism, and the cityscape of New York. It is on that level that the seemingly autonomous artwork is pulled into a network of real-life references that are familiar and have to do with everyday life in the city.

The columns' connection with New York is first and foremost established by making reference to the skyscraper as a sculptural form and by integrating everyday materials from the streets and shop fronts of Manhattan.[8] In *Bill II* the latter aspect is present in the form of photographs showing foods, such as corn on the cob, pretzels, and different kinds of German-style whole wheat bread. Pulled from old-fashioned yet still popular American cookbooks and magazines, such as the *Betty Crocker Cookbook* and *Better Homes and Gardens*, these images clearly differ from the highly stylized food photography that we encounter nowadays on Instagram or Facebook. Some of the images are details or close-ups that are hard to recognize at first. Some have faded in color and vibrancy, which makes them reminiscent of the

displays on food carts on the streets of Manhattan, where such images are supposed to attract customers yet can sometimes also have the opposite effect. A similar tension of attraction and repulsion is at play in *Bill II*. The column employs the metaphor of food and eating as a mediator between inside and outside, familiar and strange, self and other. In that, it points to the social and relational dimension of eating, which is in line with the irrefutable yet always challenging impulse in Genzken's columns to connect—with the world and with others.

The impulse to connect is part of the artist's "effort not to represent the world but to be part of it—in other words, to be modern."[9] It takes the form of an indexical relationship with the real, which is most notable in the sculpture's use of common materials and is supplemented further by the integration of photographs. In Genzken's oeuvre, sculpture and photography share a certain kind of realism that, according to Laura Hoptman, "forms one of the pillars of [her] assemblage aesthetic. The link between the two seemingly diverse mediums was made . . . through the idea that a photograph itself is a thing in the world and, as such, can stand for the thing that it depicts."[10] By applying photographs to *Bill II*, Genzken establishes a direct connection to the materiality of everyday life, thereby emphasizing both the column's indexical thrust and its social dimension. It is a dimension that exists in tandem with the sculpture's claim to be an autonomous artwork, thereby navigating an intriguing set of paradoxes, including alienation and relationality, autonomy and sociality, art and real life. Navigating the tension that arises within the fractures of these concepts and thus applying a positively crazy view to things, the columns invite us to experience some of the contradictions that make up our contemporary world, the places we inhabit, and the relations we strive to maintain.

Svea Bräunert

Notes

1. Oxford Dictionaries, s.v. "crazy," accessed June 2, 2016, www.oxford dictionaries.com/definition/english/crazy.

2. The social claim of the mirroring surfaces in Genzken's work is made explicit in the title of her series *Social Facades* (2002), which consists of twenty-five abstract collages in various reflective materials, including faux mirrors and mosaic and hologram foils, that are similar to those used in the columns and create comparable visual effects and viewing experiences.

3. Lawrence Weiner, in the documentary *This Is Isa Genzken*, produced by the Museum of Modern Art in 2013, www.moma.org/explore/multimedia /videos/288/1368.

4. Focusing on the similarities with dancing, Diedrich Diederichsen has compared the columns to feelings experienced during the early days of electronic music: "to be self-absorbed, tall and alone, and yet surrounded by others, and to know that these others in their unbridgeable individual ways feel exactly the same." Diederichsen, "Subjects at the End of the Flagpole," in *Isa Genzken: "Sie sind mein Glück,"* ed. Carina Herring (Ostfildern-Ruit, Germany: Hatje Cantz, 2000), 37.

5. Two of the other *Bill* columns are in private collections; the third belongs to the 21st Century Museum of Contemporary Art in Kanazawa, Japan. Thanks to Allison Unruh and Galerie neugerriemschneider for providing this information.

6. Laura Hoptman, "Isa Genzken: The Art of Assemblage, 1993–2013," in *Isa Genzken: Retrospective*, ed. Sabine Breitwieser et al. (New York: Museum of Modern Art, 2013), 144.

7. Marianne Hirsch, introduction to *Family Frames: Photography, Narrative, and Postmemory* (Cambridge, MA: Harvard University Press, 1997), 9.

8. In their thematic approach, appearance, and materials, the columns are also connected to other projects Genzken has conceived in relation to New York City, including her scrapbooks *I Love New York, Crazy City* (1995–96), the photographic series *New York, NY* (1998–2000), and the sculpture group *Fuck the Bauhaus* (2000).

9. Hoptman, "Isa Genzken," 132.

10. Ibid., 133–34.

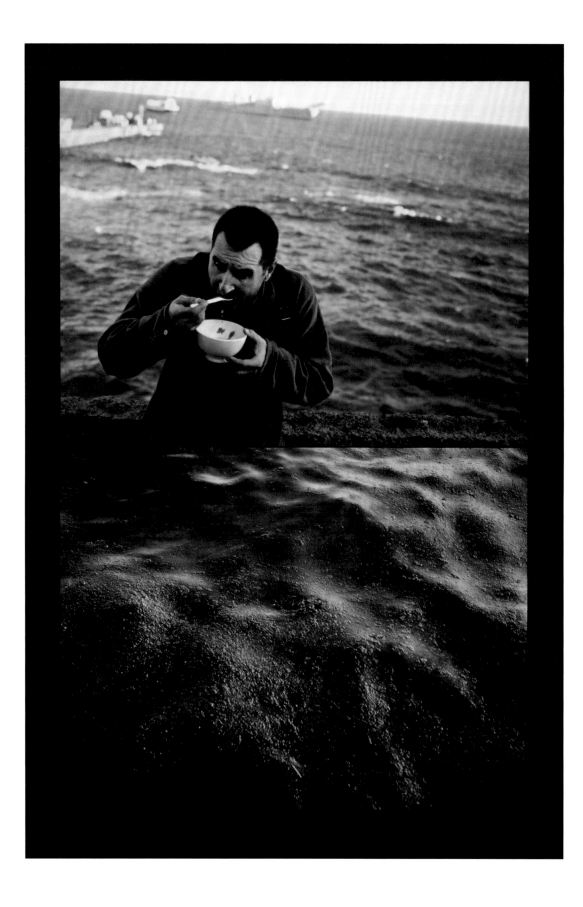

Volunteer's Soup (Isla de Ons, 12 / 19 / 02), 2002–3

Cibachrome, 3 / 5, 62 $^7/_8$ × 42 $^3/_4$"

University purchase, Bixby Fund, 2003

Allan Sekula

(American, 1951–2013)

Volunteer's Soup (Isla de Ons, 12 / 19 / 02), 2002–3

VOLUNTEER'S SOUP (ISLA DE ONS, 12 / 19 / 02) is part of Allan Sekula's photo-essay, or sequence, *Black Tide / Marea Negra*.[1] Consisting of twenty photographs in ten frames, the project documents the 2002 oil spill off the Galician coast, in the northwest of Spain. It occurred after a number of European governments failed to respond to the running aground of the tanker *Prestige*, causing the ship to break apart and release more than twenty million gallons of oil into the sea.[2] Volunteers carried out a major part of the effort to contain and clean up the oil spill. Sekula documented them and their work as well as the disastrous environmental conditions in photographs he orig-inally took for *Culturas*, a weekly magazine supplement of the Barcelona newspaper *La Vanguardia*. The photographs, most of which are arranged in pairs of two and three, portray the volunteers dressed in white overalls stained with oil. Only a few of them are shown working; most are between tasks, taking a break, eating, or socializing with one another. Other photographs depict seascapes of oil, either panoramic views giving an impression of the spill's magnitude or close-ups focusing on the oil's liquid materiality and the abstract patterns it forms on different surfaces. There is also a picture of Sekula himself, looking out from behind what appears to be a wall of black oil—an image of "the artist as witness to the seemingly insignificant details of disastrous events, one who both looks through and makes surfaces."[3]

 Volunteer's Soup is a vertically arranged diptych from the sequence that brings together two of its main motifs: the volunteers' bodies and the oil's textures. The upper photograph is a half-length portrait of a man eating a bowl of soup, with the poisoned coastal panorama behind him. Unlike the volunteers pictured in other photographs, the individual here is not wearing white overalls. Still the caption identifies him as a

volunteer—or at least as someone eating the volunteers' soup. In this moment of pause, of consumption and replenishment, he embodies a state between work and nonwork that corresponds to the status of a volunteer, who is similarly suspended between worker and nonworker. Aligned with this image of the volunteer is a photograph of the mess he is there to clean up. It is a close-up showing the water's wavy surface covered by a thickly textured layer of oil. The visceral impact of the image is immediate, graphic, appalling. Yet if the context of the upper panel and the overall sequence was not given, the subject of the photograph would not be evident. It could be an aerial view of a distant, perhaps unearthly landscape; thick blotches of black paint; an animal's fur. Hence, regardless of its seemingly stark realism, the diptych exudes an equally powerful abstract effect that is achieved not despite but because of the oil's abject materiality.

Arranging the two photographs—of a man eating soup and of the ocean covered by oil—vertically within the same frame, Sekula brings them to bear on each other. It is a technique reminiscent of modernist film montage, in which different sequential elements are juxtaposed in order to arrive at a new meaning. This meaning does not reside in the single picture but rather arises from the images building on each other and entering into a dialectical relationship. Montage hence works with the culmination of images *and* with the imaginary fissures that open up between them. Its different forms and techniques bring about new ways of seeing that instigate new ways of thinking. Montage can thus convey original ideas that come to the fore as visual composites and interstices, complements and contrasts, over time and instantaneously. *Volunteer's Soup* functions akin to such montage logic; its pictorial and political messages do not exist solely *in* the image; they also become discernible in the connections and frictions that open up *between* the images.[4]

The work's montage effects are both complementary and unsettling. The images explain and contextualize each other; their combination (actively) *makes* sense. But it also calls into question what used

to make sense and suggests new interpretations and meanings. These diverging processes take place on thematic, photographic, and aesthetic levels. The sequence *Black Tide / Marea Negra*, for instance, ties in with Sekula's long-standing engagement with the maritime world, exemplified by projects such as the photo-documentary *Fish Story* (1989–95), the essay films *The Lottery of the Sea* (2006) and *The Forgotten Space* (2010; together with Noël Burch), and the research piece *Dear Bill Gates* (1999). In these projects Sekula tackled the sea as a crucial and multifaceted space of labor, late capitalism, and globalization that is all too often overlooked. It is "the 'forgotten space' of modernity"[5] that only comes to the fore in "stories of disaster, war, and exodus."[6] The oil spill off the Galician coast is such a story of disaster. It brings the maritime world into focus and treats it as a decisively modern and late-capitalist constellation, with both oil and the ocean signaling the promises as well as the disastrous effects of a globalized market.

At the heart of this constellation is the relationship between humans and the environment. Lately this relationship has been theorized under the rubric of the Anthropocene era, which stresses that we have entered a new age in which we can no longer think about earth and its geologic systems without also accounting for human impact and its irreversible changes to the environment. As a human-made disaster the oil spill is an extreme instance of these changes. It exemplifies how a once nurturing environment has become hostile—a point driven home by the bowl of soup, alluding to the fact that the sea used to feed people in the region. With the spill, however, it has turned from nourishing to toxic. Nevertheless the man is taking it in, digesting it, and a disturbing parallel is thus evoked between soup and sea, sea and oil, and oil and soup. These liquids make for a highly immersive environment that cannot easily be contained. Depending on one's point of view, for example, the man in the upper photograph seems to be standing in a sea of oil, infused by it, and even metaphorically taking it in by spoonfuls. Similarly, the oil is spilling over into the sea. And true to the work's montage tradition, a

similar kind of spilling takes place on a visual level, for, like the liquids, each image is always on the verge of spilling over, both visually and discursively, into new meanings, new associations.

These associations have to do with the dynamic between stasis and flow, as it concerns the sea and photography alike. Even though the sea challenges spatial analysis, with its waters "constantly stirred by currents and waves that seem to erase any trace of the past," Sekula's work persistently focuses on the sea's materiality.[7] As Steve Edwards has written, "During a time when cultural debate was dominated by ideas of dematerialization, spectacle, virtuality and the like, Sekula insisted on capitalism and the material reality of the sea."[8] In *Volunteer's Soup*, this tension between materiality and immateriality manifests itself in the representation of liquids. This is most notable in the bottom photograph, which is all about oil. The image is abstract, but its abstraction arises out of its materiality and is therefore anchored in reality—the reality of oil, of a viscous liquid that tacks itself onto other surfaces, thereby turning into an image that can serve as an index of the spill.

In the process, a link is established between oil and photography, which points to a further tension in *Volunteer's Soup*, because even though the work deals with "the fluidity of the sea," it does so with the "means of the still image."[9] Nevertheless, the technique of montage sets the still photograph in motion, drawing on the dynamic exchanges between the two images. One of these exchanges concerns the different traditions of photography that Sekula explored in his writing and practice, including both realism and abstraction. What returns in *Volunteer's Soup* is Sekula's engagement with the divide between photography as evidence (realism) and photography as art (abstraction): "We repeatedly hear the following refrain. Photography is an art. Photography is a science (or at least constitutes a 'scientific' way of seeing). Photography is both an art and a science. In response to these claims, it becomes important to argue that photography is neither art nor science, but is suspended between both the *discourse* of science and that of art, staking its claims to cultural

value on both the model of truth upheld by empirical science and the model of pleasure and expressiveness offered by romantic aesthetics."[10]

Volunteer's Soup visualizes this notion of photography as neither art nor science, neither realism nor abstraction. The composition is hence not just a sensitive documentation of a natural disaster; it also constitutes an intriguing meditation on photography. It embraces the suspension of traditional forms of thinking, seeing, and representing the world. In that, it exemplifies Sekula's concept of critical realism as an exploration of social conflicts through photography, combining realism and abstraction, art and politics, aesthetics and activism.[11] In the case of *Volunteer's Soup*, this combination takes the form of a vertical montage, which triggers thoughts about the relation between humans and their environment, the politics of the sea, and the social relevance of oil and other liquids, as well as their connection to questions of labor, late capitalism, and the stuff that binds all this together, discursively and materially. For Sekula, this stuff is photography and the histories, representations, and social groundings that constitute it.

Svea Bräunert

Notes

1. Sekula prefers the concept of sequences over series, as Bill Roberts notes, due to "their coherence as uniquely determinate arrangements (generally with a beginning and an end)," which offers "more potential resistance than the 'metronomic regularity' and indifference of the series." Bill Roberts, "Production in View: Allan Sekula's *Fish Story* and the Thawing of Postmodernism," *Tate Papers*, no. 18 (2012), www.tate.org.uk/research/publications/tate-papers/18/production-in-view-allan-sekulas-fish-story-and-the-thawing-of-postmodernism.

2. The way the spill happened is typical of contemporary crimes at sea, which often result less from "the direct action of a singular actor than the inaction of many." Charles Heller and Lorenzo Pezzani, "Liquid Traces: Investigating the Deaths of Migrants at the EU's Maritime Frontier," in *Forensis: The Architecture of Public Truth*, a project by Forensic Architecture, London (Berlin: Sternberg, 2014), 659.

3. Allan Sekula, "Found Painting, Disassembled Movies, World Images: Allan Sekula Speaks with Carles Guerra," *Grey Room*, no. 55 (Spring 2014): 132.

4. In montage theory, introduced by the Russian film director and theorist Sergei Eisenstein in the 1920s, vertical montage is associated with the focus on a single shot or image. Despite its vertical arrangement, however, *Volunteer's Soup* rather calls for an associative viewing that is

traditionally connected to horizontal montage and thus to the interaction between more than one image.

5. Allan Sekula, in "Conversation between Allan Sekula and Benjamin H. D. Buchloh," in *Performance under Working Conditions: Allan Sekula*, ed. Sabine Breitwieser (Ostfildern-Ruit, Germany: Hatje Cantz, 2003), 44.

6. Allan Sekula, *Fish Story*, 2nd rev. ed. (Düsseldorf, Germany: Richter, 2002), 53.

7. Heller and Pezzani, "Liquid Traces," 657.

8. Steve Edwards, in his obituary of Sekula, "Socialism and the Sea: Allan Sekula, 1951-2013," *Radical Philosophy*, no. 182 (November-December 2013): 64.

9. Sekula, in "Conversation between Sekula and Buchloh," 49.

10. Allan Sekula, "Reading and Archive: Photography between Labour and Capital," in *The Photography Reader*, ed. Liz Wells (London: Routledge, 2003), 450. For Sekula, the two major trends in the history of photography are represented by Alfred Stieglitz's pictorialism, on the one hand, and Lewis Hine's social documentaries, on the other. For an exemplary discussion of Stieglitz and Hine as representatives of these two modes of photographic representation, see Allan Sekula, "On the Invention of Photographic Meaning," in *Photography against the Grain: Essays and Photo Works, 1973-1983* (Halifax: Press of the Nova Scotia College of Art and Design, 1984), 3-21.

11. For a discussion of Sekula's concept of critical realism, see Jan Baetens and Hilde van Gelder, eds., *Critical Realism in Contemporary Art: Around Allan Sekula's Photography* (Leuven, Belgium: Leuven University Press, 2006).

Fumihiko Maki

(Japanese, b. 1928)

Mildred Lane Kemper Art Museum, 2006

ANY BUILDING CAN BE UNDERSTOOD within larger patterns of thinking about its purposes and form, as an exploration of the design ideas behind the Mildred Lane Kemper Art Museum building at Washington University in St. Louis demonstrates. Completed in 2006, the building is the work of the Pritzker Prize–winning architect Fumihiko Maki, who began his architectural career at Washington University with his first commission, Steinberg Hall, which opened in 1960.[1]

The idea of a campus visual art and design center had been discussed since the 1980s, and Maki's long association with Washington University's School of Architecture made him a logical choice for the commission, which included both the campus of the newly formed Sam Fox School of Design & Visual Arts and its centerpiece, the Kemper Art Museum building. The Sam Fox School campus is a characteristic example of Maki's efforts to create pedestrian open spaces through the use of "group form," a concept that he first put forward as a member of the Japanese Metabolists in 1960. His return to Washington University in 1997 to begin the design of the new center was facilitated by a committee of university leaders that included Cynthia Weese, then dean of architecture, who strongly advocated his selection. This gave him a chance to further develop the trajectory of these influential early ideas, resulting in a building that exemplifies the recent trend toward university museums as public education spaces.

Born in Tokyo in 1928, Maki studied architecture at the University of Tokyo, graduating in 1952, and was then given the rather unusual opportunity to continue his studies in the United States.[2] His American education put him close to the world center of postwar developments in architecture and urbanism, as he first attended the Cranbrook Academy of Art and then studied urban design under Josep Lluís Sert, dean of the

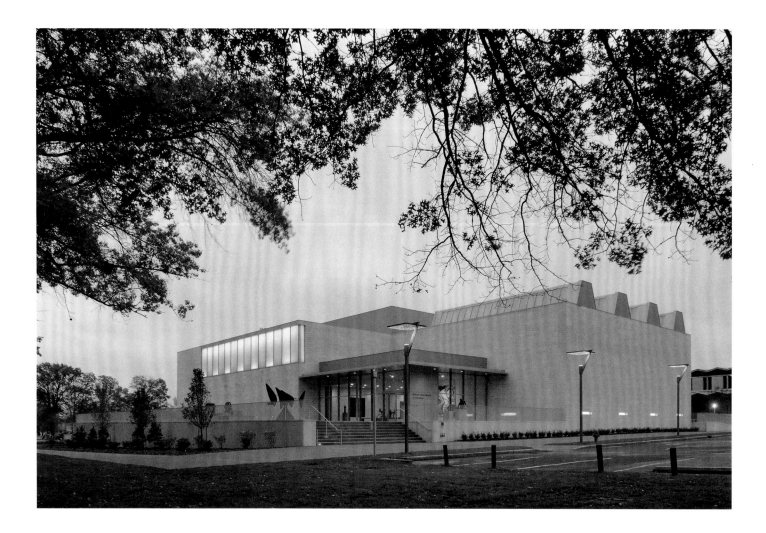

Mildred Lane Kemper Art Museum

Designed by Fumihiko Maki, 2006

Harvard Graduate School of Design. Maki arrived to teach at Washington University in 1956, a time when St. Louis was still one of the nation's largest industrial cities and the local cultural leadership was enthusiastically embracing modernism in art and architecture.[3]

In 1947 Washington University curator H. W. Janson had begun acquiring the modernist masterworks that still form the core of the Kemper Art Museum's permanent collection.[4] That same year, the winning entry in the Jefferson National Expansion Memorial competition, a 630-foot-tall stainless steel arch designed by Eero Saarinen, clearly indicated an official shift away from the classical tradition for large public monuments in the United States. Many significant works of modern architecture in St. Louis then followed, including Minoru Yamasaki's new Lambert Airport and his Pruitt-Igoe public housing complex.

Within Washington University's School of Architecture, after 1956 under the leadership of Joseph Passonneau (also a graduate of the Harvard Graduate School of Design), Maki taught design with such influential future educators as Leslie Laskey, Roger Montgomery, George Anselevicius, and, after 1960, Constantine Michaelides. Maki received the commission for Steinberg Hall in 1958 from Buford Pickens, who was by then director of campus planning after his brief and controversial architecture deanship.[5] Enthusiastically supported by the donor, Etta Eiseman Steinberg, the building was dedicated on May 15, 1960, and its innovative folded-plate concrete structure gave it a distinctive appearance. In line with the late CIAM (Congrès Internationaux d'Architecture Moderne) ideas of the time then taught by Sert at Harvard, Maki also attempted with his design of Steinberg Hall to create dramatic exterior pedestrian spaces that would relate it to its two neoclassical neighbors, Bixby and Givens Halls.

Also significant as an early influence was Maki's participation in the World Design Conference in Tokyo, a huge event at which 250 architects from twenty-seven countries met to discuss approaches to the emerging urbanization that was beginning to transform East Asia. Maki served as the translator for Louis Kahn's informal remarks to Japanese architects during this event. At that time he also joined the Metabolists, a group of young Japanese architects, critics, and design teachers that had been formed around Kenzo Tange, a Japanese CIAM representative and a major figure in postwar Japanese architecture. Maki contributed an essay to the group's only publication, which also included innovative conceptual design work by other Metabolist architects.[6]

After two years of fellowship travel across Asia and Europe, Maki returned to Washington University to cofound the Master of Architecture and Urban Design program in 1962. He then went on to teach at Harvard in urban design in 1962–65, before opening his architectural practice in Tokyo. During this seminal period in his career, Maki wrote *Investigations in Collective Form*, published by Washington University in 1964 and reprinted in 2004. In this still widely read book, he called attention to the changed conditions for urbanism in the contemporary society of the early 1960s, as the social hierarchies that modern architects had attempted to reorganize were beginning to break down.[7] He called for understanding "our urban society as a dynamic field of interrelated forces," in which the urban designer's role was not to provide a fixed order but instead to attempt to contribute to a "state of dynamic equilibrium," which would inevitably change in character as time passes. This required the use of architect-generated "master forms" at a large scale, which could be modified and altered over time, allowing for many changes of use as needed.[8] New large-scale forms were in fact appearing at during this period, in the construction of the American and Japanese interstate highway systems as well as in large new complexes such as airports, shopping malls, sports stadia, and suburban corporate and educational campuses.

In analyzing these changed postwar conditions, Maki suggested the avoidance of both the traditional "compositional form" found in classical planning and in Le Corbusier's late works, such as the master plan for Chandigarh, as well as the "megastructures" (a term that Maki coined in this book) that were then beginning to be a source of fascination for architects. Instead Maki offered the idea

of group form, which consisted of repetitive urban elements that could be assembled into open-ended arrays, linked by pedestrian circulation routes and open-air meeting places. He saw it as a way of organizing collective human spaces similar to vernacular villages of various kinds, such as those of the Greek islands or North Africa. "Group form," as Maki defined it, is "form which evolves from a system of generative elements in space."[9]

Maki's intention in advocating the idea of group form was to "express the vitality of our society" while still "retaining the identity of individual elements." He saw such collective form as evolving "from the people of a society rather than from its powerful leadership" and made a distinction between the classical compositional form of the palace complex, which is formally fixed, and the collective forms of "the village, the dwelling group, and the bazaar," which are able to grow into open-ended systems of urban form.[10]

Maki also called attention to the role of geometry in group form, which he saw as a tool in the search for group form and not an end in itself. The vernacular villages he called attention to typically had very complex patterns of site organization, reflecting their gradual construction by many hands. In his own work he abstracted such village patterns into simpler organizational patterns using rectangles and other geometric shapes. Maki also saw group form not as a formal end in itself but instead as a tool for organizing human activities such as gathering, dispersal, or resting in one place. Like the parallel ideas of the Team 10 group of architects at this time, this was an influential revision of the prewar modernist focus on "air, green, and sun" in urbanism, and it emerged from the extensive questioning of earlier modernist approaches by 1960. In an unpublished text from 1961 Maki also insisted that "the vital image of group form . . . derives from a dynamic equilibrium of generative elements—not a composition of stylized and finished objects" and as such is different from static iconic buildings independent of other structures.[11]

Although more complex examples of Maki's notion of group form exist—most notably in the Hillside Terrace housing complex in Tokyo (1967–92), the Kumagaya campus of Rissho University (1967–68), and the Fujisawa campus of Keio University (1993)— and although the Sam Fox School campus is more classical in its geometric simplicity, it is also a clear example of this concept, one that builds on Maki's earlier Steinberg Hall and that also incorporates the unfinished classical composition begun by Bixby and Givens Halls. Each of its buildings retains its individuality, while at the same time each structure is joined with others to create a varied, pedestrian-friendly, and sociable campus environment. The plan is also an open-ended concept, one that can easily be extended on either side, implying that new buildings will be organized to continue its pattern of outdoor pedestrian spaces defined by their built surroundings.

Instead of expressive architectural gestures or contextual exterior imagery, Maki finds the components of his architecture in careful design attention to basic elements such as walls, floors, vertical shafts, cellular volumes, and pedestrian links, organized primarily in terms of their functions. These he designs in relation to the effects of regional climates and cultures. In the case of the Sam Fox School campus, Maki also made reference to the urban theorist Kevin Lynch's 1954 concept of "urban grain," the general directional pattern of a particular city's block organization. In his earlier unpublished text on collective form, Maki suggested that this might perhaps be "the primary locus of regional character in urban landscape," the point where "both group form and megaform affect the urban milieu."[12]

The design results of these ideas are all evident in the Kemper Art Museum building. It is the central element of the Sam Fox School campus-within-a-campus, but it does not dominate the overall composition in a traditional way. Its site organization creates appealing exterior pedestrian open spaces within the strong east-west "urban grain" of St. Louis and also introduces a new north-south pedestrian route through the Museum itself, emphasizing its role as a cultural link between the University and the larger community. Maki's use of simple industrial materials in the windows and metal exterior wall

elements emphasizes the primarily functional nature of the building's organization, making it a deliberate modern counterpoint to the existing historical and recent campus buildings adjacent to it.

The main facade that faces the plaza is clad with Indiana limestone panels, a similar material to that used on the exteriors of Givens and Bixby Halls. It both evokes a classical facade facing an urban square and, at the same time, modifies this association through its use of a long horizontal strip window and an asymmetrically placed entry.[13] The glazing around the entrance extends eastward to light the library below and then turns the southeast corner of the exterior, creating a visual continuity with the smaller entrance plaza. On the north elevation, facing the historic tree-lined entry to the University campus, the Museum asserts a strong cultural presence with its raised steps to the prominent sculpture terrace and high clerestory windows that light the galleries within. Its relatively unadorned sides, topped to the west by the distinctive sculptural forms of a row of skylights, will allow new structures to be added on either side without disruption to the Museum's natural daylighting and internal functioning. More pragmatically, the building also functions as a circulation link on the Sam Fox School campus, both through the street-like main floor of the Museum and underground, where corridors, some with views out through the library, tie the Museum to adjacent buildings. Its finely finished, simple, rectangular internal volumes create exhibition spaces that allow the focus to remain on the artworks, making the Museum a focal point for the University's educational mission as well as a clear demonstration of Maki's urban design concepts of campus planning.

Eric Mumford

Notes

First published November 2011

1. For a good overview of Maki's career, see Jennifer Taylor, *The Architecture of Fumihiko Maki* (Basel, Switzerland: Birkhäuser, 1999).

2. As a result of World War II, few Japanese nationals were allowed to leave Japan until after 1969. Maki's relatively rare professional and academic experiences in the United States in the 1950s made him an influential figure in Japanese architecture after he returned to Tokyo permanently in 1967. After his graduation from Harvard in 1954, he worked briefly for SOM-New York and then for Sert Jackson and Associates in Cambridge, Massachusetts, before coming to teach at Washington University from 1956 to 1958 and again from 1960 to 1962. See Fumihiko Maki, "Memoir," in *Modern Architecture in St. Louis*, ed. Eric Mumford (St. Louis: Washington University School of Architecture, 2004), 90–97.

3. Maki has written about St. Louis at that time and then in 1981; see Fumihiko Maki, *Nurturing Dreams: Collected Essays on Architecture and the City*, ed. Mark Mulligan (Cambridge, MA: MIT Press, 2008), 99–100.

4. See Sabine Eckmann, "Exilic Vision: H. W. Janson and the Legacy of Modern Art at Washington University," in *H. W. Janson and the Legacy of Modern Art at Washington University in St. Louis* (St. Louis: Washington University Gallery of Art; New York: Salander-O'Reilly Galleries, 2002), 10–42.

5. Pickens was removed as dean by Chancellor Ethan Shepley after Pickens fired a number of longtime faculty members who still taught and practiced in the classical tradition in 1955, most notably Erwin Carl Schmidt, architect of the Cheshire Inn on Clayton Road and the Landmark Building on Brentwood Boulevard opposite Shaw Park. See Mumford, *Modern Architecture*, 55–56.

6. During the 1960 World Design Conference in Tokyo, the Metabolist group presented its first declaration in a bilingual pamphlet titled *Metabolism: The Proposals for New Urbanism*. Similar ideas were further developed by Fumihiko Maki and Masato Otaka in "Some Thoughts on Collective Form with an Introduction to Group Form" (unpublished manuscript, Washington University Art & Architecture Library, St. Louis, February 1961; I thank Heather Woofter for calling my attention to this document). Otaka was chief designer in the Tokyo office of another Japanese CIAM member, Kunio Maekawa. For more on both, see Zhongjie Lin, *Kenzo Tange and the Metabolist Movement: Urban Utopias of Modern Japan* (New York: Routledge, 2010).

7. By the late 1950s ambitious slum clearance and high-rise public housing efforts such as Pruitt-Igoe were beginning to be questioned by figures such as Catherine Bauer Wurster, herself an early and influential advocate of modernist public housing; the sociologist Herbert J. Gans; and Jane Jacobs, whose book *The Death and Life of Great American Cities* (New York: Random House, 1961) profoundly altered architects' ways of thinking about urban design.

8. Fumihiko Maki, *Investigations in Collective Form* (St. Louis: Washington University School of Architecture, 1964), 2–3.

9. Ibid., 11–14. Maki's idea of form draws directly from Louis Kahn's famous distinction, made in a lecture at the 1960 World Design Conference, between a platonic "form," such as a spoon, and a specific "design," with a particular shape, made in a certain way, out of particular materials. See Louis Kahn, "Form and Design," in *Louis Kahn: Essential Texts*, ed. Robert Twombly (New York: Norton, 2003), 62–74.

10. Ibid.

11. Maki and Otaka, "Some Thoughts on Collective Form," 13.

12. Ibid., 15, 17. See also Kevin Lynch, "The Form of Cities," *Scientific American* 190 (April 1954): 55–63.

13. In their initial plans for what became the Sam Fox School of Design & Visual Arts, Maki and Associates explored creating a variety of new urban spaces proportioned in the same way as canonical European urban plazas, such as the Place des Vosges in Paris and the Piazzale degli Uffizi in Florence. The general proportions of the latter are the basis for the spatial relationships among the Sam Fox School buildings in the final design. See Fumihiko Maki and Associates, "Visual Arts and Design Center, Washington University in St. Louis, Pre-Design Final Report," unpublished manuscript, Washington University Art & Architecture Library, St. Louis, October 1998, 79–81.

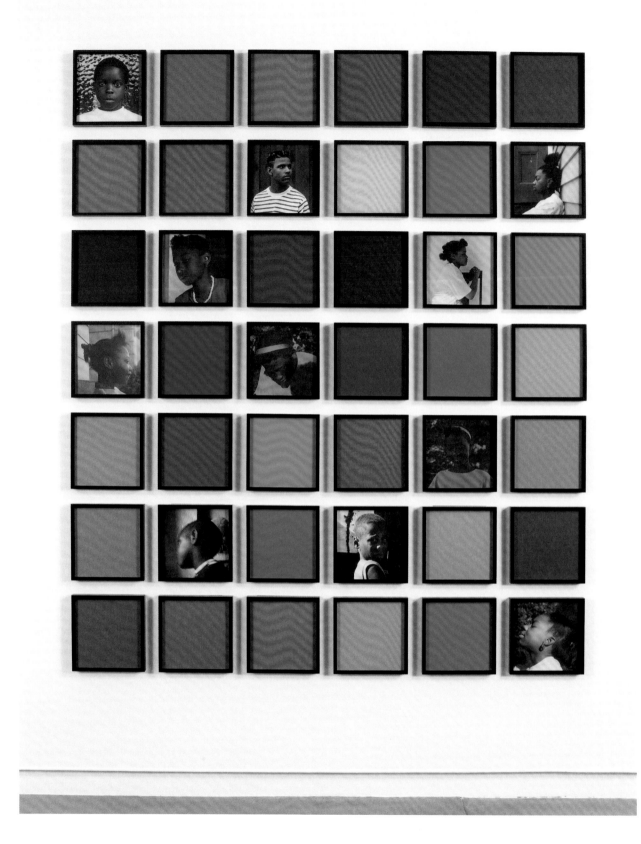

Untitled (Colored People Grid), 2009–10

Thirty-one screen-printed papers and eleven inkjet prints, AP 2 / 2 (ed.5),
87 ⁷/₈ × 75 ³/₁₆" (overall)
University purchase, Bixby Fund, and with funds from Bunny and Charles Burson,
Helen Kornblum, Kim and Bruce Olson, and Barbara Eagleton, 2014

Carrie Mae Weems

(American, b. 1953)

Untitled (Colored People Grid), 2009–10

OVER THE PAST FOUR DECADES Carrie Mae Weems's artistic practice has centered on the use of photography to explore issues of race, the body, and the power structures that shape the way we understand the world.[1] Her work often engages multilayered and poetic visual strategies to subvert cultural stereotypes, destabilizing monolithic notions of identity to embrace more complicated ways of seeing and thinking. Weems's *Untitled (Colored People Grid)* presents the viewer with a large-scale grid that brings together eleven photographic portraits of African American adolescents arrayed in an irregular sequence among thirty-one multihued monochromatic panels. The photographs, drawn from Weems's *Colored People* series (1987–90), portray introspective adolescent boys and girls at an age, as Weems put it, "when issues of race really begin to affect you, at the point of an innocence beginning to be disrupted."[2] Thus, in *Untitled (Colored People Grid)*, Weems initiates a dialogue with her own oeuvre, in particular a series whose title, which contains a term commonly used to refer to non-Caucasians from the nineteenth century until around 1960, makes direct reference to race.[3] Employing the grid, the monochrome, and photographic portraiture, she points to ways in which color has operated in reference to race in various social and historical contexts while also suggesting more expansive ways to think about color.

In her choice of the gridded format, Weems inserts herself into a legacy of artists who have engaged with this basic structure since the early twentieth century.[4] As a system based on serial repetition, the modernist grid in artistic practice can be understood as self-referential and autonomous; at the same time it informs the basic structure of the modern world, from systems of technology to the built environment. Weems's use of the grid underscores the nonhierarchical qualities of this form, as each

unit possesses the same dimensions, and whether a portrait or a monochromatic panel—whether representational or abstract—each panel is identically framed and given equal visual weight. The rejection of any clear hierarchical structure also plays out in the arrangement of the panels, as there is no discernible compositional privileging of one part of the work over another. In place of symmetry and balance, there is a dynamic visual play in the alternation of images and monochromatic panels in unpredictable intervals. The critique of systems of power plays a recurring role in Weems's work. In this light we can see the grid here as illuminating democratic overtones through its foregrounding of antihierarchical systems.[5]

In addition to the way *Untitled (Colored People Grid)* can be seen as displacing hierarchical logic, the work's formal elements also emphasize relational dynamics. This is particularly foregrounded by Weems's use of color in the composition. The colored panels, the tones of which range from bright to muted, each with an even and unmodulated surface, project forcefully from a distance and then present an optical overload when viewed up close. These panels are made from Color-aid paper, an industrially fabricated material that was initially developed in 1948 for photography studio backdrops. Within the gridded format, Weems's use of commercially produced hues also evokes the notion of color charts, through which colors are standardized for easy consumption. Given the seemingly unstructured relation of panels, however, the idea of standardization itself appears to be displaced, even parodied through the strangely individualized randomness of the relationship between the monochromes and the black-and-white photographs, which are each tinted in a different hue. In some cases the colors of the photographs correspond to the adjoining monochromatic panels, while in others they contrast. The result is a rich array of chromatic interactions that encourage the active movement of the viewer's eye across the surface of the work.

Weems's play with color on a formal level is also inextricably connected to ideas of difference and multiplicity and the social and political implications of color. While the African American youths shown in the photographs might be designated "black" today, the artist presents their portraits in the context of an adamantly diverse spectrum of color, through both the tinting of the photos and the surrounding field of monochromes. The application of the overlaid hues to the photos suggests a colored lens through which we see each image. "I started toning them in all those different colors," Weems has explained, "in the hopes of stretching the conversation beyond the narrow confines of race as we know it in the United States, starting to play out a much brighter idea about both the sort of absurdity of color and also [its] beauty and poignancy."[6] Weems's work can be understood as aesthetically disrupting and displacing any form of categorization by skin color, in part through the broad scope of colors and also through the potential of the grid's units to expand infinitely, underscoring concepts of multiplicity and diversity. Although we can read such meanings through the formal operations of the work, the title also interjects historical associations into the frame, evoking the troubled history of racism in the United States and segregation based on skin color. Yet through the contextualization of this phrase in the formal language of Weems's work, we can see it being appropriated from this racially charged context in order to take on more open-ended meanings.

In the context of the colorful grid, the tinted portrait photos operate in a different way than they did in the earlier *Colored People* series. In the earlier series the photographs are presented singly or in triplicate, captioned with phrases used by African Americans to describe variations of "black" skin tones: "Magenta Colored Girl," "Blue Black Boy," and so on. These words are printed in capital letters below a photo that is toned with the corresponding color. Having a poetic and melodic quality when read sequentially, the phrases can also be seen to critique hierarchies of color within the African American community, such as privileging lighter skin over darker skin in parallel with white hierarchies.[7] Weems's application of these skin-tone

labels was inspired by her own experience of being called a "red bone" girl when she was a child; she then explored the idea of turning around a potentially derisive nickname to see it instead in positive terms.[8] The variety of colors and the pairing of tinted photos and labels ultimately resist both the simplistic labeling of "colored" and the systems of categorization applied to the African American community, by African Americans themselves as well as by white Americans. In addition, each of the eleven portraits conveys a sense of insistent individuality through close-up framing and attention to subtle differences of mood and appearance, casting them in sharp contrast to the simplifying labels. In *Untitled (Colored People Grid)*, however, Weems has freed the portraits from those labels, so that they read primarily in a relational manner across the space of the grid. With their subjects looking directly out, up, or away from the camera, the portraits amplify the dynamics of difference and relationality, celebrating variety and individuality within a social group—African American youths—that has so often been stereotyped in American culture. In this way, by recontextualizing photographs from the earlier series within a modernist grid, Weems opens up a set of associations that take race as a point of departure for an exploration of larger issues of humanity, in this case, the complexity of color and its meanings.

Allison Unruh

Notes

1. For a comprehensive overview of Weems's career, see Kathryn E. Delmez, ed., *Carrie Mae Weems: Three Decades of Photography and Video* (Nashville: Frist Center for the Visual Arts; New Haven, CT: Yale University Press, 2012).

2. Carrie Mae Weems, quoted in Ann Temkin, ed., *Color Chart: Reinventing Color, 1950 to Today* (New York: Museum of Modern Art, 2008), 184.

3. For an account of the complexities surrounding the term *colored*, see Henry Louis Gates, *Colored People: A Memoir* (New York: Knopf, 1994).

4. For more on the aesthetics of the grid, see Rosalind Krauss's seminal essay "Grids," *October* 9 (Summer 1979): 50–64, and Sabine Eckmann and Lutz Koepnick, [*Grid<>Matrix*] (St. Louis: Mildred Lane Kemper Art Museum, 2006).

5. This can be understood, in part, as a response to the context for which she originally developed this work. The first iteration of this composition was commissioned by the Foundation for Art and Preservation in

Embassies (FAPE) program as a site-specific installation in the lobby of the US Mission to the United Nations in New York City. In this context it announces "the breadth of our country's multifaceted culture to a larger global community." Kathryn E. Delmez, commentary on *Colored People* and *Untitled (Colored People Grid)*, in Delmez, *Carrie Mae Weems*, 70. For more on FAPE, see www.fapeglobal.org. The version in the Kemper Art Museum is AP 2/2 (ed. 5); there are slight variations in the monochromatic panels between it and the version commissioned by FAPE.

6. Carrie Mae Weems, quoted in an audio guide by the Albright-Knox Art Gallery, www.albrightknox.org/collection/collection-highlights/piece :weems-colored-people-series/.

7. See Delmez, commentary on *Colored People* and *Untitled (Colored People Grid)*, 70. See also Andrea Kirsh, "Carrie Mae Weems: Issues in Black, White and Color," in *Carrie Mae Weems*, ed. Andrea Kirsh and Susan Fisher Sterling (Washington, DC: National Museum of Women in the Arts, 1993), 16.

8. "When I was a kid, I was called 'red bone,' so that idea of being a red girl as opposed to a caramel color girl or a chocolate color girl, I thought was really sort of fabulous, in a way of really being very specific about what someone looked like, what their color reflected." Weems, audio guide, Albright-Knox Art Gallery.

Tea Party, 2012

Two-color lithograph (4 / 25), 48 ³/₄ × 37 ¹/₈"
University purchase, Arthur L. and Sheila Prensky Fund and Bixby Fund, 2014

Nicole Eisenman

(American, b. France, 1965)

Tea Party, 2012

SINCE THE EARLY 1990S the artist Nicole Eisenman has created paintings and drawings of flagrantly sexual gender-neutral lovers, all-female separatist enclaves, and more recently, beer gardens, dinner parties, and poetry readings that express an incisive, humorous, and occasionally melancholic vision of a large, inclusive spectrum of humanity. In 2011, in the wake of several major life changes, the artist locked away her paints and embarked on an exclusive foray into printmaking that would last the better part of two years. Known for her figurative works that reference a variety of art historical styles and techniques to engage contemporary issues—among them interpersonal (specifically lesbian) relationships, identity, and her own self-reflexive musings on being an artist—Eisenman turned to printmaking for its singular ability to depict an array of sociocultural conditions in a relatively fluid and often urgent manner. She made scores of monotypes, woodcuts, etchings, and lithographs during this time. The inherent properties of each printing method are reflected in the final works: her monotypes evoke a playful experimentation that corresponds to the swift manner in which they were made; the woodcuts feature bold and forlorn faces rendered in a deeply worked grain; and the etchings are epic, containing fully formed scenes (from home life to local watering holes) that unfold scratch by scratch.

Eisenman's lithographs are the most introspective of her prints. To create them, she worked with Andrew Mockler of Jungle Press Editions in Brooklyn; they produced eleven prints together over a year and a half.[1] All the works depict figures—alone, as couples, and even, in a few instances, in a trio. The scenes oscillate between feelings of loneliness and alienation, on the one hand—a man holding his own shadow, a woman daydreaming in bed—and the possibility of connection, on the other, via

"sloppy barroom kisses" or a portentous game of Ouija. The prints also reflect Eisenman's deep study of nineteenth- and early twentieth-century European art, particularly Impressionism and German Expressionism. In preparation for the project, she and Mockler made several trips to the Metropolitan Museum of Art to view its print collection, studying Edvard Munch's moody, willowy portraits; Odilon Redon's oneiric figures; and Pablo Picasso's *Suite 347* (1968), among others.[2] These artists, like Eisenman, were each attracted to the directness and immediacy of lithography, with its rapid mark-making and printing properties, as well as the generative ability to "open up" lithographic stones—adding revisions to the printing surface to create new images from existing ones.

One lithograph stands out from the rest, not only for its large scale but also for its overtly political message. *Tea Party* (2012) is both a commentary on and a portrait of the conservative political movement of the same name that emerged in early 2009 during President Barack Obama's first term in office. In the print an eighteenth-century American revolutionary and a rotund businessman on the left face a skeleton on the right. Against a marbled and grainy blue and black background, they stand in a pool of water, holding onto a pole that is part scythe, part American flag, and crowned with a pineapple (the traditional symbol of hospitality in colonial America). The revolutionary sports an anus-shaped ear while the businessman's ear is pinned shut, suggesting that both are impervious to outside influence or even reason. The message of the work is clear: the crossing of political evangelism with the consolidation of capital owned by "the top 1 percent" can only be met with a swift demise.[3] *Tea Party* articulates Eisenman's political orientation, as the artist reproduces not only this particular trio of figures across her work in various mediums but also the form of the print itself. "My reiteration of the image," she says, "is a resistance that meets Tea Party members' own. It is my insistent resistance."[4]

While Eisenman's prints on the whole are poignantly evocative, channeling a variety of recognizable human experiences, including love, sex, motherhood, and alienation, *Tea Party* strays from this sensibility. It has more in common with her politically inflected paintings of the late 2000s, which directly and indirectly addressed the current affairs of the day, including the wars in Iraq and Afghanistan, the so-called Great Recession, and the bailout of the automobile industry. These works vary widely, from portraits of Buster Keaton (who happens to share an uncanny likeness with the artist) as a pensive Hamlet and a deep-sea diver, to paintings of beer gardens where one can go, as Eisenman has commented, "to socialize, to commiserate about how the world is a fucked-up place and about our culture's obsession with happiness."[5]

Eisenman estimates that she has created at least five *Tea Party* paintings, prints, and drawings since 2011, in tandem with the movement's swift ascent in contemporary American politics.[6] The name of the group is taken from the Boston Tea Party of 1773, in which American revolutionaries protested British colonial policies by dumping more than forty tons of imported Chinese tea into Boston Harbor. The movement crystallized following President Obama's announcement of the Homeowners Affordability and Stability Plan in February 2009. The bill was intended to reform the American housing market, which had plunged following irresponsible lending and wild speculation by the banking industry.[7] At present the majority of the Tea Party is active as a conservative subgroup of the Republican Party, with roughly 10 percent of Americans identifying as members.[8] Major figures include former governor of Alaska Sarah Palin, Texas senator Ted Cruz, former US representative Ron Paul, and political commentator Glenn Beck. Among the Tea Party's "non-negotiable core beliefs" are the need for a strong military, more American jobs, protected gun ownership, reduced government size and involvement, tax cuts, and strict policies on illegal immigration.[9]

Eisenman is one among several contemporary artists who have explored the Tea Party's constitutional conservatism and patriotic fervor in their work; others include Lauren Frances

Adams, Paul Chan, Goshka Macuga, and Catherine Opie.[10] Eisenman's first take on the subject, a small painting (*Tea Party*, 2011), was created in response to a prompt from the New York art critic Jerry Saltz on his Facebook page, asking artists why there had been no great art about the Tea Party.[11] In a major painting also titled *Tea Party* that followed later that year, four figures sit around a table in a bunker or closet. They settle in, prepared for impending doom: one snoozes, hugging a rifle, while her companion fiddles with sticks of dynamite. A raggedy Uncle Sam type in torn trousers slumps forward in his chair, a used tea bag dangling from his fingers. Behind them are stacked piles of gold bars (rendered in real gold leaf) alongside cans of tuna fish and a large jug of water. Depicted as isolationist and incapacitated, the movement, according to Eisenman, shares more in common with separatist militias than with politicians entrenched in Washington and as such, she suggests, is hardly equipped to deliver revolution.

Contemporary depictions of the Tea Party movement in the media stress its decentralized organization and collective power, evinced primarily through photographs of rallies and protests in which large groups of individuals band together, wave American flags, and brandish protest signs. Eisenman appropriates such popular portrayals in her *Tea Party* works, producing her own iconic image to exact political critique. Her lithograph, for example, elevates the large 2011 painting to the level of allegory. Stripping the painting of its specificity, she relies on spare formal and narrative devices to denounce American conservatism. She streamlines the movement into three figures constituting what she deems the "holy trinity" of revolutionary, businessman, and skeleton.[12] In addition, the blatantly graphic style of the figures references the satirical aim of political cartoons (which, it bears mentioning, were regularly published as lithographs in the nineteenth century). This simplification of the movement's representation, along with such cues as the figures' peculiar ears, suggests absurdity and impotence rather than the transformative momentum of a critical mass.

While Eisenman's own political position is reflected through her choice of subject matter, the formal qualities of her *Tea Party* works are indicative of a larger politics of art-making central to her practice. She does not adhere to conventional methods of applying paint to canvas or a mark to a printing plate. Globs of paint accrete in certain areas as though she were scraping off excess from her palette knife. She enunciates a figure's mouth simply by squeezing a tube of paint across the surface of the canvas to effect a tight-lipped smirk. Using painted insulation foam, she has even made several portraits—of a devil and a woman with "saggy titties"—that resemble bas-reliefs more than two-dimensional paintings. Many of her monotypes approximate finger-painting or elementary school collages in their freely associative application of both swirling ink and magazine clippings. Furthermore, Eisenman's rendering of the body (and what it variably denotes) is rarely fully or clearly determined. While nude figures—almost all women—exuberantly flaunt their sex, clothed figures often appear ambiguously gendered. *Sloppy Bar Room Kiss* (2011), another image that Eisenman has developed as both a painting and a lithograph, features two individuals in a drunken embrace. Emphasis is placed, however, on the visual symmetry of the heads turned toward each other and the scene's heightened amorous moment rather than the couple's specific sexuality. This in-betweenness is a signature feature—and, one might argue, strength—of her work. As Julia Bryan-Wilson has written, "the oscillation between texture and atmospheric mood generates productive, queer friction . . . as the eye cannot rest only on the surface of the painting, but is also pulled into its emotional punch by way of representation."[13] In other words, Eisenman's formal strategies not only are visually seductive, but even more significantly, they vibrate with deeper notions of bodily and sexual freedom—notions that stand largely in opposition to the kinds of binary, heteronormative values and unions espoused by right-wing groups such as the Tea Party.

The constructive tension between Eisenman's radically heterogeneous practice and her

repeated conjuring of the Tea Party approximates an activist intention. The Dutch critic Sven Lütticken optimistically imagines art's potential to create a space for reflection through repetition, whether, for example, in reenactments and remakes or by viewing copies of a limited, editioned work of video art. "Operating within contemporary performative spectacle, if from a marginal position," he writes, "art can stage small but significant acts of difference."[14] Extending his argument, Eisenman's multiple *Tea Party* works create a meaningful riposte to conservative ideology through their proliferation as both image and print. By animating her "holy trinity" into a serial image, she echoes its actual and continual enactment in today's public sphere. Her *Tea Party* works function as visual filibusters, disrupting the barrage of images and polemical rhetoric that cloud our newspapers, television and computer screens, and mobile devices. In effect she has staged with her "insistent resistance" her own multimedia protest. Just as a lithographic stone can be opened up and reworked to produce anew, Eisenman has created an image that opens itself up to repeated deployment in public and in private, in galleries and homes, online and in real life. Repetition can make a difference.

Kelly Shindler

Notes

First published November 2015

1. I would like to thank Andrew Mockler for generously sharing details of Eisenman's project with me, as well as for his illuminating insights on lithography in general.

2. See Faye Hirsch, "Nicole Eisenman's Year of Printing Prolifically," *Art in Print* 2 (January–February 2013), artinprint.org/article/nicole-eisenmans-year-of-printing-prolifically/, for a helpful overview of Eisenman's printmaking project. Of particular relevance to her series is Picasso's *347 Suite*, comprising hundreds of prints the artist made over a mere six-month period, at the age of eighty-six. The series is notable not only for the vast number of works and Picasso's sophisticated mastery of such etching techniques as drypoint, intaglio, and aquatint but also for the breadth of its subjects, featuring a large cast of characters (circus performers, musketeers, musicians, and so forth) that the artist developed over his career.

3. For more on the notion of "the 1 percent" see Joseph E. Stiglitz, "Of the 1%, by the 1%, for the 1%," *Vanity Fair*, April 30, 2011, www.vanityfair.com/news/2011/05/top-one-percent-201105.

4. Nicole Eisenman, conversation with the author, September 2015.

5. Nicole Eisenman, on her exhibition *Coping* at Galerie Barbara Weiss in Berlin, as told to Brian Sholis, *Artforum.com*, September 6, 2008, artforum.com/words/id=21064.

6. Eisenman, conversation with the author.

7. For more on this, see Ben McGrath, "The Movement: The Rise of Tea Party Activism," *New Yorker*, February 1, 2010, www.newyorker.com/magazine/2010/02/01/the-movement.

8. See Karlyn Bowman and Jennifer Marisco, "The Tea Party at Five," American Enterprise Institute (February 2014), www.aei.org/wp-content/uploads/2014/02/-the-tea-party-at-five-an-american-enterprise-institute-compilation_143234289171.pdf.

9. For all fifteen of the party's "non-negotiable core beliefs," see www.teaparty.org/about-us.

10. Examples of this include Opie's untitled 2010 photographs of Tea Party rallies, Macuga's tapestry *It Broke from Within* (2011), Adams's participatory installation *We the People* (2012), and Paul Chan's essay "Progress as Regression," *e-flux journal* 22 (January 2011), www.e-flux.com/journal/progress-as-regression.

11. See "'Nicole Eisenman / Matrix 248': Tea Party Time," *SFGate*, May 22, 2013, www.sfgate.com/art/article/Nicole-Eisenman-Matrix-248-Tea-Party-time-4540079.php.

12. Eisenman, conversation with the author.

13. Julia Bryan-Wilson, "Draw a Picture, Then Make It Bleed," in *Dear Nemesis: Nicole Eisenman 1993–2013* (St. Louis: Contemporary Art Museum St. Louis; Cologne: König, 2014), 99. Several art historians have begun to articulate the notion of a "queer formalism" in the work of Eisenman, Amy Sillman, Harmony Hammond, Scott Burton, and others. In addition to Bryan-Wilson's essay, see "Queer Formalisms: Jennifer Doyle and David Getsy in Conversation," *Art Journal* 72 (Winter 2013): 58–71, and William J. Simmons, "Notes on Queer Formalism," *Big, Red, and Shiny*, December 16, 2013, bigredandshiny.org/2929/notes-on-queer-formalism.

14. Sven Lütticken, "An Arena in Which to Reenact," in *Life, Once More: Forms of Reenactment in Contemporary Art* (Rotterdam, Netherlands: Witte de With Center for Contemporary Art, 2005), 60.

The following individuals and entities donated artworks, money for the purchase of artworks, or both during the years 2006 through 2016.

Anonymous

Carol Jean Schoelkopf Boss

Bunny and Charles Burson

Elissa and Paul Cahn

Elizabeth C. Childs and John Klein

Commerce Bancshares, Inc.

Connelly Family Collection

Barbara and David Detjen

Barbara S. Eagleton and Thomas F. Eagleton*

Exit Art

Andrew J. Feldman

Judy Frank* and Harris Frank

Ann and Robert L. Freedman

Howard W. French

Robert Frerck, Laurie Wilson, and family

Galerie Der Spiegel

Judith A. Garson and Steven N. Rappaport

Alvin Goldfarb*

Jan and Ronald Greenberg

Mary Hall* and Thomas Hall*

Joanne Herrmann and Douglas Milch

Island Press

David Woods Kemper Memorial Foundation

Helen Kornblum

Neela and Robert A. Kottmeier

Jane and Lawrence Kozuszek

John Frank Lesser

Judith and Jerome Weiss Levy

Barbara and Richard Mahoney

Megabucks Partnership (Mary Randolph Ballinger, Marion Black, Barbara Bridgewater, Charlene Bry, Barbara Eagleton, Jane Eiseman, Gail Fischmann, Gretta Forrester, Barbara Goodman, Jean Hobler, Lisa Imbs, Bette Johnson*, Virginia Klein, Rosie Kling, Dede Lambert, Ann Liberman, Nancy E. Loeb, Barbara Messing, Sherry Miller, Caro Schneithorst, Barbara Schukar, Caryl Sunshine, and Judy Wyman)

Peter Norton

Kim and Bruce Olson

Sheila Prensky* and Arthur Prensky

Cathy and Alex Primm

Robert Rauschenberg Foundation

Betsy Sara Ruppa and the estate of Joe Deal

Molly Smith*

Bettye Sonnenschein* and Edmund C. Sonnenschein

Jarvis A. Thurston*

Sally and John Van Doren

Andy Warhol Foundation for the Visual Arts, Inc.

Anabeth and John Weil

Mark Weil

Sherry and Gary Wolff

Nancy and Jerry Younger

* Deceased

Bradley Bailey is associate professor of art history at Saint Louis University.

Matthew Bailey teaches at St. Louis Community College—Meramec. He received his PhD in art history at Washington University in St. Louis.

Marisa Anne Bass is assistant professor of art history at Yale University. She was formerly assistant professor of art history at Washington University in St. Louis.

Svea Bräunert is a DAAD Visiting Associate Professor in German studies at the University of Cincinnati. She was formerly a Fulbright Fellow at Washington University in St. Louis and a guest curator at the Mildred Lane Kemper Art Museum.

Karen K. Butler is an independent art historian. She was formerly associate curator at the Mildred Lane Kemper Art Museum.

Bryna Campbell is an instructor of art history at Portland State University, Oregon. She received her PhD in art history at Washington University in St. Louis.

Elizabeth C. Childs is the Etta and Mark Steinberg Professor of Art History and chair of the Department of Art History & Archaeology in Arts & Sciences at Washington University in St. Louis.

Paul Crenshaw is associate professor and chair of the Department of Art & Art History at Providence College, Rhode Island. He was formerly assistant professor of art history at Washington University in St. Louis and assistant curator at the Mildred Lane Kemper Art Museum.

John J. Curley is associate professor of modern and contemporary art history at Wake Forest University, North Carolina. In 2007 he was a visiting assistant professor of art history at Washington University in St. Louis.

Sabine Eckmann is the William T. Kemper Director and Chief Curator at the Mildred Lane Kemper Art Museum. She also teaches in the Department of Art History & Archaeology in Arts & Sciences at Washington University in St. Louis.

Ryan E. Gregg is assistant professor of art history at Webster University in St. Louis.

Keith Holz is professor of art history at Western Illinois University, Macomb.

Rachel Keith is director of collections and exhibitions at the Philbrook Museum of Art in Tulsa, Oklahoma. She was formerly chief registrar at the Mildred Lane Kemper Art Museum.

John Klein is professor of art history in the Department of Art History & Archaeology in Arts & Sciences at Washington University in St. Louis.

Meredith Malone is associate curator at the Mildred Lane Kemper Art Museum.

Catharina Manchanda is the Jon and Mary Shirley Curator of Modern and Contemporary Art at the Seattle Art Museum. She was formerly curator at the Mildred Lane Kemper Art Museum.

Angela Miller is professor of art history in the Department of Art History & Archaeology in Arts & Sciences at Washington University in St. Louis.

Erin Sutherland Minter is curator of exhibitions for Special Collections, Washington University Libraries. She received her PhD in art history at Washington University in St. Louis.

Eric Mumford is the Rebecca and John Voyles Chair of Architecture in the College of Architecture and the Graduate School of Architecture & Urban Design in the Sam Fox School of Design & Visual Arts at Washington University in St. Louis.

Michael Murawski is director of education and public programs at the Portland Art Museum, Oregon. He was formerly coordinator of education and public programs at the Mildred Lane Kemper Art Museum.

Jennifer Padgett is a PhD candidate in the Department of Art History & Archaeology in Arts & Sciences at Washington University in St. Louis.

Noelle C. Paulson is an independent art historian and administrative coordinator of the Block Research Group, ETH Zurich. She received her PhD in art history at Washington University in St. Louis.

Anne Popiel is an editor and translator for academic publishing at the Potsdam Graduate School of the University of Potsdam, Germany. She received her PhD from the Department of Germanic Languages and Literatures at Washington University in St. Louis.

Matthew Robb is chief curator at the Fowler Museum at the University of California, Los Angeles. He was formerly associate curator in charge in the Department of the Arts of Africa, Oceania, and the Americas at the Saint Louis Art Museum.

Lynette Roth is the Daimler Curator of the Busch-Reisinger Museum, Harvard Art Museums. She was formerly a Mellon Postdoctoral Fellow in modern art at the Saint Louis Art Museum.

Ila N. Sheren is assistant professor of art history in the Department of Art History & Archaeology in Arts & Sciences at Washington University in St. Louis.

Kelly Shindler is associate curator at the Contemporary Art Museum St. Louis.

Allison Unruh is associate curator at the Mildred Lane Kemper Art Museum.

Anna Vallye is assistant professor of art history and architectural studies at Connecticut College and Mellon Junior Fellow in Humanities, Urbanism, and Design at the University of Pennsylvania. She was formerly a postdoctoral fellow at Washington University in St. Louis.

James A. van Dyke is associate professor of modern European art history at the University of Missouri, Columbia.

Elizabeth Wyckoff is curator of prints, drawings, and photographs at the Saint Louis Art Museum.

Orin Zahra is a PhD candidate in the Department of Art History & Archaeology in Arts & Sciences at Washington University in St. Louis.

This catalog is published on the occasion of the tenth anniversary of the Fumihiko Maki–designed Mildred Lane Kemper Art Museum building, part of the Sam Fox School of Design & Visual Arts at Washington University in St. Louis. It accompanies a building-wide installation of the permanent collection, *Real / Radical / Psychological: The Collection on Display*, on view September 9, 2016, to January 15, 2017.

Support for this publication is provided by the William T. Kemper Foundation, Elissa and Paul Cahn, Nancy and Ken Kranzberg, the Hortense Lewin Art Fund, and members of the Mildred Lane Kemper Art Museum.

EDITORIAL BOARD
 Sabine Eckmann
 Meredith Malone
 Jane E. Neidhardt
 Allison Unruh

Contributing editors: Karen K. Butler, Catharina Manchanda
Managing editor: Jane E. Neidhardt
Copyeditors: Eileen G'Sell, Karen Jacobson, Holly Tasker
Photo editor: Holly Tasker
Designer: Michael Worthington, Counterspace
Printer: Conti Tipocolor, Florence

ISBN: 978-0-936316-42-0
Library of Congress Control Number: 2016936526

PUBLISHED BY
 Mildred Lane Kemper Art Museum
 Sam Fox School of Design & Visual Arts
 Washington University
 One Brookings Drive
 St. Louis, Missouri 63130
 T. 314.935.5490
 F. 314.935.7282
 www.kemperartmuseum.wustl.edu

DISTRIBUTED BY
 The University of Chicago Press
 11030 S. Langley Avenue
 Chicago, IL 60628
 DOMESTIC
 T 1-800-621-2736
 F 1-800-621-8476
 INTERNATIONAL
 T 1-773-702-7000
 F 1-773-702-7212

Printed in Italy

Front cover:
Fernand Léger (French, 1881–1955)
Detail of *Les belles cyclistes* (*The Women Cyclists*), 1944
Oil on canvas, 29 x 36"
Gift of Charles H. Yalem, 1963

Washington University in St. Louis
SAM FOX SCHOOL OF DESIGN & VISUAL ARTS

MILDRED LANE KEMPER ART MUSEUM

POSTERS

of

WORLD WAR II

IN DEN STAUB MIT ALLEN FEINDEN

GROSS-DEUTSCHLANDS!

Peter Darman

METRO BOOKS
NEW YORK

Editorial and Design
The Brown Reference Group plc
First Floor, 9-17 St. Albans Place
London, N1 0NX

Metro Books
122 Fifth Avenue
New York, NY 10011

Senior Managing Editor: Tim Cooke
Picture Research: Andrew Webb
Designer: Phillip Stonier
Production Director: Alastair Gourlay
Editorial Director: Lindsey Lowe

ISBN-13: 978-1-4351-0438-9
ISBN-10: 1-4351-0438-2

Printed and bound in China

1 3 5 7 9 10 8 6 4 2

PICTURE CREDITS
All images from The Robert Hunt Library except the following:
Australian War Memorial Art Images: 21, 32
Library of Congress: 49, 68, 74, 77, 117, 121, 122, 123, 124, 125, 126, 129, 130, 131, 132, 133, 134, 135,
137, 138, 139, 140, 144, 145, 146, 147, 148, 149, 153, 156, 157, 158, 159, 160, 161, 163, 164, 165, 166, 167,
169, 170, 171, 174, 175, 176, 177, 179, 182, 183, 184, 185, 187, 188, 189, 190, 191, 192, 194, 195,
196, 198, 199, 201, 203, 206, 207, 208, 209, 210, 211, 212, 213, 214, 215, 216, 217, 218, 219, 223
McGill University Library: 16, 17, 18, 19, 20, 27, 28, 38, 40, 43, 46
Randall Bytwerk: 3, 61, 62, 63, 64, 65, 66, 70, 71, 73, 78, 79, 80, 81, 82, 83, 84, 85, 91
Topfoto: 52, 53, 55, 56, 57

Page 2: A Soviet wartime poster celebrating the achievements of the Bolshevik Revolution.

Contents

During World War II, all the warring nations produced thousands of posters to mobilize their respective populations for the war effort. World War II was a "total war," and thus required the total effort of not only members of the armed forces but also civilians on the home front. The poster was a simple yet powerful psychological aid to mobilizing the nation. Cheap, accessible, and ever-present, the poster was an excellent method of reaching every citizen. Whatever message a poster was conveying—patriotism, the need for greater security, increased production—it was directed at every citizen, in or out of uniform. As a member of the American Office of War Information (OWI) stated during the war: "We want to see posters on fences, on the walls of buildings, on village greens, on boards in front of the City Hall and the Post Office, in hotel lobbies, in the windows of vacant stores—not limited to the present neat conventional frames which make them look like advertising, but shouting at people from unexpected places with all the urgency which this war demands."

Nazi and Soviet propaganda

To be effective a poster needed to carry a simple yet powerful message, one that was easy to understand by everyone. Subtlety and sophistication were the enemies of an effective poster campaign. Adolf Hitler, head of the German Nazi Party and from 1933 leader of Germany, was under no illusion with regard to the intelligence of the masses: "But since propaganda is not and cannot be the necessity in itself, since its function, like the poster, consists in attracting the attention of the crowd, and not in educating those who are already educated or who are striving after education and knowledge, its effect for the most part must be aimed at the emotions and only to a very limited degree at the so-called intellect."

This reasoning was duplicated in another totalitarian regime: the Soviet Union. Posters played a crucial part in the development of the Soviet regime, first by helping the Bolsheviks to win the Civil War, and then helping them to mobilize millions of people to fulfill agricultural and industrial schemes in the 1920s and 1930s. The poster campaigns were relentless and blunt, and in case anyone failed to get the message there was a vast internal security organization—the NKVD (People's Commissariat for Internal Affairs)—

to deter any dissenters or slackers. Those who fell foul of the regime were sent to the Gulag, the vast network of labor camps that existed in the hinterland of the USSR. Once there, inmates carried on working to produce the goods the regime needed.

Once the war broke out in June 1941, the Soviets kept on mass-producing posters, but their message changed. The immediate aim was to defeat the fascist invader, though as German armies crashed into the Soviet Union in the summer of 1941 and neared the gates of Moscow, mobilizing the population to save the state itself became of crucial importance.

In the liberal democracies of Western Europe—Britain, France, and the Low Countries—poster designs were usually more restrained than those of the the totalitarian regimes, and indeed those produced during World War I. There were two reasons for this. First, there was the general postwar disillusion after 1918, particularly after the exposure of fraudulent atrocity propaganda produced by both sides in the Great War. Thus propaganda was most effective when it was least propagandistic. Second, radio, film, and newspapers combined to reduce the overall importance of the poster. But the poster was still important for conveying simple, powerful messages.

Despite their different political ideologies, the Axis states, the Soviet Union, and the Western Allies all produced posters that had broadly similar themes. First was the appeal to patriotism. If World War II was a "total war," then it was axiomatic that each participant had to convince the mass of its population to be loyal to the state. Patriotism was a prerequisite for the creation of vast conscript armies and mass mobilization of those who weren't in uniform. Group loyalty was particularly important in the Western liberal democracies, as their governments were making wartime demands on the population that would not be tolerated in peacetime.

The fight for freedom

Patriotic posters made use of emotive symbols and emblems, such as the swastika in Nazi Germany and the Stars and Stripes in the United States. Many patriotic posters were merely recruitment aids for the armed forces, with state and party insignia repeated on the uniforms worn by the men and women featured in the posters. U.S. posters often added another dimension to the patriotic theme: freedom. This was a peculiar American trait and was lacking in posters produced by other Allied nations, and obviously did not figure in the posters of the totalitarian powers, where individual freedom was sacrificed for the good

of the state. For the United States, which even in the dark days in late 1941 and early 1942 was never going to face the prospect of enemy forces fighting on home soil or its cities being bombed by fleets of enemy aircraft, patriotism alone was not enough to mobilize the masses. Freedom, especially freedom from tyranny, is a sentiment that runs deep in the American soul. The promise of bringing freedom and liberating oppressed people overseas was an ideology that many Americans embraced, and helped to convince the American public that the millions of servicemen being sent to Europe and the Pacific were fighting a worthy cause.

The second theme that war posters addressed was that of security, specifically the security of the state and hence the whole war effort. External enemies were easy to identify—they were the soldiers, tanks, ships, and aircraft of the enemy—but internal enemies were more difficult to spot.

The posters addressing security matters had similar wording and images. The most famous was the theme of "careless talk," the notion that enemy spies were everywhere and that a seemingly innocent conversation could be overheard by them, leading to the deaths of service personnel at the very least. Like patriotic appeals, security posters pointed to the need for national unity, with everyone coming together to beat the unseen foe in their midst. Such a campaign may have been effective, but it must have created a home front with high levels of paranoia.

Production posters

A far more positive, and probably effective, poster campaign was that encouraging greater production. It had to be: World War II was a war in which the fighting "teeth" at the front relied on a steady flow of war materials to keep the tanks, ships, and aircraft operating and fully loaded with armaments. This meant civilian populations had to be mobilized to work in factories to produce armaments and ammunition. And the mobilization had to be on a scale hitherto unseen in history. The posters concerned with war production usually emphasized the close relationship between the worker and the frontline soldier, and the dependence of the latter on the former. In the Soviet Union, where people had little disposable income and even if they did there was nothing in the shops to purchase, the emphasis was on mass production—literally outproducing the German enemy in everything. It was an appeal that worked: in 1942 alone the USSR built 25,000 aircraft and 25,000 tanks.

ABOVE: A photograph that not only shows the use of recruiting posters but also indicates the mood of the American public in the months after Pearl Harbor. The location is a U.S. Marine recruiting office in Boise, Idaho, in January 1942, and a member of the public has attached a sign above the recruiting poster. The original caption to the picture stated: "Perplexed is Sergeant Delbert Myers. He doesn't know who attached the sign to the Marine recruiting poster here. But he's not mad. He'd like to congratulate the guilty party."

A fourth poster theme in the war was that of the international crusade. At first the Axis nations—Germany, Italy, and Japan—seemed to have the advantage. In the first two years of the war this alliance was very successful on the battlefield, both in Europe and Asia. But after 1942, with the German defeat at Stalingrad, the entry of the United States in the war, and the subsequent Japanese defeat at Midway in June 1942, plus Allied victory at El Alamein in North Africa, the Axis alliance did not appear so all-conquering. It was the Grand Alliance, comprising the USSR, Britain, and the United States, which was actually the stronger, and the posters produced stressing the alliance emphasized the point.

The final poster category emphasized fear of the enemy. The most extreme form of this strand was Nazi Germany's anti-Semitism. Close behind anti-Semitism was the Nazi poster campaign against the Slavs of Eastern Europe and the Soviet Union. The Soviet Union was the worst of all places in Nazi eyes, as it was populated by "subhuman" Slavs and was the center of the "Bolshevik-Jewish conspiracy." Ironically, the only other nation to employ an overtly racial theme in its posters was the United States. In posters the Japanese were portrayed as rat-like vermin. Americans were in no mood to show the Japanese any mercy following their treacherous attack on Pearl Harbor in December 1941.

British & Commonwealth Posters

erman aggression in the 1930s, specifically the takeover of Austria and Czechoslovakia in 1938–1939, prompted the British Government to establish the Department of Propaganda to the Enemy and Enemy Controlled Territories, later converted into the Department for Enemy Propaganda. The Ministry of Information, which was to coordinate domestic propaganda in Britain during World War II, also appeared in 1939.

Following the outbreak of war in September 1939, the British set up four government propaganda organizations: the Ministry of Information, the Political Warfare Executive, the Political Intelligence Department, and the British Broadcasting Corporation (BBC). Of these, the Ministry of Information had the task of sustaining civilian morale. As such, it was responsible for producing propaganda posters, so-called "weapons on the wall," both for itself and for other branches of the government. As in other combatant nations, British wartime posters were often used as part of a coordinated campaign that also made use of film, radio broadcasts, pamphlets, and articles and advertisements in newspapers and magazines.

British poster artists

The individuals responsible for designing posters came from a wide variety of backgrounds, and included academics, writers, journalists, and lawyers. Their work was placed on street hoardings, inside shops, bars, factories, barracks, and offices. Britain's only official war poster designer was Abram Games, who created more than 100 posters. Among the most famous was the simple yet effective "Dig For Victory," a message so essential for an island nation whose lifeline to the United States was being threatened by German U-boats in the Atlantic. He worked with a small staff in an attic in the War Office. For his efforts in the war he was awarded the Order of the British Empire (OBE) in 1958. Another well-known poster artist was Cyril Kenneth Bird, who worked under the pseudonym Fougasse. During the war he was the art editor at *Punch* magazine. His cartoon-style poster campaign "Careless Talk Costs Lives" was among the most famous of the war, and he undertook a wide range of other wartime work for the government, including books, booklets, pamphlets, press advertisements, and even a film strip.

Involving the nation in the war effort

British wartime posters can be grouped into a number of categories. Interestingly, and unlike in World War I, there were no general recruiting posters (male conscription had been introduced in Britain in April 1939). That said, there were recruiting posters concerned with specialist services and others aimed at women (it was realized from the start of the campaign that the female population was crucial to the war effort).

Due to male conscription, Britain desperately needed people to replace the men in all work areas to ensure that the country kept running, especially when it came to the production of munitions. Other British recruiting campaigns were linked with boosting industrial and agricultural output.

Many posters produced by the British reflected what the authorities believed would happen. For

example, the government believed that London would be bombed, even gassed, as soon as the war broke out, and so began an immediate evacuation of women and children to rural areas (it was a false alarm, and so most returned). After the fall of France in June 1940, the threat of German air raids became a reality, and 600,000 children were evacuated from the capital. Indeed, by the end of 1940 only one child in six remained in London, the rest having been evacuated, some for a third or fourth time. In addition, Britain became home to thousands of civilian refugees from Denmark, Norway, the Low Countries, and France, all of whom had to be clothed, housed, and found work.

Conserving food supplies

The reality of war soon hit home when rationing was introduced in January 1940, and posters extolling the virtues of thrift and growing one's own vegetables appeared all over the country. As an island dependent on the sea lanes for the import of food and raw materials, Britain was particularly vulnerable to enemy blockade. The first foods to be rationed, in January 1940, were sugar, butter, and ham. Two months later it was meat, and in July tea, margarine, and cooking fats were added to the list. Parallel to the rationing came a poster campaign and regulations to counter the waste of food. In addition, efforts were made to encourage people to eat balanced diets to reduce the likelihood of contracting diseases stemming from malnutrition.

British propaganda was also directed at involving all of the population in the war effort. The work of the Women's Voluntary Services (WVS), for example, was crucial in the early years of the war, especially during the Blitz when German bombers were attacking many

ABOVE: The destruction of the Spanish town of Guernica by German aircraft during the Spanish Civil War (1936–1939) had demonstrated the power of modern bombers. The government feared that German bombers would drop not only bombs on British cities, but also poison gas. Therefore, gas masks were issued to all citizens following the outbreak of war. This Ministry of Home Security poster urged people to carry their gas masks at all times.

towns and cities. The WVS fed bombed-out families in emergency centers, ran clothing exchanges, information bureaus, and rest centers. They also helped people understand their ration books, cared for returned prisoners of war or foreign refugee children, and served thousands of daytime meals to workers across the country. WVS members also distributed a staggering 1.5 million meat pies each week to British workers.

Air attack featured large in posters during the early part of the war, with people being warned to always carry their gas masks, send their children to the countryside, and the location of the nearest rest center.

Digging for victory

The poster campaign to encourage everyone to "dig for victory" (though in 1940–1941 a more apt phrase would be "dig for survival") undoubtedly worked. With Britain importing only half the food the population required, more rural land was cultivated than before the war. In the cities, parks and other open spaces were given over to growing vegetables, and individual citizens had their own "victory gardens" where small amounts of foodstuffs were cultivated. In the countryside, the ploughing and cultivating was carried out by another group who would be crucial to the war effort: the Women's Land Army (WLA). Members of the WLA, who at first faced hostility from many farmers who believed they could not do farm work, undertook such back-breaking work as clearing ditches, felling trees, and driving horse-drawn ploughs. By the end of 1943, there were 75,000 young women in the WLA.

Mention should also be made of those women who served in the armed forces during the war, in the ranks of the Women's Royal Naval Service, the Auxiliary Territorial Service, and the Women's Auxiliary Air Force. Their contribution released men for other duties. Lastly, attention should be drawn to the efforts of civilian and military nurses, who universally displayed a devotion above and beyond the call of duty.

As in Axis countries, in Britain the authorities waged a campaign against those who might seriously harm the war effort. Chatterbugs, those who spread alarm and despondency, and rumor mongers were targeted especially. Most famously, people were warned that "careless talk costs lives," and therefore were urged not to talk about anything that might compromise military operations and convoy sailings. Ironically, German espionage operations in Britain were a fiasco, but the message given out by security posters was a powerful one and made everyone be on their guard against the "unseen enemy." They were also a powerful way to get the whole population involved in the war effort, by making the individual think that everything he or she might say could have a crucial bearing on the outcome of the conflict.

Raising revenue was also crucial to the maintenance of the British war effort. The posters urging savings and government bonds often featured images of babies, sometimes being menaced by the enemy. This conveyed the message that the war was being fought not only to secure victory in the present, but to lay the foundations for a better future. In the case of Britain this was undoubtedly the case, for in 1941 the government commissioned a report into the ways that the country should be rebuilt after the war. The result was the Beveridge Report of 1942, which recommended that the government should find ways of fighting the five "Giant Evils" of "Want, Disease, Ignorance, Squalor, and Idleness." This led directly to the postwar establishment of the welfare state.

The moral crusade

Unsurprisingly, Adolf Hitler figured in many British posters during the war. Dislike of Hitler and Nazism was the one certain thing that bound the people of Britain together. The view that Britain and the Commonwealth were fighting a moral crusade to rid the world of the evils of Hitlerism was a powerful motivating factor for the British. Winston Churchill summed it up when he said: "We have but one aim and one single, irrevocable purpose. We are resolved to destroy Hitler and every vestige of the Nazi regime."

It was easy for the British to hate Hitler. After all, during the Blitz thousands had been forced to take refuge in uncomfortable garden Anderson shelters, or in Underground stations in London. After a raid survivors would emerge from the shelters to discover if their houses still stood, and if their neighbors, friends, and relatives were still alive. And the raids went on for weeks, sometimes months. In such an atmosphere it was easy to hate the enemy. Even in 1944, German aerial weapons were still being launched against Britain. In June, the first V-1 flying bombs attacked the British Isles. Some 5,800 V-1s were launched against Britain in total, of which 2,420 hit London, killing 9,000 people. A smaller number of the V-2 rocket, 517, landed on London.

When German bombs were raining down on British towns and cities, it was easy to mobilize the moral commitment of the population. Indeed, the fortitude of the people during the Battle of Britain and the Blitz established a theme of British invincibility and resolution for the rest of the war.

The British Empire

When discussing British participation in World War II, mention must also be made of the colonies of the Empire and the nations of the Commonwealth. When war broke out in 1939, the British Empire held sway over a population approaching 500 million people, around a quarter of the world's population, and covered more than 20 percent of the world's total land mass. The countries of Canada, Australia, New Zealand, and South Africa enjoyed "Dominion status," which meant that each had full self-government. And whereas most British colonies were not consulted when Britain declared war on their behalf in September 1939, for the most part each Dominion state individually decided when and how it would enter the war. When war when war broke out in Europe in September 1939, Australia, Canada, and New Zealand immediately sided with the British. On September 1, 1939, the South African prime minister was Barry Herzog, the leader of the anti-British National Party. He wanted to keep South Africa neutral. However, he was deposed by his party on September 4 and replaced by Jan Smuts, who upon becoming prime minister officially declared war on Germany.

The commitment of the British colonies during the war was equally impressive. Some 500,000 Africans, more than 7,000 Caribbean people, and a total of 2.5 million Indians fought for Britain during the war. The British Government recognized the importance of harnessing the manpower of the Empire. In 1944, a government propaganda directive emphasized that "the aim must be to present a picture of the moral and material strength of Britain and the Empire designed to arouse not only admiration and goodwill but also a sense of pride in membership of the Empire."

OPPOSITE PAGE: This Ministry of Information bulletin was the first ever to be issued in Britain during the war. It was issued in Coventry, which was attacked by 500 German bombers on the night of November 14, 1940. They dropped 30,000 incendiaries, 500 tons (508 tonnes) of high explosives, 50 land mines, and 20 oil mines non-stop for 11 hours. The result was 554 dead and 865 injured.

MINISTRY of INFORMATION
BULLETIN

The following information has been prepared at the request of the Government and Local Departments concerned :—

Help your Neighbours with Water.—Will all householders who now have a supply of water please chalk up the words WATER HERE on the door or walls so that neighbours who are less fortunate may be given supplies.

Advice Bureaux.—The Citizens' Advice Bureau is now open as the Rotary Club Room, Liberal Club, Union Street, Coventry, and advice will be given free between the hours of 10.0 a.m. and 4.0 p.m. every day, Sundays included. From Saturday a second bureau will be open during the same hours on week days but not on Sundays at Radford Vicarage, Cheveral Avenue.

These bureaux provide information on all matters arising out of the present emergency.

Fire Equipment.—If any member of the general public sees any fire hose or any other fire equipment not in use, will they please report the matter to the Central Fire Station or the Central Police Station when arrangements will be made to collect it.

Vouchers for Evacuees.—Parents wishing to remain in Coventry, but who have relatives living outside the area, in whose company they can send their children under school age, should enquire at the Education Office, Council House, where travel vouchers can be issued.

Air Raid Casualties.—All air raid damage incidents and particularly public shelters have been thoroughly investigated and there is no ground for believing that large numbers of bodies remain to be recovered. It is pure rumour and to believe it is playing Hitler's game.

To Motorists.—Will motorists please park their cars off the streets wherever possible. Vehicles should not be driven into the centre of the City if it can be avoided, and they must NOT be parked in this area unless urgently required for official duties. Your co-operation in this matter is urgently requested.

Emergency Petrol.—Applicants for emergency petrol obtainable at the Council House, Hay Lane, Coventry, must produce their registration books or insurance certificates, or road fund licences.

This office will be closed on Monday the 25th inst., at 3.0 p.m., and all subsequent applications for emergency petrol by persons employed by firms engaged on work of national importance must be made to the Divisional Petroleum Officer, Birmingham, through their employers.

Tips to Shelter Users.—If you use a shelter, you can help largely in preventing illness within it. Here are some tips :
Help keep the shelter and sanitary accommodation clean.
Provide yourself with warm covering as far as you can.
Do not overcrowd sleeping space.
Gargle daily night and morning.
Bring a handkerchief and always cough or sneeze in it.
Form your own shelter committee to promote the above.
Children are better in the country than in town shelters. Evacuate your children if possible.

Coal.—All Coventry merchants have good supplies of household coal. They will especially give preference to small consumers—two bags per house—before supplying larger households who have stocks.

TRAVEL PERMITS.

Eire.—No person can go to Eire without a permit. No person between the ages of 16 and 60 can receive a permit.

Persons under 16 or over 60 must apply to the travel permit office, 36 Dale Street, Liverpool. No travel vouchers or other assistance can be given.

Discussions with the High Commissioner for Eire are proceeding with a view to Eire accepting women and children but no arrangements have yet been made.

Northern Ireland.—Mothers with children under five years of age are received in Northern Ireland if they can satisfy the Evacuation Officer that they have been able to make their own arrangements for reception in that country. Such mothers can take with them children of school age also.

Application should be made to the Education Officer, Council House.

Scotland.—Arrangements are the same as for England and Wales.

No Typhoid in Coventry.—There is no typhoid in Coventry, and the precautions being undertaken by the Medical Officer of Health are simply to ensure that there shall be no such cases.

Hot Meals.—Hot meals are now available at the Technical College. The main course is priced at 6d., sweets costing 2d. and tea 1d. Further centres will be opened shortly.

Volunteers for Rest Centres.—Those who desire to render full time voluntary assistance at Rest Centres should apply to the W.V.S. Welfare Centre, Gulson Road. Voluntary workers are also needed (preferably with canvassing experience) for the survey of available accommodation. Homeless people should be urged to apply at the Rest Centres for help and advice.

Coventry Education Committee.—The following students will attend at the Technical College as from Monday next, 25th November.

Senior day students, Army trainees, afternoon domestic students, and students of the Junior Technical, Junior Commercial, and Senior and Junior Art Students.

Sites for Temporary Shops.

The Corporation of Coventry offer vacant sites for temporary shops of asbestos and timber framing in Corporation Street (from the Gas Department Showrooms to Fretton Street) and from Mills and Mills premises to the corner of Hill Street, and also on Trinity Street. Dispossessed shopkeepers in all areas, especially those engaged in essential trades, are invited to communicate with the City Treasurer at the Council House, expressing their wishes for or against re-opening by them on the new sites of a shop for a retail trade.

Shopkeepers who would like to re-open on their existing sites in the outlying areas should communicate with the City Engineer and get advice as to the best way of re-opening.

DENNIS MORRIS,
Regional Information Officer.

22nd November, 1940.

IF YOU ARE BOMBED OUT
and have no friends to go to

ask a POLICEMAN
or your WARDEN
where to find your
REST CENTRE

ISSUED BY THE MINISTRY OF HEALTH

OPPOSITE PAGE: This Ministry of Health poster depicts Adolf Hitler trying to persuade a mother to take her children back to London. The outlines of St. Paul's Cathedral and Big Ben can be seen in the far right distance, together with barrage balloons floating over the city. This poster campaign was not a great success. As soon as war broke out in September 1939, millions of British children were evacuated from ports and cities, designated "Evacuable Areas," to rural locations called "Reception Areas." When the German bombing campaign failed to materialize, most evacuees returned home, only to depart again a year later when the Luftwaffe attacked Britain. Many child evacuees were away from their families for up to five years, and a small minority were never reunited with their families.

ABOVE: This Ministry of Health poster shows a full-length illustration of a policeman and an Air Raid Precaution (ARP) warden walking together, with the former slightly higher than the latter. Emergency Rest Centers were set up in every town and city that was bombed by the Germans during the Blitz. They were located in churches, church halls, schools, and cinemas. They provided temporary shelter for thousands of people. In Liverpool alone, over 70,000 people were made homeless during the Blitz. Rest centers were usually staffed by members of the Women's Voluntary Service.

BELOW: Air raid protection duties were a vital part of the British war effort in the first three years of the war. In September 1935, British local authorities had been encouraged to implement air raid precautions, and in April 1937 an Air Raid Warden Service was created. The campaign to recruit Air Raid Precaution (ARP) wardens was a great success: there were 1.5 million by September 1939, including women. They were responsible for maintaining the blackout, organizing bomb shelters, and reporting bomb damage. Most had full-time jobs in addition to their ARP duties.

OPPOSITE PAGE: This 1940 recruiting poster makes use of the famous words issued by Winston Churchill in a House of Commons speech made in August 1940, at the height of the Battle of Britain. "The gratitude of every home in our island, in our Empire, and indeed throughout the world except in the abodes of the guilty goes out to the British airmen who, undaunted by odds, unweakened by their constant challenge and mortal danger, are turning the tide of world war by their prowess and their devotion. Never in the field of human conflict was so much owed by so many to so few."

"NEVER WAS SO MUCH OWED BY SO MANY TO SO FEW"
THE PRIME MINISTER

MEN of VALOR

They fight for you

"When last seen he was collecting Bren and Tommy Guns and preparing a defensive position which successfully covered the withdrawal from the beach." — *Excerpt from citation awarding Victoria Cross to Lt.-Col. Merritt, South Saskatchewan Regt., Dieppe, Aug. 19, 1942*

OPPOSITE PAGE: A Canadian recruiting poster that makes the point that Canada and Britain were side-by-side in the struggle against the Axis. Canadian poster production was centralized under the Bureau of Public Information, which was taken over by the Wartime Information Board in 1942. In this poster, a Canadian beaver wears a steel helmet that sports a maple leaf, the symbol of Canada. The British lion, complete with bandaged tail, has an expression of Churchillian defiance, reinforced by the cigar in its mouth. The notion of King and Country is highlighted by the crown on the lion's head.

ABOVE: This poster is one of five posters designed by Hubert Rogers for the Canadian Wartime Information Board. It is a recruiting poster that celebrates the exploits of Lieutenant Colonel Cecil Merritt, commander of the South Saskatchewan Regiment during the Dieppe Raid in 1942. During the raid Merritt was wounded twice as he knocked out enemy pillboxes and organized a rearguard to cover the withdrawal off the beach. Captured by the Germans, he remained in captivity until the end of the war. He was awarded the Victoria Cross, Britain's highest award for gallantry, in June 1945.

PIERRE LE MOYNE, SIEUR D'IBERVILLE · 1661-1706

HIER

AUJOURD'HUI

Né à Montréal. Capitaine de vaisseau, découvreur des bouches du Mississippi, fondateur de la Louisiane, commandant d'escadre. Mort à bord du JUSTE, dans le port de la Havane, il fut inhumé dans la cathédrale de cette ville. Explorateur, intrépide marin et soldat.

Peinture par Adam Sherriff Scott, R.C.A., Notes historiques & E.-Z. Massicotte, archiviste et historien.

Make dad proud to say . . .
"My boy... in the East"

JOIN THE A·I·F

Opposite page: A recruiting poster that was part of a very successful campaign. A the start of World War II, the Royal Canadian Air Force (RCAF) consisted of 4,061 officers and airmen. The wartime total enlistment of the RCAF was nearly 250,000 men and women, of whom 94,000 served overseas. The RCAF also ran the vital British Commonwealth Air Training Plan. By the end of the war more than 8,000 officers, airmen, and airwomen had received decorations from the British and Allied governments, and 17,000 men and women of the Royal Canadian Air Force had been killed in the conflict.

Above: On September 3, 1939, Prime Minister Robert Menzies of Australia announced: "Fellow Australians, it is my melancholy duty to inform you officially, that in consequence of a persistence by Germany in her invasion of Poland, Great Britain has declared war upon her and that as a result, Australia is al o at war." During the war nearly one million Australians servec in the armed services (navy, army, and air force) or Merchant Marine, otherwise known as the Merchant Navy. This 1943 poster is recruiting for the Australian Imperial Force (AIF), part of the Australian Mil tary Forces (AMF). The AIF was formed in October 1939 as an expeditionary force, and by mid-1940 comprised the 6th, 7th, 8th, and 9th Divisions.

of Europe in 1939–1941 resulted in
men, Dutch, Belgians, and Scandinavians
ce there they either joined the British
national units. Posters such as this were
rican public that the citizens of countries
s in 1940 were still fighting the Germans.
sailor holding a Dutch flag in each hand,
d around the barrel of a naval gun.

OPPOSITE PAGE: The Squander Bug was a
poster. Posted at railway stations and in
to persuade people to put their money in
was published by the National Savings C
collective guilt of the population, it push
spending on non-essential items was an
itself is a grotesque cross between a dev
markings on its fur.

Leave rush-hour travel for war workers please

ISSUED BY THE MINISTRY OF WAR TRANSPORT AND
THE MINISTRY OF LABOUR AND NATIONAL SERVICE

" campaign was started in Britain
e war. Before the war Britain
ion tonnes) of food a year, mainly
The government realized that this
erman U-boats, and in any case
d to transport troops, weapons,
from North America. Therefore
e to grow their own food. The
een 1939 and 1945, imports of
on people had allotments by 1945.

ABOVE: On September 3, 193■
and oil were to be rationed, a■
motoring per month for each ⊤
oil as possible for the wa⁻ eff■
and other service vehicles. Th■
reliability on public transport. H
already very restricted and un■
therefore asked the general p■
needed to use public transpor⁻,
need buses and trains more.

British &

"We'll have lots to eat this winter, won't we Mother?"

Grow your own
Can your own

OWI Poster No. 57. Additional copies may be obtained upon request from the Division of Public Inquiries, Office of War Information, Washington, D.C.

U.S. GOVERNMENT PRINTING OFFICE: 1943 O—533863

...oster was designed by L.J. Trevor. The
...emand for military as well as civilian
...principal supplier of war materials
...he war. To cope with these demands,
...ernment created the Department of
...y C.D. Howe. Some 28 Crown
...e large-scale production of
...eat success. By 1942, for example,

BELOW: During the war there was an unending propaganda campaign directed at families emphasizing that thrift in the kitchen was essential to national survival. As well as this poster, there were others with the messages: "Food wasted is another ship lost," and "A sailor's blood is on your head if you waste a scrap of bread!" People took up the challenge, and the result was food recipes such as the "Austerity Pudding" made with potato, grated carrot and apple, dried fruit, dried egg, flour, breadcrumbs, cooking fat, and a scraping of precious golden syrup or marmalade.

OPPOSITE PAGE: This Ministry of Supply poster by the artist John M. Gilroy is urging people to save their kitchen waste for pig food. Pigs are relatively cheap to rear, and during the war some communities set up pig clubs, feeding the pigs on kitchen scraps and sharing the pork when the pigs were slaughtered. In addition, Hyde Park in London had its own piggery. Gilroy himself was employed by the Ministry of Information during the war.

BELOW: Another simple poster with a stark message. The "careless talk costs lives" campaign was launched in 1940 and was a great success, the Ministry of Information producing 2.5 million posters that bore the message. As this poster illustrates, the government was particularly worried about merchant convoy security during the war, as the survival of Britain ultimately relied on the supply of food and war materials from Canada and the United States.

OPPOSITE PAGE: During 1940 and 1941, when Britain stood alone in Europe against Nazi Germany, there was a great fear that the Wehrmacht would launch an invasion of the British Isles, either from the sea or dropping paratroopers. As a result, posters such as this one were posted everywhere to enable people to instantly identify enemy soldiers. Some believed that such posters served only to increase the population's paranoia.

SOS

Never in the bar or barber's
Talk of ships or crews or harbours
Idle words - things heard or seen
Help the lurking submarine

Careless talk costs lives and ships

'SPOT AT SIGHT' CHART Nº 1
ENEMY UNIFORMS

GERMAN PARACHUTIST

GERMAN SOLDIER

PRINTED FOR H.M. STATIONERY OFFICE BY FOSH & CROSS LTD., LONDON (51/990)

Be careful
what you say
+ where you
say it!

CARELESS TALK
COSTS LIVES

OPPOSITE PAGE: The posters on these pages were created by the cartoonist Cyril Kenneth Bird. During World War I Bird was an officer in the Royal Engineers. In 1915, he was blown up by a shell at Gallipoli and was not expected to live. The shell shattered his back and he was unable to walk for three years. While he was convalescing, he took lessons by correspondence from Percy Bradshaw's Press Art School. By 1937 he was the art editor at the satirical news magazine *Punch*, working under the pseudonym Fougasse (which was a small land mine of unpredictable performance).

ABOVE: During the war Bird offered his services free to the government. He believed that humor was the perfect vehicle for propaganda, and that humorous posters had to overcome three obstacles: "Firstly, a general aversion to reading any notice of any sort; secondly, a general disinclination to believe that any notice, even if it was read, can possibly be addressed to oneself; thirdly, a general unwillingness even so to remember the message long enough to do anything about it." The result was his "Careless Talk Costs Lives" series, produced for the Ministry of Information. In these posters well-known senior Nazis are within earshot of individuals innocently giving away secrets.

SALUTE THE SOLDIER

BACK THE ATTACK

Victory Loan

...oster uses fear of the enemy as a
...other and her baby are threatened by
...s, one bearing the Nazi swastika, the
...lication is clear: a dehumanized enemy
...t precious assets, and the only way to
...anese and German enemies is to buy

ABOVE: This British poster features
in profile, with a rifle fitted with a
shoulder. The whole image is shaded
tones. The War Savings Campaign
November 1939, and throughout
encouraging people to save their

BELOW: This Canadian poster was designed by the artist, author, and architect Harry Mayerovitch. By 1944, Canada had been fighting for five years. The quote by the prime minister reflected the position in the European and Pacific theaters. Italy had been knocked out of the war in mid-1943, but Germany and Japan were still fighting, However, in 1944 both countries would suffer decisive reverses that signaled their ultimate defeat.

OPPOSITE PAGE: A 1944 British poster that shows a Churchill tank, named after Winston Churchill, the British prime minister. In 1944 there were heavy British battlefield casualties following the D-Day landings in France. But the policy of unconditional surrender meant that the country was determined to carry on fighting until the Axis was completely destroyed.

Great Britain will pursue the WAR AGAINST JAPAN to the very end.

WINSTON CHURCHILL

French Posters

france, which bore the chief burden on the Western Front, suffered heavily during World War I (1,357,800 dead, 4,266,000 wounded). It is therefore not surprising that there was little enthusiasm for war among the French in September 1939. Not that the French at this stage were defeatist or pacifist. There was a general consensus after Hitler's takeover of Czechoslovakia in early 1939 that the German leader could not be trusted and that any further Hitlerite demands should be resisted. The patriotic mood was further increased when the Italian dictator, Mussolini, began to make demands for French colonies.

Poor French morale

The swift collapse of Poland had stunned the world, but the British and French in the West were relieved when no German attack was made against them in the fall of 1939. The French under General Maurice Gamelin continued to build up their forces on their border with Germany, bolstered by the vaunted Maginot Line defenses and the troops of their British allies. By May 1940 the Allies on paper were very strong: along its northeastern border the French Army deployed 3,563 tanks out of its total available force of roughly 4,000 vehicles. In addition to this French armor, the British Expeditionary Force (BEF) deployed 196 tanks, the Belgians 60, and the Dutch 40, to produce a grand total of 4,296 Allied armored vehicles in the northeastern theater. Approximately 2.9 million German soldiers faced the three million troops fielded by the Allies.

However, by this time there were severe problems in the French Army. In November 1939, the British General Sir Alan Brooke had watched a parade of French Ninth Army troops. He wrote: "Seldom have I seen anything more slovenly ... men unshaven, horses ungroomed ... complete lack of pride in themselves or their units. What shook me the most, however, was the look in the men's faces, disgruntled and insubordinate looks." Things then proceeded to get worse. The winter of 1939–1940, the so-called Phoney War, was the coldest since 1889, and many units suffered from a lack of socks and blankets. In addition, there was widespread boredom after months of inactivity. All this resulted in a serious drop in morale. This is Jean-Paul Satre's diary entry for February 20, 1940: "The war machine is running in neutral; the enemy is elusive and invisible. Most of the men are fairly receptive to the Hitler propaganda. They're getting bored, morale is sinking." Another recruit, Georges Sadoul, wrote: "End January: militarily speaking we are doing literally nothing. We are so numbed with apathy and cold that many of us do not bother to wash, or to shave."

French propaganda

And what of French propaganda? At the beginning of the war the French had the Propaganda Commissariat, which had been set up by Defence Minister Edouard Daladier in July 1939 and was headed by the writer Jean Giraudoux. The latter had made his reputation in the 1920s producing works that generally denounced militarism and promoted Franco-German reconciliation. Now he had to produce anti-German propaganda. Not surprisingly, the Propaganda Commissariat was a disaster. It was not helped by the government, which offered no guidance as to how it wanted him to present the war to the public.

After the fall of Poland many in France did not know what they were fighting for. The government refused to present the conflict as an antifascist crusade through fear of provoking Mussolini's Italy abroad and conservatives at home—a decision that illustrated the divisions among the French people.

Internal divisions

Like all European countries, France had been hit hard by the Great Depression in 1929. This resulted in political instability (there were six governments between June 1932 and February 1934) and the emergence of right-wing organizations called the "Leagues". In response the communists and socialists signed a unity pact in June 1934 (the communists had been ordered by Soviet leader Stalin not to destabilize France as he wanted an alliance with Western powers to counter the threat of Hitler in Germany). The left-wing alliance in France was called the Popular Front, and once in power after May 1936 France was gripped by mass industrial action. The legacy of the Popular Front was a right-wing hatred of the Communist Party, and the fear that France would become a satellite of the Soviet Union. These divisions did not disappear when war broke out in September 1939.

It is no exaggeration to say that by May 1940 a general sense of defeatism permeated the French armed forces. The situation was not made any better by the dire state of the army's training. For example, it was estimated in 1930 that around 18 percent of riflemen in an average regiment had never fired a rifle and 25 percent had never thrown a grenade. When the German attack came in May 1940, the French were able to offer only token resistance.

ABOVE: Over 9,000 French volunteers served with the left-wing Republican Army in the Spanish Civil War (1936–1939). This poster is soliciting financial aid for Republican survivors of the civil war and their families. Disagreements over support for the Republicans between the communists and socialists and conservatives in France in the 1930s did nothing to improve French national unity.

Surrender in June 1940 saw the establishment of the collaborationist Vichy regime in the southern half of France, but others vowed to continue the struggle to liberate their country from the Nazis under the banner of the Free French.

The surrender document signed at Compiègne preserved a much-reduced but nominally independent France. The Germans occupied the northern half of the country as well as the entire length of its Atlantic coast to the border with Spain, an area amounting to 60 percent of its prewar territory. The Atlantic coast was to be used by U-boats for raids into the Atlantic against Britain's merchant shipping, if London proved unwilling to reach a settlement. The remainder of France was left to the administration of Marshal Henri Philippe Pétain and Pierre Laval, president and prime minister respectively, who established their seat of government at the spa town of Vichy. The French Army was demobilized and disarmed, although an internal security force was permitted. The fate of the French fleet was less clear and would come to trouble Britain's politicians over the following months.

Vichy France

Vichy France's relationship with Nazi Germany remains controversial. Some French politicians held Nazi beliefs, while others simply hoped to preserve France in some semi-independent form. Nevertheless, the Germans acted ruthlessly toward Vichy, which had to pay for the upkeep of the occupation. The country's economic resources were also exploited to the fullest extent, and some 800,000 workers were encouraged or forced to work in Germany industry.

The French population suffered considerably during four years of occupation. Between 1940 and 1944, the Germans took from France an estimated 220 million eggs, 2.8 million tons (2.84 million tonnes) of wheat, 710,000 tons (721,360 tonnes) of potatoes, and 848,000 tons (861,568 tonnes) of meat. In addition, thousands of cattle were also taken to Germany. One result of this constant looting of the country's foodstuffs was the deterioration of the physical health of the French people. In 1942, for example, it was estimated that in Paris alone the average weight loss per person was 14 lb (6.4 kg).

It is also undeniable that the Vichy Government cooperated in, and initiated actions against, the country's Jewish community, and one concentration camp was actually established on French soil. But other French groups actively resisted the regime. When Germany invaded Russia in June 1941, for example, the Communist Party was reinvigorated and communists became a key part of the Resistance. The Communist Party had been weakened by government repression before the war and had lost thousands of members as a result of the German-Soviet Non-Aggression Pact of 1939. After June 1941 the Soviet Union was no longer an ally of Germany, and so the communists could abandon their view that the war was an imperialistic conflict that was against the interests of French workers.

Collaboration

The German invasion of Russia also caused great excitement among collaborationist political parties and paramilitary formations. In response, the first recruiting center was opened at 12 rue Auber, Paris, while additional recruiting centers were placed all over France. On July 7, all the leaders of these parties met at the Hotel Majestic in Paris to create an anti-Bolshevik legion, and on July 18, 1941, the *Legion des Voluntaires Francais contre le Bolshevisme* (LVF) was established.

Initially the Vichy Government had enacted a law that forbade Frenchmen from enlisting into "foreign armies" to prevent them from joining the Free French forces of the exiled General Charles de Gaulle. Since the LVF was a private affair, Marshal Pétain amended the law so there would be no barrier to Frenchmen enlisting into it. Hitler approved, but stated that membership be limited to no more than 15,000. However, the LVF received a total of only 13,400 applications to join, and of these 4,600 had to be refused on medical grounds and a further 3,000 on "moral" grounds. Many came from the militias of the collaborating political parties. Prominent among these were the men from Jacques Doriot's French Popular Party (PPF), including Doriot himself. Eventually, 5,800 Frenchmen were accepted into the LVF.

In February 1944 the German Navy began to appeal for French volunteers, the main recruiting office being at Caen in Normandy. But, as with other branches of the German armed forces, individual enlistment had taken place before that late date, especially in the traditional coastal regions of Brittany and Normandy. Between 1,000–2,000 Frenchmen served in the German Kriegsmarine in World War II. In France, the German Navy also raised an indigenous naval police known as the *Kriegsmarine Wehrmänner*.

Another separate German naval police unit of French volunteers was the *Kriegswerftpolizei*. This unit consisted of some 259–300 Frenchmen, who assisted in guarding the important U-Boat base at La Pallice near La Rochelle, in the Bay of Biscay. The Allied invasion of France in June 1944 does not appear to have deterred the German Navy from continuing its attempts to recruit Frenchmen. For example, the *Journal de Rouen* dated June 29, 1944, three weeks after the Allied landings, carried an advertisement urging young Frenchmen to join the Kriegsmarine. It stated: "To be a sailor is to have a trade, enlist today in the German Navy."

The Free French

Opposition to Vichy France and the Nazis ultimately centered on the exiled Free French under Charles de Gaulle in Britain, although many ordinary French people initially took little heed of his calls to fight the Nazis and reject the Vichy regime. Resistance grew as de Gaulle's authority and Vichy France's subservience to the Nazis became more clear, combined with the hardships that followed the looting of French foodstuffs by the Germans. The process intensified in November 1942, when German troops swept into Vichy France to prevent a possible Allied invasion from North Africa. Supported by Allied supply drops, French Resistance groups in France grew slowly and undertook a key role in aiding the freeing of the country, though after the Allies had landed in France in June 1944, not before. Regular Free French units also served with the Allied armies and played a part in the liberation of Paris itself.

OPPOSITE PAGE: "One war for one Homeland." A Free French poster emphasizing that the war against Nazi Germany goes on despite the German occupation of France. The Free French Forces (*Forces Françaises Libres*, FFL), under the leadership of Charles de Gaulle, was initially a fringe movement (de Gaulle was indicted as a traitor by a Vichy court for ignoring Pétain's armistice order). However, by 1944 there were 100,000 Free French soldiers in the Allied armies.

LIBERTÉ
ÉGALITÉ
FRATERNITÉ

UN SEUL COMBAT
POUR UNE SEULE PATRIE

N'oubliez pas Oran!

FRANÇAIS

DE 20 A 40 ANS

FAITES VOTRE DEVOIR !

Entrez dans les rangs de la

LÉGION

DES VOLONTAIRES FRANÇAIS

CONTRE LE BOLCHEVISME

POUR TOUS RENSEIGNEMENTS :

Conditions Matérielles, Maisons du Légionnaire, Colonies de Vacances, Service Social des Familles, Bureaux de Placement, etc...

ADRESSEZ-VOUS :

t Oran!" A Vichy poster. In July 1940, navy would be seized by Germany, sent er, and a carrier (Force H) to capture lers-el-Kebir, Algeria. After negotiations and sank one battleship and damaged sailors were killed in the attacks, and Britain sank to a new low.

ABOVE: A recruiting poster for the Vichy *Legion contre le Bolshevisme* (LVF) The recruits wo uniforms and had the French national arm placed on their right sleeve (the Germans r France actually declared war on the Soviet question of sending combatants to the fron October 1941 the LVF comprised two batta other ranks, with a liaison staff of 35 Germ the 638th Infantry Regiment of the German LVF was caught up in the Soviet winter cou lost half of its strength due either to enemy

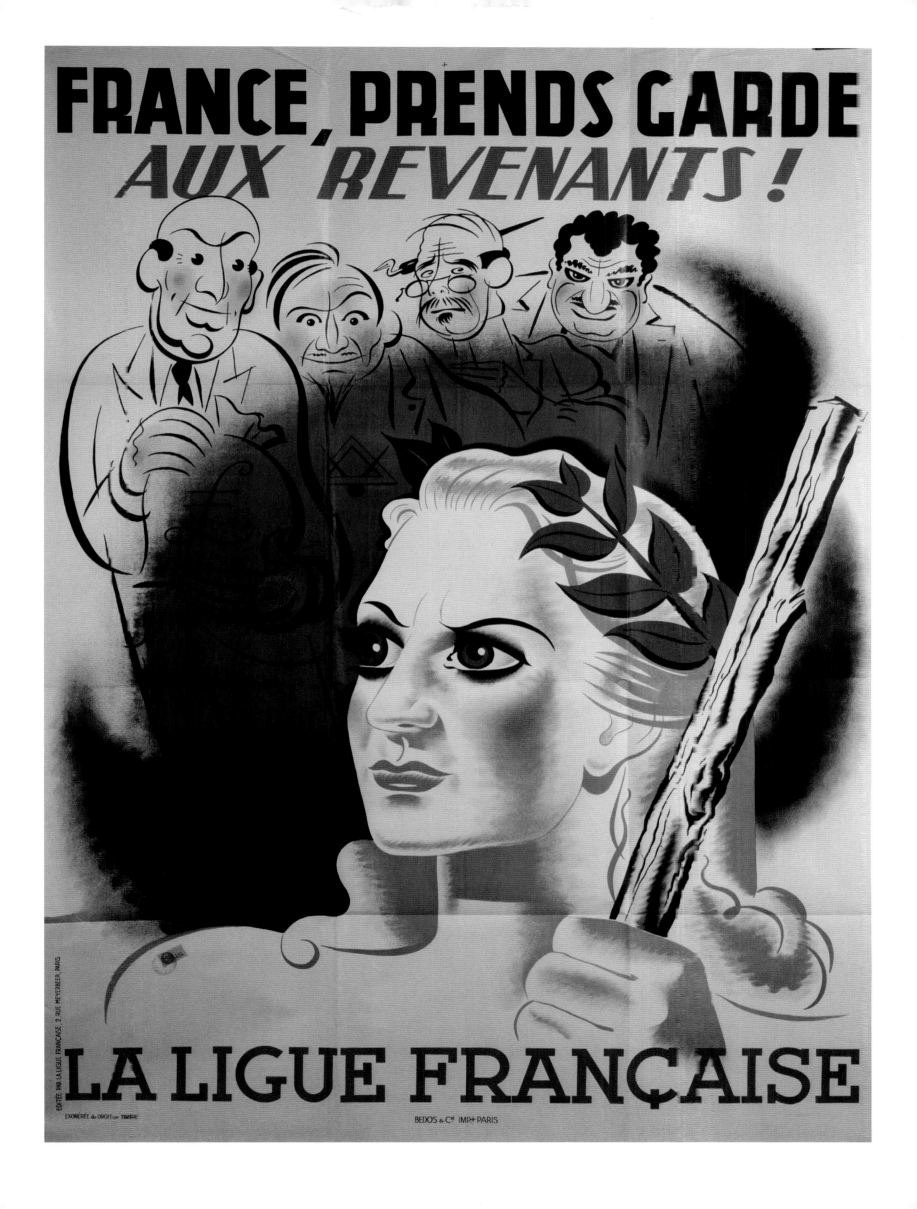

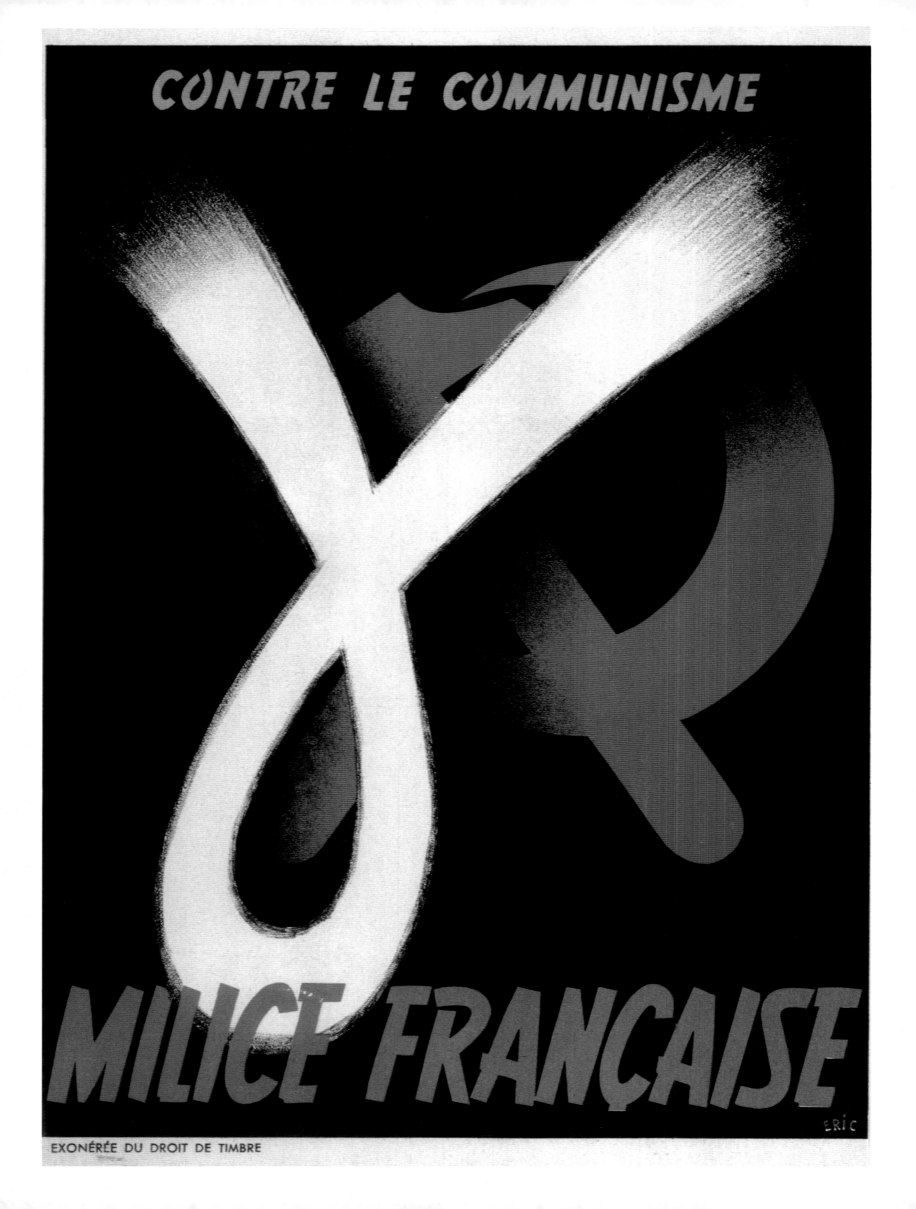

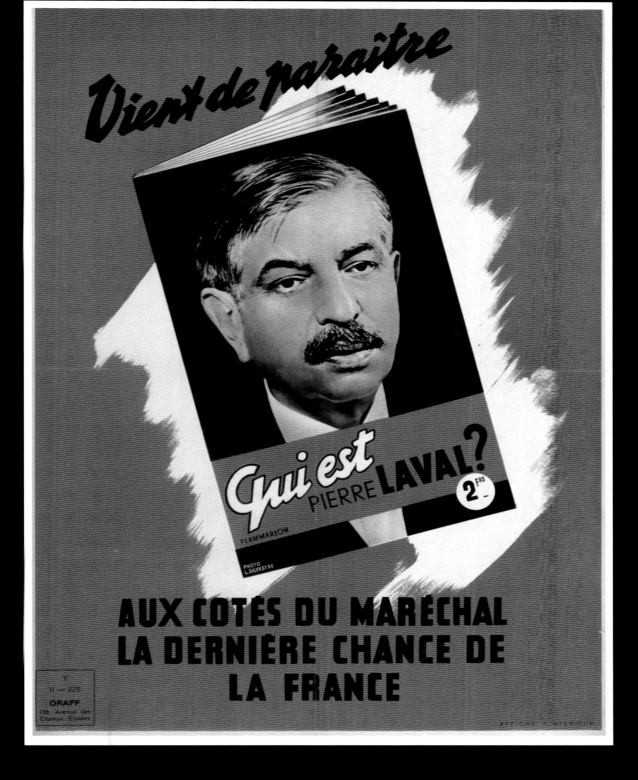

Vient de paraître

Qui est PIERRE LAVAL?
FLAMMARION
2 FRS
PHOTO L.SILVESTRE

AUX CÔTÉS DU MARÉCHAL
LA DERNIÈRE CHANCE DE
LA FRANCE

ORAFF

Opposite page: "Against communism." A recruiting poster for the Vichy regime's *Milice* (secret police). Formed in January 1943, it was made up of antiGaullists and anticommunists. Numbering 35,000 at its height, the *Milice* specifically excluded Jews from its ranks. It was created to fight members of the French Resistance, who by 1943 were beginning to increase their activities of sabotage and assassination. The *Milice* also took an active part in rounding up French Jews for deportation to the concentration camps. The inverted white ribbon was the logo of the *Milice*.

Above: An advert for a booklet about Pierre Laval. It states: "Just out—*Who is Pierre Laval?*—At the side of the marshal [Pétain]. The last hope for France." Laval was a French politician who headed the Vichy Government from 1942. He collaborated with the Germans in an effort to get the best deal for France. In a 1942 radio broadcast he declared his hope for a German victory, "because without it tomorrow Bolshevism will be everywhere." After the war he was found guilty of treason and shot in October 1945.

German Posters

according to one of the myths perpetuated by the Nazis, Allied propaganda in World War I had made a significant contribution toward the German defeat in that war. At the front the army remained undefeated (which was a lie), but at home the civilian masses, influenced by Allied propaganda, became revolutionized and incapable of supporting the army. The manufacturers of Allied propaganda would have been flattered by this eulogy, but aside from it being totally false, it does illustrate a major tenet of Nazi propaganda theory: it did not have to bear any resemblance to the truth. Indeed, lies were a useful asset, and the bigger the lie the better, because the masses could understand and digest it more easily. As Hitler himself had written: "In the big lie there is always a certain force of credibility; because the broad masses of a nation are always more easily corrupted in the deeper strata of their emotional nature than consciously or voluntarily; and thus in the primitive simplicity of their minds they more readily fall victims to the big lie than the small lie, since they themselves often tell small lies in little matters but would be ashamed to resort to large-scale falsehoods. It would never come into their heads to fabricate colossal untruths, and they would not believe that others could have the impudence to distort the truth so infamously."

Hitler on propaganda

Concerning propaganda, Hitler had written in *Mein Kampf*: "The art of propaganda lies in understanding the emotional ideas of the great masses and finding, through a psychologically correct form, the way to the attention and thence to the heart of the broad masses.

The fact that our bright boys do not understand this merely shows how mentally lazy and conceited they are. Once understood how necessary it is for propaganda to be adjusted to the broad mass, the following rule results: It is a mistake to make propaganda many-sided, like scientific instruction, for instance. The receptivity of the great masses is very limited, their intelligence is small, but their power of forgetting is enormous. In consequence of these facts, all effective propaganda must be limited to a very few points and must harp on these in slogans until the last member of the public understands what you want him to understand by your slogan. As soon as you sacrifice this slogan and try to be many-sided, the effect will piddle away, for the crowd can neither digest nor retain the material offered. In this way the result is weakened and in the end entirely cancelled out."

Joseph Goebbels

Hitler and the Nazis made great use of propaganda, especially posters, in the interwar years. The symbols of the party—the swastika, the eagle (supposedly selected by Hitler because he had seen it described in an anti-Semitic encyclopedia as the "Aryan in the world of animals"), and a wreath of laurel leaves—were seen on posters, along with strong colors, usually red, black, and white. The Nazis turned propaganda into a religion, and like all religions it needed a high priest. In 1926 they found one, when Dr. Joseph Goebbels was appointed *Gauleiter* (governor) of Berlin. The posters produced under the direction of Goebbels before the Nazis came to power in 1933 presented Adolf Hitler as the ex-serviceman in civilian clothes who was carrying on the fight as the representative of a nation that had

lost a just war. After 1933, Goebbels was appointed propaganda minister and developed the image of Hitler further. Now the Führer was carrying on the work of Bismarck (who had unified Germany in the late nineteenth century) and was about to complete it. One of the most significant posters of the period immediately before the outbreak of war was a half-length picture of Hitler with the accompanying caption: "One People, One Empire, One Leader." Indeed, so powerful was this image that throughout Germany it replaced religious pictures and crucifixes on the walls of offices and classrooms.

The Ministry of Propaganda

Goebbels' Ministry of Propaganda trumpeted two of the central planks of Nazi ideology: space and race. Germany needed *Lebensraum*, "living space," to ensure her survival as a great nation, and a strong Germany also had to be free of "contamination" with inferior races, specifically the Jews (and later the Slavs). The Jews in particular were singled out to take the blame for all of Germany's ills: not only were Jews who lived in Germany enemies of the state, but foreign nations hostile to Germany were portrayed as being manipulated by Jews. Nazi anti-Semitic posters portrayed Jews in the worst possible light: they were shifty, untrustworthy, had animal-like features (thus were less than human), and were parasites. In contrast, Germans were painted as blonde, blue-eyed Aryans who were handsome and physically fit. They were part of a new Germany, one that was establishing a New Order in Europe.

The string of German victories in the first two years of the war, when the Wehrmacht conquered Poland,

Ein Volk, ein Reich, ein Führer!

ABOVE: "One People, One Empire, One Leader." This poster, produced in early 1939 under the direction of Propaganda Minister Joseph Goebbels, was one of the most popular produced in the Third Reich both before and during the war. The half-length portrait of Hitler replaced religious paintings in homes, offices, and classrooms throughout Germany.

Norway, France, the Low Countries, and the Balkans, seemed to confirm the triumph of the New Order. German posters between 1939 and 1941, therefore, reflected these military triumphs. Posters portrayed Germany literally smashing her enemies to pieces, an apt analogy in 1939 and 1940. Likewise, the German attack on the Soviet Union in June 1941 also produced a crop of spectacular victories. German armies surrounded and destroyed Red Army formations as they drove deeper and deeper into the USSR. By December 1941 the Wehrmacht had almost captured Moscow. Almost. However, that month the Soviets launched a massive counterattack all along the line which nearly broke the German Army on the Eastern Front. The Germans now faced at least another campaigning season in Russia, against an enemy that had exceeded all expectations.

War of annihilation

The Nazis reserved a special loathing for the Soviet Union, tinged with fear. According to Nazism, the USSR was the center of the Jewish-Bolshevik conspiracy, and it was loathed because it was populated by those racial groups the Nazis despised: Slavs and Jews. These groups were fit only for two things: to act as slaves to serve a German master race who ruled a Thousand Year Year; either that or be exterminated. However, the Soviet Union also aroused fear, for east of the River Oder resided tens of millions of Slavs who posed a very real threat to the Third Reich. This meant that the war on the Eastern Front was fought with an intensity not seen elsewhere on the European continent. The result was extermination on a vast scale, against Jews, communists, and Red Army prisoners of war. In those areas under German rule, anti-partisan sweeps resulted in thousands of civilians being shot under the vague accusation that they were "bandits." Thus the war on the Eastern Front became one of annihilation between two ideologically opposed totalitarian regimes.

After January 1943, the nature of German propaganda changed. The surrender of what was left of the German Sixth Army at Stalingrad was a catastrophe for the Third Reich. The supposedly "inferior" Slavs had annihilated an army of 300,000 Germans. Suddenly, the Nazis could not say that they were the *Herrenvolk* (master race). They had been both defeated and humiliated. Thus German propaganda shouted a new message after Stalingrad: Nazi Germany was the defender of Europe's ancient civilization against the barbarian hordes of the East. As Hitler declared after the fall of Stalingrad: "Either Germany, the German

armed forces, and along with us our allies in Europe will win, or the Central Asiatic Bolshevik tide will break in from the East over the oldest civilized continent, just as destructively and annihilatingly as it did in Russia itself. Man's efforts, stretching back over several thousand years, to create a civilization would then have been in vain." This remained one of the dominant themes of Nazi propaganda to the end of the war. After Stalingrad Goebbels proclaimed a total war. In a fiery speech made to a specially selected audience in Berlin on February 18, 1943, he railed: "Now, people rise up and let the storm break loose!" As a result of the crisis German women, who until then had not been subject to compulsory work in factories or offices, were conscripted. In German-occupied Europe, further levies of forced labor were raised, and in Germany rations were further reduced.

Most propaganda was fixed on the Eastern Front, which the Nazis correctly perceived as being the theater where the war would be won or lost. Posters hammered home the threat of the "red menace," the "Bolshevik horde," and the "danger from the steppes." Whereas the posters in the early war years had featured determined Aryans, those in 1943 and 1944 portrayed grim-faced soldiers and *Volkssturm* (aged home defense recruits) clutching weapons to face the Red Army. The result of this new propaganda campaign was seemingly successful, in that Germans did resist the Soviet Union fiercely until their defeat in 1945. However, they did so because they did not want to live under Russian rule, and they also did not want to face the wrath of a Red Army bent on exacting revenge for German atrocities committed on Russian soil.

The Hitler Youth

Two other strands of German propaganda should also be mentioned. First, the Nazi obsession with the militarization of German youth. The Hitler Youth organization had one aim only: to produce a generation of German youth that was physically fit, militarily trained, and thoroughly indoctrinated in National Socialist ideology. It succeeded in all three. By 1945 millions of young Germans, both male and female, had served in the armed forces or, if they were too young, on the home front. For those fanatical Nazi youths, there was service with the 12th SS *Hitlerjugend* Division, an élite Waffen-SS panzer division.

Another major strand of Nazi propaganda was concerned with the Waffen-SS. The *Schutze Staffel* (SS) —Protection Squad—was originally formed as a bodyguard for Adolf Hitler. However, by the end of World War II the SS had become a state within a state and its

armed wing, the Waffen-SS (Armed SS), numbered one million troops. The Waffen-SS had its own distinctive creed. This was written down in its training manual: "Obedience must be unconditional. It corresponds to the conviction that National Socialist ideology must reign supreme ... every SS man, therefore, is prepared to carry out unhesitatingly any order issued by the Führer or a superior, regardless of the sacrifice involved." Heinrich Himmler, head of the SS organization, considered that his SS men were unstoppable. He told them, "I must repeat—the word 'impossible' must never be heard in the SS. It is unthinkable, gentlemen, that anyone should report to his superior, 'I can not arrange this or that' or 'I can not do it with so few people' or 'my battalion is not trained' or 'I feel myself incapable.' Gentleman, that kind of reaction is simply not permitted."

Foreign recruits

Although the Waffen-SS was primarily an armed force at Hitler's disposal for the maintenance of order inside Germany, the Führer also decreed that in time of war it was to serve at the front under army command. He believed that frontline experience for the Waffen-SS was essential if such a force was to command the respect of the German people. He also insisted that its human material was to be of the highest caliber.

From June 1941, the Waffen-SS's recruiters were keen to enlist Aryans from outside Germany. The recruitment campaign emphasized the common bonds of the Nordic race, and the threat Bolshevism posed to all the Nordic countries (at first Himmler was interested only in raising legions of Danes, Norwegians, Dutchmen, and Flemings on racial grounds). It was a message that appealed to thousands of Western European males. As the war progressed the Waffen-SS created more foreign units. One, the *Wiking* Division, made up of West Europeans, became an élite unit.

OPPOSITE PAGE: The Central Propaganda Office (*Reichspropagandaleitung*) of the Nazi Party produced weekly quotation posters that were to be displayed in party offices, military barracks, and public buildings. This one states: "National Socialism is the guarantee of victory." It was issued in the fall of 1939, just after the German invasion of Poland. The campaign lasted three weeks and was a stunning success for the Wehrmacht. The quotation posters usually carried the words of senior Nazis or popular slogans, such as "The Führer is always right."

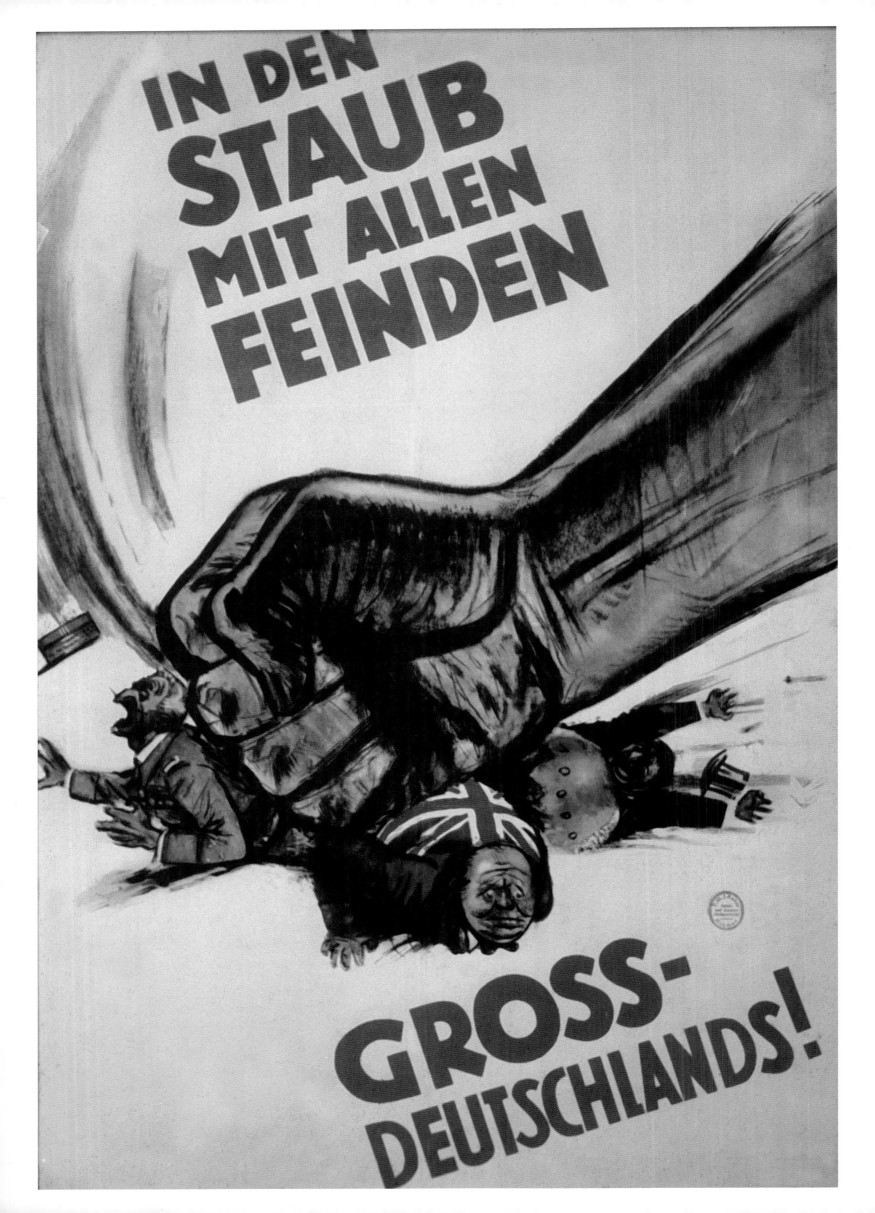

OPPOSITE PAGE: A very successful poster that was released in the summer of 1940. It literally translates as: "Into the Dust with All Enemies of Greater Germany." In May and June 1940 the German Army had done just that, conquering the Low Countries and France and forcing the evacuation of the British Expeditionary Force from Dunkirk. The German public had rightly been worried concerning war with Britain and France, whose combined might was greater than the Wehrmacht. But the Blitzkrieg campaign of 1940 had been a stunning success and had knocked France out of the war.

ABOVE: "Victory is with our Flags!" This 1940 poster was very popular, and some 650 000 copies were distributed. In Germany the war against Britain and France was packaged to the public as a revival of the 1914 conflict against Germany's "encirclement" by other European powers. The victory over both nations in 1940 was trumpeted as an end to the despised Treaty of Versailles, and revenge for the humiliation of 1918. As such, it gave a morale boost to the German people.

t industrial production,
eople: "The homeland and
id farewell to a year that was
storical victories.The German
lmighty, who has so clearly
ding by us in battle and
. He knows that we are
that we are fighting for the
ften been oppressed." This
ims: "*You* are the front!"

OPPOSITE PAGE: A weekly quotat
uses Hitler's words. "No one can
the poster might seem trite, in t
idle boast. The German Army ha
and the Balkans, and in April ha
the continent, this time from Gre
could stop the German soldier.

WO DER
· DEUTSCHE ·
SOLDAT
STEHT/
KOMMT
KEIN
ANDERER
HIN

ADOLF HITLER

HOYER

WOCHENSPRUCH DER NSDAP. / HERAUSGEBER REICHSPROPAGANDALEITUNG / FOLGE 19, 4.-9 MAI 1941
ZENTRALVERLAG DER NSDAP., MÜNCHEN W/0074

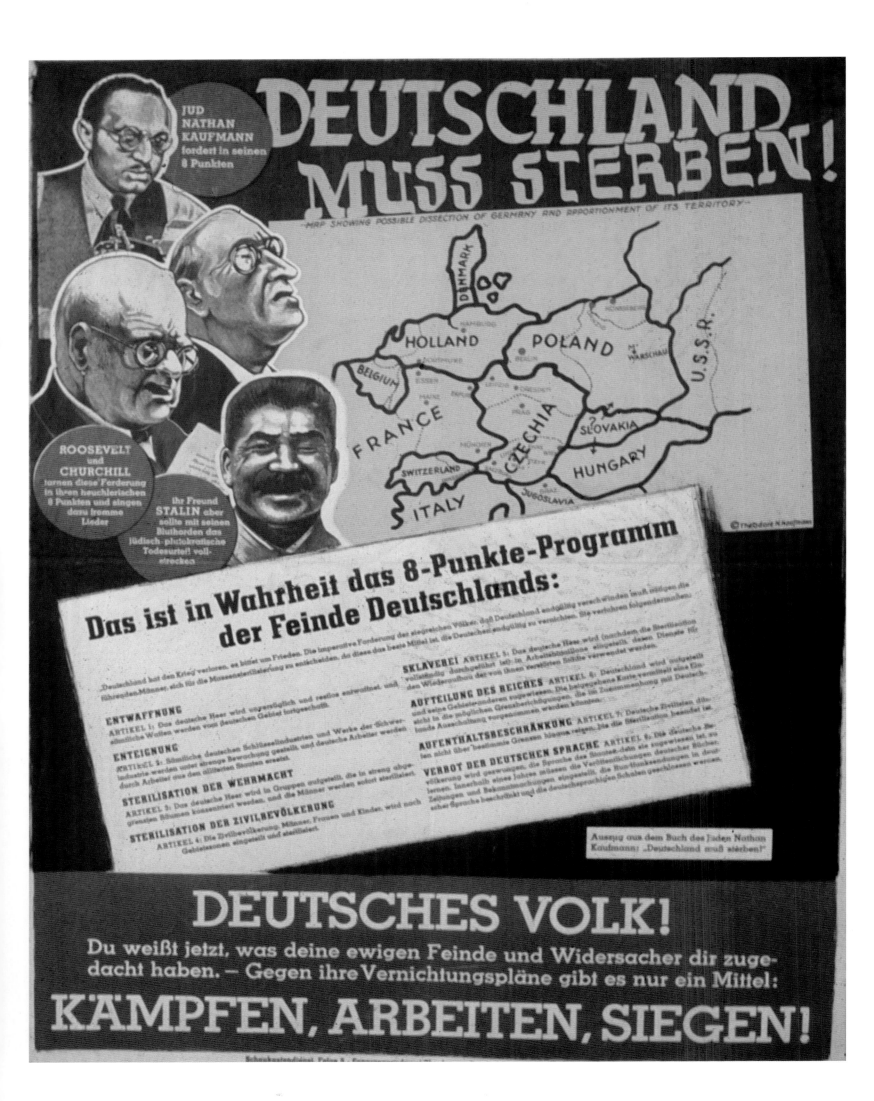

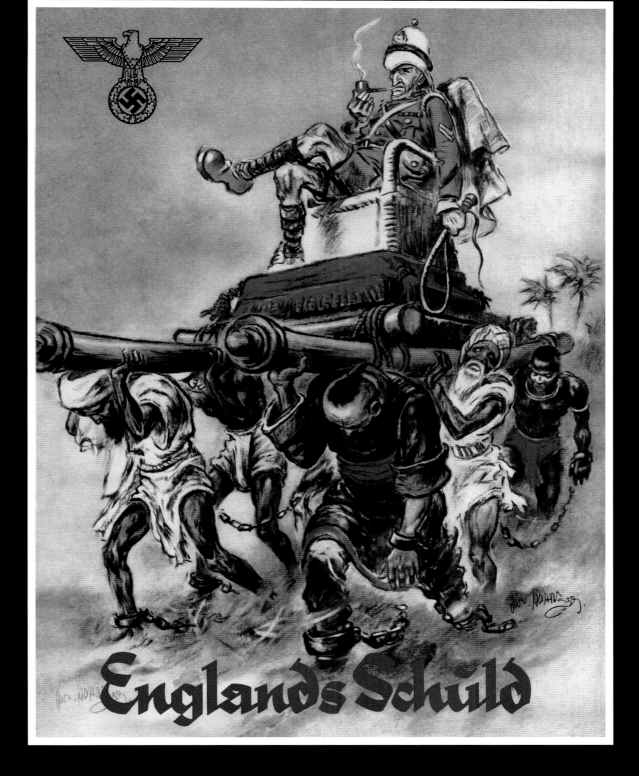

Englands Schuld

r reads: "Youth Serves the
ler Youth." The Nazis viewed
s of tomorrow. The Hitler
organization created by the
League of Young Girls, which
ague of German Girls (from
le for boys aged 10 to 14; and
d 14 to 18. By 1936, when
s compulsory, there were 5.4
movement.

OPPOSITE PAGE: "We all help wi
the home front as part of the Hi
Germans were presented as the
youth in the foreground is wear
auxiliary, called a *Flakhelfe*-. His
battery. By 1943, nearly every fl
Hitler Youth *Flakhelfers*, and by
were active on all fronts.

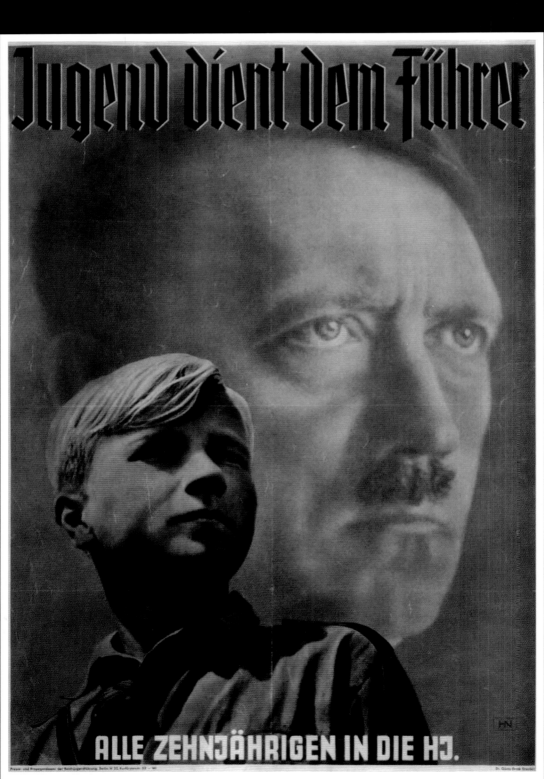

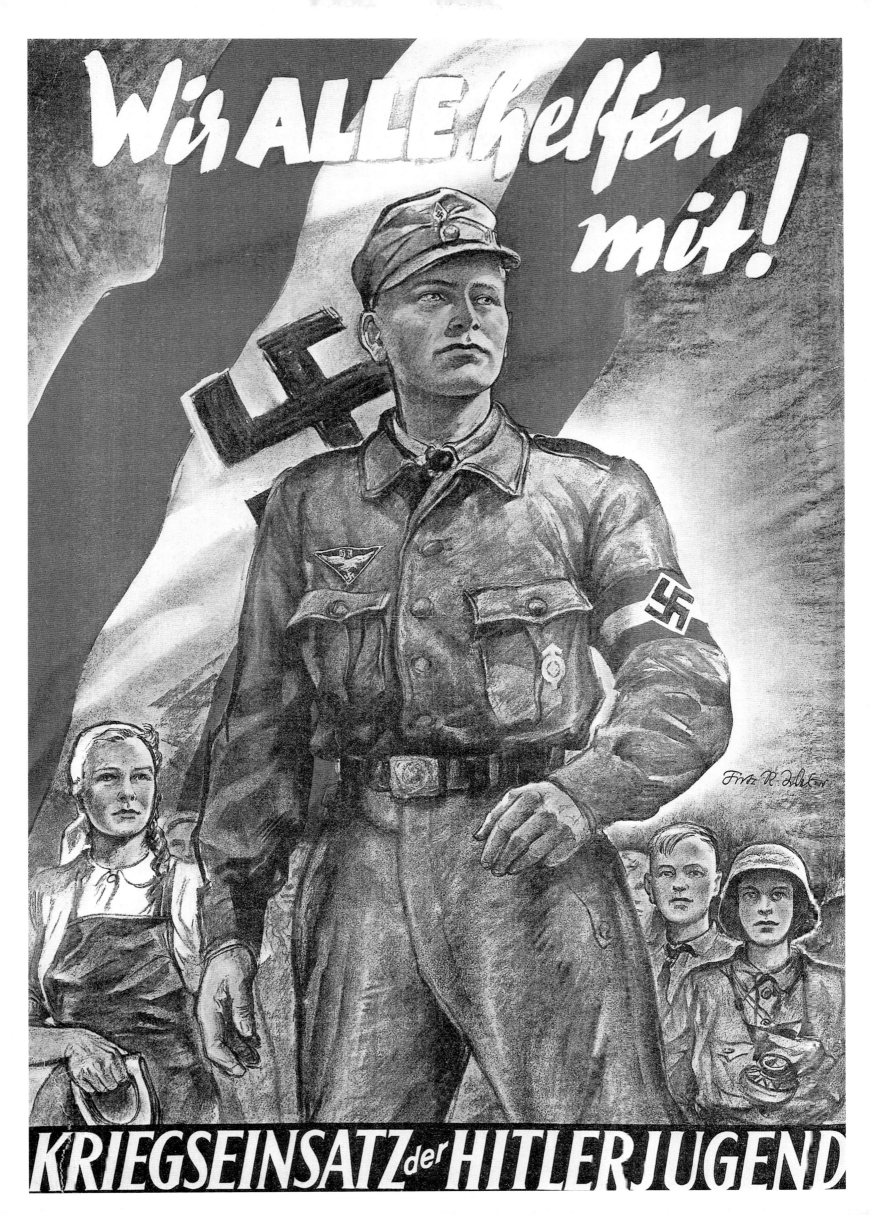

OPPOSITE: These posters were issued in late 1941 in Austria. They were aimed at complainers and those who failed to realize the greatness of life in Nazi Germany. Each poster would hang for two weeks, so the whole campaign ran for three months. Newspapers promoted it, and those attending movie theaters saw slides of the posters before the film began. The goal was to make everyone aware of the two unpleasant central figures in the campaign, and encourage them to behave differently.

1 This poster introduced the two characters: Frau Keppelmeier and Herr Lemperer. The poem runs:
> "Frau Keppelmeier, as one can see,
> Is deeply troubled as can be.
> Herr Lemperer, on the other hand,
> Eagerly hears the rumor she tells."

2 Herr Lemperer is not eager to donate to the Nazi Party's charity, the *Winterhilfswerk*, or WHW:
> "Herr Lemperer, it's very clear,
> Makes his 'sacrifice' so dear.
> 'Hey,' he mutters, 'I gives ma share!'
> Two cents is all that he can spare."

3 Frau Keppelmeier commits the crime (and it was a crime) of listening to British radio:
> "At night Frau Keppelmeier turns her dial,
> And listens in on London.
> She sits there listening to lies,
> Happily being led astray."

4 Herr Lemperer, meanwhile, has advice for Hitler's generals:
> "Herr Lemperer is a strategist.
> The most important thing in any battle
> Is to make the right attack, he says.
> Any general could learn from him.
> One need only listen to him at the pub."

5 Frau Keppelmeier, meanwhile, is having trouble finding the things she needs:
> "Frau Keppelmeier is most distressed.
> She can't get the right perfume these days.
> And our youth, why they're so immature,
> They've never heard of perfumed soap!"

6 Herr Lemperer is off to the countryside looking for black market foodstuffs:
> "Herr Lemperer, meanwhile, complains so loudly.
> The trains, you see, are sometimes late.
> In such hard times, how can he then,
> Himself punctually fill his sack?"

inger pointing accusingly at
a yellow Star of David on
bid anti-Semitism was a
ore and during the war. A
nal Jewish conspiracy
said: "We know that they
international anti-German
all accordingly. They can but
ow very well that not one
join the fight in a war, even
fit from these wars!"

depicted all the Allied powers
conspiracy. By the end of 1941
Soviet Union, and the United S
proclaimed: "I predicted on Se
Reichstag—and I am careful t
war will not end the way the J
extermination of all European
will be the annihilation of the
chillingly prophetic.

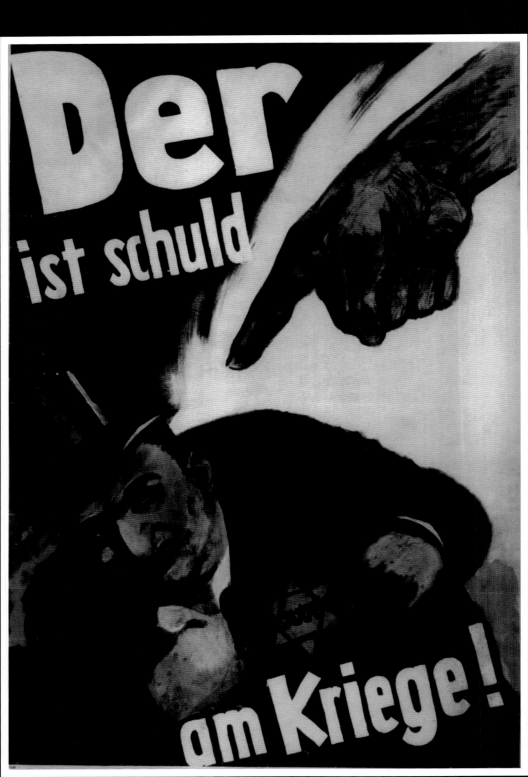

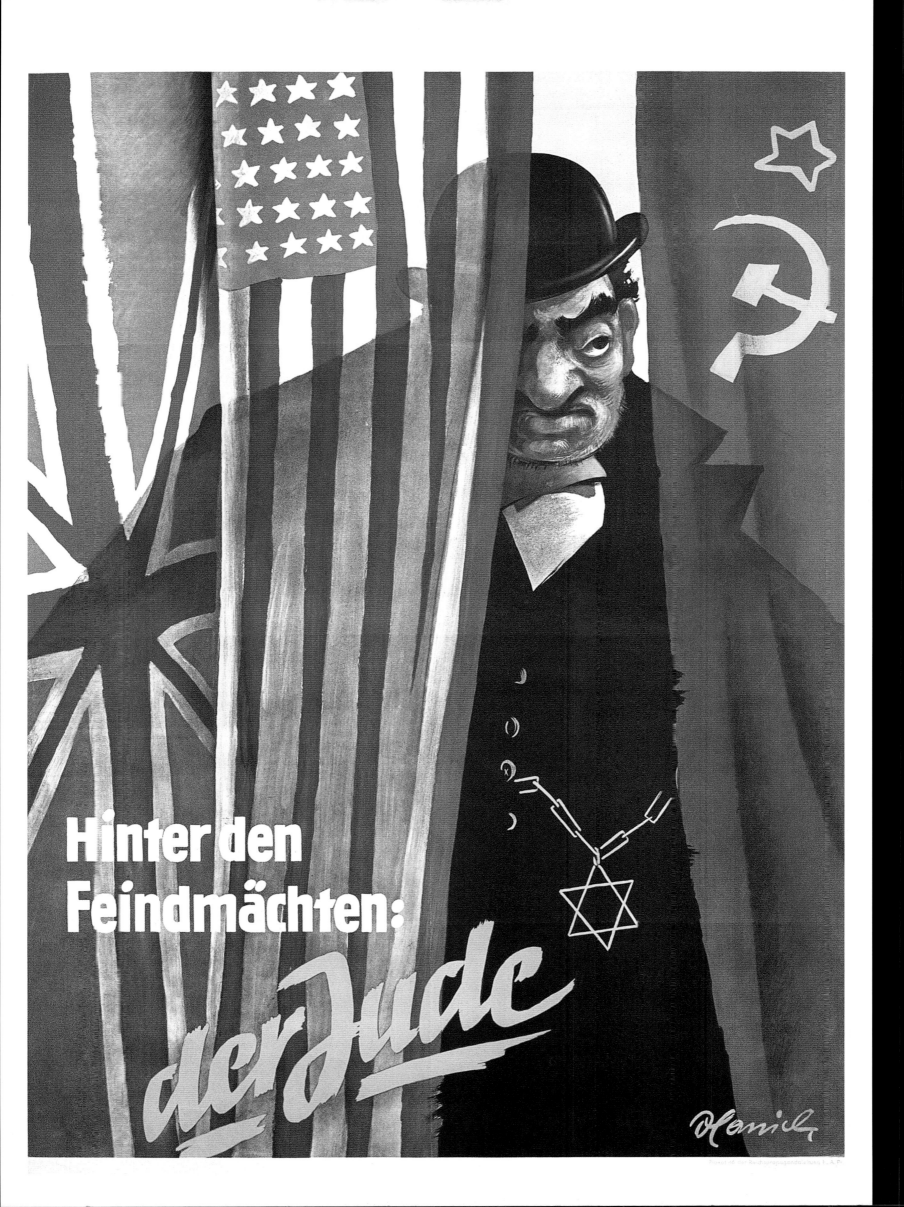

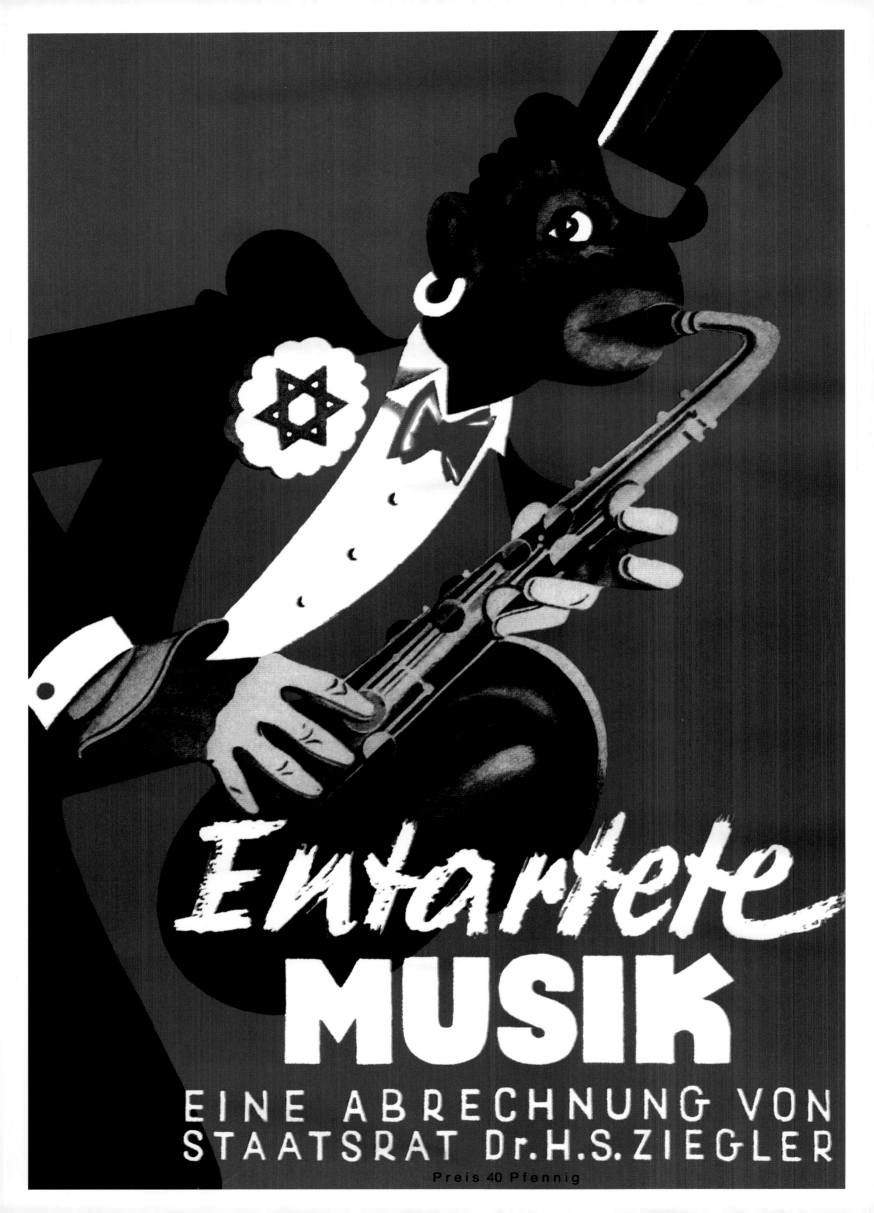

LEFT: "Degenerate Music." This poster is a crude exaggeration of the original poster for the 1927 jazz-influenced opera *Jonny spielt auf (Johnny Strikes Up)*. Its grotesque figure became the Nazi symbol for all they considered "degenerate" in the arts. The word "degenerate" in Nazi usage came from the nineteenth-century psychologist term meaning any deviance or clinical mental illness. In the Third Reich the words "Jewish," "Degenerate," and "Bolshevik" were commonly used to describe any art or music not acceptable. The Nazi *Reichsmusikkammer* (Reich Music Chamber) required a registry of all German musicians.

BELOW: "The Jew: the inciter of war, the prolonger of war." Another Mjölnir poster accusing the Jews of starting and perpetuating the war. In Nazi posters Jews were invariably portrayed in a negative light, and their physical features were almost inhuman. They are very shifty, operating in dark corners, and generally outside decent society. Jews are thus Marxists, moneyenders, profiteers, and enslavers, parasites living off ordinary Germans. Many Germans were all too ready to believe such fantasies.

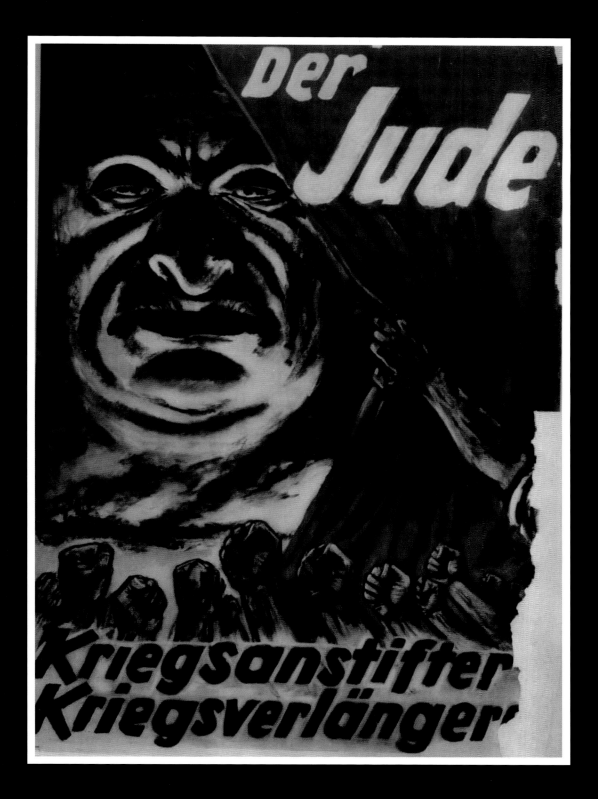

BELOW: This is a Mjölnir poster that appeared in February 1943, just after the Stalingrad defeat. It pronounces "Victory or Bolshevist Chaos." After Stalingrad, the Nazi Party's Central Propaganda Office issued a number of directives concerning anti-Bolshevik propaganda. "For the time being, propaganda against the plutocratic Western powers will be secondary to the propaganda against Bolshevism. In conjunction with our anti-Bolshevist arguments, these opponents, Churchill and Roosevelt above all, are to be presented as accomplices and toadies of Bolshevism. Bolshevism is the main enemy we have to fight against, which is the most radical expression of the Jewish drive for world domination."

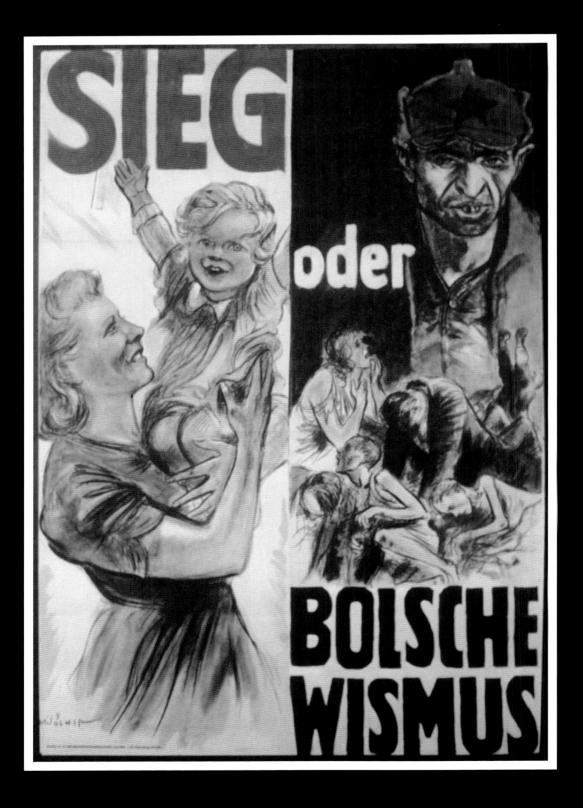

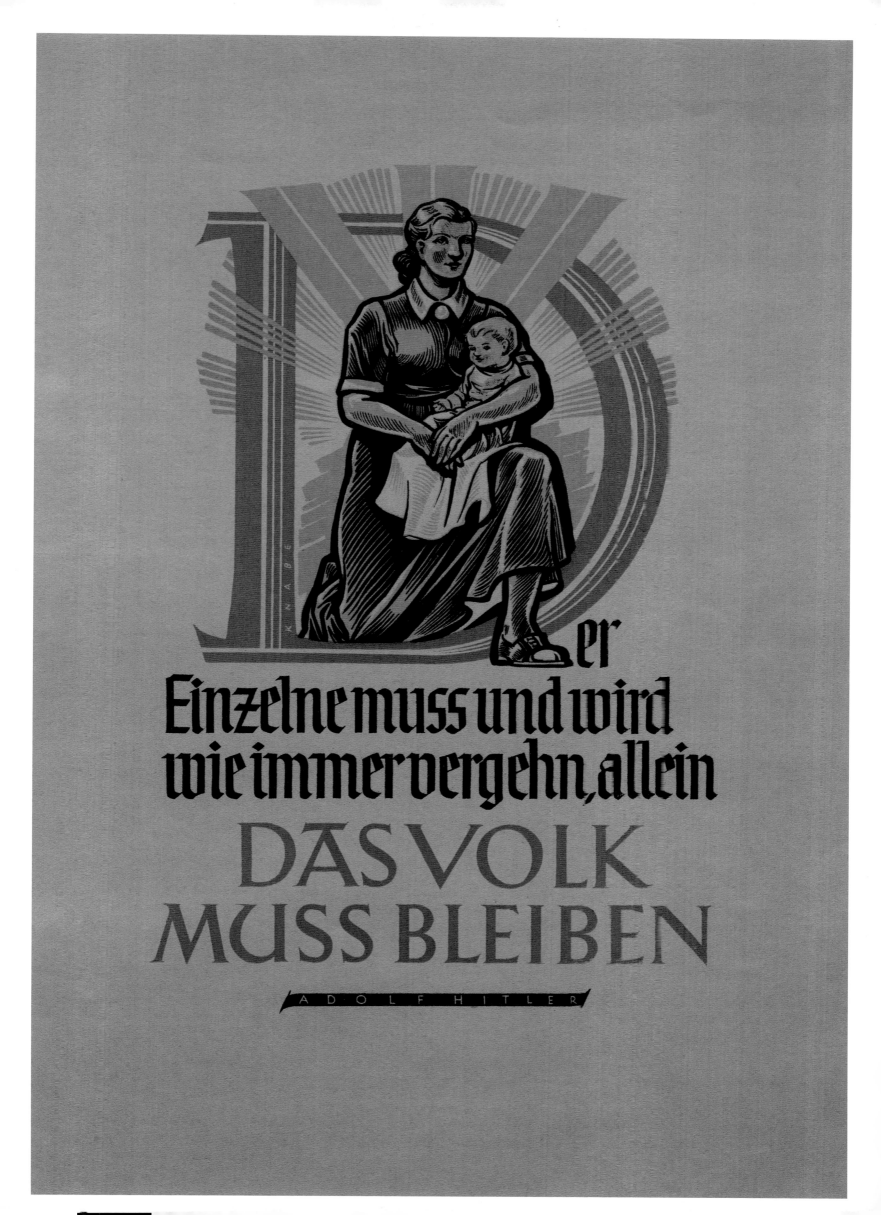

BELOW: A quotation poster issued in January 1944. "Anything is possible in this war, excepting only that we ever capitulate." By this stage of the war victory was becoming a distinctly remote possibility. Not only had the Red Army launched a series of massive counterattacks after the Battle of Kursk, which had pushed back the German Army hundreds of miles, but Italy, Germany's Axis ally, had quit the war. And fleets of Allied bombers were steadily reducing the Reich's cities to rubble.

OPPOSITE PAGE: A poster advertising a civilian defense shooting contest, 1944. The poster shows a Nazi Party official handing a rifle to a civilian, while in the background is an image of the German soldier. The three men are fine examples of the Aryan race but all three have an expression of steely determination to fight to the last. This accurately reflects Germany's plight in 1944.

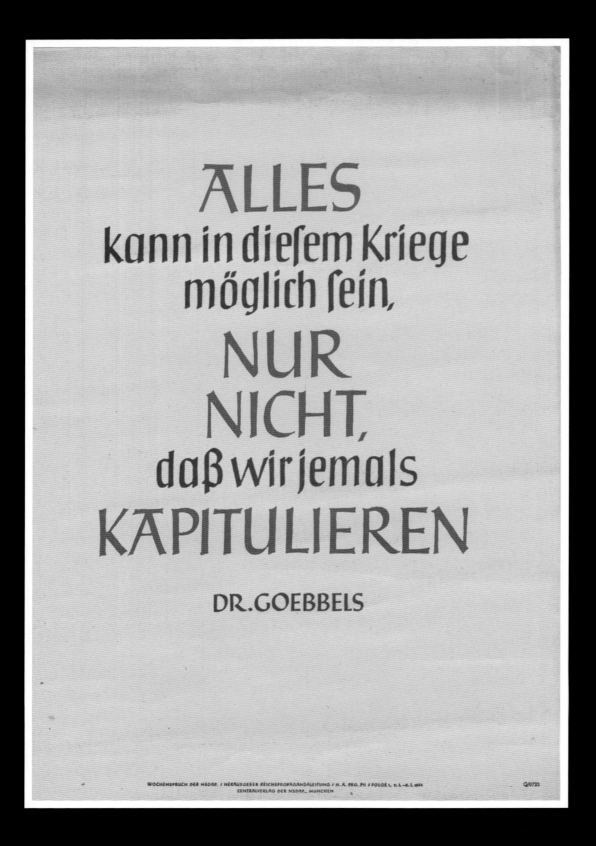

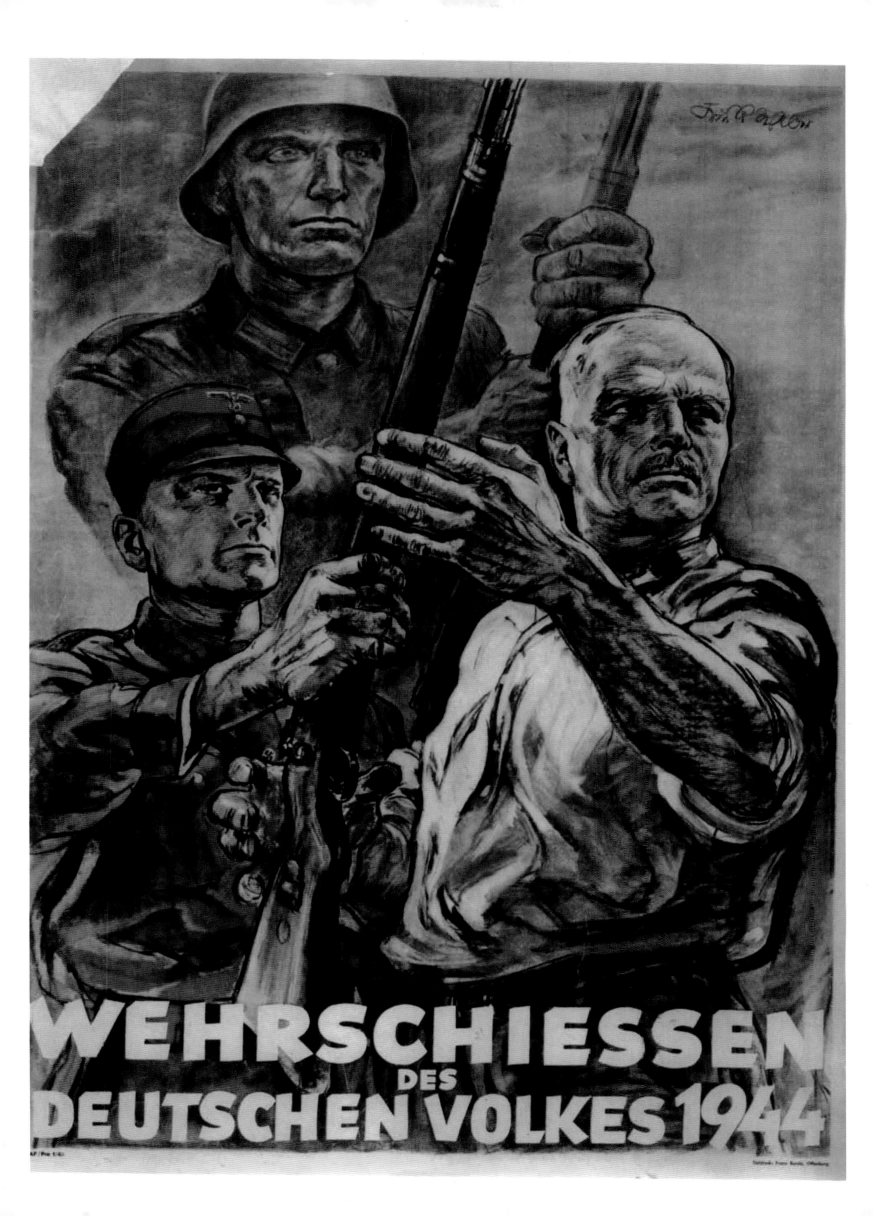

WEHRSCHIESSEN
DES
DEUTSCHEN VOLKES 1944

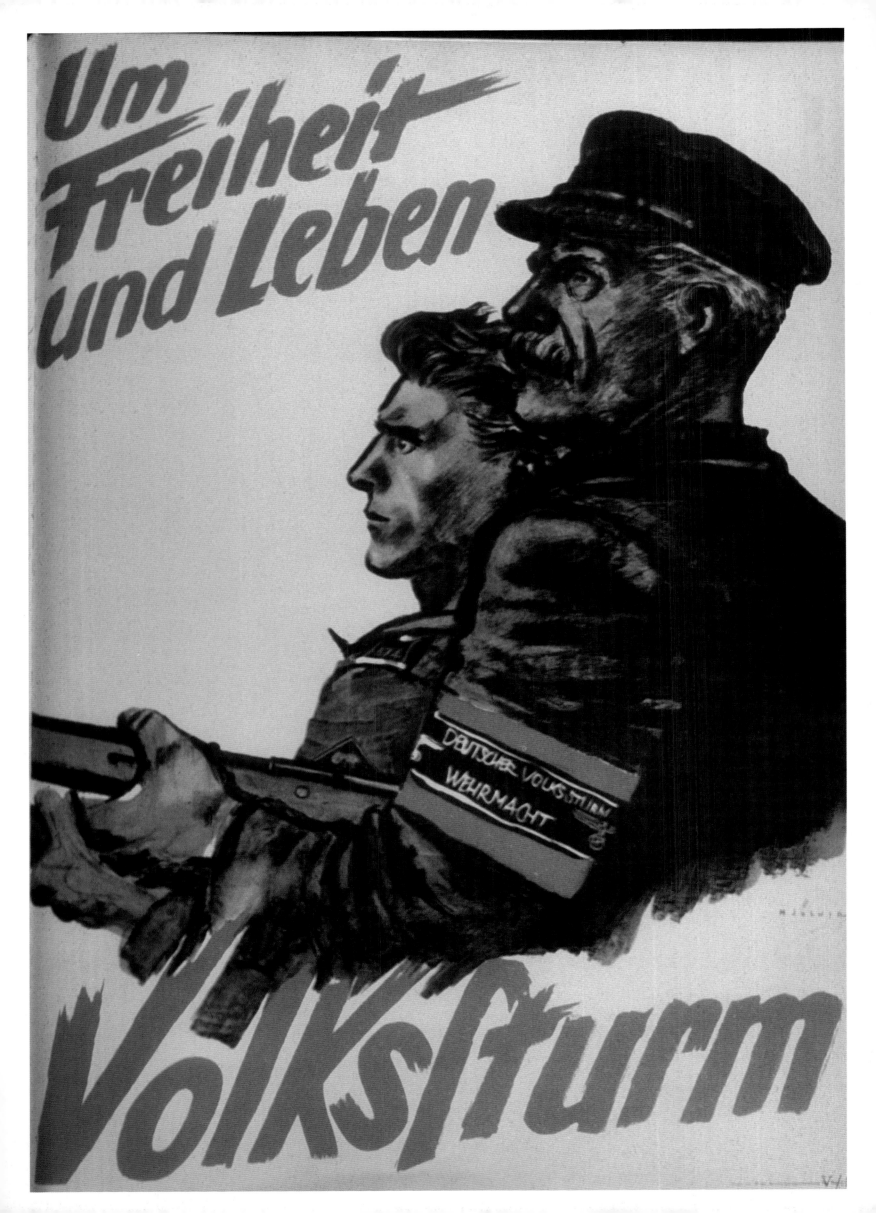

Um Freiheit und Leben

Volkssturm

poster reflects Germany's
ar of the war. The Americans and
d the Russians were poised to
. "For Freedom and Life" is the
Volkssturm (a sort of National
r had decreed that it would
between 16 and 60 who are
defend the homeland with all
em appropriate." But the
ittle training, and poor morale.

BELOW: A recruiting poster ⁻o⁻ ⁻he W
Waffen-SS was both a m⁻lita⁻y and r⁻
finest examples of the A⁻ya⁻ race. Th
this poster is surrounded b⁻ ⁻lazi ins
Nazi eagle holding a wreat⁻e⁻ swas
ribbon of the Iron Cross, a⁻d ⁻ehind
the Führer, signifying the S⁻⁻ ⁻ole as

WAFFEN
SS

Eintritt mit vollendetem 17. Lebensjahr
Kürzere oder längere Dienstzeitverpflichtung
Auskunft erteilt: Ergänzungsamt der Waffen-SS, Ergänzungsstelle VII
(Süd), München 27, Pienzenauer Str. 15

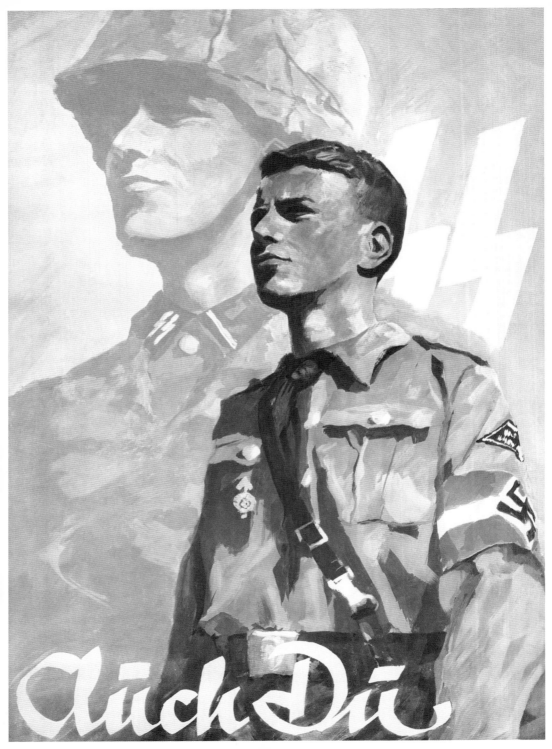

FELLES FRONT MOT BOLSJEVISMEN

BELOW: A German recruiting poster aimed at enlisting British prisoners of war into Wehrmacht service. The recruitment drive was an abject failure. A small number of British prisoners—around 60—volunteered and were formed into a unit known as the British Free Corps. It was organized by the Waffen-SS in January 1944, but was somewhat of an embarrassment to its German hosts. The unit saw no combat in the war.

OPPOSITE PAGE: An SS recruiting poster used in Norway. At the top are the words "Come with us north," and at the bottom "The Norwegian Skihunter Battalion." A Norwegian legion was formed by the Germans on June 29, 1941. It was under the control of the SS from the very beginning, a fact concealed from the Norwegian public. The legion was portrayed as a Norwegian expeditionary force fighting against Bolshevism rather than as an SS body in Hitler's pay.

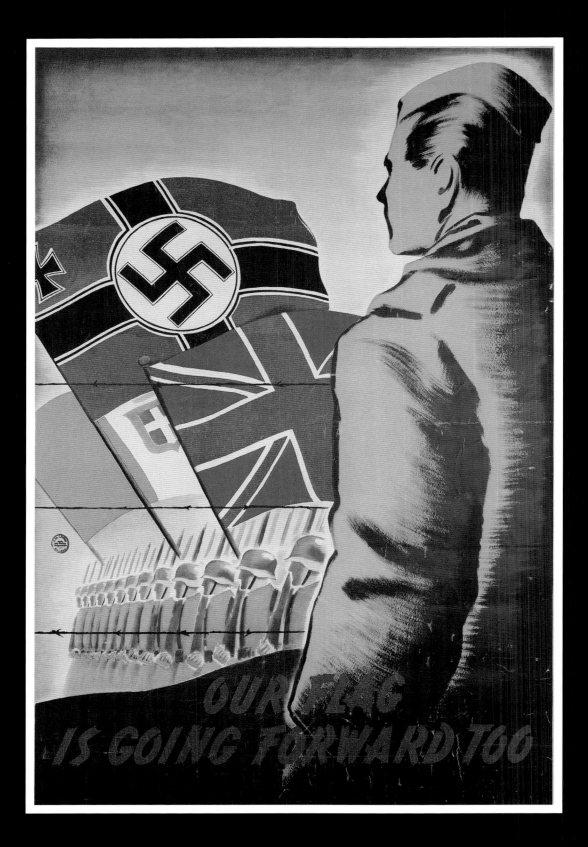

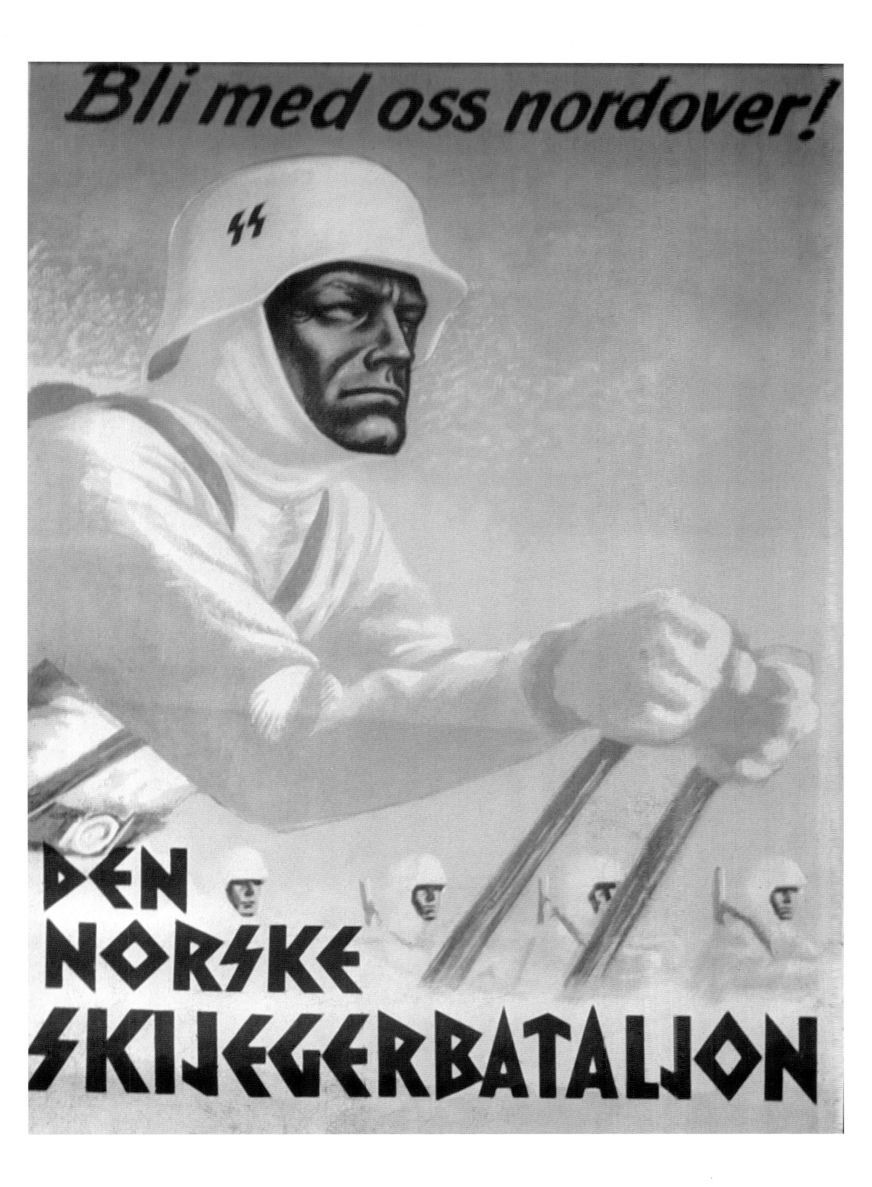

Italian Posters

World War II was a total disaster for Italy. On June 10, 1940, Benito Mussolini, the fascist leader of the country, had declared war on France and Britain. Both countries had de facto already been defeated by Germany in a Blitzkrieg campaign that had ejected the British Army from the continent and humiliated the French Army. In a speech in Rome Mussolini declared:"An hour marked by destiny is striking in the skies of our Fatherland. The hour of irrevocable decisions. The declaration of war has been sent to the ambassadors of Great Britain and France. We are entering the field of battle against the plutocratic and reactionary democracies of the West, who at every turn have impeded the march, and often threatened the very existence, of the Italian people. People of Italy! Run to your arms and display your tenacity, your courage, and your worth!"

Benito Mussolini

Benito Mussolini (1883–1945), former journalist and fascist dictator of Italy between 1922 to 1943, was obsessed with propaganda. The Italian press, radio, education, and film industry were carefully controlled to manufacture the illusion that Italian fascism was "the doctrine of the twentieth century that was replacing liberalism and democracy," and that Mussolini himself was "a man who was always right and could solve all the problems of politics and economics." The whole media was directed toward building up the cult of the *Duce* (leader). Posters, the press, radio, and cinema were all used to project his image as the omnipotent

and indispensable ruler of Italy. By the end of the 1920s, the process of what one could call Mussolini's "image-building" was well under way. The focus of this operation was on Mussolini himself as the sole fascist savior of Italy. By the end of the 1930s, a whole raft of regulations had been established by the Ministry of Popular Culture for the treatment of Mussolini in the media (newspapers, radio, and cinema): his name was always spelt with capital letters in print; newspapers were instructed exactly what to say about him; and he was never to be portrayed dancing, or with priests.

Man of the people

Italian propaganda was very different from German propaganda. Mussolini was portrayed as being "of the people" (his father had been a blacksmith). Fascist Italy was still a poor and economically underdeveloped country, a largely rural and agrarian society. In 1945, for example, over 50 percent of the working population was employed on the land. So Mussolini, stripped to the waist, working in the fields alongside peasants in the "Battle for Grain," the massive national campaign to increase cereals production and reduce dependence on food imports, was a vital propaganda device. This contrasts sharply with Nazi Germany, where posters depicted Hitler in a distant, aloof way. The German Führer, for example, would never be portrayed semi-naked working alongside farm workers.

The first fascist dictator of Europe was naturally obsessed with thoughts of personal glory. He imagined himself Julius Caesar reborn, a genius who would oversee the birth of a "New Roman Empire" in the Mediterranean. That he had no master plan for such a project was of little concern to him.

Italian propaganda promoted the idea of Italian strength. Like Hitler's Thousand Year Reich, Mussolini's Italy was on a path that would lead to glory and aggrandisement. This seemed to be confirmed when Italy overran two weaker countries—Abyssinia in 1936 and Albania in March 1939—conflicts which resulted in Italy being condemned in the international community and pushed Mussolini toward Nazi Germany. Mussolini first referred to a Rome-Berlin Axis in November 1936, and thereafter there was cooperation between the two countries in foreign policy. Both aided the Nationalists in the Spanish Civil War, and it is true to say that Mussolini and Hitler shared a deep affinity with each other as the leaders of populist and revolutionary movements.

Italian resources

In the late 1930s, Mussolini recognized that Italy did not have the resources to participate in a European war. Notwithstanding the claims of Italian propaganda, national income was less than a quarter of that of Britain. Mussolini tried to persuade Hitler not to attack Poland, but the Führer indicated that war was inevitable. *Il Duce* was content to remain neutral when Germany attacked Poland in September 1939, a stance that earned him the contempt of senior Nazis. Hermann Göring remarked that Mussolini was a man who "was yesterday ready to march and is now passive and reticent."

However, by early 1940 Mussolini was jealous of Hitler. He had nothing to compare with the territorial gains made by Germany. In May *Il Duce*'s frustration increased when Hitler struck in the West and routed Britain and France. It appeared that Germany would

BENITO MUSSOLINI
DUCE DEL FASCISMO - FONDATORE DELL'IMPERO

ABOVE: Benito Mussolini, the first fascist dictator of Europe. A man of limited talents but possessed of an enormous ego and thirst for glory. His dream of creating a "New Roman Empire" resulted in a number of disastrous Italian campaigns in World War I, most notably in North Africa and Greece in 1940. Hitler's conquests in the same year only made him more desperate to win battlefield glory.

win the war, and that Italy would receive pickings from the French Empire (in accordance with an understanding between the two dictators made before the war). To earn the right to these spoils, Mussolini decided that he must fight France—he declared war on June 10, 1940.

Balkan disaster

Unfortunately for Mussolini, in the subsequent armistice between France and Germany his claim to French overseas territory was largely ignored. Mussolini thus needed some glory to maintain his prestige abroad and rally support at home. In October 1940, therefore, he ordered an attack on Greece from the Italian colony of Albania. However, after initial Italian gains the Greeks forced the Italian Army back onto Albanian soil. By December 1940 there was stalemate on the Greek Front. To add insult to injury, the Italian fleet, at anchor at Taranto in southern Italy, was badly damaged by a British torpedo attack in mid-November. This action tilted the balance of naval power in the Mediterranean decisively toward the British.

By this date the Italian Army in North Africa had also suffered a crushing defeat at the hands of the British. Despite Italian posters proclaiming that the army was on the march to Egypt, save for the arrival of Erwin Rommel in February 1941 Italian forces might have been ejected from North Africa altogether.

Italian propaganda always talked of strength, but the reality was that there was no militaristic culture in Italy. The prestige of the army in Italy itself was not especially high, and it was the same with the navy. A major problem for Mussolini was that the armed forces were not particularly attractive to well-educated and technically skilled men, not that an industrially underdeveloped Italy possessed these in great numbers. The officer corps, therefore, was of a low caliber. The situation was made worse by the fact that much of the army's weapons and equipment were obsolete.

Mussolini believed that he could win fresh laurels for Italian arms by taking part in Hitler's attack on the Soviet Union in June 1941. He was convinced he would gain the prestige that he longed for, and Italy would share in the spoils of war. He thus joined the war against Russia and committed a force of 60,000 men to the struggle, known as the *Corp di Spedizione Italiano* (CSI—Italian Expeditionary Corps in Russia).

In July 1941, the supposedly motorized CSI followed the German Army through the Ukraine, mainly on foot. Morale was high at the prospect of an easy campaign, though, and the Germans were impressed with their Italian allies. Unfortunately this initial euphoria soon disappeared. Inadequate leadership,

armor, and transportation, plus shortages of artillery and antitank weapons, revealed the corps to be ill-equipped for the campaign. Undeterred, in March 1942 Mussolini sent more reinforcements to Russia. The 227,000 Italians on the Eastern Front became the Italian Eighth Army. In August 1942, it was guarding the Don Front north of Stalingrad with German liaison officers and formations attached to ensure its reliability. Although a Russian attack had been expected, the Italians were unable to resist the massive armored thrust that was hurled against them on December 11, 1942. II and XXXV Corps crumbled almost immediately, leaving the Alpine Corps stranded and resulting in a huge gap in the Don defenses. The lack of antitank guns and medium tanks was keenly felt in this rout. The Italians were left to fend for themselves during their retreat, in which they were harassed continually by the Red Army. In January 1943, the survivors regrouped in the Ukraine but the Italian Eighth Army had ceased to exist. The disillusioned Germans sent the survivors back to Italy.

In May 1943 the Axis war effort in North Africa came to an end, with 250,000 Germans and Italians going into Allied captivity. The war, which had never been popular among the Italian populace, was about to come to the homeland. In early July 1943, the Allies invaded Sicily, and on July 25 a vote of no confidence was passed on *Il Duce* by the Fascist Grand Council. He was toppled from power, as was the Fascist Party itself, which was dissolved. Control of the government passed to King Victor Emmanuel III and control of the army to Marshal Badoglio. Mussolini's 20-year-old dictatorship was at an end. The Italians wanted to quit the war and Badoglio entered into secret negotiations with the Allies, but the Germans moved quickly to occupy Italy. The Allies invaded Italy on September 3, 1943, but by then the Germans were firmly in control of the country and had disarmed the Italian Army.

The fascist rump state

A virtual civil war had broken out in Italy after Mussolini's fall and Italy's exit from the Axis camp. Some of the Italian forces actively resisted the Germans and were defeated and made prisoner, others deserted to swell the ranks of the resistance, but a few remained loyal to fascism and Mussolini. The Germans were anxious to utilize the pro-fascist elements in the struggle against the now greatly augmented resistance. Above all, they were determined to keep open the vital lines of communication between Austria and northern Italy. Mussolini was rescued from captivity by German special forces, and in September 1943 he established

the Fascist Republican Party as the ruling party of the Italian Social Republic. Mussolini's republic cannot be considered anything but a puppet state of the greater German Reich. Four infantry divisions were formed and trained in Germany: the *Italia*, *Littorio*, *San Marco*, and *Monterosa* Divisions. These and other units were under German control.

The failure of Italian fascism

The "Charter of Verona" of the Italian Social Republic echoed the propaganda of earlier periods. It stated: "The essential goal of the foreign policy of the Republic must be the unity, independence, and territorial integrity of the Fatherland within its maritime and Alpine frontiers constituted by nature, blood sacrifice, and history."

The Social Republic was merely a German puppet state, though, with little support among the Italian population. Italians had not only been dragged into German battles in North Africa, but had then lived under German occupation and endured two long years of war as the Allies fought their way north in the face of a dogged Wehrmacht defense. Italian towns and cities had been bombed and fought over, and the Germans had taken savage reprisals against those they suspected of being partisans. Small wonder, then, that the people took revenge on Mussolini and his mistress after they had been killed by partisans in April 1945. Their bodies were hung up in Milan's Piazalle Loreto in front of cheering crowds.

Eight days before he was shot, Mussolini gave an interview with a journalist. He talked fondly of Hitler and also of German wonder weapons that would turn the tide of the war. But in truth he was still living in the fantasy world he had inhabited since the outbreak of World War II: "The victory of the so-called Allied Powers will give to the world only an ephemeral and illusory peace," and that "history will vindicate me." He was wrong on both counts.

OPPOSITE PAGE: "Every day the battlefield nears its destination." An Italian boast that the army was heading toward Egypt following the Italian offensive from Libya launched in September 1940. In reality, the Italians advanced 65 miles (104 km) and then stopped. In December 1940, the British counterattacked and routed the Italians in a humiliating defeat. For the Italian Army, it was a foretaste of the military disasters that were to come in the war.

...se non ci fosse stata la Marcia su Roma non ci sarebbe oggi la marcia su Mosca...

FEDERAZIONE DEI FASCI DI COMBATTIMENTO DI MILANO
VENTENNALE

LA DONNA ITALIANA
COLLE SUE RINUNCE
E COI SUOI SACRIFICI,
MARCIA INSIEME AI
COMBATTENTI.

on Rome. No March on Moscow."
ion in Operation Barbarossa,
ome in 1922 and the Nationalist
he "March" was a myth created by
s. Mussolini was asked to form a
n. In this poster, an Italian fascist
ear. The Italian forces that took
ort of antitank guns, tanks, and

ABOVE: "The Italian women, by her
marches along with the fighting men
enthusiasm for the war among the
government circles the conflict was
the foreign minister Count Ciano, ex
very sad. May God help Italy!"

Below: "Conquer! For the New World Order." A poster emphasizing the Axis alliance between Japan, Italy, and Germany. To Mussolini, Japan was a Far Eastern version of Italy itself. In December 1942 he gave a speech in Rome, stating: "That Japan, which was a country as poor as we, has become, within a few months, if not the first in wealth among the nations of the world, certainly one of the first. Well, it must be recognized that this is just; that it is the reward of Japan's virtue."

Opposite page: "Young fascists—heroes of Bir-el-Gobi." This poster is one of the most accurate depictions of the North African war produced by the Italians in World War II, though they did not realize it at the time. It is supposed to portray Italian martial prowess, but in fact it is a summary of the state of the Italian Army while fighting the British in North Africa. In June 1940, Marshal Italo Balbo, Governor of Libya, told the Italian General Staff: "We don't have armored cars, the antitank guns are usually old and noneffective, the new ones lack adequate ammunition. Thus the combat becomes a sort of meat-against-iron-fighting."

GIOVANI FASCISTI
EROI DI BIR-EL-GOBI

BELOW: "Italian Workers! The 'liberators' are already thinking about the future of your children." The theme of the barbarous foe was a common one in Axis propaganda. Except with regard to Nazi fears of what the Red Army would do once on German soil, it was mostly fantasy. In fact, many Italians welcomed the Allies when they invaded the mainland in September 1943. Italians felt that their country had been engaged in an illegal and aggressive conflict, and as the war progressed with great loss of life, they became increasingly disenchanted.

OPPOSITE PAGE: A poster calling for Italians to join the Organization Todt, the Nazi organization that was responsible for building military factories and fortifications throughout the Third Reich. It employed many foreign workers, prisoners of war, and concentration camp inmates. In reality, thousands of Italians were forced to work for the organization when the Germans occupied the country, helping to build fortifications such as the Gustav Line in central Italy.

Lavoratori d'Italia!
I "Liberatori" già da oggi pensano
per l'avvenire dei vostri figli...

IMPEDISCI CHE QUESTO DELITTO SI COMPIA

Vota
BLOCCO NAZIONALE
nè reazione nè rivoluzione

OPPOSITE PAGE: A Waffen-SS recruiting poster aimed at Italians. The recruiting drive had some success. The 29th Grenadier Division of the Italian SS was composed of 15,000 Italian recruits who volunteered for service with the Waffen-SS. In addition, in September 1943 to the end of February 1944, a separate SS battalion was formed at the SS Heidelager Training Center at Debica, Poland. The volunteers came from the Italian 31st Tank Battalion of the *Lombardia* Division and the élite Alpine *Julia* Division. The formation, which had 20 officers and 571 men, was referred to as the SS Battalion *Debica*.

ABOVE: A poster of the National Bloc, one of the parties that took part in the Italian elections held in 1948. By this time the Cold War between the West and the USSR was raging and Italy became one of the battlegrounds between communism and democracy. The National Bloc (*Blocco Nazionale*) was a political coalition of liberals and conservatives. The poster plays on the fears of a communist takeover of Italy, which the Bloc believed would lead to the death of Italian freedom. The communists were not voted into power, but neither was the National Bloc. As a result, the Bloc disappeared soon after.

Japanese Posters

j apanese propaganda before and during World War II was directed toward assisting Japan become a great power in Asia. This involved carrying out an anti-Western campaign in the media (since Western colonial powers controlled lands that Tokyo coveted for the Empire of the Sun), and convincing the indigenous peoples of Southeast Asia that they would benefit more under Japanese influence rather than under European rule. Allied to this general expansionist propaganda, there was also a sense of grievance.

Japanese resentment

Despite siding with the Allies in World War I, Japan felt, with some justification, that its status in the world was not confirmed. Tokyo had gained some Pacific colonies in the Allied territorial share out, but was also forced to relinquish Chinese regions conquered during the Russo-Japanese War of 1904–1905. In Japanese eyes, insult was added to injury in 1922 when the Washington Naval Treaty limited the size of the Japanese Navy to below that of the U.S. and British fleets, despite the fact that the quality and quantity of Japanese shipping could match and even exceed Allied fleets in the Pacific.

To a people with an extremely high concept of respect, this "loss of face" was stinging, particularly amongst the leaders of the Japanese Army, whose philosophy retained strong elements of anti-Westernism. To make matters worse, the Japanese were aware that their entire industrial revolution was dependent upon U.S. and colonial imports. Almost every vital domestic and industrial product, including food, rubber, and most metals, had to be imported, and the United States supplied around 60 percent of Japanese oil. This dependence on the outside world rubbed salt into the Japanese wound, and many felt that Japan had been relegated to a second-class nation within its own geographical region of influence.

War in China

The Japanese solution to its problem was expansion, aiming to achieve self-sufficiency through conquering territories which could provide plentiful raw materials and food stocks. It first looked toward its neighbor, China. In 1931 Japan invaded and occupied Manchuria, a country rich in mineral resources, and in 1937 it invaded China itself. The war between China and Japan turned into a hugely violent and costly eight-year conflict, in which the Japanese Army committed many atrocities.

The war in China may have been seen as naked aggression in Western eyes, but in Japan it was portrayed as virtuous. Japanese propaganda was highly critical of the interference of white Western countries in Asia, specifically the French in Indochina, the British in Hong Kong and Malaysia, and the United States in the Philippines.

Japanese propaganda in the interwar period criticized Western nations for their colonies in India and Southeast Asia. White Westerners were portrayed as rich, arrogant colonists who oppressed indigenous peoples and lived off them. In government pamphlets Japanese soldiers were told that "money squeezed from the blood of Asians maintains these small white minorities in their luxurious mode of life." To make matters worse, the Western nations were stealing the

wealth of Asian nations in Japan's own backyard. It was therefore Japan's duty to free them from the grip of foreign colonialism. This theme had begun in the early 1930s. In January 1933, the Great Asiatic Association was founded by among others future prime minister Prince Fuminaro Konoye. Other association members included Admiral Nobumasa Suetsugu, later minister of foreign affairs, Minister of Foreign Affairs Koki Hirota, and General Iwane Matsui, later commander-in-chief in China. The association called attention to the "pitiable condition of the Asiatics in countries under white rule." The association advocated that "Hegemony in Asia" should be Japan's official policy. This "Asia for the Asiatics" lobby was accompanied by an intensive press campaign, which in the beginning was directed mainly at Britain as the exponent of so-called Western Imperialism. However, it was later aimed at all Western peoples.

World War II

Japanese propaganda's constant message was that white Westerners were evil and greedy. They were also immoral, as illustrated during World War II by their attacks against Pacific islands and later against Japan itself. The United States was criticized for its treatment of racial minorities and immigrants, pointing to the internment of tens of thousands of Japanese-Americans in camps in the USA.

When World War II broke out in Europe in September 1939, Tokyo saw an opportunity to increase Japanese influence and power in Southeast Asia. On September 27, 1940, with war already raging across Europe, Japan signed the Tripartite Pact with Germany and Italy. The Tripartite Pact committed the

ABOVE: "Rise of Asia." This poster portrays Japan as the savior of Asia, throwing off the shackles of white Western imperialism. It displays several themes common to Japanese propaganda: the weakness of the United States (note the American flag lying trampled on the ground), the strength of the Japanese, and the Japanese soldier ridding Asia of Western forces.

signatories to defend the other countries if they were attacked by any nation other than China or countries already involved in the European conflict. This aligned Japan with the Axis.

In September 1940, Japanese expansion proceeded when, at the invitation of the French, Japanese troops entered northern French Indochina. The Indochina acquisition gave Japan tremendous logistical strength for its war against China and numerous coastal bases to prosecute a naval campaign throughout Southeast Asia. By this time, Japan had already formulated a clear imperialist outlook, looking to establish what it called the "Greater East Asia Co-Prosperity Sphere." This envisaged an East Asia free of colonial influence and united under Japanese hegemony. Japan hoped that the Co-Prosperity Sphere would lead many colonial Asian countries to work, violently or otherwise, toward their independence from British, Dutch, and U.S. influence.

The "good parent"

In 1942, during World War II, the Japanese Government published a booklet entitled *The Greater East Asia War and Ourselves*. It described how the relationship between Asian countries would be like that of a "branch family." It stated: "America, England, Holland, and others, by military force, were suppressing and doing bad things like this to us of Greater East Asia. By our hand, Japan restored Greater East Asia and rose to our feet. And, the strong Japanese expelled the enemy from Greater East Asia. Currently, in Manchuria, everyone has begun combining their power and work. Japan and China formed an alliance. The Philippines and Burma became independent. Thailand grew larger. The people of Java, Malay, and others, too, will, by important duties, come together to work. India, too, has driven out England. From now, we will make the countries of Greater East Asia friendly to one another. We of Greater East Asia will combine our power and bring about the destruction of America, England, and others."

The message pumped out by Tokyo was that Japan was like a good parent who was concerned only with the general wellbeing of Asian countries. These are the words of Japanese Foreign Minister Hirota: "It is hardly necessary to say that the basic policy of the Japanese Government aims at the stabilization of East Asia through conciliation and cooperation between Japan, Manchukuo, and China for their common prosperity and wellbeing. Since, however, China, ignoring our true motive, has mobilized her vast armies against us, we can only counter her step by force of arms." Like naughty children, the countries of Asia did not know what was good for them. They therefore sometimes had to be punished. But always Japan was acting in their best interests; indeed, Japan failed to recognize any wrongdoings it may have committed against other countries at all.

The reality of Japanese propaganda

In posters, Japanese soldiers were invariably portrayed as strong and determined, battling to free Asia of white Western enslavers, to throw off the chains that enslaved the native peoples. Of course the Japanese wanted to rule Southeast Asia in place of the West. However, they would do so as part of a program of ethnic unity. This was the Japanese concept of *Hakko Ichiu*, or "eight corners under one roof." In this the Japanese were pandering to the idea of a common Asian race and that there should be ethnic unity under the Japanese "roof." As such, Japanese propaganda could not insult their "brethren" in the same way that it could attack white Westerners. An example of this train of thought is the attitude toward the Koreans, whom the Japanese often described in demeaning and racist language. But at the same time, the Japanese felt a parental duty toward the Koreans, believing them to be redeemable. This idea was expanded to other Southeast Asian peoples. After all; the Japanese wanted the populations of the region to believe in Japan's Co-Prosperity Sphere and take an active part in it, as well as aiding the Japanese in defeating the Western colonial powers. Persuading the Chinese, Koreans, and Southeast Asians that a unified Asia under Japanese leadership was good would be impossible if these groups were portrayed in Japanese posters and booklets as being inferior.

Unfortunately, there were far too many atrocities carried out by Japanese troops to win over the populations of occupied areas. The rape of Nanking during the Sino-Japanese War of 1937–1945 stands as one of the most shameful and controversial incidents in Japanese history. An estimated 200–300,000 Chinese prisoners and civilians were systematically slaughtered in a month-long orgy of bloodletting by Japanese soldiers. The atrocity was the logical outcome of three factors. First, total obedience to the emperor and to the military commanders in the theater (testimony from commanding officers shows that the officer class emphatically embraced the genocide). Second, the mental instability resulting from prolonged combat and separation from home. Third, the contemporary Japanese racism toward other Asian countries, the Chinese being looked on as subhuman in the same way that the Nazis viewed the Slavs of Eastern Europe and the Soviet Union.

Nanking was not the only location of Japanese atrocities during the Sino-Japanese War. One soldier, Masayo Enomoto, recorded that looting, rape, and murder were common procedures throughout the Chinese campaigns. He confesses to the group rape and murder of women in Chinese villages and even, when rape became a bore, outright torture (he confessed to dousing a young woman with petrol and setting her on fire simply as a form of entertainment). Revealingly, Enomoto admits no sense of guilt because of his total belief in the justice of fighting for the emperor. It would appear to be a sad fact that much of the cause of the Nanking atrocities was the age-old brutalization of soldiers by war and racial indoctrination, combined with the excesses people are capable of when in positions of absolute power.

The notion of purity

Japanese propaganda during World War II also sought to reinforce the image of the Japanese soldier and nation as being pure. Whereas Japan's foes were portrayed as being corrupt and immoral, propaganda told the Japanese that they were racially and spiritually pure. This being the case, the Japanese were bound to triumph over immoral and "impure" enemies, in much the same way that German propaganda spoke of the certainly of victory over "subhuman" enemies. This message undoubtedly boosted Japanese morale, even when Japan's cities were being flattened by American bombers in 1944 and 1945 and Japan was obviously losing the war. The thing that held the Japanese together was their purity, from which came their pride and strength as a nation. These attributes meant they could endure any hardships the enemy could inflict on them. The deaths of over 600,000 Japanese civilians during World War II bears witness to this outlook.

OPPOSITE PAGE: A poster for the 1940 film *The Story of Tank Commander Nishizoemi*. Commissioned by the Ministry of War, in the film the main character sacrifices his life for his men in battle during the war in China. For his sacrifice he is posthumously honored with the title of *gunshin*, or "military god." The film embodies the notion of self-sacrifice, the giving up of oneself for the greater good. It was based on the life of an actual Japanese officer.

佐野部隊長遂らざる大野挺身隊と訣別す　　　　　　　　　　　日村孝之介　筆

Opposite page: This poster attacks the British and Americans and encourages the Filipinos to throw off their imperial yoke and join the Co-Prosperity Sphere. During the war, Japanese propaganda had the task of not only addressing the home front but also persuading other Asian countries that Tokyo's rule was beneficial (after first conquering said countries). Without the support of other Asian countries, the Co-Prosperity Sphere would fail. Japanese soldiers were always portrayed in posters with bayonets fixed—reflecting the army's doctrine of mounting bayonet charges whenever possible.

Above: "Accepting an Allied Surrender." A simple poster but one that had a powerful psychological message. Japanese soldiers were highly trained and disciplined and indoctrinated in a military culture that demanded the highest sacrifices in battle. Obedience to the emperor was everything, and to retreat or be taken prisoner were acts of profound dishonor. To surrender was a disgrace, the action of someone who was weak, impure, and immoral. The implication here is that Allied soldiers are weak and immoral, reflecting the cultures of the states they serve.

BELOW: "Keep Your Lips Silent!" A Japanese version of the "careless talk costs lives" theme. Internal security was rigidly enforced in Japan. Factory police (*kempei*) were present in every war plant, and police agent provocateurs combated defeatism by deliberately making comments about the futility of the war, or corruption on the home front. Any who agreed were ruthlessly punished.

OPPOSITE PAGE: "Buy Japanese War Bonds." War production in Japan was a dismal failure, with little attempt to mass-produce anything. In 1941, for example, most of the army's trucks were imported American models, for which the supply of spare parts dried up after the attack on Pearl Harbor in December 1941.

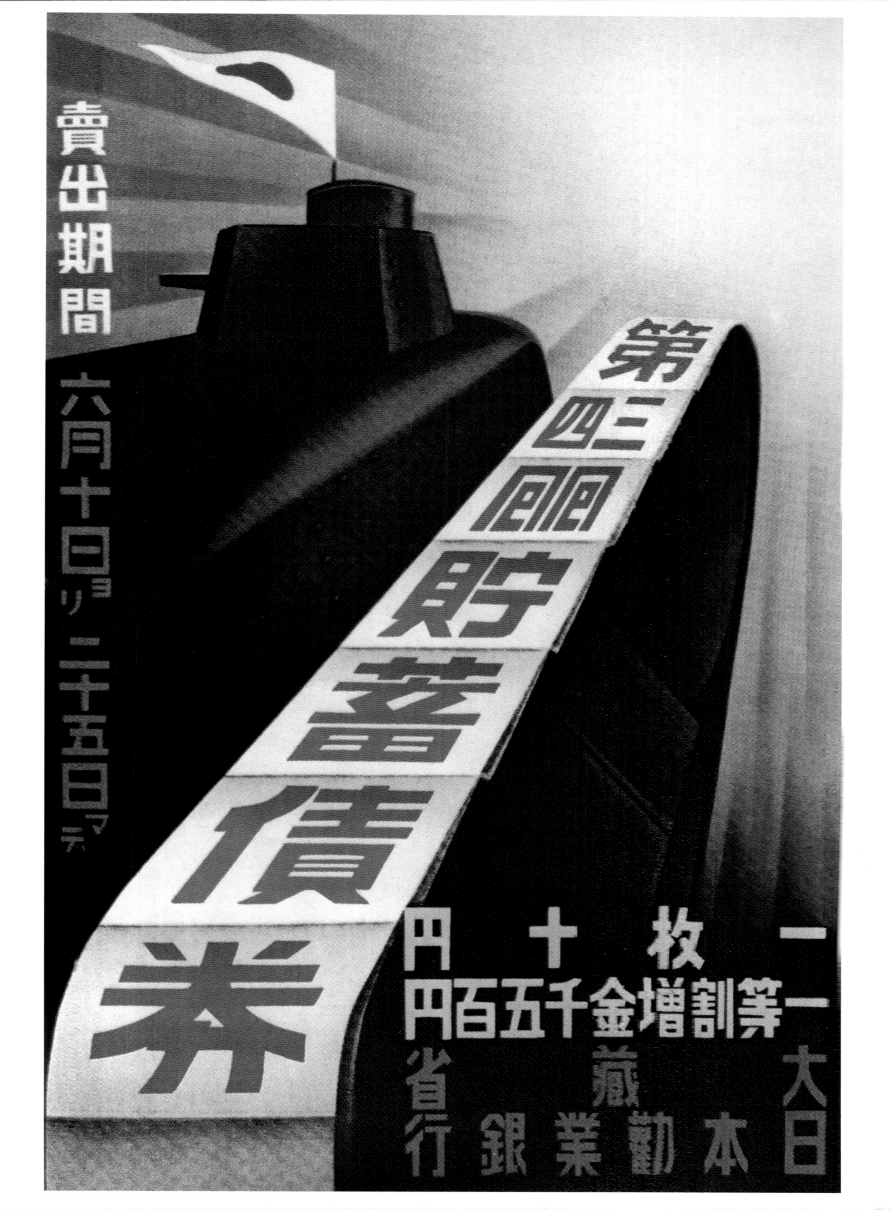

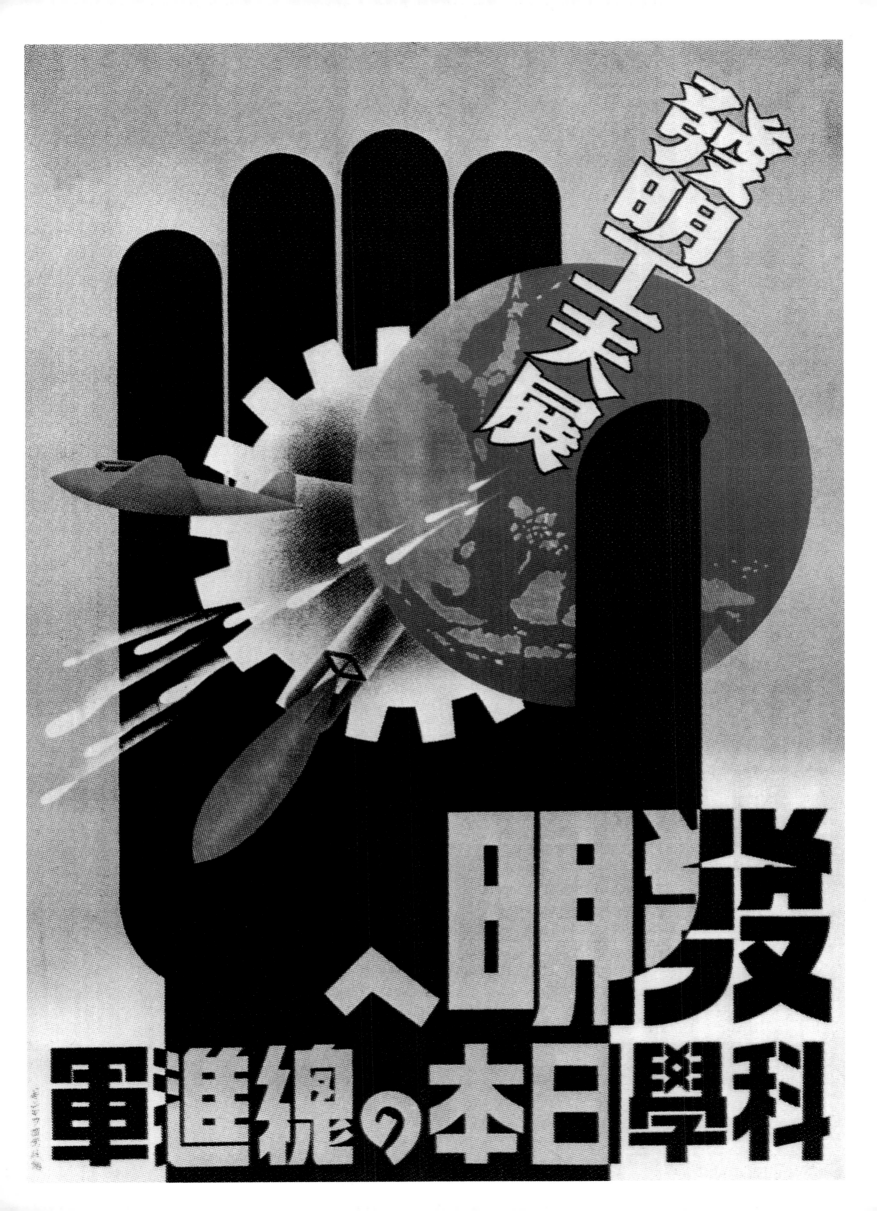

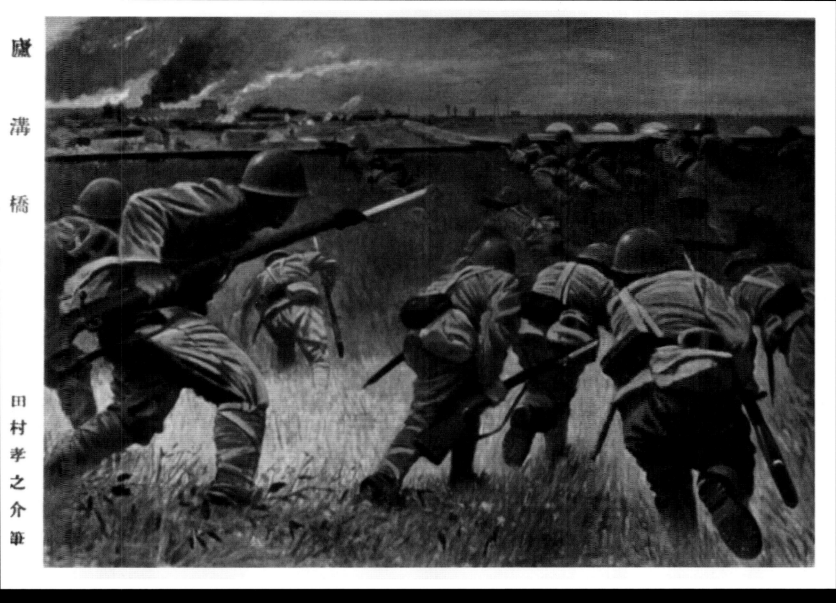

盧溝橋

田村孝之介筆

ABOVE: "Warriors Rush Into Battle." The celebration of the virtue of offensive action in general was a central theme of Japanese propaganda. Military service was ranked as the highest social [...] and the best and brightest officers were always at the front [on the] battlefield. Allied to this were deeply held religious beliefs among the Japanese. The Emperor had a divine status in the people's eyes [and] to die in battle for him was to die a holy death.

Russian Posters

for the Soviet people, World War II was a remorseless life-and-death struggle against a merciless enemy whose goal was nothing less than the enslavement of the whole population. As such, Soviet propaganda was able to claim the moral high ground in the war, notwithstanding the dreadful crimes of Stalin's regime during the 1930s, in which millions of Russians died, and the fact that the USSR had signed a non-aggression pact with Germany in 1939. Propaganda was supervised by the Directorate of Propaganda and Agitation of the Central Committee under A.S. Shcherbakov, and administered by the Soviet Information Bureau. In the first two years of the war the Soviet Union was on the defensive. Thus the propagandists responded with gusto to rally the people against the Nazi invader. Two days after the Germans attacked, the poster "We will mercilessly destroy" appeared on the streets of Moscow. It showed a caricature of Hitler with a revolver, his head breaking through the torn Soviet-German Non-Aggression Pact of 1939, only to be faced by a determined Red Army soldier whose bayonet pointed at his head (this poster first appeared on June 24, 1941).

The German threat

Relations between Germany and the Soviet Union deteriorated following Adolf Hitler's accession to power in 1933, and Moscow was convinced that Germany would embark on territorial conquest in Eastern Europe. The Soviet Union was faced with a potentially hostile Germany in the west and an anti-communist Japan in the east. Thus Stalin was forced to seek allies in an effort to protect the Soviet Union from aggression, or at least share the burden of any conflict with an aggressor.

He thus looked to the West, specifically Britain and France, as alliance partners to preserve the balance of power in Europe. However, this should not be interpreted as anything more than *realpolitik* on Moscow's part (or indeed on the Western side). Stalin was a pragmatist, and at the end of the day it mattered little to him if he concluded a treaty with Western imperialist powers or fascist states as long as his interests were served. He may have distrusted Nazi Germany, but the same was also true of Britain and France (he called the latter "the most aggressive and most militarist" of the Western states). Nevertheless, he made efforts to mend fences with the West, joining the League of Nations in 1934 and ordering communist parties abroad to abandon the revolutionary struggle. He thus abandoned the USSR's isolationism and embarked on a policy of collective security.

Western prevarication

The first real test came in the summer of 1938 when Germany threatened Czechoslovakia. Both France and the Soviet Union were treaty bound to come her aid if she was attacked, and Stalin for his part was prepared to honor his commitments. The subsequent Munich Agreement saved Europe from war but intensified Stalin's mistrust of the West. The USSR was not invited to participate in the Munich talks in September 1938. When Germany occupied the rest of Czechoslovakia in March 1939, Stalin made a fresh, albeit reluctant, effort to form a collective security alliance with Britain and France. On April 17, 1939, the USSR offered both countries an alliance that would

guarantee the integrity of every state from the Mediterranean to the Baltic. But Britain and France prevaricated. Britain did not reply until May 25, agreeing not to the treaty but the opening of preliminary discussions, and not until August 12 did French and British low-level negotiators arrive in Moscow for talks. It became clear to Stalin that Britain and France were very reluctant allies. The search for collective security was over, and the road was clear for a mutually beneficial non-aggression pact between Germany and the USSR. Despite the huge gulf in ideology, German Foreign Minister Joachim von Ribbentrop flew to the Soviet Union in August, and signed an agreement with his recently appointed opposite number, Vyacheslav Molotov, on August 22. The Ribbentrop-Molotov Pact contained a 10-year non-aggression agreement, while other clauses specified the division of Poland between the two countries. Stalin was given a free hand in Finland, the Baltic States of Estonia, Latvia, and Lithuania, and Bessarabia (in Romania). Stalin was buying time and land as a buffer against Germany. For his part, Hitler had a secure eastern border so he could campaign freely in Western Europe.

The defense of Mother Russia

"Defend Mother Russia" was the cry that Stalin used to rally the Russian people in June 1941. When Germany invaded the Soviet Union in June 1941, Stalin was initially stunned, but quickly recovered to direct the war effort. Abandoning the concept of a defense of international communism, the wily dictator instead issued a call to arms in the name of Russian nationalism (indeed, in Soviet eyes the conflict became The Great Patriotic War). Less than a week after the

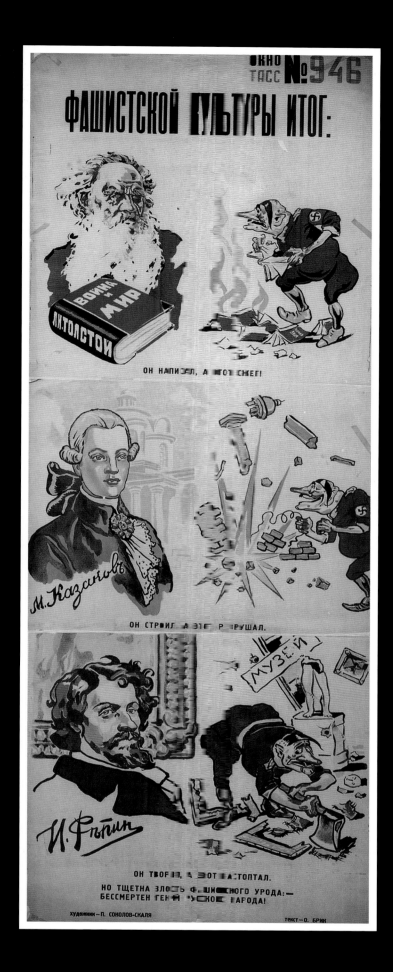

ABOVE: "The result of fascist culture." This poster by Pavel Petrovich Sokolov-Skalia (1899–1961) shows three scenes, in each of which Hitler is attempting to destroy Russian culture. The Russian cultural icons depicted are, from top to bottom: Leo Tolstoy, Mikhail Vasilyevich Lomonosov, and Peter the Great. In Soviet posters Adolf Hitler was invariably portrayed as a beast with blood-stained limbs and an insatiable appetite for gore.

German attack the State Printing Works had produced a poster with the title "The Motherland is calling You!" It was an inspired illustration. A steely faced elder mother in a shawl calls out to the observer. She is dressed in simple attire, thus enabling the vast majority of Russians to identify with her. In her hand she holds the oath of loyalty to the Red Army soldier. The poster was very popular throughout the Soviet Union, millions of copies being printed, and in all the main languages of the USSR.

In a rousing speech he gave in Moscow's Red Square in November 1941, when German panzers were fast approaching the city, Stalin invoked the memory of past Russian heroes to inspire resistance against the Nazi invader: "The war you are waging is a war of liberation, a just war. Let the heroic images of our great ancestors—Alexander Nevsky, Dmitri Donskoi, Kusma Minin, Dmitri Pozharsky, Alexander Suvorov, Mikhail Kutuzov—inspire you in this war! Long live our glorious Motherland, her freedom and her independence!"

Stalin's iron rule

A year later the Soviet people were still fighting, but had suffered enormous losses. The 1942 poster "Red Army soldier, Save Us!" epitomizes this suffering. A young mother with a child in her arms and hate in her eyes is being threatened by a Nazi bayonet. The caption in red appears to have been written by the blood dripping from the bayonet. Ironically, Stalin was largely indifferent to Soviet losses, once stating: "One death is a tragedy, one million is a statistic." When his beloved wife Ekaterina died of typhus in 1908 he reportedly said, "and with her died my last warm feelings for all human beings." His brutality was legendary: in the 1930s his efforts at collectivization resulted in the deaths of up to 10 million peasants through starvation; the Great Purge of the Red Army between 1937 and 1941 resulted in the deaths of 35,000 officers and men executed on suspicion of being "counter-revolutionaries," although they were in fact killed because in Stalin's eyes they represented a potential threat to his rule.

German forces perpetuated atrocities on a massive scale during the invasion of the USSR, and Soviet propaganda responded in kind, preaching hatred toward the enemy. German forces were presented as bestial and immoral. Like American propaganda toward the Japanese, Soviet posters created a dehumanized image of the Germans. They were "fascist beasts" fit only to be slaughtered. Berlin itself was described as the "lair of the fascist beast."

As with the enemy, no mercy was shown toward Soviet citizens who did not show a total commitment to the war effort. To ensure that the patriotism of the Russian people did not falter, Stalin's secret police and Communist Party commissars maintained rigid control over the Red Army. Supposed defeatism and cowardice were crushed ruthlessly. Between 1941 and 1942, for example, 157,593 men were executed for cowardice on the battlefield.

Stalin directed the war through the Supreme High Command (*Stavka Verkhnogo Glavnokomandovaniia*—Stavka) as commander-in-chief, supported by army officers and commissars. Stalin rarely left the Kremlin or ventured outside the USSR (he had a fear of flying). His only visits to the war zone, to the Western and Kalinin Fronts, were made on August 3 and 5, 1943, apparently for use in propaganda films. In common with Hitler, Stalin was loathe to sanction retreats (his refusal to pull back from Kiev in 1941 resulted in 660,000 Russians becoming prisoners of the Germans), but he did come to listen to commanders such as Zhukov about how battles and campaigns should be conducted. In late 1942, he had taken Zhukov's advice regarding how to trap the German Sixth Army at Stalingrad. The result had been a stunning Soviet victory that wiped out Axis forces in the Stalingrad Pocket. Similarly, in April 1943 Zhukov reported to Stalin concerning the situation in the Kursk salient, urging him to fight a defensive battle. Stalin took this advice, the Battle of Kursk was fought Zhukov's way, and the Germans were defeated.

On the road to victory

Kursk marked a turning point in the war on the Eastern Front, and so in 1943 the tragic theme of Soviet posters began to give way to more positive messages as towns and cities were liberated from the retreating Germans. There was also a growing thirst for revenge as enemy atrocities against the Soviet people were uncovered. By 1944, the chief poster theme was the forthcoming victory against the Nazis, with promises that the Red Army soldier would soon be in Berlin itself. They were not wrong. At the beginning of 1944, the Soviets deployed no fewer than 10 fronts, each one made up of between four and eight armies. The Red Army used no fewer than six tank armies during its subsequent operations in the Ukraine and Crimea. The Germans, outnumbered and outgunned, could only retreat in the face of this juggernaut. But the cost of victory was still heavy. To take Berlin itself, for example, cost the Red Army 77,000 killed and a further 272,000 wounded.

Though posters paid lip service to the alliance with the United States and Britain, Stalin viewed the Western Allies with suspicion, often accusing them of postponing the second front because they wanted to see the USSR bled white. Always putting his own interests first, he made exorbitant demands when it came to Lend Lease supplies, and planned the final Soviet offensives of the war with a Russian-dominated postwar Europe in mind.

One vast war factory

It was fortunate for Stalin, and indeed the Western Allies, that the Soviet Union could, to use Stalin's own words, be turned into a "single war camp" reasonably quickly. Soviet industry was moved en masse into the eastern hinterlands in 1941, and again in 1942 when the Germans advanced into the Caucasus, thus saving it from capture or destruction. The Soviet economy was centrally planned, which meant that before the war economists and bureaucrats had experience of building industrial plants on greenfield sites and organizing the large-scale movements of workers. This experience facilitated the evacuation of hundreds of factories and tens of thousands of workers east to the Urals, to the Volga region, to Kazakhstan, and to Siberia in 1941 and 1942. When they were up and running these factories produced thousands of tanks, aircraft, and artillery pieces. Soviet production posters had one simple message: more weapons for the front. And the workers did produce more, month after month, year after year. It was a feat of endurance that has never been equalled.

The scale of Soviet sacrifice in the war is staggering. It is estimated that 35 million Russians lost their lives during and immediately after The Great Patriotic War (when many perished during the winter of 1945–1946 due to shortages of shelter in the war-ravaged western USSR). No other member of the Allied alliance could have withstood such losses and remained in the war.

OPPOSITE PAGE: "Revenge on the Nazi plunderers." Revenge for crimes committed by the Germans on Russian soil was a common Soviet poster theme during World War II. Russians needed little prompting when it came to revenge, especially after 1943 when the Red Army began to liberate areas formerly under Nazi control and discovered evidence of atrocities.

КЛЯНЕМСЯ МСТИТЬ
ГИТЛЕРОВСКИМ ЗАХВАТЧИКАМ !

НАШИ СИЛЫ НЕИСЧИСЛИМЫ

OPPOSITE PAGE: "We will mercilessly destroy and obliterate the enemy!" This 1941 poster shows a beast-like Hitler breaking through the German-Soviet Nor-Aggression Pact of 1939. The pact had divided a conquered Poland between Germany and the Soviet Union, with the latter seizing the eastern half of the country. The pact and subsequent trade agreements between Berlin and Moscow seemed to suggest coexistence between two mutually exclusive ideologies. But on June 22, 1941, the Wehrmacht launched Operation Barbarossa, the invasion of the Soviet Union.

ABOVE: "Our forces are innumerable." This 1941 poster by Viktor Koretskii follows the theme of Soviet posters of early 1941: portraying the Soviet Union and its armed forces as stern, strong, and commanding. On paper the Red Army was very strong on the eve of Barbarossa: 5.5 million troops with over 29,000 tanks. In addition, the Red Air Force possessed 19,500 aircraft. However, in the 1941 campaign the Soviets lost 20,000 tanks and 10,000 combat aircraft. In addition, losses in troops were also huge. The Germans attacked on June 22. By July 9 the Red Army had lost nearly 750,000 killed, wounded, or missing.

ВСЕ СИЛЫ НА ЗАЩИТУ ГОРОДА ЛЕНИНА!

Above: A more traditional Soviet poster was this plea: "All forces to the defense of the city of Lenin!" Leningrad was an important Soviet armaments center (before the war it had been one of the most important centers for weapons production in the Soviet Union), as well as being home to 2.5 million people. The first German artillery shells fell on the city at the beginning of September 1941, heralding the start of a three-year siege. When the siege was lifted in 1944, between 1.5 and 2 million Russian soldiers and civilians had perished.

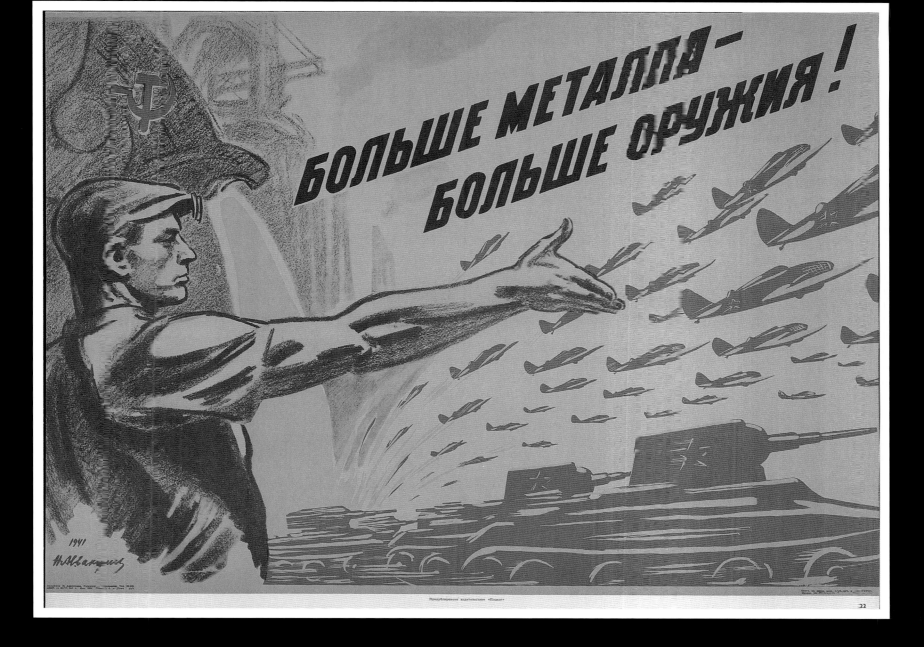

OPPOSITE PAGE: "Defend our beloved Moscow." This 1941 poster accurately sums up the desperate plight of the Soviet Union during the first six months of the war. The German attack against Moscow itself spluttered to a halt on December 4, just a few miles outside the city. Fortunately for the capital, a desperate defense, the freezing weather, and German supply problems combined to keep the invader out. On December 5, the Red Army launched a counterattack that pushed the German armies back west—Moscow had been saved.

ABOVE: "More metal, more arms!" Soviet industry responded magnificently to the demand for more armaments. In 1941 the economy produced 6,590 tanks. In 1942, after a large part of the western USSR had been lost to the Germans, 24,446 tanks were produced. Better still, many of these tanks were the T-34 model, which was better than most German tanks then in service.

BELOW: A poster that places less emphasis on party propaganda and looks instead to the heroes of Russia history. "We will fight strongly, strike desperately—grandsons of Suvorov, children of Chapaev." Behind the Red Army tanks and soldiers are (from left to right): Alexander Nevsky, a thirteenth-century Russian prince who successfully fought the Swedes and Teutonic Knights; Alexander Suvorov (1729–1800), who fought the Poles, Turks, and French and never lost a battle; and Vasily Chapaev (1887–1919), a celebrated Bolshevik hero in the Russian Civil War who was killed fighting the Whites.

OPPOSITE PAGE: "We will take their places!" A 1941 poster by Vladimir Serov urging women to replace men in the factories. In 1941 the Soviet economy was faced with complete collapse as the Germans conquered the main industrial and agricultural regions of the USSR. The Soviet Union was reduced from being the world's third largest industrial economy, behind Germany and the United States, to the lower rank of industrial nations, such as Italy. But because of the exceptional efforts of Soviet workers, including millions of women, industry was rebuilt and war production increased. By 1943, women made up just over half the industrial workforce.

ЗАМЕНИМ!

Художник В. А. Сер... Редактор Э. П. Докторов. М 20156 „Искусство" № 1895 Индекс Р-10 Тираж 30000. Заказ № 139 Государственное издательство „ИСКУССТВО" Ленинград 1941 Москва подписано в печати 5/VII 1941 г объем 1 бум. л. Цена 1 руб. Полиграфическая мастерская ЛССХ. Ленинград, ул. Герцена 38 21

ВПЕРЕД! НА ЗАПАД!

Продублировано издательством «Плакат» Первое издание осуществлено Государственным издательством «Искусство» в 1942 г.

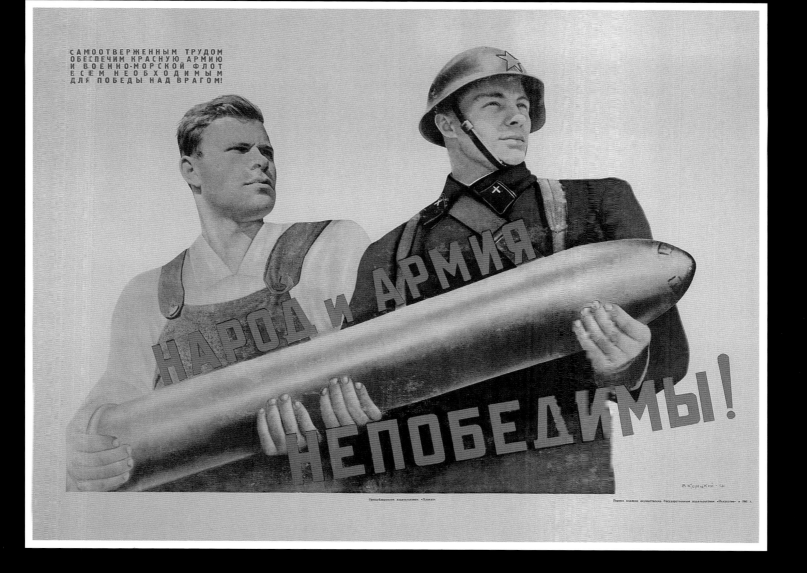

САМООТВЕРЖЕННЫМ ТРУДОМ
ОБЕСПЕЧИМ КРАСНУЮ АРМИЮ
И ВОЕННО-МОРСКОЙ ФЛОТ
ВСЕМ НЕОБХОДИМЫМ
ДЛЯ ПОБЕДЫ НАД ВРАГОМ!

НАРОД И АРМИЯ НЕПОБЕДИМЫ!

Opposite page: "Forward! To the West!" This 1942 poster carries a common Soviet slogan during the war: the desire to liberate conquered Soviet territory and drive the fascists west. However, though the Red Army launched a number of offensives at the start of 1942 they all ended in failure. By the end of March 1942, the Red Army had suffered a total of 675,315 killed and missing and a staggering 1,179,457 wounded in these offensives.

Above: "The people and the army are unbeatable!" This poster stresses the close relationship between the soldier at the front and the factory worker who supplied him with weapons and ammunition. It was fortunate for Stalin that he was at the apex of a totalitarian regime. It was thus relatively simple for the country to be turned into a "single war camp" (Stalin's words). When war broke out all holidays and leave for workers was cancelled indefinitely, hours worked were fixed at between 12 and 16 each day, and three hours of compulsory overtime was introduced.

BELOW: "Fight the enemy as our fathers and older brothers, sailors of October, fought him!" This poster was produced in Leningrad and celebrates one of the Russian Revolution's epic events: when soldiers and sailors stormed the city's Winter Palace during the 1917 revolution. Leningrad was named after the first Bolshevik leader; as such, it was fiercely assaulted by the Nazis, and just as fiercely defended by the Red Army.

OPPOSITE PAGE: This poster by Viktor Koretskii is interesting because it hints at Soviet vulnerability. "Red Army soldier, Save Us!" A young peasant mother, known as the "madonna of the front" (*frontovnaia Madonna*), holds a young male child, both of them being threatened by a blood-stained Nazi bayonet. The implication here is that the Nazi invaders threatened the vulnerable Motherland with rape and murder, and it was the task of the Red Army to save her.

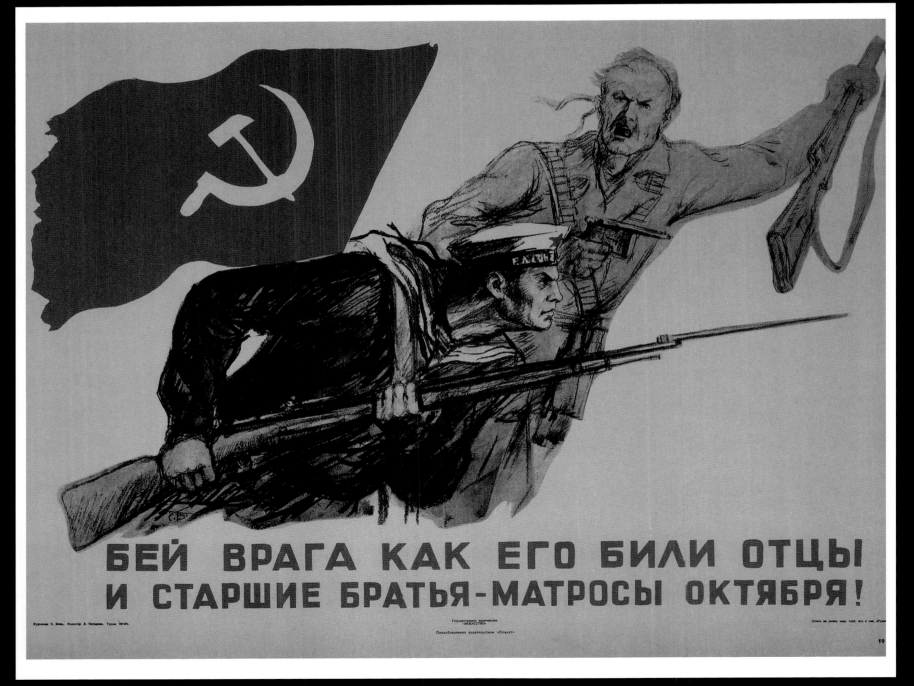

БЕЙ ВРАГА КАК ЕГО БИЛИ ОТЦЫ
И СТАРШИЕ БРАТЬЯ-МАТРОСЫ ОКТЯБРЯ!

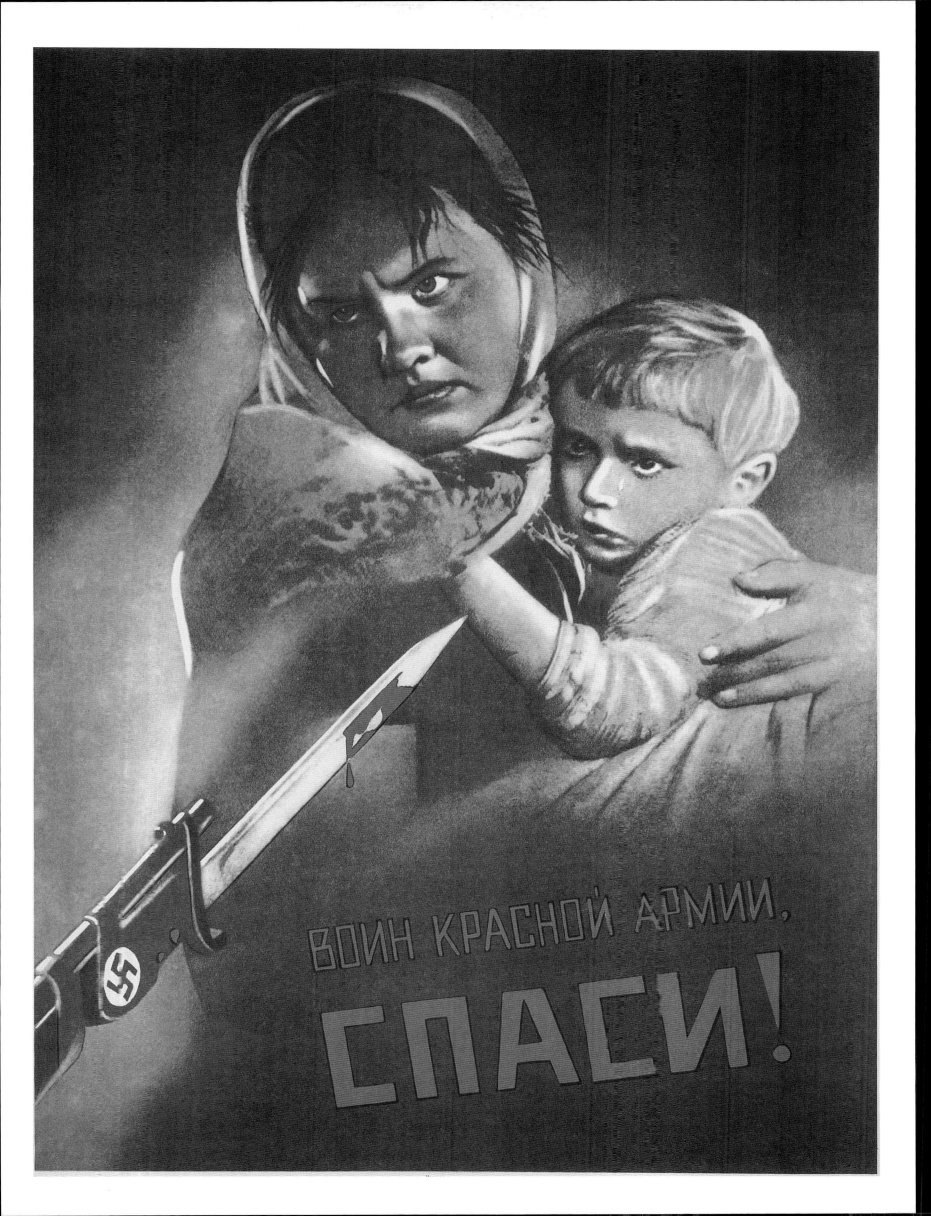

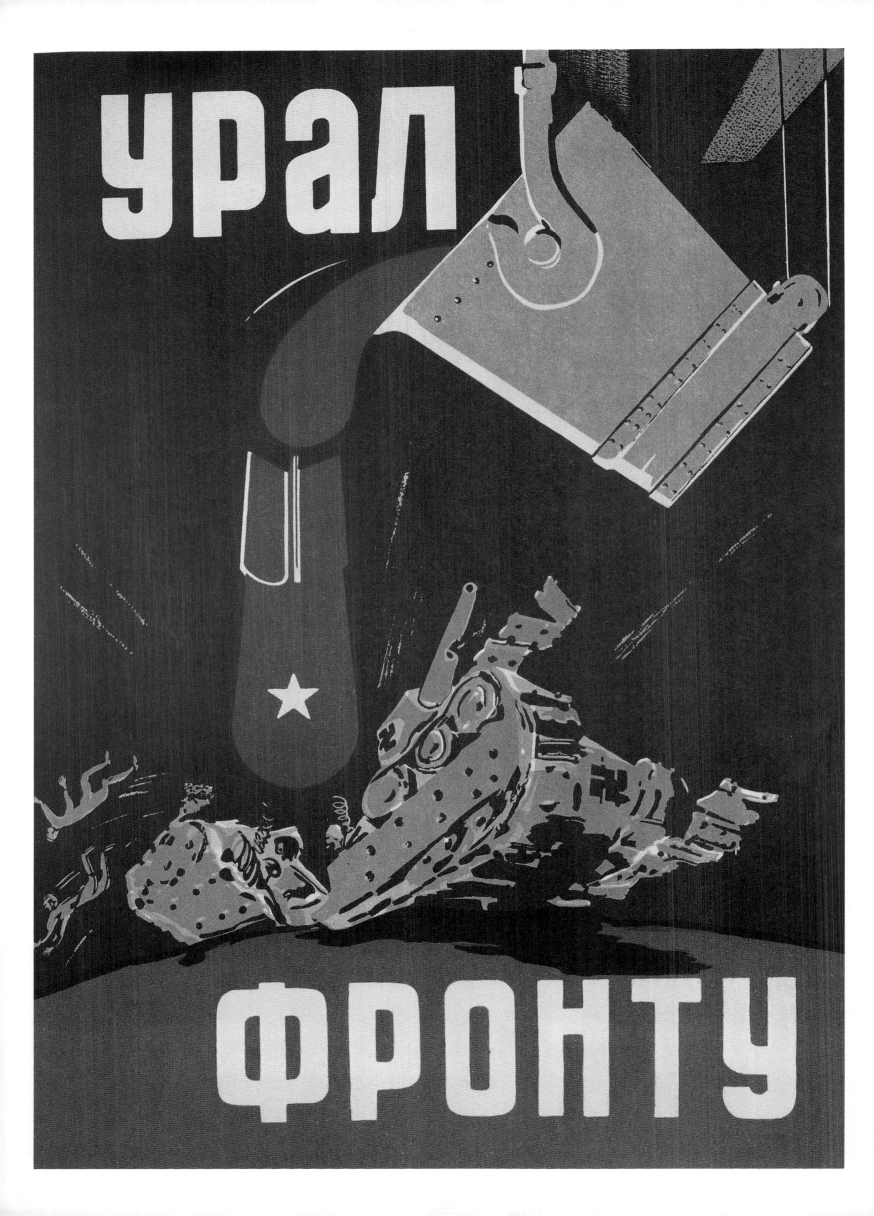

ВОИН, ОТВЕТЬ РОДИНЕ ПОБЕДОЙ!

Первое издание осуществлено Государственным издательством «Искусство» в 1942 г. Продублировано издательством «Плакат»

OSITE PAGE: "From the Urals to the Front." A simple but effective
er that points to the vast industrial output of the Urals region. The
ds were no idle boast: in the Ural cities around Magnitogorsk
et planners built massive factories. At Sverdlovsk, for example,
e was a major machine tool production center, known as
lmash." It became a major center for tank and artillery production
g the war. The output of heavy artillery increased six-fold alone
veen 1941 and 1944. Beyond the range of German bombers, the
ries in the Urals supplied tens of thousands of tanks and artillery

ABOVE: "Soldier, answer the Motherland with victory!" This post
produced in Leningrad emphasizes the appeal to patriotism and
tradition. Even the name of the conflict, "The Great Patriotic War
was designed to rouse Russian patriotism. Gone was the persec
of the church and believers. Stalin made available monies to res
churches and religious observance was openly encouraged.

СЛАВА СОВЕТСКОМУ ВОЗДУШНОМУ ФЛОТУ!

Автолитография П. М. Магнушевского. Редактор В. М. Соколов. Государственное издательство „ИСКУССТВО" М—35 РБ 2538 Тираж 3000 экз. Цена 4 р. Зак. № 1211 ЛТ УН
Ленинград 1943

Продублировано издательством «Плакат»

ВОИНЫ КРАСНОЙ АРМИИ!
КРЕПЧЕ УДАРЫ ПО ВРАГУ! ИЗГОНИМ НЕМЕЦКО-
ФАШИСТСКИХ МЕРЗАВЦЕВ С НАШЕЙ РОДНОЙ ЗЕМЛИ!

OPPOSITE PAGE: "For the Motherland!" Mother Russia holding a child inspires Russian soldiers in this 1943 poster. The almost religious imagery could not but help inspire a nation in which half the Russian people, despite the communist suppression of religion, were still Orthodox Christians. The defense of the Motherland was an idea that went back centuries in the Russian psyche. It endures still, whereas Soviet communism has been consigned to the trash can of history.

ABOVE: "Soldiers of the Red Army! Harder blows to the enemy! Let us drive the German-fascist scoundrels from our Homelands!" This poster is still appealing to Russian patriotism, though the image shows communist insignia such as the hammer and sickle and the Red Banner. The weapon being used to deliver a blow to the German on the left is the PPSh-41 submachine gun, one of the most famous small arms of World War II. Factories and workshops throughout the Soviet Union manufactured this reliable weapon, and more than five million had been produced by 1945.

and to victory!" This 1943 image
design and message of Soviet posters that
macy on the Eastern Front. The decisive
sk in July 1943 gave the strategic initiative
stern Front. The Germans never regained it.
oldiers, more tanks, and more artillery than
ond half of 1943 unleashed a series of
enemy that pushed the Germans west.

OPPOSITE PAGE: "Westwards!" A 1944 p
victories in that year. A determined Red
enemy sign saying "To the east" in Gern
in liberating conquered Russian territory
the Motherland or "our beloved Mcscov
one long catastrophe cn the Eastern Fro
the Red Army was nearing the border of

ВОИНУ-ПОБЕДИТЕЛЮ — ВСЕНАРОДНАЯ ЛЮБОВЬ!

Продублировано издательством «Плакат» Первое издание осуществлено Государственным издательством «Искусство» в 1944 г.

КРЕПЧЕ УДАРЫ ПО ВРАГУ!

**ОСВОБОДИМ РОДНЫЕ ГОРОДА И СЕЛА
ОТ ФАШИСТСКОЙ НЕЧИСТИ!**

Продублировано издательством «Плакат» Первое издание осуществлено Государственным издательством «Искусство» в 1941 г.

he message: "A nation's love to
as clear to the Soviet authorities
eated on the Eastern Front, and
ch an assault on Nazi Germany
oldiers that adorned the posters of
faces of Red Army soldiers were
they knew that they would be

BELOW: A 1944 poster that declares "We will get to Berlin!" The Red Army's Operation Bagration in June, which shattered the German Army Group Center, involved 2.5 million troops, 5,200 tanks, and 5,300 aircraft. Army Group Center numbered only 580,000 troops and 900 tanks. The offensive was a great Soviet victory, which caused the Germans to fall back west into Poland.

OPPOSITE PAGE: "So it will be with the fascist beast!" This poster is dated 1945, by which date the Red Army was about to launch its campaign to bring the war on the Eastern Front to an end. The poster shows the flags of the three main members of the Grand Alliance: the Soviet Union, the United States, and Britain. Of the three, it was the Soviet Union that had the largest armed forces fighting the Germans, with 11,500,000 troops deployed on the Eastern Front at the beginning of 1945.

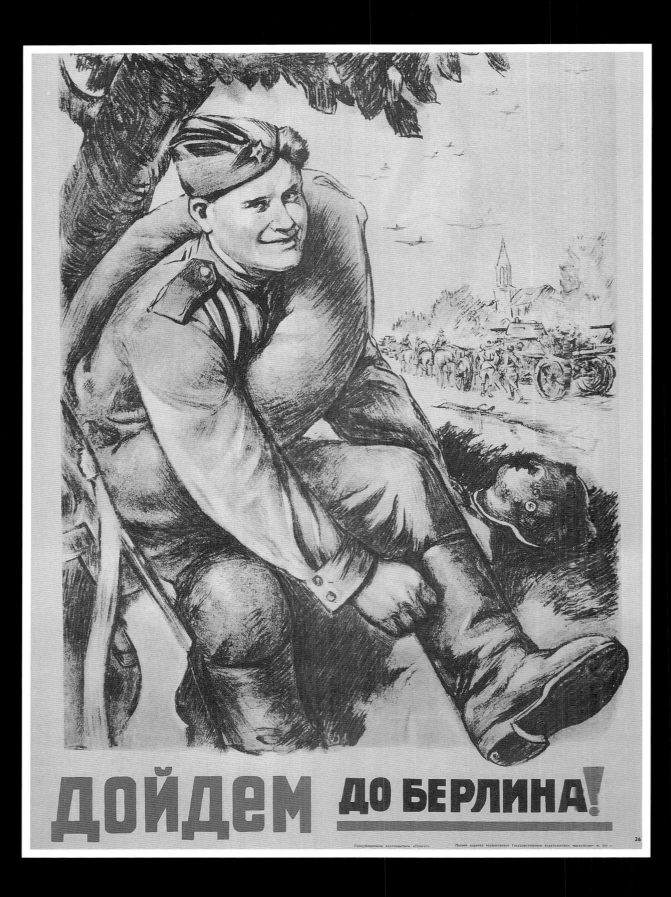

ДОЙДЕМ ДО БЕРЛИНА!

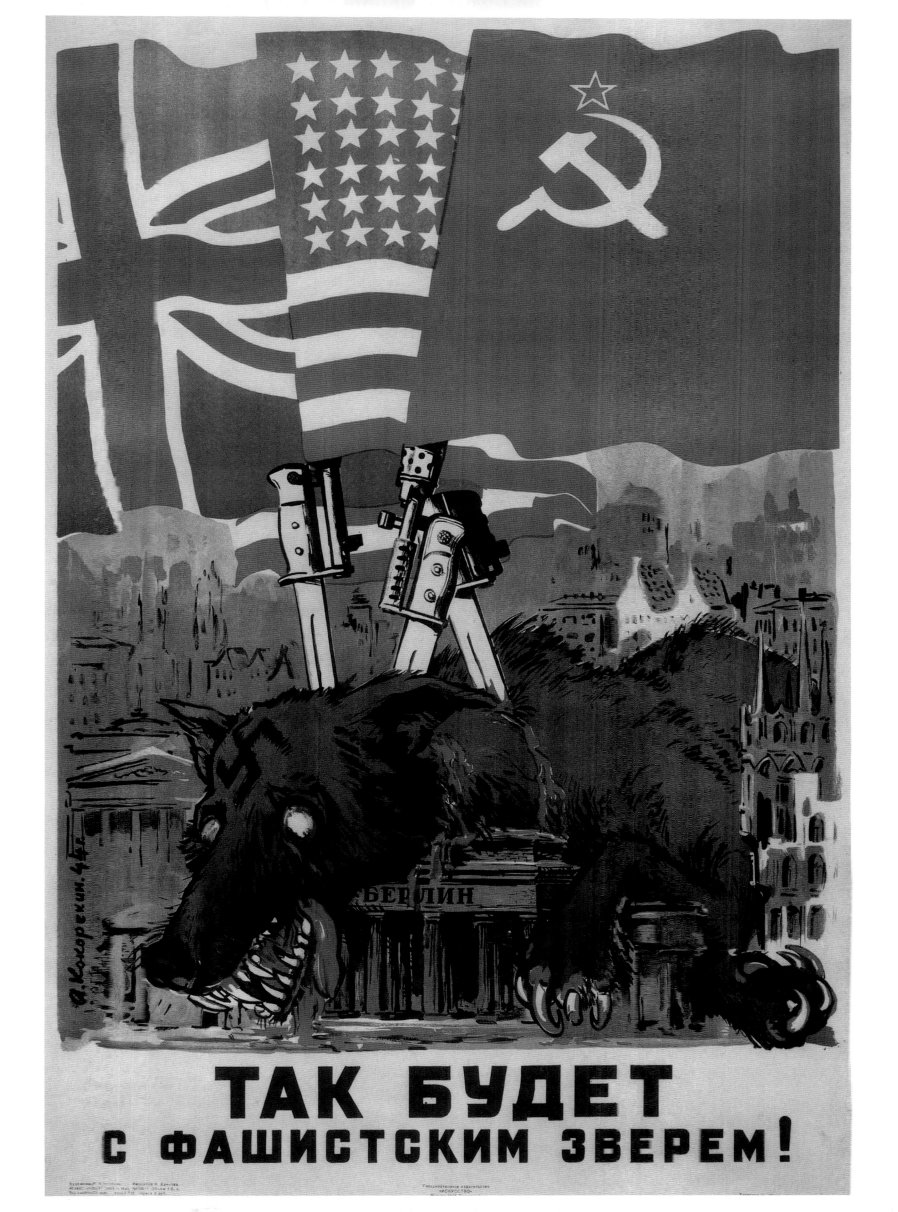

ТАК БУДЕТ
С ФАШИСТСКИМ ЗВЕРЕМ!

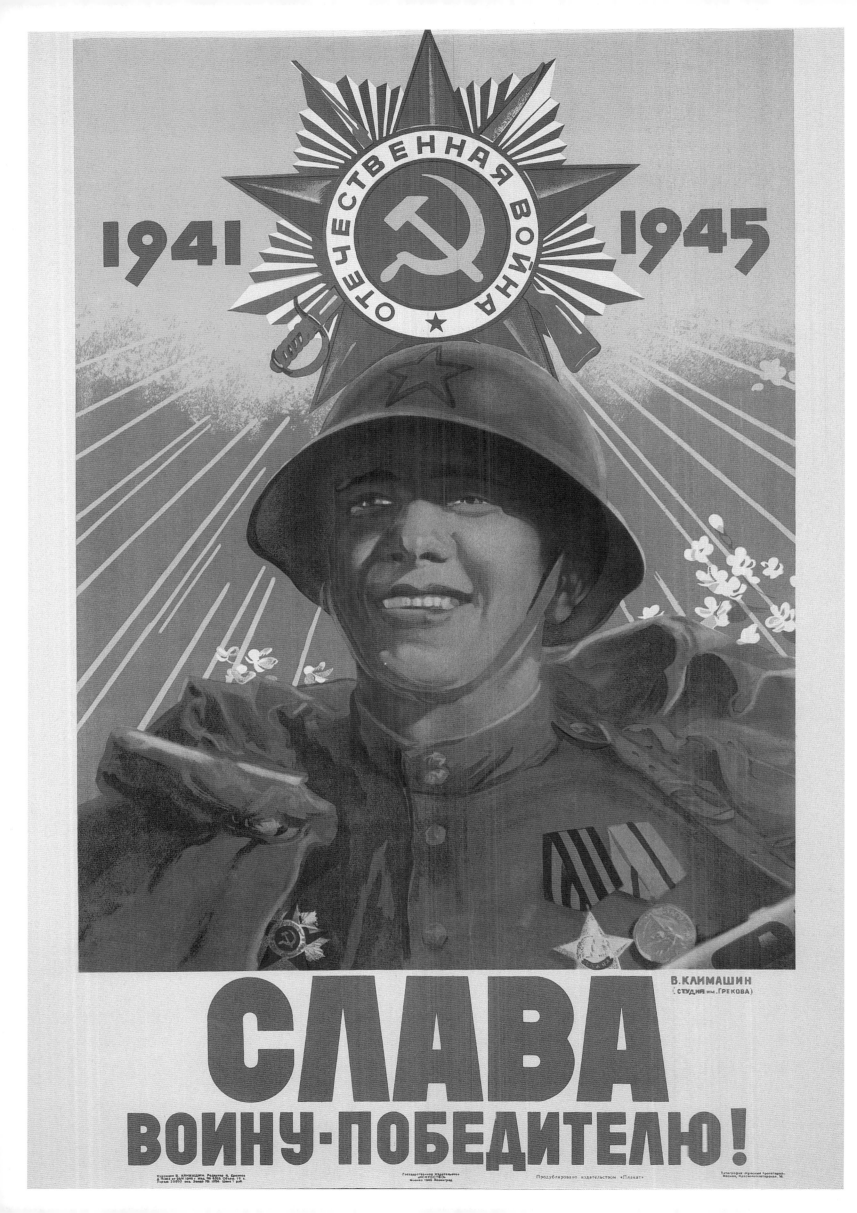

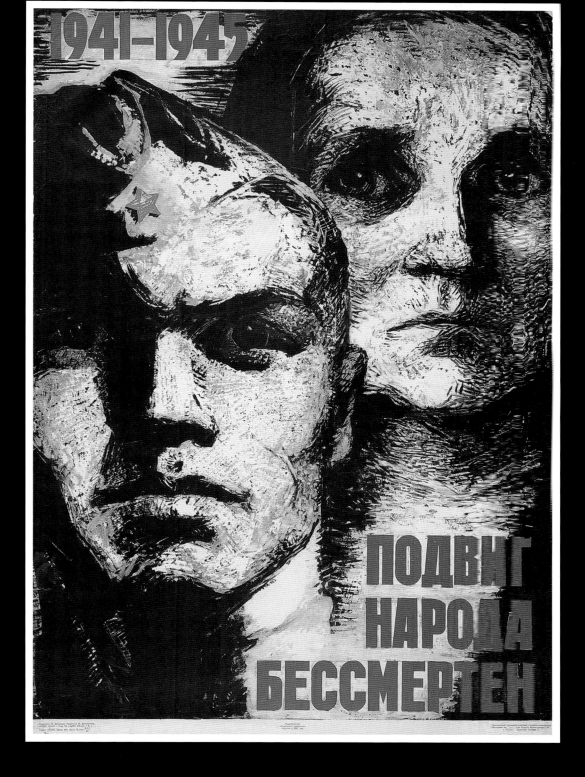

OPPOSITE PAGE: 'Honor to the victorious soldier!" With the war against Nazi Germany won, Soviet posters reverted to type, with the hammer and sickle returned to prominence and little reference to nationalism and patriotism. Nevertheless, the poster rightly salutes the efforts of the ordinary Red Army soldier, whose selfless sacrifice had enabled the Soviet Union to win the war against Nazi Germany.

ABOVE: A post-war poster created by Nina Vatolina, an artist who produced many posters both during the war and afterward. The title, "The victory of the people is eternal, 1941–1945," is a celebration of the population's efforts in World War II. It was worth celebrating. The scale of the destruction and loss of life inflicted on the USSR during four years of brutal warfare is difficult to comprehend. Estimates vary, but it is reckoned that 35 million Russians lost their lives during the Russo-German War.

United States Posters

Of all the warring nations in World War II, it was the United States that benefitted the most from the conflict. In 1941, even before she had entered the war, the United States produced more steel, aluminium, oil, and motor vehicles than all the other major nations put together. A sleeping giant before the war, by the end of it the United States was the world's greatest power, both militarily and economically. In 1941 the country was essentially a civilian economy; by 1945 it was a manufacturing collossus, having produced 297,000 aircraft, 193,000 artillery pieces, 86,000 tanks, 2 million trucks, 8,800 naval vessels, and 87,000 landing craft.

The OWI

Such a massive war effort demanded an equally large mobilization of the working population. And so the Office of War Information (OWI) was created in 1942 to be the U.S. Government propaganda agency during the war, responsible for turning the country into the "arsenal of democracy." The OWI established systems of distribution modeled upon the volunteer organizations that had been established in World War I. Posters were distributed by post offices, railroad stations, schools, restaurants, and retail store groups. The OWI also organized distribution through volunteer defense councils, whose members took the "Poster Pledge." The "Poster Pledge" urged volunteers to "avoid waste," treat posters "as real war ammunition," "never let a poster lie idle," and "make every one count to the fullest extent."

During the war the OWI developed a number of major propaganda themes for use in posters and the media in general. Immediately after the attack on Pearl Harbor (December 7, 1941) American propaganda focused on the nature of the enemy. In many publications the Japanese became the "yellow peril," and in an article on the Pearl Harbor attack, *Time* magazine talked of "the yellow bastards." In fact, the Japanese had always been viewed with suspicion. Immigration into the United States from Asia began in earnest during the early-mid 1800s, mainly in the form of Chinese laborers seeking employment in manual industries. Japanese immigration gained pace in the late 1800s, with many Japanese immigrants heading for employment on plantations in Hawaii. By 1929, there were 230,000 Japanese immigrants in the United States, most of them concentrated along the West Coast of California. There they joined thousands of Chinese workers, and around 24,000 Filipinos also arrived in California in the 1920s.

The "yellow peril"

From the moment they arrived, Asian-Americans were perceived to be a threat to American society and values, and they were branded the "yellow peril."

War posters likened the Japanese to animals such as apes, snakes, and rats, thus dehumanizing the enemy. This image was helped by the actions of the Japanese themselves. In April 1942, for example, 78,000 U.S. and Filipino troops surrendered to the Japanese in the Philippines. During the march from Bataan to Camp O'Donnell, north of Manila, the guards deprived the prisoners of food and water, and murdered any stragglers. According to the Bushido code, soldiers who surrendered rather than fight to the death dishonored themselves and forfeited any right to humane

treatment. To make matters worse, the captives had previously subsisted for months on partial rations, which meant many started out in a weakened state. Alf Larson was one of those Americans who endured the march and who later recorded his experiences during the "Bataan Death March."

Japanese atrocities

"If people would fall down and couldn't go any further, the Japanese would either bayonet or shoot them. They also would bayonet prisoners who couldn't keep up. Those who stepped out of line or had fallen out of the ranks were beaten with clubs and/or rifle butts. Some American prisoners who couldn't keep up were run over by Japanese vehicles. I saw the remains of an American soldier who had been run over by a tank. I didn't see the actual event but the Japanese just left his remains in the middle of the road. We could see them as we walked by. Wounded Americans were expected to keep up like everyone else, regardless of their condition. But, some wounded prisoners just couldn't go on. They were either bayoneted, beat with clubs, rifle butts, or shot. Some soldiers had diarrhea so bad that they couldn't keep up and the Japanese shot them. As we walked along, we could see the bodies of decomposing American soldiers and Filipino women who had been mutilated and obviously raped. I'm sure the dogs in the area got fat!" Such atrocities encouraged hatred among the U.S. public.

Posters also sounded a call to arms for the American people. They proclaimed that the United States had been viciously attacked and would not sit by and do nothing. "Avenge December 7" was a powerful message. But the United States was not simply fighting

ABOVE: J. Howard Miller's famous poster of Rosie the Riveter, "We Can Do It!" The image was modeled on Michigan factory worker Geraldine Doyle in 1942. Rosie the Riveter became an American cultural icon and came to represent the more than six million women in U.S. war factories during World War II. They made a crucial contribution to the eventual Allied victory.

Japan because of Pearl Harbor. It was also fighting against Japanese imperialist expansionism in Asia. This was a clever argument, because although the United States was not a colonizing nation, it still had authority over the entire Philippines (a legacy of its victory in the Spanish-American War of 1898) and had powerful commercial and religious interests throughout China. European and U.S. territory combined meant that the West dominated much of Pacific Asia's natural resources. Nevertheless, the idea that the United States was fighting for peace and democracy was a powerful motivator for the American people.

The just war

The liberation of oppressed peoples was also a theme of U.S. posters: to free Europe of Nazism and Asia of Japanese imperialism. For a religious people, the conviction that they were fighting a "just war" simplified things for Americans. Indeed, President Roosevelt himself was deeply religious.

Before Pearl Harbor, not all Americans were enthusiastic about joining the war. Indeed, there was spontaneous and widespread opposition to Franklin Roosevelt's obvious attempts to embroil the United States in the European war that broke out in 1939. That opposition was centered in the America First Committee. The organization had 800,000 members at its height, and had four main beliefs. First, that the United States should build an impregnable defense for America. Second, no foreign powers, nor group of powers, could successfully attack a prepared America. Third, American democracy could be preserved only by keeping out of the European war. Fourth, "Aid short of war" weakened national defense at home and threatened to involve America in war abroad. Following the attack on Pearl Harbor, on December 11, 1941, the national committee of the America First Committee voted to disband the organization.

To fight a just war against both Germany and Japan required large armed forces and massive quantities of tanks, ships, aircraft, and armaments. This meant factory production on a mass scale. The United States was a democracy whose population was accustomed to a high standard of living. Unlike in Soviet Russia, the people could not be forced to work in factories or agriculture. Posters encouraging individuals to produce more, buy war bonds, and become volunteers therefore stressed the linkage between the factory worker and the frontline soldier. The posters also stressed the patriotic nature of these efforts. "Production, America's answer," "More production," and "let's give him enough and on time" all stressed the dependence of the

armed forces on factory workers. One of the most famous production posters, "Give it your best!," was simply the American flag with the words underneath.

The campaign worked. The U.S. became an industrial giant that poured out guns, tanks, aircraft, and ships at a phenomenal rate, and in the end this was always going to be decisive. Prefabricated merchant vessels, known as Liberty Ships, were constructed at the rate of one per day at the height of the war. At the Battle of the Philippine Sea in 1944, American Admiral Marc Mitscher was happy to let his attack aircraft ditch in the sea, provided he could recover the pilots, because there were more than sufficient planes in reserve. At this battle Japanese naval aviation suffered a blow from which it never recovered. After this, the extreme courage of Japanese sailors and airmen, and their willingness to sacrifice themselves in their cause, proved fruitless. The *kamikaze* pilots inflicted great losses on the U.S. Navy (especially during the battle for Okinawa), but the issue was by then not in doubt. The greatest naval struggle in history had been won by the United States.

Aid to allies

As well as equipping its own armed forces, the United States was able to send valuable aid to the Soviet Union. Lend Lease assistance became crucial to the Red Army in the last two years of the war. Between 1943 and 1945, Western aid, specifically trucks, rail engines, and rail wagons, allowed the Red Army to maintain the momentum of its offensives by transporting troops and supplies to reinforce breakthrough armies, thus denying the Germans time to organize fresh defense lines and escape encirclements. These were the quantities of goods supplied to the Russians: armored vehicles: 12,161; guns and mortars: 9,600; combat aircraft: 18,303; aircraft engines: 14,902; trucks and jeeps: 312,600; explosives: 325,784 tons (330,997 tonnes); locomotives: 1,860; rail cars: 11,181; field telephones: 422,000; foodstuffs: 4,281,910 tons (4,350,420 tonnes); oil: 2,599,000 tons (2,640,584 tonnes); and boots: 15,000,000 pairs.

The development of the atomic bomb symbolized America's vast economic might. The "Manhattan Project" was the codename for the U.S. atomic weapons program. The origins of the project went back to 1939, when top U.S. scientists, including the influential Albert Einstein, persuaded President Roosevelt of the military possibilities for fission chain reactions of atomic elements. Official work began in February 1940 with a grant of $6,000, but on December 6, 1941—with war raging in Europe and threatening in the Far

East—the program was upgraded and placed under the jurisdiction of the Office of Scientific Research and Development. The War Department took joint management following the Japanese attack on Pearl Harbor. The program assumed the name Manhattan Project in 1942, after the U.S. Army engineers of the Manhattan district who were given the task of constructing the initial plants for the work. On July 16, 1945, the first atomic bomb was exploded at Alamogordo, New Mexico. The U.S., having invested two billion dollars in the Manhattan Project, now had its atomic bomb. The British had dropped out of atomic bomb research in 1942 in recognition that they lacked the industrial resources to pursue such a project.

The birth of a superpower

The aircraft that dropped the atomic bomb, the B-29 Superfortress, was also indicative of America's vast technological and economic resources. The B-29 was designed as an extreme long-range "Hemisphere Defense Weapon." When it entered service in July 1943, this huge 10-crew bomber had a range of 4,100 miles (6,595 km) and a bomb load of 20,000 lb (9,072 kg). It was an advanced aircraft—the gun turrets dotted around the fuselage were controlled remotely by gunners sitting inside the fuselage who aimed the weapons via periscopes. The B-29 was ideal for the vast distances of the Pacific theater. Some 3,970 B-29s were produced during the war.

The campaign to mobilize the American people to fight the war had been a great victory. The civilian workforce grew from 46.5 million in 1940 to 55 million by 1945, notwithstanding that the American armed forces by this date numbered 11 million. American farms had, in the same period, increased their production by 22 percent with a diminishing number of farmers. By such efforts had the American people helped to destroy the Axis war effort.

OPPOSITE PAGE: The America First Committee (AFC) was established in September 1940. Its aim was to keep the United States out of the European war and it was opposed to sending aid to the British, its supporters arguing that to do so would weaken home defense and might suck America into the conflict. At its height the AFC had 800,000 members. However, it was dissolved a few days after the Japanese attack on Pearl Harbor.

I WANT YOU

for the U.S. ARMY
ENLIST NOW

...ed States into the war required
...armed forces. In this Tom
...g in front of an unfurled
...ady for a fight. The image
...t involved in the war, but her

ABOVE: This poster by the a...
is one of the most con... rec...
During World War F ag...3 de...
included the far...us Un...le S...
for the U.S. Army... An a...apt...

BELOW: The Office of Civilian Defense (OCD) was headed by New York Mayor Fiorello LaGuardia. He chose the popular First Lady Eleanor Roosevelt as his assistant. By November 1940, all the states and 5,935 towns and cities had set up defense councils. This is a poster sponsored by the Philadelphia Council of Defense calling for volunteers to become air raid wardens, auxiliary firemen, auxiliary policemen, and other "services in the civilian army."

OPPOSITE PAGE: Before the United States entered the war, President Roosevelt described America as being in a "a state of unlimited emergency." As a result, he advised each city to organize its own "civil defense" system to plan and prepare for the dangers looming on the horizon. On May 20, 1941, Roosevelt created the Office of Civilian Defense (OCD) to oversee and assist this task. When war broke out, thousands of civil defense chapters were organized by volunteers across the country

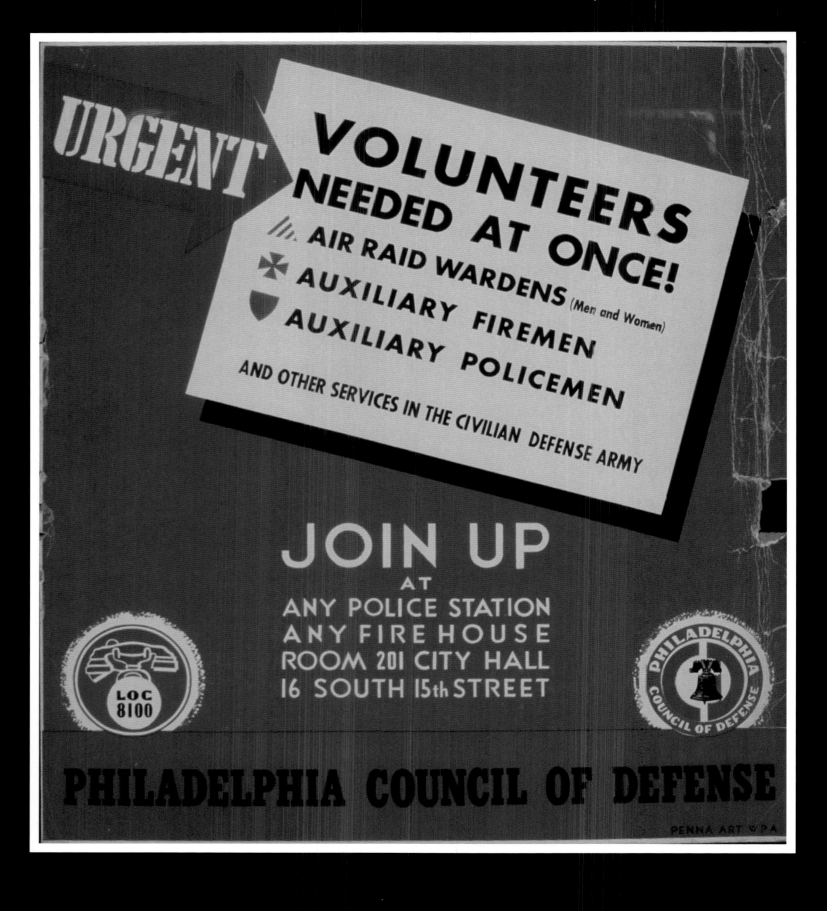

AMERICA CALLING

Take your place in
CIVILIAN DEFENSE

CONSULT YOUR NEAREST DEFENSE COUNCIL

DIVISION OF INFORMATION OFFICE FOR EMERGENCY MANAGEMENT

U. S. GOVERNMENT PRINTING OFFICE : 1941—O—423671

VOLUNTEER
CIVILIAN DEFENSE

Opposite page: This poster encourages the owners of small boats to enlist in the U.S. Coast Guard. The Coast Guard was ordered to operate as part of the U.S. Navy in November 1941, and thereafter its personnel crewed amphibious ships and landing craft, landing soldiers and U.S. Marines on beaches in North Africa, Italy, France, and the Pacific. Over 241,000 men and women served in the Coast Guard during the war, of whom 1,917 were killed.

Above: A poster issued in Alabama encouraging voluntary participation in civilian defense. The image is of an aircraft flying over the outline of the state. Throughout the state civilian defense councils ran courses instructing volunteers in how to enforce blackouts and the procedures for air raid warnings. The first state-wide blackout was held on March 17, 1942, and beginning in Mobile, every town or city with 5,000 or more inhabitants extinguished all lights.

BELOW: A recruiting poster for the American Merchant Marine, showing longshoremen loading a tank onto a ship. The Merchant Marine provided the greatest sealift in history in transporting weapons and supplies produced at home to U.S. forces scattered across the globe. The recruitment drive increased the prewar total of 55,000 experienced mariners to over 215,000. It was a dangerous vocation: 1 in 26 mariners serving aboard American merchant ships in World War II died in the line of duty, suffering a greater percentage of war-related deaths than all other U.S. services. The total killed was 9,300, and such was the loss that casualty figures were kept secret to retain mariners and maintain morale.

OPPOSITE PAGE: This poster encourages civilians to join civil defense squads. It was created by John McCrady, one of the most influential Louisiana artists of the twentieth century, who in 1942 had opened the John McCrady Art School in New Orleans. This is a Works Progress Administration poster. They were designed to publicize health and safety programs; cultural programs including art exhibitions, theatrical, and musical performances; travel and tourism; educational programs; and community activities.

OPPOSITE PAGE: This U.S. Navy recruiting poster was created by the artist and unsuccessful businessman McCelland Barclay. Before the war he painted movie poster illustrations, with Betty Grable, the most famous of all the World War II pin-up girls, being one of his subjects. He painted movie posters for Paramount Pictures and Twentieth-Century Fox. After enlisting in the U.S. Navy, he designed a number of posters and camouflage designs for the armed forces. They earned him a naval commission. He was killed in action in the Pacific in 1943.

ABOVE: This poster encourages women to become nurses' aides for the Civilian Defense Volunteer Office. It shows women in civilian clothes and nurses uniforms. The largest women's auxiliary organization was the American Women's Voluntary Services. Its members were trained to drive ambulances, fight fires, and give emergency medical aid during and after enemy bombing raids. Ironically, no bombing raids took place against American cities.

"I've found the job where I fit best!"

FIND YOUR WAR JOB
In Industry – Agriculture – Business

OWI Poster No. 55. Additional copies may be obtained upon request from the Division of Public Inquiries, Office of War Information, Washington, D.C.

PAGE: The U.S. Army Air Force came into being on June 20, [...] German Blitzkrieg in Poland and France in 1939 and [...] demonstrated how effective air power could be, and so [...]'s government began to increase the size of the air force. [...] combat groups were initially planned, but this was soon [...] to 84 combat groups equipped with 7,800 aircraft and [...] by 400,000 troops by June 30, 1942. This poster shows a [...]ring wings on his chest. Pilot training itself was the [...]ility of the Flying Training Command.

ABOVE: An Office of War Information poster of 1943 encoura[...] women to get involved in war work. Eventually around six m[...] American women entered the workforce for the first time du[...] war. Many of them were married, white, middle-class women [...] had to be encouraged to go out to work. Indeed, most had n[...] worked outside the home at all. Nevertheless, posters such a[...] one promoted the idea that it was patriotic for women to wo[...] non-traditional jobs.

Below: A recruiting poster by David Stone Martin of the African American war hero Doris "Dorie" Miller, who won the Navy Cross for his actions at Pearl Harbor on board the USS *West Virginia*. His citation reads: "Miller, despite enemy strafing and bombing and in the face of a serious fire, assisted in moving his Captain, who had been mortally wounded, to a place of greater safety, and later manned and operated a machine gun directed at enemy Japanese attacking aircraft until ordered to leave the bridge." Doris "Dorie" Miller was killed in the Pacific in 1943.

Opposite page: A 1943 poster encouraging women to undertake war work. The image is of a woman working in an aircraft factory and is based on an Alfred T. Palmer photograph. Palmer was a photographer and film maker who was the official photographer for the United States Merchant Marine and later for major shipping lines. During the war he was appointed Head photographer for the Office of War Information by President Roosevelt.

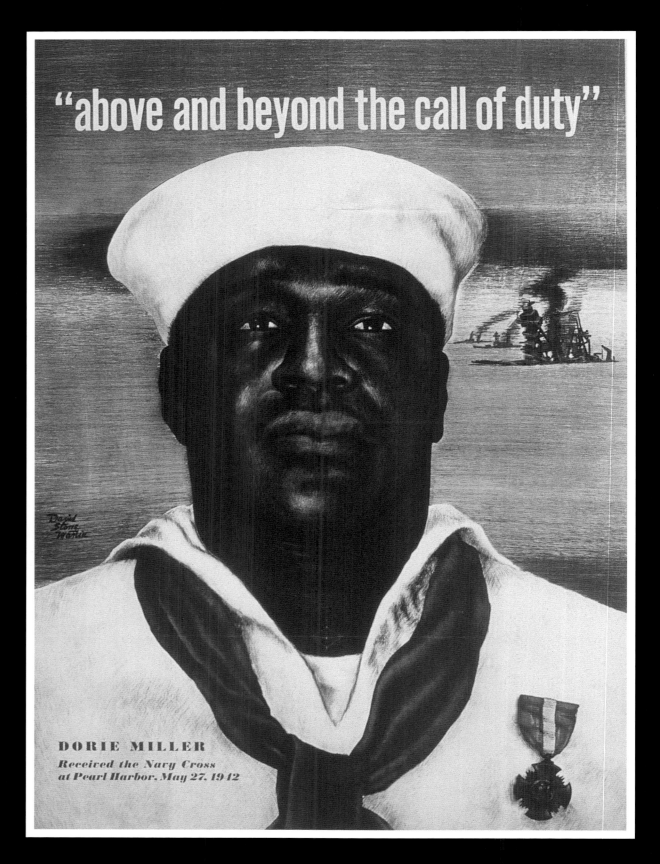

Are you a girl with a Star-Spangled heart?

Bradshaw Crandell

US

JOIN THE WAC NOW !

THOUSANDS OF ARMY JOBS NEED FILLING !

Women's Army Corps
United States Army

I'm Proud... my husband _wants_ me to do my part

SEE YOUR U. S. EMPLOYMENT SERVICE

WAR MANPOWER COMMISSION

Corps (WAC) was created for the
national defense the knowledge,
men of the nation." Applicants had
of 21 and 45 with no dependents,
00 pounds or more. The recruits
seas as stenographers, typists,
raphers, telegraph and teletype
, over 150,000 American women

BELOW: This poster by Steele Savage is the only one ever created that features women members of the U.S. Marines, the Navy's Women Accepted for Volunteer Emergency Service (WAVES), Army, and Coast Guard together. It stresses that the war is being fought for a brighter future.

OPPOSITE PAGE: The Committee to Defend America by Aiding the Allies was set up in May 1940 by William Allen White of the Kansas City Emporia Gazette and Clark M. Eichelberger of the League of Nations Association. It lobbied for the sale of warships and aircraft to Britain, the use of convoys to escort Allied supplies, and the revision of the 1935 Neutrality Act to arm U.S. ships for defense against Axis attacks. The Committee dissolved itself in January 1942 after the entry of the United States in the war.

America's answer!

PRODUCTION

JEAN CARLU

OPPOSITE PAGE: This poster illustrates one of the common techniques of American propaganda during the war: to liken the Japanese to animals such as rats and snakes. There were a number of drives for scrap during the war. In July 1941, for example, the Office of Production Management announced a two-week drive to collect aluminum cookware and other items to make aircraft. The response was massive. Unfortunately, it was discovered that only virgin aluminum was suitable to make aircraft. And so the pots and pans

ABOVE: This simple 19__ poster by Jean Carlu emphasizes America's industrial might. Carlu originally began training as an architect, but turned to commercial art after an accident in which he lost his arm. During the 1920s and 1930s he was a leading figure in French poster design. In 1940, he was in the United States organizing an exhibition at the New York World's Fair for the French Information Service when Paris fell to the Germans. This poster was voted best of the year in 1941.

BELOW: This poster reflects the diverse composition of the United States in the 1940s, and that everyone should come together in a unified effort to defeat the enemy. Not everyone was welcome, however. For example, there were around eight million German-Americans in the United States, and during the war the government used many methods to control them. They included internment, individual and group exclusion from military zones, internee exchanges, deportation, repatriation, "alien enemy" registration, travel restrictions, and property confiscation.

OPPOSITE PAGE: n this Maurice Merlin poster, employment opportunities fo⁻ farm and industrial laborers are announced. However, the appeal for manpower could not fulfil Michigan's requirements. Therefore, in 1944 and 1945 between 4,000 and 5,000 prisoners of wa⁻ worked on the state's farms. Prisoners, Italians and Germans, usual y worked six-day, 48-hour weeks. They lived in tented camps surrounded by simple wooden fences.

USA

MORE PRODUCTION

WAR PRODUCTION BOARD
WASHINGTON, D.C.

Let's give him
Enough and On Time

Opposite page: This simple poster shows a bomb heading toward the sun of the Japanese flag, which also has a swastika at its center. The artist Zudor thus shows that Japan and Germany are the common enemies and that American production will destroy them both. It was commissioned by the War Production Board. In May 1942 Vice President Henry G. Wallace stated: "Hitler knows as well as those of us who sit in on the War Production Board meetings that we here in the United States are winning the battle of production. He knows that both labor and business in the United States are doing a most remarkable job and that his only hope is to crash through to a complete victory some time during the next six months."

Above: This 1942 poster by Norman Rockwell stresses the dependence of the frontline soldier on the factory worker. Of the design Rockwell said: "When, during the recent war, the Ordnance Department gave me the suggestion for this poster, I made a rough sketch which was approved by the Army. Then a neighbor of mine, Colonel Fairfax Ayers, a retired Army officer, arranged to have a gun crew and machine gun sent to my studio. They arrived in a jeep, to the great excitement of our Arlington boys. The gunner insisted that I picture his gun in gleaming good order, but he let me rip his shirt. This final poster represents one of our grand soldiers in a tough spot on the firing line. The coil of cartridge tape and the empty cartridges show that he is about down to his last shot."

Below: This Charles Coiner poster of 1942, intended to boost war production, is a very effective design that combines a motto with the American flag. Before the war Coiner designed the Blue Eagle symbol for the National Recovery Administration. This was a federal agency created to encourage industrial recovery and combat unemployment under the Roosevelt administration. During World War II, he designed posters such as this one for the Office of War Information.

Opposite page: This poster was created by the photographer Roy Schatt, who started as an illustrator for government agencies in the 1930s, under the presidency of Franklin D. Roosevelt. In addition to his poster work, Schatt directed shows during World War II while with the U.S. Army's special forces in India. However, he is best known for his portraits of movie icon James Dean taken in the 1950s.

LIBERTY FOR ALL

KEEP 'EM FLYING

PENNA ART WPA

BELOW: One of the many posters calling for scrap drives that appeared during the war. In 1942, there were two scrap drives in San Francisco alone, in September and October. Though the scrap drives were hugely successful, some went overboard. For example, in addition to old streetcar tracks, wrought iron fences, and church bells, people also donated relics of previous conflicts, such as cannons, park statues, and other war memorials.

OPPOSITE PAGE: This poster is encouraging skilled laborers to join the Seabees, the Naval Construction Force that built advanced bases in war zones. On December 28, 1941, Rear Admiral Ben Moreell requested specific authority to raise naval construction units, and on January 5, 1942, he gained authority from the Bureau of Navigation to recruit men from the construction trades for assignment to a Naval Construction Regiment composed of three Naval Construction Battalions. This was the beginning of the famous Seabees.

UNITED WE WIN

OWI PHOTO BY LIBERMAN

WAR MANPOWER COMMISSION • WASHINGTON, D. C.

The Jap way—
COLD-BLOODED MURDER

Japs Execute Group of Tokyo Air Raiders

Bonds Will Avenge Them!

Allied Ship Toll Topped '42 Building

Downs 7 Japs In One Fight

U.S. Bonds Act Murder; Retribution Is Promised

We'll make them pay if you keep up PRODUCTION

U. S. ARMY OFFICIAL POSTER

OPPOSITE PAGE: The Office of War Information sponsored this 1943 poster, which shows factory workers at an integrated aircraft plant during World War II. Executive Order 8802, issued in June 1941, prohibited government contractors from engaging in employment discrimination based on race, color, or national origin. This resulted in tens of thousands of African Americans, both men and women, being able to find work in war production.

ABOVE: This poster makes use of the Japanese execution of three U.S. Air Force personnel who were captured after the Doolittle raid against Japan in April 1942. The raid had boosted morale in both America and Britain, and the trial and subsequent execution of three men by the Japanese outraged Allied public opinion. This poster makes use of this sense of outrage to promise retribution against Japan "if you keep up production."

BLACKOUT *means*

BLACK

ISSUED BY THE OAKLAND DEFENSE COUNCIL
WPA ART PROGRAM

...ses the importance of having finger-
...fication. Some groups had no choice in
...example, were required to register and
...be imprisoned. The Enemy Alien Act of
...ny citizen of a country with which the
...solely on their nationality, and
...nduct in World War II, this was
...nese descent, 70,000 of whom were

ABOVE: This poster issued by California
reminds citizens of the need for complete
defense procedures. People needed lit...
Pearl Harbor the residents of the state...
invasion. The state's beaches were stro...
coastal cities were blacked out, and cit...
and businesses. Radio stations went o...
were grounded, and ships were orderd...
never came, but Californians remained...

BELOW: The artist Edward T. Grigware was a War Record painter for the U. S. Navy during World War II. He did much of his work on the aircraft carrier USS *Enterprise* during the Pacific campaigns. He also produced a number of posters. This poster was issued by the Thirteenth Naval District, which consisted of the geographic areas of Washington, Oregon, Idaho, Montana, and Wyoming.

OPPOSITE PAGE: A variation on the "careless talk costs lives" and "loose lips sink ships" themes. In this Frederick Siebel poster a drowning sailor points accusingly. It was one of many American posters which warned against careless chatter concerning the locations of troops or ships. These posters were displayed in shipyards, army and navy posts, waterfront bars, and restaurants.

KEEP MUM

LOOSE TALK
COSTS LIVES

PAGE: This poster reminds citizens to be mindful of careless ___ to let the military speak for the nation. It was designed by ___ansley, who worked for a billboard company before the war. The ___witzer in the poster symbolizes America's large output of ___ry to fight the Axis alliance.

ABOVE: This poster suggests that careless communication may be harmful to the war effort, showing a train blowing up, presumably ___ result of sabotage by enemy agents. This poster was issued in M___ which during the war received more than 15,000 German and I___ prisoners of war. The initial reaction to enemy prisoners was often ___tile, with many fearing the enemy in their midst. However, Misso___ farmers experienced an extreme shortage of manpower for plan___ tending, and harvesting their crops, and the prisoners proved ex___ useful in alleviating the situation.

BELOW: A 1943 poster that reminds people that careless communication could be harmful to the war effort. Letters from service personnel were censored for two main reasons. First, if they contained anything that would be of value to the enemy, such as troop dispositions or convoy movements. Second, if they were critical of the war effort in general.

OPPOSITE PAGE: This 1943 poster depicts a dead U.S. Navy sailor on a beach, with the waves washing around him. By the second year of the war posters were beginning to show corpses, emphasizing that war is brutal and bloody. This being the case, everyone had to redouble their efforts to bring about victory.

ANTON OTTO FISCHER

a careless word...

A NEEDLESS LOSS

STAMP 'EM OUT!

Buy

U.S. STAMPS *and* BONDS

A. BYRNE

WPA WAR SERVICES of LA.

ks patriotism with the need to avoid
dge allegiance" and the display of the
he to make this a powerful poster. The
merican schoolchildren, and even by

ABOVE: A poster encouraging the p
support the war effort. The faces o
leaders (from left to right, Mussol
as Defense Bonds, their name was
Japanese attack on Pearl Harbor. D
a mere 2.9 percent return after a 1

He Gives 100%
You Can Lend 10%

Buy
WAR STAMPS·BONDS

WPA WAR SERVICES OF LA JOHN MC CRADY

SAVE FREEDOM OF WORSHIP

EACH ACCORDING TO THE DICTATES
OF HIS OWN CONSCIENCE

NORMAN ROCKWELL

BUY WAR BONDS

OPPOSITE PAGE: A war bonds poster that uses the image of a Tuskegee Airman. The Tuskegee Airmen were named after an African American squadron based in Tuskegee, Alabama in 1941. African American pilots proved their worth during the war, winning 150 Distinguished Flying Crosses, 744 Air Medals, 8 Purple Hearts, and 14 Bronze Stars. It is a sobering thought that, despite the efforts of African Americans in World War II, the U.S. armed forces were not desegregated until 1948.

ABOVE: A poster of a Norman Rockwell painting, one of his "Four Freedoms" series of paintings he created during the war. In January 1941 President Roosevelt made a speech to Congress, stating: "We look forward to a world founded upon four essential human freedoms. The first is freedom of speech and expression—everywhere in the world. The second is freedom of every person to worship God in his own way—everywhere in the world. The third is freedom from want—everywhere in the world. The fourth is freedom from fear—anywhere in the world." The speech inspired Rockwell. At first the government rejected his offer to create paintings on the "Four Freedoms" theme, using four scenes of everyday American life. But *The Saturday Evening Post*, one of the nation's most popular magazines, commissioned and reproduced the paintings. Thereafter they served as the centerpiece of a massive U.S. war bond drive.

BELOW: The U.S Treasury believed that posters conveying a "personal appeal" were the most effective. The image of the soldier throwing a grenade in this poster was thought to have this "personal appeal." The artist was Bernard Perlin, who during the war worked for *Life* and *Fortune* magazines.

OPPOSITE PAGE: A Ferdinand Warren poster selling war bonds. Like Soviet posters, U.S. propaganda art liked to portray massed armaments on the ground and in the air. Far from being fantasy, this was an accurate representation of American military might in the last two years of the war.

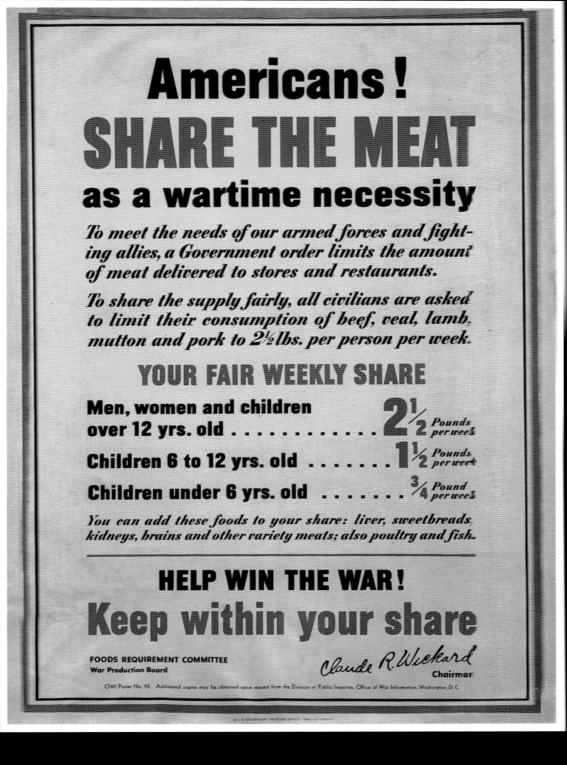

GROW IT YOURSELF

PLAN A FARM GARDEN NOW

Soil Conservation, Farm Administration, U.S. Department of Agriculture

BELOW: The government wanted a healthy population, which meant a healthy workforce and healthy recruits for the armed forces. However, a major problem was that rationing meant an enormous change in eating habits. Protein was in short supply, as meat, fish, poultry, eggs, and cheese were rationed. Many Americans found it very difficult to adjust to the enormous change in eating habits brought on by rationing.

OPPOSITE PAGE: Preventative measures were encouraged during the war. This poster highlights the potential health risks from exposure to flies. House flies may spread diseases such as conjunctivitis, poliomyelitis, typhoid fever, tuberculosis, anthrax, leprosy, cholera, diarrhea, and dysentery. Flies can also transmit diseaes to animals such as cattle, swine, and poultry.

DON'T WASTE WATER

PHILADELPHIA COUNCIL OF DEFENSE

PENNA ART WPA

ABOVE: Raymond Wilcox created this si... Pennsylvania Works Progress Administra... some 9.9 million citizens ved in Penns... each of them drank an average of 2 g... day, then they would consume almost f... liters) daily. People were therefore enco... leaky faucets, turning off the water whi... and recycling bath water to use in the...

BELOW: A poster promoting the eradication of syphilis, showing children playing and reading. The incidence of syphilis was actually very small, both among the general population and in the armed forces. For example, there were only 21,929 cases of syphilis in the U.S. Army in the European theater between 1942 and 1945.

OPPOSITE PAGE: The consumption of healthy foods was seen as a vital part of the effort on the home front. A government pamphlet printed in 1944 stated: "The slogan in this war has been 'Food Is a Weapon of War—As Important as Guns and Ammunition!' In response American farmers have planted more acreage, especially to high-nutrient crops like soybeans and peanuts, raised more livestock, particularly hogs, and produced more dairy products—cheese, butter, and eggs needed by our allies. Despite a shortage of labor and machinery, but with the help of very favorable climate, 1942 agricultural production, including crops, livestock, and livestock products, rose 24 per cent and 1943 production 29 per cent above that of the average years 1935–39."

EAT
THESE EVERY DAY

MILK—a pint for adults—more for children cheese or evaporated milk or dried milk **ORANGES** tomatoes grapefruit—raw cabbage or salad greens at least one of these **VEGETABLES** green or yellow—some raw some cooked **FRUITS** in season also dried and canned fruit **BREAD** and cereal—whole grain products or enriched white bread and white flour **MEAT** poultry fish—dried beans peas or nuts **EGGS**—3 or 4 a week cooked any way you choose or used in prepared dishes— **BUTTER** vitamin rich fats and peanut butter Then eat any other foods you may choose

This is your AIR RAID PROTECTION

Get it NOW

SAND

FIRST AID

PENNSYLVANIA STATE COUNCIL OF DEFENSE
CAPITOL BUILDING, HARRISBURG, PA. ★

ters calling to Victory Gardens, state
that contained "Fifteen Steps for the
Follow." They contained advice such as:
ably well and well exposed to sun and
recommend the atter in Western Kansas
Northeastern States good air

BELOW: A poster produced for the Office of Special Services in March 1943. At this time the Philippines was under Japanese occupation, and this intensely patriotic poster was designed to boost Filipino morale. During the occupation the Filipino resistance was extremely active, with around 260,000 people in guerrilla organizations fighting the Japanese. Their effectiveness was such that by the end of the war, Japan controlled only 12 of the 48 provinces in the Philippines.

OPPOSITE PAGE: One of the most sophisticated examples of atrocity propaganda that came out of the war. This poster by Karl Koehler and Victor Ancona won the first prize in the "Nature of the Enemy" section of the U.S. Artists for Victory competition in 1942. Interestingly, it uses a stereotype of the monocled Prussian officer that dated back to the propaganda images of World War I.

This is the Enemy

ARMY CIVILIAN NAVY

★ ★ ★ ★ ★ ★ ★

ALASKA
DEATH · TRAP
FOR THE JAP

THIRTEENTH NAVAL DISTRICT · UNITED STATES NAVY

OPPOSITE PAGE: United China Relief was founded in 1941 when five
prominent American relief organizations merged to aid the people of
China. The aim of the organization was to ease the suffering of the sick
and refugees, provide aid for wounded Chinese servicemen, and also to
aid the units fighting the Japanese in China. Note how the artist,
Martha Sawyers, has softened the Oriental features of the Chinese
people in the picture. The young child could almost pass for an all-
American girl.

ABOVE: In contrast this poster depics the
be exterminated just as one kills pests i
enemy was less than human made it ea
regularly shown to service personne tha
enemy. *Our enemy the Japanese*, produ
of War Information, Bureau of Motion P
hatred against the Japanese within he
noted: "You cannot measure the Japane
Western yardstick. Their weapons are m
years out of date"

Index

AMERICA COOKS

A CULINARY JOURNEY
FROM COAST TO COAST

Co-ordination of location photography by Hanni Penrose
Food photography by Peter Barry, Jean-Paul Paireault and Neil Sutherland

CLB 2330
© 1989 Colour Library Books Ltd., Godalming, Surrey, England.
Color separation by Hong Kong Graphic Arts Ltd., Hong Kong.
Printed and bound in Italy by New Interlitho.
All rights reserved.
This 1989 edition published by Arch Cape Press, a division of dilithium Press, Ltd.,
distributed by Crown Publishers, Inc., 225 Park Avenue South, New York, New York 10003.
ISBN 0 517 67921 3
h g f e d c b a

Previous page: Fruit Meringue Chantilly

AMERICA
COOKS

A CULINARY JOURNEY
FROM COAST TO COAST

JUDITH FERGUSON

ARCH CAPE PRESS
New York

CONTENTS

Previous pages: pumpkins ripen in the fall
sunshine in Vermont (main picture), and (inset)
Butter Fish, a Stephen Mack recipe photographed
at his Chase Hill Farm home in coastal Rhode
Island. These pages: Crudité Vegetable
Presentation with New Hampshire Horseradish and
Garlic Dip.

The food of the southwestern and western United States is a mixture too; a colorful one of Mexican, Spanish and American Indian origin. Most of the area that forms the southwestern United States was once part of Mexico and was ceded to our country after the war with Mexico ended. Spanish influence was strong in the area, but the food that has evolved owes just as much to the diet of the native Indians.

Tex-Mex style was born here, a style that has over the years Americanized many favorite Mexican dishes. When we think of Mexican food, something hot immediately springs to mind. But not all the food from this part of the country is packed with fiery chili peppers. Many dishes are a subtle combination of fragrant spices, and are a lot easier on the palate.

Tortillas, flat breads made with different varieties of cornmeal, are a staple here in the Southwest. They appear as an accompaniment to a meal, even breakfast, while also forming the foundation for many delicious appetizers and main courses.

In the western states there is also a good proportion of plain country cooking using fresh local ingredients. There are plenty of meat recipes, for this is cattle raising country, but also some for fresh trout, bass and for seafood from the Gulf of Mexico. Barbecues are a favorite way of cooking here, and everyone has a special sauce used to baste the meat. No discussion of cooking from this part of the country would be complete without mentioning chili. So popular is this soup-stew that contests are held all over the area and fierce debates arise over the best ingredients to include.

California cooking combines elements from the rest of the western states with a bit of the Southwest, a bit of the Orient and a lot of creativity and spontaneity. There is just no stopping Californians from trying something new! The Oriental influence arrived with the Chinese immigrants who came to California attracted by work on building the railroads. Spanish influence was here from the earliest days. There is a Spanish flavor to the architecture, and to the food as well.

The California style of cooking is informal but demands that great care be taken to ensure the appetizing appearance of the finished dish. Tex-Mex cooking is popular here, too, but salads like crab Louis and soups like the famous Cioppino are what classic California cookery is all about.

Vegetables flourish in the Napa and Sonoma valleys. Artichokes and avocados, real California foods that have become popular all over the country, were introduced by Italian settlers. Wine making is extremely important to California and the finished product is highly regarded, even by Europeans used to their own fine wines. In California, the spirit of experimentation and innovation definitely extends to the kitchen.

The Pacific states of Washington, Oregon, Alaska, and Hawaii are all very different and so, too, is their culinary history. Washington and Oregon are wilderness areas, with thickly forested mountains, craggy peaks and raging rivers. They also have extremely sophisticated cities like Seattle and Portland, where the restaurants are as fine as any in the country and the choice of food just as diverse. Mainly, however, these states are a collection of small towns whose livelihoods depend on the sea. Not surprisingly, fish features largely in the area's cuisine, salmon being the most prized. Often served to celebrate the Fourth of July, salmon from the Pacific Northwest is hard to surpass. Oregon is also justly famous for its oysters. Olympia oysters, some of the smallest, are the most highly valued. Delicious apples from Washington are favorites all over the country for pies, sauces, and desserts.

Alaska and Hawaii, the last two states to join the union, could not be more different. Walking along the beach in the tropical paradise that is Hawaii, it must be difficult indeed to imagine what it's like to live in Alaska, where glaciers crash into ice blue water, polar bears lumber across frozen lakes, and snowshoes are standard apparel. Alaska does have beautiful summers, too, but in our mind's eye we always visualize it in deepest winter.

Hearty food was the order of the day during the gold mining days in Alaska. Hungry miners wanted no-nonsense grub and plenty of it. However, tastes in food have changed here as they have all over the country, and a taste for fish has made Alaskan salmon and crab popular everywhere in America.

The Hawaiian Islands are a marvelous mixture of ethic groups – Caucasians, Japanese, Portuguese, Chinese, Korean – and the food is a marvelous mixture, too. Think of Hawaii and you think of tropical fruit like pineapples, papaya, guava, mangoes and bananas. These ingredients appear constantly in Hawaiian food as desserts or as additions to meat and seafood dishes. Pork is the main meat choice and, of course, seafood plays a major part in Hawaiian diets.

The Oriental inflence is strong in Hawaii and combines with the tropical produce to form a cuisine unlike that in any other part of the country. A luau, the famous Hawaiian feast, is a positive celebration of food during which cooking, eating, dancing and singing go on until the early hours of the morning.

America is indescribably rich in food tradition and history. Our carefully selected recipes capture the vastness of the United States, its natural resources and ethnic influences. *America Cooks* presents an illustrated journey across our great country. Although we could not stop in every city or village, we hope that you will enjoy visiting your neighbors to the North, South, East, and West. You will recognize both our common heritage and cultural diversity as you sample the delicious easy-to-follow recipes. The essense of the country and its people is so well revealed in traditional recipes. These recipes reflect the history of the country as it was being built and are an immediate indication of the background of the people who helped to build it. The spirit of America is also revealed in the original recipes that evolved from the growth and change of the United States.

As each new group of immigrants came to America during its history they brought their own ways of cooking with them, and their own particular tastes in food have been stamped indelibly on the appetite of the nation. However much trends in eating change, and they have enormously during the last ten years, there are recipes that remain the same and remind us of who we are and where we came from.

Game was plentiful in the thickly forested hills. Settlers from Europe were familiar with cooking game and contributed many a recipe for a rich stew based on venison, rabbit, or game birds. There were wild mushrooms to be gathered and added to omelets and soups just as there were in the Old World. New England contributed much to the country's culinary heritage, and recipes that began here spread down the Eastern Seaboard to other states that were formed from those original thirteen colonies.

The Mid-Atlantic region lies between New England and the South and its food has something in common with both. Philadelphia was of the utmost importance to the development of early America. It was here that the Declaration of Independence was signed and the Constitution drafted. Pennsylvanian recipes range from the sophisticated city food to the basic, simple farm fare of the Amish community in Lancaster County, which has a strong German influence.

New York City probably offers a wider choice of food in one place than anywhere else in the country. The recipes of every ethnic group in the nation can be sampled in New York City. Look here, too, for the very best of the new trends in cooking.

From the Delaware and New Jersey shores come an abundance of seafood recipes like crab cakes and stuffed quahog clams. You'll find delicious dishes like oysters casino and baked sea trout, and you can treat yourself to a feast of steamed crabs cooked in a spicy shellfish boil which is very southern in taste.

The southern states are often grouped together as one geographical region, and while it is true that the cooking from this region has a thread of similarity running through it, it also holds very interesting contrasts. On one hand is the gracious style of living that the South is famous for through its history and its present – a picture of elegant plantation houses with cool, shady verandas – ideal settings for a leisurely meal on a hot summer afternoon. On the other hand is its farming heritage, which supplies hearty, unpretentious fare made up of whatever ingredients were on hand, simmered slowly while the work of the day went on.

This area of the United States takes in a lot of territory – down the east coast of the country and around the Gulf of Mexico, along the Mississippi, through the mountains of West Virginia, Arkansas and Tennessee and into the horse-breeding country of Kentucky. French settlers spread their culinary heritage throughout the south, but especially in Louisiana, Mississippi and the Carolinas. Virginia and Georgia share the English heritage that is strong in New England, while the Spanish influence can be tasted in the dishes of Florida. Wherever you go in this region, though, there are familiar foods like biscuits, corn muffins, fried chicken, and country ham that immediately make you feel at home.

The bayou country, those marshy, mysterious backwaters of Louisiana, is home to a kind of cooking that is distinctly southern but also distinctly individual. It's called Cajun.

French settlers expelled from Acadia in Nova Scotia in the 18th century came to this area to join the Spanish and the black slaves already established. The word Acadian became Cajun and a new culture grew, one that was not entirely French, but a colorful mixture. The Cajuns had their own dialect of French and, of course, their own style of cooking.

Their food was based on French country cooking, adapted to the local ingredients. Cajun cooks exchanged ideas with the Spanish, African and West Indian people they met, and these different influences combined with the French influence already there. Wonderful names like gumbo, African for okra, and jambalaya appear in the Cajun culinary repertoire. Seafood figures largely in a Cajun menu, as does the use of hot spices and fiery tabasco sauce. A particular mixture called blackening is often used to give fish, poultry, or meat a crisp, tasty and charred outer coating.

Does Cajun food differ from Creole? The answer is yes and no. Both rely on brown roux, a cooked mixture of flour and oil of varying shades, to give color to sauces and to thicken them. Both are spicy, often very hot and make liberal use of tomatoes, peppers, celery, rice, orkra, and green onions. But some people say that Creole food is sophisticated while Cajun is rustic. It is difficult to capture the essence of Creole and Cajun cooking in words. The ingredients are vibrant and colorful, but not at all unusual. In the hands of these cooks though, they become something special and make both types of cooking unlike any other.

The Midwest is often called the heartland of America. Its climate is similar to that of Northern Europe and it was settled by people from that part of the world. The land was already under cultivation when they arrived. The native Indians were growing corn, squash and pumpkins, and the newcomers began to include these ingredients in their favorite recipes. Because the land was so suitable for farming, agriculture was at least as tempting a prospect as the fur trade, so many of these newcomers settled here to till the land. Later, immigrants from Germany, Scandinavia, Poland, Hungary, and the Slavic countries joined them along with Italians, and the recipes they brought with them were for comforting, nourishing and warming food. This was the kind of food to sustain them through long working days and harsh winters.

They raised dairy cattle in Wisconsin, corn in Kansas and wheat in Nebraska. While farming was and is important, this mixed group of people who became Midwesterners founded great industries and great cities, too, like Chicago. Here you'll find little restaurants in out-of-the-way places that still prepare the recipes our grandparents brought with them. Midwestern cities and their surrounding suburbs have all the diversity you could possibly want when it comes to food. You'll find old-fashioned soups and stews, hearty meat dishes, and traditional desserts.

Pot roast has always been a favorite here and has much in common with the sauerbraten recipes German settlers brought with them. Harvest vegetable soup makes good use of a bumper crop of vegetables from this farming region. Bread pudding is a perfect winter dessert and really warms up supper on a cold evening. Good down-to-earth cooking epitomizes the culinary history of the Midwest

INTRODUCTION

American cooking is a fascinating subject, but a very misunderstood one. Its image has suffered much from the recent increase in fast food restaurants. Many people think that Americans exist on nothing but hamburgers, milk shakes, and fast fried chicken. They often think that we eat huge portions of food, badly prepared and unimaginatively presented. *America Cooks* presents the glorious food of the United States.

But good cooks all over the United States know better, and they are helping to change opinions about American cuisine. American cooking is as diverse as the people who settled the country. The recipes utilize the variety and bounty of the harvests.

The early Americans, whether they came originally from England, Western Europe, Eastern Europe, Africa, or the Far East, all brought their own culinary heritage with them. Once in their new home, they did the practical thing and adapted those recipes to the local ingredients. Americans, always independent and innovative, are still experimenting with their favorite recipes today. As eating habits and tastes change, recipes are adapted to comply with those changes.

Because convenience is appreciated, more interesting frozen and packaged foods, usually based on dishes everyone already knows and likes, appear on the market all the time. However, tradition is still alive. You have only to look at a typical Thanksgiving dinner menu to know that that's true. Dishes that are cherished all over the country and those passed down through generations are an important part of our national heritage, and are far too special ever to disappear completely from American tables.

To find out more about American cooking you have to look at each region in the country – at its people, its produce, its climate, its landscape and its history. The natural place to start is where the country started – in New England and the original Thirteen Colonies.

Though not all of New England was part of the Thirteen Colonies, it was in Massachusetts that the Pilgrims landed after their long voyage from England, and thus this is one of the important regions in the birth of America.

We learn from our earliest schooldays the important part the provision of food played in the colonization of the New World. The first settlers landed with stores of hardtack (hard biscuits), cheese, beer and dried fish. This was the harsh and restrictive diet that had sustained them on their journey and, naturally anxious for some fresh food, they found the wealth of clams, oysters, and mussels very welcome. They brought seeds with them from the Old World for the crops they were accustomed to growing. When these crops failed and starvation threatened, the settlers had to turn to the crops of the New World to survive. They discovered unusual foods that were destined to become staple crops and favorites of generations of Americans.

The first colonists learned about the local foods from the native Indians. They found out about corn, squash, tomatoes and pumpkins. The Indians had succeeded in domesticating wild turkeys, and introduced the colonists to what was to become the centerpiece of our national feast.

Cranberries, a true North American food, proved to be very versatile. The Indians used this berry as a fabric dye and a poultice for arrow wounds as well as for food. Pilgrim women soon discovered that cranberries brightened up a meal, and they began making sauces, pies, breads and puddings with them. Here were all the makings of the first Thanksgiving dinner – a celebration of hard work and survival. We still enjoy these same foods every year at Thanksgiving.

The English colonists left their stamp on our earliest recipes, giving us the meat pies and steamed puddings still found in our national fare. But immigrants of other nationalities have had just as large an influence on what we eat today. Recipes brought from home were adapted to make use of ingredients available in the new land. For instance, one of the most American of dishes – clam chowder – is said to have French origins. French fishermen used to celebrate the safe return of the fleet by contributing a portion of the catch and cooking it right at the dock in large kettles – *chaudières* – from which the word chowder is derived. The fish was combined with salt pork, onions, potatoes, and milk to make a thick, creamy soup-stew that was a meal in itself. Since clams were cheap and plentiful in this part of the world and available without going to sea, they formed one of the variations that evolved from these dockside soups.

How tomatoes first slipped into clam chowder no one really knows. New Englanders, though, maintain that they don't belong there! Controversy has raged for at least a century over the use of tomatoes in clam chowder. So seriously do New Englanders take the taste and appearance of one of their favorite soups that a bill was even introduced in one of the states' legislatures outlawing the use of tomatoes in this dish.

Seafood played a very important part in the diets of the early settlers. They learned from the Indians how to dig for clams and how to steam them in pits dug on the beach. They built wood fires in these pits, placed on the clams, covered them with seaweed and then blankets weighted down with stones. This was the beginning of the New England clambake. Lobsters were everyday fare, and so cheap and plentiful that hosts often apologized to their guests if this was all there was to eat.

America Cooks

CHAPTER

1

SOUPS AND APPETIZERS

Previous pages: Mrs. Samuel G. Stoney's Black River Pâté – a South Carolina recipe of French origin. Below: Cornmeal Pancakes – a light appetizer New Mexico style.

MRS. SAMUEL G. STONEY'S BLACK RIVER PATE

This is an old French Huguenot dish which has been in the Stoney family for generations.

Preparation Time: 45 minutes
Cooking Time: approximately 1 hour

INGREDIENTS

3 parts leftover venison
1 part butter
Coarse black pepper and salt to taste

METHOD

Put the venison through the finest blade of a meat grinder twice. Work the pepper into the butter and add salt to taste. Combine the venison and seasoned butter in a Pyrex dish and pound with a wooden mallet until the pâté forms a solid mass. Smooth the top and bake at 325°F for approximately 1 hour, or until golden brown. Chill before serving.

To serve, cut into thin slices and serve with hominy or salad. The pâté will keep indefinitely in the refrigerator.

MRS. WILLIAM S. POPHAM (NEE STONEY)
CHARLESTON, SC
(FROM "CHARLESTON RECEIPTS,"
COMPILED AND EDITED BY THE JUNIOR
LEAGUE OF CHARLESTON, INC.)

Facing page: Tomato and Celery Soup, a hearty dish from the Bluegrass State.

TOMATO CELERY SOUP

The addition of the fresh vegetables makes canned tomato soup taste homemade.

Preparation Time: 15 minutes
Cooking Time: 5 minutes
Serves: 4

INGREDIENTS

1 small onion, chopped
½ cup finely chopped celery
2 tbsps butter
1 10½oz can of tomato soup
1 can water
1 tsp chopped parsley
1 tbsp lemon juice
1 tsp sugar
¼ tsp salt
⅛ tsp pepper

GARNISH
¼ cup unsweetened cream, whipped
Chopped parsley

METHOD

Sauté the onion and celery in the butter, but do not brown. Add the tomato soup, water, parsley, lemon juice, sugar, salt and pepper. Simmer for 5 minutes. The celery will remain crisp. To serve, pour into 4 bowls and top each with a spoonful of unsweetened whipped cream and a sprinkling of chopped parsley.

COURTESY ELIZABETH C. KREMER
FROM THE TRUSTEES HOUSE DAILY
FARE, PLEASANT HILL, KENTUCKY
PLEASANT HILL PRESS, HARRODSBURG,
KENTUCKY 1970 AND 1977

CORNMEAL PANCAKES

Cornmeal, either yellow, white or blue, is an important ingredient in Southwestern recipes. Here it's combined with corn in a light and different kind of appetizer.

Preparation Time: 30 minutes
Cooking Time: 3-4 minutes per pancake
Serves: 4

INGREDIENTS

1 cup yellow cornmeal
1 tbsp flour
1 tsp baking soda
1 tsp salt
2 cups buttermilk
2 eggs, separated
Oil
10oz frozen corn
Red pepper preserves
Green onions, chopped
Sour cream

METHOD

Sift the dry ingredients into a bowl, adding any coarse meal that remains in the strainer. Mix the egg yolks and buttermilk together and gradually beat into the dry ingredients. Cover and leave to stand for at least 15 minutes. Whisk the egg whites until stiff but not dry and fold into the cornmeal mixture.

Lightly grease a frying pan with oil and drop in about 2 tbsps of batter. Sprinkle with the corn and allow to cook until the underside is golden brown. Turn the pancakes and cook the second side until golden. Continue with the remaining batter and corn. Keep the cooked pancakes warm. To serve, place three pancakes on warm side plates. Add a spoonful of sour cream and red pepper preserves to each and sprinkle over finely sliced or shredded green onions.

Simmer for 20 minutes. Purée the pumpkin mixture in small batches, adding cream to each small batch. Return the soup to the rinsed out pot and reheat gently. Serve hot.

NEW ENGLAND CULINARY INSTITUTE,
MONTPELIER, VT

Facing page: Cream of Pumpkin Soup – delicious and warming fare for the cold November evenings. This page: the placid waters of the Scioto flow past government buildings in Columbus, Ohio.

CREAM OF PUMPKIN SOUP

There are more ways of using a pumpkin than just as a pie filling, and this soup is one of the nicest. For fun, use a hollowed out, well-cleaned pumpkin as a tureen to serve the soup.

Preparation Time: 25 minutes
Cooking Time: 20 minutes
Serves: 4-6

INGREDIENTS

4 tbsps butter
1 large onion, thinly sliced
1 pumpkin, 4-5lbs in weight
Nutmeg
Salt and pepper
1 cup heavy cream

METHOD

Wash and peel the pumpkin, remove the seeds and cut the flesh into cubes with a sharp knife. Set aside. Melt the butter in a large pot and add the onion. Sweat the onion slowly until it is fairly tender. Add the pumpkin chunks and 1 quart of cold water. Season with salt and pepper and a pinch of nutmeg.

OLD-FASHIONED SPLIT PEA SOUP WITH HAM

This soup is a favorite all over the country, but the addition of a ham bone is particularly New England-style. Garnishes such as crôutons, bacon bits or chopped parsley lend added interest to this soup. The addition of crusty bread and a salad creates a wonderful, hearty repast.

Preparation Time: 30 minutes plus overnight soaking
Cooking Time: 1½-2 hours
Serves: 8

INGREDIENTS

1lb dried, green split peas
2½ quarts water
2lbs ham hocks or a meaty ham bone
¼lb onion, diced
¼lb carrots, peeled and diced
¼lb celery hearts and leaves, finely diced
2 tbsps bacon or pork renderings
2 medium bay leaves
2 whole cloves
3 whole black peppercorns
½ tsp garlic powder
½ tsp thyme
1 tsp Worcestershire sauce

America Cooks

CHAPTER

4

POULTRY
AND GAME

Previous pages: Breasts of Chicken Vicksburg, a refined Southern way of serving chicken.
Right: buttressed trees in Mississippi swampland.

BREASTS OF CHICKEN VICKSBURG

This delicious chicken is sure to be as popular with your guests as it is with the guests at the Magnolia Inn in Vicksburg

Preparation Time: 30 minutes
Cooking Time: 45 minutes
Serves: 6

INGREDIENTS

6 chicken breasts, split and skinned
¼ cup flour
2½ tsps salt
1 tsp paprika
½ cup butter
¼ cup water
2 tsps cornstarch
1½ cups half and half or light cream
¼ cup sherry
1 cup mushrooms, sliced
1 cup Swiss cheese, grated
½ cup fresh parsley, chopped

TO SERVE

6 slices of bread, toasted and with the crusts removed
6 thin slices of cooked ham

METHOD

Coat the chicken pieces with a mixture of the flour, salt and paprika. Melt half of the butter in a heavy skillet with a cover. Lightly brown the chicken in the hot butter, then add the water and simmer the chicken, covered, for 30 minutes, or until tender. Remove the chicken and set aside. Blend ¼ cup of the half and half into cornstarch. Add this to the drippings in the skillet and cook over a low heat, stirring constantly. Gradually add the rest of the half and half and the sherry. Continue cooking and stirring until the sauce is smooth and thickened. Add the grated cheese to the hot sauce and blend until the cheese is melted. Sauté the mushrooms in the remaining butter, drain and add to the sauce. Gently warm the ham slices.

To serve, place the pieces of toast on a large, oblong platter. Top each with a slice of warm ham, then a chicken breast. Cover each serving with the hot sauce. Garnish with chopped parsley and paprika. The serving may also be arranged separately in small individual casserole dishes.

MARTIN LAFFEY,
DELTA POINT RIVER RESTAURANT,
VICKSBURG, MS

BARBECUE CHICKEN

Here is a delicious alternative to Southern Fried Chicken.

Preparation Time: 20 minutes
Cooking Time: 1 hour 20 minutes
Serves: 4

INGREDIENTS

1 fryer chicken (about 2½lbs), cut into pieces
½ cup flour
Salt and pepper

SAUCE

1 medium onion, chopped
2 tbsps vegetable oil

The sternwheeler *Tom Sawyer* (above) on the Mississippi River at St. Louis, Missouri recalls the state's colorful and elegant past. Something of the South's famous hospitality and elegance can be captured in dishes such as Chicken and Dumplings (facing page).

2 tbsps vinegar
2 tbsps brown sugar
¼ cup lemon juice
1 cup ketchup
3 tbsps Worcestershire sauce
½ tbsp prepared mustard
1 cup water
Dash Tabasco sauce

METHOD

Shake the chicken pieces in a paper bag containing the flour, salt and pepper. Brown in a heavy skillet using a small amount of vegetable oil. Drain off any excess oil and place the chicken in a shallow baking pan. Set aside while you prepare the sauce. To make the sauce, brown the onion in the vegetable oil in a heavy skillet. Add the remaining sauce ingredients and simmer for 20 minutes. Pour the sauce over the chicken and bake, uncovered, at 325°F for 1 hour, or until the chicken is tender. Baste frequently with the sauce during the cooking time.

DORIS BELCHER, MEMPHIS, TN

CHICKEN AND DUMPLINGS

Chicken and Dumplings brings all the warmth and friendliness of a Georgia country kitchen home to you.

Preparation Time: 20 minutes
Cooking Time: 2½-3½ hours

Serves: 6-8

INGREDIENTS

1 large boiling hen
4oz butter
Water to cover
Salt and pepper to taste

DUMPLINGS

4 cups plain flour
1½ cups ice water

GARNISH

Fresh or dried parsley

METHOD

Place the hen and the butter in a large pot and pour over water to cover. Boil for 2-3 hours, or until the hen is very tender, adding extra water if necessary. Remove the hen and allow to cool, reserving the broth. When the hen is cool enough to handle, remove the bones, cut the meat into serving-size pieces and return to the broth. To prepare the dumplings, make a well in the middle of the flour. Pour in the ice water and blend with a fork or with your fingers until the dough forms a ball. Roll out thinly and cut into 2-3-inch-wide strips. Bring the chicken and broth to the boil and season to taste with salt and pepper. Slowly drop the dough strips into the broth. Simmer for 2-4 minutes, or until the dumplings are tender. Serve immediately, garnished with dried or fresh parsley.

SARALYN LATHAM, THE WILLIS HOUSE, MILLEDGEVILLE, GA

CHICKEN AND SEAFOOD ROLL-UPS

These are delicious served with a mushroom cream sauce for a special occasion.

Preparation Time: 30 minutes
Cooking Time: 20-25 minutes
Serves: 8

INGREDIENTS

8 chicken breasts, boned
2 cups stuffing, such as seasoned bread or corn bread
crumbs, moistened with stock
1 cup shrimp, cooked and sliced in half
8oz crab meat
1 cup flour, seasoned with salt and pepper
4 eggs, beaten
1 cup milk
12oz butter

METHOD

Combine the stuffing, shrimp and crab meat. Spoon this mixture over the chicken breasts. Roll up the chicken, tucking the ends inside. Dip the rolls first in the beaten eggs, then in flour, then in the milk, then in flour again. Melt the butter in a skillet until bubbling. Gently brown the roll-ups, then drain and place them in an oiled baking pan. Bake at 350°F for 20-25 minutes.

SARALYN LATHAM, THE WILLIS HOUSE,
MILLEDGEVILLE, GA

RIVER INN QUAIL

Definitely a dish for special occasions, this is deceptively simple, impressive and perfect for entertaining.

Preparation Time: 25 minutes
Cooking Time: 45-50 minutes
Serves: 4

INGREDIENTS

12 dressed quail
6 tbsps butter
3 tbsps oil
1 clove garlic, crushed
4oz mushrooms, sliced
4 tbsps chopped pecans or walnuts
4 tbsps raisins
1 cup chicken stock
Salt and pepper
3 tbsps sherry
1 tbsp cornstarch
1 tsp tomato paste (optional)
1 bunch watercress

METHOD

Rub each quail inside and out with butter. Pour the oil into a baking pan large enough to hold the quail comfortably. Cook in a pre-heated 350°F oven for about 25 minutes, uncovered. Remove the pan from the oven and place under a pre-heated broiler to brown the quail. Add garlic, mushrooms, pecans, raisins and stock to the quail. Replace in the oven and continue to cook, uncovered, until the quail are tender — a further 20 minutes. Remove the quail and other ingredients to a serving

Facing page: Chicken and Seafood Roll-Ups. Below: Broad Street, Charleston, South Carolina.

dish, leaving the pan juices behind. Mix the cornstarch and sherry and add it to the pan, stirring constantly. Place the pan over medium heat and cook until the cornstarch thickens and clears. If the baking pan isn't flameproof, transfer the ingredients to a saucepan before thickening the sauce. Add tomato paste, if necessary, for color. Pour the sauce over the quail and garnish with watercress to serve.

PIGEONS IN WINE

Pigeons are country fare and these are treated in a provincial French manner with the Cajun touch of white, black and red pepper.

Preparation Time: 30 minutes
Cooking Time: 50 minutes-1 hour
Serves: 4

INGREDIENTS

4 pigeons
½ tsp each cayenne, white and black pepper
2 tbsps oil
2 tbsps butter or margarine
12oz button onions
2 sticks celery, sliced
4 carrots, peeled and sliced
4 tbsps flour
1½ cups chicken stock
½ cup dry red wine
4oz button mushrooms, quartered or left whole if small
3oz fresh or frozen lima beans

Below: Pigeons in Wine.

2 tsps tomato paste (optional)
2 tbsps chopped parsley
Pinch salt

METHOD

Wipe the pigeons with a damp cloth and season them inside the cavities with the three kinds of pepper and a pinch of salt. Heat the oil in a heavy-based casserole and add the butter or margarine. Once it is foaming, place in the pigeons, two at a time if necessary, and brown them on all sides, turning them frequently. Remove from the casserole and set them aside. To peel the button onions quickly, trim the root ends slightly and drop the onions into rapidly boiling water. Allow it to come back to the boil for about 1 minute. Transfer to cold water and leave to cool completely. The skins should come off easily. Trim roots completely. Add the onions, celery and carrots to the fat in the casserole and cook for about 5 minutes to brown slightly. Add the flour and cook until golden brown, stirring constantly. Pour in the stock and the wine and stir well. Bring to the boil over high heat until thickened. Stir in the tomato paste, if using, and return the pigeons to the casserole along with any liquid that has accumulated. Partially cover the casserole and simmer gently for about 40-45 minutes, or until the pigeons are tender. Add the mushrooms and lima beans halfway through the cooking time. To serve, skim any excess fat from the surface of the sauce and sprinkle over the chopped parsley.

CHICKEN NUEVA MEXICANA

A very stylish and contemporary dish, this uses ingredients that have always been part of the cuisine of the Southwest.

Preparation Time: 1 hour
Cooking Time: 50 minutes
Serves: 6

INGREDIENTS

6 chicken thighs, skinned and boned
2 tbsps mild chili powder
2 tbsps oil
Juice of 1 lime
Pinch salt
Oil for frying

LIME CREAM SAUCE
¾ cup sour cream or natural yogurt
1 tsp lime juice and grated rind
6 tbsps heavy cream
Salt

CORN CRÊPES
1 cup fine yellow cornmeal
½ cup flour
Pinch salt
1 whole egg and 1 egg yolk
1 tbsp oil or melted butter or margarine
1½ cups milk
Oil for frying

GARDEN SALSA
1 large zucchini
1 large ripe tomato
2 shallots
1 tbsp chopped fresh coriander
Pinch cayenne, pepper and salt
1 tbsp white wine vinegar
3 tbsps oil

AVOCADO AND ORANGE SALAD

2 oranges
1 avocado, peeled and sliced
Juice of 1 lime
Pinch sugar
Pinch coriander
6 tbsps pine nuts, toasted

METHOD

Place the chicken in a shallow dish. Combine the chili powder, oil, lime juice and salt and pour over the chicken. Turn the pieces over and rub the marinade into all the surfaces. Cover and refrigerate for 2 hours. Combine all the ingredients for the Lime Cream Sauce and fold together gently. Cover and leave 2 hours in the refrigerator to thicken. Sift the cornmeal, flour and salt for the crêpes into a bowl or a food processor. Combine the eggs, oil and milk. Make a well in the center of the ingredients in the bowl and pour in the liquid. Stir the liquid ingredients with a wooden spoon to gradually incorporate the dry ingredients. Alternatively, combine all the ingredients in a food processor and process until smooth. Leave the batter to stand for 30 minutes whichever method you choose. Trim the ends of zucchini and cut into small dice. Peel the tomatoes and remove the seeds. Cut the tomato flesh into small dice. Cut the shallots into dice the same size as the zucchini and tomato. Combine the coriander, cayenne pepper, vinegar, oil and salt, mixing very well. Pour over the vegetables and stir to mix. Cover and leave to marinate. Heat a small amount of oil in a large frying pan and place in the chicken in a single layer. Fry quickly to brown both sides. Pour over remaining marinade, cover and cook until tender, about 25 minutes. Heat a small amount of oil in an 8 inch crêpe or frying pan. Wipe out with paper towel and return the pan to the heat until hot. Pour a spoonful of the batter into the pan and swirl to coat the bottom with the mixture. Make sure the edge of each crêpe is irregular. When the edges of each crêpe look pale brown and the top surface begins to bubble, turn the crêpes using a palette knife. Cook the other side. Stack as each is finished. Cover with foil and keep warm in a low oven. Pour about 2 tbsps oil into a small frying pan and when hot add the pine nuts. Cook over moderate heat, stirring constantly until golden brown. Remove and drain on paper towels. Peel and segment the oranges over a bowl to catch the juice. Cut the avocado in half, remove the stone and peel. Cut into thin slices and combine with the orange. Add the remaining ingredients for the salad, except the pine nuts, and toss gently to mix. To assemble, place one corn crêpe on a serving plate. Place one piece of chicken on the lower half of the crêpe, top with a spoonful of Lime Cream Sauce. Place a serving of Garden Salsa and one of Avocado and Orange Salad on either side of the chicken and partially fold the crêpe over the top. Scatter over pine nuts and serve immediately.

VENISON STEW

Preparation Time: 30 minutes
Cooking Time: 2 hours 10 minutes
Serves: 6-8

INGREDIENTS

3lbs venison shoulder or leg, cut into 2 inch pieces
2 cups dry red wine
4 tbsps red wine vinegar
1 bay leaf
2 tsps chopped fresh thyme or 1 tsp dried thyme
6 juniper berries, crushed
3 whole allspice berries
6 black peppercorns
1 clove garlic, crushed
4 tbsps oil
2 carrots, cut into strips
1 onion, thinly sliced
2 sticks celery, cut into strips
8oz mushrooms, sliced
Chopped parsley to garnish

METHOD

Combine the wine, vinegar, bay leaf, thyme, juniper berries, allspice, peppercorns and garlic with the venison, and marinate overnight. Remove the meat from the marinade and pat dry on paper towels. Reserve the marinade for later use.

Left: Bison at Yellowstone National Park's Opalescent Pool, Wyoming.
Below: Venison Stew.

Above: Brunswick Stew.

Facing page: Chicken with Red Peppers.

8oz salt pork, rinded and cut into ¼ inch dice
3 medium onions, finely chopped
3 pints water
3 14oz cans tomatoes
3 tbsps tomato paste
4oz fresh or frozen lima beans
4oz corn
2 large red peppers, seeded and cut into small dice
3 medium potatoes, peeled and cut into ½ inch cubes
Salt and pepper
1-2 tsps cayenne pepper or tabasco, or to taste
2 tsps Worcester sauce
1 cup red wine

METHOD

Shake the pieces of chicken in the flour in a plastic bag as for Fried Chicken. In a large, deep sauté pan, melt the butter until foaming. Place in the chicken without crowding the pieces and brown over moderately high heat for about 10-12 minutes. Remove the chicken and set it aside. In the same pan, fry the salt pork until the fat is rendered and the dice are crisp. Add the onions and cook over moderate heat for about 10 minutes, or until softened but not browned. Pour the water into a large stock pot or saucepan and spoon in the onions, pork and any meat juices from the pan. Add the chicken, tomatoes and tomato paste. Bring to the boil, reduce the heat and simmer for about 1-1½ hours. Add the lima beans, corn, peppers and potatoes. Add cayenne pepper or tabasco to taste. Add the Worcester sauce and red wine. Cook for a further 30 minutes or until the chicken is tender. Add salt and pepper to taste. The stew should be rather thick, so if there is too much liquid, remove the chicken and vegetables and boil down the liquid to reduce it. If there is not enough liquid, add more water or chicken stock.

CHICKEN WITH RED PEPPERS

Easy as this recipe is, it looks and tastes good enough for guests. The warm taste of roasted red peppers is typically Southwestern.

Preparation Time: 30-40 minutes
Cooking Time: 30 minutes
Serves: 4

INGREDIENTS

4 large red peppers
4 skinned and boned chicken breasts
1½ tbsps oil
Salt and pepper
1 clove garlic, finely chopped
3 tbsps white wine vinegar
2 green onions, finely chopped
Sage leaves for garnish

METHOD

Cut the peppers in half and remove the stems, cores and seeds. Flatten the peppers with the palm of your hand and brush the skin sides lightly with oil. Place the peppers skin side up on the rack of a pre-heated broiler and cook about 2 inches away from the heat source until the skins are well blistered and charred. Wrap the peppers in a clean towel and allow them to stand until cool. Peel off the skins with a small vegetable knife. Cut into thin strips and set aside. Place the chicken breasts between two sheets of plastic wrap and flatten by hitting with a rolling pin or meat mallet. Heat 1½ tbsps oil in a large

Heat the oil in a heavy frying pan or casserole and brown the venison on all sides over very high heat. Brown in several small batches if necessary. Remove the venison and lower the heat. If using a frying pan, transfer the venison to an ovenproof casserole. Lower the heat and brown the vegetables in the oil until golden. Sprinkle over the flour and cook until the flour browns lightly. Combine the vegetables with the venison and add the reserved marinade. Cover and cook the stew in a pre-heated 300°F oven for about 2 hours. Fifteen minutes before the end of cooking time, add the mushrooms and continue cooking until the meat is tender. Garnish with parsley before serving.

BRUNSWICK STEW

Peppers, potatoes, corn, tomatoes, onions and lima beans are staple ingredients in this recipe, which often includes squirrel in its really authentic version.

Preparation Time: 1 hour
Cooking Time: 2 hours
Serves: 6-8

INGREDIENTS

3lbs chicken portions
6 tbsps flour
2 tbsps butter or margarine

frying pan. Season the chicken breasts on both sides and place in the hot oil. Cook 5 minutes, turn over and cook until tender and lightly browned. Remove the chicken and keep it warm. Add the pepper strips, garlic, vinegar and green onions to the pan and cook briefly until the vinegar loses its strong aroma. Slice the chicken breasts across the grain into ¼ inch thick slices and arrange on serving plates. Spoon over the pan juices. Arrange the pepper mixture with the chicken and garnish with the sage leaves.

NEW ENGLAND ROAST TURKEY

The Thanksgiving celebration would not be the same without a turkey on the table. Native Indians first domesticated the bird and introduced the early settlers to it.

Preparation Time: 25-30 minutes
Cooking Time: 4-4½ hours
Serves: 10-12

INGREDIENTS

1 fresh turkey weighing about 20lbs
⅓ cup butter

SAUSAGE STUFFING

4 tbsps oil
4oz sausage meat
3 sticks celery, diced
2 onions, diced
1 cup chopped walnuts or pecans
1 cup raisins
1lb day-old bread, made into small cubes
1 cup chicken stock
¼ tsp each dried thyme and sage
2 tbsps chopped fresh parsley
Salt and pepper

METHOD

Singe any pin feathers on the turkey by holding the bird over a gas flame. Alternatively, pull out the feathers with tweezers. Remove the fat which is just inside the cavity of the bird. To prepare the stuffing, heat the oil and cook the sausage meat, breaking it up with a fork as it cooks. Add the celery, onion, nuts and raisins and cook for about 5 minutes, stirring constantly. Drain away the fat and add the herbs, cubes of bread and stock, and mix well. Season to taste. Stuff the cavity of the bird using your hands or a long-handled spoon. Save some stuffing to tuck under the neck flap to plump it. Sew the cavity of the bird closed, or use skewers to secure it. Tie the legs together but do not cross them over. Tuck the neck skin under the wing tips and, if desired, use a trussing needle and fine string to secure them. Place the turkey on a rack, breast side up, in a roasting pan. Soften the butter and spread some over the breast and the legs. Place the turkey in a pre-heated 325°F oven and cover loosely with foil. Roast for about 2 hours, basting often. Remove the foil and continue roasting for another 2-2½ hours, or until the internal temperature in the thickest part of the thigh registers 350°F. Alternatively, pierce the thigh with a skewer — if the juices run clear then the turkey is done. Allow to rest for about 15-20 minutes before carving. Make gravy with the pan juices if desired and serve.

CHICKEN POT PIE

Not a true pie, this dish is nevertheless warming winter fare with its creamy sauce and puffy biscuit topping.

Facing page: Mystic Seaport, Connecticut's recreated shipbuilding town, is a living monument to the state's seafaring past.

Left: Chicken Pot Pie.

Preparation Time: 25 minutes
Cooking Time: 20-30 minutes
Serves: 6

INGREDIENTS

4 chicken joints, 2 breasts and 2 legs
5 cups water
1 bay leaf
2 sprigs thyme
1 sprig rosemary
1 sprig fresh tarragon or ¼ tsp dry tarragon
4 whole peppercorns
1 allspice berry
4 tbsps white wine
2 carrots, peeled and diced
24 pearl onions, peeled
6 tbsps frozen corn kernels
½ cup heavy cream
Salt

BISCUIT TOPPING

3½ cups all-purpose flour
1½ tbsps baking powder
Pinch salt
5 tbsps butter or margarine
1½ cups milk
1 egg, beaten with a pinch of salt

METHOD

Place the chicken in a deep saucepan with water, herbs and spices and wine. Cover and bring to the boil. Reduce the heat and allow to simmer for 20-30 minutes, or until the chicken is tender. Remove the chicken from the pot and allow to cool. Skim and discard the fat from the surface of the stock. Skin the chicken and remove the meat from the bones. Continue to simmer the stock until reduced by about half. Strain the stock and add the carrots and onions. Cook until tender and add the corn. Stir in the cream and add the chicken. Pour into a casserole or into individual baking dishes. To prepare the

topping, sift the dry ingredients into a bowl or place them in a food processor and process once or twice to sift. Rub in the butter or margarine until the mixture resembles small peas. Stir in enough of the milk until the mixture comes together. Turn out onto a floured surface and knead lightly. Roll out with a floured rolling pin and cut with a pastry cutter. Brush the surface of each biscuit with a mixture of egg and salt. Place the biscuits on top of the chicken mixture and bake for 10-15 minutes in a pre-heated oven at 375°F. Serve immediately.

Right: New Hampshire's abundant game is used to full effect in this attractive Brace of Duck in Pears and Grand Marnier presentation.

BRACE OF DUCK IN PEARS AND GRAND MARNIER

This dish is perfect for entertaining because it is impressive while being very easy to prepare. Fruit is always the perfect complement for the richness of duck and the mustard, Grand Marnier and honey add extra interest to the sauce. With New Hampshire's abundance of game, this sauce can also be used with wild duck.

Preparation Time: 20 minutes
Cooking Time: 50 minutes
Oven Temperature: 400°F
Serves: 4

INGREDIENTS

2 whole duck breasts cut from 6lb ducklings

SAUCE
2 ripe pears, peeled, cored and seeded
1 tsp mustard
1 cup Grand Marnier
1 cup honey

METHOD

Roast the two duck breasts in a hot oven for about 30 minutes. Meanwhile, prepare the sauce. Purée the pears with the mustard, Grand Marnier and honey. Simmer for about 20 minutes. When the duck has cooked for 30 minutes, drain off the fat, place the duck breasts back in the pan and pour over the sauce. Lower the oven temperature to 400°F and bake for another 20 minutes. Skim any fat from the sauce and pour over the duck to serve.

JAMES HALLER'S KITCHEN
PORTSMOUTH, NH

POACHED CHICKEN WITH CREAM SAUCE

Plainly cooked chicken can be as flavorful as it is attractive.

Preparation Time: 25 minutes
Cooking Time: 1 hour 10 minutes
Serves: 4

INGREDIENTS

4½lb whole roasting chicken
8-10 sticks celery, washed, cut into 3 inch lengths and tops reserved
4oz bacon, thickly sliced
2 cloves garlic, crushed
1 large onion, stuck with 4 cloves

Facing page: Poached
Chicken with Cream
Sauce.

1 bay leaf
1 sprig fresh thyme
Salt and pepper
Water to cover
⅓ cup butter or margarine
6 tbsps flour
1 cup light cream

METHOD

Remove the fat from just inside the cavity of the chicken. Singe any pin feathers over gas flame or pull them out with tweezers. Tie the chicken legs together and tuck the wing tips under to hold the neck flap. Place the chicken in a large casserole or stock pot. Chop the celery tops and add to the pot. Place the bacon over the chicken and add the garlic, onion with the cloves, bay leaf, sprig thyme, salt, pepper and water to cover. Bring to the boil, reduce the heat and simmer gently, covered, for 50 minutes, or until the chicken is just tender. Cut the celery into 3 inch lengths and add to the chicken. Simmer a further 20 minutes, or until the celery is just tender. Remove the chicken to a serving plate and keep warm. Strain the stock and reserve the bacon and celery pieces. Skim fat off the top of the stock and add enough water to make up 2 cups, if necessary. Melt 1 tbsp of the butter or margarine in the casserole and sauté the bacon until just crisp. Drain on paper towels and crumble roughly. Melt the rest of the butter in the casserole or pan and when foaming take off the heat. Stir in the flour and gradually add the chicken stock. Add the cream and bring to the boil, stirring constantly. Simmer until the mixture is thickened. Untie the legs and trim the leg ends. If desired, remove the skin from the chicken and coat with the sauce. Garnish with the bacon and the reserved celery pieces.

Right: timeless farming
methods in use by
Pennsylvania's Amish
community.

CHICKEN ST. PIERRE

A French name for a very Southern combination of chicken, lima beans, peppers and onions made into a spicy, aromatic stew.

Preparation Time: 35 minutes
Cooking Time: 40 minutes
Serves: 4-6

INGREDIENTS

3lb chicken, cut in 8 pieces
⅓ cup butter or margarine
3 tbsps flour
1 large red pepper, diced
1 large green pepper, diced
6 green onions, chopped
½ cup dry white wine
1 cup chicken stock
6oz lima beans
1 tsp chopped thyme
Salt, pepper and pinch nutmeg
Dash tabasco (optional)

METHOD

To cut the chicken in 8 pieces, remove the legs first. Cut between the legs and the body of the chicken. Bend the legs backwards to break the joint and cut away from the body. Cut the drumstick and thigh joints in half. Cut down the breastbone with a sharp knife and then use poultry shears to cut through the bone and ribcage to remove the breast joints from the back. Cut both breast joints in half, leaving some white meat attached to the wing joint. Cut through bones with poultry

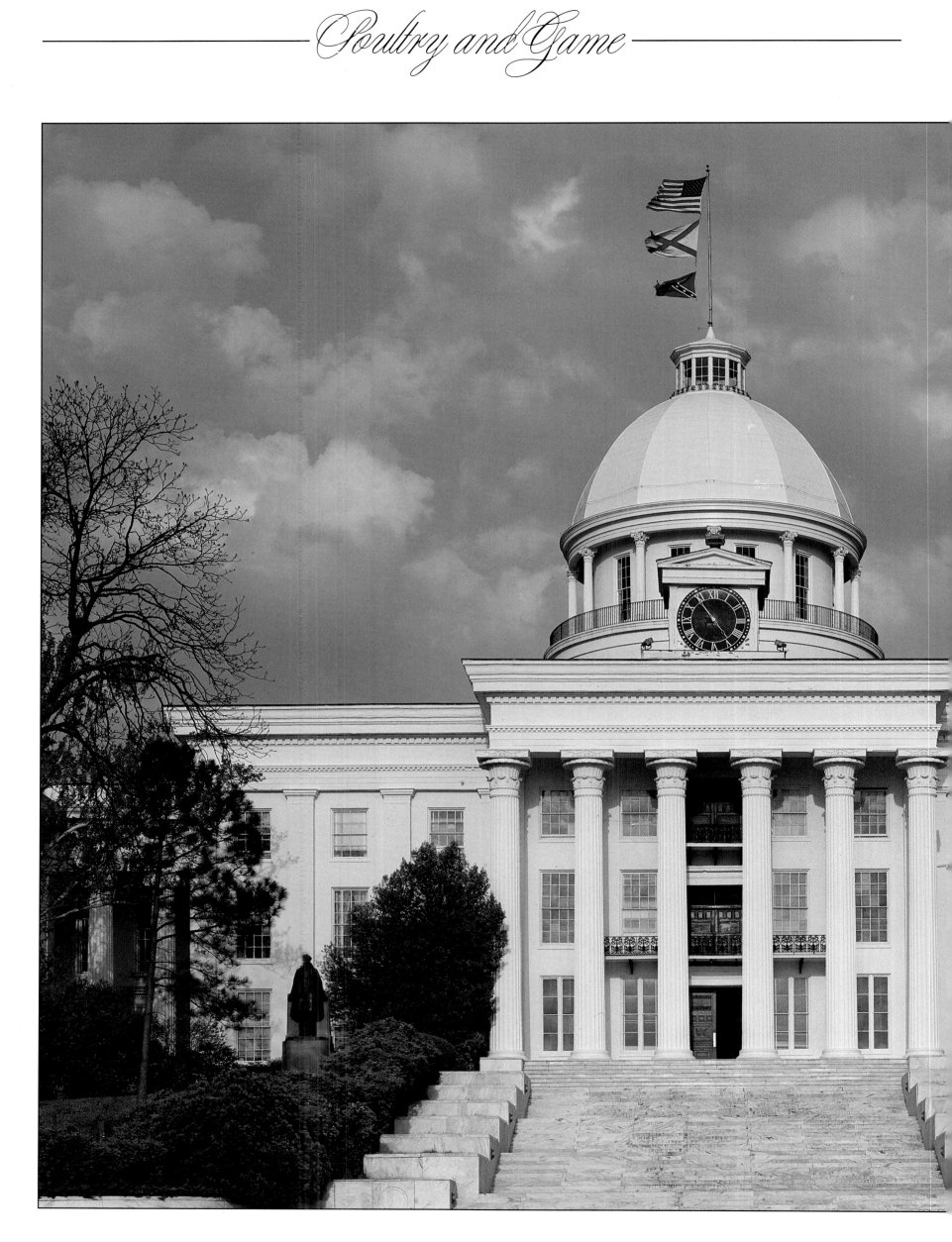

shears. Heat the butter in a large sauté pan and when foaming add the chicken, skin side down. Brown on one side, turn over and brown other side. Remove the chicken and add the flour to the pan. Cook to a pale straw color. Add the peppers and onions and cook briefly. Pour on the wine and chicken stock and bring to the boil. Stir constantly until thickened. Add the chicken, lima beans, thyme, seasoning and nutmeg. Cover the pan and cook about 25 minutes, or until the chicken is tender. Add tabasco to taste, if desired, before serving.

COUNTRY CAPTAIN CHICKEN

A flavorful dish named for a sea captain with a taste for the spicy cuisine of India.

Above: Country Captain Chicken.
Left: the Alabama State Capitol, Montgomery.

Preparation Time: 30 minutes
Cooking Time: 50 minutes
Serves: 6

INGREDIENTS

3lbs chicken portions
Seasoned flour
6 tbsps oil
1 medium onion, chopped
1 medium green pepper, seeded and chopped
1 clove garlic, crushed
Pinch salt and pepper
2 tsps curry powder
2 14oz cans tomatoes
2 tsps chopped parsley
1 tsp chopped marjoram
4 tbsps currants or raisins
4oz blanched almond halves

METHOD

Remove skin from the chicken and dredge with flour, shaking off the excess. Heat the oil and brown the chicken on all sides until golden. Remove to an ovenproof casserole. Pour off all but 2 tbsps of the oil. Add the onion, pepper and garlic and cook slowly to soften. Add the seasonings and curry powder and cook, stirring frequently, for 2 minutes. Add the tomatoes, parsley, marjoram and bring to the boil. Pour the sauce over the chicken, cover and cook in a pre-heated 350°F oven for 45 minutes. Add the currants or raisins during the last 15 minutes. Meanwhile, toast the almonds in the oven on a baking sheet along with the chicken. Stir them frequently and watch carefully. Sprinkle over the chicken just before serving.

CORNISH HENS WITH SOUTHERN STUFFING

Cornbread makes a delicious stuffing and a change from the usual breadcrumb variations. Pecans, bourbon and ham give it a Southern flavor.

Preparation Time: 45-50 minutes
Cooking Time: 14 minutes cornbread
45 minutes–1 hour for the hens
Serves: 6

INGREDIENTS

Full quantity Corn Muffin recipe
2 tbsps butter or margarine
2 sticks celery, finely chopped
2 green onions, chopped
2oz chopped country or Smithfield ham
2oz chopped pecans
2 tbsps bourbon
Salt and pepper
1 egg, beaten
6 Cornish game hens
12 strips bacon

METHOD

Prepare the Corn Muffins according to the recipe, allow to cool completely and crumble finely. Melt the butter or margarine and soften the celery and onions for about 5 minutes over very low heat. Add the ham, pecans, cornbread crumbs and seasoning. Add bourbon and just enough egg to make a stuffing that holds together but is not too wet. Remove the giblets from the hens, if included, and fill each bird with stuffing. Sew up the cavity with fine string or close with small skewers. Criss-cross 2 strips of bacon over the breasts of each bird and tie or skewer the ends of the bacon together. Roast in a pre-heated 400°F oven for 45 minutes – 1 hour, or until tender. Baste the hens with the pan juices as they cook. Remove the bacon, if desired, during the last 15 minutes to brown the breasts, or serve with the bacon after removing the string or skewers.

Right: Cornish Hens with Southern Stuffing.

CHICKEN CROQUETTES

This is a delicious and economical way to use up leftover chicken. Try serving the croquettes with Mushroom Cream Sauce.

Preparation Time: 30 minutes
Cooking Time: 2-4 minutes each
Serves: 8-12

INGREDIENTS

2 cups dry bread crumbs
1½ cups chicken broth
4 cups cooked chicken
1 cup mushrooms
1 tsp chopped onion
½ cup chopped celery
½ tsp salt
⅛ tsp red pepper
1 tbsp chopped parsley
Dash lemon juice

TO FRY

1 cup dry bread crumbs
1 beaten egg
2 tbsps water or milk

METHOD

Soak the bread crumbs in the broth. Meanwhile, grind together the chicken and mushrooms, Combine with the soaked bread crumbs and the rest of the ingredients and allow to cool. Shape into 24 croquettes and chill. To cook, dip each croquette into dry bread crumbs, then into a mixture of beaten egg and water or milk, and finally into bread crumbs again. (This is the secret of good croquettes!) Fry in deep fat, heated to around 375°F, or until a 1 inch cube of bread browns in 1 minute, until golden (approximately 2-4 minutes).

COURTESY ELIZABETH C. KREMER
FROM THE TRUSTEES HOUSE DAILY
FARE, PLEASANT HILL, KENTUCKY
PLEASANT HILL PRESS, HARRODSBURG,
KENTUCKY 1970 AND 1977

Above: Chicken Croquettes.

America Cooks

CHAPTER

5

VEGETABLES
AND SALADS

Previous pages: Butter Bean Salad – a salad with a difference from Alabama.
Facing page: Red Pepper Preserves can add color as well as spice to a main course or appetizer.

BUTTER BEAN SALAD

This salad is a delicious alternative to a mixed green salad, and could form the basis of a light luncheon when served with fresh, hot biscuits.

Preparation Time: 15 minutes
Cooking Time: 40 minutes
Serves: 8

INGREDIENTS

30oz fresh or frozen butter beans
4 cups water
1 tsp salt
4 hard-boiled eggs, chopped
1 small onion, finely grated
1 cup mayonnaise
¾ tsp prepared mustard
¾ tsp Worcestershire sauce
¾ tsp hot sauce

METHOD

Boil the butter beans in the water and salt for 40 minutes. Drain, then combine with the rest of the ingredients. Refrigerate the salad overnight and serve on a bed of lettuce.

STURDIVANT MUSEUM ASSOCIATION, SELMA, AL

Below: Succotash, a dish with a particularly American history.

RED PEPPER PRESERVES

This sweet but hot and spicy condiment adds a bright spot of color and Southwestern flavor to a main course or appetizer.

Preparation Time: 20 minutes
Cooking Time: 20-25 minutes
Makes: 2 cups

INGREDIENTS

5 red peppers, seeded
3 red or green chilies, seeded
1½ cups sugar
¾ cup red wine vinegar
1 cup liquid pectin

METHOD

Chop the peppers and chilies finely in a food processor. Combine the sugar and vinegar in a deep, heavy-based pan and heat gently to dissolve the sugar. Add the peppers and bring the mixture to the boil. Simmer for about 15 or 20 minutes. Stir in the pectin and return the mixture to the boil over high heat. Pour into sterilized jars and seal. Keep for up to one year in a cool, dark place.

SUCCOTASH

A tasty side dish with a strange name, this was inherited from the American Indians, who made it a full meal by adding meat or poultry to it.

Preparation Time: 10 minutes for frozen vegetables
25 minutes for fresh vegetables
Cooking Time: 5-8 minutes for frozen vegetables
8-10 minutes for fresh vegetables
Serves: 6

INGREDIENTS

4 oz fresh or frozen corn
4 oz fresh or frozen lima beans
4 oz fresh or frozen green beans
3 tbsps butter
Salt and pepper
Chopped parsley

METHOD

If using frozen vegetables, bring water to the boil in a saucepan and, when boiling, add the vegetables. Cook for about 5-8 minutes, drain and leave to dry. If using fresh vegetables, bring water to the boil in a saucepan and add the lima beans first. After about 2 minutes, add the green beans. Follow these with the corn about 3 minutes before the end of cooking time. Drain and leave to dry. Melt the butter in a saucepan and add the vegetables. Heat slowly, tossing or stirring occasionally, until heated through. Add salt and pepper to taste and stir in the parsley. Serve immediately.

CORN PUDDING

Preparation Time: 20 minutes
Cooking Time: 45 minutes
Oven Temperature: 350°F
Serves: 6-8

INGREDIENTS

2 cups Carnation milk or thin cream
2 cups canned or fresh corn
2 tbsps melted butter
2 tsps sugar
1 tsp salt
¼ tsp pepper
3 eggs, well beaten

METHOD

Add the milk, corn, butter, sugar and seasonings to the eggs. Pour into a well greased casserole and bake in a moderate oven for about 45 minutes or until the pudding is set. Insert a knife into the center of the pudding and if it comes out clean the pudding is done. For variety, add ¼ cup chopped green peppers or pimento, ½ cup minced ham or chopped mushrooms.

ISABELLA WITT,
DEAN'S MILL FARM,
STONINGTON, CT

Right: Grilled Vegetables, photographed at the home of Arnold Copper, Stonington.

GRILLED VEGETABLES

Cooking food outdoors has long been popular in the United States; it was in colonial times and still is to the present day. Vegetables are delicious with just a hint of charcoal taste and these can be used to accompany grilled meat or for a vegetarian barbecue.

Preparation Time: 30 minutes
Cooking Time: 15-20 minutes

INGREDIENTS

Any combination of the following: summer squash, zucchini squash, yellow onions, yellow, green or red peppers, scallions, large mushrooms, tomatoes, eggplant or other seasonal fresh vegetables

MARINADE
1 stick butter, melted
½ cup fresh lemon juice
Freshly ground pepper

METHOD

Prepare the vegetables as follows: cut summer squash and zucchini squash in half, lengthwise. Cut yellow onions in half around the equator and leave the peels on. Cut the peppers in half, lengthwise and remove the seeds but leave on the stems. Trim the root ends and the thin green ends of the scallions. Trim the stems from the mushrooms. Remove the stems from the tomatoes. Cut the eggplant in half, lengthwise or in quarters if very large. Melt the butter in a small saucepan and add the lemon juice and the pepper. Cook the onions, squashes and eggplant first as they will take the longest to cook. Baste the cut side of all the vegetables and place cut side down on the grill. When they have lightly browned, turn and baste well again. Complete the cooking of the squash, onions and eggplant on their skin sides. Halfway through their cooking time, add the peppers, mushrooms, scallions and tomatoes. Baste all the vegetables well as they cook. If using cherry tomatoes, warm them on the grill for a few seconds, but not for long or they will split and become mushy. The marinade is also excellent when used with chicken.

DANIEL ROUTHIER,
DEAN'S MILL FARM,
STONINGTON, CT

QUICK-FRIED VEGETABLES WITH HERBS

Crisply cooked vegetables with plenty of chives make a perfect side dish, hot or cold.

Preparation Time: 25 minutes
Cooking Time: 5 minutes
Serves: 6

INGREDIENTS

4 sticks celery
4 medium zucchini
2 red peppers, seeded
3-4 tbsps oil
Pinch salt and pepper
1 tsp chopped fresh oregano or marjoram
4 tbsps snipped fresh chives

METHOD

Slice the celery on the diagonal into pieces about 1½ inch thick. Cut the zucchini in half lengthwise and then cut into ½ inch thick slices. Remove all the seeds and the white pith from the peppers and cut them into diagonal pieces about 1 inch. Heat the oil in a heavy frying pan over medium high heat. Add the celery and stir-fry until barely tender. Add zucchini and peppers and stir-fry until all the vegetables are tender crisp. Add the salt, pepper and oregano or marjoram and cook for 30 seconds more. Stir in chives and serve immediately.

CRUDITÉ VEGETABLE PRESENTATION WITH NEW HAMPSHIRE HORSERADISH AND GARLIC DIP

Raw vegetables with dips are easy to prepare and serve and they add a splash of color to an hors d'oeuvre selection. Using a cabbage to hold the dip is a whimsical touch, and you can eat the dish!

Preparation Time: 40 minutes plus overnight chilling
Serves: 8-10

Facing page: the Scottish Rith Cathedral, Indianapolis.

Left: Quick-Fried Vegetables with Herbs.

Right: Sweet Potato
Pudding.
Facing page: Turnip
Greens.

INGREDIENTS

½ lb broccoli flowerets, washed
¼ lb cauliflower flowerets, washed
¼ lb julienne strips of carrot and celery
4 asparagus tips, cut into 3-inch lengths
4 radish rosettes
8 sprigs fresh parsley
1 head red kale or Savoy cabbage

DIP

6oz fresh dairy sour cream
1 tbsp minced fresh garlic
1 tbsp minced fresh horseradish
½ tsp white pepper
½ tsp sea salt
¼ tsp dry mustard
1 tsp cognac

METHOD

Blend all the dip ingredients together and chill 24 hours. Make the radish rosettes and clean and trim the vegetables. Hollow out a space in the cabbage deep enough to hold the dip, fill and place in the middle of an attractive serving dish. Arrange all the vegetables around the cabbage to serve.

GREGORY MARTIN,
WHITE RABBIT CATERING,
HOOKSETT, NH

SWEET POTATO PUDDING

All puddings are not necessarily desserts. This one goes with meat or poultry for an unusual side dish.

Preparation Time: 25 minutes
Cooking Time: 45 minutes–1 hour
Serves: 6

INGREDIENTS

2 medium-size sweet potatoes
2 cups milk
2 eggs
¾ cup sugar
1 tsp cinnamon
¼ cup pecans, roughly chopped
2 tbsps butter
6 tbsps bourbon

METHOD

Peel the potatoes and grate them coarsely. Combine with the milk. Beat the eggs and gradually add the sugar, continuing until light and fluffy. Combine with the cinnamon and the pecans. Stir into the potatoes and milk and pour the mixture into a lightly buttered shallow baking dish. Dot with the remaining butter. Bake about 45 minutes to 1 hour in a pre-heated 350°F oven. Bake until the pudding is set and then pour over the bourbon just before serving.

TURNIP GREENS

Try these greens, which are familiar fare throughout the South.

Preparation Time: 15 minutes
Cooking Time: 45 minutes
Serves: 4

INGREDIENTS

2oz lean salt pork
2 cups boiling water
2lbs turnip greens
Salt to taste

METHOD

Rinse the salt pork, score several times and add to the boiling water. Simmer rapidly for 15 minutes. Meanwhile, wash the greens thoroughly and remove any tough stems. Tear into small pieces. Add to the pork, packing into the saucepan if necessary. Cover and simmer over medium heat for 30 minutes, or until the greens are tender. Taste the broth halfway through the cooking time and add salt if necessary.

CREATIVE CATERERS,
MONTGOMERY, AL

POTATO PANCAKE

This is a great favorite for lunch with apple sauce and is also good as a side dish with braised meats. The coarse grating blade of a food processor can be used to prepare the potatoes more quickly.

Preparation Time: 20-25 minutes
Cooking Time: 10-11 minutes
Serves: 6

INGREDIENTS

3lbs chef potatoes (not baking variety)
1 cup clarified butter
Salt and pepper

Right: Boise, Idaho.

METHOD

Wash and peel the potatoes. Using a mandoline or grater, cut the potatoes into shoestring pieces. Place one or two tablespoons of the butter into a small skillet (5 inches in diameter) on medium heat. Put enough of the shoestring potatoes to cover the bottom of the pan into the hot butter. Season to taste with salt and pepper. Cook the potatoes over medium heat, shaking the pan frequently so they do not stick to the bottom. Press the potato mixture down into the pan with a spoon or spatula, lower the heat and continue cooking slowly for 5-6 minutes. Flip the pancake over and finish cooking the other side for an extra 5 minutes. Remove from the pan and serve immediately or keep warm. Repeat the process until all the potato is used.

NEW ENGLAND CULINARY INSTITUTE,
MONTPELIER, VT

ALL-AMERICAN POTATO SALAD

Here is a delicious salad to serve with the Triple Bean Salad Piquant for a gorgeous summer meal.

Preparation Time: 15 minutes
Cooking Time: 2 hours or more
Serves: 8

INGREDIENTS

4 cups diced cold boiled potatoes
1-2 tbsps minced onion
¼ cup celery, chopped (optional)
2 tbsps chopped pimento
½ cup mayonnaise
¼ cup chopped dill pickle
½ tsp prepared mustard
½ tsp salt
Pepper to taste
2-3 hard-boiled eggs, coarsely chopped

METHOD

Combine all the ingredients except for the eggs, and toss carefully until well mixed. Add the eggs, reserving some for a garnish, and mix gently. Garnish the salad with the reserved eggs and chill for at least 2 hours before serving.

DORIS BELCHER, MEMPHIS, TN

CREAMED ONIONS

Whole small onions in a creamy, rich sauce are part of Thanksgiving fare, but they are too good to save for just once a year.

Preparation Time: 30 minutes
Cooking Time: 10 minutes for the onions and 10 minutes for the sauce
Serves: 4

INGREDIENTS

1lb pearl onions
Boiling water to cover
2 cups milk
1 bay leaf
1 blade mace

Facing page: Squash with Blueberries.

2 tbsps butter or margarine
2 tbsps flour
Pinch salt and white pepper
Chopped parsley (optional)

METHOD

Trim the root hairs on the onions but do not cut the roots off completely. Place the onions in a large saucepan and pour over the boiling water. Bring the onions back to the boil and cook for about 10 minutes. Transfer the onions to cold water, allow to cool completely and then peel off the skins, removing roots as well. Leave the onions to drain dry. Place the milk in a deep saucepan and add the blade mace and the bay leaf. Bring just to the boil, take off the heat and allow to stand for 15 minutes. Melt the butter in a large saucepan and, when foaming, stir in the flour. Strain on the milk and discard the bay leaf and blade mace. Stir well and bring to the boil. Allow the sauce to simmer for about 3 minutes to thicken. Add salt and white pepper to taste and stir in the onions. Cook to heat through, but do not allow the sauce to boil again. Serve immediately and garnish with chopped parsley, if desired.

STUFFED ACORN SQUASH WITH A RUM GLAZE

Squash has a subtle flavor that blends well with other ingredients.

Preparation Time: 30 minutes
Cooking Time: 1 hour
Serves: 4

INGREDIENTS

2 even-sized acorn squash
⅓ cup butter or margarine

Right: Stuffed Acorn Squash with a Rum Glaze.

2 cooking apples, peeled, cored and cut into
½ inch pieces
½ cup pitted prunes, cut into large pieces
1 cup dried apricots, cut into large pieces
½ tsp ground allspice
6 tbsps rum
½ cup chopped walnuts
½ cup golden raisins
½ cup packed light brown sugar

METHOD

Cut the squash in half lengthwise. Scoop out and discard the seeds. Place the squash skin side up in a baking dish with water to come halfway up the sides. Bake for about 30 minutes at 350°F. Melt half the butter in a saucepan and add the apple, prunes and apricots. Add the allspice and rum and bring to the boil. Lower the heat and simmer gently for about 5-10 minutes. Add the nuts and golden raisins 3 minutes before the end of cooking time. Turn the squash over and fill the hollow with the fruit. Reserve the fruit cooking liquid. Melt the remaining butter in a saucepan and stir in the brown sugar. Melt slowly until the sugar forms a syrup. Pour on fruit cooking liquid, stirring constantly. Bring back to the boil and cook until syrupy. Add more water if necessary. Spoon the glaze onto each squash, over the fruit and the cut edge. Bake for a further 30 minutes, or until the squash is tender.

SQUASH WITH CALIFORNIA BLUEBERRIES

This vegetable dish will steal the scene at any meal, so serve it with simply cooked poultry or meat.

Preparation Time: 30 minutes
Cooking Time: 50-55 minutes
Serves: 6

INGREDIENTS

2 acorn squash
1 small apple, peeled and chopped
4 tbsps light brown sugar
Freshly grated nutmeg
4 tbsps butter or margarine
6oz fresh or frozen blueberries

METHOD

Cut the squash in half lengthwise. Scoop out the seeds and discard them. Fill the hollows with the chopped apple. Sprinkle on the sugar and nutmeg and dot with the butter or margarine. Place the squash in a baking dish and pour in about 1″ of water. Bake, covered, for 40-45 minutes at 375°F. Uncover, add the blueberries and cook an additional 10 minutes.

HARVARD BEETS

One of the best known dishes using this readily available root vegetable. The color makes this a perfect accompaniment to plain meat or poultry.

Preparation Time: 20 minutes
Cooking Time: 40-50 minutes
Serves: 6

Left: Sunset over Upper
Herring Lake, Michigan.

INGREDIENTS

2lbs small beets
Boiling water
3 tbsps cornstarch
½ cup sugar
Pinch salt and pepper
1 cup white wine vinegar
¾ cup reserved beet cooking liquid
2 tbsps butter

METHOD

Choose even-sized beets and cut off the tops, if necessary. Place beets in a large saucepan of water. Cover the pan and bring to the boil. Lower the heat and cook gently until tender, about 30-40 minutes. Add more boiling water as necessary during cooking. Drain the beets, reserving the liquid, and allow the beets to cool. When the beets are cool, peel them and slice into ¼ inch rounds, or cut into small dice. Combine the cornstarch, sugar, salt and pepper, vinegar and required amount of beet liquid in a large saucepan. Bring to the boil over moderate heat, stirring constantly until thickened. Return the beets to the saucepan and allow to heat through for about 5 minutes. Stir in the butter and serve immediately.

NAPA VALLEY ARTICHOKES

The Napa Valley is wine growing country, so white wine is a natural choice for cooking one of California's best-loved vegetables.

Preparation Time: 30 minutes
Cooking Time: 40 minutes
Serves: 4

Above: Napa Valley
Artichokes.

Facing page: Zucchini
Slippers.

INGREDIENTS

4 globe artichokes
4 tbsps olive oil
1 clove garlic, left whole
1 small bay leaf
1 sprig fresh rosemary
2 parsley stalks
4 black peppercorns
2 lemon slices
1 cup dry white wine
1 tbsp chopped parsley
Pinch salt and pepper
Lemon slices to garnish

METHOD

Trim stems on the base of the artichokes so that they sit upright. Peel off any damaged bottom leaves. Trim the spiny tips off all the leaves with scissors. Trim the top 1″ off the artichokes with a sharp knife. Place the artichokes in a large, deep pan with all the ingredients except the parsley. Cover the pan and cook about 40 minutes, or until artichokes are tender and bottom leaves pull away easily. Drain upside down on paper towels. Boil the cooking liquid to reduce slightly. Strain, add parsley and serve with the artichokes. Garnish with lemon slices.

CABBAGE
AND PEANUT SLAW

Boiled dressings are old favorites in the South. This one gives a lively sweet-sour taste to basic coleslaw.

Preparation Time: 30 minutes
Serves: 6

Right: Cabbage and
Peanut Slaw.

INGREDIENTS

1 small head white cabbage, finely shredded
2 carrots, shredded
2 tsps celery seed
1 cup dry-roasted peanuts
1 egg
½ cup white wine vinegar
½ cup water
½ tsp dry mustard
2 tbsps sugar

METHOD

Combine the vegetables, celery seed and peanuts in a large bowl. Beat the egg in a small bowl. Add vinegar, water, mustard and sugar and blend thoroughly. Place the bowl in a pan of very hot water and whisk until thickened. Cool and pour over the vegetables.

ZUCCHINI SLIPPERS

Preparation Time: 30 minutes
Cooking Time: 23-25 minutes
Serves: 6

INGREDIENTS

6 even-sized zucchini
4oz cottage cheese, drained
4oz grated Colby cheese
1 small red pepper, seeded and chopped
2 tbsps chopped parsley
Pinch salt and cayenne pepper
1 large egg
Watercress or parsley to garnish

METHOD

Trim the ends of the zucchini and cook in boiling salted water for about 8 minutes, or steam for 10 minutes. Remove from the water or steamer and cut in half. Allow to cool slightly and then scoop out the center, leaving a narrow margin of flesh on the skin to form a shell. Invert each zucchini slipper onto a paper towel to drain, reserving the scooped-out flesh. Chop the flesh and mix with the remaining ingredients. Spoon filling into the shells and arrange in a greased baking dish. Bake, uncovered, in a pre-heated 350°F oven for 15 minutes. Broil, if desired, to brown the top. Garnish with watercress or parsley.

CORN IN THE SHUCK

Southern cooks have developed special methods to preserve the wonderful fresh flavor of summer vegetables. Here is an example.

METHOD

Cut off the top 2 inches of an ear of corn to remove the silk. Remove the outer leaves of the shuck down to the fresh green leaves. Boil the ears in a covered pot for one hour. Remove from the water and pull back the shuck enough to wrap a napkin around it and use it as a handle. Dip the corn in melted butter, then salt and pepper to taste. Corn cooked in this way will retain all of its delicious natural flavor.

BENNETT A BROWN III,
LOWCOUNTRY BARBEQUE CATERING,
ATLANTA, GA

Above: Fresh Creamed Mushrooms.

Right: opulent Southern architecture on Jekyll Island, off the coast of Georgia, recalls a bygone age.

FRESH CREAMED MUSHROOMS

For a recipe that has been around since Colonial times, this one is surprisingly up-to-date.

Preparation Time: 20 minutes
Cooking Time: 7 minutes
Serves: 4

INGREDIENTS

1lb even-sized button mushrooms
1 tbsp lemon juice
2 tbsps butter or margarine
1 tbsp flour
Salt and white pepper
¼ tsp freshly grated nutmeg
1 small bay leaf
1 blade mace
1 cup heavy cream
1 tbsp dry sherry

METHOD

Wash the mushrooms quickly and dry them well. Trim the stems level with the caps. Leave whole if small, halve or quarter if large. Toss with the lemon juice and set aside. In a medium saucepan, melt the butter or margarine and stir in the flour. Cook, stirring gently, for about 1 minute. Remove from the heat, add the nutmeg, salt, pepper, bay leaf and mace and gradually stir in the cream. Return the pan to the heat and bring to the boil, stirring constantly. Allow to boil for about 1 minute, or until thickened. Reduce the heat and add the mushrooms. Simmer gently, covered, for about 5 minutes, or until the mushrooms are tender. Add the sherry during the last few minutes of cooking. Remove bay leaf and blade mace. Sprinkle with additional grated nutmeg before serving.

HOT PEPPER RELISH

Prepare this colorful relish in the summer, when peppers are plentiful, but save some to brighten up winter meals, too.

Preparation Time: 30 minutes
Cooking Time: 45 minutes
Makes: 4 cups

INGREDIENTS

*3lbs sweet peppers (even numbers of red, green,
yellow and orange, or as available), seeded
4-6 red or green chilies, seeded and finely chopped
2 medium onions, finely chopped
½ tsp oregano
½ tsp ground coriander
2 bay leaves
Salt to taste
2 cups granulated or preserving sugar
1½ cups white wine vinegar or white distilled vinegar*

METHOD

Cut the peppers into small dice and combine with the chilies and onions in a large saucepan. Pour over boiling water to cover, and return to the boil. Cook rapidly for 10 minutes and drain well. Meanwhile, combine the sugar and vinegar in a large saucepan. Bring slowly to the boil to dissolve the sugar, stirring occasionally. When the peppers and onions have drained, add them and the remaining ingredients to the vinegar and sugar. Bring back to the boil and then simmer for 30 minutes. Remove the bay leaves and pour into sterilized jars and seal.

BAKED VIDALIA ONIONS

Vidalia onions are large, sweet onions which are flat at both ends. They are grown in the area surrounding Vidalia, Georgia and are delicious eaten raw.

METHOD

To prepare, peel off the outer skin of the onion and cut a thin slice off both ends so that the onion will sit flat. Cut a small well into one end. Place a bouillon cube inside and cover with a pat of butter. Wrap the onion with a square of heavy aluminum foil. Place the wrapped onions on a baking sheet and bake at 350°F for 1½-2 hours, or until the onion is soft. Loosen the foil and transfer the onion to a small bowl using a slotted spoon. Pour the juices over the onion to serve.

ANN DORSEY, FULL SERVICE CATERING,
ATLANTA, GA

COLESLAW

The unusual salad dressing, delicately flavored with dill, makes this coleslaw something special.

Preparation Time: 30 minutes
Serves: 6-8

INGREDIENTS

*1 medium cabbage, shredded
3 carrots, shredded*

Above: Baked Vidalia Onions.

Facing page: Hot Pepper Relish.

Above: Boston Baked Beans, the original American "fast food."

METHOD

Combine the cucumber and onion slices. Sprinkle with the salt and sugar, then add the vinegar and celery seed. Mix thoroughly to combine. Cover and chill until ready to serve.

Garnish this crisp, cool salad with slivers of red radishes for a lovely summery contrast.

PAT COKER, NASHVILLE, TN

BOSTON BAKED BEANS

The first American "fast food", these beans were frozen and taken on long journeys to re-heat and eat en route.

Preparation Time: 20 minutes with overnight soaking
for the beans
Cooking Time: 3½ hours
Serves: 6-8

INGREDIENTS

1lb dried navy beans
5 cups water
4oz salt pork or slab bacon
1 onion, peeled and left whole
1 tsp dry mustard
⅓-½ cup molasses
Salt and pepper

METHOD

Soak the beans overnight in the water. Transfer to fresh water to cover. Bring to the boil and allow to cook for about 10 minutes. Drain and reserve the liquid. Place the beans, salt pork or bacon and whole onion in a large, deep casserole or bean pot. Mix the molasses, mustard, salt and pepper with 1 cup of the reserved bean liquid. Stir into the beans and add enough bean liquid to cover. Expose only the pork rind on the salt pork and cover the casserole. Bake in a pre-heated 300°F oven for about 2 hours. Add the remaining liquid, stirring well, and cook a further 1½ hours, or until the beans are tender. Uncover the beans for the last 30 minutes. To serve, remove and discard the onion. Take out the salt pork or bacon and remove the rind. Slice or dice the meat and return to the beans. Check the seasoning and serve.

DRESSING

¾ cup mayonnaise
1oz red wine vinegar
½ tbsp dill
2 tsp salt
⅛ tsp pepper

METHOD

Combine the shredded carrots and cabbage in a large bowl. To prepare the dressing, blend all the dressing ingredients together in a separate bowl until smooth. Pour this dressing over the shredded vegetables and toss until well coated. Chill well before serving.

ANN DORSEY, FULL SERVICE CATERING, ATLANTA, GA

MARINATED CUCUMBERS

Preparation Time: 20 minutes
Serves 8

INGREDIENTS

4 cucumbers, sliced
1 small onion, thinly sliced
¼ cup sugar
⅔ cup vinegar
½ tsp celery seed
1½ tsps salt

SOUTHERN-STYLE POTATO SOUP

Makes a refreshing soup on a hot day.

Preparation Time: 30 minutes, plus chilling
Cooking Time: approximately 50 minutes
Yield: 1½ quarts

INGREDIENTS

1½ cups green onions, white part only, diced
½ cup onions, chopped
1 tbsp butter
3 cups baking potatoes, peeled and diced
3 cups hot water
3 tsps salt
1 cup hot milk
½ tsp white pepper
1 cup light cream
1 cup heavy cream
8 tsps chopped chives

Facing page: Scotts Bluff, Nebraska.

METHOD

In a heavy 4-quart pot, sauté the onions in the butter until soft, but not brown. Add the potatoes, hot water and 2 tsps of the salt. Simmer, uncovered, for 30-40 minutes, or until the potatoes are soft. Liquidize the potatoes and onions, and return to the pot. Add the hot milk, and slowly bring the soup to a boil, stirring often to keep the potatoes from settling. Add the remaining salt and the pepper. Remove from the heat and strain through a sieve. Cool the soup, stir, then strain again and add the light and heavy cream. Serve chilled and garnished with the chopped chives.

STURDIVANT MUSEUM ASSOCIATION,
SELMA, AL

WALNUT GROVE SALAD

Walnut Grove is a town famous for its walnuts! They add their crunch to a colorful variation on coleslaw.

Preparation Time: 25-30 minutes
Serves: 6

INGREDIENTS

1 small head red cabbage
1 avocado, peeled and cubed
1 carrot, grated
4 green onions, shredded
1 cup chopped walnuts
6 tbsps oil
2 tbsps white wine vinegar
2 tsps dry mustard
Salt and pepper

METHOD

Cut the cabbage in quarters and remove the core. Use a large knife to shred finely or use the thick slicing blade on a food processor. Prepare the avocado as for Avocado Soup and cut

Far left: the dramatic Chicago nighttime skyline. The city's rich ethnic mix ensures a widely varied choice of culinary styles.

Left: Walnut Grove Salad.

Facing page:
presentation is important
to the success of many
dishes, as suggested by
this impressive
Chartreuse of
Vegetables.

it into small cubes. Combine the cabbage, avocado and shredded carrot with the onions and walnuts in a large bowl. Mix the remaining ingredients together well and pour over the salad. Toss carefully to avoid breaking up the avocado. Chill before serving.

HEARTY SPINACH SALAD

This salad is substantial enough to be served as a light luncheon dish.

Preparation Time: 15 minutes
Serves: 6

INGREDIENTS

1lb spinach
½lb fresh mushrooms, sliced
3 hard-boiled eggs, sliced
6 slices bacon, cooked and crumbled

METHOD

Wash the spinach thoroughly and tear it into bite-sized pieces. Toss the spinach with the mushrooms, eggs and bacon in a large salad bowl. Pour Green Goddess Salad Dressing over and serve at once.

ANN HALL, GREY OAKS,
VICKSBURG, MS

CHARTREUSE OF VEGETABLES

A chartreuse in French cooking is a molded dish that has one main ingredient complemented by smaller quantities of choicer ingredients, in this case, fluffy mashed potatoes with a selection of colorful garden vegetables. Be generous with the quantity of mashed potatoes because this is what holds the dish together. Don't be afraid to try it; it only *looks* complicated.

Preparation Time: 40 minutes
Cooking Time: 25 minutes
Oven Temperature: 425°F
Serves: 6–8

INGREDIENTS

Potatoes, peeled and cubed
Carrots, cut in julienne strips
String beans, trimmed
Peas
Zucchini
Summer squash
Cabbage leaves
Brussels sprouts
Cauliflower flowerets

METHOD

Cook the potatoes about 20 minutes and drain them well. Dry over heat while mashing. Trim the carrot sticks and string beans to fit the height of a soufflé dish. Slice the zucchini and summer squash, trim down thick ribs of the cabbage leaves and trim the ends of the Brussels sprouts. Parboil all the vegetables for about 2 minutes. Drain and rinse under cold water and leave to dry. Butter a soufflé dish thickly. Arrange a row of peas along the edge of the bottom of the dish. Next to the peas arrange a row of sliced zucchini and

then fill in the center with circles of summer squash. Line the sides of the dish with carrot sticks and string beans, alternating the two. Butter will hold the vegetables in place. Carefully spread a layer of mashed potato over the bottom and up the sides to completely cover the carrots and beans. Add a thick layer to hold the vegetables together. Place a cabbage leaf or two on top of the potatoes and press gently to firm the vegetables. On the cabbage make a circle of Brussels sprouts around the outside edge and fill in the center with cauliflower. On top of that arrange another circle of zucchini and summer squash. Top with a cabbage leaf and fill with more mashed potatoes, smoothing the top. Bake in a preheated 425°F oven for 20 minutes. Remove from the oven and allow to set for 3-5 minutes before inverting onto a serving dish. If necessary, loosen the sides of the chartreuse from the dish with a sharp knife before turning out.

JAMES HALLER'S KITCHEN
SOUTH BERWICK, ME

MINTED MIXED VEGETABLES

Carrots, cucumber and zucchini are all complemented by the taste of fresh mint. In fact, most vegetables are, so experiment.

Preparation Time: 25-30 minutes
Cooking Time: 6-10 minutes
Serves: 4-6

INGREDIENTS

3 medium carrots
1 cucumber
2 zucchini
½ cup water
1 tsp sugar
Pinch salt
1½ tbsps butter, cut into small pieces
1 tbsp coarsely chopped fresh mint leaves

Right: Minted Mixed
Vegetables.

Above: Creole Tomatoes from Louisiana are a perfect side dish for grilled chicken or fish.

Facing page: Squash Side Dish.

draining spoon. Place immediately in a bowl of ice cold water. Use a small, sharp knife to remove the peel, beginning at the stem end. Cut the tomatoes in half and scoop out the seeds. Strain the juice and reserve it, discarding the seeds. Place tomatoes cut side down in a baking dish and sprinkle over the reserved juice. Add the sliced pepper, onions, garlic, wine, cayenne pepper and salt. Dot with butter or margarine. Place in a preheated 350°F oven for about 15-20 minutes, or until tomatoes are heated through and tender, but not falling apart. Strain juices into a small saucepan. Bring juices to the boil to reduce slightly. Stir in the cream and reboil. Spoon over the tomatoes to serve.

SQUASH SIDE DISH

Preparation Time: 20 minutes
Cooking Time: 15 minutes
Serves: 8

INGREDIENTS

3 tbsps butter
1 medium onion, chopped
1 medium bell pepper, diced
2 medium zucchini squash, sliced
2 medium yellow summer squash, sliced
14½oz can tomato wedges
½ tsp garlic salt
Salt and pepper to taste

GARNISH

Fresh parsley
Grated Parmesan cheese

METHOD

Melt the butter in a heavy skillet, add the onion and cook until transparent. Stir in the bell pepper and continue cooking until soft. Add the squash and seasonings, cover, and simmer until just tender. Drain the tomatoes, reserving the liquid, and add them to the skillet. Cook for an additional 5 to 8 minutes, adding some of the reserved liquid if needed.

Garnish this colorful dish with parsley and sprinkle with Parmesan cheese before serving.

DORIS BELCHER, MEMPHIS, TN

FRIED OKRA

Cornmeal and okra, two Southern specialties, combine in a classic vegetable dish that's delicious with meat, poultry, game or fish.

Preparation Time: 15-20 minutes
Cooking Time: 3 minutes per batch
Serves: 4-6

INGREDIENTS

1 cup yellow cornmeal
1 tsp salt
2 eggs, beaten
1½lbs fresh okra, washed, stemmed and cut crosswise
into ½ inch thick slices
2 cups oil for frying

Left: fertile farmland in Crawford County, Iowa.

METHOD

Combine the cornmeal and salt on a plate. Coat okra pieces in the beaten egg. Dredge the okra in the mixture. Place the oil in a large, deep sauté pan and place over moderate heat. When the temperature reaches 375°F add the okra in batches and fry until golden brown. Drain thoroughly on paper towels and serve immediately.

Above: Fried Okra. Brought to America by African Slaves, okra is a popular vegetable in Southern cooking.

America Cooks

CHAPTER

6

CHEESE, EGGS, PASTA AND RICE

Previous pages:
Chanterelle Omelet.

CHANTERELLE OMELET

Chanterelles, those very French mushrooms, are also frequently found growing wild in wooded areas in Vermont. Avoid washing them, since they absorb water. Just wipe them with damp paper towels if cleaning is necessary. The omelet itself takes less than a minute to cook, so all the ingredients should be at hand before proceeding.

Preparation Time: 15 minutes
Cooking Time: 2-3 minutes
Serves: 1

INGREDIENTS

2 tbsps butter
3 eggs at room temperature
3oz fresh chanterelle mushrooms
2 tbsps finely chopped parsley
Salt and pepper

METHOD

Slice the mushrooms and melt 1 tbsp of the butter in a small pan. Sauté the mushrooms quickly, season with salt and pepper and add the chopped parsley. Set aside and keep them warm. Beat the eggs thoroughly with a fork or whisk in a small bowl. Place the remaining butter in an omelet pan and heat until foaming but not brown. Pour in the eggs and swirl over the bottom of the pan. Immediately stir the eggs with a fork to allow the uncooked mixture to fall to the bottom of the pan. When the mixture is creamily set on top, scatter over the sautéed chanterelles and roll the omelet in the pan by flipping about a third of it to the middle and then flipping it out onto a hot plate.

NEW ENGLAND CULINARY INSTITUTE,
MONTPELIER, VT

SAN FRANCISCO RICE

This rice and pasta dish has been popular for a long time in San Francisco, where it was invented.

Preparation Time: 25 minutes
Cooking Time: 20 minutes
Serves: 4

Right: San Francisco's Golden Gate Bridge.
Top right: San Francisco Rice, a quick and easy vegetarian dish.

Above left: California
Wild Rice Pilaff.
Above: Spicy Rice and
Beans.

INGREDIENTS

4oz uncooked long grain rice
4oz uncooked spaghetti, broken into 2" pieces
3 tbsps oil
4 tbsps sesame seeds
2 tbsps chopped chives
Salt and pepper
1½ cups chicken, beef or vegetable stock
1 tbsp soy sauce
2 tbsps chopped parsley

METHOD

Rinse the rice and pasta to remove starch, and leave to drain dry. Heat the oil in a large frying pan and add the dried rice and pasta. Cook over moderate heat to brown the rice and pasta, stirring continuously. Add the sesame seeds and cook until the rice, pasta and seeds are golden brown. Add the chives, salt and pepper, and pour over 1 cup stock. Stir in the soy sauce and bring to the boil. Cover and cook about 20 minutes, or until the rice and pasta are tender and the stock is absorbed. Add more of the reserved stock as necessary. Do not let the rice and pasta dry out during cooking. Fluff up the grains of rice with a fork and sprinkle with the parsley before serving.

CALIFORNIA WILD RICE PILAFF

Wild rice adds a nutty taste and a texture contrast to rice pilaff. It's good as a side dish or stuffing.

Preparation Time: 25 minutes
Cooking Time: 20 minutes
Serves: 4

INGREDIENTS

4oz uncooked long-grain rice, rinsed
2oz wild rice, rinsed
1 tbsp oil
1 tbsp butter or margarine
2 sticks celery, finely chopped
2 green onions
4 tbsps chopped walnuts or pecans
4 tbsps raisins
1½ cups chicken or vegetable stock

METHOD

Heat the oil in a frying pan and drop in the butter. When foaming, add both types of rice. Cook until the white rice looks clear. Add celery and chop the green onions, reserving the dark green tops to use as a garnish. Add the white part of the onions to the rice and celery and cook briefly to soften. Add the walnuts or pecans, raisins and stock. Bring to the boil, cover and cook until the rice absorbs the liquid and is tender. Sprinkle with reserved chopped onion tops.

SPICY RICE AND BEANS

A lively side dish or vegetarian main course, this recipe readily takes to creative variations and even makes a good cold salad.

Preparation Time: 25 minutes
Cooking Time: 50 minutes
Serves: 6-8

INGREDIENTS

4 tbsps oil
2 cups long grain rice
1 onion, finely chopped

1 green pepper, seeded and chopped
1 tsp each ground cumin and coriander
1-2 tsps tabasco sauce
Salt
3½ cups stock
1lb canned red kidney beans, drained and rinsed
1lb canned tomatoes, drained and coarsely chopped
Chopped parsley

METHOD

Heat the oil in a casserole or a large, deep saucepan. Add the rice and cook until just turning opaque. Add the onion, pepper and cumin and coriander. Cook gently for a further 2 minutes. Add the tabasco, salt, stock and beans and bring to the boil. Cover and cook about 45 minutes, or until the rice is tender and most of the liquid is absorbed. Remove from the heat and add the tomatoes, stirring them in gently. Leave to stand, covered, for 5 minutes. Fluff up the mixture with a fork and sprinkle with parsley to serve.

Far right: the Mission of San Miguel in Santa Fe. Sometimes fiery and often colorful, recipes from this region are always popular. Above right: Chili Rellenos.

CHILI RELLENOS

Organization is the key to preparing these stuffed peppers. Fried inside their golden batter coating, they're puffy and light.

Preparation Time: 40 minutes
Cooking Time: 3 minutes per pepper
sauce 15 minutes
Serves: 8

INGREDIENTS

Full quantity Red Sauce
(see recipe for Southwestern Stir-fry)
8 small green peppers
4 small green chilies, seeded and finely chopped
1 clove garlic, crushed
1 tsp chopped fresh sage
8oz cream cheese

Facing page: the classic
New Orleans Jambalaya,
a filling rice and seafood
stew.

The Italian influence in
American cuisine has
been considerable, but
nowhere is it more
obvious than in New
York. Below: Fettucine
Escargots with Leeks
and Sun-Dried
Tomatoes.

2 cups grated mild cheese
Salt
Flour for dredging
Oil for deep frying
8 eggs, separated
6 tbsps all-purpose flour
Pinch salt
Finely chopped green onions

METHOD

Blanch the whole peppers in boiling water for about 10-15 minutes, or until just tender. Rinse them in cold water and pat them dry. Carefully cut around the stems to make a top, remove and set aside. Scoop out the seeds and cores, leaving the peppers whole. Leave upside down on paper towels to drain. Mix together the chilies, garlic, sage, cheeses and salt to taste. Fill the peppers using a small teaspoon and replace the tops, sticking them into the filling. Dredge the peppers with flour and heat the oil in a deep fat fryer to 375°F. Beat the egg yolks and flour in a mixing bowl until the mixture forms a ribbon trail when the beaters are lifted. Beat the whites with a pinch of salt until stiff but not dry. Fold into the egg yolk mixture. Shape 2 tbsps of batter into an oval and drop into the oil. Immediately slide a metal draining spoon under the batter to hold it in place. Place on a filled pepper. Cover the tops of the peppers with more batter and then spoon over hot oil to seal. Fry until the batter is brown on all sides, turning the peppers over carefully. Drain on paper towels and keep them warm on a rack in a moderate oven while frying the remaining peppers. Sprinkle with onions and serve with Red Sauce.

NEW ORLEANS JAMBALAYA

An easy and extremely satisfying dish of rice and seafood. Sometimes garlic sausage is added for extra spice.

Preparation Time: 40 minutes
Cooking Time: 25-30 minutes
Serves: 4-6

INGREDIENTS

2 tbsps butter or margarine
2 tbsps flour
1 medium onion, finely chopped
1 clove garlic, crushed
1 red pepper, seeded and finely chopped
14oz canned tomatoes
4 cups fish or chicken stock
¼ tsp ground ginger
Pinch allspice
1 tsp chopped fresh thyme or ½ tsp dried thyme
¼ tsp cayenne pepper
Pinch salt
Dash tabasco
4oz uncooked rice
2lbs uncooked shrimp, peeled
2 green onions, chopped to garnish

METHOD

Melt the butter in a heavy-based saucepan and then add the flour. Stir to blend well and cook over low heat until a pale straw color. Add the onion, garlic and pepper and cook until soft. Add the tomatoes and their juice, breaking up the tomatoes with a fork or a potato masher. Add the stock and mix well. Add the ginger, allspice, thyme, cayenne pepper, salt and tabasco. Bring to the boil and allow to boil rapidly, stirring for about 2 minutes. Add the rice, stir well and cover the pan. Cook for about 15-20 minutes, or until the rice is tender and has absorbed most of the liquid. Add the shrimp during the last 10 minutes of cooking time. Cook until the shrimp curl and turn pink. Adjust the seasoning, spoon into a serving dish and sprinkle with the chopped green onion to serve.

FETTUCINE ESCARGOTS WITH LEEKS AND SUN-DRIED TOMATOES

These dried tomatoes keep for a long time and allow you to add a sunny taste to dishes whatever the time of year.

Preparation Time: 15-20 minutes
Serves: 4-6

INGREDIENTS

6 sun-dried tomatoes or 6 fresh Italian plum tomatoes
14oz canned escargots (snails), drained
12oz fresh or dried whole-wheat fettucine (tagliatelle)
3 tbsps olive oil
2 cloves garlic, crushed
1 large or 2 small leeks, trimmed, split, well washed and finely sliced
6 oyster, shittake or other large mushrooms
4 tbsps chicken or vegetable stock
3 tbsps dry white wine

6 tbsps heavy cream
2 tsps chopped fresh basil
2 tsps chopped fresh parsley
Salt and pepper

METHOD

To "sun-dry" tomatoes in the oven, cut the tomatoes in half lengthwise. Use a teaspoon or your finger to scoop out about half the seeds and juice. Press gently with your palm to flatten slightly. Sprinkle both sides with salt and place tomatoes, cut side up, on a rack over a baking pan. Place in the oven on the lowest possible setting, with door ajar, if neccessary, for 24 hours, checking after 12 hours. Allow to dry until no liquid is left and the tomatoes are firm. Chop roughly. Drain the escargots well and dry with paper towels. Place the fettucine in boiling salted water and cook for about 10-12 minutes, or until al dente. Drain, rinse under hot water and leave in a colander to drain dry. Meanwhile, heat the olive oil in a frying pan and add the garlic and leeks. Cook slowly to soften slightly. Add the mushrooms and cook until the leeks are tender crisp. Remove to a plate. Add the drained escargots to the pan and cook over high heat for about 2 minutes, stirring constantly. Pour on the stock and wine and bring to the boil. Boil to reduce by about a quarter and add the cream and tomatoes. Bring to the boil then cook slowly for about 3 minutes. Add the herbs, salt and pepper to taste. Add the leeks, mushrooms and fettucine to the pan and heat through. Serve immediately.

CHEESE OR VEGETABLE ENCHILADAS

Many dishes in Southwestern cooking have Mexican origins, like these tortillas filled with achoice of cheese or spicy vegetable fillings.

Preparation Time: 1 hour
Cooking Time: 23-28 minutes
Serves: 4

INGREDIENTS

8 Tortillas (see recipe)
Full quantity Red Sauce (see Southwestern Stir-fry)

CHEESE FILLING

2 tbsps oil
1 small red pepper, seeded and finely diced
1 clove garlic, crushed
1 tbsp chopped fresh coriander
½ cup heavy cream
½ cup cream cheese
½ cup mild cheese, grated
Whole coriander leaves

VEGETABLE FILLING

2 tbsps oil
1 small onion, finely chopped

Right: Flourless
Chocolate Cake.

the meringues in a tree formation using the fruit and cream mixture to hold the meringues together. Garnish with the remaining fruit and sprinkle with grated chocolate.

PATRICIA McLAUGHLIN,
THE LOBSTER POUND RESTAURANT,
LINCOLNVILLE BEACH, ME

FLOURLESS CHOCOLATE CAKE

This is part mousse, part soufflé, part cake and completely heavenly! It's light but rich, and adored by chocolate lovers everywhere.

Serves: 6

INGREDIENTS

1lb semi-sweet chocolate
2 tbsps strong coffee
2 tbsps brandy
6 eggs
6 tbsps sugar
1 cup whipping cream
Powdered sugar
Fresh whole strawberries

METHOD

Melt the chocolate in the top of a double boiler. Stir in the coffee and brandy and leave to cool slightly. Break up the eggs and then, using an electric mixer, gradually beat in the sugar until the mixture is thick and mousse-like. When the beaters are lifted the mixture should mound slightly. Whip the cream until soft peaks form. Beat the chocolate until smooth and shiny, and gradually add the egg mixture to it. Fold in the cream and pour the cake mixture into a well greased 9″ deep cake pan with a disk of wax paper in the bottom. Bake in a pre-heated 350°F oven in a bain marie. To make a bain marie, use a roasting pan and fill with warm water to come halfway up the side of the cake pan. Bake about 1 hour and then turn off the oven, leaving the cake inside to stand for 15 minutes. Loosen the sides of the cake carefully from the pan and allow the cake to cool completely before turning it out. Invert the cake onto a serving plate and carefully peel off the paper. Place strips of wax paper on top of the cake, leaving even spaces in betweeen the strips. Sprinkle the top with powdered sugar and carefully lift off the paper strips to form a striped or chequerboard decoration. Decorate with whole strawberries.

FOUR-LAYERED CHEESECAKE

The chopped almonds and shredded coconut that form the base of this cheesecake make a delightful change from the graham cracker crust found on most cheesecakes. Also, this crust couldn't be simpler. Various flavors in the layers combine beautifully to make a cheesecake that tastes as good as it looks.

Preparation Time: 30 minutes
Cooking Time: 1 hour 55 minutes
Oven Temperature: 425°F reduced to 225°F
Makes: 1 10-inch cake

INGREDIENTS

½ cup butter, softened
¾ cup each of chopped almonds and shredded coconut

FILLING

3lbs cream cheese
4 eggs
½ cup flour
1 cup confectioners' sugar
½ cup dark bittersweet chocolate, melted
½ cup cognac
½ cup almond paste
½ cup Amaretto

Below: Four-Layered Cheesecake.

½ cup praline paste
½ cup Frangelico
½ cup white chocolate, melted
2 tbsps vanilla
½ cup rum

METHOD

Grease the inside of a 10″ springform pan generously with the softened butter. Dust the pan with a mixture of almonds and coconut. Press the mixture against the butter to help it stick. Combine the cream cheese, eggs, flour and confectioners' sugar and beat until well mixed. Divide the mixture into quarters and add to one quarter the melted dark chocolate and the cognac. Pour this mixture into the pan on top of the crust. To the second quarter, add the almond paste and amaretto and mix well. Carefully spread across the first layer. To the third quarter, add the praline paste and Frangelico. Blend again and lightly spread on top of the last layer. To the final quarter, add the melted white chocolate, vanilla and rum. Pour this over the top and carefully spread out. Place in the oven at 425°F for 15 minutes; reduce to 225°F and bake for another hour and 45 minutes. Remove and allow to cool completely before refrigerating. Chill for 24 hours before serving. Decorate the top with chocolate leaves.

JAMES HALLER'S KITCHEN,
PORTSMOUTH, NH

FRESH FRUIT COBBLER

Serve this tempting dessert warm with cream or whipped cream. You can vary the fruit to suit the season.

Preparation Time: 30 minutes

Cooking Time: 30 minutes
Serves: 6-8

INGREDIENTS

¾-1 cup sugar
1 tbsp cornstarch
1 cup water
3½ cups sliced fresh fruit (for example apples, peaches or berries, plus juice)
½ tbsp butter
Pinch cinnamon

PASTRY

1 cup all-purpose flour
⅓ tsp salt
⅓ cup plus 1 tbsp shortening
2-3 tbsps cold water
½ tbsp butter, melted
Pinch cinnamon

METHOD

Combine the sugar, cornstarch and water and bring to a boil. Boil for 1 minute, then add the fruit and juice and cook for a further minute. Pour into a well buttered 1½-quart baking dish. Sprinkle lightly with the cinnamon and dot with the butter. Prepare the pastry by combining the flour and salt. Cut in the shortening until the mixture resembles coarse crumbs. Sprinkle in the water and mix gently until the dough can be formed into a soft ball. Roll out on a floured surface to a ⅛-inch thickness. Cut the dough into ½-inch-wide strips and arrange in a lattice pattern over the fruit. Brush the pastry with melted butter, sprinkle with cinnamon and bake at 400°F for 30 minutes, or until the cobbler is golden brown and bubbly.

DORIS BELCHER, MEMPHIS, TN

Facing page: the boiling waters of the Beaver River, Minnesota.

Left: Fresh Fruit Cobbler.

Left: the *Memphis Queen III* on the Mississippi near Memphis.

PUMPKIN PIE

American Indians taught the settlers about the pumpkin and it was one of the crops that helped to save their lives.

Preparation Time: 30 minutes
Cooking Time: 50-60 minutes
Makes: 1 Pie

INGREDIENTS

PASTRY
1 cup all-purpose flour
Pinch salt
¼ cup butter, margarine or lard.
Cold milk

PUMPKIN FILLING
1lb cooked and mashed pumpkin
2 eggs
1 cup evaporated milk
½ cup brown sugar
1 tsp ground cinnamon
¼ tsp ground allspice
Pinch nutmeg
Pecan halves for decoration

METHOD

To prepare the pastry, sift the flour and a pinch of salt into a mixing bowl. Rub in the fat until the mixture resembles fine breadcrumbs. Stir in enough cold milk to bring the mixture together into a firm ball. Cover and chill for about 30 minutes before use. Roll out the pastry on a lightly-floured surface to a circle about 11 inches in diameter. Wrap the pastry around a lightly-floured rolling pin and lower it into a 10 inch round pie dish. Press the pastry into the dish and flute the edge or crimp with a fork. Prick the base lightly with the tines of a fork. Combine all the filling ingredients in a mixing bowl and beat with an electric mixer until smooth. Alternatively, use a food processor. Pour into the pie crust and bake in a pre-heated 425°F oven. Bake for 10 minutes at this temperature and then lower the temperature to 350°F and bake for a further 40-50 minutes, or until the filling is set. Decorate with a circle of pecan halves.

PEARS IN ZINFANDEL

Zinfandel has a spicy taste that complements pears beautifully.

Preparation Time: 25 minutes
Cooking Time: 50 minutes
Serves: 6

INGREDIENTS

3 cups Zinfandel or other dry red wine
1 cup sugar
1 cinnamon stick
1 strip lemon peel
6 Bosc pears, even sized
4 tbsps sliced almonds
1 tbsp cornstarch mixed with 3 tbsps water
Mint leaves to garnish

METHOD

Pour the wine into a deep saucepan that will hold 6 pears standing upright. Add the sugar, cinnamon and lemon peel, and bring to the boil slowly to dissolve the sugar. Stir occasionally. Peel pears, remove 'eye' on the bottom, but leave

Above: Pears in Zinfandel.

INGREDIENTS

Favorite recipe for a 10-inch 1-crust pastry shell

FILLING
2 cups puréed butternut squash
2 whole eggs, beaten
1 cup sugar
¾ cup milk
½ cup heavy cream
¼ tsp salt
½ tsp each ginger, nutmeg, cinnamon and allspice
1 tsp grated lemon rind
1 tsp lemon juice
4oz butter, melted and cooled

WALNUT TOPPING
3 tbsps brown sugar
2 tbsps butter
1 tbsp milk
½ cup chopped walnuts

METHOD

Mix all the filling ingredients together well and pour into the unbaked prepared pie shell. Bake until a skewer inserted into the center of the filling comes out clean, about 1 hour 45 minutes. Before the pie cools, combine the topping ingredients and melt over gentle heat. Spoon over the pie and allow to cool completely before cutting to serve.

CRANBERRY PUDDING

This is a steamed pudding in the English tradition, made American by the use of cranberries and brought up-to-date by the addition of wheatgerm and honey.

Preparation Time: 25 minutes
Cooking Time: 1½ hours
Serves: 8

INGREDIENTS

1½ cups sliced cranberries
3 tbsps sugar
1½ cups whole-wheat flour
2 tsps baking powder
½ tsp salt
1 tbsp milk powder
¼ cup wheatgerm
2 eggs, well beaten
½ cup honey
⅓ cup milk

LEMON SAUCE
½ cup sugar
3 tsps cornstarch
1 cup boiling water
Juice and rind of 1 lemon
1 tbsp butter

METHOD

Place the cranberries and sugar in a bowl and leave to stand. Place all the dry ingredients in a large bowl and mix the liquid ingredients separately. Gradually add the liquid ingredients to the dry ingredients, stirring well. Fold in the cranberries and spoon into a well greased 2 pint pudding bowl or pudding basin. Cover with a sheet of wax paper and then seal the bowl or basin well with foil or a lid. Place on a rack in a pan of simmering water. Cover the pan and steam for 1½ hours. Check the level of the water occasionally and add more water if necessary.

on the stems. Stand the pears close together in the wine, so that they remain standing. Cover the pan and poach gently over low heat for about 25-35 minutes, or until tender. If the wine does not cover the pears completely, baste the tops frequently as they cook. Meanwhile, toast almonds on a baking sheet in a moderate oven for about 8-10 minutes, stirring them occasionally for even browning. Remove and allow to cool. When pears are cooked, remove from the liquid to a serving dish. Boil the liquid to reduce it by about half. If it is still too thin to coat the pears, thicken it with 1 tbsp cornstarch dissolved in 3 tbsps water. Pour syrup over the pears and sprinkle with almonds. Serve warm or refrigerate until lightly chilled. Garnish pears with mint leaves at the stems just before serving.

SQUASH PIE WITH WALNUT TOPPING

This is delicious change from the traditional pumpkin pie.

Preparation Time: 25 minutes
Cooking Time: 1 hour 45 minutes
Oven Temperature: 350°F
Makes: 1 10-inch pie

Facing page: Cranberry Pudding.

Meanwhile, prepare the lemon sauce. Mix the sugar and cornstarch together in a saucepan and stir in the boiling water gradually. Add the rind and juice of the lemon and bring to the boil. Stir constantly until thickened and cleared. Beat in the butter and serve warm with the pudding. If preparing the sauce in advance, place a sheet of wax paper or plastic film directly over the sauce to prevent a skin forming on the surface.

Right: Ala Moana Park, Oahu, Hawaii.
Above: Mango and Coconut with Lime Sabayon – a delicious blend of exotic fruit.

MANGO AND COCONUT WITH LIME SABAYON

The taste of mango with lime is sensational, especially when served with the deliciously creamy sauce in this stylish dessert.

Preparation Time: 40 minutes
Cooking Time: 8 minutes
Serves: 4

INGREDIENTS

2 large, ripe mangoes, peeled and sliced
1 fresh coconut
2 egg yolks
4 tbsps sugar
Juice and grated rind of 2 limes
½ cup heavy cream, whipped

METHOD

Arrange thin slices of mango on plates. Break coconut in half and then into smaller sections. Grate the white pulp, taking care to avoid grating the brown skin. Use the coarse side of

Facing page: Fresh Raspberries with Cream.

the grater to make shreds and scatter them over the mango slices. Place egg yolks and sugar in the top of a double boiler or a large bowl. Whisk until very thick and lemon colored. Stir in the lime juice and place mixture over simmering water. Whisk constantly while the mixture gently cooks and becomes thick and creamy. Remove from the heat and place in another bowl of iced water to cool quickly. Whisk the mixture while it cools. Fold in the whipped cream and spoon onto the fruit. Garnish with the grated lime rind.

GUAVA MINT SORBET

When a light dessert is called for, a sorbet can't be surpassed. The exotic taste of guava works well with mint.

Preparation Time: 2-3 hours including freezing
Makes: 3 cups

INGREDIENTS

4 ripe guavas
⅔ cup granulated sugar
1 cup water
2 tbsps chopped fresh mint
1 lime
1 egg white
Fresh mint leaves for garnish

METHOD

Combine the sugar and water in a heavy-based saucepan and bring slowly to the boil to dissolve the sugar. When the mixture is a clear syrup, boil rapidly for 30 seconds. Allow to cool to room temperature and then chill in the refrigerator. Cut the guavas in half and scoop out the pulp. Discard the peels and seeds and purée the fruit until smooth in a food processor. Add the mint and combine with cold syrup. Add lime juice until the right balance of sweetness is reached. Pour the mixture into a shallow container and freeze until slushy. Process again to break up ice crystals and then freeze until firm. Whip the egg white until stiff but not dry. Process the sorbet again and when smooth, add the egg white. Mix once or twice and then freeze again until firm. Remove from the freezer 15 minutes before serving and keep in the refrigerator. Scoop out and garnish each serving with mint leaves.

FRESH RASPBERRIES WITH CREAM

This is a simply prepared dessert with eye-appeal and lots of flavor. Any fresh berry or combination of berries lends itself easily to this recipe.

Preparation Time: 15 minutes

Right: Guava Mint Sorbet.

Serves: 6

INGREDIENTS

*3 cups fresh raspberries or a combination
of different berries
1½ pints fresh heavy cream*

METHOD

Select the raspberries or other berries as fresh as possible.
Pick over and discard bruised or damaged berries. Rinse only
if absolutely necessary. Arrange the berries carefully in
stemmed glass dessert dishes. Drizzle each serving with
2fl oz of heavy cream and serve.

CHEF STEPHEN MONGEON,
THE RED LION INN,
STOCKBRIDGE, MA

APPLE PANCAKE

These apple pancakes are similar to ones prepared in Germany
and also have something in common with the French fruit
and batter pudding called clafoutis.

Preparation Time: 30 minutes
Cooking Time: 25-28 minutes
Oven Temperature: 375°F reduced to 350°F
Serves: 6

INGREDIENTS

*2½ cups all-purpose flour
2oz shortening
8 eggs
1 pint buttermilk
1¾ tsps salt
1¾ tsps sugar
1¾ tsps baking soda
1½ tbsps baking powder
1 tbsp vanilla extract
1 tsp ground cinnamon
⅛ tsp ground nutmeg
2 tbsps melted butter
2 large MacIntosh apples, peeled, cored and diced
1 large MacIntosh apple, peeled, cored and sliced*

GLAZE

*6oz pure maple syrup
4 tbsps apple cider
2 tbsps melted butter
½ cup dark brown sugar*

METHOD

Combine all the dry ingredients and add the shortening, eggs,
buttermilk, vanilla, cinnamon, nutmeg and melted butter.
With a wooden spoon, mix all the ingredients together. Do
not over-mix; the mixture should look lumpy. Add the 2 diced
apples and fold into the mixture. Allow to stand for 15 minutes
before cooking.

Meanwhile, make the glaze. Combine the butter and cider
over a low heat and add the sugar, maple syrup and mix well.
Lightly brush 6½" French crêpe pans with softened butter.
Heat in the oven for 3 minutes. Remove the pans from the
oven and ladle in about 6 fl oz of the batter, bringing it to within
a ¼ inch of the top of the pan. Decorate each pancake with
4 of the reserved apple slices. Return to the oven for a further
10 minutes. Reduce the heat to 350°F and bake for 15-18
minutes, or until a skewer comes out clean from the center
when tested. Remove from the oven and allow to stand for